THE PELICAN HISTORY OF ART

Founding Editor: Nikolaus Pevsner

Joint Editors: Peter Lasko and Judy Nairn

Henri Frankfort

THE ART AND ARCHITECTURE OF THE ANCIENT ORIENT

Henri Frankfort was one of the foremost authorities in the world on the archaeology and history of
the Ancient Near East. A member of one of Sir Flinders Petrie's expeditions to Egypt in
1922, he remained there for seven years as Director of Excavations of the Egypt Exploration Society.
From 1929 to 1937 he took charge of the Oriental Institute of Chicago's excavations in
Iraq, where the city of Sargon of Assyria, at Khorsabad, and new sites north-east of Baghdad were
discovered and excavated. In 1938 Dr Frankfort went to Chicago to teach at the Oriental
Institute of the University, where he had been appointed Research Professor of Oriental Archaeology
in 1932. From 1949 until his death in 1954 he was Director of the Warburg Institute and
Professor of the History of Pre-Classical Antiquity in the University of London. His published works,
besides numerous articles, include *Archaeology and the Sumerian Problem*, *Kingship and the
Gods*, and *The Birth of Civilization in the Near East*.

Henri Frankfort

*THE ART
AND ARCHITECTURE
OF THE
ANCIENT ORIENT*

Penguin Books

Penguin Books Ltd, Harmondsworth, Middlesex, England
Viking Penguin Inc., 40 West 23rd Street, New York, New York 10010, U.S.A.
Penguin Books Australia Ltd, Ringwood, Victoria, Australia
Penguin Books Canada Ltd, 2801 John Street, Markham, Ontario, Canada L3R 1B4
Penguin Books (N.Z.) Ltd, 182-190 Wairau Road, Auckland 10, New Zealand

First published 1954
Second (revised) impression 1958
Third (revised) impression 1963
Fourth (revised) impression with additional bibliography 1970
First paperback edition, based on fourth hardback impression, 1970
Reprinted 1977, 1979, 1985

Library of Congress Catalog Card Number: 70-128007

ISBN 0 140561.07 2

Set in Monophoto Ehrhardt
by Oliver Burridge & Co. Ltd, Crawley, Sussex
Made and printed in Great Britain by
Butler & Tanner Ltd, Frome and London

Designed by Gerald Cinamon

CONTENTS

ACKNOWLEDGEMENTS

The author (who died in 1954, while the original hardback edition was still going through the press) was grateful to colleagues and heads of institutions who generously put photographs at his disposal or permitted him to reproduce illustrations. Their courtesy has been acknowledged in the list of illustrations. He was under an obligation to the John Simon Guggenheim Foundation which enabled him to revisit the Near East by the grant of a Fellowship. The book has profited greatly by the criticisms and suggestions of Dr Helene J. Kantor; by Miss G. Rachel Levy's revision of the text; and by the willingness of the publishers to have many of the text figures drawn especially. This work was carried out by Mr Donald Bell-Scott and Mr Paul White. The map was drawn by Mrs Sheila Waters.

This edition is based on the fourth (revised) hardback impression issued in 1970.

INTRODUCTION

Strictly speaking, a history of the art of the ancient Near East has never been written. Twenty-five years ago it would have been impossible to make the attempt, for most of the monuments illustrated in this volume have only been discovered since then. But even to-day a basic difficulty remains. There is nothing resembling the continuity of tradition which has preserved our familiarity with the art of classical antiquity. We may be attracted by the peculiar beauty of some Near Eastern works, and repelled by others; in either case they remain enigmatic, unless we acquire some insight into the spiritual climate and the geographical and historical conditions in which they were created. In other words, it is the archaeologist who must build the scaffold from which we can view these ancient monuments as works of art. Once this is done, we see in their proper light not only the individual works, but ancient Near Eastern art as a whole.

The art of the ancient Near East occupies a peculiar position, in that it brought into being many of the artistic categories which we take for granted. When, in Egypt or Mesopotamia, men built monumental temples or erected statues, or steles, they discovered modes of expression without precedent. These innovations in the field of art constitute but one aspect of a change by which prehistoric cultures were transformed into the first great civilizations.

For untold centuries the ancient Near East, like the rest of Asia, Europe, and North Africa, sustained a sparse population of farmers. They dwelt in small villages or homesteads which were self-supporting, self-contained, and practically unchanging. The crafts of agriculture and stockbreeding, spinning and weaving, flint-knapping and pot-making were known, and art consisted in the adornment of man's person, or of his tools and chattels. But between 3500 and 3000 B.C. two societies of an entirely different order emerged within this vast continuum of prehistoric village cultures. The Mesopotamians congregated in cities, the Egyptians united under the rule of a single divine king. Writing was invented, copper was employed for implements instead of stone, and trade with foreign countries assumed unprecedented proportions. It was then that monumental architecture and sculpture made their appearance.

The change took place almost simultaneously in Mesopotamia and Egypt, Mesopotamia starting a little earlier. It is certain that the two countries were in contact, and that Egypt was stimulated by the Mesopotamian example. Yet there is no question of slavish imitation. In fact it is characteristic of this pre-classical world that it possessed, at all times, two distinct centres. Egypt and Mesopotamia were the focal points of civilization from about 3000 until 500 B.C., when Greece took the lead. But from the very first the two centres showed different, and often contrasting, mentalities.

The other countries of the ancient Near East – Asia Minor, Syria, Palestine, and Persia – lack cultural continuity. Their art shows a succession of more or less promising starts which lead no-where. It may be that some of these peoples were not gifted in the plastic arts, for there is a

striking discrepancy between their artistic and their literary achievements. If we think of the poetic splendours of the Old Testament, or even of the poetry in the Ras Shamra texts, we shall look in vain for a single Syrian or Palestinian work of art that reaches comparable levels. But we must also remember that these countries were politically unstable. Small independent principalities were frequently established, only to succumb again to the armies of Egypt or Assyria, or to be overrun by barbarian hordes. In epochs of prosperity feverish attempts were made to equal the magnificence of Thebes or Babylon, so that the prestige of some local potentate might be enhanced. But under such conditions neither originality nor artistic maturity can be expected, and even the best of the various local schools are manifestly derivative. Asia Minor, Syria, Palestine, and Persia must, therefore, be treated as peripheral regions where art reflected – within narrow limits – the contemporary achievements of Egypt and Mesopotamia.

Yet their adaptations and combinations of borrowed themes show sufficient originality to be of interest, so much more since the peripheral regions served as transmitters of the Near Eastern repertoire to Greece. I could have made this relationship of the ancient Near East with Greece, and hence with Western art as a whole, my main theme. For while it is true that we are estranged from ancient Near Eastern thought by the sway which Greek philosophy and biblical ethics hold over our own, there has never been a corresponding break in artistic continuity. It would, in fact, be tedious to stress in this book every first appearance of an architectural device, a sculptural form, a decorative theme which has subsequently become part of the repertoire of Western art. But there are two reasons against placing this aspect of the ancient Near Eastern achievement in the foreground. It would, in the first place, have required a very full treatment of the minor arts. And, in the

second place, it would have reduced the history of ancient Near Eastern art to a mere prelude to that of classical antiquity, whereas ancient Near Eastern art deserves, on the contrary, to be studied for its own sake. And even if some of the works which will be illustrated here inadequately realize their obvious purpose, they possess the merits of experiments and discoveries and are significant in their consequences.

The structure of the ancient Near East determines the lines along which exposition must proceed. This volume will first follow the development of Mesopotamian art, and then discuss the peripheral schools to which it gave rise at various times. A separate volume is dedicated to Egypt.

The general reader may find that the interpretation of individual works, and the historical connexions between distinct schools and regions, are sometimes substantiated with more detail than he requires. But conclusions drawn from discoveries so recently made cannot hope to command general assent unless they are well founded. A more apodeictic style would, moreover, have given a false impression of finality.

*THE ART
AND ARCHITECTURE
OF THE
ANCIENT ORIENT*

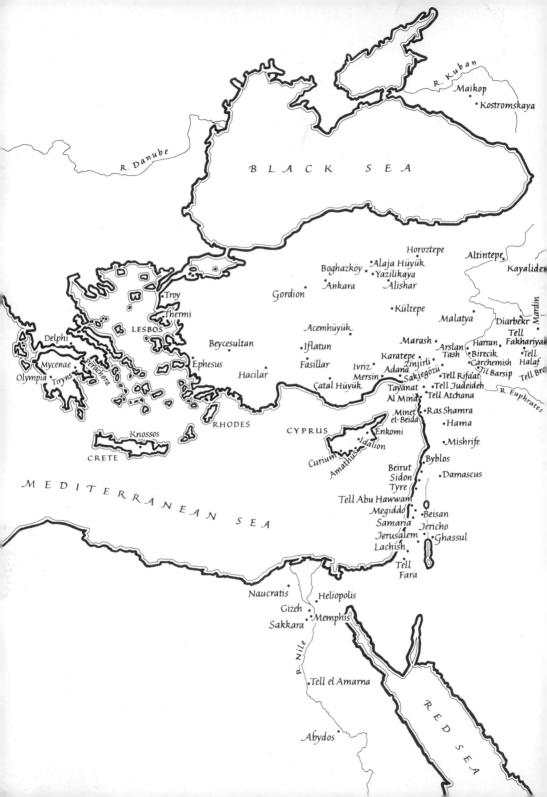

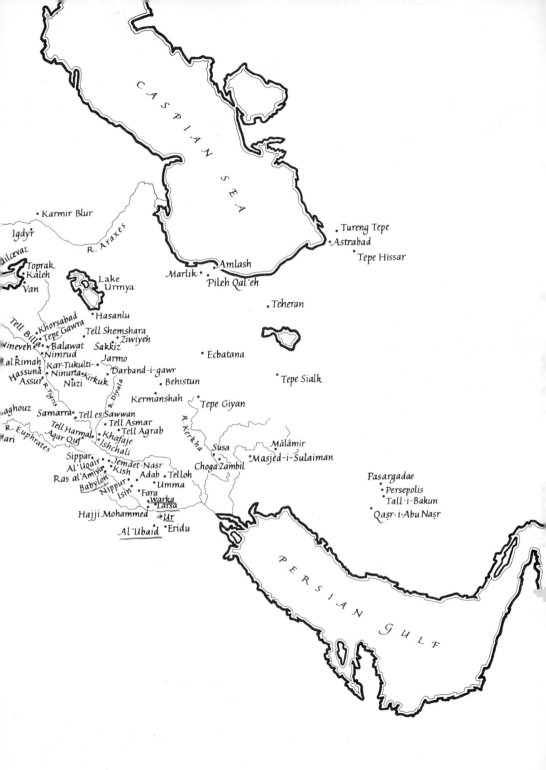

MESOPOTAMIA

CHAPTER I

THE EMERGENCE OF SUMERIAN ART:

THE PROTOLITERATE PERIOD[1] (CIRCA 3500–3000 B.C.)

INTRODUCTION

Mesopotamia is ill defined. To the west it fades into the emptiness of Arabia; in the north it can barely be separated from the fertile plains of north Syria, with which it is, indeed, connected by a main artery of caravan traffic along the Euphrates. Eastwards a wide range of foothills leading up to the Persian and Armenian highlands is under the influence of the people of the plains, but never wholly under their control.

The great transition from relative barbarism to civilization took place in the extreme south of Mesopotamia, in the region called Sumer or Shumer by its early inhabitants.[2] The earliest settlers had descended from south-west Persia, when a progressive change in the climate was slowly turning the highlands into deserts and the pools and reed swamps of the plain into marshes which were, here and there, inhabitable. The earliest settlers are called the Al 'Ubaid people,[3] after the place where their remains were first discovered, and the period of their predominance the Al 'Ubaid Period.[4] They were established in the plain, as is generally thought, by 4000 B.C., and may have arrived earlier. Farther to the north, where diluvial soil had provided dry land, immigrants from Persia had arrived at an even earlier age. Their distinctive pottery, found at Samarra on the Tigris, at Baghouz near Abu Kemal on the Euphrates, at Nineveh, at Hassuna, and a number of other sites in the north, is superior to that of the Al 'Ubaid people, and may serve here as representative of prehistoric art in Mesopotamia [1].[5] Its decoration consists chiefly of narrow zones

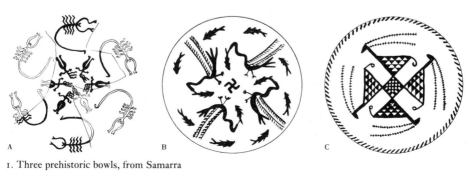

A B C

1. Three prehistoric bowls, from Samarra

closely packed with 'geometric' designs, but on the inside of plates or open bowls appear more ambitious compositions, which show a tendency to whirl-like movement. Notice the streaming hair of the women, and also the scorpions, of illustration 1A; the fishes and birds (which hold fishes in their beaks) of illustration 1B; and the swastika at the centre of illustration 1B, which joins in this pressure on the circle in one direction. Illustration 1C shows how the predilection for whirl-like designs transformed the Maltese cross, a common and suitable centre design for bowls, into a toy-wheel of goats, by the simple device of prolonging one side of each triangle and making it into a neck of a goat's head with backward-sweeping horns. A little tail (inappropriately shaped) was added to the opposite end of each triangle. This 'animation' of an abstract design is less common than the gradual transformation, in the course of copying, of a natural representation into an abstract pattern, which is best illustrated in the early pottery of Susa or Persepolis (illustration 394, and pp. 333 ff.), but both phenomena do occur, and it is as one-sided to explain all representations as later additions to an abstract repertoire as to deny, with some theorists, that the inherent rhythm of abstract designs has ever been spontaneously employed for decoration. It must be added that in Mesopotamia, as elsewhere, the finely decorated pottery of prehistoric times has no successor; it seems that the improvement of technique enabled stone and metal vessels to take the place formerly occupied by fine decorated pottery, and that from the Protoliterate Period onward plain pots of baked clay were used as kitchenware only.

The prehistoric clay figurines of men and animals do not differ in character from similar artless objects found throughout Asia and Europe. A history of art may ignore them, since they cannot be considered the ancestors of Sumerian sculpture. But Sumerian architecture has antecedents in the prehistoric age.

ARCHITECTURE

The natural conditions of the plain did not favour the development of architecture. It lacked timber and stone. For shelters, sheep-pens, huts, and the like, the tall reeds of the marshes could be used. Larger and more permanent structures had to be built from the one material that was everywhere available, and that in unlimited quantities – the alluvial mud of the plain. Mudbricks had been invented in Persia before the Al 'Ubaid people descended into the flat country: they were oblong, dried in the sun, and set in mud mortar when walls were constructed.

At Abu Shahrein, ancient Eridu, the successive phases of a temple have been recovered, which show development from a primitive to an advanced stage of architectural design.[6] The earliest layers contain a shrine measuring only about twelve by fifteen feet and of the simplest shape. But it contained two features which were never to be abandoned: a niche in one wall marked the place of the god's appearance, and perhaps already at this stage of his statue or emblem; and an offering table of mud-brick was constructed a little in front of the niche. In the course of subsequent rebuildings the temple was enlarged and improved; the thin walls were strengthened with buttresses, and although these were purely practical in origin, they were soon used to add some variety to the exterior of the building. Mud-brick is unattractive in colour and texture, but buttresses regularly spaced can produce contrasts in light and shadow which rhythmically articulate the monotonous expanse of wall. Within the Al 'Ubaid Period the transformation of a utilitarian device to an art-form was completed, and down to the Hellenistic Age Mesopotamian temples continued to be distinguished from secular buildings by buttresses and recessed walls. The early stages of this development were not confined to the south. At Tepe Gawra, in the north, a temple shows walls buttressed inside and outside [2];[7]

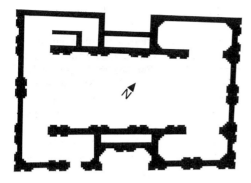

2. Tepe Gawra, temple in stratum XIII

the doorway opens between stepped recesses which effectively emphasize an entrance in a façade. Yet the position of the buttresses is obviously related to the problem of roofing the enclosed space. They occur where beams or rafters rest upon the walls, and although spaced more or less regularly, they have not become pure decoration.[8]

The temple of Tepe Gawra appears rather tentative and experimental when we compare it with the last temple built at Abu Shahrein (Eridu) during the Al 'Ubaid Period. This has left the earlier buildings far behind in its clear and purposeful plan[9] [3]. The central space – the cella or actual shrine – is clearly set off from the subsidiary rooms located in the corner bastions. The buttresses have become a regular feature of the outer walls. An altar, placed against one of the short walls, is faced by an offering-table. The building is entered through one of its long walls by means of stairs leading up to the platform on which it is placed. All these features remain distinctive of Mesopotamian temples in subsequent periods.

Since writing was unknown at the time, we cannot know what god was worshipped in this shrine. But there is at least a likelihood that it was Ea, who was the chief deity of Eridu in historical times. This god was manifest in the sweet waters ('he has built his chamber in the deep'). And since water is beneficial, since, moreover, it 'avoids rather than surmounts obstacles, goes round, and yet gets to its goal',[10] Ea was worshipped as the god of wisdom, of

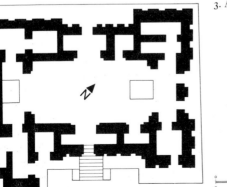

3. Abu Shahrein, temple VII

helpful magic and medicine; a friend to man. Now, at Eridu the offering-table and the floor of the shrine were at one stage found to be covered with a thick layer of fishbones. This suggests that even in the Al 'Ubaid Period the god was revered of whom it was said:

When Ea rose, the fishes rose and adored him,
He stood, a marvel unto the deep . . .
To the sea it seemed that awe was upon him;
To the Great River terror seemed to hover
 around him
While the south wind stirred the depth of
 the Euphrates.[11]

The layout of the shrine would not disclose whether or not it was dedicated to Ea. The same type of structure served all the gods, and there is no doubt that this type was evolved from that found at Tepe Gawra and Eridu. The subsequent development begins with the transformation of the prehistoric peasant society to one of a more complex order, a change to which we have referred in the Introduction. The new epoch is called the Protoliterate Period, because the invention of writing was one of its most momentous innovations. Another was the founding of cities and, with it, the formation of the political entity characteristic of Mesopotamia – namely, the city-state. The social life of a community which remained agricultural in essence was henceforth concentrated in the towns.

However, Sumerian society was not secular, and the towns were dominated by one or more shrines [36, 115]. Their structure, their very appearance, revealed a basic belief (explicitly stated in Sumerian poetry and in the Babylonian Epic of Creation) that man was created to serve the gods. The city was a means to this end; each township was owned by a deity in whose service the community enjoyed prosperity.

At Warka, the biblical Erech, this conception found a grandiose expression. A temple of the Protoliterate Period, preserved by an extraordinary chance,[12] and probably dedicated to the god Anu, repeats in its plan [4] the main features of the shrine at Eridu [3], but the process of clarification has proceeded farther. The corner bastions are gone and the plan has become a simple oblong decorated with a uniform system of buttresses and recesses. The principal change, however, appears in the elevation. The platform found at Eridu is here replaced by an artificial mountain, irregular in outline, and rising forty feet above the featureless plain, a landmark dominating the countryside for miles around [5]. Its corners were orientated to the points of the compass. Access was by a stair built against the north-eastern face and leading to the summit.[13] There, on a terrace without parapet, where sun and wind ruled unchallenged above the vast expanse of fields and marshes, stood the small whitewashed shrine.[14] Its outer wall shows multiple recesses, strengthened with short round timbers, between the buttresses.[15]

A step at the south-western side leading to the top of the plinth marked the entrance. One passed through a vestibule which was one of a series of small rooms placed along the long sides of the building, and reached the cella at its centre. In one corner stood a platform or altar. It was four feet high, and a flight of small narrow steps led up to it. In front, at a little distance, was an offering-table of brick, and a low semicircular hearth had been built up against it. The interior of the shrine was decorated with recesses, and the sloping sides of the artificial mound also show shallow recesses between buttresses of brick.

The huge communal labour which went into the building of this sanctuary did not serve a purely architectural purpose. It was an attempt to bridge the chasm which separates humanity from the gods. The Mesopotamian deeply felt the enormity of the presumption that man should offer residence to a deity, and the gigantic effort spent on the erection of a temple tower may well have strengthened his confidence that contact with the superhuman powers would be achieved. In any case, the temple tower (or Ziggurat)[16] was sacred. The names by which some

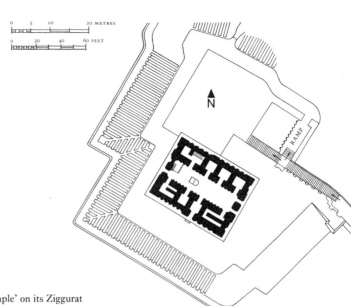

4. Warka, the 'White Temple' on its Ziggurat

5. Warka, the 'White Temple' on the archaic Ziggurat

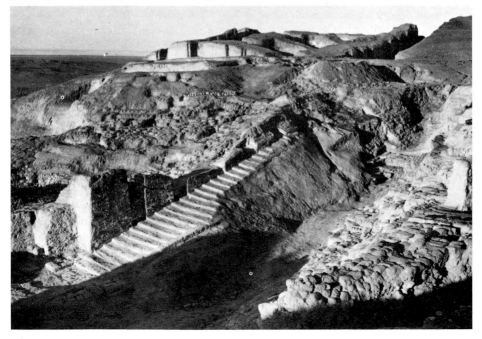

of them were known in later times have been preserved, and they indicate that they were intended not merely to resemble, but to be, 'mountains'. The Ziggurat of the storm god Enlil was, for instance, called 'House of the Mountain, Mountain of the Storm, Bond between Heaven and Earth'. But in Mesopotamia 'mountain' was a religious concept of many-sided significance. It stood for the whole earth, and within it, therefore, were concentrated the mysterious powers of life which bring forth vegetation in spring and autumn, and carry water to dry river-beds. The rains, too, come from the mountains, and the Great Mother, source of all life, is named Ninhursag, Lady of the Mountain. The mountain, then, was the habitual setting in which the superhuman became manifest, and the Sumerians, in erecting their Ziggurats with an immense common effort, created the conditions under which communication with the divine became possible.

The shrine on the top of the Ziggurat was called Shakhuru, which means 'waiting-room' or 'room one passes through'.[17] In the temples on ground level this name was given to the antecella, the room before the Holy of Holies [114, left bottom], where the faithful awaited the opening of the cella and the epiphany of the god. It seems, therefore, that the temple on top of the Ziggurat was thought to be a hall, where the manifestation of the god was likewise awaited. We do not know whether the Anu Ziggurat at Warka possessed a second temple on ground level, as was the usual arrangement in later times.

However this may be, and although not all sanctuaries included a temple tower or Ziggurat, all were given a token elevation above the soil. A temple at Al 'Uqair which was contemporary with, and of precisely the same dimensions as the temple on the Anu Ziggurat at Warka, stood on a platform but fifteen feet high.[18] It was irregular in ground plan, like the Ziggurat at Warka, but it rose in two distinct stages. In this respect it resembled the Ziggurats of later times,

which were staged towers with the shrine placed upon superimposed blocks of masonry, each smaller than the one below. Herodotus, when he visited Babylon, saw a temple tower with seven stages, each painted a different colour. Since these later Ziggurats resemble the platform of Al 'Uqair in possessing distinct stages, and that of Warka in being of great height, we may conclude that elevation and staging became conventional characteristics, but that they had at first been optional, and that the two Protoliterate shrines at Warka and Al 'Uqair did not differ in essentials. The significance of the Ziggurat was symbolical, and the symbolism could be expressed in more than one way. The same idea, which was unequivocally expressed in a high artificial mountain, could also be rendered by a mere platform a few feet high. One might call the platform an abbreviation of the Ziggurat, if that wording did not suggest that the Ziggurat was the earlier form. That, however, is by no means certain; in fact, it is more probable that the platform of the earliest temples at Eridu, of the Al 'Ubaid Period, already represented the sacred 'mountain'. We may perhaps assume that it was only the unprecedented man-power which the foundation of cities put at the disposal of the leaders of the community which enabled the men of Warka to give to the fundamental notion of their sacred architecture such concrete expression.[19]

The shrine we have just described was not the only one built at Warka in Protoliterate times. The sacred precincts of the goddess Inanna, the 'Lady of Heaven', called Ishtar by the Semitic-speaking inhabitants of Mesopotamia, was situated close by the Ziggurat of Anu. The ruins of Eanna, the precinct of the Great Mother, have yielded large temples of similar tripartite plan and certain details of architectural decoration to which we shall return [8,9].[20] At another site, Khafaje, we find modifications of the original plan, as known at Al 'Uqair and Warka [4]. This plan, open to all sides, was ill suited for a shrine

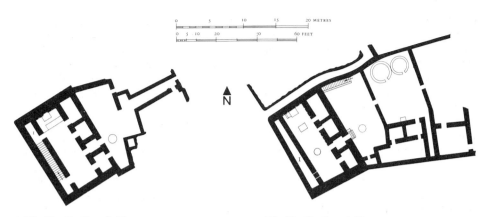

0 5 10 15 20 METRES

0 5 10 20 30 60 FEET

N

6. Khafaje, Sin Temple II

7. Khafaje, Sin Temple V

situated among houses, but its adaptation in fact changed its character. At first [6] the temple was given an entrance at one side only, and the openings of illustration 4 became mere niches in the outside walls. At the opposite side of the shrine a suite of small rooms had corresponded exactly with those near the entrance vestibule. At Khafaje [6] this second suite of rooms has been replaced by a single narrow space accommodating a stair to the flat roof and a store-room underneath the stair.[21] But in addition to these internal changes some organization of the area adjacent to the entrance had become necessary. A number of activities connected with the religious service were carried out on the open spaces of the Anu Ziggurat at Warka. Tethering-rings built into the ramp leading to the top[22] indicate that sacrificial animals were temporarily tied there. But where a temple was constructed among houses, space had to be found for such purposes within the built-up area. We observe at Khafaje that an irregular plot of ground, such as happened to be available, was walled in to serve as a forecourt [6]. In illustration 7, a later stage of the same building, three successive courts were walled off, each accommodating against its southern wall storerooms, offices, and other quarters required by the temple staff.

Bread-ovens were placed in the second court, while the innermost court now contained the staircase to the roof which had formerly occupied the south-western space beyond the cella. That space (marked 1 in illustration 7) was blocked up and disused, probably to prevent a continuous coming and going through the sanctuary – for during summer the early hours of the day and the evening and night are passed on the roofs. The purely practical change in the plan of the temple – the development of forecourts, the blocking of entrances, the disuse of the space beyond the cella – had the effect of changing the character of the shrine. From an isolated building open on all sides [4] it became a complex structure, in which the cella was no longer the central feature, but an innermost sanctuary.

As it happens, we cannot follow this development at Warka, but another feature of Proto-literate architecture is well represented there, while it survives in small fragments only on other sites: its mural decoration. At Warka we can study an amazing and highly original attempt on the part of these early builders to disguise the ugliness of the material which they were forced to use. We have already seen how they used recesses and whitewash, expedients which remained popular down to Hellenistic times. They

are fully compatible with the austere, massive, rectangular forms which imparted monumentality to the public buildings of Mesopotamia. But the architects of Protoliterate times experimented with two additional methods of decoration: a plastic enrichment of the walls, and patterned colouring. The first expedient, which really does violence to the character of brick architecture, was revived only on one or two later occasions.[23] Polychromy, on the other hand, became common towards the end of the second millennium B.C., when the Assyrians had learned the art of glazing on a large scale and used coloured (and sometimes moulded) glazed bricks to produce figured panels or to cover whole wall surfaces.

The methods of the Protoliterate builders, however, were different from this. They covered walls, and even the columns of a colonnade (columns measuring nine feet in diameter) and the semi-engaged columns of adjoining walls [8] with a coloured and patterned weather-proof

8. Warka, columns covered with cone mosaics

skin. This consisted of tens of thousands of small clay cones, about four inches long, separately made, baked, and dipped in colour, so that some had black, some red, and others buff tops. These cones were inserted side by side in a thick mud plaster in such a way that zigzags, lozenges, triangles, and other designs appeared in black and red on a buff ground. After a while the technique was simplified [9]; the cones were only used in flat rectangular panels which were framed by edgings of small baked bricks. In this way a great deal of labour was saved, but the weird, exuberant richness of the earlier mosaics could not be achieved. It is even possible that the most accomplished examples of the earliest method have been entirely lost (many more cones have been found loose in the soil than were retained in their original positions), and that these included representational designs as they existed in the later phase when baked brick edgings framed the panels. At that time there were also plaques of baked clay in the form of rosettes and of goats and heifers. These plaques were entirely covered with circular reed impressions, as if to suggest that they consisted of separate cones,[24] and it therefore seems likely that prototypes composed of such separately inserted cones had once existed. Their subject – rows of animals – recurs in the contemporary temple at Al ʿUqair, not in the form of cone-mosaics but of wall paintings. The geometrical motifs of illustrations 8 and 9 are also repeated at Al ʿUqair in paintings. They adorn the walls and the front of the altar. The meaning of the friezes of animals and rosettes will become clear when we consider the works of sculpture found in these temples.

APPLIED SCULPTURE AND RELIEF

Sumerian art, although born in the newly founded cities, expressed man's unshakeable attachment to nature. The gods were manifest in sky and earth and water, in moon and sun, in storm and lightning. The public festivals cele-

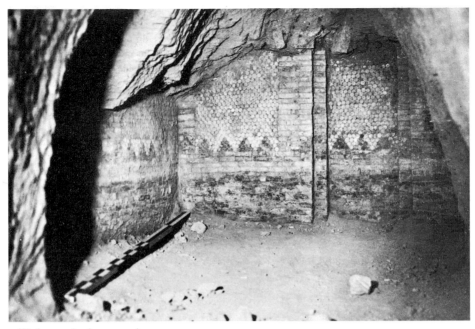

9. Warka, panels of cone mosaics

brated the main events of the farmer's year, the most important religious occasion being the New Year festival, held at the critical turn of the seasons, when, after winter, or after the much more terrible summer, nature's vitality was at its lowest ebb and all depended on the turn of the weather. During the sterile season the god who personified generative force, and who is best known as Tammuz, had vanished or died; and the Great Mother, who was worshipped at Warka and throughout the land, had suffered a bereavement in which the people shared. They found expression in public wailings and in the rites of mourning and atonement which opened the New Year celebrations. In the course of the festival, which lasted several days, the god was discovered, liberated from the land of death and resurrected. Then the sacred marriage of the divine couple ensured nature's fertility and man's prosperity for the coming year.

It is this festival which is depicted on an alabaster vase [10,11], over three feet high, which was found in temple ruins of the Protoliterate Period at Warka. The main scene appears in the uppermost band, and the lower registers seem at first sight to be mere decoration. Its elements are, however, appropriate to their setting.[25] The lowest band consists of plants and animals in which the goddess is manifest and which sustain man: ears of barley alternate with date-palms, and sheep with rams. The next frieze shows men bringing gifts, naked, as was common then and throughout Early Dynastic times when man approached the gods. The many small differences between individual figures destroy, on closer scrutiny, the impression of a merely orna-

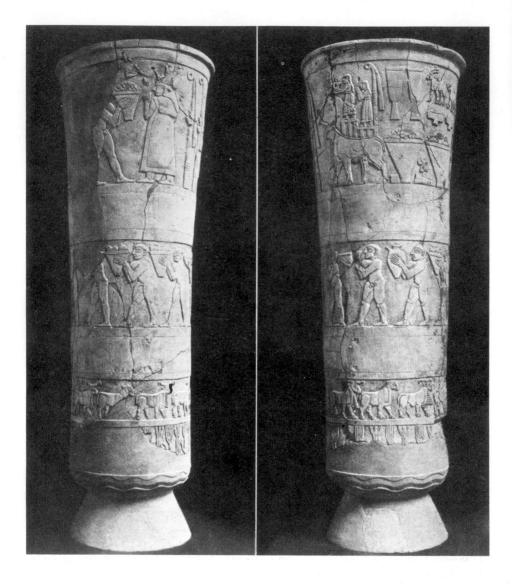

10 and 11. Vase, from Warka. Alabaster.
Baghdad, Iraq Museum

mental frieze, and one notices that even here the figures are rendered with such vigour and directness that they seem vibrant with the excitement of the occasion, and therefore intimately connected with the main scene. Of this a few fragments are unfortunately missing, above and before the figure of the goddess, and we do not know, therefore, whether she wore the horned crown which distinguished the gods on later monuments. She is receiving a basket of fruit, like those carried in the frieze below. Behind her stand two reed bundles bound in a peculiar fashion; they identify her, for such a bundle is the pictographic prototype of the character with which her name was written in historical times. The presenter of gifts who appeared behind the naked priest is lost; this was probably the bearded person of a king, or leader, known from seal engravings of this period [25A]. He offers her, as a suitable wedding gift, a richly decorated and tasselled girdle, of which one end is well preserved [cf. 27].

Behind the goddess other gifts are piled up – mostly in pairs. There are two vases, shaped like the one whose decoration is here described and which we know, from fragments found, to have

a problematical object, either an ideogram or, more likely, a piece of temple furniture. It consists of the large figure of a ram supporting a two-staged Ziggurat or temple platform, shown by reed bundles to be a shrine of the goddess. Upon it stand a man and a woman.[27]

In this frieze the goddess is not, or is hardly, larger in size than her worshippers, as she would be in an Egyptian rendering of such a scene. Her appearance in the frieze does not interrupt the continuous design which encircles the vase. But the main subject, far from being submerged in a decorative scheme, merely crowns a design which in all its constituent parts reflects with a peculiar intensity the profound significance of the ritual which it depicts. By its subject and style it allows us to perceive the spiritual climate in which the art of this period came into being.

Vividness and vigour mark all the works of this great creative age; and the carving of figures shows, moreover, certain distinctive features. The stocky, muscular men with their emphatic but not entirely balanced stride recur on contemporary seals [27]. The animals of the lowest frieze are matched by those carved on the side of a stone trough [12], an object which probably

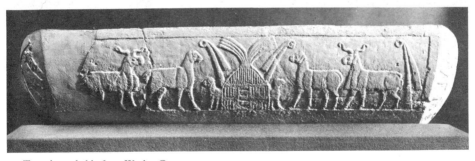

12. Trough, probably from Warka. Gypsum.
London, British Museum

been one of a pair. We see, moreover, two vases, in the shape of a goat and a lion respectively, and recognizable as vessels by the rimmed opening on the animals' backs.[26] In front of these gifts is

served to water the temple flock. Their pen, plaited of reeds, resembles the present-day dwellings of the Marsh-Arabs.[28] But it is crowned, not only by the uncut flowering ends

of the reeds, but also by the bundles which proclaim it sacred to the goddess. Lambs leap forth from the pen to meet the returning flock. On the sides of the trough are flower rosettes which represent the vegetable kingdom of the goddess.[29]

We have seen that rosettes and herbivorous animals in terracotta were used as architectural decoration in the temple. There were also friezes of rams carved in stone, with holes drilled into their backs so that they could be attached to the wall by means of copper wire.[30] The spectator sees their bodies in profile, but they turn their heads towards him, as does the ram in illustration 13. This particular figure has dowel-holes in the base and a silver rod rising from its back.

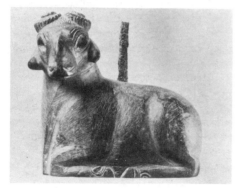

13. Ram-shaped support, from Warka.
Berlin Museum

14. Head of a ewe, from Warka. Sandstone.
Berlin Museum

It served as support of an offering stand or incense burner. We do not know the purpose of the figure to which belonged the splendid sandstone head of illustration 14, with the beautiful rendering of the ears, the bold curves of forehead and face, and the soft prehensile lips.[31]

During the latter part of the Protoliterate Period both the subjects and the style of carving changed. The thin, finely modulated relief was displaced by coarser, flat relief with incised instead of modelled detail;[32] or it was combined with a relief so heavy that parts of it appear to be modelled in the round. At the same time new fantastic subjects disturbed that serenity of natural life which was the exclusive concern of the earlier works. The bowl of illustration 15 exemplifies only the change in style. Its subject is the well-established combination of herbivorous animals and plants[33] – here a bull with an ear of barley, four times repeated round the vase – which evokes the goddess or the god. But the heads of the bulls project from the vase, they are almost worked in the round, and this device recurs on a number of sculptured stone vases. The bodies of the animals are no longer rendered by modelling, but incised lines are used to bring out the details. They are inexpressive and conventional. For instance, the twice-scalloped line on the bull's thigh is mechanically repeated in

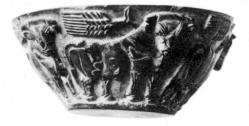

15. Stone bowl decorated with bulls and ears of corn.
Baghdad, Iraq Museum

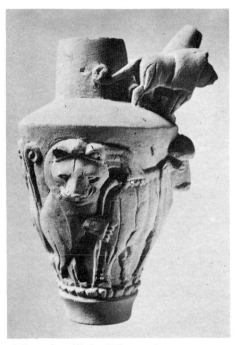

16. Ewer, from Warka. Yellow sandstone.
Baghdad, Iraq Museum

reliefs throughout this period. It recurs on the ewer of yellow sandstone of illustration 16; here, however, the advantages of the bold new relief, the striking contrasts of light and shadows, are apparent. But the gain is more than offset by the coarsening of the relief, shown at its worst in the clumsy rendering of the lions' fore-paws.[34]

That the rich and showy effects of the new type of relief expressed the taste of the later part of the Protoliterate Period is shown by a group of vases of dark stone, decorated with inlays of shell, red jasper, and mother of pearl.[35] The same colour scheme and the same type of geometric decoration are found in pottery. The vessels are covered with a red wash, but on the shoulder the natural colour of the clay is left visible to form the buff background for panels of geometric design executed in red and black. This three-colour scheme is identical with that of the cone mosaics and of the paintings in the temple of Al 'Uqair.

We have said that the stone vases reveal a change of subject as well as a change of style. The ewer of illustration 16 introduces the theme of combat which remained a popular subject in Mesopotamian art in all later periods. We do not know what the attack of the lions on the bulls signifies; in later times all kinds of fantastic creatures take part in the struggle. We do know that the Mesopotamians took a grim view of the world, and saw it as a battle-ground of opposing powers. It is unlikely that the ewer merely depicts the trivial occurrence of the depredations of beasts of prey among the herds; for an Elamite seal of this period shows two equivalent groups: a bull dominating two lions and a lion dominating two bulls [25C]. A lion-shaped vase appears among the gifts of the goddess in illustrations 10 and 11 to whom cattle were sacred. Ishtar, in later times, was a goddess of war as well as of love. The terrifying nature of the divine was at all times present to the mind of the Mesopotamians, as we know from their literature. It is probable, therefore, that the struggle between

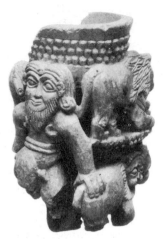
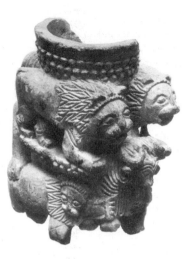

17 and 18. Cup with sculptured figures, from
Tell Agrab. *University of Chicago, Oriental Institute*

lion and bull stands for a conflict between divine forces, and one may surmise that the lion represents the destructive aspect of the Great Mother, an aspect which was recognized but believed to be held in check as a rule. It is generally re-strained by two creatures, of whom one, a bull-man, has not yet been found on Protoliterate monuments. The other figure, a naked hero, occurs commonly at this period [17–19]. In illustrations 17 and 18 he is shown holding two

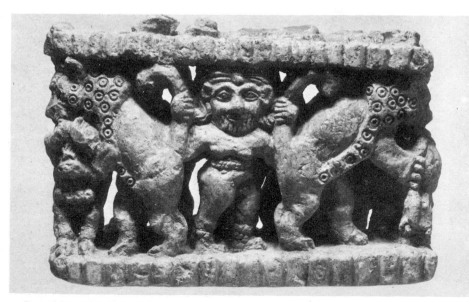

19. Base of cup with sculptured figures,
from Tell Agrab. *Baghdad, Iraq Museum*

lions with his hands, having tucked the tails of another pair of lions under his arms. He is hardly a mere mortal, in spite of all the homely detail of his rope girdle and mountaineer's shoes with upturned toes [19].[36] Nor is the victim of the lions an ordinary animal. He is a bearded bull, a mythological creature of unexplained character.[37] His head, beard, and forefeet form the narrow side of the object in illustration 19, and the attacking lions rest their front paws on his back. The object itself, like that depicted above, is the elaborately carved support of a vessel used to place offerings before the gods. In illustrations 17 and 18 the cup is visible. In illustration 19 only the lower tier of a carved support is preserved. The cup was placed on the upper tier among further carvings which are also lost. The change from flat modelling to high relief has here reached its extreme. The removal of all background [19] and the freeing of the figures [17,18] without destroying their peculiar flatness illustrate a characteristic of such an experimental phase as the Protoliterate Period in

Mesopotamia (and the First Dynasty in Egypt), namely a confusion of the various categories of artistic expression, the potentialities and limitations of each category being only gradually recognized.

SCULPTURE IN THE ROUND

We have met sculpture in the round used as architectural decoration in illustrations 13 and 14. No such use can be imagined for the three works which must now be discussed. Illustration 20 shows a woman's head, or rather face, for the stone is flat at the back, with drill holes for attachment to a statue presumably of wood. The head must have been very nearly life-size (the face is eight inches high) and was found at Warka. By analogy with later usage one assumes that the eyebrows were inlaid with lapis lazuli and the eyes with shell eyeballs and lapis lazuli or obsidian pupils. The flat ridges that mark the hair and the deeply-cut parting were originally overlaid with a sheet of gold or copper which

20. Head of a woman, from Warka. Marble. *Baghdad, Iraq Museum*

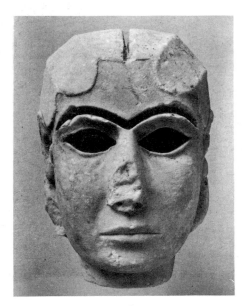

was fastened with small metal studs, in holes drilled into the stone in inconspicuous places; one is visible on the right below and behind the ear. The hair was no doubt rendered by fine engraving in the metal, so that the present unsatisfactory contrast between the subtly modelled face and the large flat ridges of the hair does not express the artist's intention. In fact the extraordinary sensitivity with which the face is modelled – the smooth forehead, the soft cheeks, the noble mouth – was almost certainly offset by a colourful setting, a statue of other materials in which only the exposed flesh of the face was rendered by the luminous marble.

We do not know whom this figure can have represented, or even whether a goddess or a mortal appeared in such exalted beauty. Nor is there another work to match it.

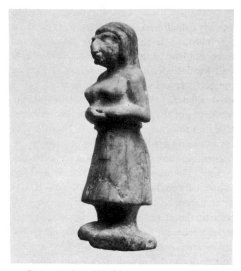

21. Statuette, from Khafaje.
Baghdad, Iraq Museum

22 and 23. Monster. Crystalline limestone.
Brooklyn Museum, Guennol Collection

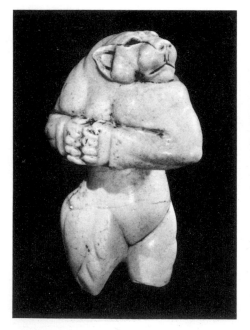

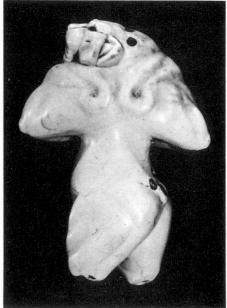

To the latter half of the Protoliterate Period belongs a small statuette (four inches high) from Khafaje [21]. It shows a woman with a bare torso and hair hanging loosely down the back, with hands folded in the attitude assumed before the gods. It lacks the restraint of the head of illustration 20, but shares its exactness in the rendering of the physique of the model. This tendency towards naturalism, which merely enriches the plastic forms of the head, appears in the little figurine as a kind of irrepressible vulgar vitality. The woman stands with her bare feet four-square on the ground and the head is poised quite naturally. This freedom of pose and the realistic modelling of the breasts and the posterior were never found in later times. The eyebrows are not joined (as always later), but are heavy, the cheeks are fleshy; the large nose, damaged at the tip, looks more excessively hooked than was intended. Like Egyptian works of the corresponding stage of development, the Mesopotamian sculpture here described lacks the later discipline of style, but achieves an effect which could not even be attempted once an established convention had defined artistic aims more closely.

The third work of sculpture in the round which survives is likewise small but of a different order [22, 23].[38] It represents a daemonic being, and stands at the head of a long line of monsters which appear in all the great periods of Mesopotamian art and convincingly express the terror with which man realized his helplessness in a hostile universe. The monster of illustrations 22 and 23 denies one even the comfort of recognition: viewed as anthropomorphic the body appears bestial, but if one views it as a lioness it has a ghastly air of mis-shapen humanity. There is, however, no uncertainty about the cruelty of the mouth on the point of baring its fangs while the clutched claws unbend.

It is paradoxical that this vision of terror has been carefully embellished with pellets of lapis lazuli inlaid at the tail and in the mane. It shares this feature with amulets of the period,[39] and it may well be that our figure, too, had an apotropaic function. The lines of the muscles at the shoulder-blades suggest the symbol of the mother goddess,[40] and once again we suspect that her destructive aspect has here found expression in art.

COMMEMORATIVE RELIEF

The stele of illustration 24 should, as far as we can judge, be considered a secular work. It is a boulder, now chipped and damaged at the edges, and must have been brought to Warka from abroad, since it is black granite. It is smoothed on one side and shows two scenes carved in the flat relief of the latter half of the Protoliterate Period. It resembles the figurine of a woman

24. Stele, from Warka. Granite.
Baghdad, Iraq Museum

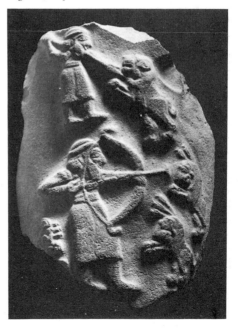

from Khafaje in the naturalness and vivacity of the poses; note, for instance, how the archer, in taking aim, draws in his head between his shoulders. The hunter appears in the dress and with the distinctive coiffure which characterize leaders, perhaps kings, on Protoliterate monuments, and which remained in use for princes until the times of Sargon of Akkad [74, 75, 88, 89]. The hunter is shown destroying lions with spear and arrows. If we realize that with this monument the commemorative stele makes its first appearance in the history of art, the events which it commemorates seem hardly adequate to explain the innovation. There again we must acknowledge some uncertainty as to their meaning. Two and a half millennia later Assurbanipal displayed his courage and skill in killing lions [211, 212], but one does not expect this emphasis on the sportsmanship of a ruler in the very period when cities were being founded and

when communal life seems to have been stronger than at any other age. Is it possible that the battle with wild beasts was a phase in the reclamation of marsh and wasteland indispensable to the development of the city-state, so that the valour of this leader deserved to be commemorated by a public monument? If so, it is odd that neither the 'king' nor the occasion is specified, although writing was known at the time and was extensively used in the administration of the temples. This anonymity would seem to nullify the effect of the monument, and appears even odder if we remember that in Egypt the first steles, as well as other historical reliefs, are inscribed with the name of the ruler who erected them and often also with the name of his defeated enemies or of the locality.[41] The same anonymity attaches to another historical record of the Protoliterate Period. It shows a 'king' leaning on his spear upon the battle-field among

25. Seal impressions of the Protoliterate Period

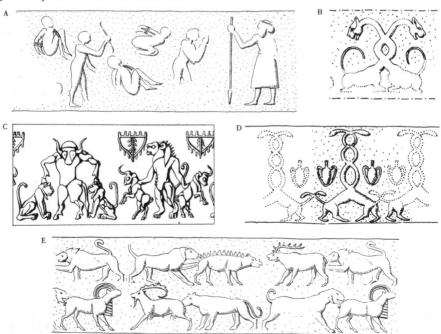

bound captives and enemy dead. This scene was engraved upon a cylinder less than two inches in height and employed as a seal; in fact, several impressions of clay sealings were used for the partial reconstruction of the design in illustration 25A.

CYLINDER SEALS

The scene of illustration 25A would seem unsuitable to a seal design, because a seal does not offer scope for epic treatment. Its appearance among glyptic designs once again emphasizes the fact that in the formative phase of a new movement in art the distinctions between the categories are still vague.

The Mesopotamian seal has a peculiar shape [26], a small cylinder engraved on the outside, and thus impressing its distinctive design when rolled over the clay of a tablet or of the sealing of a package of merchandise. The awkward problem of inventing designs for such seals seems to have been congenial to the Mesopotamians and to have challenged their ingenuity. Elsewhere, for instance in Greece, the seal-cutters are often believed to have been inspired by extant works of painting or sculpture, but Mesopotamian mural paintings and other large-scale decoration, on the contrary, often seem to depend on the compositions of the seal engravers. It is for this reason that we must consider the seals in some detail, quite apart from the fact that they display the inventiveness and the originality of the Mesopotamian designers most strikingly.

It is clear that the design on a cylinder seal can be seen in its entirety only when one turns it in one's fingers. For instance, the cylinder in illustration 26 shows a 'king' feeding the herd of the temple. He is depicted with an ear of barley in each hand facing six head of cattle, in two rows of three, and he is followed by a servant carrying a further supply of barley.[42] Of all this only a fraction appears in our plate. Seal designs

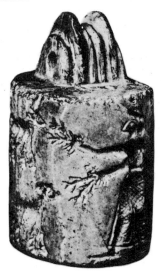

26. Cylinder seal.
Paris, Louvre

can be made available for study only by illustrating, not the seals, but their impressions. Illustrations 25–9 illustrate the variety of Protoliterate seals.

We find, in the first place, narrative scenes like the feeding of the temple herd which we have just described, or a ceremony near a temple [27]. But this type of design has great disadvantages, for the surfaces covered by the impression will, in practice, hardly ever coincide precisely with the circumference of a seal. A sealing on a bale of goods will be narrow and take only part of the impression; a clay tablet may be wider and take more than a single revolution of the cylinder. In the first case only part of the narrative will appear; in the second case there will be repetition of fragments on one or both sides of the scene. The latter is the case in illustration 27; the temple should appear only once, and that in the middle of the impression, with the three large figures approaching from the right and the boat from the left.

The disadvantages of a narrative may be overcome if the importance of the subject is so reduced that incomplete or redundant fragments do not matter. The animal frieze is an example of this. But to be really satisfactory the cylinder design must possess an inner harmony capable of asserting itself even within mere fragments. An attempt to achieve this is shown in illustration 25E, where the groups of animals attacked by beasts of prey face in different directions, so that there is a play of antithetical correspondences which effectively unites the whole composition. As a rule this result is best achieved by closely interwoven heraldic groups such as illustrations 25B, C, and D, and 28. The two ibexes of illustration 29, to analyse just one

design, cover the whole circumference of the seal,[43] but their repetition merely enlarges a harmonious whole without disturbing its beauty. Both facing and averted the animals make a splendid symmetrical pattern, and the hiatus that would otherwise occur on either side is filled, once by an eagle with spread wings, and once by a pair of copulating vipers and a flower. In illustration 28 the even spacing and continuity of the design are obtained by the intertwining of the necks and tails of the monstrous quadrupeds, and only the space above required a filling motif, which was supplied by the lion-headed eagle.

The seal last described again illustrates that decline in quality which distinguishes the

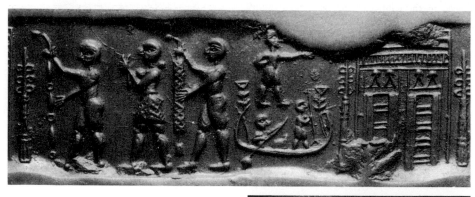

27. Cylinder-seal impression.
New York, Nies Collection

28. Cylinder-seal impression, from Tell Billa.
Baghdad, Iraq Museum

29. Cylinder-seal impression.
Baghdad, Iraq Museum

second half of the Protoliterate Period from its earlier phase. It may be due to the great demand for seals caused by a rapidly expanding economy; tablets now increase in numbers and are found even abroad. In the seal of illustration 28 a bow drill has been used to hollow out the main mass of the figure. In earlier times this procedure had left no trace. But in illustration 28 the round holes which had served to block out the subject were not properly obliterated by subsequent work with the graver. The designs executed with this implement alone became careless scratchings, and sometimes drill-holes and lines make up some sort of pattern which can neither be called decorative nor recognized as a subject. A new type of thin, tall cylinder, with purely geometric arrangements, was introduced in the course of the period, but soon became involved in the general decline in seal cutting. The seals of the latter half of the period have only an archaeological interest and need not, therefore, detain us here.

The earlier seals, on the other hand, are carefully incised gems. If a single scene is represented, it is drawn clearly and vividly, and in the balanced friezes the greatest inventiveness is shown.[44] The subjects are very varied. The 'king on the battlefield' [25A] and the scene of a herdsman defending a calving cow against a lion[45] are, we presume, secular subjects. But the majority of the designs reflect the same religious preoccupations as the other works of the period. One seal shows in an abridged form the upper register of the vase of illustrations 10 and 11.[46] In another [27] the girdle which is presented to the goddess on that vase is carried by the third of the three men approaching the temple; the other naked man carries a bead necklace. Between these priests walks a man who looks like a suppliant conducted by the two priests to the Mother Goddess. On the opposite side of the temple[47] another man appears to move towards her shrine with outstretched arms while two others punt and steer towards it a boat decorated with flowers. The extraordinary vivacity of these lithe figures makes one almost forget that their actions remain completely enigmatic to us.

Even designs which are mainly decorative use religious motifs. The serpent-necked lions of illustration 28 and the copulating vipers of illustration 29 are known as manifestations of the chthonic aspect of the god of natural vitality, who is manifest in all life breaking forth from the earth. The eagle, lion-headed or otherwise [28, 29], represents the god as bringer of the fertilizing rain. It is the bird Imdugud which represents the dark clouds of the storm.[48] The ibexes and the rosette, like any combination of herbivorous animals and plants, point to the Great Mother.

The seal engravings, many times more numerous than all the other works of art that have come down to us, disclose most fully the richness and vigour of this first great phase of Mesopotamian culture. Like the larger works in stone, they show vigour and sensitivity, and a great eagerness to explore the possibilities of expression. The true measure of the achievement of the Protoliterate Period can be taken only when we see it against the foil of the prehistoric age which preceded it and which produced only in its architecture a prototype of the splendour that was to follow.

THE EARLY DYNASTIC PERIOD

(CIRCA 3000–2340 B.C.)

INTRODUCTION

The beginning of the Early Dynastic Period is
marked by a strong artistic revival within an
unbroken cultural continuity. The Protoliterate
Period did not end in decline; it had, on the
contrary, seen a dense settlement of the country,
with much reclamation of land and founding of
new cities; its contacts with foreign countries
had also increased, and its products have been
found as far apart as Persia, Egypt, and Troy.
Nevertheless the deterioration of the arts had
been marked.

The first phase of the Early Dynastic Period
(there are three phases)[1] opened with a renewal
of glyptic art [30]. No attempt was made to
enrich the subject-matter. A single or double
file of goats or oxen was the usual motif. This
was designed in a few lines, and the remainder

30. Brocade Style seal, from Khafaje

of the surface was ornamented with fishes, stars,
crosses, lozenges, and the like. In other words,
any additional importance which a subject
might impart is suppressed in favour of pure
decoration. It is the even spacing, the intricate
interlocking of forms which is an innovation.
This style is called the 'Brocade Style', because
the regular recurrence of small space-filling

motifs and the even density of pattern are
characteristic of woven or embroidered stuffs,
where no thread can be allowed to pass over a
long distance behind the cloth. On the seals this
style was adopted because it produced the un-
broken frieze in which impressions of any length
could give the effect of completion. The
principle had been known during the Proto-
literate Period but lost in its final decline. It now
became the basis of new experiments.

In the stone vases the new approach is equally
marked. To describe it we must follow it into
the next subdivision, the Second Early Dynastic
Period, since the precise stage reached at the
end of the First cannot be determined. The
vases are made of green steatite, a material rarely
used before this time. They are covered with a
closely drawn network of figures in flat relief,
obviously related to the Brocade Style of the
seals. None of the early examples is complete.
One from Bismaya [31] shows a figure with
plaited hair, approaching from the left and bear-
ing a branch, to meet a group of musicians: two
men play on harps or lutes, then follows a
drummer, carrying his instrument under his
left arm while strumming with the knuckles and
fingers of his right hand. After him comes a
trumpeter. These figures all wear feathers in
their hair, and their kilts were inlaid with pieces
of white limestone, of which one has been pre-
served. The lowest row of figures, which we
have described, derives some order from the
fact that it follows the base of the vessel. Above
it figures of men appear in wild confusion. They
are shown running to the right where a large
figure is blocked out and was once inlaid. The

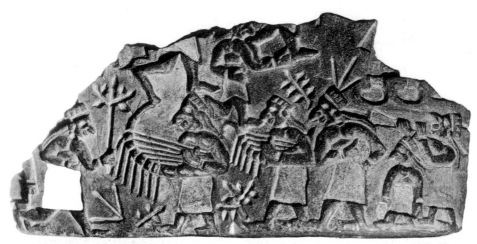

31. Vase, from Bismaya. Steatite.
University of Chicago, Oriental Institute

feet and the front edge of its long kilt are preserved. It may have represented a god or a king. The few intervals between the figures are engraved with plant designs.[2]

The vase of illustrations 32 and 33 shows a more orderly arrangement. It contains a pair of humped bulls, of the Indian zebu breed, which is not native to Mesopotamia. But the vase was not imported. The snakes with drill holes which were once filled with coloured inlays of paste or stone recur at Khafaje[3] and elsewhere.[4] Other elements of the decoration likewise recur on Mesopotamian vessels of steatite. The meaning of the design remains obscure. It seems certain that it is in some way concerned with the great natural forces which the Mesopotamians worshipped. It consists of four groups, forming a continuous frieze of even density, as on the cylinder seals. A long-nosed, long-haired Sumerian figure is seated upon two humped bulls; above are a snake, the crescent moon, and a six-leaved rosette, the last possibly emblematic of the planet Venus, a manifestation of Inanna–Ishtar. From the hands of this personage flow two streams of water. Plants which

appear in front of one bull and at the rim of the vase may well be thought to spring from this life-giving stream. In another group the same (or a similar) personage appears standing between, or upon, two panthers. The rosette recurs; this time the hands grasp snakes. They possibly symbolize the fertility of the earth, balancing the fertilizing power of water in the other group. But this is a mere hypothesis, as is the suggestion that the rosette in both groups may identify the chief figure with Inanna. When we follow the design on the right we meet the scorpion of the Agrab vase, and then a fresh group: a lion and an eagle devouring a bull. The space left between this scene and the first is occupied by a date-palm flanked by small cunning bears who lick their paws after eating the sweet fruits.

A word must now be said about the chronology of these interesting vases. None of them was found among remains of the First Early Dynastic Period, but the feathers worn by the men of illustration 31 recur on an inscribed limestone relief, known as the 'Personnage aux Plumes', from Telloh which can be assigned to this period on palaeographic grounds.[5] It is

32 and 33. Vase, from Khafaje,
with drawing of complete design. Steatite.
London, British Museum

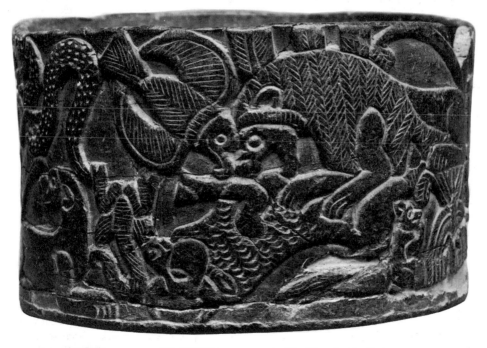

difficult to know how close in time the other vases stand to the earliest of the group. Several of them may belong to the Second Early Dynastic Period.[6] In the Third the decoration has lost its figures altogether, and the steatite vessels themselves seem to be exclusively of a squat cylindrical type. They sometimes show buildings of wattle or matting,[7] and sometimes only the patterns to which matting gives rise.[8]

Like the seals and the stone vases, the pottery of the First Early Dynastic Period shows a close patterning of the surface. For the first time vessels are entirely covered with a fine network of incised ornament, and the polychrome pottery of the earlier age survives in the 'scarlet ware', which is technically inferior (the red wash is not fast), but shows not only the shoulder but most of the vessel densely ornamented with designs; these are sometimes geometrical, sometimes representational. In all the applied arts the beginning of the new period is characterized by innovations of a similar nature. Contemporary works of free-standing sculpture have not yet been discovered.

ARCHITECTURE

In architecture the new age is characterized by the introduction of a somewhat inappropriate building material, the plano-convex brick, flat on one side and curved on the other, where finger-marks are often left by the hand that pressed the mud into the brick mould.[9] Foundations were constructed of rough untrimmed blocks of stone where these could easily be obtained, at Mari[10] and at Al 'Ubaid.[11] At Ur such blocks were used to build corbelled vaults over tomb chambers erected underground

[34]. In domestic and sacred architecture the vault played no part, so far as we know. The arch, constructed of plano-convex bricks, was used over doorways in houses.[12]

In their plans the buildings show continuity with the preceding age. The same temple at Khafaje which illustrated how the original plan of a shrine – self-contained and open on all sides – was modified when used in a built-up area (pp. 22–3 above) develops further during the Early Dynastic Period. We observe [35] that

35. Khafaje, Sin Temple VIII

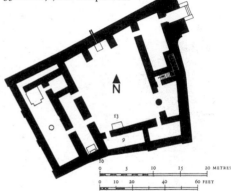

the court has now become an established feature of the building. A monumental entrance,[13] flanked by two towers, gives access to it. In the past one or two steps had led up to the plinth on which the shrine was placed [7]. Now an impressive stairway approaches the entrance [35].

On the middle Euphrates Early Dynastic architecture showed some peculiarities not found elsewhere. The temple of Ishtar, at Mari,[14] had an oblong shrine with a 'bent axis' approach, as in the south, and was founded on

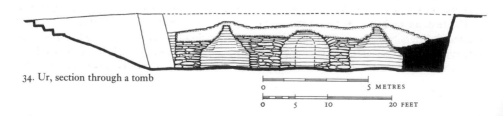

34. Ur, section through a tomb

36. Khafaje, temple oval.
Reconstruction by Hamilton D. Darby

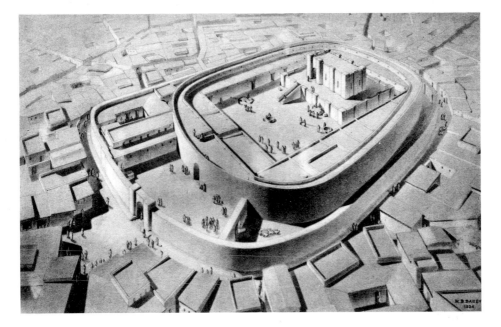

layers of untrimmed stones, like the temple at Al 'Ubaid. But the walls were built of bricks which are flat, not plano-convex. Moreover, the colonnades of the Protoliterate temple of Warka have a successor here, although the columns are reduced to more reasonable proportions, about three and a half feet in diameter. There are five of them, forming a cloister on two sides of a court. In the south, columns are found only once in Early Dynastic times, at Kish, where they are five and a half feet in diameter and support the roof of a long hall, and the portico roof over a parapet, in a secular building.[15]

The temples we have described retained to the end the irregular form, due to their gradual extension within the town where adjoining properties limited the builders. When a temple was newly planned in an open space, a regular square or oval form was adopted. The square or oblong plan always remained in use; the oval [36] is distinctive of the Early Dynastic Period.[16] It is well to remember that no merely utilitarian considerations determined the work. Before the foundations of the temple oval were laid, the whole area, which had been occupied by private houses, was excavated down to virgin soil, more than twenty feet below ground level. This huge excavation was next filled with clean desert sand which must have been brought from some distance. On top of the clean – or, to use the ritual term, pure – soil the foundations were built. They followed the outline of the building, but were packed in clay up to a height of about three and a half feet, so that the whole oval actually

stood on a platform of that height, although only its upper part appeared above the ground. Stone steps led up to the gate in the outer wall, which was flanked by two towers [36]. On the left, when one entered the forecourt, there was a separate building, resembling in plan a large private house, but it contained a little shrine, and it probably housed the offices of the temple administration. These were situated round an open court reached by a passage at the foot of the outer enclosed wall of the oval.

From the forecourt of the temple a few steps led to the deep, well-protected gate of the inner enclosure. The inner court was spacious; it contained a well and circular basins of baked brick lined with bitumen. These probably served for ritual ablutions. At the foot of the platform upon which the temple stood there was an altar where animal sacrifices were offered. The platform was about twelve feet high; this can be calculated by the steps which are preserved. The temple which originally stood upon it is entirely lost. What appears in our reconstruction shows the standard type in its simplest form, which was well preserved at Tell Asmar. The shrine has been given an arched doorway, such arches having been found in a private house of the period at Tell Asmar.[17]

The rooms round the court of the temple oval were not used for the cult, or, at least, served it indirectly. Some were workshops of stone-cutters or copper-workers, others bakeries, stores for agricultural implements, and so on. The great temple complex which appears in illustration 36 as the centre of the settlement cannot be properly understood by referring to religious practice alone. It requires some knowledge of the peculiar relationship which was believed to exist between society and the super-human powers on which it depended. The gods were powers manifest in nature and worshipped throughout the land. But there was no political entity comprising the nation. The effective political unit was the city-state, and each of the

gods owned one or more of the cities. Their earthly rulers were stewards of the divine overlord, and their people were dedicated to his service and looked to him for protection against their enemies and against such natural calamities as floods and drought, marsh fires and storms which threatened civilized life in Mesopotamia and were all regarded as manifestations of specific divinities. The god who owned the city was its advocate in the assembly of the gods. The doctrine of the divine overlordships had far-reaching consequences in the political and economic spheres. It resulted in a planned society best described as theocratic socialism. All the citizens, high and low, laboured in the service of the god and fulfilled allotted tasks. All tilled his fields and maintained the dykes and canals required for irrigation. Resources and labour were effectively pooled – seed corn, draught animals, ploughs, and other implements were supplied by the temple. Craftsmen kept this equipment in order and regularly presented a quota of their produce to the temple. So did fishermen and gardeners, and indeed all other artisans. They were organized in guilds under foremen. The harvest of the gods' fields and orchards, gardens and cane-brakes, was likewise stored in the temple and regularly distributed to the community in the form of periodical and special (festival) rations. The rooms round the inner court of the temple oval at Khafaje were stores and workshops required for such purposes.

At the time when texts became numerous enough to throw light on the working of this system – that is, towards the end of the Early Dynastic Period – it was already in dissolution. The leaders who still called themselves 'stewards of the god' were in practice established as dynasts in the cities. But the temples played a dominant part in the national economy until the end of the third millennium, and it is this function which explains such architectural complexes as were discovered at Khafaje, Tell

Asmar, Tell Agrab, and, of a later age, at
Ishchali [115], Ur and elsewhere.

Inside the shrine the statue of the god stood
in front of a niche at one end of the long narrow
cella which one entered through one of the long
walls (the 'bent axis approach'). The space
nearest to the statue might be marked as
separate from the area of the congregation by
piers against the side wall and this device ulti-
mately developed into the broad cella with a
central door [e.g. 114]. In front of the niche
supporting the statue was a brick platform
which served as an altar. A little farther away
there was often a brick offering table, but other
kinds of supports were also available. There
were tall pottery stands in which flowers,
branches, and clusters of fruit were placed.
Carved stone or bronze figures [39, 49, 69]
supported small bowls or vases filled with un-
guents· or incense [37]. Rush lights [38] and

37. Early Dynastic seal impression.
Berlin Museum

larger offering stands [93], perhaps representing
a two-staged temple platform or Ziggurat, were
also in use.[18] Along the walls, on low brick
benches or on the ground, stood statues of the
devotees.

SCULPTURE IN THE ROUND

All Mesopotamian statuary was intended for
temples; the human form was translated into
stone for the express purpose of confronting the

38. Rush light stand, from Kish. Copper.
Chicago, Natural History Museum

god.[19] The statue was an active force; it was
believed to possess a life of its own. Gudea, ruler
of Lagash in a later period [97–100], erected a
statue which was called 'It offers prayers'.[20]
Another was entitled 'To my king [the city god
Ningirsu] whose temple I have built; let life be
my reward'.[21] Here the statue is, as it were,
charged with a message; first it names the reci-
pient of the petition, then the request itself.
And about two thousand years after Gudea, a
king of Assyria wrote, 'I installed my royal

statue . . . to appeal for life for myself before the gods in whom I have faith',[22] while a text of Gudea, giving instruction to the statue, begins: 'Statue, say to my king . . .'[23] The 'king', in this text, was again the city god, and the statue was to report to him perennially the great deeds which Gudea had performed in his service. The statues of priests and notables served the same purpose.

The cult statue, the figure of the deity which was placed on the altar before the niche at the narrow end of the shrine, was alive with a vitality of a higher order; for the god himself was immanent in the figure. But very few cult statues have come down to us, since they were mostly made of precious materials or decked with gold and other valuables. But it so happens that we possess two examples of the Second Early Dynastic Period.[24] They belong to a group of ten figures which seem to have formed the complete sculptural furniture of a sanctuary at Tell Asmar [39] and were at some time – either when danger threatened or when the shrine was completely renovated – buried together under the floor beside the altar. The two divinities are differentiated from their worshippers in three respects: by their stature, by the presence of identifying emblems on their bases, and by the huge diameter of their eyes. The figure of the god [40] is about thirty inches high, that of the

39. Group of statues, from the Abu temple, Tell Asmar.
Baghdad, Iraq Museum, and University of Chicago, Oriental Institute

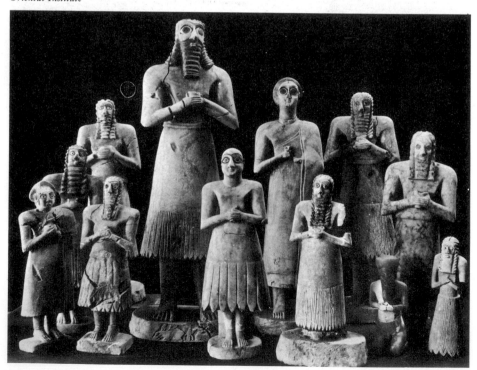

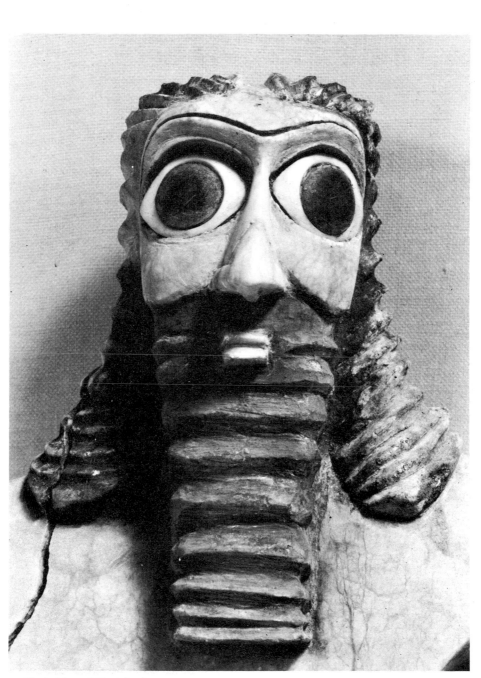

40. Head of the god Abu (cf. 39)
Baghdad, Iraq Museum

41 and 42. Statue of a priest, from Tell Asmar.
University of Chicago, Oriental Institute

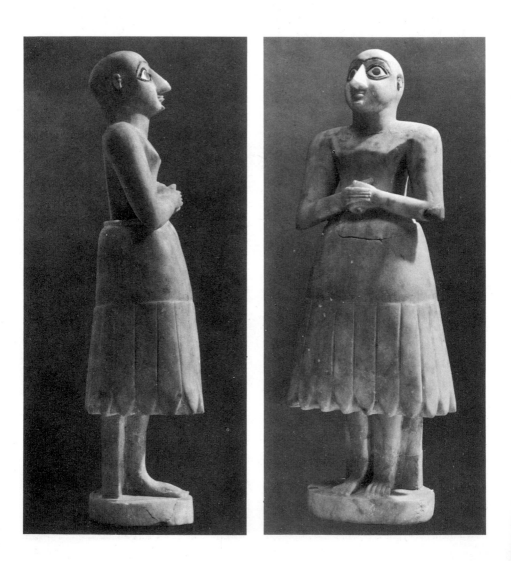

priest [41, 42] about sixteen inches, that of the bearded man of illustration 43, where the feet are missing, twelve inches. The base on which the statue of the god stands bears a design in relief: an eagle (probably lion-headed, but the head is lost) and on either side a gazelle with the branch of some plant, a group which we have recognized as the emblem of the deities who were worshipped in the Protoliterate temples at Warka. We know, from an inscribed copper vessel which belonged to the temple, that this deity at Tell Asmar was called Abu, 'the Lord of Vegetation'.

The statue of the mother goddess is identified in a very direct way: a tiny standing figure was inserted into the base, representing her son. In quality her image is far inferior to that of the god, and the immense eyes fail in their effect. The statue of the god, on the other hand, possesses a magnetism of which no one who has seen the original can remain unaware. It seems charged with a fierce power, appropriate to the source of the vitality of plants and beasts and men.

The deities each carry a cup, and this recurs in the hands of some of the worshippers; occasionally they grasp a branch [44, 45] or a flower as well. This probably means that these men had represented themselves and the gods as participants in the greatest feast in the calendar, when, at the New Year, the human and divine spheres for an instant seemed to touch.[25] If our interpretation is correct, the ten statues found together at Tell Asmar constitute a group, not only by the circumstance of their discovery and the homogeneity of their style, but also because they were intended to represent the gods and the congregation at that most auspicious moment when man felt himself closest to the deities he revered.

The statues representing mortals vary much in quality [39]. The best show an intensity well in keeping with the belief that a hidden life animated them [41–3]. It is possible to distinguish

the means by which this effect was mainly realized: a reduction, or rather a concentration, of all shapes to abstract, almost geometrical forms. The kilt, for instance, is rendered as a truncated cone. The bare upper parts of the bodies are square in section, with an almost brutal limitation of the primary consciousness

43. Statuette, from Tell Asmar. Gypsum. *New York, Metropolitan Museum of Art*

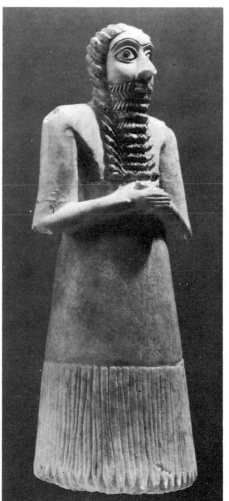

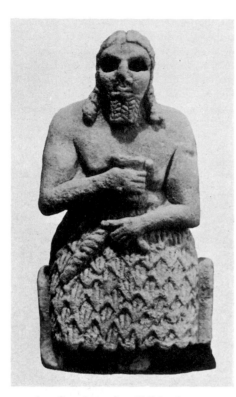 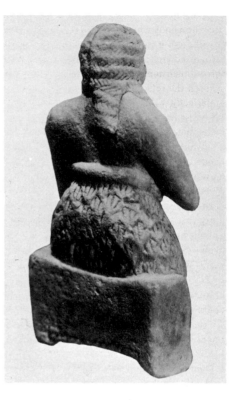

44 and 45. Seated man, from Tell Agrab.
University of Chicago, Oriental Institute

of the body as consisting of chest, flanks, and back. In illustrations 41 and 42 the chest muscles are rendered by planes meeting in a sharp ornamental line; the first or little finger in a closed hand becomes a spiral, the chin a wedge, the ear a double volute. The shapes of skull, cheeks, and arms are less easily described, but are equally abstract, and equally plastic. The hair is rendered in two strictly symmetrical halves, clamped round the face and setting it off in a system of horizontal ridges. This system harmonizes with that of the beard [46], which fits in the profile with the triangles of nose and lips. But both in front and side views the intent eyes are the centre of the plastic composition. Whatever the differences between individual statues, the formal principles are the same, and their logic is astonishing. This is a plastic style in which the chaotic reality of visual impressions is mastered by the creation of a perfectly homogeneous, self-contained, three-dimensional form, of an abstract order.

Perhaps it should be said that one need not impute any reasoning of this kind to the ancient sculptors. An analysis of works of art rationalizes and makes explicit what was intuitively created. But the sculptures we have described present in an extreme form one of the possible

solutions to the problem of all sculptors – how to create a body which asserts its reality in space. It will do so if its own spatial volume is clearly recognized and convincingly established. If its three-dimensional character is not properly stressed the sculpture appears improbable and imperfectly realized. From the fifth century B.C. the West has rendered the human figure as a living, potentially mobile organism, involved in a network of relationships, and to be comprehended by the spectator only in a circular movement that can encompass the whole range of its complex functions.[26] In pre-Greek times it was not organic unity, but abstract, geometric unity that was sought. The main masses were arranged in approximation to some geometrical form – the cube or cylinder or cone; and the details were stylized in harmony with the ideal scheme. The clear three-dimensional character of these geometrical bodies was reflected in the figures composed under this rule. And it is the dominance of the cylinder and the cone which imparts unity and corporeality to the Mesopotamian figures: note how the arms, meeting in front of the bodies, and the fringed lower edge of kilts, emphasize the circumference, and thereby the depth as well as the width. This geometric approximation establishes the figures emphatically in space.

It also explains the spellbound appearance of all pre-Greek sculpture in the round. Only the choice of the ideal form differs: in Egypt it is the cube or oblong rather than the cylinder or cone. Once chosen, the formal ideal remains dominant; throughout all changes of style Egyptian sculpture is squared, Mesopotamian sculpture is rounded. In Egypt front, sides, and back are joined as brusquely as possible and the limbs do not overlap from one plane into the other; in Mesopotamia, at all times limbs and clothing are made to emphasize the rotundity of the stone. In Egypt the seated figure with its many right angles – at knees, elbows, and hips – is the

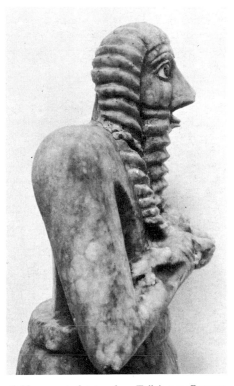

46. Upper part of statue, from Tell Asmar. Gypsum. *University of Chicago, Oriental Institute*

favourite and most effective sculptural subject. The Mesopotamian sculptor is apt to botch this pose by either reducing or exaggerating its crucial element: the horizontal expanse from hip to knee. No one seeing the front view of the figure in illustrations 44 and 45 can be certain that it is a seated, not a standing figure. In another statue, from Khafaje,[27] the head is the apex of a cone, of which the surface descends almost uninterruptedly from the face along the arms held before the chest to the absurdly protruding knees. Even in illustration 56, where the natural proportions are preserved, the roundness of all edges and the over-all pattern

of the fleecy kilt are seen to obscure the motif if we compare it with the treatment it would receive in Egypt. In Mesopotamia the standing figure is the most popular as well as the most successful subject of statuary.

We have said that the abstract form to which the figure approximates remains unchanged throughout the history of a country's art. But the manner of approach varies. The first school of Early Dynastic sculpture [39–42, 46–8] devotes itself to geometric approximation with passionate intensity. It reduces to abstractions not only the main forms, but even details like chins, cheeks, and hair. It is truly a school of carvers rather than modellers, to which single-mindedness and coherence impart its peculiar beauty.

The richness of these works is enhanced by polychromy. The stone is a veined gypsum; the eyeballs are cut from shell, the pupils from lapis lazuli or black limestone. Hair and beard are covered with a black bituminous paint, which also fills the incised eyebrows and serves as mastic in which the eyes are set. In the heads of women the hair is treated in the same way. In a figurine from Tell Asmar,[28] the parting was neatly picked out by a strip of mother of pearl set in the bitumen. In illustrations 47 and 48 the hair was modelled in bitumen (of which traces remain) and protruded as a fringe from beneath the finely plaited headcloth. The ears are fully pierced, and were probably supplied with earrings of gold wire. The inlays of the eyes have not been found.

The carvers of this school proceeded with a boldness which would have horrified those true and congenital workers in stone, the contemporary Egyptians. The arms are cut free from the body, even the legs are sometimes freed and intended to carry the weight of the body without the support of a back pillar. Breakages were frequent, and many statues were repaired in antiquity. Nor were the legs and arms only liable to crack or snap off, though those are the commonest fractures. The sculptors attempted to prevent them either by leaving stone between the legs, or by making a back pillar, or even (as in the figures of our god and goddess from Tell Asmar) by giving the ankles a preposterous depth and thickness [39]. This blemish may be

47 and 48. Head of a woman, from Tell Agrab. *Baghdad, Iraq Museum*

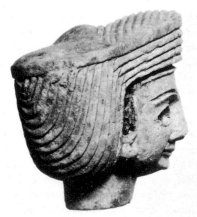 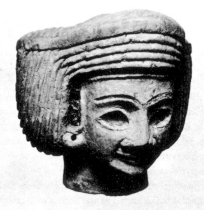

called a minor one, but a number of other works are undeniably failures, grotesque and ugly. The explanation of all these peculiarities is simple; stone was too rare a material for the Mesopotamians ever to have become familiar with it in the manner of the Egyptians. In the Nile valley a strong tradition of stone carving could be developed in the workshops, so that a very high level of craftsmanship was maintained, and even uninspired works were almost always adequate.

The Mesopotamian style of sculpture which we have described is also represented by works in metal. Remarkable figures were cast in copper as early as the Second Early Dynastic Period. Of the most ambitious one so far known a mere trace remains: at Tell Agrab we found a well-shaped foot which must have belonged to a nearly life-size copper statue. It may be, of course, that the statue was of some other material with only the face, the hands, and the feet cast of copper, or that the body and limbs consisted of copper sheets hammered over a bitumen core. This method was used for some large figures of lions found at Al 'Ubaid, belonging, presumably, to the Third Early Dynastic Period (see below).

At Khafaje three complete figures of copper were found, of which the largest measured about thirty inches and the other two [49] each about sixteen inches. Their heads were provided with a four-armed claw upon which plates with offerings or bowls of incense were placed before the gods. They resemble, therefore, on the one hand the copper rushlights found at Kish [38], and, on the other, the small stone figures from Tell Asmar and Tell Agrab, some of which bear on their head a vessel or a hollowed-out turban [39]. In all these cases, where the figures are not statues in the narrow sense, but temple furniture, they are naked, wearing only a triple girdle. We cannot decide whether they depict human or mythological beings. Perhaps these naked girdled figures are another version of the hero of

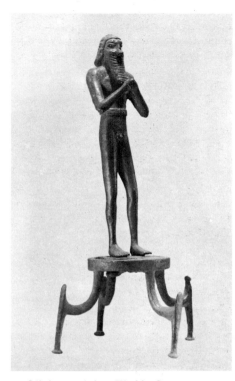

49. Offering stand, from Khafaje. Copper.
University of Chicago, Oriental Institute

illustrations 17–19, and of the seals of all later ages.[29] In the seals his regular companion is the bull-man [82] and a fine if incomplete figure of a bull-man, carved in the early style in green serpentine, has been found at Umma. He stands upright, and his two horns, like those of the goat in illustration 69, would require a third point to serve as support for bowls with offerings. He resembles in all details the bull-man commonly occurring on cylinder seals of this and later periods. He is strikingly tall and slender, ithyphallic and wearing a triple girdle – and must be considered as a rendering in the round of the same benevolent demon. His horns and his legs below the knee were cast in metal and attached in sockets cut into the stone. The locks which

descend on either side of his face and his beard were also of metal and riveted to the stone.[30]

There are some small pieces of metal work which are very ingenious and elaborate. One, a double vase, found, and no doubt used, in the temple at Tell Agrab, has as support a pair of strictly antithetical wrestlers, on whose heads the vessels seem to be balanced [50]. From the

When we now review the statuary of the Second Early Dynastic Period as a whole, the works in stone and in metal appear as equals; neither shows influence of the other. This is most unusual. At no other time do we find Mesopotamian sculpture which represents so outspokenly and exclusively the formal language of the stone-cutter. The contrast is not between

50. Offering stand, from Tell Agrab. Copper. *Baghdad, Iraq Museum*

51. Model of a chariot, from Tell Agrab. Copper. *Baghdad, Iraq Museum*

same site comes the little model of a chariot drawn by four onagers.[31] Even though the surface is badly corroded, some trace of the subtle modelling survives in the animals, especially their heads. The chariot is as lightly built as is compatible with strength. It has no body, the driver stands on two treads above the axle and has thrown back his kilt to free his legs; for he must grip with his knees a kind of wooden centre-piece, covered with a fleece, to keep his balance in his springless vehicle. The span of four is guided by reins fixed to rings in the upper lips of the asses, and by a whip, now lost [51].

the actual materials, metal and stone, of course, but rests in the method of achieving plastic forms. The sculptor liberates the figure he has conceived from the enclosing block; the metal-worker builds up his wax model by adding material to an amorphous core until the form is complete. To individual artists as well as to nations either one or the other procedure is more congenial; they either proceed *per forza di levare* or *per via di porre,* as Michelangelo put it. And the congenial method will prevail over the other, to the extent that the characteristic forms of the favoured technique will be imitated

in works produced by the other. In Egypt, for instance, stone carving was the leading craft, and works in wood and metal did not exploit the potentialities peculiar to these materials, but followed the canon of the stone-cutter. In the Mesopotamia of later times metal seems to have become the leading craft and influences work in stone. It may be relevant to remember that Mesopotamia is a land where clay and mud must needs be used for a variety of purposes – for pots and tablets, for gutters, pipes, window-grilles, for figurines and relief – and that consequently modelling was the commonest of all Mesopotamian techniques. However this may be, Mesopotamian works in metal, although rare (for they were usually melted down in later times), show a remarkably high quality, and stonework displays modelled forms [e.g. 97, 98] in all subsequent periods. The abstract style of the Second Early Dynastic Period never reappeared.

It was succeeded by a style which is not merely a modification, but, in its most striking aspects, the antithesis of the earlier one [52–60]. Instead of sharply contrasting, clearly articulated masses, we see fluid transitions and infinitely modulated surfaces. Instead of abstract shapes, we see a detailed rendering of the physical peculiarities of the model. By a new and subtle treatment of the surface the base of the skull is differentiated from the neck, the bony forehead and temples from the soft cheeks. This manner, whatever its virtue, is a denial of the values which the older style realized by the tautness of its simplified surfaces. In second-rate works the attention now given to the differentiation of surfaces produces a disintegration of plastic coherence. In the best works this danger is avoided and a new sensitivity to subtle changes in physical substance imparts life to figures which lack the earlier vigour and intensity.

Conversely, some details of the older style appear crude in the light of the new; the flat ridges which once rendered the mouth are re-

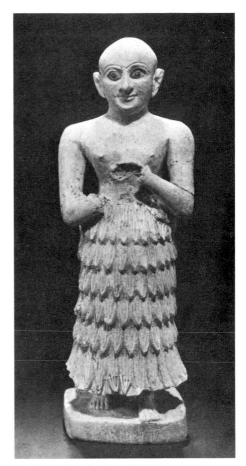

52. Statue of a priest, from Khafaje.
Philadelphia, Pennsylvania University Museum

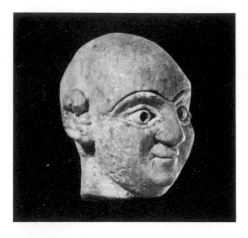

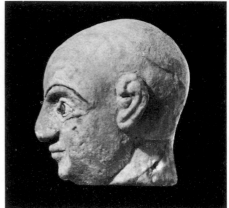

placed by delicately curved lips which rise at the corners in a contented, somewhat complacent, smile [53]. A double chin adds to the impression of material well-being, and folds of fat are sometimes indicated between chest and stomach. Collar-bones and nipples are now also shown. The square section formerly given to the bare body is rounded out, the kilt is rendered with all the detail of its fleece-like surface and loses its stark geometric outline. In illustration 56 the realistic tendency has even affected the rendering of accessories, like the wickerwork seat, and the kilt is entirely free from stylization [cf. 44, 45]. A certain preciousness appears in the treatment of the beard, where the curls, turning at the tips, are separated by a series of drill-holes. This device is also found in a figure of Lugalkisalsi from Warka,[32] 400 miles to the south, and illustrates the uniformity of style through the whole of Mesopotamia; for the figure of illustration 56 comes from Mari on the middle Euphrates. The fashion of shaving the head while growing a luxuriant beard was prevalent[33] at Mari, but it is also found at Assur[34] and Khafaje.[35] It is worth while to compare this detailed rendering of the beards with the succession of ridges which served in the earlier style. The heads also have been transformed; the proportion between skull and face has changed entirely. In the older style the cranium was unnaturally reduced in volume because the whole treatment of the head aimed at giving a plastic setting for the face with its piercing eyes. In the later style the natural proportions are restored.

The change of style need not be a result of the influence of modelled works to which we have referred. It is quite likely that the Early Dynastic sculptors, having followed abstraction to its utmost limits, began to explore the possibilities offered by the opposite approach. But the causes of the change must in any case remain an open question. We know only that the realistic style is found throughout the country in the Third Early Dynastic Period and already existed in the Second.[36] We also know that it was never abandoned.

We have referred exclusively to figures of men in discussing style; the figures of women are, on the whole, of lesser quality and their stylistic character becomes blurred. The contrast between the images of god and goddess in illustration 39 is typical, not exceptional. Most of the surviving statues of women belong to the later style. This is probable in illustration 57, a female figure from Mari, with a headdress not,

53 and 54. Priest's head, from Khafaje.
University of Chicago, Oriental Institute

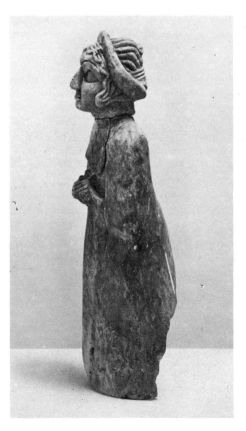

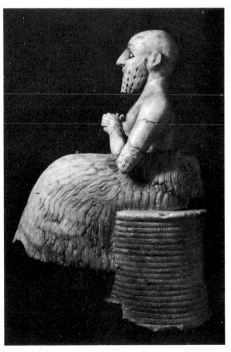

55 (*left*). Statue, from Khafaje.
Baghdad, Iraq Museum

56 (*above*). Statue of Ibihil, from Mari.
Paris, Louvre

57. Female figure, from Mari.
Aleppo Museum

58. Statue, from Khafaje.
University of Chicago, Oriental Institute

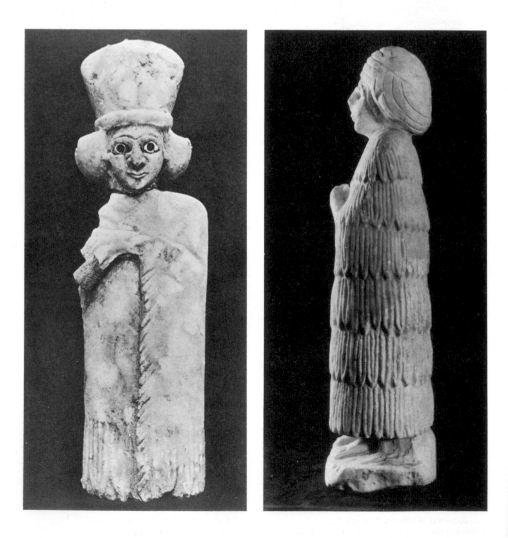

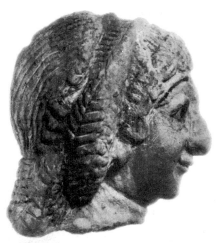
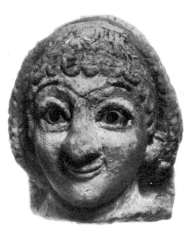

59 and 60. Head, from Tell Agrab.
Baghdad, Iraq Museum

so far, found elsewhere. It is certain for the figures of illustrations 58–60. The hair is generally shown as in illustrations 59 and 60, with the long plait wound round the head, which gives, in front view, a good frame to the face.

Non-human figures are known in both styles. Illustration 61 shows the front part of the armrest of a throne. It depicts one of the monstrous creatures which populated the fairy-land of contemporary seal designs. The heavy mane of a bison surrounds an enigmatic bearded face; the horns are broken off. It is the human-headed bull. His counterpart, the bull-man, is known in sculpture in an offering stand discussed on p. 53.

The cow of illustration 62 is made of translucent serpentine. It has a beard, which is here shown as a ritual appendage, bound round the muzzle. At the back of the head two locks of human hair descend from between the horns as

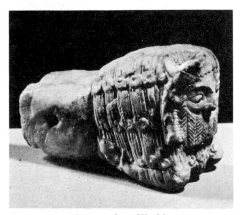
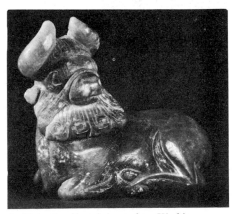

61. Arm-rest of throne, from Khafaje.
Philadelphia, Pennsylvania University Museum

62. Statuette of bearded cow, from Khafaje.
Serpentine. *Baghdad, Iraq Museum*

if one viewed from behind a deity wearing a horned crown. It is likely that the cow represented the goddess Nintu, 'Lady of Births', since it was not only found in her temple but would fit a pedestal built on its altar. The meaning of the beard remains unknown; it recurs often when animals embodying some superhuman power are represented [e.g. 64, 65]. The small green figure is oddly impressive, powerful out of all proportion to its size; the scheme of the earlier stone vases [15, 16], where animals *passants* turn their heads at right angles to face the beholder, acquires a new meaning where the beast possesses this weird numinous power and the beholder is a worshipper of the embodied deity.

The cow of Nintu and the arm-rest with the human-headed bull belong to the end of the Second Early Dynastic Period, the period when the second, realistic style had been established.[37] This style in stone sculpture is contemporary with an extraordinary efflorescence of statuary in copper and gold. Copper lions served as guardians of the temple of Ninhursag, 'Lady of the Mountain', at Al 'Ubaid.[38] It has not yet been decided whether the heads were cast or hammered over a bitumen core. The bodies were certainly made of hammered sheets of copper riveted together. The creatures show their teeth, and a protruding tongue of red jasper adds to their fierce appearance; so do the large inlaid eyes. Lions' heads of the same type, but carved in stone, come from Lagash, and the device of guardian lions survived to the Hammurabi period and re-emerged later in Assyria.

The friezes of stone animals discovered in the Protoliterate temples of Warka [13, 14] find their counterpart in metal at Al 'Ubaid. A series of standing bulls, and another of calves kneeling down, turn their heads outwards in the old-established manner.[39] The bodies of the calves are worked in relief, but the heads were cast separately and are entirely detached from the wall. We do not know where these friezes appeared in the building, since they were discovered in a trench, thrown there, no doubt, on the occasion of a renovation of the temple. We are equally in the dark about a great symbolic panel, found in the same temple [63]. It shows in the centre the lion-headed eagle Imdugud, gripping a stag with either claw. The gesture does not represent aggression but affinity: the same deity is symbolized by bird and deer. The combination adorns the base of the statue of the

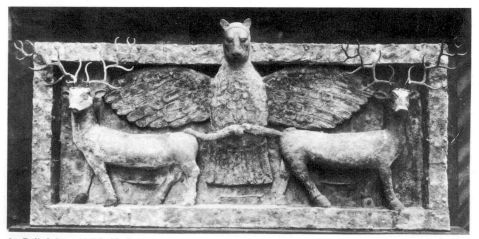

63. Relief, from Al 'Ubaid. Copper.
London, British Museum

64. Harp, from Ur.
London, British Museum

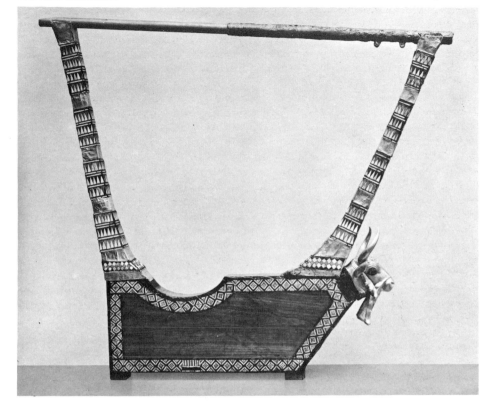

god Abu [39], where plants are added to the herbivores. If the eagle is correctly interpreted as the embodiment of the black rain-clouds, his presence in the temple of the Mother Goddess Ninhursag (Lady of the Mountain) is easily explained. At Lagash the god was said to enter the temple 'like a rumbling storm, like a bird of prey descrying its victim', when he arrived for his sacred marriage with the goddess. The absence of plant motifs in the copper relief is compensated by the large number of rosette flowers which were composed of petals cut from red and white stone mounted upon terracotta nails which were fixed in the walls of the temple.

The heads of the three animals on the copper panel are cast separately. Such cast heads are occasionally found in the ruins without any trace of the decayed bodies of sheet copper. They may, therefore, belong not to architectural friezes of the type just described, but to objects of perishable material, such as furniture. Lion heads, for instance, were used ornamentally as parts of a wooden sledge; and the heads of herbivores occur on harps. It is possible that differences in pitch corresponded with an attachment to harps of the head of a bull, a cow, a calf, or a goat.

Illustration 64 shows a reliable reconstruction of one of the harps found at Ur. The sound-box was of wood which had, of course, decayed. But its shape was preserved by the order in which shell, lapis lazuli, and red jasper had been set in

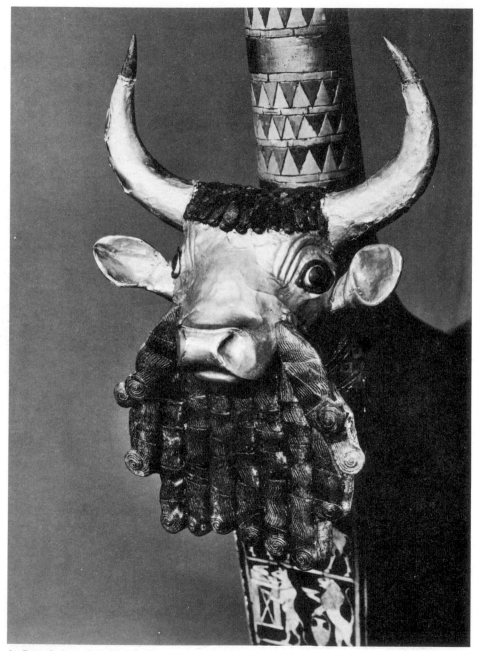

65. Part of a harp, from Ur (cf. 78).
Philadelphia, Pennsylvania University Museum

bitumen. Triangles of the same materials, alternating with bands of gold-leaf, had covered the uprights which supported the bar to which the strings were attached. It seems that the instrument was conceived as a creature giving forth music, for its head, cast in gold, is attached to the sound-box. The bull's head of illustration 65 is fixed to a harp in the same manner. There gold-leaf is modelled over a core, and lapis lazuli is used to render the beard, the shaggy hair between the horns, the horn tips, and the eyelids and pupils. The splendid goat's head of illustration 67 may also be derived from an instrument. It is cast in copper, superbly modelled, and conveys the uncanny character of the goat to perfection.

The animal which forms the centre of the strange and beautiful object of illustration 69 seems equally daemonic. From a wooden base, covered with coloured stone inlays in bitumen, a tree rises. Its branches end in leaves and in the symbolical rosette-flower. A billy-goat has put its forefeet on the branches and peers through the foliage. Its heavy coat is rendered by separately carved pieces of shell and lapis lazuli, set in the bitumen that covers the wooden body. The two horns are cut from lapis lazuli. A piece of wood that gives rigidity to the body emerges between the shoulders and is covered with gold-foil. Originally[40] its top was on a level with the tip of the horns so that bowls and saucers with offerings could be placed upon it. We know from a contemporary seal design [37] how such objects were used. The stand of illustration 69 represents in the round that combination of herbivore with plant which we have repeatedly met as symbol of the great gods of natural fertility. But as it comes to life in the stand it has acquired an extraordinary potency. It appears in the full mystery of its animal vitality, not sub-human,

66 (*left*). Rein ring with gold onager, from Ur. *London, British Museum*

67 (*above*). Head of a goat, from Nippur. Copper. *Philadelphia, Pennsylvania University Museum*

68. Jewellery of Queen Shubad, from Ur.
Philadelphia, Pennsylvania University Museum

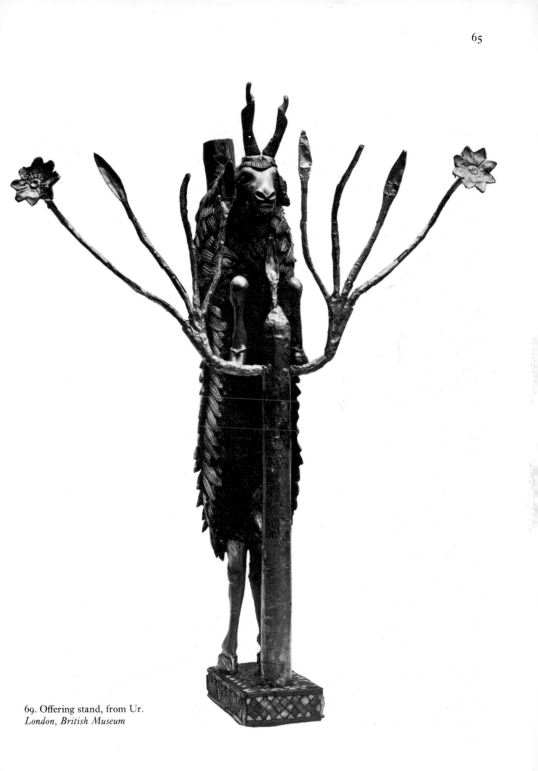

69. Offering stand, from Ur.
London, British Museum

but superhuman. Its close relation with the fertility gods is shown on an Akkadian seal [96A], where it puts its forefeet familiarly on the god's knee, while a man and woman humbly approach with their offerings. Tammuz is called in a hymn 'husband of Ishtar the bride . . . creating the seed of cattle, head of the stalls' but also 'leading goat of the land'. Such phrases, and the image of the seal design, reveal the inadequacy of the usual colourless phrases that the goat is sacred to Tammuz or symbolizes him, or that the god is the embodiment of the male principle in nature and manifest in the fertility of the flocks. The works of art reveal how inevitably our abstractions miss the directness with which the god's manifestation was experienced, and how the animals appeared charged with his essence, and hence with the very life of the immortals. In the emblem on the base of the statue of illustration 39, in friezes, on seals, or on vases, beasts and plants may seem to us mere ornaments, and we must reconstruct the meaning they had for the ancients by an intellectual effort. But in the offering stand of illustration 69 the gold animal thrusting its head among the artificial branches reflects with awe-inspiring directness the divine power which was once thought to be at rest on the altar.

ENGRAVING AND RELIEF

The vase of illustration 70, from Telloh (Lagash), is made of silver and set on a copper stand. It bears on the neck an inscription of Entemena, king of Lagash, and shows two engraved friezes, separated by a band with the herringbone which is likewise common on gold vases from Ur. But the extreme simplicity of shape is never combined with engraving at Ur; nor is the engraving there representational. Entemena's vase is a display piece, presented to the temple of the god whose emblems are engraved on it. At Lagash he was called by a purely local name, Ningirsu, but he is none other than the god of the natural life whom we have met even on monuments of the Protoliterate Period. The frieze of calves on the shoulder of the vase resembles (down to the pose of the forelegs) the copper frieze of the temple of the Mother Goddess Ninhursag at Al 'Ubaid. At Lagash Ningirsu was considered also as the bringer of rainstorms and inundations, and since both rain and the rise of the waters in the Tigris are sudden and violent, Ningirsu had a violent, warlike character. Hence the predominance of lions, and of the lion-headed eagle, Imdugud, personification of the storm-clouds, in the imagery of Lagash. On the main frieze of our vase the bird occurs four times; first he grasps a pair of lions, then two goats, again a couple of lions, then a pair of oxen. The combination of these creatures circumscribes the sphere of action of the god: his violence, in war, in rainstorms, in floods; and his beneficent manifestation in natural life.

It is characteristic of Mesopotamian art that the four groups showing Imdugud with a pair of animals are not merely set side by side. They are interlocked. The claws of the birds clasp the lions; the lions sink their teeth into the faces of the ruminants, which again are held by the claws of the next bird and bitten by the lions of the adjoining group. A continuous frieze results. It is as if the cylindrical form which dominates sculpture in the round, glyptic, and mural decoration in Mesopotamia had so strong an appeal that every opportunity to emphasize its characteristics was welcome to the designer. The continuous cylindrical surface caused him to animate the creatures in his design so that each made the one gesture, with claws or mouth, which closed the ring. We shall see the same thing on the cylinder seals of the period.

It recurs on several votive mace-heads. One of these, dedicated to Ningirsu by Mesilim, king of Kish,[41] shows on top the lion-headed eagle, and on the circumference a series of lions, each of which attacks the one in front and is in turn attacked by the one behind. Once more the

70. Vase of Entemena, from Telloh. Silver, on copper foot. *Paris, Louvre*

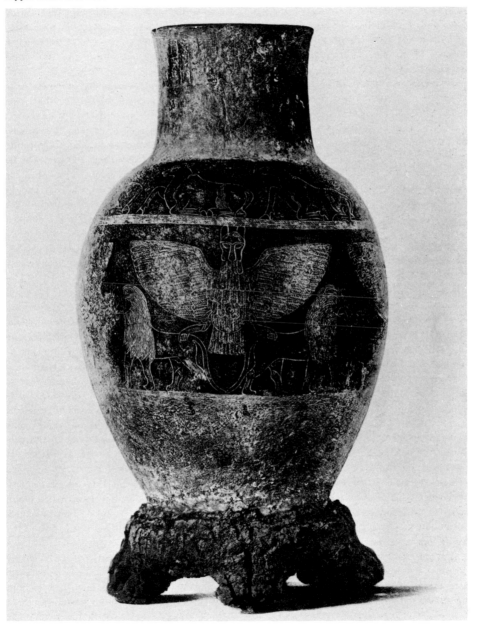

design is interlocked and continuous. But the device is not applied mechanically. In the mace-head of illustration 71, for instance, the lion-headed eagle, occurring four times, as on Ente-mena's silver vase, grasps gazelles in each instance. Hence the four groups remain separate and the roundness of the mace-head had to

71. Mace-head. *Copenhagen, National Museum*

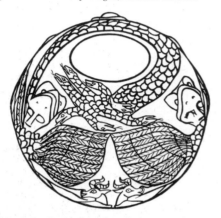

be emphasized by another device, namely by the sweep of the seven-headed hydra across the top.[42]

We must now consider a class of stonework which betrays little concern with decorative effect, but aims at clarity of representation, namely, square plaques of limestone pierced in the middle. The earliest of these date from the Second Early Dynastic Period, and they continue until the end of the Third. On the early plaques the relief is clumsy, executed in two planes without modelling. The scenes possess, however, a certain liveliness. The majority render a single subject, a feast in which a male and a female personage are the chief participants. In illustration 72 they appear in the top row. On the right a bearded man, holding a bunch of dates or a leafy branch in his left hand, receives a cup from a servant. On the left a woman is

seated with cup and branch. A maidservant behind her chair waves a circular fan with one hand and holds a wine-jar in the other. In the middle appear two entertainers, drawn back to back for symmetry's sake; one plays the harp, while the other dances with folded arms a kind of hornpipe.[43]

The second register, divided into three parts by the space for the central hole, shows the bringing of provisions for the feast: on the left two men carry a large beer-jar slung from a pole. One of them has also the circular pot stand on which the pointed vessel will be placed. On the other side meat on the hoof is brought in the form of a goat; the servant carries a large knife in his hand and a pile of loaves on his head. Below is a groom with an empty war chariot, preceded by a spearman and followed by a man who carries some object – probably a pot – tied to a pole over his shoulder. It will be seen that the fragments of illustration 72 do not fit properly. They did not, in fact, belong to the same relief. The main sections were found at Khafaje, but the missing left-hand bottom corner was completed in the illustration by using a portion of relief found at Ur. I mention this not only to explain the illustration, but also to emphasize the fact that identical or closely similar plaques of this type were set up in temples throughout the land.[44] The subject which first suggests itself – namely, a feast held after return from a victorious war – is excluded by the absence of any specific feature identifying the historical occasion. Other aspects, too, point to a recurrent, and in fact a ritual occasion for the erection of these plaques. The attitude of the main celebrants, with cup and branch, will be remembered in the statues set up in the temple of Tell Asmar before the gods (p. 49 above), and we have suggested that these referred to the celebration of the New Year Festival, when a common rejoicing united mortals and immortals. Other features in the plaques (for instance the empty war chariot) are not

72. Stele, from Khafaje, with a fragment, from Ur.
Baghdad, Iraq Museum

incompatible with this supposition. Some variations in the composition of these stone plaques occur. The lower register may show a rowing boat instead of a chariot; or scenes of entertainment: men wrestling and boxing[45] or dancing[46] or climbing trees.[47] In the upper register the divine participants are sometimes shown, served by priests in ritual nakedness. But some plaques are too different to be considered variants of illustration 72. They may show libations being poured before the gods, and a few seem purely decorative. Yet on one of these, that of the High Priest Dudu of Lagash,[48] we find, besides symbols of the god Ningirsu, an inscription saying

that the plaque was dedicated 'as a support for a mace'.[49] Maces, such as that shown in illustration 71, were common votive offerings to the gods. They were kept, like other emblems, in the temple, and in later times (and perhaps also in the Early Dynastic Period) they played a part in the administration of oaths.[50] It is possible that the plaques with festival scenes served the same purpose as that of Dudu, namely to support a divine emblem; it is also possible that they were pegged to the temple wall in honour of the benefactor who had contributed the means for holding the feast. But none has been found in its original position.

73. Stele, from Telloh.
Paris, Louvre

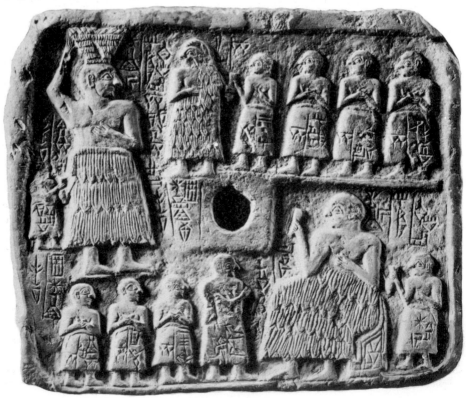

A few generations before Dudu a ruler of Lagash, Urnanshe, had a plaque [73] made. In its carving it shows a great advance over the earlier type shown in illustration 72; the details of the figures are now modelled, not engraved. Yet it is an artless piece of work. Urnanshe is shown carrying a basket of mud to mould the first brick of a new temple he is to build. In the right-hand bottom corner he celebrates the completion of the work. His family is commemorated by two stiff rows of figures, identified by their names.

We know that steles existed on which historical events were commemorated, but since the wars between the city-states seesawed without decision, not one of these monuments has survived complete. The best-preserved fragment was found at Lagash [74–5], and records a victory of its ruler Eannatum over the neighbouring city of Umma. The people of this city had destroyed a boundary stone solemnly set up under a previous king and had occupied fields belonging to Lagash. In the upper part of the stele [74] Eannatum is seen advancing before the phalanx of his heavy infantry; the spearmen are protected by a wall of shield-bearers. They march over the prostrate bodies of the enemies. On the right vultures and lions are shown devouring naked corpses. Below this scene of carnage Eannatum again appears, this time in his war-chariot [cf. 76], followed by his light infantry. He seems to lift his spear against the king of Umma. The same or a similar scene is repeated in the bottom row, where the head of the victim, looking back over the bare heads of his retreating troops, is struck by the spear of a figure now lost. In the lowest register Eannatum (of whose figure only the feet are preserved) presides over the burial of his dead. They are laid out side by side, and their comrades, carrying earth in baskets on their heads, fill the common grave. Meanwhile the king worships the gods by pouring a libation over two vases

filled with branches. An ox pegged to the ground is sacrificed to Ningirsu.

The side of the stele which we have described records the events as they had been observed to occur; the other side [75] reveals the hidden forces which brought them about. The god Ningirsu himself had taken up the just cause of his city; he caught the men of Umma in his net and destroyed them. The net is closed by – or, at least, seen to hang from – a handle in the shape of the god's emblems: the lion-headed eagle over two lions. In his right hand the god holds a mace. His figure, occupying two-thirds of the height of the stele, is followed by a smaller divinity under the lion-headed eagle, while below it the god's chariot is depicted. The front of it, with the curved end of the pole, the rein ring crowned by the figure of a lion, and the wings of the lion-headed eagle, are visible, before the small head of the divinity.[51]

It is clear that decorative considerations played only a minor part in the composition of the steles of victory. The clarity of the pictorial narrative was all that mattered. Thus the designer disregarded the edges of the stone; in illustration 74 the last ranks of the troops following Eannatum are simply drawn on the narrow side of the stele, as if the stone had the curved surface of the cylinder.

The fragments of similar steles found elsewhere are too small to allow their designs to be reconstructed. But victories in war were also recorded on a smaller scale on objects which could be displayed indoors. On more than one site delicately carved pieces of shell or mother of pearl have been found, which had been inlaid in bitumen. The result was some such arrangement as is shown on the so-called 'standard' from Ur [76–7]. We do not really know the use of this object, and the absence of inscriptions suggests that it may have served to decorate pieces best described in a general way as furniture.[52] The two panels slant inwards, so that the

74. Side and obverse of Eannatum's stele of victory, from Telloh. *Paris, Louvre*

75. Reverse of Eannatum's stele of victory, from Telloh. *Paris, Louvre*

sides of the object are trapezoid. These sides are decorated with mythological subjects, but the main panels show two complementary events: a victory and a feast. Each subject is divided into three registers, and framed by borders of lapis lazuli set diamond-wise in bitumen and edged with shell. The main scene occupies the upper register, while the others record subsidiary events, for there is no strict time sequence. On the side where a military victory is shown, the king, half a head taller than his men, has des-cended from his chariot. Spear in hand, he inspects captives. They are naked, and some of them wounded. The preceding engagement is depicted below. At the bottom the chariots advance over the bodies of the dead, each with a driver and a spearman whose javelins project from a quiver. In the middle register infantry-men despatch some enemies and take others captive. On the other side of the standard [77] there is the celebration after the victory. It differs from the feasts on the square relief plaques in

76. Obverse of inlaid panel, from Ur.
London, British Museum

77. Reverse of inlaid panel, from Ur.
London, British Museum

that women do not participate, and no one
carries branches or flowers. The king sits facing
his officers, is larger than his boon companions,
and wears a kilt which is, at least in the render-
ing, more elaborately tasselled than theirs. On
the right a man plays a harp of the type of illus-
tration 64 (it is carried by a shoulder-strap) and
the woman behind him would be a singer or a
dancing-girl. The connexion between the feast
and the military success is made clear by the
bottom register, where the spans of onagers can
only be explained as war booty. Portable spoils
are carried on the back on regular wooden packs
held by straps passing round the forehead of the
porters.

The technique of inlay was widely used in
Early Dynastic times; it allowed for graceful
design and rich effects in colour and texture,
and is found on boxes, gaming boards and so on.
The soundboxes of harps were similarly decor-
ated, and that of the harp of illustration 65
shows some extraordinary scenes [78]. Upper-
most appears the hero of illustrations 17–19
protecting two human-headed bulls, a theme
used so frequently and in such varying contexts
that one is tempted to suppose its meaning to be
less important than its decorative effect. But no
such uncertainty attaches to the other scenes;
nothing could be clearer and more specific. A
wolf and a lion serve at table – but the diner is
not depicted. The wolf has carved the meat and
brings dressed boar's and sheep's heads and a
leg of mutton. The carving-knife is stuck in his
belt. It is of a pattern found in the tombs of Ur
and elsewhere[53] and misnamed dagger. The
lion follows the wolf, carrying a large jar of
liquor, apparently wound round with wicker-
work, and a bowl or lamp. The relief plaques,
the 'standard' from Ur, and many seal designs
show that music was played during meals; and
so we see the bear steadying a large harp which
the ass plays. A small animal – a fawn, perhaps,
or a jerboa – sits at the feet of the bear and shakes
a rattle – the Egyptian sistrum – while beating a

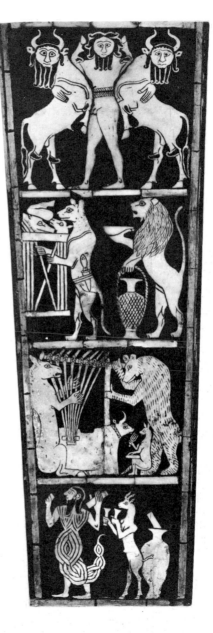

78. Inlay on soundbox of a harp, from Ur (cf. 65).
Philadelphia, Pennsylvania University Museum

tambourine or drum held on its lap. The lowest panel is less clear. A scorpion-man carries an object which we cannot recognize. This seems to belong to the tall jar, since a similar object projects from its mouth. Can they be clay tablets? The gazelle which follows him holds tumblers or perhaps incense burners.

We lack all guidance in this fantastic world. Only the scorpion-man is mentioned in texts: in the Epic of Gilgamesh he is a guardian of the place of sunrise, a function which seems irrelevant in the context of our inlays. It has sometimes been said that the animals are masked men, but this seems unlikely.[54] They have been equipped with human hands for paws only in order to enable them to carry objects, strum the harp, and so on. In any case, if masked men performed these scenes the implication would be that the animals were believed once to have performed them. But we know nothing of the occasion when this was supposed to have taken place, and cannot judge, therefore, whether it reflects myth, ritual, or fable. On a sealing from Ur the lion is the hero of a similar feast.[55] Seated on a throne, he swills from beakers handed to him by an antelope on its hind legs. A donkey brings a jar of drink. Another, likewise upright, plays the harp, and a third the cymbals. On a sealing from Tell Asmar[56] a lion and an ass sit on either side of a jar of beer, from which they drink

79 and 80. Early Dynastic II seal impressions.
Baghdad, Iraq Museum

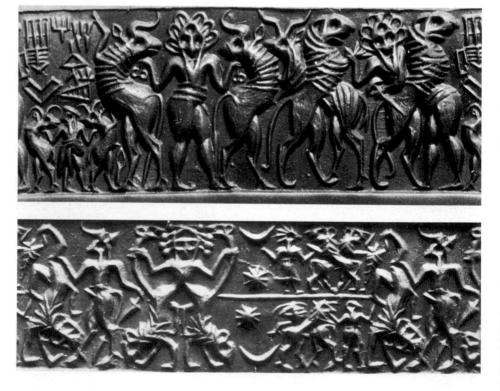

through a drinking-tube. One and a half millennia later, the animal orchestra appears again on some rough stone reliefs found in a palace at Tell Halaf in north Syria.[57] It is unlikely that mere fables were the subject of works of art of this importance. More probably we have here traces of ancient myths. On the harp from Ur they are presented in the charmed manner of Sumerian art which suspends our disbelief when it converts the world of fairy-tale into reality. It is in such a world that the benign human-headed bull of illustration 61 and the demonic goat of illustration 69 exist, and the animals and monsters of the harp inlays celebrate their festival.

glyptic, but also of the metalwork and textiles of Mesopotamia, and through these the art of Greece and Persia, and even of medieval Europe. The starting-point is, as we have seen (p. 39), in the Brocade Style which developed one of the tendencies first observed in Protoliterate times, where every subsequent development has its roots. The Brocade Style sacrificed subject to design; simple linear figures were scattered over the surface to form a continuous frieze of even density. The style was, in its purest form, elegant but jejune, and its subject-matter was soon enriched. In the Second Early Dynastic Period this process continued, but the stylistic principles remained unchanged. The design

81. Early Dynastic III seal impression.
De Clercq Collection

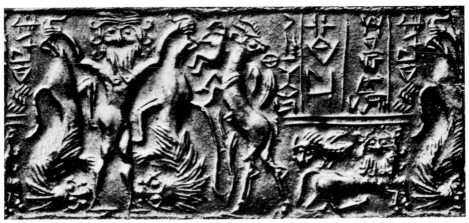

GLYPTIC ART

The seal designs of the period are very largely renderings of this same fantastic world [79–87], but in them it is subjected to the decorative requirements peculiar to the seal. In attempting this the Early Dynastic seal-cutters were so successful that their inventions have decisively influenced the repertoire, not only of later

was still mainly linear, and wider surfaces, such as the bodies of animals, were flat and without modelling [79, 80]. Plasticity was introduced only in the Third Early Dynastic Period.

The seal-cutters made much use of that animation which enabled the engraver of the silver vase of illustration 70 to produce a continuous design. When he made the lions attack the neighbouring herbivores, he united juxtaposed

82. Early Dynastic II seal impressions, from Fara

figures into a closed chain. On the seals the commonest subject is a frieze of animals and fantastic creatures which seem to be engaged in a free-for-all fight. We do not understand the implications of this theme, which is a favourite one with the Mesopotamian artists of all periods, but a somewhat clumsy design like illustration 83A shows that one of the sources of the friezes was the defence of herds and flocks against the depredations of lions. Whether the calf's head drawn on the left is merely a space-filler or is meant to represent a victim of the beasts of prey we do not know, but the bull which collapses under the lion's paws is reprieved in the nick of time by two bull-men. The same elements are used to produce the more sophisticated seals which display an astounding gift of invention, since they are often but variations on the same theme. The particular requirement of a seal – namely, that it should bear an individual, distinctive engraving – offered a challenge to the designers to which they responded with delight. In illustration 82B three bull-men restrain two lions, while a bull stands by unharmed. Two heads of goats are space-fillers. There is nowhere a hiatus in the frieze, yet the figures are not crowded. The facts of the scene – the killing

of livestock by lions – which are presented plainly in illustration 83A, are taken for granted, and the interest centres in the composition. Another version is illustration 79, where we meet the naked hero of illustrations 17–19. He holds the beard of a wild ox in either hand, and is shown once more bending past a lion which he seems to stab with a dagger in the hindquarters while grasping the forepaw of another lion. This latter beast is drawn across a goat facing to the left. The crossing of figures is now a favourite device; it increases the density of the design and makes space-filling motifs, such as heads, plants, and the like, superfluous. The same illustration also shows how an inscription was treated during this period. It appears on the left, not separated from the rest of the design by a frame, but seemingly part of it. The space left over below the written signs is filled by the hero between two goats, drawn on a smaller scale than the rest of the scene. These designs are entirely homogeneous (that is, linear) and continuous: it is not possible to isolate the impression of a single revolution of the cylinder seal, since the ends are carefully dovetailed, a feature obscured by the neatness of modern draughtsmen, who arrest the loose ends which they really should

show on both sides of their copies; the photographs do show them.

The design of illustration 82A is even more complicated. Again two rampant lions flank a central figure, as in illustration 82B. But this time the figure is not their master but their victim, a goat, drawn with two heads to fill the broad space between the lions. As in illustration 82B, two bull-men attack the lions in the rear, but the heads of the beasts are turned outward, towards their attackers. The group of animal and plant which fills, in illustration 82B, the space left on the cylinder after the group of five had been drawn, is replaced in illustration 82A by a filling showing lion and bull-man in combat.

The detailed comparisons of these two seals may serve as an illustration of the rich variety produced by modifications in the composition of a few recurring motifs. The goat with the two heads gives the clue to the monsters which are frequent on these seals. One type appears in illustrations 80 and 82C. His tressed and bearded head is shown in full-face, and the trunk and arms are human; but the 'legs' are lions standing on their forefeet, while their tails end in panthers' heads which the arms of the creature thrust away from its face. It would be useless to expect the literary sources to disclose the nature of this extraordinary monster; it originated 'on paper', a product of the craftsman's fancy. Two stages of its genesis can be recognized in our plates. In illustration 80, on the left, a bull-man dispatches with a dagger a lion which he holds upside down by the hind legs. In illustration 81, a slightly later seal, the naked hero grips two lions in this position. The three elements of the group have coalesced, fused by the draughtsman's imagination into a single, more marvellous creature, to take for a moment its place among the mythical bull-men and human-headed bulls, the lions and lion-headed eagles. Other monsters, too, came into being in this fashion. Even when subjects more significant

83. Early Dynastic II seal impressions:
(A) from Tell Agrab, (B) from Khafaje

than the animal frieze were rendered, the design showed the closely spaced, symmetrical, or repetitive character of a textile pattern. That is the case, for instance, with the sun-god in his boat [83B], which we shall discuss later. A story is but rarely told in a straightforward manner, without attempt at decorative effect.

The strength of the seals of the Second Early Dynastic Period lay in the rich variety of designs which were neither purely ornamental nor clearly representational and which derive their fascination from the ambiguity of their subject as well as from their formal beauty. They were executed in a linear, disembodied style whose possibilities were exploited to the full.

The next development was a movement away from this method of engraving. The Third Early Dynastic Period returned to the modelling in relief which had been common in the Proto-literate Period, but had been lost during its final decline, and had been neglected in the First Early Dynastic revival of the Brocade Style. The Third Early Dynastic Period kept to the themes of the preceding age, but made them appear more substantial. The potentialities of modelling were recognized and the depth of the figure was no longer treated as an inevitable but

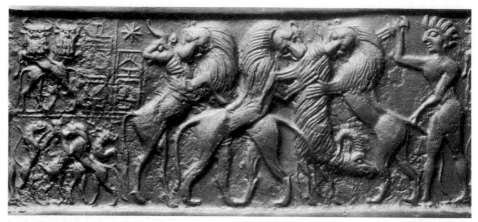

84. Early Dynastic III seal impression.
Baghdad, Iraq Museum

85. Early Dynastic III seal impression.
The Hague, Koninklyk Penningkabinet

aesthetically indifferent consequence of the technique of engraving. The new style gave importance to parts of the design which its predecessor had used cavalierly. A comparison of the seals of illustrations 84–6 with the earlier one of illustrations 79 and 80 brings out the lack of interest of the flat surfaces in the animals' hindquarters or the hero's legs. In illustration 81 the body of the rampant gazelle is still nearly flat, but the hero's body and the lions' hindquarters are truly modelled, and the play of light and shadow lifts these areas out of their previous insignificance.

The lions in illustration 81 (as in most of the seals of the Third Early Dynastic Period) show their face in front view, while it had been ren-

dered before in profile [80, 82]. The frontal view allowed the contrast between face and mane to achieve its full plastic effect; similarly the ibexes and stags of illustration 86 stand out against the embroidery of plant design covering the background, while in the earlier style [82B] the space-filling plants are a part of a homogeneous linear design, equal in value to the animals. But even in the Third Early Dynastic Period so strongly marked a contrast between figures and background is rare. On the whole the figures appear modelled against a neutral, smooth background. The elaboration of plasti-

put as upright as possible while crossing others [84, 87A]. This cross movement of figures becomes, in fact, the main device of composition and is handled with virtuosity. In the best examples the fantastic world of play and struggle remains a compelling vision; but it no longer bears analysis. The earlier designs had, for all their ingenious interlacings, remained variations of a recognizable theme, the defence of herbivores against beasts of prey. The relations between the individual figures, their character as aggressor or victim of attack, were never obscured. But in the wild mêlée of the later seals

86. Early Dynastic III seal impression.
Baghdad, Iraq Museum

city increases the volume of the figures. The lion's head seen from the front or from above shows a splendid and massive mane. Even the faces of heroes and bull-men become broader as well as more plastic. At the same time the friezes grow more crowded; the older well-spaced groups of three or five figures, symmetrically arranged [82], become rare, and most figures are

erstwhile allies may become antagonists if it suits the draughtsman's convenience. Both sides are, moreover, strengthened; the stag and the leopard are added to the cast of figures, no doubt to counteract the monotony which the exclusive use of the criss-crossing shapes would otherwise produce. For the same reason animals – mostly victims – are often inverted. In the usual frieze

of crossing animals all the formal interest lies in the upper half of the design, the lower part merely consisting of legs, which may be elegantly spaced, as in illustration 85, but remain rather dull [87A]. The placing of one or more of the animals upside down [84] corrects that shortcoming. The strength of the tendency to-sidiary motif; there were no vertical breaks at any point. The harmonious spacing of the design ensured the effect of either long or short impressions taken from the seal. This principle was basic to the Brocade Style and was well maintained, even towards the end of the Third Early Dynastic Period, when crossing figures

A
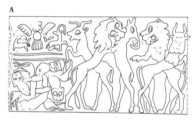

B

87. Early Dynastic III seal impressions:
(A) from Fara. *Berlin Museum*
(B) *Amsterdam, Allard Pierson Museum*

wards decoration for its own sake is shown by the swastika of lions [87A] and the circle of four men each of whom holds his foeman by the ankle while threatening him with a dagger [87B].

The stress on plasticity did not destroy linear beauty. In fact the elaboration of tails and hair tufts in illustration 85 shows a new sophistication, if compared with illustration 79. But the tendency to increase both the mass of the modelled figures and their number became ultimately incompatible with the established schemes of composition and destroyed them. The difficulties were twofold. One of them concerned the inscriptions which, in the past, could be absorbed in the linear design but now appeared as an intrusion between the modelled figures. A greater difficulty was the unevenness of surface which resulted from the crossing of such relatively substantial figures [84]. This might go so far as to prevent the making of a clean impression; in any case it was aesthetically unacceptable.

Throughout the Early Dynastic Period the beauty of a seal required a continuous design of even density. Each hiatus was filled by a sub-were piled up in the friezes. But when the figures became more substantial, the frieze appeared overloaded [84]. The figures require space and air – and so we notice at the end of the period an innovation which really consisted in a pulling apart of the interlaced figures, and thereby an introduction of a hiatus between each struggling group [85]. The effect is splendid; even vigorous modelling does not produce heaviness. But the frieze as a whole has lost its coherence; we now see three distinct groups placed side by side on the seals' surfaces. The basic principle of Early Dynastic seal design has been sacrificed. Yet once again, as at the end of the Protoliterate Period, the disintegration of a prevalent glyptic style becomes the starting-point for a fresh development at the opening of a new age. There is, however, one difference: the end of the Early Dynastic Period is in no way an age of decline. And the changes which we are about to describe amount to a transformation of Mesopotamian art while it was at the height of its power.

THE AKKADIAN PERIOD

(CIRCA 2340–2180 B.C.)

Throughout its history, Mesopotamian art exhibits a curious polarity. It reveals on the one hand a love of design for its own sake, and on the other a delight in physical reality. In the Protoliterate Period the seal designs illustrate both tendencies, separately or combined. Later, in the First and Second Early Dynastic Periods, decorative traits prevail. During the Third, in such seals as those of illustrations 84–6, the tendency towards the concrete finds renewed expression, and it gains predominance in the reign of Sargon of Akkad. The change of style might therefore be regarded as a mere shift of emphasis within the native tradition, but such an interpretation of the Akkadian achievement would be quite inadequate. The innovations are too striking; and the few splendid works which survive [88–91] cannot be understood without reference to matters which are altogether extraneous to the field of art.

The accession of Sargon of Akkad, his conquest of the various city-states, his organization of a realm which retained its coherence for over a century under his descendants, permanently affected, not only the art, but also the language and political thought of Mesopotamia. Under the appearance of familiar procedure – the piecemeal subjection of the city-states to a single ruler – a new enterprise was set afoot widely different from the ephemeral achievements of earlier conquerors. For in Sargon's person an element of the population which had hitherto remained inarticulate now asserted itself and took command. The Akkadians had affinities with the Syrians, but they were not foreigners. We do not know when they infiltrated into

Mesopotamia nor what were their numbers in the south; but by the end of the Early Dynastic Period they were predominant in the central districts, round modern Baghdad, and farther north along the rivers.

The heart of Mesopotamian civilization lay to the south, in Sumer. There the great transformation of prehistoric culture had taken place in the Protoliterate Period, and from there Sumerian influence had radiated far into Persia and Anatolia, Syria and Egypt.[1] The main route of this transmission ran along the Tigris and Euphrates. At Tell Brak, on the Khabur river, a tributary of the Euphrates, there stood in Protoliterate times a shrine which was to all intents and purposes a Mesopotamian temple.[2] At Mari on the middle Euphrates[3] and at Assur on the Tigris[4] the local script and statuary, amulets and beads, were indistinguishable from those used in Sumer proper during Early Dynastic times.

The inhabitants of those more northerly regions were, however, not Sumerians. We know very little about their culture before they adopted Sumerian civilization, but we do know that they spoke a Semitic language and therefore followed traditions which differed from those of Southern Mesopotamia. We may surmise that the differences went deep, for the Sumerian and Akkadian tongues are not even distantly related: the first is agglutinative, the latter inflectional, and vehicles of thought so utterly diverse in structure point to an equally profound contrast in mentality.[5] When, therefore, Akkadians adopted Sumerian civilization, they were bound to make a change even where they merely wished to copy. And sometimes

they made an intentional change; for instance, they used the Sumerian script for writing the Akkadian language. It is significant that this was done not only in official inscriptions but also in business documents, indicating that the new dynasty represented a numerous and important section of the populace. It is also significant that contemporary texts never treat Sargon's rule as a foreign domination. His accession marked a shift in the relative importance of two elements of the settled population of the land. There was no break in continuity. Sargon's rise to power conformed with an established pattern. In the past, too, usurpers or energetic local rulers had sometimes dominated large parts of the country. But Sargon's unification proved more permanent precisely because the established political structure of Sumer had no traditional compelling force for the Akkadians. These latter did not necessarily think of dominion in terms of the city-state. Among other Semitic-speaking people – the Hebrews, Aramaeans, and Arabs – the bond of blood, of family, clan, or tribe, has always been stronger than all others. The Akkadians may well have held a conception of monarchy in which loyalty to the ruler, as tribal chief, replaced the purely local, civic loyalties of the Sumerian cities, and the extent and structure of any political unit coincided with the area held by the tribe.

Sargon and his successors took measures which pointedly disregarded the local units and aimed at strengthening the bonds between the king and his followers; personal loyalty rather than local patriotism was now to sustain the State. Under Sargon's grandson, Naramsin, governors of cities styled themselves 'slaves of the king', who himself assumed a title – King of the Four Quarters (of the Universe) – which proclaimed him the potential ruler of the whole earth.

It is precisely this new conception of kingship which is expressed in the works which we shall now describe [88, 89, 91]. They possess a secular grandeur without precedent in Mesopotamia. The bronze head, miraculously preserved in a rubbish-heap at Nineveh,[6] is three-quarters life-size. The hair is bound in the manner of Eannatum [74] and the fashion goes back to Protoliterate times [24], a clear instance of the survival of Sumerian tradition. It is plaited, wound round the head, and gathered in a chignon at the back, while a gold diadem supports the plait. The fine but elaborate treatment of hair and beard makes a splendid setting for the smooth face and noble mouth. The eyes were

88 and 89. Head of an Akkadian ruler, from Kuyunjik. Bronze. *Baghdad, Iraq Museum*

inlaid with costly stones which have been gouged out. The tip of the nose was flattened by a fall.

Even the most realistic works of Early Dynastic times [52–60] seem but tentative approaches to the rendering of physical substance which has been triumphantly achieved in this bronze head. Notice, in profile, how the eye is set in its socket; the shaping of the upper lip; the nostril and the temple; the surety of touch; the infinite play of surface. It is true that the bronze head and the small Early Dynastic works

in stone are not strictly comparable. But an Akkadian stone head from Bismaya [90] differs from the earlier heads after the manner of the bronze.[7] It shows the same firm yet sensitive modelling, the same lack of the small full curves of the Third Early Dynastic style. Its forms are more spacious. Technical details, such as the inlaying of eyes and eyebrows, bespeak the continuity of tradition. And in Akkadian works of lesser quality the affinities with the older period are so pronounced that it is sometimes only possible to assign a work to the Akkadian

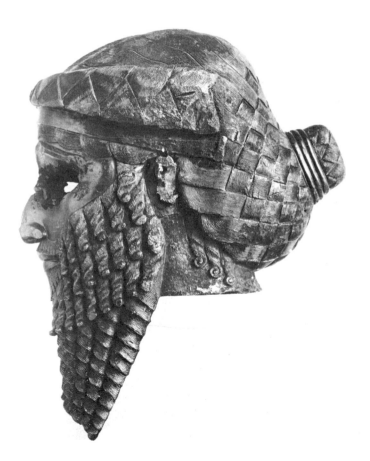

Period because an inscription names the reign in which it was made.[8]

The stele of Naramsin [91] matches the bronze head in beauty, vigour, and originality.[9] The stone is broken at the top and damaged by water below. It is nevertheless certain that no other figures occupied the upper portion where the king stands, alone, under the heavenly bodies in which the gods are manifest. Naramsin himself is deified:[10] he wears the horned crown of divinity. He holds his bow in one hand, an arrow in the other. His battle-axe hangs in the hollow of his left arm. Below him his soldiers climb the wooded mountainside. The repetition of their stride renders the relentless character of their advance more effectively than the massing of figures in the stele of Eannatum [74]. The antithesis of their ascent appears in the broken remnants of the enemy's force on the right, fleeing or imploring pity. Naramsin stands above this agitation with one foot upon the bodies of the vanquished, near him the unscaled summit of the mountain, above him the great gods.[11]

From the reign of Sargon fragments of at least two steles survive.[12] They lack the grandeur which the unified composition, the concentra-

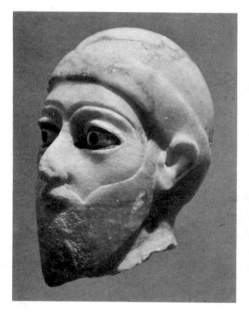

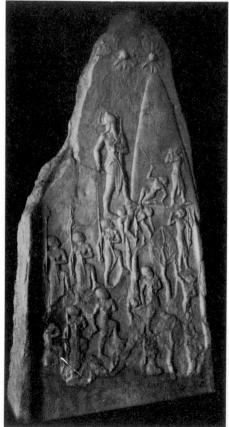

90. Head, from Bismaya. Gypsum.
University of Chicago, Oriental Institute

91. Stele of victory of Naramsin.
Paris, Louvre

tion of an event in one significant moment, imparts to the stele of Naramsin. Sargon's steles were, in every respect, more primitive; in shape they were boulders, as of old [24], and the scenes are divided into registers which followed the irregular surface of the stone. Sargon is made rather larger than his soldiers, but does not wear the crown of the gods. He is identified by an inscription. Another fragment shows a battle scene with birds of prey and dogs devouring the enemy dead. A third also renders a motif found on the stele of the vultures of Eannatum: the enemy is 'caught in a net', a recurring image of Sumerian poetry that has here been given plastic expression. But on Eannatum's stele the god holds the net; on Sargon's steles it seems to be held by the king, over whose victory divinity presides. The gods are not shown as intervening in human affairs, but the king of their election acts in the fullness of his power.

The fragments of Sargon's steles stand in a direct line between those of Eannatum and of Naramsin, but in motifs and composition they are closer to the first. There is no trace of the unified and truly monumental design which distinguishes the stele of Naramsin. An earlier treatment of the subject seems, however, to survive in a stele cut in the face of the cliffs overhanging the gorge of Darband-i-Gawr in the Qara Dagh.[13] The huge figure of Naramsin towers over the bodies of his enemies. His army is omitted, and the scene of the battle is not shown either; it is the gorge itself. The rock carving might be judged a simplified copy of the stele, but is probably earlier because more primitive. While the rock relief shows the king in the act of scaling the mountain, the stele makes the soldiers ascend while the king stands impassive, the victor in possession of the field.

The reign of Naramsin exhibits the highest achievement of Akkadian sculpture. We do not know whether the same is true of architecture, since no evidence of importance survives. But the art of engraving developed the new style to

its maturity within the forty years of Sargon's reign. Under his successors excellent work was done, but on established lines. The new development took its start from the last style of the Early Dynastic age, as represented by illustrations 85 and 87B, where figures no longer cross each other and the groups are separately drawn. We have seen that this thinning out of the friezes became necessary when modelling was introduced. But in the Early Dynastic seals the modelling remained subservient to the decorative scheme; it added interest and life to the designs without changing their imaginative

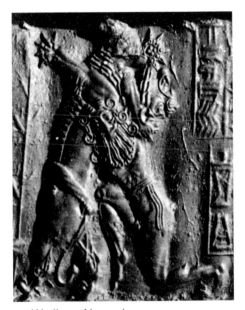

92. Akkadian seal impression:
Fragment showing a hero throttling a lion.
London, British Museum

character. Under the Akkadians, on the other hand, modelling was employed to achieve verisimilitude [92–5]. This was a new departure; neither the friezes nor the individual figures of the Early Dynastic seals permitted a realism

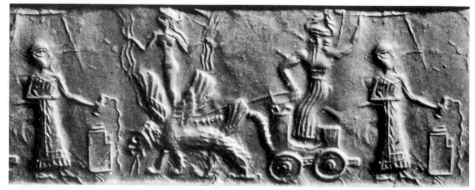

93. Priest libating before weather-gods.
New York, Pierpont Morgan Library

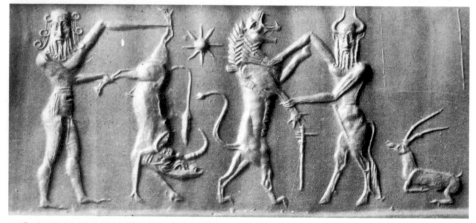

94. Seal with blank panel for inscription, from Tell Asmar.
Baghdad, Iraq Museum

93 to 95. Akkadian seal impressions

which placed the physical nature of each living creature in the centre of the artist's interest. For in a continuous frieze the function of each combatant is more important than his corporeality. Even in such seals as illustration 85 the subservience of the figures to the unity of the frieze is evident; note, for instance, the horizontal alignment of the heads and eyes (isocephaly).

In the Akkadian seals the figures are isolated, not only because their greater plastic volume requires an empty space to balance it, but also because the seal-cutter is absorbed in the rendering of the concrete details of their physical appearance. Sometimes he concentrates so intensely upon bony structure, taut muscles, curly hair, that he disposes of the relation between his figures in a summary fashion. An indifferently lengthened arm connects the antagonists [94]. More often his interest in the concrete leads to a new version of his traditional subject. In Early Dynastic times the theme of combat was a pretext for the display of decorative ingenuity; in Akkadian times it was taken for what it is; in looking at such a seal in illustration 92, one almost listens for the gasping breath of the throttled lion vainly pawing the air.[14] Yet

it would be misleading (here, as so often) to speak of realism, for the situations depicted are fantastic enough. But the traditional themes were not rejected on that score, and not only accepted, but imagined quite concretely; the desultory skirmishes of the earlier friezes were replaced by fierce encounters.

The isolation of the figures does not always destroy the continuity of the design. In illustration 94, for instance, it is maintained by the careful disposition of the tails of lion and buffalo, and by the Venus-star and battle-axe used as space-fillers. The absence of hiatus in this seal would be striking if the purchaser had availed himself of the opportunity to have his name engraved upon it; a space was left open for this purpose above the recumbent antelope. But even where, as in this case, a continuous frieze is made, the Akkadian designs are static, while the crossed figures of Early Dynastic designs carry the eye from one side to the other throughout its length. There is also less variety in the Akkadian friezes; stag, panther, goat, and ox have been eliminated and the composite creatures have mostly disappeared; for the new insistence on corporeality emphasized their monstrosity to an

95. Servants of Sargon of Akkad.
De Clercq Collection

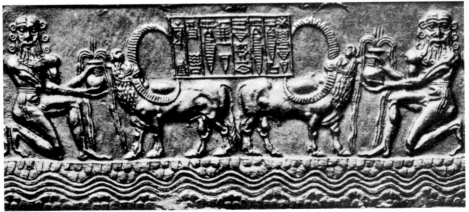

extent that precluded the necessary suspension of disbelief. That is proved by the rare occurrences of human-headed bulls in the earliest phase of Akkadian glyptic. They look neither enchanted, as in Early Dynastic, nor demonic, as in Assyrian times, but merely absurd. Only the bull-man, forerunner of the faun, haunts the Akkadian designs with his ambiguous vitality. As a rule the Akkadian friezes show but two pairs of combatants: hero and bull-man as victors, lion and bull or buffalo as victims. The scheme of the continuous frieze is, therefore, impoverished by the reduction in the number and variety of its figures, and by their isolation. But in Akkadian times this scheme of composition became uncongenial. It was replaced by a static, antithetical, heraldic composition with an inscribed panel as its central feature.

The Early Dynastic seal-cutters had never solved the problem of how an inscription could be integrated with their figures. Originally they did not set it apart [79] and it looked like an awkward space-filler. Later [85] it was framed below but left open at the sides; the problem it presented was evaded. But the Akkadians faced it squarely and solved it by making the inscription the very centre of their compositions. It was flanked by pairs of combatants, in the manner of heraldic supporters [95]. These seals reveal the polarity of Mesopotamian art in a novel form. While the figures are rendered with all the concrete details of their physical reality, they are presented in a purely ornamental arrangement. Illustration 95 offers actually a variant of the usual scheme; the hero does not destroy the buffaloes but waters them from a spherical vessel which is a common feature of Mesopotamian imagery.[15] It stands for the source of all water and hence for the origin of life. The significance of the buffaloes remains obscure.

Unusual subjects are much more frequent in the Akkadian Period than at any other time. The frieze of combatants had been developed to its rich variety because of its decorative potentialities which the Early Dynastic seal-cutters prized. The turn towards the concrete which marks the Akkadian style led, necessarily, away from the frieze, and a larger proportion of seals showed narrative scenes, definite events, either in the world of the gods or in that of men. Such subjects had been relatively rare in Early Dynastic times, but when we happen to know an earlier version of a subject popular in Akkadian times, the difference in treatment is revealing. The sun-god in his boat may serve as an example. Illustration 96B shows the Akkadian version. The god is characterized by rays springing from his shoulders. He holds the steering-oar of a boat which moves of its own accord. This is indicated by the shape of the prow, which ends in the figure of a demon or god handling a forked punting pole. Fishes sport along a triple zigzag line. In the field, to the left, the goddess of vegetation appears; she holds plants in both hands, and an ear of corn sprouts

96. Akkadian seal impressions: (A) from Tell Asmar, (B) *Paris, Bibliothèque Nationale*

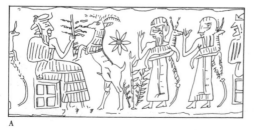

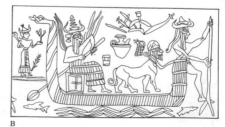

A

B

from her body. Once again we lack texts which would explain this conjunction of deities, but the seal possibly represents the sun's progress through the night, beneath the earth which is the domain of the goddess.[16] In any case, the sun-god, too, is represented in an aspect which the majority of the texts ignore; they usually describe him as the supreme judge, but on our seal he carries a plough, a large vessel, and some other objects in his boat, while a human-headed lion is tied to the prow. The stern ends in a snake's head, and in the snake the fertility of the earth is symbolized, as we recognize from other monuments.[17] A number of Akkadian versions of this scene are known, but illustration 83B shows an Early Dynastic rendering. While the Akkadian engravers aimed single-mindedly at clarity of representation, at a precise rendering of concrete detail, so that we should be in no doubt of the meaning if only we shared with them the mythological premisses, the Sumerian draughtsman reduced even a scene of this type to a homogeneous 'brocade' pattern. In the midst of this network of lines we notice the animated boat, propelled by its own mysterious power. It contains only the sun-god; his equipment is scattered over the field; immediately behind his barque appears the human-headed quadruped (the forefeet are lost in the chipping of the cylinder's edge). Above its back we see the large vessel and the plough. Behind him moves a scorpion-man with uplifted arms. It is, of course, possible that he was intended to precede the sun-god's vessel, for in the tightly interwoven design there is no indication where the scene begins or ends. The space left above the scene we have described is filled with designs which seem to have no bearing on it, but merely avoid a hiatus: the bird Imdugud holding a horned beast in either claw, and, on the left, a lion and a goat; there was no room for the complete animals, and their forequarters only are drawn. The delineation is very vivid; the boat, the quadruped, the scorpion-man move almost feverishly, but the main interest of the seal-cutter was the production of an uninterrupted, closely interwoven design, while the Akkadian aimed at clarity with his widely spaced, sedately moving figures.

Sometimes men are shown approaching this world of the gods; they bring gifts, either as respectful familiars [96A], or betraying the distance between human and divine. A good example of this last is shown in illustration 93, where a libation is poured before two weather-gods. The imagery is striking and appropriate; the lightning flashes as the god's whip with which he spurs on the fire-spitting dragon who draws his chariot. The noise of its heavy solid wheels is the thunder. These images describe the terrifying nature of a Mesopotamian storm. Its beneficent aspect is represented by the goddess, standing on the dragon's back, dispensing rain with both hands. The worshipper stands outside the space in which the gods function. He pours his libation over an altar shaped like a two-staged temple tower. The gods appear as a vision which he contemplates.

The theme of the weather-gods in action is treated differently in other seals.[18] For instance, a number of the dragons are drawn obliquely across the cylinder to render the wild confusion of the storm at its height; conversely, the event may be rendered without reference to actuality, by a god aiming his arrow at the Bull of Heaven (symbolizing drought), while a storm-demon stands by.

The Akkadian seals, like those of Early Dynastic times, evoke a world of the imagination. But it is no longer the world of the fairy-tale. It is a grim world of cruel conflict, of danger and uncertainty, a world in which man is subjected without appeal to the incomprehensible acts of distant and fearful divinities whom he must serve but cannot love. This sombre mood, which was first expressed in Akkadian times, remained characteristic of Mesopotamian art throughout its history.

THE NEO-SUMERIAN PERIOD

(2125–2025 B.C.)

AND THE PERIOD OF ISIN, LARSA, AND BABYLON

(2025–1594 B.C.)

LAGASH

The Akkadian dynasty was overthrown by the Guti, wild mountaineers from the north-east who contributed nothing to the civilization of the plain which they ransacked. The Akkadian kings had fought them repeatedly, and rock steles carved in the homeland of the barbarians recorded their initial successes and were intended to deter further assaults. But the mountaineers gradually gained ascendancy, the dominion of the latest Sargonid kings was narrowly circumscribed, and the Guti finally entered the plain and held it for about sixty years. After that, the Sumerian south took up the challenge, drove them out, and reunited the realm under the kings of Ur. But before this occurred one city-state seems to have escaped from the Guti or to have paid blackmail to their chieftains. In any case, the city of Lagash flourished exceedingly and produced, under Gudea and his son Ur-Ningirsu, exquisite works of art and literature.[1]

In the sculptures from Lagash – modern Telloh – the technical achievements of the Akkadian period are utilized, but of the aspirations of that time not a trace remains. Piety replaces vigour. We know from texts that the domination of the Guti was felt as a cruel humiliation, and Neo-Sumerian art, from Gudea of Lagash to the end of the Third Dynasty of Ur, dwelt with complacency on the close relation with the gods which was the prerogative of the lawful occupants of the land. Gudea's works do not reflect a shadow of the troubles of the age, but are pervaded by the confidence and gaiety of the truly devout. A score of statues represents the ruler, standing or seated, with folded hands, bare-headed or wearing a woollen cap. They resemble one another so closely that our illustrations 97–9 adequately represent the whole group. The material is costly and very hard diorite, carved with complete mastery and brought to an extraordinary perfection of finish; note the long, fine fingers, the bare right arm, the feet, the manner in which the body is indicated under the woollen shawl. The sculptors of Gudea combine, in all these respects, the traditions of the Akkadian school, as is shown by a damaged diorite statue of Sargon's son Manishtusu.[2] Although the intense vitality of the best Akkadian works is absent from Gudea's sculpture, they possess the same firmness and precision of modelling and the same richness in the play of light provoked by the stone. The monumentality of these statues can best be appreciated if we compare them with a work which renders the same subject in an entirely different way [100]. This is a small statuette of green serpentine, light and graceful; this effect is achieved by an inner logic which combines the

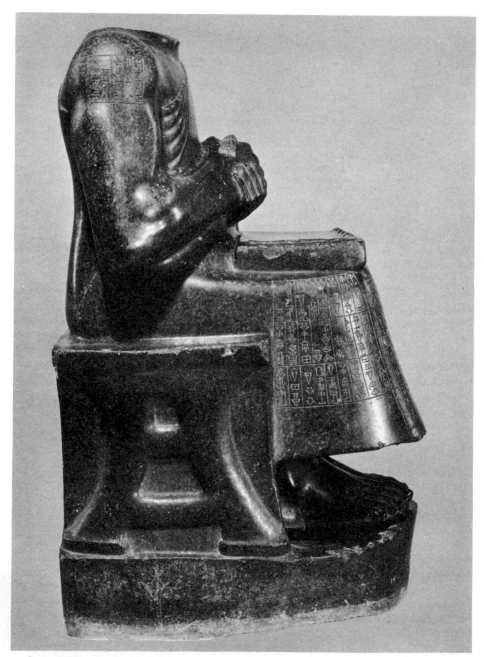

97. Gudea holding the plan of a building,
from Telloh. Diorite. *Paris, Louvre*

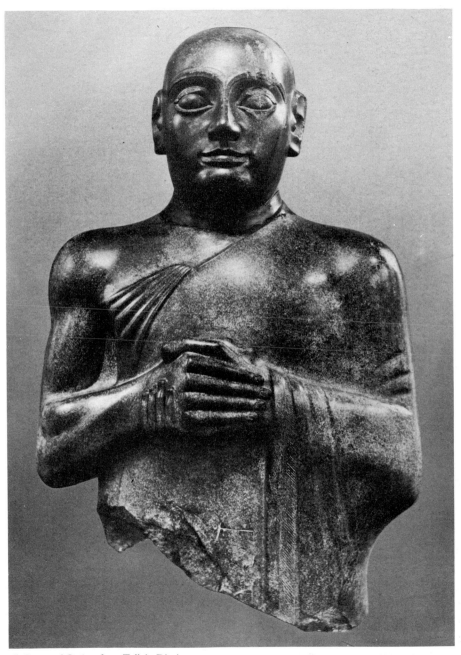

98. Statue of Gudea, from Telloh. Diorite.
London, British Museum

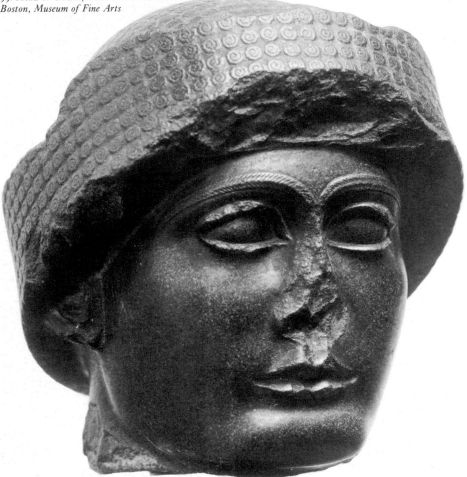

99. Head of Gudea, from Telloh. Diorite.
Boston, Museum of Fine Arts

properties of the semi-translucent stone, the elegance of the contour, the contrast between the broad shoulders and the narrow waist, and even the unusual gesture. The fingers of the right hand direct our glance beyond their clasp to the long vertical edge of the shawl, while in the monumental statues of diorite the hands form part of the great curve by which the arms emphasize the roundness of the ideal form, the cylinder. In these larger figures the gesture of the clasped hands is as logically used as that of the pointed fingers which play their part in the composition of the statuette. Notice, in the diorite statues, the other features that emphasize the cylindrical form, such as the folds of the shawl under the right arm and the roundness of the base. In the serpentine statuette, too, as in all Mesopotamian sculpture, the composition is

cylindrical, but its slender elegance obscures the abstract framework which the monumental figures accentuate. Illustration 97, where Gudea holds a drawing-board on which the plan of a temple is to be traced by means of ruler and stylus,[3] shows how awkwardly square elements are fitted in. The seat, too, seems refractory; it could not be rendered in the round without deep undercutting, and was therefore left more or less block-shaped; but, in contrast with Egyptian usage, its squareness is as far as possible mitigated by the treatment of the sides.

The statues were, as we have seen (pp. 45-6 above), placed in the temples as a perpetual reminder of the ruler's faithful service of the gods, and as active interceders on his behalf. His images were credited with power, and this power was sustained by offerings of food and drink. The dedicatory inscriptions took account of the divine hierarchy. The statuette of illustration 100, for instance, was dedicated to the goddess Geshtinanna, and bore the name: 'She transmits prayers'. But the statues dedicated to the city-god, Ningirsu, or to the Mother Goddess, interceded directly, and bore such names as: 'I am the shepherd loved by my king [i.e. Ningirsu]; may my life be prolonged'.[4]

A combination of serenity and forcefulness is characteristic of the statuary of Gudea, and the texts bear out this impression. While Gudea maintained prosperity and peace in the midst of chaos, he ascribed his good fortune to his excellent relations with the deities. These looked with favour on a city ruled by a king devoted to their service. Gudea rebuilt their temples with an extraordinary expenditure of energy and wealth, and he buried in their foundations an account of his activities. These texts are most unusual. They describe, not only the facts, but also the moods of the king during the slow and laborious fulfilment of his task,

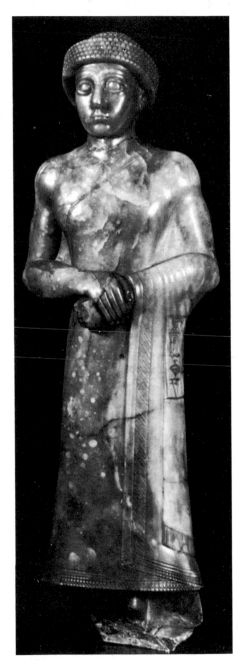

100. Statuette of Gudea, from Telloh. Serpentine. *Brussels, Adolphe Stoclet Collection*

beginning with the first intimation that something was expected of him (the gods prevented the Tigris from rising at the time of the inundation); the dreams which were sent to him when he slept in the temple, and which were only clarified by degrees; the long preparation of the site; the purification of the city; the collection of the materials; the final dedication to and occupation by the gods. These texts, though damaged and often equivocal or obscure, possess, even in translation, an extraordinary poetic force, and a spirit closely related to that expressed in the sculptures. They convey Gudea's awareness that his devotion had found fulfilment in a relation of trust and goodwill on the part of the gods. The following passage may count as a poetic equivalent of the sculptures. It was spoken by the god Ningirsu in the dream which finally overcame Gudea's doubts as to whether he was indeed called upon to undertake the huge task of rebuilding Eninnu, the temple of the god. Note that abundance follows the 'humid wind' which brings the rain:

> When, O faithful shepherd Gudea,
> Thou shalt have started work for me on Eninnu,
> my royal abode,
> I will call up in heaven a humid wind.
> It shall bring thee abundance from on high
> And the country shall spread its hands
> upon riches in thy time.
> Prosperity shall accompany
> the laying of the foundations of my house.
> All the great fields will bear for thee;
> Dykes and canals will swell for thee;
> Where the water is not wont to rise
> To high ground it will rise for thee.
> Oil will be poured abundantly in Sumer in thy time,
> Good weight of wool will be given in thy time.[5]

Of the costly objects with which Gudea furnished the temple, only a few survive. A limestone basin[6] was decorated with goddesses holding the miraculous 'flowing vase', and they are linked with each other, so that each holds her own vase in the right hand and supports

with her left the vase of her neighbour. The water flows downward in a double stream to cover the earth, and more water streams from the sky, emerging from round vases borne by goddesses like illustration 111. These figures have been called the earliest representation of angels, but the heads and arms are not attached to wings, but to bodies clothed in the gown with wavy folds which the standing goddesses also wear. The same motif recurs in the stele of Urnammu [110] from which illustration 111 is taken.[7]

Another of Gudea's basins was decorated with lions[8] like some of the mace-heads dedicated to Ningirsu.[9] Others were merely inscribed. A fragment of a stele shows a harp being played in the temple.[10] Another stele, of which only the curved top is preserved, gives a scene which was also engraved on Gudea's personal seal: the ruler, held by the hand of his 'personal god', his special protector Ningizzida, is introduced into the presence of the great gods.

101. Pitcher of Gudea. Steatite. *Paris, Louvre*

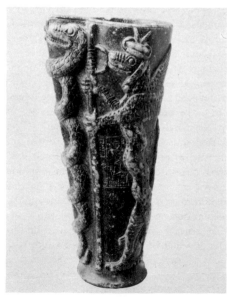

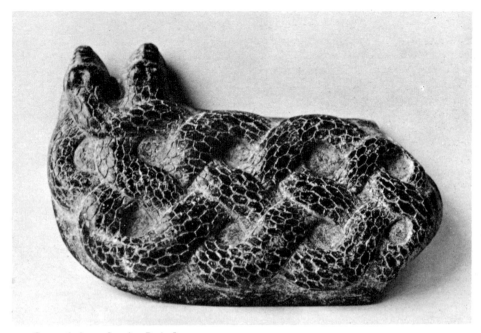

102. Cover of a lamp. Steatite. *Paris, Louvre*

On the seal the god who gives audience is, once again, a deity who dispenses water from the 'flowing vase', here marked as the source of life by the plant sprouting from it.

Gudea dedicated the steatite vase of illustration 101 to his 'personal god' Ningizzida, who represents natural vitality in its chthonic aspect, and is therefore identified by two intertwined snakes, originally pairing vipers [29]. The dragon, too, counts as a spirit of the earth and appears regularly as the symbol of this god.[11] Intertwined snakes are rendered also in the fine steatite cover of a lamp or dish [102], but the dedication was apparently engraved on the missing portion of the vessel.

Whether the human-headed bull of illustration 103 belongs to the age of Gudea is uncertain. It may be earlier (i.e. Akkadian) or later, but its mildness would agree with the art of Lagash. Notice how even here the creature's extended

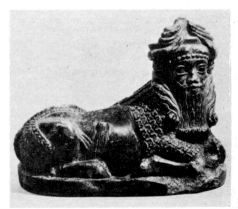

103. Human-headed bull. *Paris, Louvre*

attitude, which would easily fit into an oblong, has been rounded by the movement of the head. The block form, which was dominant in Egypt, is avoided in Mesopotamia.

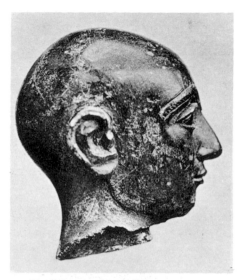

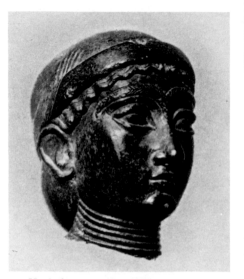

104. Head of a man, from Telloh.
Paris, Louvre

105. Head of a woman, from Telloh.
Paris, Louvre

106. Foundation figure. Copper.
Paris, Louvre

Of Ur-Ningirsu, Gudea's son, several statu-
ettes have been preserved. They resemble
closely those of Gudea, but the base of one of
them has been enriched by a frieze in relief
of kneeling figures bearing offerings.[12] The king
is clean-shaven and wears a woollen cap; but
in another work[13] he is heavily bearded and his
head covered by a low conical cap, or possibly
natural curls. This odd appearance remains
without parallel. The figures of private people
found at Lagash have all shaven polls and are
beardless, perhaps because they represent
priests [104]. Female figures are rare [105]. The
high quality of the workmanship equals that of
the royal statues. The metal work of the period
is mostly lost to us. Inscribed bronze pegs were
driven into the foundations of buildings, and
these were sometimes held by a divinity [106].
Sometimes the upper part of the pegs rendered
the ruler, in a conventional way, in the act of

carrying on his head the basket of clay used for the moulding of the first brick of the new temple [cf. 73].[14] Sometimes the peg was topped by the figure of a bull; these were significantly used for the temple of Inanna-Ishtar.

THE THIRD DYNASTY OF UR

The peace and prosperity of Lagash, during the upheaval of foreign rule, mark the city as a backwater. History passed Lagash by. When the south rose and drove the Guti back to their mountains, it was under the leadership of Erech and Ur. Lagash became a dependency when Urnammu of Ur established a united realm which lasted for over a century (the Third Dynasty of Ur). Although its scribes used Sumerian in most official documents, the dynasty did not abolish the Akkadian language, and in the very conception of kingship over the land it accepted the political innovation of Sargon. The notion found theological expression in the theory that 'kingship had descended from Heaven' and was bestowed upon one city at the time, but only for a limited period. Then the gods, at their pleasure, granted kingship over the land to another city. The local rulers became vassals, or even mere officials, under the king of Ur.

The art of this phase of Sumerian revival is not well known; it resembles that of Gudea rather than that of Akkad. The contrast is most

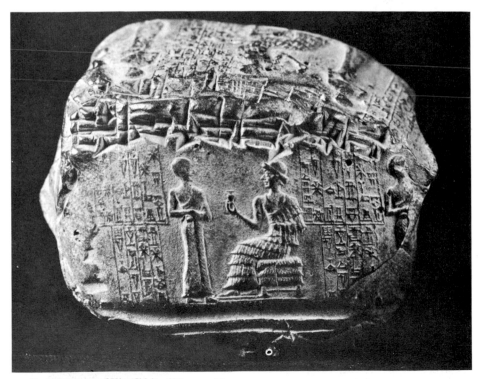

107. Seal impression of King Ibisin of Ur on a tablet. *Philadelphia, Pennsylvania University Museum*

striking in the seal designs. The almost inexhaustible variety of Akkadian times has vanished, and in practice a single theme holds the field, the so-called presentation scene, which shows either the king before a god, or, as in illustration 107, an official before the king of Ur. The subject was rare in Akkadian times, but it became common at Lagash under Gudea.

The period of the Third Dynasty of Ur was one of great achievement, not only in the economic sphere, but in every field. Many of the greatest works of Mesopotamian literature were now either composed or for the first time written down. But only a few works of art survive, and those are too fragmentary to give a fair impression of their original character. Moreover, there are no criteria for separating sculpture of the Third Dynasty of Ur from that of the succeeding Isin–Larsa Period.

The sadly damaged head of illustration 108 is almost the only certain example of sculpture in the round belonging to this period. It shows perhaps an excessive delight in plastic details. The head of the god in baked clay [109] represents a somewhat coarser type.

The first king of the Dynasty, Urnammu, erected a stele at Ur of which fragments survive. The original was ten feet high and five feet wide [110]. At the top the king was shown pouring libations before the throne of a deity, while above him a goddess holding the flowing vase [111] sends water from the sky. This upper part, like the register beneath it, originally showed the same scene repeated twice; the king, once facing to the right and once to the left, stands before a god in one case, a goddess in the other. The repetition destroys the narrative interest; perhaps it is merely a symmetrical rendering of Urnammu's worship of a divine couple – the moon-god Nannar and his consort Ningal – enthroned side by side in their shrine. In any case, the stele, like the seal designs, illustrates the

108. Head of a woman, from Ur. Marble.
Philadelphia, Pennsylvania University Museum

109. Head of a god, from Telloh. Terracotta.
Paris, Louvre

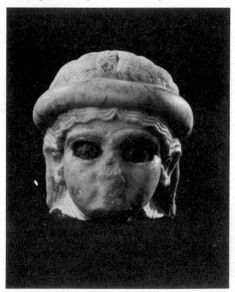

110 (*left*). Restored stele of
Urnammu, from Ur.
*Philadelphia, Pennsylvania
University Museum*

111. Goddess pouring
water from the sky,
from the stele
of Urnammu (cf. 110)

same absorption in ritual which distinguishes the art of Gudea from that of the Akkadians.

The god holds an emblem conventionally known as 'the ring and staff' and often interpreted as a symbol of justice. This is probably correct, but on this stele the symbolic objects are recognizable for what they are, namely, a measuring rod and line.[15] The figurative use of measuring instruments as symbols of justice is understandable, and the detailed rendering on the stele is, perhaps, due to the nature of the event commemorated on this monument: the founding of the god's temple by Urnammu. Below the scene analysed, the king is shown carrying builders' tools on his shoulder. A priest assists him, and he is preceded by a god. Fragments indicate that a procession moving in the opposite direction filled the remainder of the register; we have here, then, again, a static antithetical grouping of figures, not a consecutive narrative. Traces of a ladder below suggest that building operations were actually depicted. On the other side of the stele we see, at the top, a repetition of the scene with which we started our description, and, below, ceremonies related to the dedication of the temple. Men pour blood from the carcass of a decapitated lamb – a rite known in the later New Year Festival to have served as the ritual purification of the building. An ox is cut up; huge drums are sounded. On a flat band of stone between two registers a list of canals dug by Urnammu is engraved. This stele, then, is poles apart from those of Eannatum, Sargon, or Naramsin. It is a monument of piety, not of worldly achievement, and this explains the static, hieratic, character of the composition. It would be rash to deny that the kings of Ur erected steles to commemorate their victories; they were active soldiers as well as administrators. But so far not a trace of secular monuments has been found.

The most impressive building of Urnammu was the Ziggurat of the moon-god. It stands within a court, as does the temple-platform in the oval at Khafaje [36], and was orientated with its corners to the points of the compass. It measures 190 by 130 feet, and is therefore oblong, and not square, as in later times. Its outer face, which shows a batter [112, 113], is decorated with buttresses. Layers of matting are built into the brickwork at intervals to strengthen its cohesion.

On the north-east side three stairways give access to the first stage. In their angles two solid bastions were constructed; they partly supported a gatehouse built where the three stairways met. The central stair continued beyond the gatehouse until it reached the summit of the second stage; this has been calculated at seventeen feet above the top of the first. It is generally supposed that there was yet a third stage, but this is uncertain,[16] and nothing is known of the temple which stood on top of the Ziggurat, except that Nebuchadnezzar seems to have rebuilt it in blue glazed bricks, as he did in his capital, Babylon, where Herodotus observed that each of the seven stages had a different colour, the uppermost being blue.

We have discussed the significance of the Ziggurat above (pp. 20–2). Of the majesty of this great ruin, as it lies nowadays in the desert, the photographs of illustrations 112–13 give some slight impression. The large buildings found near the Ziggurat in the sacred enclosure are not sufficiently clear to warrant discussion here.[17]

We gain some impression of the public buildings of the period at Tell Asmar, ancient Eshnunna [114]. They were built on a smaller scale, for Eshnunna was a provincial city compared with Ur, the capital of the land. The square building on the right is a temple for the worship of Gimilsin (or Shusin) the king of Ur.[18] Thus the vassalage of the formerly independent city-states found manifest expression in an official cult. The temple is a typical example of a sanctuary at the end of the third millennium

112 and 113. Ur, Ziggurat

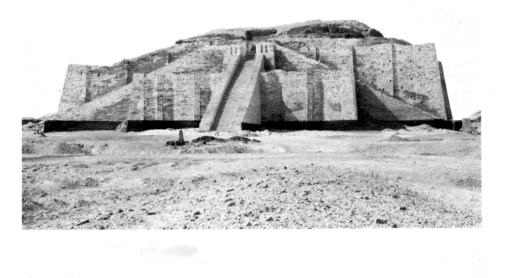

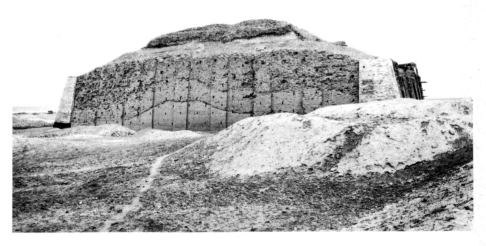

114. Tell Asmar, Gimilsin temple
and palace of the rulers of Eshnunna by the end
of the Third Dynasty of Ur

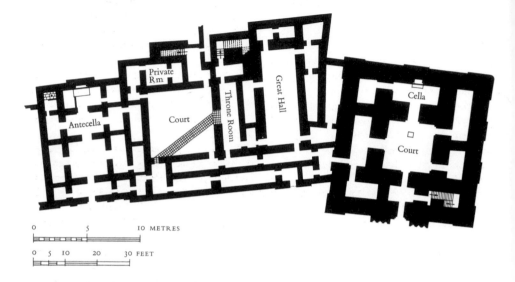

B.C. The outside is decorated with flat buttresses, but the entrance is emphasized by two towers ornamented with stepped recesses [cf. 115]. It leads into a lobby or porters' room, with stairs, on the right, leading to the roof. Beyond the lobby is a square court, with the cella at the far end. The statue of the god stood in a niche, with a pottery drain before it to dispose of the liquids poured in libation [cf. 110]. To the left of the cella is a vestry or sacristy. The altar was not placed in the cella (as in the Early Dynastic and Protoliterate shrines) but was erected in the court.

Against the temple, and joining it at an acute angle, stood the palace of the local governors. At its extreme western end the palace chapel repeats, with a few modifications, the plan of the temple of Gimilsin. It differs in the possession of an antecella, and of a bathroom and other accommodation for resident priests from the larger temple, but was, like the latter, accessible from the palace as well as from the street. This point is of greater importance than has been realized. If the palace entrances are viewed as the main entrances, both shrines show the traditional 'bent axis approach', and this view of the layout is justified since the Gimilsin temple, as seat of the state cult, no less than the palace chapel was an accessory of the rulers' palace. The official processions would use the entrances which appear to us as side entrances. Gates towards the street were, however, required, since each temple was an important economic unit, where a great deal of business was transacted. In practice the street entrances were much more frequented than those connected with the palace, and so the bent axis approach was superseded. We shall see that a similar development took place also in temples not connected with palaces (see pp. 107–9 and

illustration 115); it explains the fact that in the second and first millennium B.C. the cella generally lies in the axis of the main entrance, which, historically speaking, has usurped this function.[19]

The palace was entered in the angle where it joins the Gimilsin temple. The visitor had to pass through two long, narrow guardrooms after leaving the lobby. It was thus impossible for enemies of the prince to force an entry by surprise. A path paved with baked bricks marked the crossing of the main court and ensured dry passage to visitors during the winter. The broad, narrow room facing the court was probably the throne room, like the corresponding chamber at Mari. Behind it lay the great hall, used perhaps for festivities, but probably also, and mainly, as a centre of the administration. It was surrounded by government offices. The ruler's residential quarters may have been on a first floor to which stairs found north of the throne room gave access. Or he resided outside. But on the north side of the square palace courtyard there is a suite, consisting of vestibule, ante-chamber, audience chamber, and cabinet, where the ruler (we presume) normally transacted business, the throne room being used for ceremonial occasions only.

The appearance of such a complex can be imagined by analogy with illustration 115, a reconstruction of the temple at Ishchali. This building post-dates the fall of Ur, and we must for a moment describe the sequel of that event.

THE ISIN–LARSA PERIOD

The last king of the Third Dynasty of Ur was overthrown by a combined attack of Elamites from the east and Amorites from the north-west. The invaders settled and mixed with the older population, and the traditional Mesopotamian pattern of political existence asserted itself as soon as the central power had collapsed, that is, a number of independent city-states now existed side by side. This phase is called the Isin–Larsa Period (2025–1763 B.C.) after the two who were rivals for hegemony. Babylon played no important part until Hammurabi (1792–1750 B.C.) came to the throne. He succeeded in uniting the whole country once more after the defeat of Larsa (1763 B.C.), Eshnunna, and Mari.

But we cannot distinguish the art of Hammurabi's time or of that of his successors of the First Dynasty of Babylon from that of the Isin–Larsa period, unless the monuments are inscribed.

The temple of Ishchali [115] was built after the fall of Ur and belonged to the independent kingdom of Eshnunna, with its capital at modern Tell Asmar, east of the Diyala river, in the neighbourhood of Baghdad. The building was dedicated to a form of the Mother Goddess, Ishtar-Kititum. It stood upon a platform, but the main shrine, at the western end (at the back, in illustration 115), was elevated yet again above this common level of the temple. Viewed from the main courtyard the general situation resembles that at Khafaje [36]: to reach the shrine from the court, which is surrounded by subsidiary buildings, one has to mount a platform and turn sharply to the right to face the deity in her sanctuary. But at Ishchali the architectural arrangements are much more complex. Instead of a single-chambered shrine there is again a court; and the deity is approached through an antecella, as in the palace chapel, on the left in illustration 114. We insist on the comparison with Khafaje to emphasize the continuity of an architectural development which the elaboration of the later plans tends to obscure. In contrast with Khafaje, we find that the elevated platform of Ishchali has a gateway leading directly into the street, and viewed from this entrance the shrine of Ishtar-Kititum lies on the central axis; but the comparison with the temple oval demonstrates that here, as at Tell Asmar [114], the street entrance is, historically,

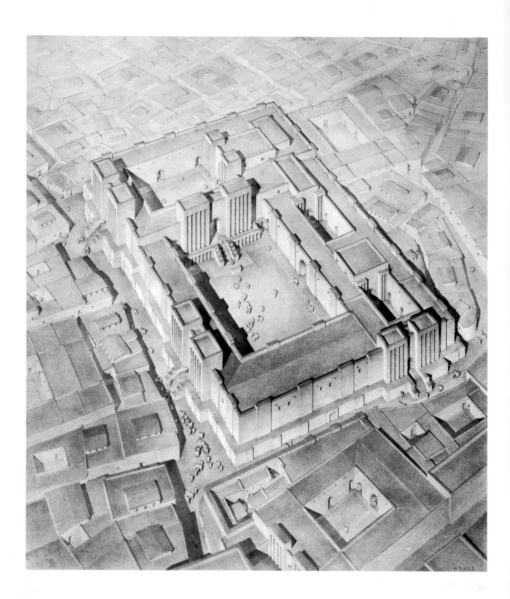

115. Ishchali, temple of Ishtar-Kititum.
Reconstruction by Harold D. Hill

an addition to an original scheme with a 'bent-axis' approach. The same applies to the second sanctuary, in the north-west corner of the building, where a 'bent-axis' connected shrine and court, while an entrance leading from the street was placed opposite the cella.

It remains to explain the broad, shallow cella of these temples; for hitherto a long, narrow room had been customary [3, 6, 7, 35]. The broad cella is merely the most sacred part of the long room converted into a separate unit. This development starts in Early Dynastic times, when an attempt was made to demarcate the position of the altar and divine statue and set it apart from the area where worshippers gathered. At Assur and elsewhere[20] this was done by means of piers. The same method was still used at Assur in the time of the Third Dynasty of Ur [116]. Steps led from the forecourt into a long room where the statue of the god stood before the short wall at the north end; but the effect of the piers is here clearly that of a separation between a broad but shallow cella and a long antecella. The next step could be either an adaptation of the antecella to the shape of the cella or the substitution of an open court for the

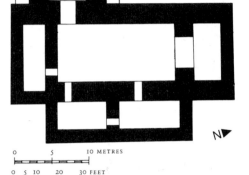

116. Assur, Assur temple E

antecella. Both alternatives appear in illustration 114. I emphasize these details of the plans because far-reaching conclusions have been based on differences in temple plans. Distinct ethnic groups have been proclaimed the builders of temples which, however different they may appear, can now be seen as successive stages in a continuous architectural development.[21]

117. Ur, a private house

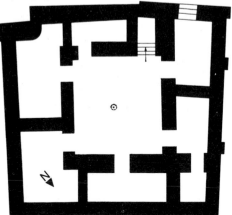

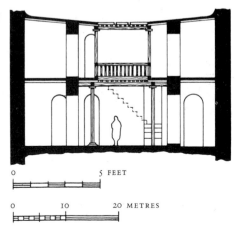

The temples and palaces were the only buildings with aesthetic pretensions. The cities, at this as at all other times, consisted of conglomerations of mud-brick houses, placed along narrow, crooked streets and lanes.[22] The layout of the individual houses was mostly determined by the shape of the plot of land available to the builder. In earlier times they had mostly consisted of a large room, more or less in the centre of an irregular set of smaller rooms. At Ur, during the period we are discussing, the better houses show a more spacious plan. In the centre was an open court paved with baked bricks [117]. It was surrounded by a single row of rooms, one of which served as entrance lobby and another as a stair-well. The stairs led to a

118. Statuette of the goddess Ningal, from Ur.
Philadelphia, Pennsylvania University Museum

wooden balcony round the court, and the individual rooms of the upper floor were entered from this balcony. Exactly similar houses are in common use in Baghdad today. Sometimes a room was set aside to serve as a house chapel; it was distinguished by a mud-brick altar decorated with miniature buttresses and recesses.[23] Small shrines, consisting of one or two rooms, were erected here and there at the corner of a lane or at crossroads. We may well begin our discussion of the arts of the period with the statues found in these chapels.

They are, on the whole, clumsy figures, made of gypsum and representing a goddess in a flounced robe.[24] But a statuette like that of illustration 118 indicates the ideal which the majority of craftsmen working for private persons were unable to realize. It represents the goddess Ningal, spouse of the moon-god Nannar, who was the tutelary deity of Ur, and it was dedicated by the high priestess of the goddess who was a daughter of king Ishme-Dagan of Isin. Yet the modelling even of this excellent figure seems a little hard and insensitive in comparison with similar works of an earlier age [105, 108].

In small shrines reliefs of baked clay could replace the cult statue; but the profile, used exclusively in narrative reliefs, was unsuited to a plaque representing the deity in the actual rites, and reliefs placed over the altars of shrines show the gods in full front view, which establishes a relation with all who approach. In illustration 119 a fine example of such a relief is preserved.[25] It is in keeping with the sombre mood of Mesopotamian religion that so sinister a figure should receive a cult. The goddess is winged, and the legs, between knee and talon, are feathered. She is a bringer of death. Moving soundlessly and at night, men sometimes catch sight of her in the guise of an owl, but her irresistible power, her truly terrifying nature, is leonine rather than bird-like. We know of a goddess Lilith whose name is rendered in the Authorized Version as

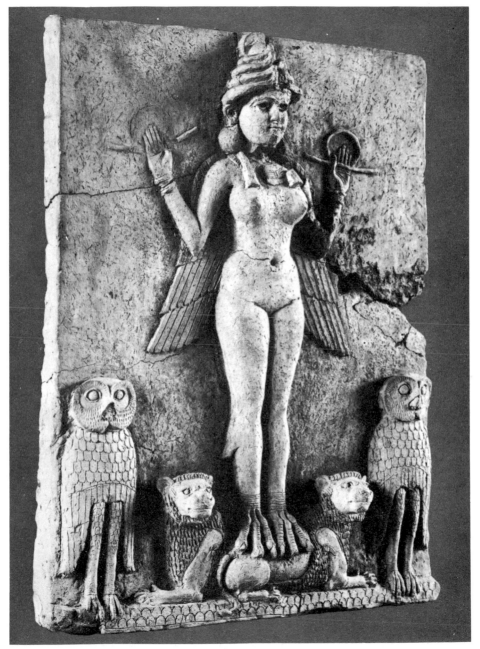

119. Relief of Lilith. Terracotta.
Collection Colonel Norman Colville

'screech owl' (Isaiah xxxiv, 14), and who is mentioned in an early fragment of the Gilgamesh Epic as having built her house in the middle of a hollow tree, as owls do. In later times she was known as a succubus who destroyed her lovers, but the existence of the relief shows that she represented a power susceptible of worship. The symbols which she holds in her hands and displays so emphatically seem to be measuring ropes, which we discussed in connexion with the stele of Urnammu (see p. 104). They may indicate the limited span of man's life or his judgement at death. The whole apparition is set on a ledge covered with a scale pattern, the conventional rendering of 'the mountain'. This, as we have seen (p. 22), is in Mesopotamia the 'religious landscape' *par excellence*, as the reed marsh is of Egypt and the mound of Golgotha in Christianity, and therefore the normal setting for the epiphany of a god. The relief was coloured, and traces of paint still adhere to it; the body of the goddess was red, the feathers of her wings and those of the owls are black and red alternately, and the manes of the lions black.

Reliefs of this type, and also cult statues, were copied on a small scale and were distributed in large numbers as clay reliefs pressed from moulds. These turn up in temples and also in private houses, and there is no doubt that they were placed on the domestic altar. Some of them might be bought by pilgrims or visitors at famous shrines; others were obtained at the local temple, and represented the deity under whose special protection the family lived. An example of this popular class of object is illustration 120, which shows the Mother Goddess as 'Lady of Births' (Nintu).[26] As the sun-god appears with rays emanating from his shoulders and Ningizzida with snakes or dragons, so Nintu shows at each shoulder a child's head, while two naked embryonic figures appear on either side, with the symbol of the goddess above them.

120. Nintu, the Lady of Births.
Baghdad, Iraq Museum

While the majority of these plaques represent deities, there are a number with subjects more or less difficult to explain. Illustration 121, a bitch and puppies, may stand for the Mother Goddess in her form as Gula, whose symbol was

121. Relief of mastiff and puppies. Terracotta.
University of Chicago, Oriental Institute

122 (*below*). Relief of a god killing a fiery cyclops,
from Khafaje. Terracotta.
Baghdad, Iraq Museum

123 (*right*). Relief of a harpist. Terracotta.
University of Chicago, Oriental Institute

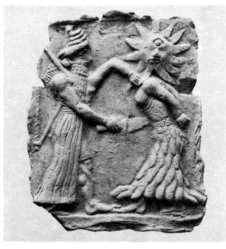

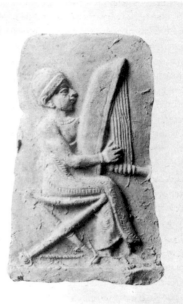

a dog. But we do not know who was the destroyer
of the fiery cyclops [122], who the harpist [123],
or the man riding a bull [124], or any number of
other personages represented in these plaques.
For they were not inscribed; writing being the
business of professional scribes, inscriptions
would have been useless to the average house-
holder. Nor were inscriptions needed. But we
who do not share the common knowledge of the
time are left in the dark by these representations.

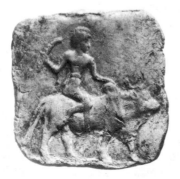

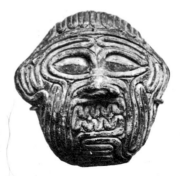

124. Relief of a man riding a bull. Terracotta.
University of Chicago, Oriental Institute

125. Relief of the demon Humbaba. Terracotta.
London, British Museum

The design of another kind of plaque [125] has been plausibly explained as the face of the monster Humbaba, which was occasionally seen in the entrails of a sacrificial animal which were inspected to obtain omens. On the plaque the face is rendered by a single continuous band, to suggest the entrails, in which the face appeared, no doubt, somewhat more equivocally.

There is no point in showing more examples of this very varied class of popular works, since they are mostly of indifferent quality. Figurines of clay were also made,[27] but these lack all pretence to art and seem to have been mere tokens for services rendered in the temple and charged, as it were, with the merit acquired by the act. The majority represent either men bringing a kid or lamb for sacrifice; or naked women who had offered themselves in the service of the goddess. There is no reason to see in them representations of deities, although these do occasionally occur among the figurines. But they are characterized by the horned crown. The large lions guarding the temple entrances were sometimes made of clay [126] instead of bronze.[28]

Illustration 127 shows a fine rendering in gypsum of the bearer of a victim for sacrifice, from Mari. We cannot be sure that it belongs to the Isin–Larsa Period; it might be inherited from an earlier age, and the tasselled robe of our figure would suggest this; but the shape of the head, the headdress, and the rendering of the beard point to the later age, and I have therefore placed it at the beginning of works of sculpture from the Isin–Larsa and Hammurabi Periods.[29] It emphasizes our ignorance of the distinctive marks of these periods; the statue of Ningal, too

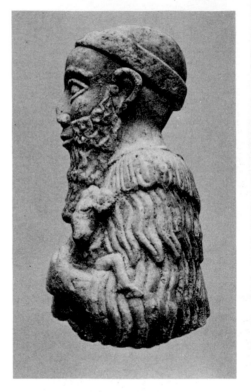

126 (*left*). Guardian lion, from the temple at Tell Harmal. Terracotta

127 (*above*). Offering bearer, from Mari. Gypsum. *Aleppo Museum*

[118], could not have been dated with any precision if it had not been for its inscription.

The statues of the princes who ruled the various city-states after the fall of Ur are often inscribed, but their sequence is not always known. The elegance and fineness of the figurine of Iti-ilum of Mari [128] are contrasted with the larger statues from that site in a way recalling the contrast between illustration 100 and illustrations 97-9. Of the larger statues from Mari, that of Puzur-Ishtar [129] is closest to the statuette. It combines a broad but

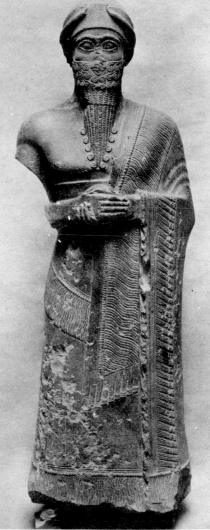

128. Iti-ilum of Mari.
Paris, Louvre

129. Puzur-Ishtar of Mari. *Istanbul,*
Archaeological Museum, head in Berlin Museum

sensitive treatment of the bare parts of the body with an extraordinary elaboration of all those details of dress and hair which are capable of ornamental treatment. The pair of horns enclosing the round cap reminds one of the pretensions of some of these rulers. At Eshnunna, for instance, some wrote their names with the determinative of divinity, of which the horns in our statue are the pictorial equivalent.

The statue of Ishtup-ilum of Mari [130] shows an almost brutal simplification of forms. This is a provincial trait. It recurs in an even more extreme form in north Syria. Statues of rulers of Eshnunna are also known.[30] They are coarser than that of Puzur-Ishtar and more florid than that of Ishtup-ilum. The folds in the

130. Ishtup-ilum of Mari.
Aleppo Museum

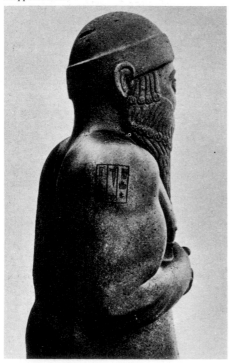

robes are heavier, the muscles more bulging but flaccid, and heavy bead necklaces are added to the costume. At Assur the local rulers set up similar statues.[31] They wear a long kilt, not a shawl, and the dress is treated summarily, but the muscles of the bare body are vigorously rendered, and the shoulder-blades are made into striking ornaments of the normally uninteresting back view. The best preserved of the four statues wears the necklace of heavy beads, which seems to have been characteristic for sculpture of the time of Hammurabi. It appears on his own stele [134], in the statues of rulers of Eshnunna, and again in the statue of the goddess from Mari [131, 132]. Even as late as the beginning of the Isin–Larsa Period the usage of earlier times [105] had survived, and necklaces were rendered by thin horizontal ridges without indication of the individual beads. This treatment was in keeping with the fine, mostly linear, rendering of all other details in those times; in comparison, the forms of the Hammurabi Period appear inflated and flabby.

The goddess, once again, pours water from a flowing vase. We have met this motif often, and shall soon find it applied to Kassite architecture; but the figure from Mari is unique in that it actually dispensed water. A channel drilled from the vase to the base, and no doubt connected by piping with a tank placed at a higher level in or behind a wall, turned the vessel of the goddess into a true fountain. The vertical wavy lines engraved in her gown do not merely represent folds, but render streaming water, as is shown by the fishes engraved alongside. The statue finds parallels on the one hand in the basin of Gudea (p. 98), and on the other in Late Assyrian temples at Khorsabad, where pairs of male gods holding the vase flanked the entrance of each temple in the palace of Sargon.

If we consider the style of the sculptures discussed so far, their traditional character stands out. Allowing for differences in quality, the continuity which links them, through the

131 and 132. Goddess holding a flowing vase,
from Mari. *Aleppo Museum*

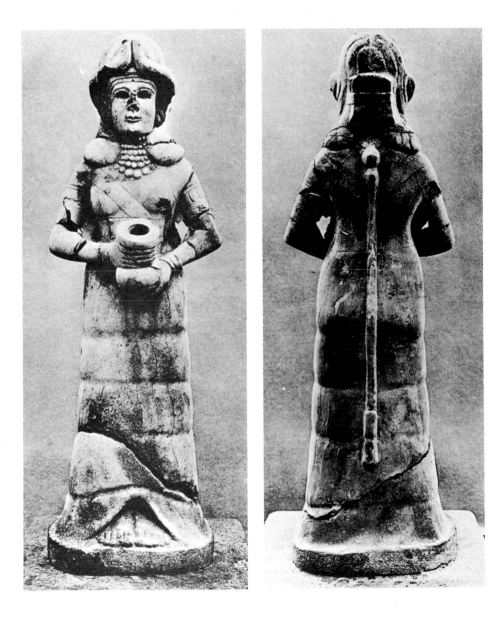

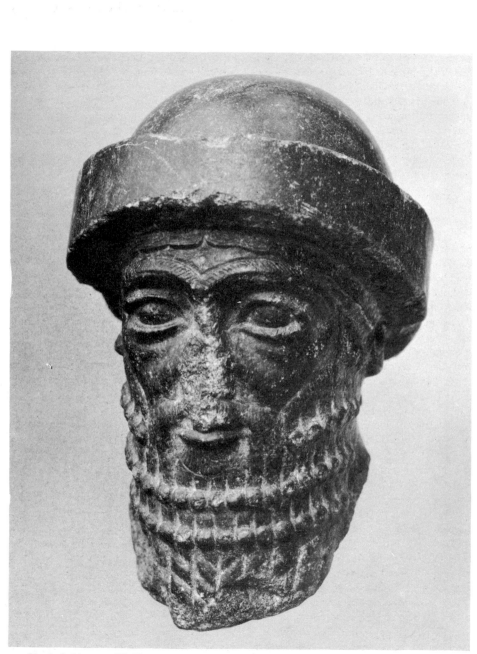

133. Head of a king, possibly Hammurabi.
Black granite. *Paris, Louvre*

statues of Gudea, with the Akkadian Period is clear. Yet if we compare the statuette of Iti-ilum [128] with that of Gudea [100], one notices, in the figure from Mari, a greater emphasis on the rendering of substance; compare the tassels at the edge of the shawl – and one may remember that Akkad, Eshnunna, and Mari all lie to the north of Sumer proper.

HAMMURABI OF BABYLON

The greatest surviving work of the period, a king's head in black granite [133], is usually regarded as a portrait of the greatest figure of the age, Hammurabi of Babylon (1792–1750 B.C.). This view is attractive and may be correct; we have no means of knowing. The sculptor's interest in physical substance has led him to an almost impressionistic rendering of the face. The moustache and the short hairs below the lower lip are lightly scratched in. They form a transition to the more formal rendering of the beard. The hair that is just visible under the woollen cap is also rendered conventionally, with gentle waves combed sideways from a parting in the middle, like those of the goddess with the flowing vase and of earlier works. The eyebrows meet in the middle, but are lightly crosshatched, not patterned with herringbone, as in the past. The eyes with the heavy lids differ from those carved in Gudea's time [e.g. 104] in that they are not mere rims of even thickness round the eyes, but subtly change, being thicker at the outside than in the middle. In fact, the conventional traits which the sculptor retained merely emphasize the greatness of his achievement; they are subsidiary features in a whole which has no parallel among extant works. Yet it would be contrary to all we know of ancient Near Eastern art to see in the granite head an individual portrait in our sense. But the rugged, worn, immensely powerful physiognomy certainly embodies a conception of the ruler which

differs from that expressed in illustrations 97–100 as well as from the Akkadian image of kingship [88, 89]; and these varying conceptions did correspond to some extent with actuality, even though we cannot be sure of the precise nature of that correspondence. In any case the comparisons bring into relief the novelty of method and the mastery of the sculptor of the granite head.

There are two works in stone and one in bronze purporting to represent Hammurabi.[32] The stone 'portraits' are reliefs; one is a small limestone plaque merely showing the king's figure beside an inscription. It was dedicated on his behalf to the goddess Ashratum by a provincial governor, and does not call for comment.[33] The other relief [134] is carved at the top of the large irregular stele on which Hammurabi's famous legal code was inscribed. The king stands before the throne of the sungod, the supreme judge; and the conjunction of the two figures, although conforming to the conventional scheme of the presentation scene, has here been rendered with a fresh awareness of its extraordinary nature.[34] It conveys, not only a sense of confrontation, but of communication between the lord of justice and the lawgiver. We remember a phrase from one of the king's inscriptions: 'When Shamash with radiant face had joyfully looked upon me – me, his favourite shepherd, Hammurabi'[35] and also that other phrase in the preamble of the code of laws, stating that he was called 'to cause justice to prevail in the land, to destroy the wicked and the evil, that the strong might not oppress the weak'.[36]

The scene shown in our illustration is two feet high. Below it appear the cuneiform signs of the code which covers the rest of the boulder which is over seven feet tall and measures three feet in circumference at the base. The engraving of the signs is very fine, but the scene above them is worked in the heavy rounded relief

134 (*below and right*). Stele with the law code
of Hammurabi, showing the king before the sun god.
Paris, Louvre

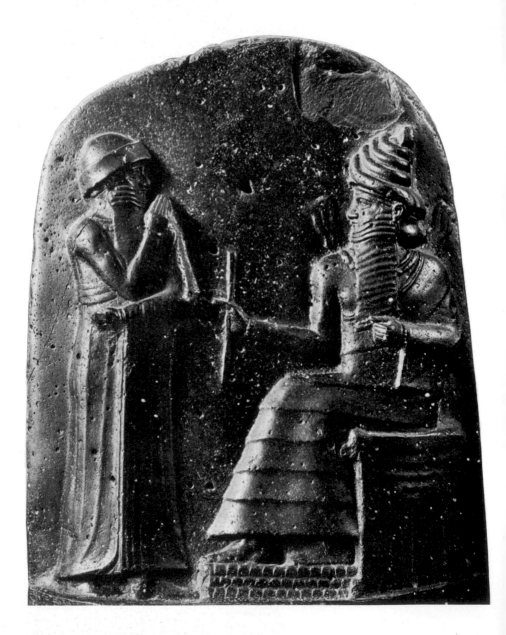

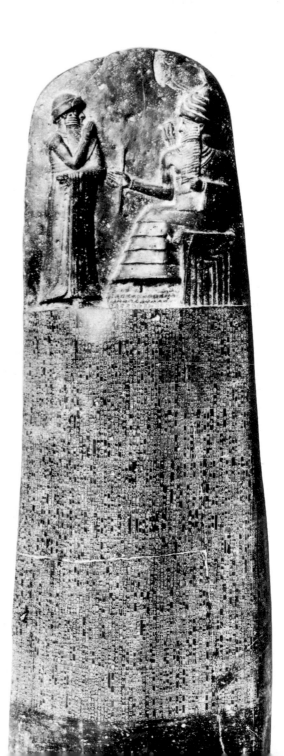

found also on the steles of Urnammu [110].
Neither the robes nor the beards of the figures
show the fine engraving of detail in which earlier
periods delighted.

A bronze statuette shows Hammurabi kneel-
ing, no doubt before the god in whose temple it
was placed [135]. In a relief on the side of the
base the king is shown once again in this attitude
before a goddess on a throne, but the accom-
panying inscription states that the object was
dedicated to the god Amurru for the life of
Hammurabi. On the other side of the base a
ram is depicted in relief, which may be the
attribute of either god or goddess. In front there
is a small basin, either imitating a bowl for water
or intended to hold grains of incense. The face
and hands of the king are covered with gold

foil. But the most striking feature, here as in
the granite head of illustration 133, is the in-
tense animation of the work. The attitude of
genuflexion – just completed, the head some-
what withdrawn between the shoulders, the
left arm tightly pressed against the body, the
right hand making the appropriate gesture – all
this is of a piece, a single purposeful movement
convincingly rendered.[37]

Probably somewhat older than the piece just
described are two bronzes found at Ishchali and
representing a pair of four-faced deities. The
god [136] stands with one foot on the back of a
ram, which identifies him as one of those em-
bodiments of natural vitality to whom we have
referred more than once; whether he appears
here as Amurru or in another form we do not

135. Statuette of Hammurabi kneeling in adoration.
Bronze. *Paris, Louvre*

136. Figure of a four-faced god, from Ishchali.
Bronze. *University of Chicago, Oriental Institute*

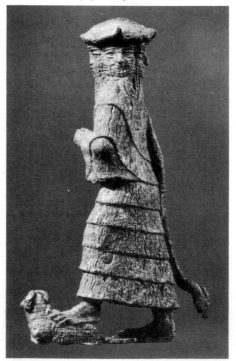

know. He holds a scimitar, now damaged, in his right hand. His four faces are neatly joined, the beard providing a good transition. The figure of his consort[38] is inferior, in the same manner as the goddess of the hoard from Tell Asmar is inferior to the god as a work of art [39]. She is seated, and holds the 'flowing vase' with both hands. Her gown is covered with the vertical wavy lines we met in the statue from Mari [131, 132]. There is no attempt to conceal the crude junctures of her four faces, though locks of hair might have been used to advantage for this purpose, and this is the main reason why she lacks the startling plausibility of the god. The headdress of both figures is peculiar. That of the god, although it resembles a beret, may consist of one pair of horns above each face, but one would

expect in that case a conical cap of felt. The crown of the goddess is in the shape of an altar or temple above a pair of horns, a type of headdress which makes its appearance also on the seals of the period.[39] There are no texts which we can refer to these remarkable figures.

In the period of Isin, Larsa, and Babylon which we are discussing, a number of fine stone vases were made. The stone mastiff of illustration 137 was dedicated by king Sumu-ilum of Larsa. The fragment of illustration 138 represents a fairly large class of vases cut in soft bituminous stone, and decorated with animals. These are subordinated to the purpose of ornamentation, but yet retain something of their peculiar character. Ibexes kneeling on their forelegs serve as supports to a large tripod or the

137. Vase in the shape of a mastiff, of Sumu-ilum of Larsa. *Paris, Louvre*

138. Fragment of a bowl, from Ishchali. Stone. *Baghdad, Iraq Museum*

139. Jewellery of the priestess Abbabashti, from Warka. Agate set in gold. *Baghdad, Iraq Museum*

140. Top of a ceremonial staff in the shape of a ram's head, from Ur. *London, British Museum*

141. Vase, from Susa. Stone. *Paris, Louvre*

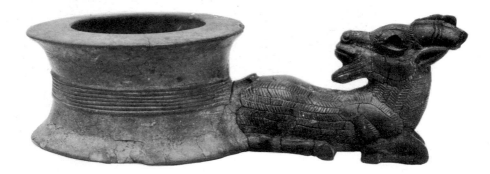

forepart of a bull or goat forms a handle to a dipper.[40] The mouflon of illustration 138 was repeated three times round the bowl. With its head modelled in the round, while the body appears in relief along the vase, it revives a decorative scheme of great antiquity [16]. The proud attitude of the animal and the splendid sweep of its horns make this one of the best examples of this type of vase.

<center>✳</center>

There is no reason to doubt that the walls of public buildings were often decorated with paintings. It so happens that they have only survived in the Protoliterate temple of Al 'Uqair, and, again, in the palace of the kings of Mari, which Hammurabi destroyed in his thirtieth year. The fragments recovered fall into

two groups: traditional designs known from seals, and narrative scenes with subjects met sometimes on steles but including, possibly, original compositions. This last group comprises three types of scene:

1. Mythological, and of these one fragment survives.[41] It shows a bearded figure, full-faced underneath a kind of vault studded with white circles, either stars or raindrops; the latter is suggested by a glazed tile from a middle Assyrian palace.[42]

2. War scenes; here, too, only a few fragments of enemy soldiers survive.[43]

3. Scenes of offering [142]. A large figure, dressed in a fringed shawl, appears at the head of two registers of subsidiary figures, wearing similar dresses and, in addition, the felt caps still used in Syria and northern Iraq. They lead

142. Fragments of
wall paintings
from Zimrilim's
palace at Mari.
*Aleppo Museum
and Louvre*

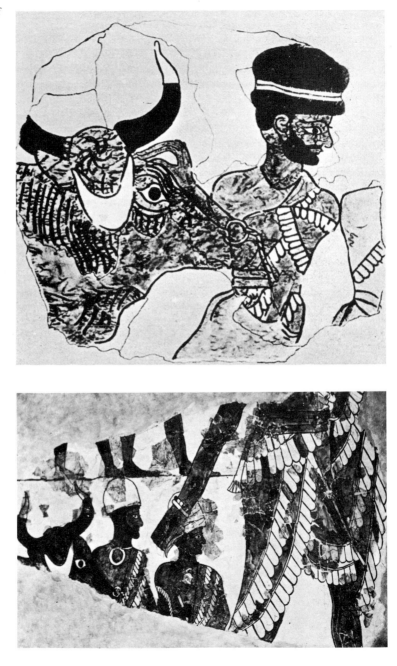

some sacrificial bulls with gilded or silvered horn tips and crescent pendants tied round their horns.

The liveliness of these groups of designs contrasts not a little with the hieratic stiffness of the conventional scenes, remarkable only in the fact that they are executed in paint. There are two murals of this type, the largest of these measuring over eight feet in width and six feet in height. It consists for the larger part of a symmetrical framework of trees, monsters, and interceding goddesses, which encloses a small oblong presentation scene. It is purely conventional and can be matched on countless seals; it can therefore only represent a traditional, ritual scene.[44] The whole design is surrounded by a border of running spirals, intruders from the West, and, in particular, from the Aegean.[45] It recurs in a court and in one of the king's private rooms,[46] and also round his throne-base.[47] It was about seven feet square, and decorated on top with panels imitating marble, surrounded by a running spiral. But at this time contact with the West did not influence Mesopotamian art deeply; this happened only when the upheavals which brought about the downfall of Hammurabi's dynasty had broken down the traditional frontiers.

Glyptic art suffered a decline after the Akkadian Period. The piety which pervades the works of Gudea of Lagash and of the Third Dynasty of Ur is reflected in the seals by the elimination of all the varied subjects evolved in Sargonid times. They show almost exclusively the 'presentation scene' (illustration 107; see p. 102 above) with or without an interceding goddess.[48] The uniformity destroyed the *raison d'être* of seal designs which was the impression of an individual distinctive mark; this function was taken over by the inscription.

The Isin–Larsa Period brought a loss of refinement without any increase in vitality. The First Dynasty of Babylon returned to the use of seals distinguished by the design rather than the inscription, by combining the whole or parts of 'presentation scenes' with a number of secondary motifs, a method which never resulted in unified compositions. Towards the end of the period the number of figures was often reduced and the main burden carried once more by the inscription. And this arrangement formed the basis of Kassite glyptic in subsequent centuries.

THE ART OF THE KASSITE DYNASTY

(CIRCA 1600–1100 B.C.)

The accession to power of the Kassites, a foreign dynasty, represents the culmination of two centuries of disturbances. Even before Hammurabi had succeeded to the throne of Babylon (1792 B.C.) hordes of immigrants, irrupting, as so often, out of Central Asia, had appeared on the fringes of the civilized world. Asia Minor had been invaded, and ultimately subjugated, by people of an Indo-European tongue, the Hittites. Farther to the south, in Syria and Palestine, mixed forces advanced into, and eventually overran, Lower Egypt, where their rule is known as that of the Hyksos or Shepherd Kings. From the Kurdish mountains warriors of uncertain lineage – the Kassites – descended into the plain. They attacked Babylon and, although Hammurabi's successor repelled them (1742 B.C.), they established themselves in the north.[1] They extended their power after 1595 B.C., when a king of the Hittites, Mursilis I, made a sortie from Anatolia and sacked Babylon. After this raid he returned to his highlands, and in the vacuum which he left the Kassites assumed power.

In both northern and southern Mesopotamia the authority of the Kassites was challenged. In the marshes at the mouth of Tigris and Euphrates a 'Sea-land Dynasty' ruled independently; and in the north, in Syria, a band of Indo-European-speaking people – Aryans in the strictest sense, who worshipped Mitra, Varuna, and other Indian gods – created an independent kingdom, centred on the Khabur river but reaching, in the west, almost to the Mediterranean, and in the east as far as Kirkuk. These people – the Mitannians – thus included

in their domain that northern portion of Mesopotamia which was later to gain its independence as the realm of the god Assur, Assyria.

During the ethnic upheavals of the eighteenth century B.C. Assyria, too, received immigrants. They were the Hurrians – people who had moved westwards and southwards in the wake of, or intermingled with, Hittites, Hyksos, and Kassites, and spread over northern Mesopotamia into Syria and Palestine. They lacked political talents and appear everywhere under foreign leadership, but they formed an important element among the subjects of the Mitannians.

In the history of art these newcomers remain indistinguishable. One cannot speak of a Hurrian, Hyksos, or Kassite style. One chiefly notes their power of destruction, a disruption of the established forms of Egyptian and Mesopotamian art, followed, after a while, by a new combination of the scattered elements. In Mesopotamia the traditional themes were enriched by foreign admixture, of Syrian, Aegean, or even Egyptian origin. The presence of these derivations is easily explained. The migration had broken down frontiers and carried foreign influences through the lands which were overrun. The Assyrians in particular became well acquainted with the art of the West, while they were dominated by the Mitannians until the middle of the fourteenth century B.C. The Kassites in southern Mesopotamia remained, on the whole, in the Babylon tradition. At Ur existing temples were restored and rebuilt, and the same was done elsewhere. At the new capital, Dur Kurigalzu, which was founded twenty miles to

the west of what is now Baghdad,[2] a Ziggurat was built within a system of courts surrounded by single rows of chambers and approached by three stairways. In all these respects the sacred mountain resembled that of Ur, but the royal palace, which is as yet incompletely known, shows a combination of rooms and courts which seem to differ from the usual Mesopotamian arrangements. Moreover, it appears to have had one court bordered on two sides, and perhaps surrounded, by an ambulatory with square pillars. Colonnades are rare in Mesopotamia, but neither those in the Early Dynastic palace at Kish[3] nor those of the Isin–Larsa Period at Mari[4] suggest cloisters. A corridor in the palace shows a dado, four feet high, which portrays a procession of court officials, stiffly and clumsily drawn. This motif also seems new, although the scarcity of the evidence prevents us from affirming that it is so. Finally we must describe a temple built at Warka by the Kassite king

Karaindash (about 1440 B.C.) and dedicated to the Mother Goddess Inanna [143, 144]. The long cella is entered through a door in the main axis, immediately beyond the entrance; the bastions at the corners are another unusual feature of the plan. And the elevation shows a novel application of an ancient motif: male and female deities bearing the 'flowing vase' are placed in the recesses which decorate as usual the outside of the temple. They are part of the architecture, since they are built up of moulded bricks. The robes of the goddesses fall in the vertical wavy lines already found on Gudea's basin, and the statue from Mari [131, 132]. The male gods are chthonic beings; the upper part of their bodies emerges from 'the mountain', here, as usual, marked by a scale pattern. The water which flows from the vases is brought in horizontal streams to the buttresses between the figures, and from these wells up and descends in a double stream. It falls, below, on two round-

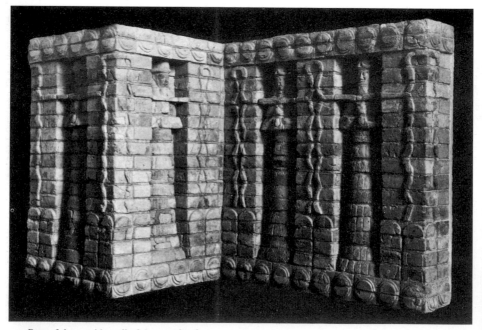

143. Part of the outside wall of the temple of Karaindash, Warka (cf. 144). *Berlin Museum*

144. Warka, temple of Karaindash

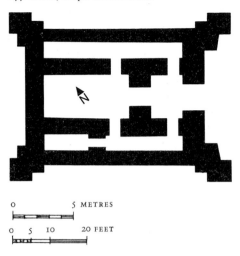

0 5 METRES

0 5 10 20 FEET

historic times in Eridu to the south as well as in Tepe Gawra to the north [2, 3]; we know they were discontinued in the south. Did they survive in the north in the periphery of Assyria? And is it an accident that the procession of officials painted in the Kassite palace at Dur Kurigalzu finds its nearest parallel in the palace of Sargon of Assyria, at Khorsabad? The cloister of the Kassite palace most closely resembles those of the Hittite temples of eastern Anatolia [250, 251]. It may well be that such scattered similarities will prove to be without significance; but they are worth listing because we may discover that the art of the Kassite period incorporates traits from the semibarbaric culture of its homeland somewhere to the north and east of Mesopotamia.

The recent excavations of Dur Kurigalzu laid bare a number of small works modelled in clay which are of some merit. Illustration 145 shows the head of a man, with a painted moustache,

topped steles, as it seems; perhaps this design once more indicates the earth. It is not certain whether these figures stood all round the building, but the excavator assumed so, because of a large number of additional fragments.[5]

The moulded bricks which form figures in relief were not known before Kassite times, and this innovation was splendidly applied, almost a thousand years later, in the Neo-Babylonian temples [233]. But the other features of Kassite architecture which are without precedent in southern Mesopotamia point in a general way to the north; and it may well be that they reflect usages of the Kassite homeland. The long cella with an axial entrance through the narrow wall is customary in Assyria in later times; it may be the result of the process described above by which the 'bent-axis' approach became secondary; it may likewise represent a type of shrine to which the Kassites and the northern elements of the Assyrian population were accustomed.[6] The corner buttresses were known in pre-

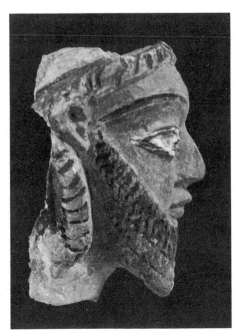

145. Head of a man, from Dur Kurigalzu. Terracotta. *Baghdad, Iraq Museum*

apparently kept short, and a full beard, a fashion known already in Early Dynastic times in Khafaje, Mari, and Assur [e.g. 56]. The flesh is painted red; hair and beard are black, the eyes are inlaid. The lioness of which we show the head in illustration 146 is more precisely modelled and at the same time more vivid.

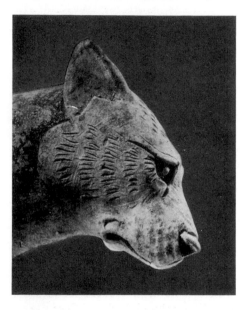

Of the stone work of the period, only sculptured boundary stones (*kudurru*) survive. The custom of marking the limits of fields by reliefs naming the gods who vouchsafed the permanence of the boundary was very old; we have seen the Eannatum boundary stone, set up at the limits of the field which the ruler of Lagash took again from Umma. For reasons which we do not know, sculptured boundary stones are exceptionally numerous during Kassite times.[7] They were either covered entirely by the emblems of the gods invoked to protect the boundary, or they show the image of the ruler who has made a donation of the fields in question and now guarantees their possession to the owner [147]. Even in that case divine emblems

recall the sanctity of the covenant; conversely, a royal inscription is often to be found on kudurru which depict only divine symbols. The stone we illustrate belongs to the end of the Kassite Period, to the reign of Marduk-nadin-akhe (*c.* 1100), shortly before the Assyrians subjugated the south of Mesopotamia for good.

146. Head of a lioness, from Dur Kurigalzu. Terracotta. *Baghdad, Iraq Museum*

147. Boundary stone of Marduk-nadin-akhe. *London, British Museum*

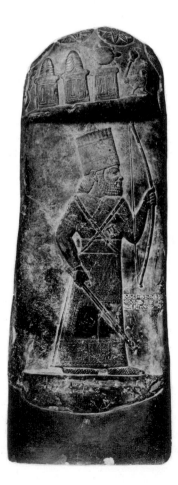

THE BEGINNINGS OF ASSYRIAN ART

(CIRCA 1350-1000 B.C.)

The early history of Assyria is wrapped in obscurity. Early in the eighteenth century B.C. Shamsi-Adad I had attempted to establish an independent kingdom in the north and had succeeded, for a time, in dominating even Mari.[1] But Hammurabi of Babylon restored the traditional ascendancy of the south over Assyria. It continued for another four hundred years, until, in the turmoil of the Amarna period, Assyria rose above its neighbours and the Mesopotamian centre of gravity was shifted. The south was weak under the foreign Kassite dynasty (see p. 127 above). The Hittites, advancing into Syria, disrupted the kingdom of Mitanni of which Assyria, at least as far east as Kirkuk, had formed a part (see p. 135 below). And Egypt, the ally of the Mitannian kings, was absorbed by internal problems arising out of Akhenaten's religious revolution. Able rulers succeeding one another at Assur quietly and gradually established the independence of their homeland during the second half of the fourteenth century B.C.

Assyrian art was born at this time; the little we know of the earlier (Old Assyrian) period shows as exclusive a dependence on Babylonia proper as the contemporary works from Mari. A headless stone statue[2] resembles our illustration 130 very closely in style; and the cylinder seals of the period are, for all intents and purposes, part of the glyptic art of Hammurabi's dynasty. But in the fourteenth century an art emerged which, for all its derivations, possessed an individual character, not only in style but also in subject-matter. It depicted secular subjects with an interest in actuality for which no incident seemed too trivial. In religious matters, on the other hand, it displayed a cold formalism, which did not allow man to meet the gods face to face but only to perform the established rites before their statues and emblems. In both respects Assyrian art was to remain true to its beginnings; they represented, apparently, distinctively Assyrian points of view, and their prevalence in the art of the fourteenth century B.C. is the more remarkable because much in it, of a less essential nature, was derivative.

A number of decorative motifs and technical processes are of western origin; they represent the legacy of Mitannian rule which had united Assyria with Syria. The ties with the south were stronger and more important; the relation between Assyria and Babylonia can best be compared with that of the Late Roman republic with Greece. In both cases cultural dependence was taken for granted, although a difference in outlook was acknowledged; and force was required to quell the political vagaries of the older nation.

Babylon remained the cultural centre of western Asia, and Assyrian scribes, and kings like Assurbanipal, collected and copied the literary, religious, and scientific texts of the south. The cult of the state god, Assur, had so many features in common with that of Marduk of Babylon, that it is hard to distinguish the two.[3] Moreover, Assur, like Marduk, was apparently a specialized form of the personification of natural life worshipped throughout the country from the earliest times onward. Such a god is represented in a gypsum relief [148] which was found in a well in the temple of

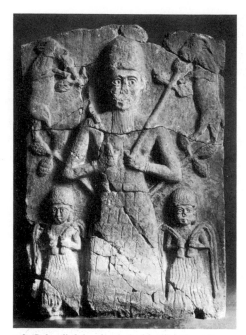

148. Cult relief showing god of fertility, from Assur. Gypsum. *Berlin Museum.*

Assur at Assur. The frontal composition shows that it served in the cult (cf. illustration 119 and p. 110). Every element of the design is known from earlier times. The lower part of the body of the god, as well as his cap, shows the scale pattern by which 'the mountain' is traditionally rendered; it could not be expressed more clearly that the divinity is immanent in the earth. Plants

spring from his hips and hands, and goats (representing animal life) feed on the plants. A similar design occurs on a cylinder of the Proto-literate Period,[4] and illustration 96A shows an Akkadian version of the theme. Two subsidiary deities carry the 'flowing' vase [cf. 95, 111, 131, 132]. The relief indicates, therefore, that there was no break in continuity between the art of Assyria and the art of Babylonia and Sumer.

But it is different in the case of the altar of Tukulti-Ninurta I (*c.* 1250–1210 B.C.) [149]. The relief on the front shows a rite performed before the very object which it decorates. The king bearing a sceptre is first shown as he approaches, then as he kneels before the altar, carved with the emblem of the god Nusku. The almost intimate meeting between king and god which was depicted on steles from the time of Gudea down to that of Hammurabi is not considered possible in Assyria. In both art and literature the gods appear withdrawn from the world of men, and we do not know whether this reflects a profounder awareness of the transcendence of divinity, or whether, on the contrary, the prominence of the emblems indicates an approach to fetishism. However that may be, the directness and vividness of the earlier scenes are no longer found. If the god is seen in a cult scene, he appears as a statue standing on a base [150B], but in mythological scenes (for instance, when destroying monsters) the base is absent. In former times this distinction between the god and his statue had never been made.

150. Middle Assyrian seal impressions

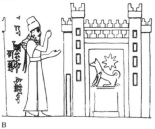

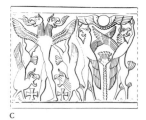

A

B

C

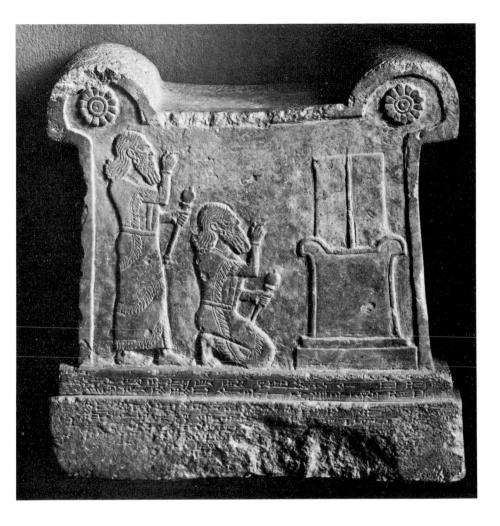

149. Altar of Tukulti-Ninurta I, from Assur.
Berlin Museum

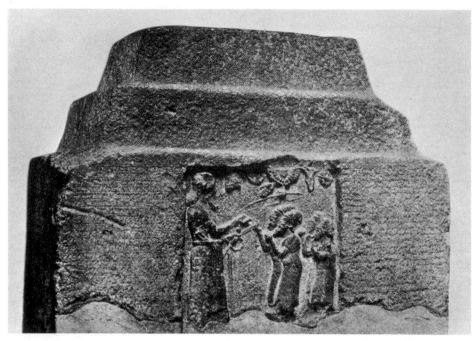

151. Top of obelisk. Granite.
London, British Museum

The distance between god and men is impressively rendered on a scene of the so-called 'broken obelisk' set up by one of the successors of Tiglathpileser I (*c.* 1110 B.C.) [151]. While vassals pay homage to the king, two hands emerge from a cloud above; one holds a bow, and this probably identifies the god as Assur; the other hand makes a gesture expressing divine approval of the king's glorification. On either side of the cloud appear symbols of other deities.

In a later glazed slab of the reign of Tukulti-Ninurta II – part of the revetment of a wall – the same idea is expressed. The god actively supports king and people but remains in his own inaccessible sphere. Above the royal chariot Assur appears in the flaming disk of the sun drawing his bow against the enemies of Assyria.[5] Even here it is not forgotten that Assur is a power of nature; the clouds charged with heavy drops of rain which cluster along the upper edge of the design represent a blessing brought by the god. The appearance of Assur, with wings and a feathered tail [cf. 180], is curious; it is generally explained as a derivation from Egypt,[6] where Horus, the god incarnate in Pharaoh and manifest in the falcon, was represented as a sun disk between (originally: supported by) two wings. The winged sun disk appears in Syrian cylinders of about the middle of the second millennium, in its original meaning, the wings rendering the sky supporting the sun; and this is incorporated in the 'aedicula' in which the Hittite kings wrote their names [266]. The

immense prestige of Egyptian kingship supplied a pattern which the rulers of western Asia followed in so far as the national conceptions of royalty allowed it, and Assur was pre-eminently the protector of the king and country of Assyria, and could be regarded by Asiatics on whom the dogmatic precision of Egyptian theology was lost as an equivalent of Horus. But it is also possible to conceive that the god derived his peculiar appearance from an age-old native tradition; perhaps the two factors worked together in the shaping of Assyrian iconography. We have met the lion-headed eagle Imdugud [63, 71, 87] as a personification of the storm clouds which bring rain, and, therefore, as an aspect or manifestation of such gods as Ningirsu, who were also leaders in war. Assur can be considered the Assyrian form of the Sumerian divinity, worshipped under many names from the oldest times. And the view that the feathered body of Assur replaced Imdugud becomes even more probable, if we observe that Imdugud is not found on Assyrian monuments, and yet was known in the first millennium, as an ornament on bronzes from Luristan (p. 346 and illustration 410 below). Once again the complex origins of Assyrian art present a problem which cannot as yet be solved.

Other surviving Middle Assyrian works illustrate the distinctive Assyrian attitude, not only in religious but also in secular art. Scenes of warfare included a leisurely procession of chariots in which the king does not dominate the scene but appears with his soldiers among all the details of an actual campaign. This is a common subject. An altar,[7] a companion piece to illustration 149, shows Tukulti-Ninurta I between two figures holding the sun symbol; and on its base (where the altar of the illustration has an inscription) it shows the Assyrian chariotry advancing through mountainous country. The same subject appears on a panel built up from polychrome glazed bricks.[8] This technique was used at Babylon to great effect in later times [233, 438] but it was first developed in Assyria on the basis of technical knowledge derived from the West. Glazing of beads and small objects had been practised throughout the Near East from the fourth millennium B.C., but with greater skill in Egypt than elsewhere, especially during the Middle Kingdom (about 2000 B.C.). When, at the time of the Hyksos invasion and the related popular movements, the established frontiers were ruptured, the practice of decorating large objects with multicoloured glazes spread to Crete, Rhodes, Cyprus, Syria, and Assyria. In Part Two of this volume we shall discuss the effect of this diffusion of a new technique in the peripheral regions; it is peculiar to the Assyrians that they applied it to architectural decoration. Certain themes, too, spread through the various countries of the Near East during, or immediately after, the great invasions of the eighteenth century B.C. Two of these became standard motifs of Assyrian art; they made their first appearance in the mural paintings [152, 153] with which Tukulti-Ninurta I decorated the palace in the residential city, Kar Tukulti-Ninurta, which he built two miles upstream from Assur.[9] They also occur on royal seals of the fourteenth and thirteenth centuries [150C]. One of these motifs is an elaborate and highly artificial 'sacred tree',[10] the other is the crested griffin.[11] Both were unknown in Mesopotamia before the north had endured Mitannian rule; they are found throughout the kingdom of Mitanni. A variant of the griffin, the griffin-demon, has a similar distribution. The griffins often appear in association with the 'sacred tree', and continued to do so in Late Assyrian times [187].

The sacredness of trees and plants, or rather the belief that divinity was manifest in the vegetable kingdom, was, as we have seen, one of the oldest tenets of Mesopotamian religion. It is merely the form in which the belief finds

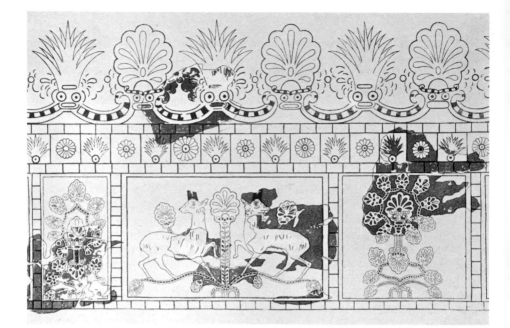

152 and 153. Watercolour copies of fragments of
wall paintings from the palace of Tukulti-Ninurta I
at Kar Tukulti-Ninurta

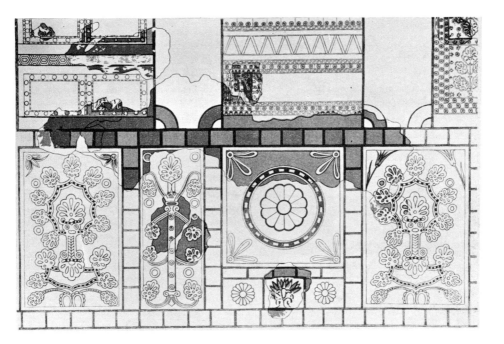

expression that has changed by the fifteenth century B.C. On monuments of an earlier date the trees and plants appear with some degree of verisimilitude, and it is only possible for us to decide whether they are intended to represent natural or symbolical objects when the context in which they appear is unequivocal. But in Assyria a corresponding symbolism finds expression in the purely artificial designs of illustrations 150C and 224, which, at a first glance, might appear to be used as pure decoration. Now there are sufficient instances of the performance of ritual acts in connexion with the artificial 'sacred tree' to exclude ornamental preoccupations as its source. We know, moreover, that a bare tree-trunk, round which metal bands, called 'yokes', were fastened and to which fillets were attached,[12] was used in the New Year's Festival in Assyria, in contrast with the usage of the south. In Syria, too, a 'bedecked maypole' was an object of worship, and on one Syrian cylinder seal the head of the deity dwelling in the object emerges at the top.[13] The prominence of the 'sacred tree' in Assyria [224] is yet another instance of the tendency to represent gods by their symbols; the relief of illustration 148 uses the more direct language of the immemorial *southern* tradition.

In architecture the only demonstrable influence from the west and north consists of a technical innovation. As we shall presently see, stone slabs put on edge were used as a revetment of the lower parts of walls in palaces and other secular buildings. But in planning, and in temple architecture as a whole, Assyria followed the usages of the south, though with certain modifications of the Babylonian norms which probably represent Assyrian innovations.

The ancient sanctuary of Ishtar at Assur, which goes back at least to Early Dynastic times,

0 5 10 20 METRES

0 20 40 60 FEET

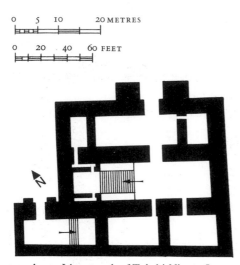

154. Assur, Ishtar temple of Tukulti-Ninurta I

was rebuilt by Tukulti-Ninurta I according to the old scheme, with a subsidiary shrine added [154, 155]. The statue of the goddess was, as of old, placed at one of the ends; but it was elevated higher than had been usual either in the south, or in earlier times at Assur. It stood in an alcove

which was almost a separate room, at the top of a flight of steps. This arrangement is characteristic of Assyrian temples [e.g. 156]. In the south, as we have seen, the statue of the god stood, at first, upon a block of masonry which served as an altar, before a niche; sometimes a few steps led up to it. In the time of the Third Dynasty of Ur, when larger statues seem to have come into use, these were placed in a niche, again reached by a few shallow steps. The Assyrian arrangement with its alcove high above the level of the temple proper differs greatly in its general effect from that of the south. It represents, perhaps, in the language of architecture that same awareness of the distance between gods and men which distinguishes the Assyrian rendering of religious subjects in art.

It is likely that, from this point of view, the Ziggurat had a special appeal for the Assyrians, since it rose so high above the world of man. It was, in fact, attached to a number of Assyrian temples, with a revealing modification of the southern plan: the three open stairways giving easy access to the tower from the court are superseded by a more difficult mode of approach.[14] Often we are left in doubt as to its

155. Assur, Ishtar temple of Tukulti-Ninurta I. Reconstruction

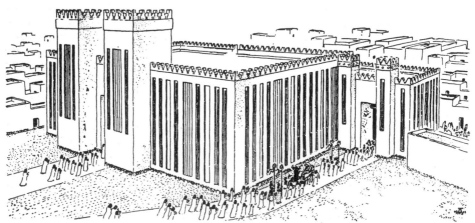

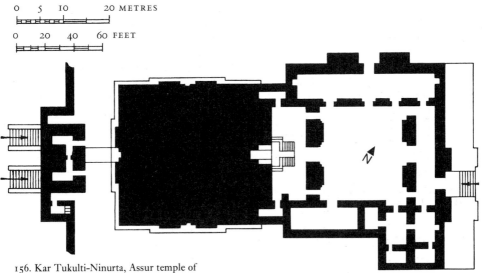

156. Kar Tukulti-Ninurta, Assur temple of
Tukulti-Ninurta I

precise nature, and the Ziggurats then appear altogether inaccessible, but this is no doubt due to their bad state of preservation. Nevertheless, we can be certain that such great stairways as, for example, at Ur [112, 113] would have left traces if they had been used. We seem actually to have evidence of an arrangement which might easily become incomprehensible when a temple fell into decay: the Assur temple at Kar Tukulti-Ninurta [156] was built up against the Ziggurat, as had been the case at Mari.[15] The Assur shrine had two entrances, like the temple of Ishchali [115], and in both cases one entrance provides a straight and the other a bent axis approach to the cella.[16] We have discussed already the origin of this arrangement (pp. 107–9); we may now add that it was adopted in the north and south at about the same time.[17]

The broad, shallow cella with its podium lies in front of a recess which is deeper than the southern niches and is cut into the body of the Ziggurat, as if to emphasize that the god, in his epiphany, came forth from the mountain [cf. 148]. The Ziggurat is square (over ninety feet

at the base) and has no stair or ramp leading up to it. But in front of its south-western face lies a building which could very well accommodate a staircase. It has been supposed, and I think rightly, that the roof of this gatehouse might be connected by a bridge with the top of the first-stage of the Ziggurat.[18]

The great Ziggurat of Assur, in the city of Assur, seems also to have been accessible by means other than stairs or ramps. It stood alone in an enclosure, like the Ziggurats of Ur and Erech, while the temple was a separate building. In illustration 157 the corner of this temple appears on the extreme right. Then follows the Assur Ziggurat, next the Old Palace, the centre of the administration. To the left of this is a public square (*Tarbas Nishe*, Square of the Foreign Peoples), with on the far side the double temple of Anu and Adad (Heaven and Storm) with two Ziggurats presumably accessible from the temple roof, and on the near side the double temple of Sin and Shamash (Moon and Sun). The very large building on the extreme left is the New Palace, with the temple of the god

157. Assur, the northern part of the city.
Reconstruction by Walter Andrae

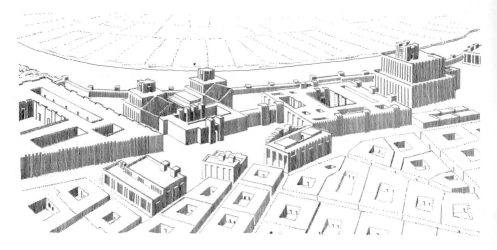

Nabu on the near side of the street running past it.

Most of these buildings were destroyed to such an extent that only foundations survive. It is, therefore, impossible to discuss them in detail. But the variety in their planning is, nevertheless, revealing. While the Assur Ziggurat stood alone, and the Sin-Shamash temple and the Nabu temple were without towers, the Anu-Adad temple consisted of two identical shrines, placed side by side between two square Ziggurats. In all these temples there was a narrow, deep cella opening from a broad, shallow room, as we find later in Khorsabad [167]. In the Sin-Shamash temple the two shrines faced one another across an intervening square court; in the Anu-Adad temple[19] they were placed side by side, separated by a narrow passage. It is clear that many experiments in the combination of architectural units were made during this time, and it is, therefore, all the more likely that the differences between Assyrian and Babylonian architecture are due to intentional innovations on the part of the Assyrians.

We know nothing of the elevations of these Ziggurats, except that contemporary seal engravings show four or five stages decorated with recesses.[20] The temples, too, were depicted on seals. In illustration 150B, we see two towers flanking the entrance which shows an altar placed inside; it is shaped like that of our illustration 149. The figure of a dog which it supports in illustration 150B may be the emblem of the goddess Gula, a form of the Mother Goddess. The temple shown in illustration 150A was probably dedicated to Ea, since his emblem, the goatfish, surviving as our Capricorn, flanks the entrance. We cannot say, of course, whether it was carved in stone or cast in bronze or rendered in glazed bricks, but the designs are valuable sources of our knowledge of Middle Assyrian architecture: they prove that crenellations crowned the walls and towers, which were decorated with the usual recesses. Once more the perennial preoccupation with drought is betrayed: above the shrine clouds are seen from which rain descends on either side.

I have described the scanty remains of the Middle Assyrian Period in some detail, because

it was an epoch of artistic energy upon which the subsequent development was founded. All the distinctive features of Assyrian art were given shape in the last centuries of the second millennium B.C. But the only monuments which adequately reveal the astonishing vitality and power of the period are the seal designs. One must remember not only the dull mediocrity of glyptic art in the Kassite south, but also the impoverishment, in both subject matter and design, which had followed the great Akkadian Age to appreciate the achievements of the Middle Assyrian seal-cutters [158–64]. Once again the challenge that each seal must show an individual design was accepted with alacrity. The makeshifts of the Hammurabi Period, which differentiated the seals by the elaboration of inscriptions (a method adhered to also in Kassite times), or by the dull juxtaposition of unconnected motifs, were abandoned. A wealth of new subjects made their appearance, engraved in the grand manner, and spaciously composed. Some of them seem to be straightforward renderings of natural scenes, vivid and beautifully executed. A deer moves cautiously between trees;[21] a ewe suckles its lamb.[22] Such subjects – a stag, a tree, a mountain, and a plant in illustration 161 – sometimes form the continuous frieze so dear to the designers of the Early Dynastic Period. It is characteristic that this scheme of composition, so eminently suitable for a design impressed by an engraved cylinder, becomes once more popular [158–64].

But it is possible that we misinterpret the combination of stag and mountain if we see in it a mere nature scene. The fact that vegetation is caused to sprout from the mountainside recalls the relief of illustration 148, and we may well have here an allusion to the earth as the depository of the divine vitality which pervades nature; the seal would then be a rendering of a theme which was at least two thousand years old [29]. Religious overtones are unmistakable in the next seal [162]. The bulls and the triple tree in

158 to 160. Middle Assyrian seal impressions:

158. Lion, winged horse, and foal.
London, British Museum

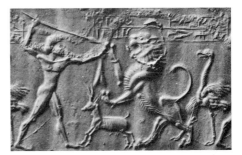

159. Hunter and game.
London, British Museum

160. Winged demon pursuing an ostrich.
New York, Pierpont Morgan Library

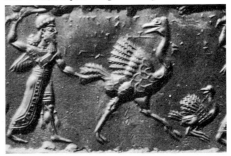

161 to 164. Middle Assyrian
seal impressions:

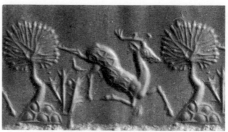

161. Leaping deer and tree.
New York, Pierpont Morgan Library

the centre are drawn as vividly as the stag in its setting; but the bulls are flanked by the artificial 'sacred tree'. It is possible to assert that it was used here as a space-filler, but the meaning of most of the new designs escapes us. The theme of conflict reappears with all the fierceness which characterizes the renderings of the Akkadian Period; but on the Middle Assyrian seals it was less often subjected to a heraldic arrangement and never used to support an inscribed panel. Inscriptions are added occasionally, in horizontal lines above or between the figures. The latter are spaced with the freedom of mastery. Notice the daring and elegance of illustration 163, where a lion centaur destroys a puny lion. Compare the power of the lion in illustration 159, where it attacks a naked hunter, who recalls black-figured Attic vases, but here faces the strangest gathering of game. Or see the noble Pegasus defending a wingless foal against a lion bristling with rage [158]. More purely linear designs are also known [164].

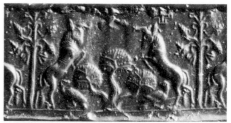

162. Bulls, birds, and trees.
London, British Museum

The affinities of these seals with those of the Akkadian Period are unmistakable, but this may well be due to a similar outlook rather than to tradition. For one thing, the mythological subjects which fascinated the Akkadian artists [92] were not revived in Middle Assyrian times. Beyond fights with animals and monsters, in which the gods cannot be identified and of which, in any case, the religious import is a matter of surmise, no acts of the gods are depicted. Men pray or offer incense or libations before a divine statue[23] [150B] or a shrine or a Ziggurat.[24] Ritual alone represents religion on the Middle Assyrian seals.

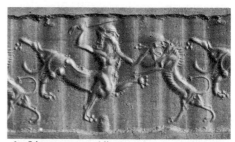

163. Lion centaur and lion.
Berlin Museum

164. Monster attacking a bull, sun disk, and worshipper. *New York, Pierpont Morgan Library*

THE LATE ASSYRIAN PERIOD

(CIRCA 1000–612 B.C.)

The history of the Assyrian empire is dominated by the perennial problem of Mesopotamian statecraft; how could a stable polity be established in a country without natural boundaries and exposed to the depredations of barbarians based on impregnable mountain fortresses? Year after year the Assyrian armies marched east, then north, then west in a scythe-like sweep which aimed at assuring the safety of the homeland. The theme of war chariots with their teams painfully toiling over mountain ranges occurs in the art of almost every reign. It seemed always necessary to push on a little farther to destroy the next – perhaps the last – centre of rebellion; after Kurdistan, Armenia; after Syria, Palestine; and finally the Sinai desert was crossed and Egypt invaded. Esarhaddon destroyed Memphis in 671 B.C.

The palaces of the kings were decorated with long friezes of paintings or reliefs in which the interminable campaigns were recorded. They are not summarized, or symbolized as in Egypt, but shown in all the multifarious detail of their actuality, monotonous when viewed from a distance but full of varying incidents when lived through day after day. It is the experience of the soldier which the reliefs and paintings relate.

ARCHITECTURE

The palaces themselves of which these pictorial epics constitute the grim glory are, with one exception, very inadequately known. There would be no point in discussing here the ruins of Nineveh or Nimrud. But Sargon II's palace at Khorsabad has been systematically investigated[1]

and it may serve as an example of the rest. It was built towards the end of the second of the three great periods into which we may divide Late Assyrian art. All of them coincide with reigns in which the government was strong and active, so that the mountaineers were kept at bay, Babylon held in subjection, and the trade routes protected. The first of these periods comprises the reigns of Assurnasirpal II and his son Shalmaneser III (883–824 B.C.). The second period falls in the later half of the eighth century B.C. and covers the three reigns of Tiglathpileser III, Shalmaneser V, and Sargon II (742–705 B.C.); the third falls in the reign of Sennacherib (705–681 B.C.) and of Assurbanipal (669–626 B.C.).

The capital of the country shifted during this long passage of time. Assurnasirpal II built Nimrud (Calah); Sargon II Dur Sharrukin (Khorsabad); his successors resided again at Nineveh. Provincial palaces are known in Syria at Til Barsip (Tell Ahmar) and Khadatu (Arslan Tash). They date probably from the reign of Tiglathpileser III.

Sargon II founded his residential city a little to the north-east of Nineveh. It was dedicated in 706 B.C., shortly before the king's death, and it was deserted under his successor. Only the most important public buildings had been finished, and the private houses, not protected by superimposed debris, have been destroyed by the plough which has passed over them for two and a half millennia.

The city [165] covers almost a square mile. Two gates are set on either side, except in the north-west, where one gate is replaced by a

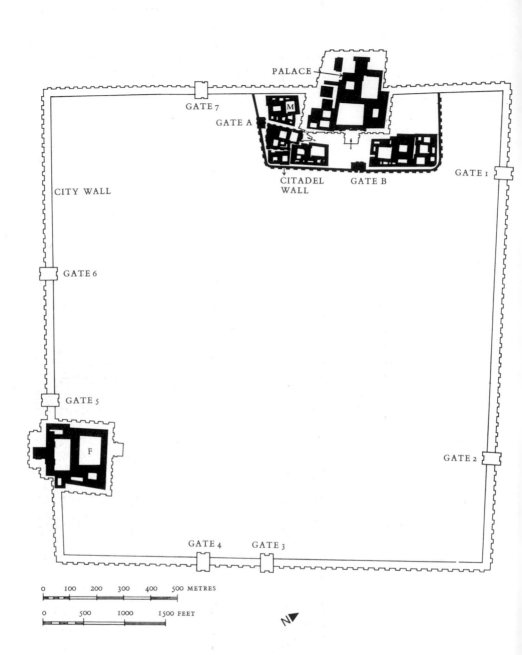

PALACE

GATE 7

GATE A

M

GATE 1

CITY WALL

CITADEL
WALL

GATE B

GATE 6

GATE 5

F

GATE 2

GATE 4 GATE 3

0 100 200 300 400 500 METRES

0 500 1000 1500 FEET

N

165. Khorsabad (Dur Sharrukin)

bastion built out on both faces of the town wall. It served as a platform for the royal palace. At the southern end of the town a similar fortress protected the entrance through gate 5, the most important one, since the traffic to Nineveh and the south passed through it. It has been thought that the building F served as a palace for the crown prince, who fulfilled certain well-defined functions in the administration of the kingdom; but there is no evidence regarding its occupant.

Near the royal palace a number of official buildings was grouped within the enclosing wall of a citadel. Illustration 166 shows a reconstructed view as it would have appeared from the top of the Ziggurat in the royal palace. The inner area of the town must be left a blank, since we know nothing of the street plan; some houses near gates 4, 5, and 6, and near building F, have been drawn in.

It is clear that the planners aimed at regularity, and the frequent deviation from the right angle is due to imperfect methods of surveying. It is, for instance, characteristic of their love of symmetry that each side of the square should have two gates, for the lie of the land does not permit an equal flow of traffic in all directions. Gate 2 faces the ridge of Jebel Maklub, which can only be crossed farther to the north-west, beyond the road passing through gate 1. Traffic leaving by gates 3 and 4 would have to join the

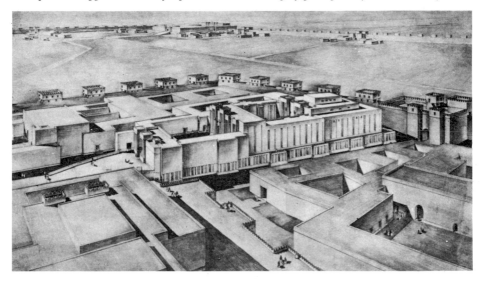

166. Khorsabad (Dur Sharrukin),
view from the Ziggurat of Sargon's palace.
Reconstruction by Charles Altman

main road to Nineveh (which passed through gate 5) for any point south of the capital. But a regular plan, an abstract symmetry, was apparently aimed at. The siting of the buildings within the citadel does not suggest this, but here two reasons combine to cause confusion, the imperfect setting out of the enclosure wall and platform, and the empirical procedure employed in the construction of large buildings. In a country where paper, or even papyrus, was

unknown, there could not be measured drawings; the few surviving sketch plans on clay tablets are so much abbreviated as to be barely comprehensible to us. But we know that large buildings were composed by joining a number of traditional units. One of these is the group: square court, throne room, and great hall found in the palace of Eshnunna [114]. It recurs at Mari and, somewhat modified, in the Assyrian palaces and the buildings within the citadel.[2] It would seem that, once a site had been allotted, the plan was worked out, to some extent, on the spot. Building M, for instance, has a regular oblong nucleus of rooms spaced round two rectangular courts. But since it stood askew to the city wall, and also to the Nabu temple on its farther side, the regular central portion received two irregular wings on either side. It is possible that the orientation of the Nabu temple, which is out of alignment with every other feature of the citadel, was dictated by religious considerations; there are some indications that the planet or constellation which was one of the manifestations of each deity was sighted in some connexion with the founding of the temple, but the exact rules have not been recovered, and can hardly be reconstructed where the surveying methods were so inexact. And it is quite possible that the original intention had been to make a straight street from gate A to the square in front of the palace, but that a miscalculation in the placing of gate A, or of the corner of the platform (since it deviated so much from the right angle), may have initiated a series of makeshifts of which the present plan is the outcome. Elsewhere irregularities may be explained as a result of property rights of buildings standing at the time construction was started; but at Khorsabad the builders had free play, for the city was erected where none had stood before, and their achievements allow us, therefore, to draw conclusions about procedure which are exceptionally illuminating.

The city gates and the gates of the citadel were designed on the same plan, with two towers flanking the entrance, and two transverse guardrooms where ingress could be opposed by force and where, in peacetime, police and customs officers were stationed. The actual passage through the gate was lined with gypsum slabs placed on edge and supported by a plinth. These protected the walls for five or six feet against damage by carts and other traffic and also presented difficulties for enemy sappers in times of siege. They appear clearly in illustration 179, a photograph taken when the inner gateway was still filled with fallen debris. It appears beyond the sculptured slabs of the outer portal; and within the debris the white plaster lining the inner surface on both sides of the second gate appears clearly; even the curve of its vault is indicated by a line of white plaster, appearing in the shadow on the right. Below these plastered surfaces one sees the orthostats on their plinths. Such orthostats were unknown in the south (where stone had to be imported), but they were used in Hittite buildings at Boghazköy and elsewhere in the fourteenth century B.C.,[3] and in north Syrian buildings of the same or an even later date, at Alalakh (Tell Atchana). At Boghazköy the jambs of the outer gateway were sometimes carved with guardian figures such as lions or sphinxes [248]. In Assyria this was also done, and it is therefore most probable that Assyria followed a Syro-Anatolian example in the use of stone orthostats. But she surpassed the inventors in the application of their method. The decorated orthostats at the outer entrance to the citadel are thirteen feet high and fourteen feet long.

The winged human-headed bulls (Lamassu) are known to be genii protecting the palace. One of them is figured in a relief showing how timber felled in the mountains and intended for the palace is transported by sea; here the Lamassu appears among ships and waves to guard the

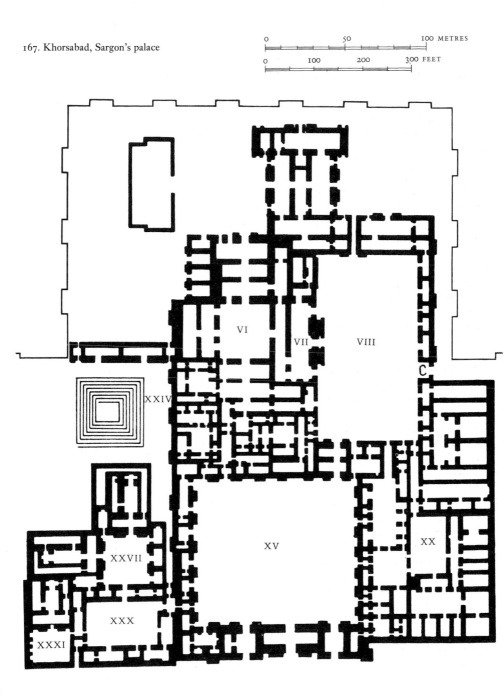

167. Khorsabad, Sargon's palace

0 50 100 METRES

0 100 200 300 FEET

VI
VII VIII
C
XXIV
XV XX
XXVII
XXX
XXXI

transport.[4] At the gate their power was relied upon to prevent the entry of evil forces. A second genius, holding a sprinkler and a metal vessel with holy water, supports the Lamassu [180]. At the palace entrance Lamassu appeared again, and the ways into the throne room were guarded by a concentration of figures which produced an overwhelming impression of power [168].

The citadel gate led into a street which passed between the Nabu temple and building M; next it passed underneath a stone viaduct which connected Sargon's palace with the Nabu temple so that the king, when visiting the shrine, need not descend into the great open square at the end of the street we have been following. This square, like the 'Square of the Foreign Peoples' at Assur [157], was in many ways the heart of the city. Here the populace gathered on important occasions; from here religious processions and military expeditions set forth. Here the people could find a last refuge if the town should be invaded. The broad ramp leading from the square to the palace enabled war chariots to reach the city's fortifications and to proceed over it to any point where an enemy might succeed in scaling them.

The palace [167][5] resembles in general plan those of other kings which are only partially known. The triple entrance, at the top of the ramp, was again guarded by demons and genii and led into a large court (xv), each side of which measured 300 feet. On the right were offices and service quarters, on the left three large and three smaller temples, planned on the same lines, but on a smaller scale than the Nabu temple, which we shall presently discuss. Behind this great court, and accessible through a series of rooms, were the king's residential apartments. Farther on were the state rooms grouped around a small square court (vi) with the great throne room (vii) on the right. Foreign embassies and other groups or individuals received in audience would approach through the large court (viii) and pass between the demonic guardians [168] into the royal presence. The walls surrounding the court were revetted with stone orthostats showing the king and his courtiers over life size [198]. It is clear that they achieved an impression which was thoroughly calculated. The Assyrian kings had aimed for generations at striking terror into neighbouring people, or subjects inclined to rebellion, by a ruthless cruelty which, they hoped, would ultimately establish peace. It was in keeping with their policy that petitioners, ambassadors, or vassals, awaiting an audience, should end their passage through a splendid structure before these long rows of images. By their size, their impassivity,

168. Khorsabad, Sargon's palace, main entrance to Sargon's throne room

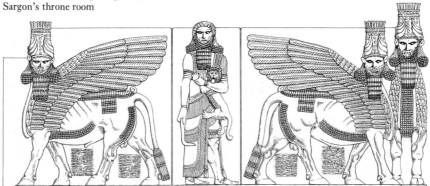

their exclusive orientation towards the sovereign, the reliefs could not fail to make the visitor aware of the king's immense power and his own impotence. Once admitted through one of the three doors, the petitioner stood in the brilliantly painted hall with the throne before a huge monolithic orthostat built into the narrow wall on the left. The throne base was likewise of stone, carved with a relief showing Sargon standing in his war chariot above the bodies of the slain while soldiers pile up pyramids of heads before him.

*

Since the ritual duties of the king of Assyria exceeded those of any of his predecessors,[6] and his function as mediator between society and the gods was most exacting, it was convenient (if nothing else) that temples should form part of the palace complex. The Ziggurat which stood behind these shrines may have served all six of them; there is no reason for us to connect it with one rather than another. It showed, when discovered a hundred years ago, a character entirely different from that of the temple towers of southern Mesopotamia. There were actually three stages, and part of the fourth was preserved [169]. Each of them was eighteen feet high and decorated with recesses; each was

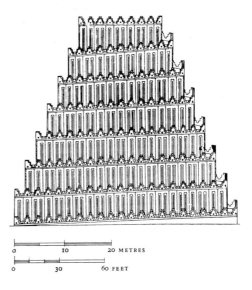

169. Khorsabad, Ziggurat.
Reconstruction by Victor Place and Albert Thomas

painted a different colour: the lowest white, the next black, the third red, and the fourth white. Perhaps this was bleached blue, for the succession of colours of the three lowest stages corresponds with Herodotus's report on the tower of Babylon, where the fourth stage was blue.

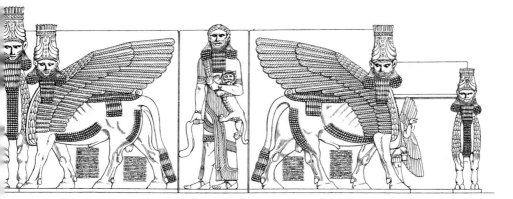

Whether there were seven stages at Khorsabad, as there were at Babylon, we have no means of knowing. If this was so, the uppermost stage would have measured only fifty feet across, and the shrine would have been a small one. In favour of the assumption of seven stages is the fact that they would give the tower a height equal to the length of the base (143 feet), and this was, according to Strabo, the case in Babylon. But the distinctive feature of the Ziggurat of Sargon is the connexion between the stages: a continuous ramp winds round the core of the building from the base to the summit. It was about six feet wide and edged with a crenellated parapet. There were not, then, properly speaking, stages, as at Ur, but vertical faces on each side separating successive turns of the ramp.

The temple of Nabu [166, centre; 170, left] repeats the plan of the palace temples on a grand scale. The whole is placed on a terrace, ten to twenty feet high above the sloping ground, and entirely paved with baked bricks set in bitumen. Its outer face was decorated with buttresses and recesses built in mud-brick and whitewashed. Large ornamental clay nails with glazed heads were inserted in a horizontal row.[7] A ramp led to the front gate which was set back between two towers decorated with plastered half-columns of mud-brick. A similar gate led from the forecourt to the second court, but this was further embellished by pedestals on either side, which bore a revetment of multicoloured glazed bricks [171]. Similar pedestals were found in the palace temples. They supported cedar masts overlaid with bronze bands embossed with religious emblems, like the bull-man and the fish-man.[8] Their upward termination cannot be reconstructed. The meaning of the masts, of the engraved figures, and also of the figures in glazed bricks is a matter of surmise. The latter,

170. Khorsabad, citadel.
Reconstruction by Charles Altman

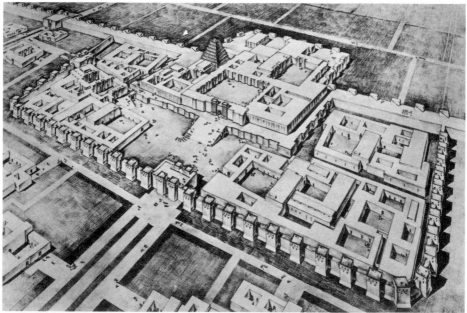

171. Khorsabad, panel of glazed bricks
flanking the entrance to the palace temples

being placed side by side without any connexion between them, may represent constellations, but they are not distinctive of Nabu, since they recur identically before the entrance of the three larger temples of the palace.

Another large building at Khorsabad, palace F [172], is incompletely known, but it contains a feature not encountered in the royal palace. In the left-hand part of illustration 172 we see a pillared portico which leads to a passage and so connects one of the main courts with the terrace. The stone bases of the portico columns [173][9] resemble closely those used in north Syrian architecture, and Sargon actually refers to 'a portico patterned after a Hittite palace, which they call a *bît-hilani* in the Amorite tongue, I built in front of their [i.e. the palaces'] gates. Eight lions, in pairs, weighing 4,610 talents, of shining bronze ... four cedar columns, exceedingly high ... I placed on top of the lion colossi and set them up as posts to support their entrances'.[10]

In elucidation of this text it must be recalled that the Assyrians designated as 'Hittites' the population of north Syria (hence the 'Amorite tongue'), and double lion bases for columns were common in Syria in Sargon's time [331, 332].[11] But the Assyrian uses *bît-hilani* as the name of an entrance building, a portico 'built in front of their gates'. It was only this part of the north Syrian plan which was taken over.[12] At Nineveh, too, a portico with two columns was

172. Khorsabad, palace F

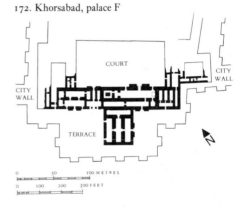

173. Column base, from Khorsabad

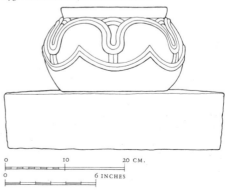

found, and it gave, as at Khorsabad, access to a passage;[13] it was a gatehouse, not, as in north Syria, a self-contained building. Even in Syria, at Arslan Tash, the Assyrian architects used a pillared portico merely to connect two courts.[14]

In the palace of Arslan Tash the arrangement of the private apartments is exceptionally clear [174]. The main room of the suite is no. 7. It has stone rails for a movable hearth. The inner room (6) is connected with a bedroom (5) and a bathroom (4). Another, smaller, bedroom suite with bath (1, 2, 3) is connected with the main room. The recess (8) of the court would accommodate the bodyguard.

Before leaving the subject of Assyrian architecture a word must be said about the private houses. As far as they are known, they differ from those built at Ur during the Isin–Larsa Period [117], which were centred round a square court and resemble the houses of that and earlier epochs found elsewhere, for instance at Tell Asmar, in possessing a central oblong room or court. In a history of art they do not call for comment.

174. Arslan Tash, Assyrian palace, private apartments

175. Statue of Assurnasirpal II, from Nimrud. *London, British Museum*

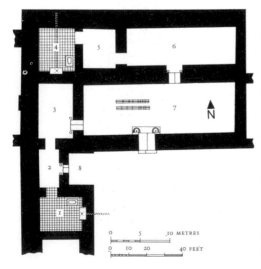

SCULPTURE IN THE ROUND

Assyrian sculpture in the round is, as far as it is known, insignificant. We have a few uncouth statues of deities standing with folded hands;[15] they represent, probably, secondary figures, like those holding a flowing vase in the temples of Khorsabad. Some royal statues of the ninth century B.C. are known; and of these the figure of Assurnasirpal II [175], three feet high, is the most complete. It is not only impersonal, as one would expect, but dull. The composition is indifferent; the various regalia and the details of the costume are not really integrated; the basic shape, a flattened cylinder, is weakly emphasized by the fringes of the shawl in which the

176. Head of amber statuette of illustration 177.
Boston, Museum of Fine Arts

177. Statuette of an Assyrian king. Amber.
Boston, Museum of Fine Arts

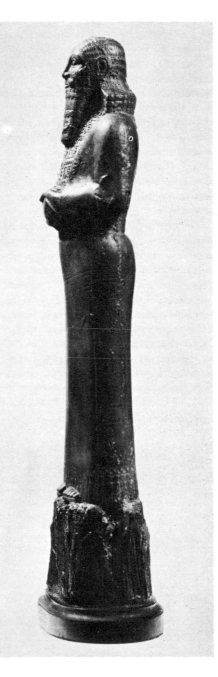

king is swathed. The mediocrity of the statue
becomes clear if we compare it with a figurine
of an unidentified king carved in amber [176,
177]. It is true that this belongs to a different
category; it is a jeweller's piece, and it differs
from the stone figures as the figurines of Gudea
[100] and Iti-ilum [128] differ from contem-
porary monumental works; those are light and
graceful, where these are ponderous. But the
contrast goes deeper, as a comparison of the
heads shows. In both cases we see a typical
Armenoid physiognomy, and the question of
likeness does not arise. But the amber statuette
presents a spirited rendering. The low forehead;

the broad, short skull; the strong nose; the fine mouth – these may be conventional features, but they are modelled with intense interest, as features of a living face. The stone statue, on the other hand, displays a mask.

The amber of the statuette is inlaid with a gold setting for precious stones, which apparently represents a pectoral. This kind of ornament is never shown in the reliefs, and may well be an attribute of the religious functions of the king. With these the reliefs are not concerned. The folded hands of the amber statuette represent, in any case, a ritual gesture of immemorial antiquity.

There remains a group of works in stone which is hard to classify. The guardians of the palace gates [168, 178, 179, 180] can neither be called sculptures in the round nor reliefs. Assyrian relief is always low and flat. Moreover, it is conceived as a self-contained world, from which no glance or gesture moves outward towards the spectator. All relations are limited to the plane in which the action unfolds itself. But the guardians of the gates are emphatically concerned with those who approach them [168]. Even the bulls with bodies in profile turn their heads to scrutinize the visitor and to cast their spell over potential evil.

But these figures are not quite sculpture in the round; the human-headed bulls or the lions or bulls which sometimes take their place are not freed from the slab in which they are carved. Moreover, they do not, as is usual in Mesopotamian sculpture, show a cylindrical or conical composition. They are squared, to fit the building which they guard. They have, in fact, distinct front and side views, and consequently show five legs when viewed obliquely. The front view belongs to one elevation of the gate, the profile to another. The sculpture is subservient to the architecture; it is applied art. Yet the finish and precision are superb, and it is remarkable that huge figures like these should be enriched by the finest and most carefully engraved details. In Egypt the colossi of the New Empire are a great deal coarser and clumsier than the normal statues, which are three-quarters life-size or smaller. But in the figures from Khorsabad – those from Nimrud are a little inferior – there is not only exquisite modelling (note the fine wrist and hand holding the sprinkler in illustration 180) but a profusion of ornament: tassels at the kilt, a row of embroidered rosettes edging the shawl, bracelets and wristlets. The hair and feathers, too, exploit their decorative potentialities to the full.

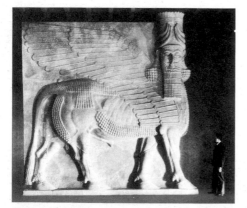

178. Winged bull guarding the entrance to the throne room, from Khorsabad (cf. 168). *University of Chicago, Oriental Institute*

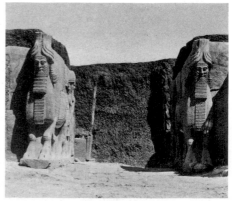

179. Khorsabad, citadel, gate A

180 (*opposite*). Khorsabad, citadel, gate A, winged genius (cf. 179)

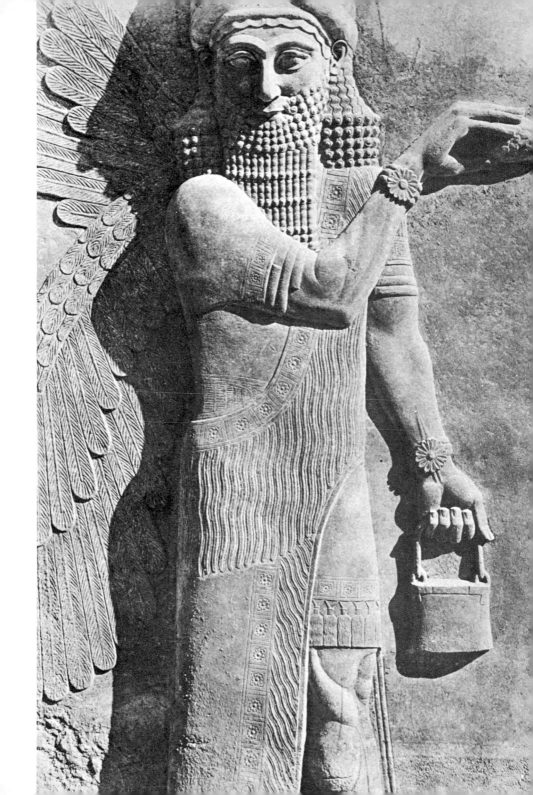

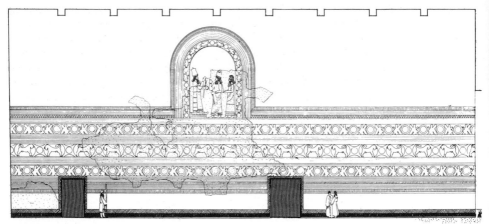

181. Khorsabad, citadel,
Residence K, Room 12, painted wall.
Reconstruction by Charles Altman

RELIEF AND PAINTING

The same loving treatment of details which we observed in the guardian figures of the palaces marks the reliefs proper which constitute the greatest and most original achievement of the Assyrians. In fact, the history of Assyrian art is mainly the history of relief carving.

In earlier times, relief had been confined to steles, and its possibilities had thus been limited. In Late Assyrian times, too, steles were set up [230]. Their designs were simple and monotonous; the general scheme resembled that of the upright panel painted on the wall of the great hall of Residence K [181, 196]. The king either stands in front of the statue of a god or he merely makes the gesture of adoration, and divine emblems appear in the field over his head; or enemies make obeisance before him. In this case the king may hold a rope fastened through their noses [cf. 230].

A variant of the stele is the so-called 'obelisk' [193], a standing stone, more or less square in section, bearing designs and texts on all four sides. Illustration 151 shows the top of one, set up by a successor of Tiglathpileser I (after 1089 B.C.). A similar monument was erected by Assurnasirpal II;[16] it is too much damaged for illustration, but is of great interest. Its reliefs are arranged in narrow bands, one above the other, but each band continues round the four sides of the stone; for instance, a war chariot is shown on one face of the obelisk, but of its horses one sees only the hindquarters; their front parts appear round the corner, on the next face. It has been suggested[17] that this is due to Mesopotamian preference for cylindrical shapes; the square form of the obelisk was uncongenial and was, in fact, ignored. But it is also possible to explain this oddity of composition in another way: the Assyrians may have been impatient of the limitations which the high, narrow surface imposed, because they desired above all to present a circumstantial narrative. Later, under Shalmaneser III [193], a more orderly decoration of the obelisk was planned, and the submission of Jehu of Israel, the reception of his tribute, and other scenes, are placed in small closed panels on the four faces of the stone. But by this time another means of rendering a con-

tinuous and detailed story had been evolved: the stone revetment of the palace walls was used as its vehicle.

We have seen that in Middle Assyrian times wars were recorded on panels of glazed bricks. The custom was not entirely abandoned in later times (see p. 134),[18] but usually, in the ninth century, the stone slabs which covered the lower parts of the walls in the rooms and corridors of Assurnasirpal's palace were used for this purpose. These stones were about seven feet high, and sometimes their whole surface was covered with one single design. More often, however, they were divided horizontally. A band of inscription was made to separate two strips of reliefs, each about three feet high. The rooms were thus surrounded by two continuous narrow bands pre-eminently suited for carrying the slow-moving pictorial record of the kings' campaigns, which was the main subject of the Assyrian artists and a new genre which they invented.[19]

It is almost impossible to give an adequate impression of these designs. We must necessarily select illustrations and avoid repetitions. But repetition is of the essence of this remarkable art, which conveys the moral that Assyrian power is irresistible by showing, with meticulous care, this power in action. We see the march of armies, subjugating, burning, killing, punishing, with devastating monotony, in country after country. The charging chariot, which appears on the left of illustration 182, is a recurring motif throughout this series of reliefs. Several slabs show these war-engines advancing against retreating enemies, while the infantry despatch the wounded left on the field. The more complex scenes which we reproduce appear as highlights of a continuous and unchanging story: the Assyrians advance; enemies flee. Opposition is centred in a city; it is taken, its leaders are impaled or killed in other ways; then the inexorable chariotry presses on again. But, whatever the tenor of the tale, its details are rendered

with the greatest vividness and variety, and the artist's ambitions are unprecedented, and astonishingly bold if we remember the means at his disposal. The orthostats, divided into two, gave him strips about three feet three inches high, and these were intended to accommodate little more than a normal standing figure. This is most clearly shown in illustration 189; but illustration 184 demonstrates how much could be achieved by the use of what we must call 'background'. The siege depicted in front of the king and his shield-bearer is an elaboration of originally secondary motifs; the starting-point of the development is shown on the left of illustration 182, which alone represents in our illustrations the numerous scenes of war chariots in action to which I have referred. The king has just despatched an enemy chief whose body, slumping from his vehicle, appears underneath the royal team; the enemy charioteer, bending forward (he is shown underneath the heads of Assurnasirpal's horses), tries to drive on his charges, but one horse is wounded and sinks on to its knees. Assurnasirpal already aims beyond this group.

The main theme, which we have described, is enriched by certain additions. The god Assur, drawing his bow in support of his protégé, appears above the king. We know that he is thought to hover high among the clouds But next to him appear examples of the usual scenes with which the space above the chariots is filled. We see an Assyrian stabbing a fallen enemy whose friend vainly tries to save him; farther to the right is a figure in the attitude of a diver, which actually renders a dead body lying on the battlefield over which the Assyrians sweep forward. It is clear that no attempt has been made to account for the actual disposition of these various groups and figures in space. The events are translated into the autonomous world of the reliefs, and the background is ingeniously used to indicate, in a general way, the setting of the main action. Water is indicated below the king's

182. Assurnasirpal II at war, from Nimrud.
London, British Museum

183. Fugitives crossing a river, from Nimrud.
London, British Museum

chariot, so the engagement is supposed to take place near the stream or moat protecting the town. Single combats appear to be fought among the trees of the city's outworks; they indicate, together with the groups above the horse, that the king's charge is accompanied by a massacre of the enemy. There are also conventional features in the designs; it is, for instance, usual for a wounded or dead enemy to appear under the hoofs of the horses, like the wounded lion in illustration 185; and the chariot of the

enemy chief in illustration 182 is but an elaboration of this motif.

The number of orthostats was so great that the story could be told at a leisurely pace. In illustration 183 a whole section is used to render a quite secondary incident. The Assyrian vanguard has reached the rocky edge of a river flowing round a fortified city. Some of its inhabitants – perhaps a reconnaissance party – have been surprised on the banks and try to reach safety by swimming across. One relies on

184. City attacked with a battering ram, from Nimrud. *London, British Museum*

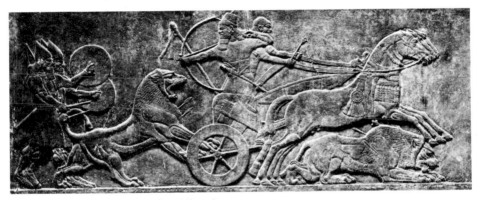

185. Assurnasirpal II killing lions, from Nimrud. *London, British Museum*

the power of his 'crawl', but is hit by arrows while in the water. The others are supported by sewn-up animal skins, which they have not had time to prepare and which they attempt to inflate further while floating. The ruler of the city seems frozen into inactivity while he watches from a tower; two of the women raise their hands in despair.

Illustration 184 is much more complicated. The relief is, once again, intended to be just over a figure's height, as is shown by the main scene.

The king draws his bow protected, like the soldier kneeling just in front, by a wattle shield held by a companion. Well to the left of the king appears the beleaguered city. Its garrison lets fly with arrows; the women have mounted the towers, whether to throw missiles or to beg for mercy, a break in the relief prevents us from knowing. But dead bodies of defenders hurtle down from the ramparts or hang limp over the battlements. In the left foreground two Assyrians (curiously without the protection of shield-

bearers) are breaking down the brickwork of the outer defences. Meanwhile a huge battering-ram is moving from the right against the city gate. It is crowned by a tower from which archers attempt to safeguard it. Nevertheless, the garrison has succeeded in catching the swinging ram in a chain which is being pulled up to dislodge it from its bearings. But two Assyrians with grappling hooks pull the chain down and will strip it off. Yet another danger threatens the war-engine: fire brands are thrown against it. They appear in front of its tower. But in the middle foreground two men kneel by the water and fill a vessel to moisten the outside of the ram.

Other scenes show Assurnasirpal's bivouac, with his tent and the grooming of the unharnessed horses;[20] the army being ferried across a river, with the chariots mounted in coracles (circular boats, the modern gufas of Iraq made of wattle and pitch), while the horses, their bridles held by the men in the craft, swim the stream; foot-soldiers also swim, sometimes assisted by floats of inflated skins.[21] Elsewhere one sees the triumphant return of the army; the chariotry with its standard, the infantry carrying cut-off heads, while a vulture flies away with one of these trophies.[22] Or one sees the king's chariot being led off the field.[23] But in between these scenes appear the battles, the burning cities, the unrelieved, sustained efficiency of Assyrian warfare.

Some reliefs show the king finding distraction in hunting [185]. The incident shown here was depicted in much greater detail by Assurbanipal two centuries later. It does not represent an event taking place in the open, but within a square formed by the shields of soldiers within which lions were released to be shot down by the king from his chariot. One lion, wounded, and perhaps left for dead, has turned and attacks Assurnasirpal from the rear. The king swings round, still holding his bow, which was aimed at a more distant beast, compelled to use it at close quarters. But some of the soldiers have already run up with drawn swords to protect their lord, while the charioteer continues to give undivided attention to his team. The horses are aware of the danger, as their ears show.[24]

We must presume that such scenes were intended to demonstrate the king's prowess, but the effect is heightened by indirect means. Whether intentionally or not, the lion appears as the main actor. His immensely powerful body dwarfs all the other figures. It is characteristic of the Assyrian style that this incident is only the culminating point in a series of reliefs showing chariots driving up and down, leaving dead or dying lions on the field.[25] Once a snarling beast, looking over its shoulder, attempts to evade the hunter.[26] The king's sport ends in solemnity: a relief shows him pouring libations over the bodies of the dead beasts. He is surrounded by fully armed officers, while a courtier attends with a fly-whisk and two musicians play their lutes.[27]

An equally sombre formality transfuses the huge design of which illustration 186 shows two-thirds. It covers the full seven feet of the orthostat's height, and the figure on the right of our illustration is followed by a companion similarly attired, while a winged demon closes the scene on this as on the left-hand side. These superhuman beings sprinkle holy water from their bucket, strengthening the power of the king as the genius in illustration 180 strengthens that of the Lamassu at the palace gate. This pompous setting for the simple act of taking refreshment emphasizes the sacred character of the Assyrian king, elected by the gods, although not himself of divine substance. At his coronation these words were spoken:

Before Assur, thy god, may thy priesthood
 and the priesthood of thy sons find favour,
With thy straight sceptre make thy land wide;
May Assur grant thee quick satisfaction,
 justice, and peace.

186. Assurnasirpal II, from Nimrud.
London, British Museum

187. Griffin-demons and sacred tree, from Nimrud.
London, British Museum

The two kinds of reliefs found in the palace of Assurnasirpal correspond severally to the invocations in the first and last lines of our quotation. The narrow strips show the satisfaction of power, but also the vain attempts to establish justice and peace by means of a terror planned as retribution of resistance. The larger and more formal designs, of which illustration 186 gives an example, proclaim the sanctity of the king's priestly person. They show, for instance, Assurnasirpal beside the sacred tree, often repeated on either side of it for the sake of symmetry, while winged genii or griffin-demons sprinkle him with holy water.[28] Illustration 187 shows such a group without the king. This slab was appropriately placed in the niche behind the throne in the north-west palace at Nimrud. Its design recalled the supernatural protection

which the king enjoyed and had the effect of a splendid wall tapestry. Similar designs were embroidered on the royal garments [224].

It is strange that the king is never depicted in a ritual act, if we exclude such details as the libation over the game killed in the hunt, for in Assyrian times the responsibility of the king for the actions of the people as a whole was stressed to an unusual degree. The king was manipulated almost like a talisman – or he became the scapegoat, charged before the gods with all the sins of the community. Hence his time was largely taken up with penitence and prophylactic magic.[29] Of these acts nothing is recorded in the imagery of the Assyrian palaces.

Only one relief with a mythological scene has been preserved. It was found in the temple of the god Ninurta at Nimrud [188]. A winged god

188. Weather-god and dragon, relief from the
temple of Ninurta, Nimrud

or genius holds a thunderbolt and seems to
pursue a dragon. But the impression of conflict
may well be misleading, for this dragon had
represented the thunderstorm from early times
(illustration 93 and p. 91), and the relief may
show the common action of a weather-god and
his adjunct.[30]

The reliefs we have discussed impress us by
their vividness and variation. Yet they appear,
on closer inspection, to use a very limited set of
formulas, which are adapted to various purposes
or combined in different ways. An example of
this is found in the hunting scenes. In one of
these the king grasps a wild bull by the horn
while plunging a sword between its shoulders.
He stands in his chariot, turned backwards, as
in illustration 185. In fact, the group of chario-
teer and king is identically rendered, even to the

position of Assurnasirpal's head; only the pos-
ture of the arms is changed to suit the action.
Sometimes recurring elements are combined in
different ways to avoid monotony. The scene in
which the king pours libations over slain bulls
and lions closely resembles that in which a vassal
kisses his foot [189]. The former subject in-
cludes a bearer of the royal sunshade, and two
pairs of men (one of them being a musician)
alternate with a single figure before the king; in
the second group a single person is followed by
two pairs; and in yet a third the king is attended
by a more elaborate suite. In this way each scene
gets a particular character, while yet a strict
homogeneity unites the series as a whole. The
forcefulness of the designs, combined with an
economy of formulas, suggest that the reliefs of
Assurnasirpal II are perhaps in fact, and not

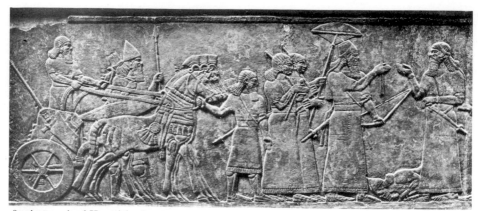

189. Assurnasirpal II receiving homage, from Nimrud. *London, British Museum*

merely as a result of the accident of discovery, the first attempts at narrative mural decoration on a large scale.

Under the next king, Shalmaneser III (859–824 B.C.), the new style was applied to metal work. Hinges of the palace gates were ornamented with bronze bands which were nailed down on the leaves of the wooden doors. These were six feet wide and over twenty feet high, and moved on pivot shafts eighteen inches in diameter. The bronze bands were eight feet in length, eleven inches in height, and only one-sixteenth of an inch thick; over thirteen of these have been preserved.[31] Like the orthostats, they are divided into two registers, and within these bands, which are each five inches high, innumerable small figures act the story of the king's wars [190–2]. They were first engraved

190. Assyrians receiving tribute, from Balawat.
London, British Museum

191 (*opposite page*).
Tribute from Tyre;
Assyrians on the march,
from Balawat.
London, British Museum

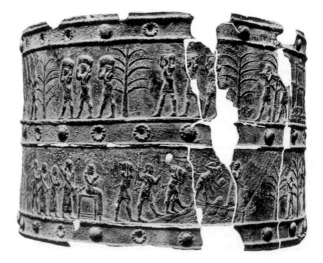

and then embossed by hammering the metal from the back on a bed of bitumen. There is little beauty in this mass of detail, but much liveliness and an indefatigable urge from episode to episode.

In illustration 190, in the upper strip, the southern Mesopotamian city of Bit Dakuri appears on the extreme right, and the Chaldean inhabitants are shown carrying tribute through their date-groves towards Assyrians. In the lower strip an officer, seated on a stool and accompanied by his staff and guards, watches the deposition of the Chaldean tribute at a pontoon-bridge. The text of the king's annals referring to the event reads as follows: 'I went down to Chaldea, I conquered their cities. To the sea which they call "The Bitter Water" [the Persian Gulf] I marched. The tribute of Adini, son of Dakuri . . . silver, gold, Ushû-wood, and ivory, I received in Babylon.'

The river is narrower at the top of the strip than at the bottom, but in other bands this difference cannot be observed, so that it is unlikely that a phenomenon of perspective is rendered here. In any case, the narrowness of the strips, just over the height of a standing figure,

prevented a number of problems from becoming acute, and the draughtsmen undertook the expression of complicated situations without any hesitation. When a situation can be rendered by mere juxtaposition, the result is quite unequivocal. In illustration 191 we see two scenes from the campaign of 858 B.C. The upper register shows the Phoenician city of Tyre, securely situated on a rocky island off the coast, sending tribute ashore to placate the king who was subjecting the mainland population. A text describes the campaign as follows: 'The upper cities of the land of Amurru and the Western Sea I overwhelmed like mounds in the track of a storm. The tribute of the kings of the sea coast I received. Along the coast of the wide sea I marched righteously and in triumph.'[32] In the lower strip the army leaves camp (shown empty, on the left, with its towered wall) to capture the city of Khazazu, an inland settlement.

Illustration 191 shows only part of the scene. The porters, who are depicted in the upper strip as wading in from the boats where they have taken their load, continue along this band for an equal space beyond what is shown; they are headed by Assyrian officials. Shalmaneser

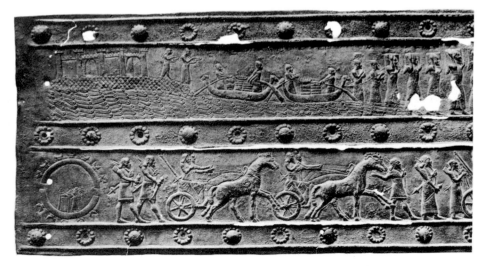

has descended from his chariot and awaits them under a sunshade. The gifts consist of bronze cauldrons, trays containing other valuable objects, and bales of goods. In the lower strip, too, the movement towards the right continues beyond the fragment which we have illustrated. Again the king is shown dismounted, and now waits under a portable tent to receive the captives from Khazazu. 'Two thousand eight hundred of their fighting men I slew; fourteen thousand six hundred I carried away as prisoners.' Our illustration shows well how the sense of forward movement is maintained throughout the design; the line of porters, like the rows of prisoners, falls in, as it were, with the march of the army which appears here in the lower register. At no point does an incident interrupt the continuity of the campaign, except once, in a most curious and original scene [192]. The subject is the discovery of the sources of the river Tigris. The text reads: 'I entered the sources of the river; I offered sacrifices to the gods; my royal image I set up,' and on the Black Obelisk [193] the event is commemorated a little more fully:

In the seventh year of my reign I marched against the cities of Khabini of Til-Abni. Til-Abni, his stronghold, together with the cities round about it, I captured. I marched to the source of the Tigris, the place where the water comes forth. I cleansed the weapon of Assur therein; I took victims for my gods; I held a joyful feast. A mighty image of my majesty I fashioned; the glory of Assur, my lord, my deeds of valour, all I had accomplished in the lands, I inscribed thereon and I set it up there.

The scene on the section adjoining the left of our illustration is described by L. W. King[33] as follows (it refers to the lowest strip):

[We see] the arrival of Shalmaneser at the natural tunnel in the limestone hills through which the Bylkalim-Su, one of the headstreams of the Tigris, flows in its upper course. . . . An Assyrian force of infantry, cavalry, and chariots advances up the left bank of the shallow stream. The king, having left his chariot, has mounted a horse, and followed by his bodyguard on foot has just crossed the stream at the

192. Assyrians at the source of the Tigris, from Balawat.
London, British Museum

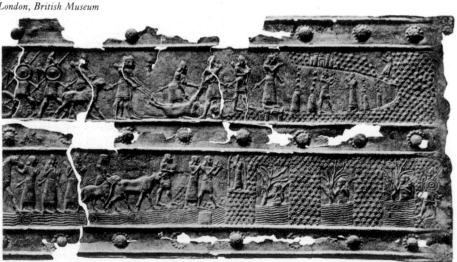

mouth of the gorge through which it emerges into the plain.

At this point our illustration takes up the tale. A ram and a bull are brought for sacrifice. The mountains are indicated according to an immemorial convention, namely by a scale pattern. The subterranean course of the water is depicted in three places where the mountainside is, as it were, removed, and we see men holding firebrands standing waist-deep in the water. Where the river emerges, a sculptor has thrown a square object into the current (a block of stone or a scaffold), which supports him while he chisels a stele with the figure of Shalmaneser in the face of the rock.

In the upper frieze we see the source of the stream. It is a grotto in which drops fall from the ceiling on the stalagmites below. A sculptor is once more at work with hammer and chisel. This time he seems to be engraving an inscription, for a scribe stands by apparently holding a tablet. In front of the grotto a bull is slaughtered. On the mountain is a castle or fortified settlement; to the right appears, it seems, a native amazed at the intrusion. But on the left we catch a glimpse of the Assyrian army, leaving this scene with its purposeful stride, bound for further exploits.

With bronze work and wall reliefs turned into pictorial chronicles the obelisks became truly commemorative steles. The Black Obelisk [193] was set up by the king, who had the gates of his palace decorated in the manner we have just described. While here, and also on the wall reliefs, the inscriptions are mere legends added to the designs, the obelisk carries the story in words which are illustrated by the designs of the twenty-four oblong panels on the sides of the monument.

193. Black Obelisk of Shalmaneser III, from Nimrud.
London, British Museum

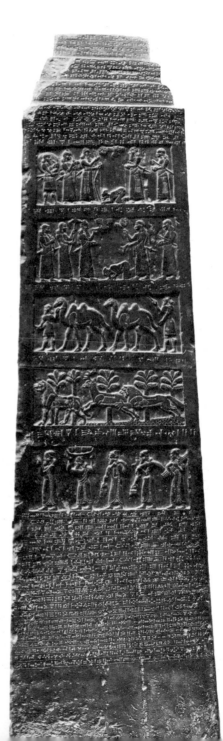

At this point we may look back and realize the originality of Assyrian narrative relief. It has no antecedents inside or outside the country. In the stele of Eannatum [74, 75] a number of incidents are rendered, but their sequence in time is left vague. In that of Naramsin [91] a single significant moment is depicted, and it epitomizes the military achievement. In Egypt victory is rendered in so generalized a form that a design may stand for any battle, and merely records that Pharaoh has once again upheld the divine order against the powers of chaos and rebellion. One has to go to the columns of Trajan and Marcus Aurelius in Rome to find a parallel for the Assyrian reliefs.

The carving of these friezes is as curious as their subject matter and their composition. The relief is very low and often flat. It never renders spatial depth. In illustration 185 the shoulders and fore paws of the lion lie in the same plane as the wheel of the chariot that covers the feet; the hooves of the three horses stand on the same ground line. The surface of the relief is here and there modelled – for instance, the spine of the lion and its shoulders are rendered plastically. The chief details are, however, conveyed by engraving rather than modelling. Incisions are more frequent and more abrupt and vigorous

than in Egyptian relief, which is also very low. In illustrations 180 and 186, for instance, the juxtaposition of strongly modelled and of almost flat but engraved relief is very striking. A last peculiarity lies in the fact that the inscriptions are sometimes cut across the figures.

Between Shalmaneser III and Tiglathpileser III (745–727 B.C.) Assyria suffered a decline, and of those eighty years hardly any works have been preserved. There are not many reliefs of Tiglathpileser III either, but these include friezes about three feet wide, some with detailed accounts of campaigns, and others with larger figures belonging to solemn scenes, which cover the whole surface. But there is one innovation which was to have great consequences. In some reliefs [194] the surface exceeds the height of a single figure considerably and this compels the designer to consider the disposition of his figures more carefully; there are many more possibilities, and since the narration of events is his business, there will be a tendency to increase the verisimilitude of the representations by rendering more elaborately the interrelations of the figures in space. Illustration 194 presents a border case where the intentions of the artist remain obscure. We see a conquered and deserted city. A battering-ram is left against

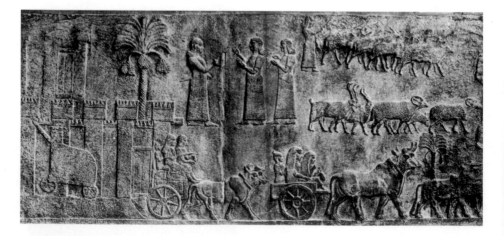

194 (*opposite*). Booty from a city taken by
Tiglathpileser III. *London, British Museum*

195. Religious ceremony, time of Tiglathpileser III,
from Nimrud. *Woburn Abbey, Duke of Bedford*

the walls; the population are compelled to seek
out the new habitat which the conqueror has
assigned to them. They leave in ox-carts; their
animals are driven off by the Assyrians. Two
scribes, under the dictation of an officer, cata-
logue the spoil. There is a certain spaciousness
in the design, and it has been thought[34] that the
sloping line which can be reconstructed under
the hoofs of the animals suggests an elementary

rendering of perspective. It is uncertain whether
this particular effect was intended. An artist
bold enough to draw without ground line and
wishing to render the irregular conglomeration
of animals which form a flock, might well draw
them as they appear in our illustration without
second thoughts. Another relief from this reign
[195] shows part of a procession of unarmed
men moving in some ceremony. Perhaps they
clap their hands in accompaniment to music.
They are followed by a figure attired in a lion
mask from which a cloak (bearing rows of tassels,
it appears) falls down over his back and sides.
The man holds a whip, and possibly imperson-
ates some demon of disease. Whatever its precise

196. Khorsabad,
Residence K, Room 12,
wall painting

meaning (and the texts do not throw light on this ceremony), the design shows that the Assyrians had not lost the typical Mesopotamian gift of embodying fear and terror convincingly in monstrous apparitions.

Tiglathpileser III also built, in all probability, two palaces in Syria.[35] One of these, at Til Barsip, contained wall paintings instead of reliefs. All the usual subjects – war, hunting, submission of enemies, winged genii – appear; the paintings are the equivalent of reliefs, but rather clumsy provincial works, lacking the richness of plasticity without displaying the directness attainable in brushwork. Purely decorative wall paintings were well preserved too; the scheme of illustration 196 was found with bulls, winged genii, or goats flanking a circular or square ornament. The same design was used in the north-west palace of Nimrud.[36]

The arrangement of such patterns consisted of a number of horizontal bands, as in the hall of Residence K at Khorsabad [181, 196]. The dominant colours of the painted bands are bright blue and red, with white and black as secondary colours. The effect is garish, but if the light entered only through the three doorways it may have been sufficiently subdued to reduce the gaudiness and give the painting depth and sparkle. The stele-like design above the decorative bands may have been distinctive of audience halls. In the restoration it shows an open space above the figures because the plaster has been lost; it was certainly not a blank, but displayed divine symbols [cf. 230]. This panel was not placed in the middle of the wall, but opposite the main doorway.[37]

The representational paintings of Tiglathpileser III resemble both paintings and reliefs

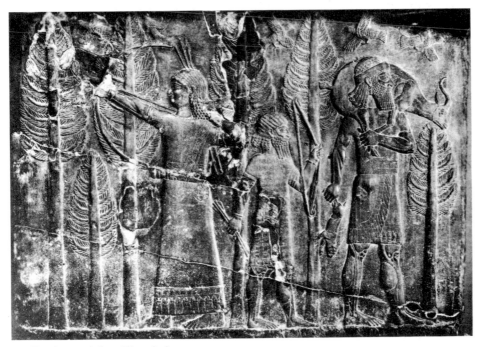

197. Hunting scene, from Khorsabad.
London, British Museum

198. Courtiers facing Sargon, from Khorsabad.
University of Chicago, Oriental Institute

199. Men bringing offerings, from Khorsabad.
Paris, Louvre

from the palace of Sargon II at Khorsabad. The characteristic profile of the figures in Sargon's relief [198] repeats the painted outlines of the Til Barsip faces. The relief from Tiglathpileser's palace at Nimrud [195] also clearly resembles the Khorsabad figures, yet it enables us to gauge the new emphasis on representative display which marks the art of Sargon. Recently painted scenes of an earlier period have been discovered at Nimrud.[38]

Sargon's reliefs are perhaps less varied than those of earlier reigns. A fragment of the wars against Mardukapaliddina, king of the Sea-land, was recovered recently.[39] There was also a square room at Khorsabad, at the extreme north-western end of the palace [167], which was decorated all round with scenes of hunting [197]. Sargon appears in his chariot; courtiers and soldiers shoot at the birds or carry a variety of game. Among their quarry appears a gazelle, which is at home in the steppe, and appears incongruously in the setting of the wooded foot-hills within easy reach from Sargon's residence, which is depicted here so well. But in any case we should not exaggerate the realism of the Assyrian artists; note the regular alternation in the size of both the figures and the trees in these reliefs, which aims at (and achieves) a harmonious disposition of the design at the cost of verisimilitude; the effect resembles that of a richly figured tapestry. There were two bands of these scenes, each three feet nine inches high, with a band of inscription two feet three inches wide to separate them.

The hunting scenes are rare; many of the Khorsabad reliefs serve not narrative but representational purposes. The huge figures of the king and his courtiers, over nine feet high, cover the walls with their formal processions [198, 199]. They create the effect of impersonal authority, a powerful hierarchy moving at the will of its master, an administration so far elevated above the king's other subjects that these can but submit to its commands. The

extraordinary elaboration of detail – hair and costume, bracelets, sword-hilts, furniture – sustains the main impression by unobtrusively flaunting the riches of which the court disposes. A sparing use of colour seems to have heightened the effect of the reliefs; the eyes were outlined with black, the hair was tinted black, and traces of red also survive.

In the palace of Assurnasirpal II similar designs were found [186], but they were rare in comparison with the narrative reliefs, isolated panels, framed by supernatural beings. At Khorsabad the huge courts showed a succession of figures, converging towards Sargon. Their splendour and majesty appear clearly if we compare them with those of an earlier reign [194, 195]. At Khorsabad the emphasis was mostly on the simple fact of royal power rather than on the king's prowess in the achievements of war or in the struggle with wild beasts. The king's power cannot be questioned. In the common scenes of tribute bringers such as are shown in open courts and corridors, no detailed story is given. One sees grooms leading the king's horses, in lively, well-executed groups. In such reliefs the beholder cannot become absorbed in considering events and their implications. He is simply confronted with a number of splendid animals of which the king disposes.

At the beginning of the seventh century B.C. in the reliefs of Sargon's son Sennacherib the potentialities of large stone surfaces were fully exploited for an evocation of the setting in which the action took place. Illustration 200 shows the capitulation of Lachish in Palestine. Vines growing on the hills are drawn at the top; the whole surface is covered by the scale-pattern used from immemorial times to render mountains. Sennacherib is seated on an elaborate throne before his tent, and receives his commanders, while Jewish prisoners kiss the ground before him. The king's chariot, riding-horses, and charioteer stand in the foreground. But may we use this word? Is there a near and far

200. Sennacherib at the capitulation of Lachish,
from Kuyunjik (Nineveh).
London, British Museum

expressed in this scene? Does the disposition of the figures over the stone represent their actual position during the surrender? On the whole one must say 'no'. The figures are grouped round the king as their centre. But it has been shown that a vague suggestion of depth, and hence of space, follows from the manner in which the background is drawn into the design.[40] It is no longer quite neutral, as it was under Assurnasirpal II and Shalmaneser III. The king's tent appears to be pitched upon a small eminence or bluff on the hillside – a likely enough choice in actuality. Its surface is indicated by a ground line, a traditional aid in the arrangement of figures. But the side of the hillock is merely adumbrated by the spacing of the officers who mount it to report to the king. It is a result of this rendering that the horses appear to us to be drawn in the foreground, the vines in the background of the scene. We could not use these terms with any justification in describing illustration 194. Even in illustration 200 there is no question of a coherent rendering of space, as is shown by the drawing of the guards between horses and hillock, and of the kneeling inhabitants of Lachish.

A similar rendering of the setting is used in the illustration of Sennacherib's campaign in the marshes about the mouths of Euphrates and Tigris [201–2]. The conditions shown in these scenes still exist today along the Shatt el Arab; water, and a wilderness of reeds nine feet tall, cut by narrow channels, as in the foreground of our illustrations. Here the marsh-Arab leads an amphibious existence, fishing and keeping a few buffaloes on islands which are often no more than a mat of beaten-down reeds. All transport is by skiffs of reeds covered with bitumen, and in the reed huts 'on the rush-strewn and miry floor sleep men and women, children and buffaloes in warm proximity . . . the ground of the hut often oozing water at every step'.[41]

These impenetrable marshes, like the mountains on the north-east, offered hiding-places to all who opposed Assyrian rule, and they were never fully subjugated. The reliefs show Sennacherib's troops invading the area, using the local reed skiffs. The inhabitants, living on the very surface of the water, on bent and matted reeds, hidden in the bushes, seem sometimes to escape notice. Mostly they are routed out. On the right a boat with captives lands while another approaches the shore carrying soldiers with cut-off heads as trophies; captured women and a few male captives. Illustration 201 shows that the Assyrian draughtsman combined such a scene with the age-old scheme of superimposed friezes without any qualms. This proves that

201. Sennacherib's war in the marshes, from Kuyunjik. From a drawing. *London, British Museum*

202. War in the marshes, detail of illustration 201.
London, British Museum

we are apt to misinterpret his intentions in the composition of his 'landscapes', because they appear to us as attempts to render a single visual impression. But in his pictorial account of the war the scenery was an element like any other; a detailed record of warfare in the marshes required that the peculiar nature of the setting be rendered, and this could be done adequately now that the rigid use of narrow friezes had been relaxed through the changes in the reigns of Tiglathpileser III and Sargon II. When the captives of the marshland had to be enumerated, the strips offered advantages and were used without hesitation in conjunction with the more modern scenes; on the right of illustration 201 the two modes of composition merge into one another. The friezes continue across the next stone, and this part of the design does not differ in essentials from similar subjects treated on the gates from Balawat [190, 191].

In the reign of Sennacherib a curious attempt was made to combine the advantages of a large surface used for a single narrative with that of the orderly arrangement of figures offered by the narrow strips [203]. The surface is divided into three registers; the episode of the campaign is treated at the top and bottom, and the central strip defines the event geographically; for we can hardly speak of a 'setting' when the landscape elements are concentrated into a strip by themselves. One relief shows at the top the taking of a city, at the bottom Sennacherib in his chariot receiving captives. Between them flows a broad river.[42] Another shows the advancing army of Assyria, with a neat alternation of vines and palms in the central strip. Yet another represents the return of the victors carrying heads as trophies. The interest of these reliefs of Sennacherib is the treatment of a surface combining three strips in a single unit. This is also done, and with greater ingenuity, in the record of Assurbanipal's Arab war [204]. The desert scenery was not suited to pictorial rendering, and we find, as of old, three strips each accom-

203. Sennacherib at war, from Kuyunjik.
From a drawing. *London, British Museum*

modating a standing figure with a little width to spare. But instead of being used merely for an enumeration of episodes, the latter are so composed that something more than the bare occurrence is recorded. The main motifs are spaced diagonally across the three strips and suggest the forward urge of the pursuit: the galloping camel in the upper right-hand corner recurs a little more towards the left in the middle strip and yet farther towards the left in the lowest. There the Assyrian horseman is placed at the foot of the descending diagonal; but the movement does not end here. It rises again from the camel in front of him, through the horseman in the second strip to the galloping camel in the upper left-hand corner. The fragmentary figures at the edge of the stone indicate that this compositional skeleton underlies the whole scene, transfusing it with the agitation and forward urge of the swift, confused, headlong pursuit. The smaller figures sustain this movement, the spearmen and archers by their ges-

tures, the prostrate bodies of the dead by their emphasis on the horizontal. Even the static groups do not interrupt the current; the collapsing camels are part of it, and its speed is stressed where it swirls, in the lowest strip, round two dismounted Arabs in desperate colloquy. The novelty and power of this composition can best be seen when it is compared with the Arab war of Tiglathpileser III, rendered in strips, which are, in the old manner, used as independent units.[43]

In Assurbanipal's war against the Elamites the new treatment of the strips, as a mere convenience for the designer and not as separate entries in the pictorial chronicle, is applied with the greatest effect, and that in two directions. Either the central register is made to cover a considerable height of stone, and the upper and lower strips become its subsidiaries [205], or the separation between the registers is not drawn and survives, ghost-like, in the grouping of the actual figures [208]. We shall start, however,

204. Assurbanipal's Arab war, from Kuyunjik.
London, British Museum

with a discussion of illustration 205 which may count as a prelude to both.

First of all it must be noted that the use of a larger surface for the rendering of a single episode has no decorative significance, but serves only the cause of narrative. Illustration 205 merely shows the lower half of an orthostat, which exhibits in its upper half three more registers with a separate episode. This episode, and the one illustrated, are continued over two more orthostats to the left, and the aspect of the wall as a whole has no aesthetic appeal and lacks unity. It offers merely a vast number of figures bound in their horizontal strips.[44]

The event which we illustrate is the capitulation of Madaktu, an Elamite city. It is quite deserted; the population has gone forth to submit to the Assyrians, who are shown farther to the left on this wall. In the upper left-hand corner appear the last men of a long row kissing the earth before the victors. But in the strip below, the main body of Elamites appears in front of the chariot shown in the illustration. Note that the seated charioteer, too, makes the gesture of submission; but the groom needs his hand to hold a spirited horse and a mule. Below women and children leave the city, preceded by a mixed band of musicians. One or two of the

205. Capture of Madaktu, in Elam, from Kuyunjik. *London, British Museum*

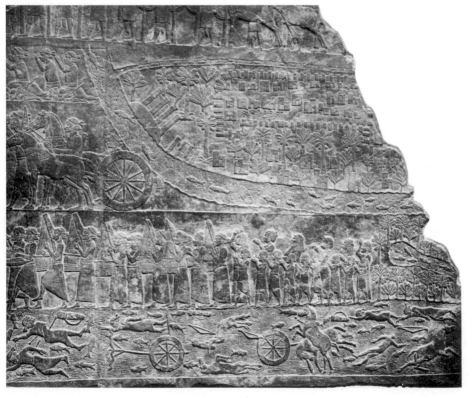

women make gestures of despair, but most of them, and all the children, clap their hands, indicating no doubt that they sing to the tune of the instruments. The third inevitable element of an oriental procession of this kind is represented by the foremost harpist and by the lute-player; they are pervaded by the rhythm of their music and fall into a dance-step. The whole scene is edged by the kind of strip which appears in the middle of some of Sennacherib's reliefs [203]: it shows the river Kerkha carrying the carcasses of horses, slain Elamites, and their equipment downstream.

The city is named in cuneiform characters; it is shown with its river and moat, its citadel (on the left) and its individual houses and town wall. Between this wall and the river there seems to be a suburb with houses placed among palm-groves and gardens. From a palm-grove on the river-banks the procession of non-combatants emerges, and it is a pity that damage to the stone prevents us from seeing whether the topo-graphical situation was further clarified. As regards the composition, the strip containing the city is the most important one. Beyond it, on the left, the two processions of Elamites end, and there the Assyrian commander and his chariots form a pendant to the city in a group occupying the whole height of the strip.

This gradation of the surface into main and subsidiary strips rendering a single episode is used most effectively by Assurbanipal's design-er. In illustration 206 the city of Hamanu is destroyed. Assyrian soldiers wielding picks and crowbars break down the towers. Timbers and bricks fall down, and fire has been put to the main gate and other parts of the fortifications. Another group of soldiers marches down the hill carrying a variety of loot: one recognizes weapons and copper cauldrons. The Assyrian bringing up the rear has commandeered the two Elamites to carry his share. The question arises here, more insistently than anywhere else,[45] whether the observation of a phenomenon of

perspective is used, in whatever degree of iso-lation, in the rendering of the road, or whether its widening towards the 'foreground' is a con-sequence of the desire to draw the little pro-cession without cutting across the farther edge of the road; the 'forward' or lower edge is any-how used as a ground line supporting the figures, and it will be a matter of personal predilection which explanation carries the more weight.

The main scene of destruction and capture is edged by a narrow strip showing the relaxation of life in camp. One soldier stands on guard fully armed, while a woman – presumably a camp-

206. The sack of the city of Hamanu, from Kuyunjik. *London, British Museum*

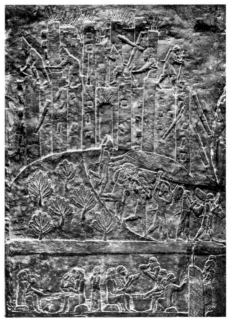

follower – cracks a joke with him. She sits at the camp-fire with other soldiers who have put their equipment aside and eat and drink in cheerful companionship.

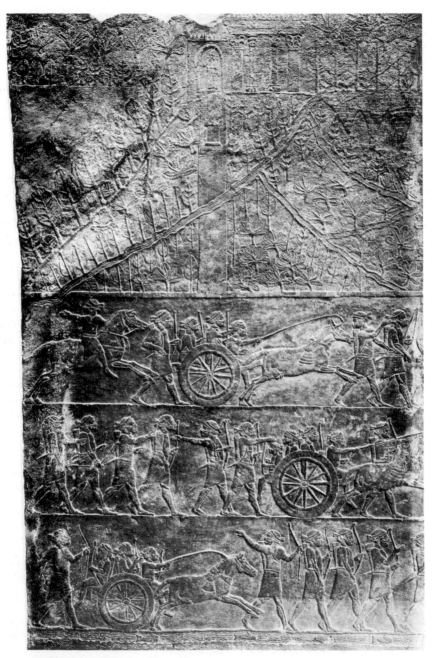

207. Elamites in flight, from Kuyunjik.
London, British Museum

In illustration 207, showing the Elamite army in retreat, the army appears in the subsidiary strips, while the mountainous region through which they flee towers above the men. Subtleties in the composition (resembling those in the Arab war relief) convey the speed of the movement. The pony-carts loaded with soldiers are spaced diagonally; the regular stride of the men on foot and the gestures of some of the figures sustain the continuous and concerted movement towards the right: notice, for instance, in the uppermost of the three friezes, on the right, the man who signals that a pony-cart, which has caught up with a column of infantry, can pass.

Above this orderly but hasty retreat appears a scenery of extreme complexity. Although badly damaged by fire and salt, the main features can still be discerned.[46] Among the trees at the top rises a building with two columns *in antis*. Columns and pilasters are crowned by capitals with stylized plant-like ornaments and the base of the columns are similarly adorned; they can be matched by column bases actually found at Khorsabad.[47]

To the left of the building a stele of an Assyrian king marks the region as subjected territory and the warring Elamites as rebels. The monuments are placed on a wooded hillside; a straight path leads up to the stele and to the altar placed in front of it. The path is crossed by an irrigation channel from which branches diverge to the right; its water reaches the hillside over an aqueduct built of stone across the valley. It shows the pointed arches known from the viaduct connecting the Nabu temple and the palace hill at Khorsabad, and from an aqueduct of Sennacherib.[48]

We must not interpret a relief like this too literally; we cannot say that the Elamites fled past the hill and its stele, for the action and the scenery are separated, as they were in some reliefs of Sennacherib [203]. The scenery shows outstanding features of the region through which the Elamites retreat, and they may have

been chosen to point the contrast between the lasting works of civilization – religion, the king's government, irrigation – and the agitation of the fleeing tribes.

The rendering of the decisive battle with the Elamites [208] shows one of the boldest compositions of Assyrian art. The Assyrians, pressing on from the left, massacre stragglers and drive the main body of the enemy into the river on the right. There is a noticeable crescendo in the composition. On the left there are pairs of combatants – wounded or dying Elamites remonstrating with their Assyrian persecutors (e.g. middle of second strip); or (on the border line of the upper and middle strip to the left of centre) an Elamite archer running while attempting to help a stumbling comrade who is hit in the back by an arrow. At this point the formal separation between the two registers has been abandoned and, further (i.e. on the right), the whole height of the stone seems to have been used with absolute freedom. As a result of this we gain an impression of an increasing turmoil when we follow the battle from the left to its final phase on the river bank.

Yet even here the division into registers is kept in the arrangement of the figures; the lines of separation, although not carved in the stone, have evidently given the artist some support in the composition of the battle-piece, and he has clearly marked them in the disposition of his figures. We can best follow his scheme of work by starting at the bottom. The mounted lancers would fit in the traditional frieze, like those of illustration 204. Once we look at them with this in mind the upper edge of the register, which is, at the same time, the ground line of the next strip, becomes clear. Just to the right of centre [208] the actual ground line (see the left half) is just visible, and its continuation consists of a number of prostrate bodies. Four dead Elamites, and one dying, are lined up, but the existence of this aid to composition is cleverly camouflaged by the posture of the wounded man

and by the tree which overlaps the feet of the second and the headless trunk of the third figure from the left. The hidden ground line divides, in fact, the entire composition, for it is carried across the river by the alignment of a quiver, a fish, and a dead horse floating on its back.

The upper limit of the second or middle register (of which we have traced the ground line) is marked by the carcass of a horse. This strip is a little wider, and the upper part is filled (as it was filled two centuries earlier, in Assurnasirpal's reliefs) with the enemy dead, on whom the vultures feed.

The discovery of the hidden supports of the draughtsman does not diminish one's admiration for his virtuosity. But not even he represents a coherent space, and it would, therefore, be wrong to speak of 'cavalier perspective',[49] as

208. The defeat of the Elamites, from Kuyunjik. *London, British Museum*

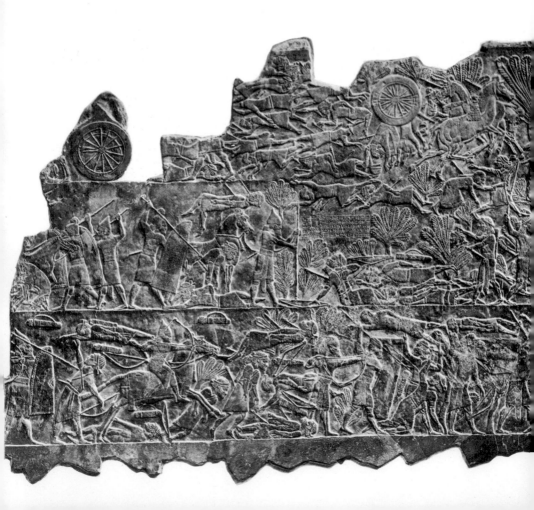

is often done. This becomes clear if we trace the overlappings of three figures standing near the water's edge in the middle register. In front of the small palm tree a soldier stoops to pick up an enemy's bow, quiver, and helmet. His legs are drawn in front of an archer shooting at Elamites afloat in the river; and the archer's forward foot is, again, traced in front of a spearman who would be standing in front of him if we read perspective into this scene. These discrepancies show that we should not do so; even here the world of art is a world of its own which represents but does not copy visual reality.

In earlier reigns the character of a pictorial chronicle was reinforced by the presence of inscriptions on the raised bands which separated the registers of reliefs. The composition of a single event over a number of strips which are,

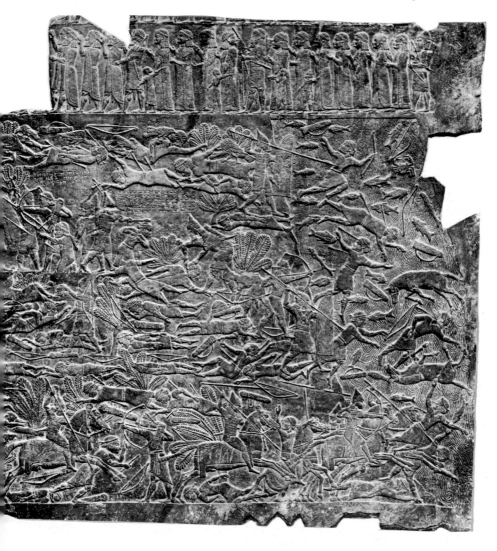

at most, separated by a ground line called for another method of identifying figures and events. This is done by panels of inscriptions which do not seriously interfere with the impression of a mêlée which this relief conveys. By means of these labels some salient features of the engagement can be described. To the upper right of centre in illustration 208 a group of Assyrian foot-soldiers has driven Teumman, the king of Susa, to a last stand. His son is hit by an arrow in the stomach and has fallen on his knee, begging for mercy. Teumman draws his bow for the last time. To the right he is seen crumpling under the shattering blows of an Assyrian's mace. Beyond the little tree the outcome of the encounter is shown: an Assyrian cuts off Teumman's head; the decapitated body of his son lies across his legs.

Looking back on the astonishing achievement of these pictorial chronicles we must remind ourselves of their limitations. It has rightly been said that their art 'never transcended the purely episodic. Throughout a period in which the violence of one small nation brought a staggering amount of suffering to countless peoples, pictorial art recorded battle after battle in a scenic display unhampered by metaphysical considerations, with a brutal secularity which, for all its freshness and vigour, had something shallow and naïve. Victory was a man-made thing, it was devoid of symbolical quality which it had had before both in Egyptian and Mesopotamian art.'[50]

*

Between wars animals were killed. It is uncertain whether the lion and lioness of illustration 209 were intended to give Assurbanipal sport. They are shown in the royal park amidst palms and trees to which vines cling laden with grapes. Lilies and daisy-like flowers are in bloom. This shady idyll is an exception among the animal reliefs of Assurbanipal; as a rule they are scenes of carnage, which are incorrectly described as hunts. For the animals, at any rate the lions, were killed in an open space cordoned

209. Lions in royal park, from Kuyunjik. *London, British Museum*

off by soldiers forming a wall with their shields. Within this wall the lions were released from rough wooden cages [210] by men themselves protected by a similar cage. The king shoots arrows at the approaching beast, and if these do not kill it and it springs, it is killed by the spears of the bodyguard. Attendants stand behind the king to hand him his arrows. It is, of course, a mistake to read the picture as if a number of lions were released simultaneously. A single

tions. How could artists whose delight in the varied incidents of actual life is so outstanding render an encounter from which the royal protagonist would, at the very best, carry away a left arm maimed for life? The answer is that the draughtsman omitted only one detail which would have disfigured the king, but which was still a standing feature of such duels when they were fought, up to quite recent times, on the upper reaches of the Euphrates.[51] The lion-

210. Lion released and killed, from Kuyunjik.
London, British Museum

animal is shown here in three successive positions. It is most impressive when it emerges from the cage. The thrill experienced time and again at this moment, when the outcome is uncertain and the powerful creature takes the measure of his opponent, left its trace in the artist's work; the lion just freed from the cage is drawn larger, more powerful, than when it is wounded and attacks. In certain renderings of its release it has a nightmarish quality. In the fray the invincible king detracts from the lion's glory.

Sometimes [211] the king is shown despatching an animal with his sword. This scene is astonishing, for the Assyrian artist, whatever his methods, represents real events. If we disregard the winged demons and other products of the religious imagination we shall not meet in Assyrian art the rendering of impossible situa-

killer wrapped his left arm in a huge quantity of black goats'-hair yarn or tent-cloth, to protect it against the fangs and claws of the beast. When the lion attacked it was offered the left arm to maul, and the right hand holding the sword was free to despatch it. Our illustration 211 shows the moment when the sword strikes home, and reveals that extraordinary subtlety of observation which distinguishes the animal drawings of the Assyrians. The lion's force is suddenly broken, the huge paws are paralysed. Compare them with the extended claws of the springing lion in illustration 212. The snarl stiffens, and in a moment the heavy body will sink towards the ground.

It may be that some animals were unwilling to fight, and at times Assurbanipal is shown twisting a lion's tail while the animal wheels round in fury. But in addition to these combats

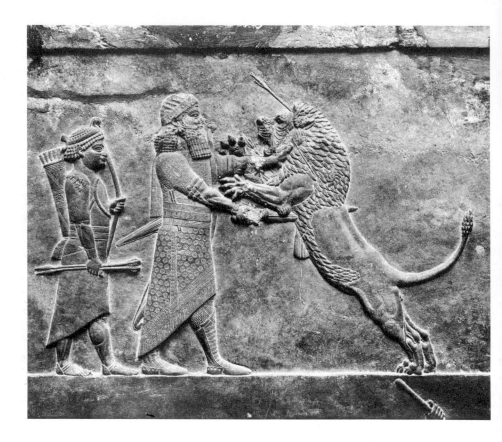

211. Assurbanipal killing a lion, from Kuyunjik.
London, British Museum

on foot there were also chariot courses, in which the king shot while his vehicle sped through the arena strewn with dead bodies [212]. Once again we need not assume (nor is it likely) that all these animals were released at once; but occasionally a victim thought to be dead would return to the attack. Assurnasirpal, too, depicted this kind of incident [185], and the comparison of his relief with that of his successor, two hundred years later, shows the change which had taken place in Assyrian art. The abstract but splendid design of the ninth century is replaced by one more complex, less decorative, and very close to reality. The king remains concentrated on his aim and gives no attention to the desperate beast who springs at its torturer. The chariot, packed to capacity, carries two spearmen detailed to cope with the unexpected.

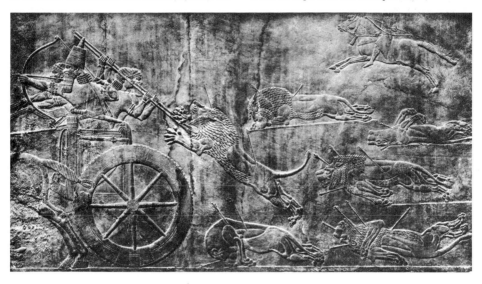

212. Lion springing at Assurbanipal, from Kuyunjik.
London, British Museum

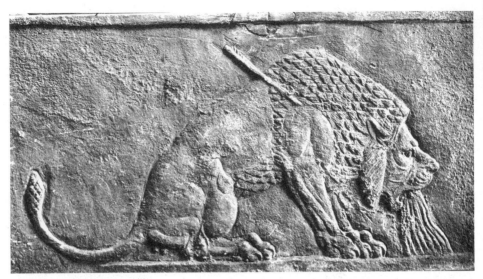

213. Dying lion, from Kuyunjik.
London, British Museum

The love and care expended on the rendering of the dead and dying animals [212–14] turn these scenes, intended as a pictorial epic, into a tragedy in which the victims, not the victor, play the chief part. Viewed in a similar manner, the hunts of inoffensive game appear as elegies. Among the panicking wild asses [215] is the mare, looking round, before breaking into a gallop – note the tension of its pace – at the awkward foal which she must abandon to the mastiff.

In illustration 216 we are for once spared the spectacle of slaughter and given a supreme example of the Assyrian's mastery of design. In most of the hunting scenes the spacing is bold; here the animals are spaced so widely that they would fall apart into an incoherent conglomeration, were it not that the rhythm of their pace binds them together across the intervals. One gets the impression, not of separate animals, but of a herd grazing, dispersed in the open plain. They move in unison, and the pointed grace of their steps is beautifully observed. But the buck bringing up the rear is disturbed, and has just caught sight of the approaching men; his scamper (note the poised foreleg) will send off the whole herd in speed over the face of the desert.

Illustration 216 does not give an impression of the relief as it appears on the walls. In close proximity to the alarmed buck, the source of his disquiet is shown: a beater has dismounted and waves his riding-whip to drive the herd within reach of the king's arrows. If we falsified the impression by depicting the herd by itself, we should have distorted it no less by including the beater, for modern eyes accustomed to taking in the whole of a work of art are not likely to detect the subtleties with which the animals and their behaviour are rendered when these are dominated by a large prosaic figure. We may

214. Dying lioness, from Kuyunjik.
London, British Museum

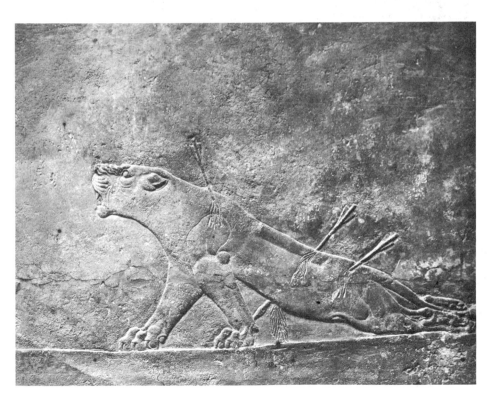

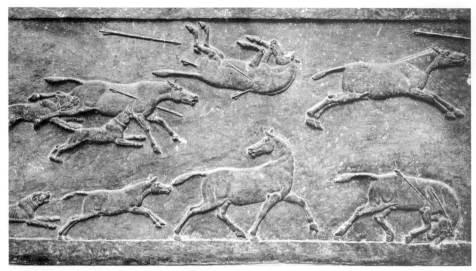

215. Wild asses hunted with mastiffs,
from Kuyunjik. *London, British Museum*

imagine that for the ancients the excitement of the hunt which these compositions revived, unified their diverse elements, without loss to the intensity with which each was perceived. Nevertheless, there is a curious discrepancy between the supreme artistry of the hunting scenes and the position in which they are displayed. The herd of gazelles appears in the lowest of three strips. In the second of these, above the gazelles, we see an entirely unconnected subject, drawn on a scale which dwarfs the gazelles, and of so dramatic a nature as to distract attention from the lower strip altogether. Assurbanipal is shown on horseback spearing a lion while another lion attacks his spare mount from the rear, and two grooms hasten forward, but are too far away to assist the king. Above this, in the uppermost of the three strips, an even more breathtaking encounter – resembling illustration 211 – is shown. The hunt of the wild asses also appears in a bottom register, with the gathering of dead lions before Assurbanipal above it, and, in the topmost strip,

the release of a lion from its cage. The hunting of timid game was perhaps considered of secondary importance, and therefore depicted where one had to stoop to study it. But the quality of the reliefs does not show a gradation of this type, and it is not true that the bottom strip is subordinated to that in the middle. In fact, the wall as a whole was never considered at all, and there is nowhere a unified mural decoration in relief. An individual scene might be given epic breadth, either by formal means such as those which unify the three strips depicting the Arab war (pp. 178–9) or by a suppression of the tripartite division of the slabs, as in illustration 208. But the beholder was evidently supposed to concentrate upon episode after episode, and the impression which the wall made as a whole was never considered.

The extreme sensitivity which the Assyrian artists displayed when depicting animals found little scope among other subjects. In illustration 217 Assurbanipal is seen taking refreshment in a garden, shaded by a vine trained overhead.

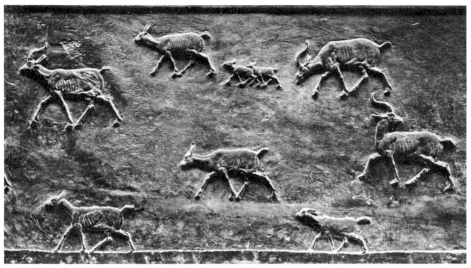

216. Herd of gazelles, from Kuyunjik.
London, British Museum

Bow, sword, and quiver are placed on a table near at hand, and the king reclines on a bed with a blanket thrown over his legs. He does not wear his usual dress, but a soft, closely fitting pullover decorated with narrow patterned bands. He holds a flower in his left hand and a drinking-cup in the other. His heavy necklace hangs from the head of the bed.

The queen sits stiffly on a chair. Both king and queen are protected by attendants from the ubiquitous flies, and servants bringing trays from the left are likewise handling fly-whisks. A harpist and drummer make music at a little distance, and one imagines that the song and twitter of the birds shown in the trees mingle with the heavier sounds. It is with a shock that

217. Assurbanipal and queen taking refreshment in a garden, from Kuyunjik. *London, British Museum*

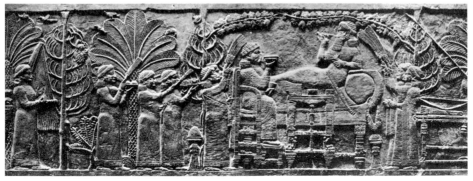

one observes, amid all this quiet pleasure, the severed head of Teumman, king of Susa, dangling from the tree near the harpist.[52]

APPLIED ARTS

The wealth of details of the Assyrian reliefs makes them a source of knowledge of furniture, a subject on which we have little information during other periods of Mesopotamian history. The furniture used by Assurbanipal [217] is heavy and ornate. Bronze castings serve for the feet, and as connecting-rods; these can be seen in the centre of Assurbanipal's table and at the side of his queen's chair. Behind this chair appears a leg of the king's bed, which ends below in a cast figure of a couchant lion; the upper end of the leg shows a panel which is probably inlaid with ivory, for it resembles such inlays found at Khorsabad [383]. These are of Syrian or Phoenician manufacture, in contrast with engraved ivories like illustration 218, which seem to be native Assyrian.[53] The square box standing on the table on the right has a close parallel at Megiddo in Palestine, where a box carved in ivory with winged sphinxes and lions was found.[54] This elaborate furniture accompanied the king on his campaigns. In illustration 200 Sennacherib is seated on a throne with heavy feet shaped like pine-cones; connecting-rods with sleeves in the characteristic shape of pairs of double volutes and three rows of figures, presumably cast in metal or carved in ivory, 'support' the king with uplifted arms – a motif possibly of Hittite origin and surviving into Persian times. The stool of Assurnasirpal II [186] is simpler, but shows similar features; bronze rams' heads at the top and the connecting sleeves with double volutes. His footstool has lion feet. Bronze castings for furniture were found at Altin Tepe, near Erzinjan, where the kingdom of Urartu or Ararat flourished. In the ninth century B.C. Shalmaneser III came into conflict with this power; and the wars continued

218. Assyrian inlay of ivory, from Nimrud

until the end of the Assyrian empire. But the material culture of Van was evidently under Assyrian influence; in fact the bronze fittings of furniture strike one as thoroughly Assyrian in motifs and taste.[55]

219 (*top left*). Cup in the shape of an antelope's head.
Bronze. *Copenhagen, National Museum*

220 (*left*). Weight in the shape of a lion,
from Khorsabad. Bronze. *Paris, Louvre*

221 (*above*). The demon Pazuzu.
Paris, Louvre

Among other objects in metal are cups [219], dishes,[56] weights in bronze in the shape of animals [220],[57] engraved bronze bands,[58] and figures of the demon Pazuzu of the south-east wind, who brings diseases [221]. If the sensitive rendering of animals and the delighted and meticulous care of small details are characteristic of Assyrian art, the power of giving convincing shape to imaginary creations is one of the oldest gifts of the Mesopotamians. The

small bronze of illustration 221, a truly sickening monstrosity, fiercely alive, shows that the Assyrians had lost none of this power.

The lampstand (if it is such)[59] of illustration 222 stands midway between the two other objects. The figure is hardly ornamentalized. It stands upon a column base of the north Syrian type used also in Assyrian architecture for porticoes [173]. The three legs consist of ducks' heads and bulls' hoofs. This combination of heterogeneous elements is well in keeping with the baroque richness of the furniture illustrated in the reliefs. The feet of the lampstand show that the 'zoomorphic juncture' which was to

play so important a part in Scythian art was known in Assyria; it was also known in the kingdom of Urartu round Lake Van[60] and it is impossible to say in which region it originated.

In the cup of illustration 219,[61] the natural forms are completely reduced to ornaments. The ears and horns of the antelope lie against the side of the cup, and a ridge connecting the root of the horns with the ears continues round the cup as a row of spiral curls, the Assyrian convention for the rendering of hair. There is a fringe of similar curls across the forehead. The eyes and eyebrows and the veins of the face have been made into ornamental designs so far

222. Stand or lamp. Bronze.
Erlangen University

223. Door-sill decorated in relief with a carpet design, from Khorsabad. Marble

224. Relief with the embroidered tunic of
Assurnasirpal, from Nimrud

removed from nature that one would wonder whether the cup might not be of Achaemenian workmanship if it were not for the frieze of figures along the rim, which are purely Assyrian.

The Assyrian reliefs also allow us to form an idea of the rich decoration of their textiles. Door-sills of temples and palaces were engraved with designs which render carpets [223]. The king's robe [224] was embroidered with decorative motifs of the greatest variety: at the top a four-winged genius, kneeling, holds in each hand a lion attacking a bull – a motif at least two thousand years old! Then follow genii confronting the sacred tree, and palmettes and rosette borders. Other pieces[62] show gazelles and antelopes in varying combinations with plant-motifs, ostriches, lions, wild bulls, sphinxes, griffin-demons, and so on. Some of these recur on vases of polychrome faience [225];[63] all of them are used on the cylinder seals of the period.

In illustrations 226–8 designs which are mainly decorative show the same qualities of vigour, precision, and pompous splendour which characterize so many Assyrian ornaments. The seal [228] shows two tall figures – perhaps the king – in an attitude of prayer flanking a group consisting of two scorpion-men, guardians of the place of sunrise in the Epic of Gilgamesh, who appropriately support the wings symbolizing the sky and a divine triad manifest in it. A curious design below probably indicates a temple. To the left appears a demonic hunter, holding two stags and two gazelles. This figure makes his appearance in the Middle Assyrian Period, and the seal and its motifs are entirely Assyrian. The first seal, although truly Assyrian in every respect, illustrates the survival of older traditions. A man stands in adoration before a statue of the goddess Ishtar, in the full panoply of a war goddess, mounted on a leopard. But her star, the planet Venus, is fixed to her crown, and her immemorial connexion with the life of nature is recalled by the flowering palm tree and the two ibexes. The crossing of

225. Glazed faience vase, from Assur.
Watercolour copy

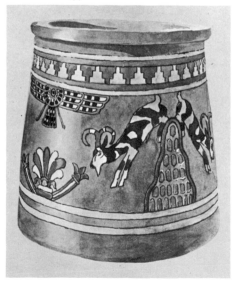

226 and 227. Assyrian cylinder seals.
London, British Museum

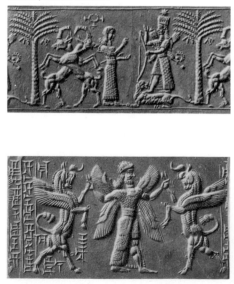

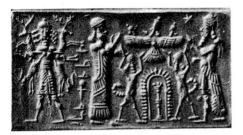

228. Assyrian cylinder seal.
Berlin Museum

these animals and the continuous frieze repre-
sented by this design recall Early Dynastic
usage, just as the heraldic group of illustration
227 resembles Akkadian compositions and the
juxtaposition of unconnected motifs of illustra-
tion 228 that of the First Dynasty of Babylon.
In Assyrian glyptic art every principle of com-
position known in the past was once more
triumphantly applied. Together with the cylin-
ders, stamp seals were used, but their designs
offer nothing that is not represented, mostly in
superior form, on the cylinders.

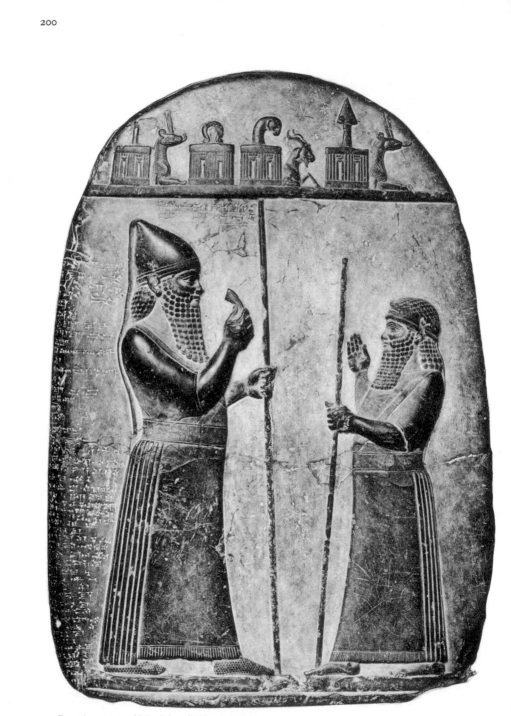

229. Boundary stone of Mardukapaliddina (714 B.C.).
Berlin Museum

THE NEO-BABYLONIAN PERIOD

(CIRCA 612–539 B.C.)

Nineveh fell in 612 B.C. before an alliance of Medes and Scythians, who had been attacking the empire for some considerable time. Nabopolassar, a Chaldean, who had been an Assyrian commander in the south, had established himself as king of Babylon a few years before the catastrophe, and under his dynasty the spiritual capital of Mesopotamia experienced an Indian summer. In the seventy-odd years of its independence an astounding amount of building was undertaken. Nabopolassar and his son Nebuchadnezzar reconstructed the temples of many cities throughout the land, often using baked bricks; they also built themselves huge palaces in Babylon; and even Nabonidus, the last Neo-Babylonian king, continued in the .same manner.

If the scale of the buildings was Assyrian, they represent in other respects a revival of Babylonian traditions and cannot be treated as a mere appendix to the history of Assyrian art. Reliefs show that even in the years of Assyrian domination the traditions of the south survived. Many boundary steles are much closer to the Kassite relief of illustration 147 than to any Assyrian works. The boundary stone of Marduka-paliddina [229] records a gift of land to a vassal and puts it under the protection of the gods whose symbols appear at the top. The function and design of the monument are Babylonian, not Assyrian, and this is also true of the physiognomies of the king and his vassal. The reduced size of the latter figure would also be hard to match in Assyrian reliefs, and the style of the carving is decidedly Babylonian; the soft and rounded forms recall the steles of Hammurabi and Urnammu [110, 134] rather than those of the Assyrian kings [230] which are contemporary with it. Notice, for instance, the treatment of the arms. There is a certain elegance in the portly Babylonian figures; the sweep of their garments, the fine-boned hands,

230. Stele of Esarhaddon, from Zinjirli.
Berlin Museum

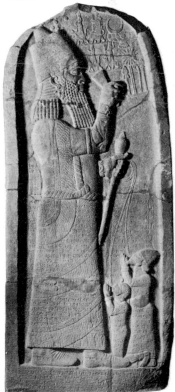

wrists, and feet are treated in a manner un-known in Assyria. This elegance is also distinc-tive of Neo-Babylonian seal designs, which lack the Assyrian fierceness. Note, further, that the Babylonians rendered a true profile and did not extend the shoulders in the plane of vision, like those, for instance, at Khorsabad. It is likely that this innovation is due to the heavy relief, almost modelled in the round, and this again is an old Babylonian usage, employed in the steles we referred to above.

The affinities of the stele of illustration 231 are more complex. It was set up in 870 B.C. by King Nabuapaliddina to commemorate his

231. Building inscription of Nabuapaliddina (870 B.C.). *London, British Museum*

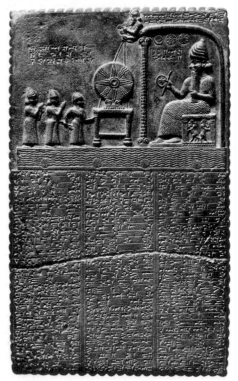

restoration of the temple of Shamash at Sippar. The text mentions the ancient statue of the sun-god, and it is probably shown in its shrine. It exhibits a number of archaic features; its costume goes back to the third millennium [110]; its gesture and the ring-and-staff are as old; and the bull-men on the side of its throne are constant adjuncts of the sun-god in the time of Sargon of Akkad and Hammurabi, but are rare in Assyrian iconography.

The three approaching puny figures also con-form to an ancient model; the high priest of Shamash grasps the hand of the king, whom he introduces to the god, while an interceding god-dess lifts her hands in prayer, as she does on the stele of Urnammu and the painting in the palace at Mari. But the group is rendered in the idiom of a more timorous age, for on the older monu-ments the men are hardly smaller than the deity whom they approach. The ritual paraphernalia in front of Shamash are likewise without prece-dent in older times. It may be that the influence of Assyrian art, which was much concerned with the instruments of worship – emblems, altars, divine statues – makes itself felt here. The sun symbol is mounted on a small stand placed upon a table, and is supported from above by two deities. The high priest touches the table, the approach to the god has become less direct than it had been in ancient times.

We have no important works in stone from the Neo-Babylonian period, but numerous large buildings in which southern traditions were maintained. The temple at Babylon of the Mother Goddess Ninmah is typical [232].[1] There is no need to demonstrate in detail that its plan shows closer affinities to those of Tell Asmar-Eshnunna and Ishchali [114, 115] than to the Assyrian temples [154, 156]. The shapes of cella and antecella and the low platform for the statue of the deity are the decisive features in these comparisons.

At Ur as well as at Babylon great palaces were built and here, too, baked brick was used on an

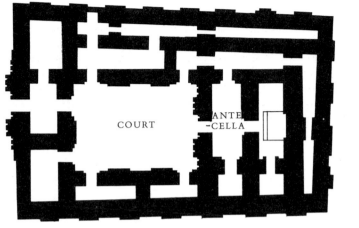

232. Babylon, Ninmah temple

unprecedented scale. Nebuchadnezzar's great palace at Babylon presents a maze of small units combined in a complex measuring 900 by 600 feet in all. Little can be said about it, since except for the throne room none of the rooms can be identified. The throne room differs from that of Sargon's palace at Khorsabad; the Assyrian king was enthroned in front of a short wall at the end of the room, while the niche of Nebuchadnezzar's throne stood in the centre of a long wall and faced the entrance. The outward appearances of the two chambers differed also; instead of the overpowering concentration of demonic guardians at the doors [168] and the nine-foot images of Sargon and his courtiers, we find at Babylon a resplendent façade of glazed bricks, showing, against a deep blue background, a pattern of slender masts with volute and palmette capitals, connected by graceful flower designs, all rendered in white and yellow and sky blue.[2] Only at the base there was a dado of snarling lions, but they do not face the visitor (as do the guardian figures in Assyria), but form a frieze of profiles, once more executed in glazed bricks. A greater difference from the Assyrian decoration cannot be conceived.

The plan of Nebuchadnezzar's city shows the palace situated roughly in the middle of the northern town wall, between the Euphrates on the west and the main north–south avenue. This was the scene of the great processions which took place on various religious occasions. Farther to the south on the avenue stood Esagila, the main temple of the city-god Marduk; north of it, in a separate enclosure, stood Etemenanki, Marduk's Ziggurat, the 'Tower of Babel'.

Of this famous structure only the ground plan and traces of the three stairs leading up to it have been preserved, and the numerous attempts to reconstruct it belong to archaeology and not to the history of art, since not one of them is fully supported by evidence. In addition to the mere outline preserved in the soil, we have a tablet giving measurements and the eye-witness account of Herodotus.[3] But separately and in combinations these sources do not solve the ambiguities and uncertainties which remain.[4]

Where the processional way, after skirting the enclosure of the Ziggurat and the palace, left the inner town, a splendid gate was erected. It was called the Ishtar gate and decorated with glazed bricks where bulls and dragons appeared

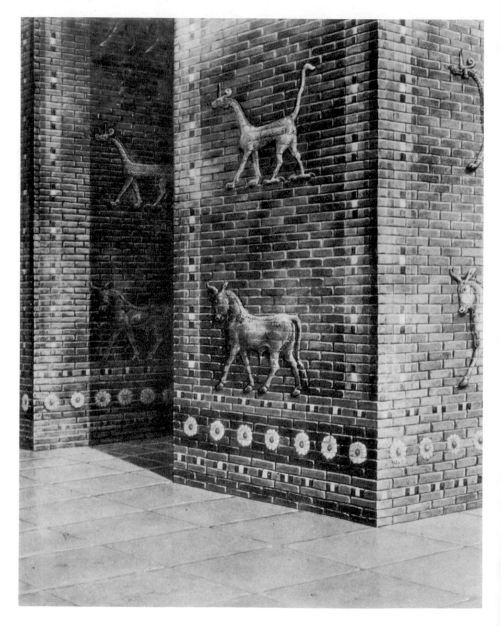

in relief on a blue ground [233]. The bulls were yellow, with their hair, distributed decoratively rather than in imitation of nature, in blue. The dragons, sacred to Marduk, were white, with details rendered in yellow. At Khorsabad panels of polychrome glazed brick had been used [171], but these figures were flat. At Babylon the bricks were moulded and the animals appear in relief; the play of light added brilliance to the deeply saturated colour contrasts which imparted extraordinary splendour to the vast structure.

The last great phase of Mesopotamian independence is inadequately represented by the surviving remains, however impressive these may be. There is a scarcity of works of the period which makes it impossible to estimate its artistic achievements. The seal designs are more elegant but less forceful than those of Assyria, with a few idiosyncrasies in subject-matter. There was an intense literary activity, and it was from Neo-Babylonian sources that the Hellenistic world acquired its knowledge of astrology and other Mesopotamian sciences; but Neo-Babylonian art did not affect the West. It was from Assyria that Greece and Etruria obtained their models during their 'orientalizing period' through the intermediacy of the Phoenicians.

THE PERIPHERAL REGIONS

ASIA MINOR AND THE HITTITES

INTRODUCTION

Various finds, such as cylinder seals and tablets, prove that Mesopotamian influence pervaded all the surrounding countries during the latter part of the Protoliterate Period, towards 3000 B.C. It even reached Egypt, where an autochthonous civilization was likewise in its formative phase and was stimulated and enriched by an acquaintance with Mesopotamian achievements.[1] But among the immediate neighbours of Sumer no comparable developments took place. They merely advanced a little beyond the limitations of prehistoric village culture and required about a thousand years to catch up with the deep and rapid changes which had taken place in Mesopotamia and the Nile valley. Moreover, the peripheral regions never achieved the cultural and political stability of the two great river civilizations. It is true that according to Egyptian standards even the Mesopotamian development appears continually disturbed by historical contingencies. But if we compare it with the developments in neighbouring countries, the continuity of Sumerian, Babylonian, and Assyrian culture stands out. It was modified but never destroyed by the invasions and changes in hegemony which threw the country into confusion at frequent intervals. Elsewhere in Asia – in Anatolia, Syria, Palestine, and

Persia – similar upheavals had a more destructive effect, because the cultural fabric was less resistant. There may have been a certain degree of continuity which survived the ethnic and political cataclysms, but at this distance of time we cannot recognize it. It is this circumstance, and not a scarcity of evidence which future discoveries might remedy, that makes it impossible to write a history of the art of any of those countries. Works of interest and merit were occasionally produced, but they appear without ancestry and remain without heirs. They are, moreover, exceptions among a mass of monuments showing lack of skill rather than of stylistic character. Yet it was through the odd peripheral schools that some of the great achievements of ancient Near Eastern art affected the art of Europe, first in the sixth and seventh centuries B.C. and then again in the Middle Ages.

ANATOLIA UP TO THE MIDDLE OF THE SECOND MILLENNIUM B.C.

In Asia Minor the seaboard with its valleys differs from the rest of the peninsula. Whenever a culture arose which was peculiarly Anatolian it was centred in the uplands. The Mediterranean littoral was in many respects an outpost of Aegean culture, although it also retained links

with the plateau. Western Anatolia and Cilicia were therefore peripheral regions in more senses than one.

During the better part of the third millennium B.C. Asia Minor produced nothing that can be included without qualification in a history of art. Works of sculpture were apparently unknown, excepting at Hissarlik, the site of Troy, on the Hellespont, where a limestone stele carved with the rough delineation of a human face has been found.[2] Architecture was purely utilitarian; it used rough stones, or sun-dried bricks on stone foundations. Town walls and gates of these materials assumed impressive dimensions.[3] And there is one feature of domestic architecture which cannot be ignored here. In western Anatolia, houses were designed in a manner which gained great significance in the second and first millennium B.C. At Hissarlik [234], and also in the closely related settlement at Thermi in Lesbos,[4] the private houses show a peculiar and very rigid plan. It consists of two, or at most three, rooms placed one behind the other. The main chamber had a hearth, generally in the centre; an ante-chamber or portico

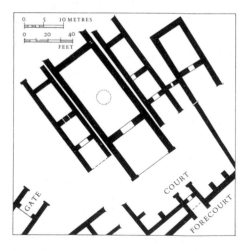

234. Hissarlik (Troy), second city, gates and palaces

was placed between this and the forecourt or street, and another small apartment was sometimes found at the back of the main room. The house was, therefore, long and narrow, and the unit was never expanded sideways or connected with other units. If more accommodation was required, a number of units were placed side by side. This very peculiar type of house is an early version of the Homeric house, the megaron. It is also found in prehistoric Thessaly[5] and possibly farther to the north, in Transylvania, and it clearly belongs to the Western elements of north-west Anatolian culture. There would be no reason to mention these rough dwellings here, were it not for the splendid megara built at Tiryns and Mycenae 1,500 years later. Moreover, the Greek temple *in antis* is based on the same plan. But these temples and the Mycenaean palaces adhere strictly to one standard arrangement. In prehistoric times the megaron was used more tentatively; for instance, the number of rooms and the position of the hearth varied. Nevertheless, it is clear that the popular dwellings of north-west Anatolia and the Balkans supplied the scheme which the purposeful architects of a later age transmuted into an art-form.

The plastic arts make their appearance in Asia Minor after 2500 B.C. At that time a wealth of metal – copper, silver, and gold – became available for weapons, tools, and ornaments, not only in Anatolia but throughout the mountain ranges: at Hissarlik in the west, at Alaja Hüyük in Cappadocia, in the Kuban valley north of the Caucasus, and, near the south-eastern shores of the Caspian, at Tureng Tepe near Astrabad and at Tepe Hissar near Damghan. Everywhere the products of the smiths and jewellers betray a greater or lesser dependence on the brilliant achievements of the Third Early Dynastic Period in Sumer [63–70]. The absence of ores in Mesopotamia called for a continuous importation of metal, in whatever form; and it seems that the trade which supplied the Sumerian

235. Pin, ear pendants, and bracelet from the
second city at Hissarlik (Troy)

craftsmen with their raw materials broke down the comparative isolation of the highlanders. Their ores or ingots may occasionally have been obtained in exchange for finished products from the Mesopotamian workshops. However this may be, the influence of southern prototypes is noticeable in all the sites which we have named, although they were not slavishly copied.

In the second city of Hissarlik (Troy) several hoards of jewellery were buried before the town was sacked. They were recovered by Schliemann and include pins and bracelets [235, B and D] decorated with spectacle spirals of gold wire soldered on a smooth background of sheet gold. Ear pendants [235, A and C] were made of gold wire, decorated with rosettes and with minute

chains from which ornaments of gold foil were hung. These are sometimes shaped like leaves, sometimes like a human figure, and decorated with patterns of punched dots. There were also diadems with a thick fringe of such little chains and ornaments, short in the middle and long at the sides, so that the gold would cover the hair on either side of the face. Some elements of these composite ornaments have Mesopotamian prototypes, but their combination is quite new and the Trojan hairpins, the ear pendants, and the diadems have, in fact, a distinctly barbarian originality. The total absence of natural representations bespeaks the persistence of prehistoric idiosyncrasies.

If we disregard the coarse clay figurines of animals and women, which resemble those found throughout the Near East and elsewhere at widely differing periods, we may say that the earliest works of representational art in Anatolia are the copper deer and oxen of illustrations 236-9. They were found at Alaja Hüyük, east of Ankara, in tombs richly equipped with weapons, ornaments, and gold vases. The objects in our illustrations seem to have been fastened to the top of poles, and are therefore called standards.[6] Some of them are openwork disks; others are diamond-shaped and show swastikas instead of the usual criss-cross pattern. Small disks or diamond-shaped pendants are sometimes attached to the outer edge. In some cases a stag or a bull pierces the disk which surrounds it like a halo [236]. It is evident that the relation between animal and disk is a close one, for even where the beast is omitted, the disk is mounted upon a pair of horns [238]. Where, however, there is no disk, the animal stands within a circular band [237]; and where even this frame was absent [239] separate standards with disks were placed in the same tomb. It has been suggested that the disks represent the sun; this may be a purely modern association, but if it were true, one would have to assume that the animal was considered a manifestation of the sun-god. There can be little doubt that the standards were religious symbols. They were certainly not military ensigns, since they also occur in the tombs of women.[7]

The animal figures are large and heavy, solidly cast in bronze. The stag of illustration 239, one of the best preserved ones, is twenty-one inches high. The head and antlers are covered with silver foil and the body is inlaid

236 to 239. 'Standards', from Alaja Hüyük. *Ankara Museum*

236

237

with silver. It shows a curious contrast in modelling. The body and limbs of the animal are over-simplified; not so the antlers, and especially their coronets. Only in this detail do the makers display any interest in natural forms. The elongated rendering of the face and the transposition of the markings of the deer's coat into zigzags, crosses, and concentric circles show so distant a relation to the living animal that one is apt to see in the rendering of such creatures an

And the Hittites had certainly entered Anatolia from outside.

Now a discovery to the north-east, beyond the Caucasus and at the eastern end of the Black Sea, may throw light on the origin of the people buried at Alaja Hüyük. At Maikop in the Kuban valley a chieftain's tomb was discovered which consisted of a timbered chamber buried under a barrow. The body had been laid out in the chamber under a baldachin, and was equipped

238

239

innovation within an art hitherto confined to the abstract decorations of Neolithic times.[8]

The standards from Alaja Hüyük are without parallel in the Near East, but a conjecture about their place in the history of art is possible. It can be argued (though not proved) that their makers had recently entered Anatolia from the north-east and, also, that they constituted the advance guard of the Hittites. The latter point would be of considerable interest, since it was only during the Hittite empire that an original, indigenous school of art flourished in Anatolia.

240. Shoulder design on a vase, from chieftain's tomb, Maikop

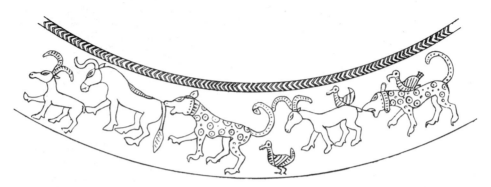

with arms and many vessels of gold and silver. Some of the weapons resembled Mesopotamian examples; of the vessels this can only be said with some reserve. The herringbone pattern edging the frieze in illustration 240 and the animal frieze itself, with its alternation of carnivores and ruminants, is thoroughly Mesopotamian. This is also true of the profile of the bulls, which display a single horn, and even the bear, standing underneath a tree on its hind legs and licking a paw [243, top], can be matched on an Early Dynastic vase [32]. Yet the scenery of this vase [241–3] is without parallel. One hardly dares to accept the suggestion which has been made by the discoverer[9] that the rugged peaks on the neck indicated the Caucasus and the sea without an outlet into which two rivers flow the Caspian – or even the Black Sea. But the Przewalski horse which the lions stalk belongs certainly to the local fauna.[10]

The baldachin over the chieftain's body probably consisted of cloth on which were stitched figures of bulls and lions cut from gold foil. Its four supports passed through the bodies of bulls cast in solid gold or silver [244, 245]. They are smaller than the figures from Alaja

Hüyük and their modelling is superior. But they show the same heaviness in form (which is never found in the Mesopotamian animals cast in metal, for instance, on rein-rings);[11] and they possess the same odd elongation of the muzzle which we observed in illustration 239. Moreover, there are other similarities between the two sites. At Alaja Hüyük, too, the bodies were placed in a timbered funerary chamber; they were in some cases covered with red ochre, a custom found throughout south Russia and notably at Maikop.

The prevalence of the stag at Alaja Hüyük is also revealing. It rarely counted as a sacred animal in the Near East, but it did receive worship both from the dwellers on the Eurasian steppes and from the Hittites who differed in this respect from their neighbours.[12] There is, then, some probability that the people buried at Alaja Hüyük entered Cappadocia from the Russian or Central Asian steppes; and that some similarity existed, perhaps due to continuity, between their beliefs and those of the Hittites.

In probing Hittite origins in relation to the finds from Alaja Hüyük, we are inevitably drawn into a discussion of historical develop-

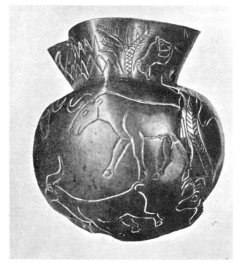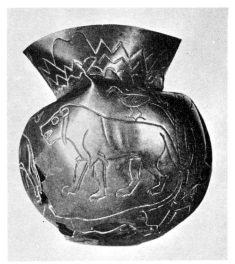

241 to 243. Vase, from chieftain's tomb, Maikop,
Kuban, with drawing of engraved design.
Leningrad, Hermitage

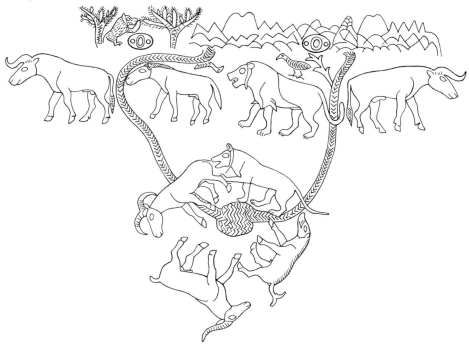

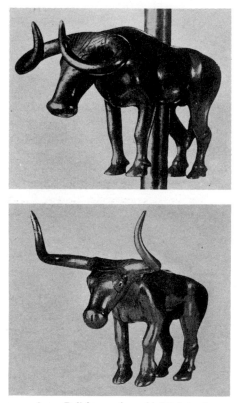

244 and 245. Bull figures, from chieftain's tomb, Maikop. *Leningrad, Hermitage*

migration which brought the Hittites to Anatolia reached its peak in the eighteenth century B.C., when the Kassites entered Babylonia and the Hyksos Egypt. In contrast with these two groups, the Hittites, like the Mitanni who settled in north Syria, spoke an Indo-European language. The Hittites, like the Mitanni, always remained a minority in their new domains. They formed a dominating class imposing unified rule upon aboriginal populations who had never shown any political aptitude, and had been governed by a variety of local princelings. There is no evidence that the Hittites disturbed this order in the beginning. They did not sweep over the country in a mass migration, but established themselves by infiltration, and so obtained power in some principalities. We know this from cuneiform documents – business archives of Assyrian traders of about 1970–1875 B.C. which mention local rulers bearing names which the imperial Hittite tradition recognized; a text of one of them, written in Indo-European Hittite, has actually been preserved.[13] We do not know to what extent the ruling people, the Hittites proper, took over beliefs and practices of the natives, and the worship of the stag may have been one of these. In that case the princes buried at Alaja Hüyük would be the vanguard of the Hittites. Yet it is difficult to consider them aboriginals in view of the foreign affinities of their tombs; and it seems a little far-fetched to claim that they were immigrants from the same direction from which a few centuries later the Hittites invaded Anatolia and yet had no relationship with them. The evidence which we possess is entirely inconclusive, but it does not exclude the possibility that the standards of illustrations 236–9 are the earliest Hittite works of art. Unfortunately there is a break in our evidence between the period of the tombs of Alaja Hüyük and the empire. The beginning of the second millennium was a period of disturbance and the Hittites suffered much from dissensions within the ruling class.

ments. For these take the place of artists' biographies where no individual craftsmen are known, and their work must be reckoned as the artistic expression of the group to which they belong. It is the definition of this group which presents our problem. For Hittite records do not reach back to the time of the Alaja Hüyük tombs (*c.* 2300–2000 B.C.), and it is not, as a rule, assumed that Hittites were in Anatolia at the time; but there are analogies for movements of people extending over several centuries. The

THE HITTITE EMPIRE
(CIRCA 1400–1200 B.C.)

In the fourteenth century B.C. a great king, Suppiluliumas, created order in Cappadocia, defeated Mitanni in north Syria, and penetrated, about 1360 B.C., far into Syria and northern Palestine. In these regions the Egyptian vassals were adequately supported by the Pharaoh Akhenaten, who was absorbed in his religious reforms. A distinctive Hittite art was created at this time, which lasted until about 1200 B.C., when barbarian hordes overran Anatolia and the Levant.

The originality of Hittite art is marked and the quality of its best sculpture is high. It has no antecedents in Anatolia, and if the notion that lions and monsters should guard a palace entrance was derived from Mesopotamia[14] it was developed in an unprecedented manner. Instead of the bronze statues of Al 'Ubaid and Mari, and the pottery lions of Khafaje and Tell Harmal, we find, in Anatolia, large figures cut in stone and forming an indissoluble part of the architecture. When these guardians are sphinxes instead of lions [249] the borrowing of the motif emphasizes the originality of its application; they wear a headdress recalling (though differing in detail from) the fashion of Egyptian women of the Middle Kingdom. Yet the sphinx probably reached Asia Minor by way of Syria, where the male symbol of Pharaoh's superhuman strength was converted into a female monster. The 'winged disk' reached Anatolia from the same quarter. It was originally derived from Egypt, where it symbolized Horus, the sky- and sun-god who was immanent in Pharaoh and manifest in the form of a falcon. But when it crowns royal names on Hittite monuments [266] it assumes a distinctively Syrian form, exemplified (like the female sphinx) in Syrian seals of the middle of the second millennium.[15] But such derivations are of minor importance, since Hittite art as a whole possesses a pronounced individuality. Before we turn to Hittite art we shall describe its architectural setting.

Architecture

For the foundations and the lower parts of public buildings stone was commonly used, either in the form of rough blocks or, later, in that of dressed stones. Sometimes the lowest course of a wall, which rested on a foundation of rough blocks, consisted of finely worked slabs set on edge (orthostats). The upper portions of the walls were built of sun-dried bricks strengthened with wooden beams. This technique, as well as the use of orthostats, is found in north Syria, at Atchana (Alalakh) in the plain of Antioch, several centuries earlier (see below, p. 231), and we do not know whether it reached Anatolia, together with such motifs as the winged disk or the sphinx, and the Hurrian gods which entered the Hittite pantheon, from Syria, or whether it has its antecedents in an older and common architectural tradition.

Features of exceptional importance, such as the jambs of town gates or the sills of temple entrances, were made of worked stone, either huge monoliths or combinations of a few large blocks fitted together. One gets the impression of an austere but grand cyclopean architecture [246], in harmony with its mountainous setting.

The Hittite capital, Hattusas, lies on a rocky plateau near the Turkish village of Boghazköy. It was strongly fortified, and the walls, with towers placed at frequent intervals, skilfully exploit the contours of the terrain. At the southern end of the city, where the approach was easiest, an ingenious construction still stands on the hill called Yerkapu, which is in part artificial. The double town wall mounts to its summit and stone stairways lead from east and west to gates placed in towers in the outer wall; having passed these, one reaches the city through a single gateway in the high inner wall. But from the inside

246. Boghazköy, Royal Gate, from within

247. Alaja Hüyük, orthostats and Sphinx Gate

248. Boghazköy, Lion Gate

a hidden tunnel descends underneath these defence works for a length of 210 feet, and emerges inconspicuously at the foot of the hill, half-way between the two stairways. Here sorties could be made in times of siege. Similar tunnels are found at Alishar[16] and at Ras Shamra.[17]

The town gates [246-9] had an inner and an outer gateway. Ramps lead up to them skirting the town wall so that they could be covered by archers posted upon the wall. The outer gateway was deeply set between two towers and could therefore be effectively defended. In illustration 247 the sculptured orthostats outline the projecting tower on the left of the outer gateway which appears on the right of our illustration, between the two sphinxes carved in the door jambs. This is the entrance to the Hittite fortress at Alaja Hüyük. At Boghazköy one of the gates was guarded by lions [248]. When there were no carvings, the door jambs were monoliths of a curious elongated curved shape [246]. The inner gate was flush with the inner face of the town wall. In one case, at the Royal Gate of Boghazköy [246], an inner door jamb bears a figure in relief of a god [255] which we shall discuss in due course.

It is difficult to convey here the aesthetic qualities of this architecture: the rugged force of the stonework at crucial points such as gateways; the sustained might of the turreted walls following the contours, rising to the strongpoints on the hills, circling the city in a complete realization of purpose. Neither the sacred nor the civic architecture of the Hittites equals their defence works in grandeur.

Within the city five temples were unearthed. The largest of these [250] again suggests a fortress, for it is surrounded by a ring of magazines. The others [251] do not bear the same

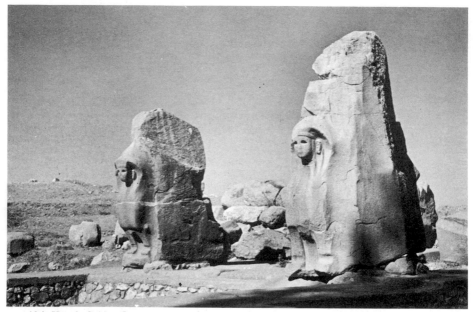

249. Alaja Hüyük, Sphinx Gate

character. They seem to have been enclosed by a wall leaving a considerable amount of free space round each building.

We do not know what gods were worshipped in any of these temples. Even the designation 'temple' is not based on any but circumstantial evidence, which we must summarize. We know that temples owned gardens, fields, and cattle; that, in addition to priests and musicians, craftsmen and other workers were in their employ; and that tribute in kind was received. The ring of magazines (and possibly, workshops) can thus be explained, but not the peculiar irregularities of the plans. The main features, however, can be understood from a text describing a religious festival,[18] especially if we apply them to the large temple of illustration 250 (it measures 480 by 400 feet in all), which is most completely preserved. The description mentions that the king, at the head of a procession,

enters the precincts through a gatehouse or propylaeum, such as we see on the right-hand side, near the bottom. It leads into an extension of the paved court surrounding the shrine which contains a square stone basin opposite the gatehouse. Water from a well was piped to this basin through baked clay tubes. The text describes how the king performs a ritual hand-washing after his arrival in the precincts. He next enters the sanctuary, takes his place upon a throne, and after certain ceremonies a communal meal is eaten and food and drink are offered to the gods. This meal might have taken place in the rectangular central court of the shrine, or in the colonnade adjoining it. Near this colonnade, in the court, there is a small building which has been supposed to serve for the renewed lustrations mentioned in the text. But it may equally well have been the chamber in which the king sat enthroned when he withdrew the cloth covering

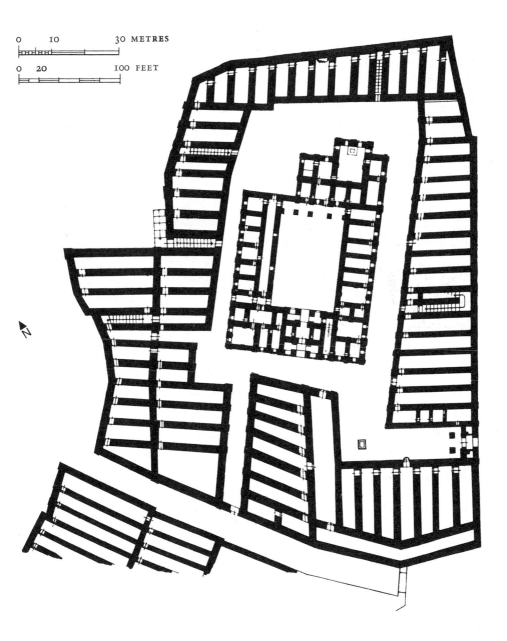

O 10 30 METRES

O 20 100 FEET

N

250. Boghazköy, Temple I

the sacrificial loaves, and divided them with his spear. This separate structure recurs in Temple V and at Yazilikaya [260].

Beyond the colonnade lies another section of the shrine; the lower parts of its walls were built of granite, while those of the first were of limestone, and it is not centred on the axis of the front part. At the back of its largest room stands a stone base for the statue of a divinity. The only means of access leads from the colonnade through two anterooms.

Some of the magazines surrounding the actual shrine contained large storage jars, shown in the plan. At two points there are staircases, while a third, at the sharp angle where the magazines jut out to the left, leads from the outside to a secondary entrance. Yet another entrance is seen in the middle of the south-west wall.

Without the ring of magazines the temple would lack the seclusion which we expect in a Near Eastern sanctuary. In Egypt and Mesopotamia small barred windows were placed high up in outside walls and the rooms received much of their light from the temple courts. In the Hittite temple there is a central court, but the rooms surrounding it have large windows in their outer walls. Even the Holy of Holies, with the statue of the god, has four windows. The temple we have discussed, Temple I, is situated in the north of the town. Four others were built to the south [251]. They lack the ring of magazines, but a wall starting from the town wall near the Royal Gate and surrounding Temple V may also have enclosed the others. These southern temples, built perhaps at a later date than Temple I, resemble one another more closely than the larger building in the north. Their plans are less clearly articulated. The shrine of Temple I is an emphatic architectural composition; the splendid gateway firmly marks the main axis; the single colonnade, at the end of the court, leads on in the direction of the Holy of Holies. It may be said that the southern temples have sacrificed clarity to elegance. They

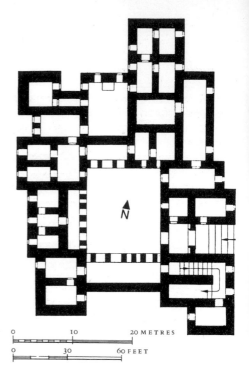

251. Boghazköy, Temple III

open up on all sides; irregular groups of rooms project or recede and, within, the courts are almost turned into cloistered quadrangles by the colonnades and walls, pierced by long windows, which surround them.

The similarities and differences shown in illustrations 250, 251, and 260 demonstrate the range and variety of this most original architecture of the fourteenth and thirteenth centuries B.C. At present we know nothing of its antecedents, except that some of its features were found in Syria early in the second millennium, in the palace of Yarimlim at Atchana (Alalakh; see below). It may, therefore, be a mere accident of discovery that a common feature of Syrian temples and palaces in the first millennium B.C., namely the placing of columns on the back of the lions [332, below], is first found at Boghazköy, in the colonnade of Temple III.[19]

Sculpture

Not only the lions of the columns which we have just mentioned, but all imperial Hittite sculpture is subservient to architecture. Free-standing statues have not been found,[20] and the lions and sphinxes which guarded the gates at Boghazköy and Alaja Hüyük are more intimately joined to the structure than their prototypes in Mesopotamia and Egypt had ever been. There is no precedent for these semi-engaged figures, whose front parts project from the door jambs, while their bodies may or may not be indicated in relief on the sides of the stones.

The scale of these gate figures is equally new. The sphinxes at Alaja Hüyük [249] stand seven feet high; the monoliths in which they are carved reach a height of ten feet. It is clear that figures on the scale of the terracotta or copper lions of the Mesopotamian temples, or even of the sphinxes and rams which form avenues at Karnak and Deir el Bahri, would have looked puny and ineffectual before the cyclopean walls of the Hittites. But size alone does not explain the unexpected fact that the addition of figures did not diminish, but enrich the majesty of this architecture. It is the bold modelling which creates a harmony with their surroundings.

As works of art the Hittite sculptures present an enigma. Those found at Boghazköy reveal a competence in carving which presupposes a sound tradition of craftsmanship. This can best be seen in the detail of one of the sphinxes from Yerkapu [252, 253]. Nothing among the numerous sculptures of the first millennium from eastern Anatolia and north Syria (Chapter 10 below) approaches this standard. Now, there is a letter from a Hittite king of the beginning of

252. Face of sphinx, from Yerkapu. *Istanbul Museum*

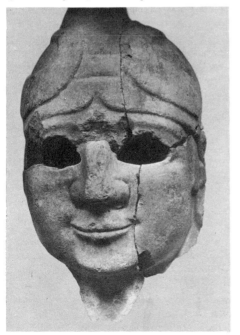

253. Sphinx, from Yerkapu (cf. 252)

254 and 255. Boghazköy, Royal Gate, outer jamb,
figure of a god

the thirteenth century, Hattusilis III, who asks
a king of Babylon to lend him a sculptor. The
Hittite promises to send him back as soon as he
has finished his work, as he had already done on
a former occasion when borrowing a sculptor
from the Kassite's father.[21] There is no Kassite

sculpture in the round for comparison, but in
one respect Hittite carving has closer analogies
to Babylonian than to Egyptian or Assyrian
work; it uses a very heavy, thoroughly plastic
relief, while Egypt and Assyria use flat relief
with a subtly modulated surface. In Babylonia,

during the Dynasties of Akkad, Ur III, and Babylon, relief is also entirely plastic [91, 110, 134]. The sculptor of the god of the Royal Gate at Boghazköy [254, 255] goes even further; the face is free for almost three-quarters of its depth, and at Yazilikaya, the open-air sanctuary near Boghazköy, the reliefs show less deep but nevertheless complete modelling [261, 262, 264, 266]. There is no question of any of these sculptures looking like Mesopotamian works; but their formal peculiarities would be explained if we could assume that a Babylonian artist instructed Hittite sculptors in the procedures of his craft. The physiognomy of the god of the Royal Gate and of the sphinxes is distinctively Anatolian, and returns in the bronzes of illustrations 257–9. Dress and weapons, and the details of the lions and sphinxes, are also peculiar. There is no

256. Boghazköy, Lion Gate, head of lion (cf. 248)

doubt that a vigorous, original, and capable school of sculptors existed during the fourteenth and thirteenth centuries in eastern Anatolia.

The sphinxes at Yerkapu had a lion's body and wings, and wore a horned cap crowned by three pairs of volutes each encircling a rosette.[22]

When seen in this baroque context [253] the remarkable qualities of the modelling of the face are easily overlooked [252]. The lions from the Lion Gate are likewise plastic in their main effect [248], but a detailed study [256] shows how elaborately their simplicity is modified by engraving. The bases of columns in the shape of lions which were found in Temple III at Boghazköy lack these engravings and are also less forceful; the jaws are closed and yet the tongue projects; a sign of incipient conventionalism.[23]

In the gate figures of Boghazköy there is a curious discrepancy between the excellent modelling of the upper part and the clumsy, lifeless treatment of the legs and feet; the same contrast is seen in the sphinxes at Alaja Hüyük [249]. These are probably meant to be female. Their headdresses combine a garbled rendering of the headcloth of Pharaoh with a woman's fashion of the Middle Kingdom, consisting of two pigtails, flung forward on either side of the face, with their ends wound round flat circular disks.[24] The Yerkapu sphinxes wear these under their horned cap of Mesopotamian origin. The necklace of the Alaja Hüyük sphinxes is not known elsewhere. The Hittite sphinxes probably follow Syrian prototypes, and the deviations from Egyptian usage may be Syrian. In the period between 1950 and 1750 B.C. Egypt dominated the Levant,[25] as we shall see, and small but beautifully cut sphinxes of Amenemhat III and IV were sent to Syria and excavated at Ras Shamra and Qatna.

The god carved on the inside of the Royal Gate belongs to the same school as the lions and sphinxes [255]. If he is less effective than these and, in fact, disturbing, this is due to his ambiguous character as a carving. Like other works of ideo-plastic or pre-Greek art, the figure combines front views and profiles. In the low relief of Egypt or Assyria the figures seem to move in a world of their own, the flat world of the relief, and the combination rarely troubles

us. But the vigorous and detailed modelling of the Hittite figure and the emphatic contrast between figure and background emphasize the abrupt juxtaposition of front-view trunk and profile legs, to name but the most striking anomaly.[26] The sculptor's contemporaries would not have been struck by this, but we must allow for it, in order to appreciate the quality of a work which is both vivid and vigorous. It has a fresh and novel style within an established convention. The modelling excellently renders the musculature of arms and legs; its care and precision are such that even details like the cuticles of the nails of the left hand are shown; and a great deal of engraving is added, exactly as it was in the case of the gate lions. The nipples of the breast are surrounded by whirls of hair, and the whole chest covered by a network of finely drawn, connected spirals which might suggest a coat of mail but probably represent hair, for they recur in the lions from Malatya, as we shall see [271]. The loincloth shows horizontal bands of herringbone and running spiral patterns, and ends in a fringe which passes diagonally across the front. Its lower edge is somewhat misdrawn. This awkwardness, like that shown in the legs of lions and sphinxes, is characteristic of a school of art in an early experimental stage. Hittite art never progressed further.

The figure has sometimes been considered a king – hence the designation Royal Gate – but the Hittite rulers are never depicted in the panoply of war, not even in the rock sculptures which presumably proclaimed their overlordship over outlying parts of the peninsula. They always appear in the long robe and skull-cap shown in illustration 266, where the king appears in the protective arm of a god. In the relief from the Royal Gate the figure wears a crested helmet with cheek-pieces, which is characterized as a divine attribute by the bull's horns indicated in relief. They occur also on the crowns of the sphinxes of Yerkapu. The battle-axe might be viewed as a weapon of war, but it

257. Rein ring, from Boghazköy. Bronze. *Paris, Louvre*

is a common attribute of the weather-gods prominent in the Hittite pantheon. Yet this axe, like the rest of the equipment of the god – the wide metallic belt and the sword with an inverted crescent-shaped pommel and a curved tip to the scabbard – are characteristic Hittite objects of which examples have been found in excavations. They also recur in the bronze statuettes [258, 259] which render gods, and which are closely related, not only in these details, but also in their facial type and modelling, to the Boghazköy sculptures. The matter is of some importance, since great numbers of west

Asiatic bronzes are known, but few can be assigned to a given period. That of illustration 257 was found at Boghazköy.[27]

According to our present knowledge, the scope of the plastic arts in the Hittite capital was severely limited. There were no free-standing statues except in the temples. There were no narrative reliefs. Sculpture seems to have had a religious function.

An important set of reliefs has been found in an open-air sanctuary at Yazilikaya, about one and a half miles to the north-east of the Hittite capital [260–6].[28] We do not know whether this

258. Figure of a god. Bronze.
Paris, Louvre

259. Figure of a god. Bronze.
Berlin Museum

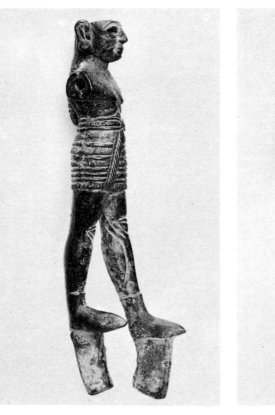

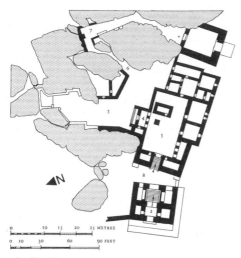

260. Yazilikaya

group of rocks was a sacred spot before imperial days, but in the thirteenth century (and probably earlier, in the fourteenth) reliefs were cut on some of the inner faces, and buildings were added to isolate the two galleries and supply a fitting approach [260]. It is uncertain whether some parts of the reliefs and buildings are older than the rest,[29] but the main scene is certainly of a piece.

One approaches from the north-west [bottom of 260], where a propylaeum (1) opened at the end of a wall which is now broken away but which at one time joined the rocks. Within this gatehouse, stairs led to a higher level, where an open space (2), closed by rocks on the left, corresponds with the forecourt of a temple. Another flight of steps led into the temple's

261. Yazilikaya, central group of gods

inner court (3). Here stood the separate rectangular building also observed at Boghazköy in Temples I and V [250]. A square pedestal placed before it has no equivalent elsewhere; it may have been an altar. The analogy with other temples would suggest a Holy of Holies on the south-east side, opposite the entrance. But the colonnade through which one usually reached it was here on the north-east (left) of the court (4), and through it one descended a few steps into the main gallery (5) between the rocks. Here a huge gathering of the gods confronts the visitor. On the walls two great processions, numbering seventy figures, converge from either side to the wall at the back. Gods approach from the left, goddesses from the right. Where the rock face was broken, masonry supplied the basis for the

carving. One is reminded of a phrase which often occurs in the texts: 'the thousand gods of the realm of Hatti [i.e. of the Hittites].'

The large panel at the back of the main gallery shows the meeting of the supreme god and goddess and their nearest relatives [261]. The curious symbols which they appear to grasp are the hieroglyphs with which their names are written. In the same way a deceased Hittite king is identified [262, left]. Deified after death, he appears in the procession of gods under the 'winged disk' which denotes royalty.[30]

The composition of the reliefs is simple, even naïve; yet, as figure follows figure, a setting is created to which the central panel achieves a climax. And within this panel the chief persons stand out. Behind the god two deities bestride

262. Yazilikaya, part of the procession of gods

mountain peaks. Teshub, their leader, is also supported, but beneath his feet the mountains come to life, and reveal the *numina* which inhabit them; they wear the pointed hats of the gods, and with bent head carry their master on their shoulders [261]. The goddess who faces the god stands on a panther walking on mountains. She is the Hepat, sun-goddess of Arinna, who was regarded as the protectress of the state. Her son by Teshub follows her, also supported by a panther. Then come two goddesses over a

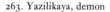

263. Yazilikaya, demon

double-headed eagle. This last combination shows that we interpret the design too literally when we speak of the Hittite (or Assyrian) gods as if they rode animals. The designs simply aim at identifying the gods by combining them in an unequivocal manner with their attributes. The mountains are visible here, as in Mesopotamia, as the specific setting of divine manifestations.

The plan of illustration 260 shows how walls constructed in both galleries rectified the irregularities of the rocks and guided the worshipper from the main gallery (5) to the smaller one (7). The plan is, however, deceptive in that the building in the upper right-hand corner does not, as already mentioned, belong to the same period as the others, nor is it likely, as we noted above, that the small gallery was accessible from the outside, for fallen rocks close this exit and entry had to be made by the narrow climbing passage, thirty feet long, from the main gallery. Its entrance (6) was guarded by two winged lion-demons [263], and the type of approach would seem to suggest that this smaller gallery was the most sacred part of the shrine. But its reliefs are less elaborate than those of the main gallery, and consist, not of connected representations, but of independent panels which neither in form nor in content suggest a coherent design. One shows twelve identical gods, with tall hats and scimitars; a similar group brings up the rear of the procession of male deities in the main gallery. Opposite this small procession is placed a huge relief, ten feet high, which stands all by itself [264, 265]. A sword or dagger, shown as if its point had been stuck into the rock,[31] has a hilt consisting of two lions – this resembles an Early Dynastic dagger from Mesopotamia[32] – but above it one sees two foreparts of lions (this is common in Early Dynastic maceheads in Mesopotamia) and the pommel of the sword consists of the head of the divinity, the *numen* of this sacred weapon. We are, unfortunately, in the dark about the significance of this impressive design. A little farther on appears

264 and 265. Yazilikaya, sword god

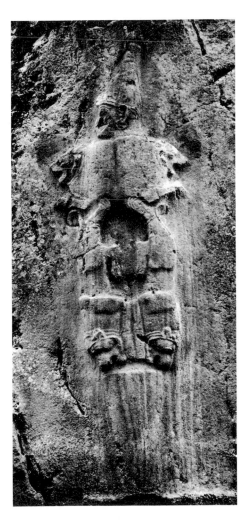
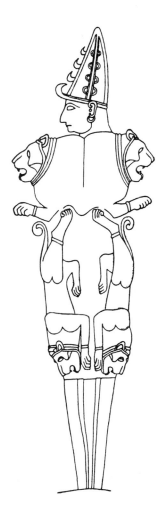

266. Yazilikaya, the king in the protection of a god

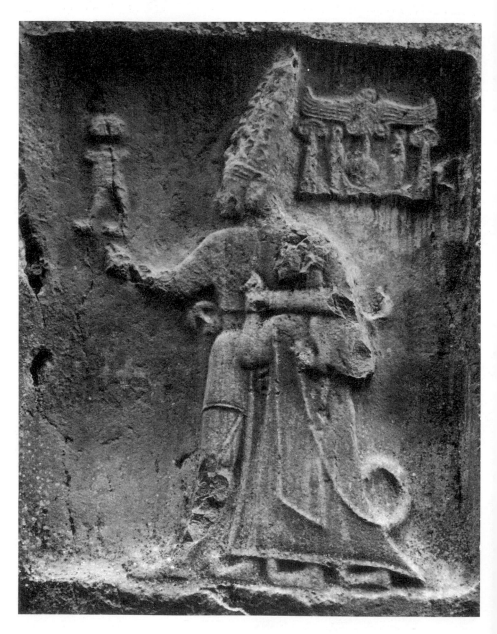

the panel reproduced in illustration 266. A king, Tudhaliyas IV, who reigned about 1250 B.C. is here shown held protectively by the same deity who appears immediately behind the chief goddess in the central scene of the main gallery; the king's name is given in the so-called aedicula or cartouche appearing above. This grouping of king and god recurs on some Hittite royal seals.

Comparing the reliefs of the two galleries one may venture a guess as to the different uses to which they were put. It has been suggested[33] that the main gallery was used for the swearing of state treaties and other functions which took place, before the thousand gods of the realm of Hatti.[34] The south gallery may have served for the installation of the king or other rites of royalty.[35] But these suggestions are incapable of proof, since our knowledge of Hittite religion is still scanty.

The style of carving of the reliefs at Yazilikaya is similar to that used in the capital; the rock carvings show the same heavy relief and truly plastic forms which we found in the gate figures from Boghazköy [248, 255]. They corroborate our view that a distinct school of sculpture existed in eastern Anatolia during the Hittite empire. However, its extant works are few, and that perhaps not only as a result of destruction and loss. It seems that the Hittite sculptors were given much less scope than those of Egypt and Mesopotamia. The Hittite kings, great conquerors though they were, did not commission pictorial records of their wars. Hittite art was religious and the king, as we said, is exclusively shown with the long priestly gown, the round cap and curved staff which are attributes of his sacred office. He wears these even when he is depicted on the face of the rocks in outlying or recently conquered parts of his realm, as at Sirkeli in Cilicia,[36] or on orthostats as at Tell Atchana near Antioch.[37] At Alaja Hüyük,[38] too, the king appears in this garb on the orthostats which decorate the base of the

tower protecting the sphinx gate [247]. Inside the gate, on one of the door jambs, appears the double-headed eagle which is associated with two goddesses at Yazilikaya [261] and which, at Alaja Hüyük, too, 'supports' a goddess (not a king, as has been said). The eagle grasps an animal, probably a hare, in either claw forming a group which was popular in Mesopotamia in Early Dynastic times [63, 70], although the double-headed eagle only appears there with the Third Dynasty of Ur.[39] The orthostats are covered with elaborate scenes, but they are poorly cut; they entirely lack the corporeality which the thorough modelling imparted to the figures at Boghazköy and Yazilikaya. At Alaja Hüyük the figures are merely outlined and stand quite flat above the background, which has been chiselled down. The details are rendered by engraved lines, not by modelling. Each orthostat is treated as a whole to the extent that figures do not overlap their edges, but a single scene may cover several stones. On the left of the gate the king is shown before an altar placed in front

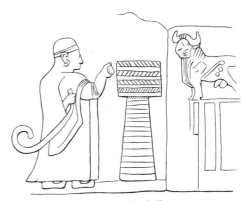

267. Alaja Hüyük, king adoring bull

of a deity represented by a bull [267; and the extreme right of 247]. He is followed by attendants, one of whom brings a goat and three

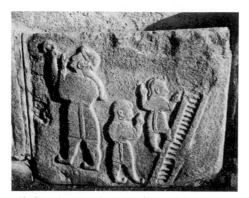

268. Sword eater and acrobats, from Alaja Hüyük.
Ankara Museum

269. Alaja Hüyük, lion hunt

rams, presumably for sacrifice. Three acrobats are shown performing their tricks [268]: one is balanced on an unsupported ladder, and the one looking to the left is a sword eater. On the next stone two figures, facing to the left, carry, the one a monkey or baboon, or perhaps a trained dog, the other a kind of guitar. No more is preserved of the sculptures on this portion of the Sphinx Gate, but on the opposite side a procession of figures approaches a goddess who is depicted on her throne and holds a mirror.[40] Some blocks were found out of place, and they do not seem to belong to the series we have described. Their subjects are commonplaces in ancient Near Eastern art, but have so far not been found elsewhere in the Hittite empire, and their treatment is quite individual. A hunter on foot receives a springing lion on his spear, while his two dogs attack the great beast [269]. A kneeling hunter aims his arrow at a charging boar. The stone, in this case, is divided into two, and below the archer a stag is shown nibbling an ornamental plant. This stag, and those appearing on another block [270], bear on the body

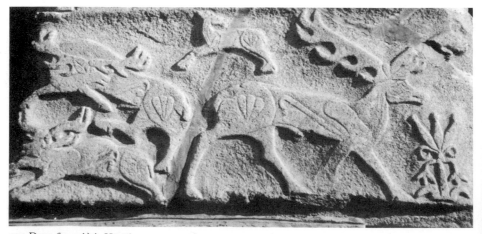

270. Deer, from Alaja Hüyük.
Ankara Museum

designs which seem additions rather than renderings of their anatomy. They are seen on two seals of King Muwatalli, who lived in the fourteenth or thirteenth century B.C.;[41] and, again, on a sculptured door jamb decorated with a snarling lion which resembles those found at Boghazköy on column bases of Temple III.[42] But the lion of the door jamb at Alaja Hüyük holds down a bull-calf which shows the quasi-hieroglyphic designs on its body. Another gate lion from Alaja Hüyük,[43] which is badly damaged, seems to stand over a prostrate man.[44] Another block shows a charging bull.

It may be owing to the lack of monuments from other sites that the repertoire of Alaja Hüyük seems exceptionally rich; it is, in any case, impossible to derive it from outside sources.[45] The kneeling archer is actually known from a Hittite seal.[46] The primitive scheme of composition of these reliefs from Alaja Hüyük, a mere juxtaposition of figures, sometimes even without a ground line to connect them, is characteristic of Hittite art as a whole. Even at Yazilikaya the composition of the friezes is elementary.

We return to ritual scenes with the reliefs at the Lion Gate of Malatya. At this site work of three periods has been found, but there can be

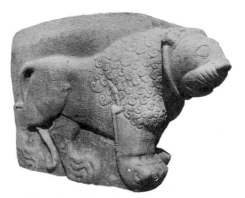

271. Lion, from Malatya.
Ankara Museum

no doubt that some of it goes back to the empire. There has been great hesitation in admitting this, and, as a compromise, it is assumed that these sculptures represent imperial survivals after the migrations of the early twelfth century had swept through Anatolia. I see no adequate grounds for such a view.[47] The lions guarding the gate [271] show a number of peculiarities which link them with the art of Boghazköy; their manes are rendered by connected spirals, exactly like the hair on the chest of the figure at the Royal Gate [255]. The small round marks

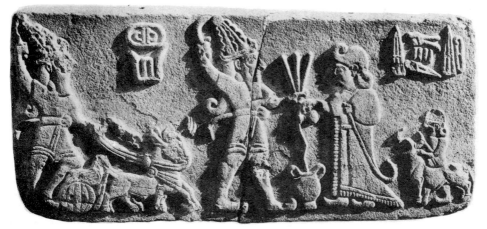

272. King libating before the gods, from Malatya.
Ankara Museum

between their eyes occur in the lions from Boghazköy [256].

The slabs with reliefs found built into the towers of the Lion Gate show scenes of worship [272]. The king,[48] and occasionally the queen, is observed pouring a libation before various gods while a servant holds a sacrificial animal. The gods sometimes appear in groups and are identified by the same attributes as those depicted at Yazilikaya. The most striking link with imperial art appears on the left of our illustration. The god shown there mounts a chariot drawn by a sprightly stepping bull, and this motif occurs identically in the rock sculpture of Imamkülü [273], which belongs to the imperial period. Here the god and his chariot appears over the personified mountains which we know from Yazilikaya, where they carry with bent heads the chief god in the central panel. Yet another link between Yazilikaya and the reliefs from Malatya and Boghazköy exists in the occurrence of a deified former king, under the winged disk,

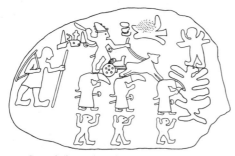

273. Imamkülü, rock sculpture

receiving honours like any god. Finally, when the queen is shown pouring a libation, she worships a goddess supported by two flying doves, once again a figure known from Yazilikaya.

But if the provincial art is linked with that of the capital by its repertoire, the peculiar style of the capital is not found elsewhere. At Alaja Hüyük, at Malatya, and at Tell Atchana near Antioch (where a relief of King Tudhaliyas of

the thirteenth century has been found)[49] the carving is flat and entirely without plastic sense. Details are engraved, but workmanship is poor; at best the proportions and gestures of some figures are convincing or even spirited, as in the hunter and the boar at Alaja Hüyük. If the work at Boghazköy was carried out in collaboration with a Babylonian sculptor, the difference from all provincial work would be explained, for there was no native tradition of stonework. Yet the provincial craftsmen showed enterprise as designers. The acrobats and hunters from Alaja Hüyük display originality, and at Malatya one of the orthostats belonging to the same series as our illustration 272 presents, for the only time in Hittite art, a mythological scene.[50] But Hittite art appears a stunted growth; and furthermore it was crushed by the great migration which initiated the dark ages for the Levant as well as for Greece.

Hittite rock sculptures are found at various localities in Anatolia. They are rough and simple, showing the figure of the king in relief on a smoothed surface on the face of a cliff. The royal name is generally added in hieroglyphs, and there is sometimes a second figure.[51] Three works of a different nature require notice here. Two of them are located in Lycaonia, the third in Cappadocia.

On a hillside at Fasillar lies a stele, twenty-two feet tall.[52] It represents a god with uplifted arm standing upon supporters who bow their heads under his weight. Their attitude and their pointed caps remind one of the similar bearers of deities at Yazilikaya [261] and Imamkülü [273]. At Fasillar the supporters are flanked by lions. The comparisons we have just made suggest that the stele belongs to imperial Hittite times, although no other free-standing steles are known from that period and the lions do not resemble those we have described above. But the stele of Fasillar does not resemble monuments of the first millennium either, and its style is hard to judge. Its rough surface may either be

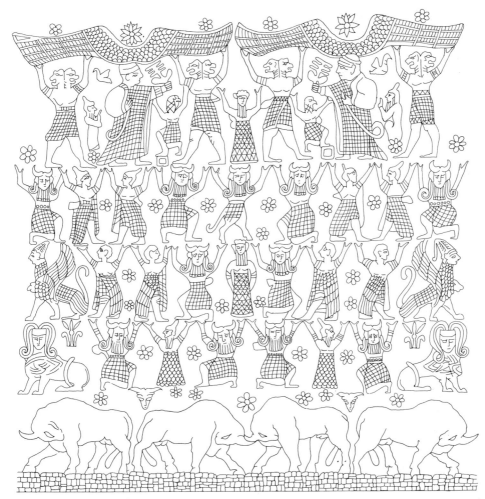

274. Ivory plaque, from Megiddo (*over life size*)

due to weathering or it may have been intended to receive the final finish at its destination, but it was abandoned on the way.[53] Such evidence as we have favours, therefore, the attribution to imperial times.

The next monument is, unfortunately, badly damaged and weathered, but its composition is unusually bold, and it enables us, moreover, to assign an important ivory carving to the im-

perial period. The relief appears on the outside of a building of rectangular stone blocks standing at a spring at Iflatun Punar.[54] Figures support winged disks with uplifted arms. Such figures recur on the third monument which must be mentioned, the rock relief of Imam-külü [273], where, at the bottom, three figures carry the personified mountains which in their turn support the god and his chariot.[55]

Similar supporters occur on the ivory plaque from Megiddo [274], which seems to have formed the side of a casket. Though found in Palestine it was doubtlessly made for a Hittite king, and represents Hittite rather than Syrian design. Separate motifs can often be matched on seal cylinders of the second Syrian group: the rosettes, the bull-men, the helmeted gods, the gods emerging from the mountain,[56] heads with the typical wig of the Egyptian Middle Kingdom.[57] But this headdress occurs also at Alaja Hüyük [249], and the bull-men supporters and the god emerging from the mountain are known at Yazilikaya. It is impossible to say whether the Hittites derived these motifs from a Syrian repertoire, or whether the Syrians used them under Hittite influence. Irrespective of this wider problem, three arguments point to a Hittite origin of the ivory plaque. The squatting winged sphinx with a pointed cap and a lion's head growing from her breast[58] recurs on a gold signet ring of imperial times.[59] Moreover, the accumulation of supporting figures is Hittite; on Syrian monuments they appear as a pair or trio under the sun-disk. Finally, the main theme, in the upper register, shows the Hittite king in his characteristic garb with the Hittite winged

disk above.[60] I am inclined to assign this ivory to the fourteenth century, after Suppululiumas' conquest of Syria and Palestine (see below pp. 262–3), since at any other time the presence of a Hittite royal casket at Megiddo would be hard to explain.

The minor arts of the Hittite empire show some continuity with earlier times. The seal designs, often of great merit, contain animal figures and other motifs related to earlier glyptic.[61] The bronze figurines which we have discussed (p. 225 above) are modelled in the style of the stone carvings at Boghazköy, but other objects, such as the rein ring of illustration 257, resemble in the treatment of the figures the bronzes from Alaja Hüyük [236–9], which, as we have seen, may well be early Hittite products. The fragment of a metal belt from Boghazköy [275], 4 inches high, is interesting, because it is known from the monuments as a characteristic element of Hittite attire [255, 257–9]; because of its design, and because of its technique. It consists of a thin sheet of silver cased in two sheets of bronze. The outer sheet has a sunk design of interlocked spirals which is picked out with gold wire. The spirals recall Aegean designs, and in Crete similar wide metal belts

275. Metal belt, from Boghazköy

0 5 CENTIMETRES 0 3 INCHES

were worn. Polychromy in metals, although probably invented in Syria,[62] is best known in the famous daggers from the shaft graves in Mycenae. The cosmopolitan trade of the period is illustrated by the discoveries at Tell Atchana in the plain of Antioch, where an ivory with a purely Mycenaean design was found as well as one decorated with the Hittite 'royal sign'. It is therefore impossible to say where the belt from Boghazköy was made. But whether it came from the Aegean, Syria, or Anatolia, the spiral design is borrowed from the Aegean, a debt repaid a thousand years later, when Hittite as well as Syrian designs supplied patterns for the Proto-Corinthian vase painters.

276 and 277. Head of a figure, from Jericho.
Clay, with eyes of shell.
Jerusalem, Palestine Archaeological Museum

THE LEVANT IN THE SECOND MILLENNIUM B.C.

INTRODUCTION

Syria, of which Palestine is the southern extension, is without unity. Even the landscape shows great variation. Wide steppes stretch across the northern end right to the hills of Kurdistan. Farther south lies the Arabian desert, and near the coast the snow-capped Lebanon with the Anti-Lebanon, a maze of rich valleys with perennial springs and streams. In the north this luxurious scenery is repeated on a smaller scale at the bay of Alexandretta with the Amanus range. To the south Mount Carmel and the Judaean and Transjordan hills – less barren in antiquity – present a miniature version of a not dissimilar setting. Throughout Syria the contrast between the coastal plains and the uplands has always been pronounced. But the cultivators and traders of the coast, and the farmers of the interior, were all liable to be overrun by the nomadic or semi-settled tribes 'between the desert and the sown'. Moreover, the great powers considered the whole region as their sphere of influence, and Babylonia or Egypt, the Hittites or the Assyrians, dominated at various times parts or the whole of the region between Asia Minor and Sinai. Where there is never undisturbed growth, there can be no continuity in the arts.

Some isolated works of sculpture survive from the end of the fourth and from the third millennia B.C., and these will have to be discussed before we can deal with the second millennium, in which the Levant flourished greatly. Perhaps the earliest, certainly the most original, of these are figures from the so-called neolithic layers of Jericho.[1] Illustrations 276 and 277 show the head of one of the best preserved of these figures. The face is nine inches high, and the whole statue was nearly natural size. Although primitive, the original is weirdly impressive. It is made of unbaked clay, while the eyes consist of orange-yellow sea-shells, carefully built in while the clay was still soft, so that the eyelids could be modelled over the edges of the shells. The clay is covered with a drab wash, and on this surface the hair and beard are indicated with a dark reddish-brown paint. Such fragments of the limbs as are preserved show the same vivid untaught modelling. One does not know whether the figure was built up round an armature. It was part of a group of three consisting, apparently, of man, woman, and child, and there were remains of two such groups. The male figure was in either case very much larger than the female, and it is perhaps worth remembering that in the Early Dynastic group found at Tell Asmar [39] the god was disproportionately larger than the goddess. But we do not know whether the Jericho triads represent mortals or divinities.[2] Recently seven heads probably belonging to the same school of sculpture as the triads were found in Jericho, also in the neolithic layers.[3] Here actual skulls were incorporated in the work and the features were modelled in clay over the bony structure of the face. The eyes were inlaid with shells, and at least one of the heads resembles in its general proportions and appearance that of illustrations 276 and 277. It seems reasonable to connect these prepared skulls with a cult of ancestors.

To the earliest metal age belong the remains of a mural painting found a little to the south of Jericho, at Tell Ghassul. It included a large eight-pointed star, and traces of the figures of gazelles, birds, and possibly human beings.

278. Figures, from Tell Judeideh. Bronze.
Boston, Museum of Fine Arts

In the plain of Antioch, on a small hill called Tell Judeideh, six bronze statuettes, three male and three female, were found in layers contemporary with the first half of the Early Dynastic Period in Mesopotamia [278].[4] In these layers Mesopotamian cylinder seals and their imitations have been found, and one assumes that the technique of casting with wasted wax (à cire perdue) was derived from Sumer. It is possible that the very function which the statues served agrees with Sumerian usage. In the temple of Tell Agrab three copper figures were found, one of a woman entirely naked, and two of naked men wearing belts. The same absence of clothing marks the Syrian figurines. In Sumer worshippers appeared naked before the gods, and a Sumerian temple (if we judge by the objects found there) stood at Tell Brak in Protoliterate times, 250 miles east of Tell Judeideh. It is possible, therefore, that the bronze statuettes represent worshippers placed in effigy before the gods. But the figures are clearly Syrian. The men wear the broad metallic belt later used by Hittites and Cretans as well as Syrians; and the man's silver 'helmet' probably represents the tall conical felt hats worn to this day in north Syria and Jebel Sinjar, and depicted on Syrian monuments of all periods. The men, moreover, wear their hair short and shave their moustaches, while the Sumerian either shaved the face and head completely, or wore hair and beard both long. The gesture of the women, holding their breasts, is found in Mesopotamian clay figurines or plaques, but here again we do not know whether these represent goddesses or votaries. The same doubt exists, of course, in connexion with the bronze figurines from Tell Judeideh. But it is perhaps significant that the hands of the men are pierced; they grasped objects now lost, perhaps because they were of silver which has corroded. One thinks of the axe which is the regular attribute of the weather-gods who dominate the Syrian pantheon in later times.[5]

The effect of the male figure in our illustration is impaired by the displacement of the silver headgear which was pressed crookedly over the face during the five thousand years in which it lay buried in the soil. There are also shortcomings which obscure the real qualities of these figures. The woman's face is spoiled by the clumsy placing of each pupil in the middle of the eyeball, without consideration of their combined effect. In the male figure the upper part of the body has been negligently shaped. But the legs are well-formed, sinewy limbs, and the carriage of the head is free and natural. The face is well proportioned but for the exaggerated eyes, and the tight-lipped mouth is excellently rendered. These are details, but the general impression is positive rather than negative; the primitive and awkward features do not destroy the vigour and plausibility of these statuettes.

Farther to the east, at Tell Brak, north of the Khabur valley, several heads carved in gypsum or alabaster have been found in a temple with cone mosaics and numerous other features characteristic of Mesopotamian temples of the Protoliterate Period.[6] Illustration 279 shows the best and largest of the heads; it is seven inches high. Perhaps 'mask' would be a better designation, for all of them have a groove gouged out at the back by means of which they were mounted on statues of other material, perhaps polychrome wood. Only the flesh-parts, face and neck, would then be rendered in the lucent stone. The holes showing at the top and bottom of the carving in illustration 279 would have accommodated the pegs by which it was fastened to its wooden support, and the excessive length of the neck is explained if we assume that it was inserted for about two inches into the body. Headgear of other material was fastened above the masks, and the smaller ones have conical dowels, carved in one piece with the face, round which bitumen or clay, or even a piece of carved wood, could be applied.[7] In illustration 279 the top of the stone shows the

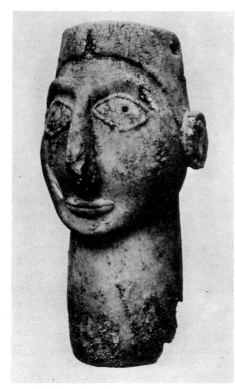

279. Head, from Tell Brak. Gypsum.
London, British Museum

prototypes cannot be established; for we know next to nothing of sculpture in stone during the latter part of the Protoliterate Period. The splendid head from Warka [20] was also a mask fixed to a figure of other material, and such masks are found occasionally among Early Dynastic stone work.[9] The peculiar rendering of ears and eyes has Early Dynastic parallels,[10] and the joined eyebrows as well as the prominent narrow-ridged nose are Mesopotamian features. The eyes are over-large and the pupils misplaced (as in the figures from Tell Judeideh), but the modelling of the lower part of the face is not without charm, while the other three heads from Brak are extremely rough.[11]

These earliest Syrian sculptures show greater independence of Mesopotamia than the cylinder seals of the same age, which often follow southern models very closely. But faithful although provincial imitations of Mesopotamian sculpture were found at Jebelet el Beida, some forty miles west of Tell Halaf, in the Khabur valley. They were discovered on a hilltop where, presumably, a shrine had once stood;[12] the group consisted of one statue and two steles of black basalt [280] and we can, for once, define their prototypes with precision. The beards of the figures consist of strands running parallel on either side of a series of oval hollows drilled out in the middle. This manner of rendering the beard is usual at Mari [56], and recurs in a statue of King Lugalkisalsi of Erech,[13] a work which belongs to the Third Early Dynastic Period. Their Syrian imitations cannot be much younger; perhaps they are as late as the reign of Sargon of Akkad. The steles are evidently monuments set up to commemorate or proclaim the subjection of the Khabur region to a Mesopotamian ruler. There is a rock stele of Naramsin a little farther to the north, near Diarbekr, and we know that his predecessor, Manishtusu, another son of Sargon, was still depicted in Early Dynastic style.[14] The statue, almost seven feet high, shows a bearded man in a tasselled

edge of the hair, parted in the middle. Perhaps the coiffure was modelled above this in bitumen, which also covered as a thin paint the portions of hair rendered in stone. The emphasis on the hair and the smooth cheeks and chin suggest to me (though there can be no certainty) that the head is that of a woman, especially since one of the smaller heads[8] has a pointed chin, resembling that of the figure of illustration 278, where a beard is clearly indicated. This head has a dowel which may well have supported the conical felt cap which was (and is) a part of male attire in north Syria.

There is no doubt that these carvings reflect Mesopotamian influence, although the exact

dress which leaves the right arm and shoulder bare but covers the left shoulder. This dress is worn by Eannatum on the Stele of the Vultures [74], but also by Sargon of Akkad on his stele of victory. The right hand holds a mace; the head is so badly damaged as to be featureless.

One of the two steles is supposed to show a figure standing on a bull, which would indicate a god, and be a deviation from Early Dynastic usage; but the assumption rests on a reconstruction which is insufficiently founded. It was worked on both sides, and this is also true of the stele we illustrate here [280]. This is eleven and a half feet high, thirty-four inches wide, and twenty-eight inches thick. Its main design shows a huge figure in the tasselled robe described above, holding a mace or battle-axe in one hand. The hair is bound up in a chignon at the back of the head, another feature which connects the stele with pre-Sargonid and Sargonid Mesopotamia. But the cap shown on the stele points to the age of Sargon, for it frequently occurs on Sargonid seals and never in the Early Dynastic Period. A ground line separates the main figure from a subsidiary compartment in which two soldiers, apparently carrying

280. Stele, from Jebelet el Beida

battle-axes, represent the victorious army. This, too, reflects Mesopotamian usage, but the grotesque distortion of all the figures is characteristic of the peripheral regions.

With this stele we have completed our survey of Syrian works of sculpture antedating the second millennium B.C.[15]

EGYPTIAN PREDOMINANCE
(2000–1800 B.C.)
AND BABYLONIAN PENETRATION
(1800–1700 B.C.)

At the opening of the second millennium B.C. the energetic kings of the Egyptian Twelfth Dynasty dominated the Levant. For a thousand years Egypt had imported timber from the Lebanon, and the port of Byblos had handled these exports. Now, from about 2000 to 1800 B.C., some of the finest products of Egyptian craftsmanship entered Syria. Many of these came from the royal workshops, and one wonders whether some sort of Egyptian overlordship was acknowledged in the various places – Megiddo, Byblos, Ras Shamra, and even Qatna, inland – where royal sphinxes, jewellery inscribed with Pharaoh's name, and statues of high officials have been discovered. It has been argued that these officials were resident high commissioners and envoys,[16] but we have no records of Asiatic campaigns such as the New Kingdom has left us, and it must also be remembered that in Egypt foreign trade was a prerogative of the government carried on under the fiction that the importations constituted tribute due to Pharaoh as Lord of All, and that the price paid was a spontaneous gift made by him to loyal vassals. The presence of high Egyptian officials and the sending of royal gifts do not, therefore, prove an actual political suzerainty of Egypt over the Syrian ports. However this may be, the local rulers of the Levant became possessed of exquisite works of art, and although Syrian works of this period are comparatively

rare, they do show that the Syrian craftsmen responded to the stimulus of these imports. They did so in a fashion which was to remain characteristic: foreign motifs were copied without precision and without regard for their meaning, to become elements in decorative designs, which are vivid and rich at their best, and gaudy and overcharged at their common worst. This is as true of Byblos and Ras Shamra in the second millennium B.C. as of the Phoenician cities in the first.

Egyptian examples exerted their strongest influence where a native tradition existed, as in metalwork. The exquisite pieces of sculpture in the round which were sent to Syria remained apparently without influence. But three steles found at Ras Shamra are attempts to use Egyptian methods for the expression of native ideas, while whatever was borrowed was freely modified. One god[17] holds the crook of Pharaoh in one hand, but a spear – not an Egyptian attribute – in the other. He wears the characteristic shoes of the Asiatic mountaineers, with upturned toes; he also wears the 'torque' – a solid metal neckband of a type widely diffused in Europe during the Bronze Age, known in the Caucasus, and found at Byblos and Ras Shamra in the period 2000–1800 B.C. It is a great pity that we cannot see (for the stone is damaged) whether the feather-like plant motif – perhaps a palm frond – merely decorated the god's headdress or was presented as part of his body. It is combined with a spiral projection derived from the Red Crown of Lower Egypt. This stele was found together with two others resembling it, and differing from that of illustration 294. One shows a god who holds the Egyptian Waz-sceptre, like a truly Nilotic divinity; the other depicts a goddess wrapped in the wings of a great bird, a type of dress common with the goddess Nut or Mut in Egypt.

The influence of Egypt on Syrian jewellery was similar but went farther. In the tombs of the rulers of Byblos splendid ointment pots of obsidian (volcanic glass) and gold were found, with caskets of ivory, ebony, and gold; pectorals of gold and semi-precious stones; mirrors and scarabs. Many of these objects were inscribed with the names of the Pharaohs Amenemhet III and IV.[18] Local products were decorated with Egyptian motifs and even hieroglyphs. The latter betray by their clumsy, un-Egyptian forms their Syrian origin. They spell out the names of the local prince in whose tomb the object was placed – a scimitar of bronze on which the midrib showed the Egyptian uraeus inlaid with gold wire, and the hieroglyphic inscription in gold and silver on a blackened ground. This technique of metal polychromy (niello) makes its earliest appearance here (see above, p. 237). It was quite unknown in Egypt at the time; it appears there after the invasion of the Asiatic Hyksos, towards the end of the sixteenth century, in the tomb of Queen Aah-hotep.[19]

The finest examples of ancient niello are found in Greece; they include daggers discovered in the shaft graves of Mycenae[20] which are likewise dated to the sixteenth century B.C. If there was an appreciable Asiatic influence in the Aegean in and after the Hyksos Period, it followed channels opened up by the lively intercourse of the preceding age, the age of Egyptian hegemony under the Twelfth Dynasty.[21] The movement in the opposite direction is difficult to define. At Byblos, in the princely tombs, silver vessels were found which include fragments of cups with the running spirals often called Aegean; but no Aegean counterpart is known. The pattern of running spirals is ultimately derived at Byblos, as at Mari, from the Aegean, but not necessarily at this time or through the work of silversmiths.[22] The very fact that these vessels are of silver favours an Asiatic origin. Silver vessels were found with Mesopotamian cylinder seals and amulets in bronze chests deposited by Pharaoh Amenemhet II in the temple of Montu at Tud in Upper Egypt.[23] One of

these[24] has a handle like that of the famous gold cups from Vaphio in the Peloponnese. But there are no exact Aegean parallels for the other vessels, and the hoard as a whole is best explained as tribute sent from Asia. Like the cup from Byblos, these vessels would merely reflect Aegean influence on the Levant.[25]

The uncertainty attaching to the homeland of Aegean derivations is emphasized by the large number of indubitable imitations of Egyptian objects. In the same tomb at Byblos which contained the silver vessels, was found a breastplate of sheet gold which follows the pattern of the Egyptian 'broad collar'. When such collars were worn by the living, they consisted of separate strands of beads and pendants held together by a falcon-head 'clasp' at either end. In sheet gold they were put round the necks of mummies,[26] but those from Byblos differ in certain details – the feathering of the big falcons' faces, and the objects held by the smaller falcon – and must, therefore, have been made locally. The methods of design of the Byblite goldsmiths can be followed clearly on a dagger with a hilt and sheath of embossed and engraved sheet gold [281]. The figure on the hilt strikes one as Egyptian in general appearance. Yet it could not be matched on any genuinely Egyptian monument.[27] Not only its excessive slenderness but also the absence of sceptres or other attributes in its hands is un-Egyptian. The crown recalls the 'White Crown' of Pharaoh, but lacks its globular ending; in this case the difference is not a result of careless copying, since we know that a tall headdress with a flat flower-like top was used in Syria.[28] Whether this itself represents an imitation of the 'White Crown' is another question.[29]

The design on the sheath includes one unmistakable Egyptian motif: the baboon held on a rope by a kneeling man. It occurs already in tombs of the Old Kingdom. The dress of all the men, a short kilt, and also their short hair and beardless faces are derived from Egypt, not from Syria. The lion and antelope is a commonplace of design all over the ancient Near East. The man on the donkey is exceptional, perhaps a native invention; he carries, at any rate, a scimitar, which is a native weapon. This mounted figure conveniently fills the widest part of the sheath, as the fish fits the narrow end.[30]

282. Dagger hilt, from Sakkara

Another example of Syrian metalwork [282][31] is closely related on the one hand to the dagger we have just discussed and on the other to the

281. Gold dagger and sheath, from Byblos

scimitars with barbarian inlaid hieroglyphs from the Byblite tombs. The design on the hilt is conventionally described as a hunting scene, but is evidently composed with an exclusive regard for the decoration of the given surface. There can be no doubt that this dagger is of Syrian workmanship, but it was found in a tomb in Egypt, where a man with the Semitic name of Abd was buried; and the inscription on the handle names the Hyksos king Apepi and his retainer. The handle aptly illustrates the permanence of the Syrian style of design, which arose when Egypt dominated the Levant, and continued after the collapse of the Middle Kingdom, when the Asiatic Hyksos overran Egypt, in the eighteenth century B.C.

But in north Syria the decline of Egypt created a vacuum which was filled by an intensification of the age-old influence of Mesopotamia. Its impact can be observed with particular clarity at Tell Atchana, ancient Alalakh, situated in the plain of Antioch at the point where the road from Aleppo to the coast crosses the Orontes.[32]

A palace was founded at this site by one Yarimlim, who was in correspondence with Hammurabi of Babylon and Zimrilim of Mari [283]. It rose on three terraces above the town, and is more interesting as a link in the chain of architectural developments than because of its intrinsic value. There is little purposeful planning. It lacks monumentality and is essentially an elaborate dwelling. But in the northern part we find for the first time basalt orthostats used as a revetment for the lowest part of the walls, a usage found later in Anatolian Hittite and in Assyrian buildings. The door-sills, too, were made of basalt. Wood was extensively employed to strengthen the mud-brick upper portions of the walls and also for door-frames and for the pillars in the colonnade between two rooms (5 and 5A on the plan). By all these devices the northern part of the palace was adapted to the representative functions of kingship. The southern part, on the other hand, is purely domestic. It is more flimsily built, of mud-brick alone, and skirts the enclosure wall of the citadel at the top; it continues farther to the south, but the remains there are very fragmentary. It is characteristic that these domestic quarters, and not the state apartments, occupy the highest of the three terraces. They are similar to what the

283. Tell Atchana, palace of Yarimlim

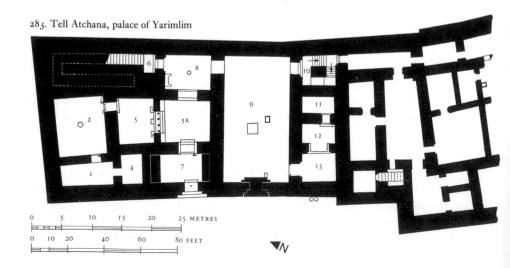

living quarters in any rich private house might have been, grouped round a rectangular open court. A stairway (in 10) leads down to the main court and up to what must have been a splendid suite of rooms on a second storey, for high in the upper debris of rooms 11–13[33] were fragments of painted plaster and basalt bases for wooden columns which must have fallen from above. The plaster is said to show bands of blue and yellow; or of yellow, red, and black; also bulls' horns, perhaps a bull's ear; and a tree or

building, and we shall see that they prefigure the *bît-hilani* which was the distinctive palace of the same region in the first millennium B.C.

The head of illustrations 284–6 was found in a chapel adjoining the palace of Yarimlim.[34] It is the only piece of statuary found in Syria which was made by a thoroughly competent artist. This sureness of touch, the coherence of the

284 to 286. Head of Yarimlim (?) of Alalakh. *Hatay Museum*

shrub with twigs and leaves sketched in dark green on a greyish-green ground colour, which itself appears against a red background. The description partly resembles, and partly differs from, the contemporary paintings of Mari, but nothing more can be said until the fragments are published. It seems, in any case, that some of the state apartments were found on the south side of the main court, adorned with basalt orthostats like the rooms to the north of it. These had also basalt door-steps, fine cement floors, and white walls where no trace of wall paintings was found. A few steps lead up to room 5, which one entered through a wide doorway carried by four wooden pillars. Room 2 was raised yet one step higher and had a central column. Rooms 5 and 2 were evidently the most important in the

work, betray a hand trained in a well-established school. One thinks naturally of Mesopotamia, but there are nowhere close parallels. The 'head of Hammurabi' [133] is much more impressionistic in its surface treatment; and the sculptures from Mari are more conventional and coarser than our piece. There is no evidence as to the sitter's identity, but it is natural to think that it represented Yarimlim, the builder of the palace in which it was found. It has an astonishing freshness, and many details cannot be matched elsewhere. I do not now refer to the curious headdress, from which the hair protrudes in conventional spiral curls, but to the rendering of the mouth, the eyebrows (which do not join in the middle), and to the lively and alert carriage of the head as shown in the back view.

A small and badly damaged head was found together with the one just discussed; it seems ill-proportioned and conventional,[35] and no other objects of the period deserve mention.

THE MITANNIAN ERA
(CIRCA 1450–1360 B.C.)

The peaceful and prosperous age of Yarimlim was followed by a period of confusion. Hammurabi conquered Mari about 1760 B.C., and may have advanced as far north as Alalakh. Mursilis I, the Hittite king, destroyed Alalakh in the course of his raid on Babylon about 1595 B.C. Soon afterwards the Hyksos, driven out of Egypt, were pursued by the Pharaohs of the Eighteenth Dynasty, anxious to establish their dominion over the homeland of the hated barbarians. Their piecemeal conquests were consolidated by Thutmosis III between 1500 and 1450 B.C., and the peace thus imposed on the Levantine coast found its counterpart inland, where the state of Mitanni had maintained itself. This kingdom soon entered into an alliance with Egypt which was sealed by the marriage of Mitanni princesses to successive Pharaohs. A period of great prosperity lasted until 1360, when the Hittite king Suppiluliumas, unwisely drawn into a dynastic quarrel by the Mitannian royal house, crossed the mountains and subjugated Syria.

We have stated before (p. 214) that the Mitanni were newcomers in the north Syrian plains who spoke an Indo-European tongue, worshipped Indra, Mitra, and Varuna, and imposed political unity on the natives. The population thus temporarily united into a single state was by no means homogeneous; it contained, among older strains, a recently immigrated element, the Hurrians, who had arrived a little in advance of the Mitanni, presumably as part of the same movement of peoples which caused ultimately the Hyksos invasion of Egypt. Of the Hurrians little is known outside their language, but they formed an important element in the state of Mitanni. Throughout the kingdom, documents were written in Hurrian. But neither the Hurrians nor the Mitannians possessed an art of their own,[36] the latter resembling in this respect all other peoples speaking Indo-European tongues. Unlike the Greeks, however, the Mitanni were not granted the respite indispensable for the formation of an individual art under foreign stimulus. Throughout the Mitannian domains the distinct origins of the elements of design remain clear. Mesopotamian traditions were combined with those of the local regions and also with stimuli received from Egypt and from the Aegean. A distinctively Mitannian style of design is found only on seals and on pottery. Illustration 287 shows a characteristic symmetrical seal design

287. Mitannian seal impression

in two tiers, in contrast with Mesopotamian usage which, in older periods, sometimes divided the surface horizontally, but did not space its motifs freely above as well as beside one another. The commonest motifs on Mitannian seals are the Pillar of Heaven, the sacred tree, and the griffin.[37] Fine specimens of this school are rare, but there is a widely distributed popular style, which is not a derivative, but, on the contrary, the foundation, of the more sophisticated style.

The painted pottery characteristic of Mitanni, which is known under a variety of names,[38]

is shown in illustration 288. Two examples come from the extreme east of the kingdom, from Tell Billa, north-east of Mosul; the others from the west, Alalakh (Tell Atchana) in the plain of Antioch. It is represented elsewhere, at Nuzi, Assur, Nineveh, Tell Brak, Hama, Tell Tayanat, and Ras Shamra.[39] It appeared about the reign of Shaushattar, in the middle of the

288. Mitannian pottery,
from Tell Atchana and Tell Billa

fifteenth century B.C., and continues at Alalakh, in elaborate examples of mostly large vessels, into the thirteenth century B.C. The commonest form is a tall cup, gracefully decorated with white designs on a dark ground. It has been thought that this pottery shows Aegean influence, for, although the tall cup with the button foot is common in Mesopotamia and Syria from the beginning of the second millennium, the white-on-dark designs have no antecedents. But by 1450 B.C. the Cretan vogue of this technique was long past, and the running spirals were well established in both Egypt and the Levant.[40] Moreover, the birds, guilloches, and other motifs are thoroughly Asiatic. The complicated baroque designs which include a 'double axe' are the latest phase of this ware at Alalakh. It is unknown elsewhere, and cannot be of Aegean derivation.[41] It is true that at Alalakh a porphyry pedestal lamp was found, of Cretan type, and probably manufacture,[42] but Cretan imports are exceedingly rare in the Mitannian area, and Aegean influence in the Levant remains an elusive factor during this period.

There is neither architecture nor sculpture which we may call Mitannian, and neither the capital nor the precise extent of the kingdom is known. All we can do is survey the region which the Mitanni ruled or which shared, at least, the prosperity consequent upon the comparatively stable conditions which they created.

Our survey starts far in the East, at Kirkuk, beyond the Tigris, where a city called Nuzi (which had existed from Early Dynastic times) had been occupied by Hurrians acknowledging Shaushattar of Mitanni as their overlord.[43] It is remarkable that the temples were planned on lines familiar from Early Dynastic times and which we have described above [6, 7, 35]; but the entrance of one of them was apparently flanked by two pairs of lions, one pair standing and one crouching [289]. This is an old Mesopotamian usage, but the Nuzi lions are rather

smaller than the copper and terracotta specimens of earlier periods, and they are glazed. Glaze had been used for beads and small objects in Mesopotamia, but its wide application to vases and figures, and a little later to orthostats and bricks, goes back to the period under discussion. Whether it was contact with Crete or with Egypt that was responsible for this innovation we cannot decide; in the Egyptian Middle Kingdom, but also in Middle Minoan Crete, objects such as vases and figurines were coated with polychrome glazes, and both countries traded with Mitanni.

If the technique of glazing large objects was new, modelling in clay was an old art in Mesopotamia, and the crouching lions from Nuzi are very well made. The pair of standing lions[44] is less satisfactory. They are built up of separate parts: body and head, legs and base, but the body seems to have been modelled on a plank or mat. It has a flat underside, quite out of keeping with the rest. But this blemish only obtrudes itself in profile, and in a figure guarding a gate the front view is, of course, the most important.

The crouching lion [289], likewise about one foot long and ten inches high, is, however,

289. Lion, from Nuzi. Glazed pottery.
Philadelphia, Pennsylvania University Museum

completely successful. The compact, muscular figure, excellently proportioned, resembles Assyrian work of later times rather than its Babylonian predecessors.

In the same temple a green faience head of a boar [290] was found. It is small – the disk is about five inches in diameter – but very well modelled. It is, perhaps, best understood as the head of an ornamental nail. Such nails, with glazed round knobs, were driven into the walls of the temples in horizontal rows in Assyrian times. But in earlier times too ornamental nails, whose heads, for instance, formed rosettes of coloured stones, had been used in temple architecture. The boar's head of illustration 290 seems to have been pressed from moulds consisting of two identical halves; and this process suggests that a considerable number were made.

At Nuzi samples of mural painting survived too [291]. They were found in private houses where they emphasized the most important section of the room. This section corresponded with the area round the altar in a temple. We have seen that this stood in front of the short wall farthest away from the entrance. In private houses the host and his guests were evidently

290. Knob in the shape of a boar's head, from Nuzi. Faience. *Baghdad, Iraq Museum*

seated in the same place, and while the other walls were covered with an even colour, grey for instance, one short wall, behind the owner's place, was divided into three vertical panels,

291. Fragment of a wall painting, from Nuzi palace

coloured grey-red-grey and separated by a guilloche or twist. Above these panels there might be a decorative design of the type shown in illustration 291. This painting is a striking illustration of the fashion (found throughout Mitanni) of combining designs and motifs of quite separate origins. While the guilloche or twist was used in Mesopotamia from Early Dynastic times, and occurs in wall paintings in the palace of Zimrilim at Mari, the female heads are shown by the cow's ears, and the form of their coiffure, to represent the Egyptian goddess Hathor. The three little feathers on her head are a purely Asiatic addition. The plant designs in the panels are typically Syrian transformations of Egyptian prototypes. It would be pleasant if we could be sure that the bulls' heads represent the Aegean in this medley, and this is quite possibly the case, but such heads also occur in contemporary ceilings in the tombs at Thebes in Egypt, and also, as space-fillers, on contemporary Syrian seals.[45]

Moving westwards we meet another type of painting at Tell Brak [292]. Among pottery

292. Painted cup, from Tell Brak

usually decorated with geometric designs occurs a cup where such ornaments are confined to a secondary position, while the main surface shows the face of an ill-shaven man with sidelocks. The temptation to look upon this cup as a joke, a precursor of the toby jug, would probably lead one astray, for a similar vessel, in a different technique and of an earlier period, was found at Jericho.[46] And a little later cups with human faces – this time of women – occur throughout the Levant. But the meaning of illustration 292 remains obscure.

The next site, to the west, is Tell Atchana (ancient Alalakh) in the plain of Antioch. A number of ivories found here[47] show the same mixture of foreign and native features which we observed in the Nuzi wall paintings. Egyptian influence is represented by a toilet vase with a handle shaped like a duck's head and neck; Hittite influence by a fragmentary inlay with a griffin bearing a lion's head on its breast (see above, p. 236) and by a disk with the 'signe royal';[48] Aegean influence by the handle of a small tool with a Mycenaean scroll pattern.[49] Most of these ivories were found in the palace of King Niqmepa, who acknowledged Shaushattar of Mitanni (about 1450 B.C.) as his overlord.[50]

There was, apparently, no sculpture in stone of the quality of the head of Yarimlim. The pieces which survive do not possess any common features. A statue of King Idrimi of Alalakh bears an important historical inscription which covers most of the figure but is a most clumsy and primitive piece of carving.[51] If it had not been for the text it would probably have been ascribed to the third millennium. At Tell Fakhariyah, near Tell Halaf, on the Khabur, two alabaster statuettes painted red were found which are equally primitive but quite dissimilar to Idrimi's statue.[52] And at Alalakh, in Niqmepa's palace, a number of small stone figures turned up, so coarse that they seem mere fetishes.[53] These heterogeneous works represent the unaided attempts of the Syrians. There

was no native tradition of stone carving comparable with those of the minor arts, especially work in metal and in ivory. But a single headless statue found at Ras Shamra betrays Mesopotamian influence in the composition. The feet are placed together, and on either side stone is left standing between the base of the statue and the lower edge of the garment, so that the figure is strengthened and less likely to snap at the weakest place, about the ankles. The dress consists of a mantle or shawl with a very heavy edge, a covering well known from seals and bronzes [cf. 297].

Architecture in north Syria possessed a sound tradition, and the palace of Niqmepa continued in the style of Yarimlim's architects, although it dispensed with terraces built at different levels [293]. It used wood, moreover, in a most lavish fashion, proof of the abundance of timber on the Amanus, and on the hills in the plain of Antioch which are now so sadly deforested. The building stands on stone foundations, the lower parts of the walls, up to almost three feet, consisting of coursed rubble outside and basalt orthostats within. Next follows a construction of wood and bricks: beams, sometimes as much as a foot in diameter, are laid flush with the inner and outer faces of the walls, and support short timbers lying across the wall at intervals of two to four feet. The interstices are filled with sun-dried bricks. These are followed by more beams supporting timbers, and so on. This use of wood is extravagant and out of all proportion to its usefulness. The mode of construction was invisible, for the wall was plastered, but it survived at Tell Tayanat, the eighth-century successor to Alalakh, and also at Zinjirli (pp. 284–5 and illustration 333 below).

The plan shows two distinct parts: a main section (rooms 1–10), and a later addition, built as a separate unit round the north and east sides of the main building and accessible only through the latter. The forecourt of the palace was irregular because of the older buildings

round it. One entered it from the north-west corner, and followed a path of baked bricks which would not get slippery and muddy in rainy weather like the remaining stamped-clay floor of the court. The palace entrance was a portico with two columns on limestone bases, placed at the top of a short flight of steps. To the right was a guardroom through which one entered the annexe of the palace. To the left another guardroom gave access to the upper storeys by means of a built-in staircase, and also to the main court (2). On the two narrow sides of this court are suites, each of two connected offices; at the back are two suites of residential quarters. One consists of three rooms only, presumably a bedroom (4) with bathroom (3) and lavatory. The other suite is much larger (rooms 5–10), but contains likewise a bathroom (7) and lavatory (6). The annexe consists of magazines and offices, and contained the state archives (11). In this room walls and floors were covered with a white cement plaster, and the tablets – probably packed in jars or baskets – were placed on low shelves around the walls. Fragments of treaties and many royal letters were found here. Room 12 was, one presumes, the office of the scribes.

The wide doorways supported by a column are remarkable. They recall porticos in Egyptian private houses at Lahun (Middle Kingdom), and if the parallel holds good, the spaces south of them were not rooms, but light-shafts or small courts with one part covered in. There was, however, a second storey in the annexe, and it has even been supposed that the extreme thickness of the walls at the northern and south-eastern ends indicates a third storey.

The palace of Niqmepa is of great interest as an example of the type of building which developed into the *bît-hilani*, the palace distinctive of north Syrian architecture in the first millennium B.C. The entrance is not decorated with sculpture, the portico (1) and the main apartment (4) are less elongated than in the later

buildings, and these two rooms are part of a more complex architectural unit than one finds, for instance, at Zinjirli. But the differences mark the true *bît-hilani* as a specialized form of the type of construction known about 1500 B.C. in Niqmepa's palace. And we can follow its history – or rather its prehistory – back to the eighteenth century B.C., for the elements of Niqmepa's buildings are all present in the state apartments of the palace of Yarimlim [283], where they are less clearly grouped. There the steps and pillared entrance which lead into the reception-room (5) are part of the interior appointments of the northern block of the palace. Yet the main room (2) lies behind portico and reception-room exactly as it does in Niqmepa's palace and in the later *bît-hilani*. Even the characteristic situation of the staircase immediately to the side of these two rooms occurs in the palace of Yarimlim. It is merely necessary to eliminate the three rooms (7, 5A, and 8) which separate the portico from the main court (9) to obtain the arrangement of Niqmepa's palace, in which an impressive ornamental feature obtains its full effect by contrasting the façade of the apartments, where the ruler fulfils his representative functions, with the spacious and semi-public area of the main court. The architects of Niqmepa show a distinct concern for appearances, and their structure is distinguished from the homely palace of Yarimlim as a manifestly public building is from a rich dwelling. The general trend shown by a comparison of the two plans would suffice to account for the elimination of the rooms which separated so effective a feature as the portico from the main court, but a recently discovered palace at Ras Shamra corroborates our surmise,[54] since it shows a plan which can be regarded as a transition from the older to the younger scheme of the Alalakh palaces. It possesses, like the palace of Yarimlim, a monumental group (rooms 1–5 in illustration 283; cf. p. 246) comprising a portico with two columns

at the head of some steps, and behind it a square room with a central column. To the right of these rooms lies, in both palaces, a staircase, of which the long central support is preserved. In both palaces the whole of this monumental suite of rooms forms an almost self-contained structure, but at Ras Shamra it is placed in the forepart of the building, and the rooms built at the back of it resemble in character those which lie in front in the palace of Yarimlim. The palace of Niqmepa shows a plan more fully integrated than that of the palace of Ras Shamra, which is roughly contemporary with it; but if the latter shares a certain incoherence with the palace of Yarimlim, it resembles that of Niqmepa by the position of the state apartments.

The origins of the *bît-hilani* are thus found in Syrian architecture of the second millennium B.C. There is no reason for calling these palaces Mitannian, for they are not found throughout the kingdom (at Nuzi, as we have seen, local architectural traditions persisted), and their antecedents go back to such buildings as the palace of Yarimlim, which antedates Mitanni by three centuries.

The affinities of the other buildings at Ras Shamra are difficult to assess. Few are well enough preserved. During the Mitannian era the city was equipped with a port at Minet el Beida, and with a wall of rough stonework recalling those of Hissarlik (Troy I) built 1,500 years earlier.[55] It was provided with a tunnel or postern for sorties during siege, resembling those found at Boghazköy, Alishar, Mycenae, and Tiryns. It seems likely that there is a connexion between the Anatolian and Syrian instances, but we do not know where the device originated.

It was also at this time that an alphabet consisting of twenty-nine cuneiform signs was invented at Ras Shamra. The texts written in this script are couched in a language closely related to Hebrew and Phoenician; they include mythological poems depicting vividly the quarrels and feasts of the gods. It is natural that one should

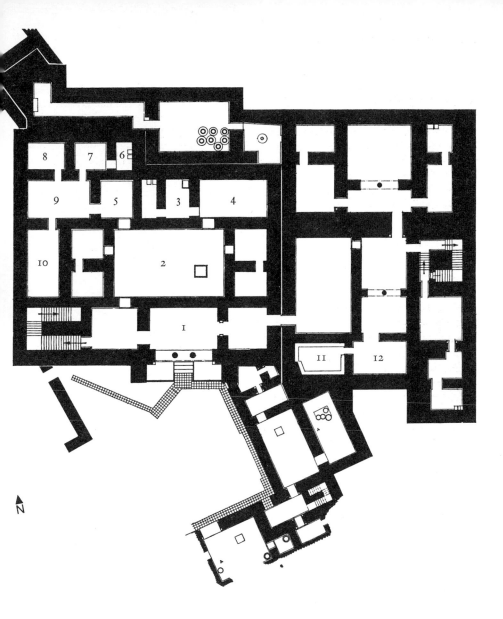

0 5 15 METRES

0 10 30 60 FEET

wish to recognize these passionate divinities on the monuments where gods are depicted. This, however, is impossible. Even in Mesopotamia, where our material is much more extensive, we succeed not as often as one would expect in establishing correspondences between the imagery of the monuments and passages in the texts. Considering the stele of illustration 294, it is a safe guess that it shows a weather-god, because these were all-important in the Syrian pantheon. The two undulating lines at the bottom of the stele probably indicated the mountains where he resides, and the zigzagging butt of his spear, with its strange excrescences, could very well indicate lightning. Yet all this is surmise.

The costume of the god has affinities with Syria and Anatolia. The pointed helmet occurs on seals of the Second Syrian Group[56] and in a bone figure of a god found at Nuzi.[57] The horns which indicate divinity and the curled locks occur on the same group of cylinders. The broad metallic band, the sword with the curved tip, the kilt divided into narrow horizontal bands, recall the god on the Royal Gate at Boghazköy [255].

While the accoutrement of the god points to the north, the style of the figure has southern affinities. The attitude, with lifted mace, repeats the traditional pose of Pharaoh victorious over his enemies; the slenderness of the figure, the modelling of the knees, the absence of shoes or sandals, and the omission of toes in the drawing of the feet, confirm that the formal inspiration of the stele was Egyptian. The steles of an earlier age found at Ras Shamra (p. 244 above) also showed Egyptian influence, but in a different manner. They borrowed objects and attributes from Egyptian renderings of gods, but they lacked the orderly arrangement of illustration 294 – the ground line, the raised border at the edge of the stone. In illustration 294, on the other hand, the subject is purely Asiatic, but its clarity of disposition and its strong yet diversified outline are derived from Egyptian art.

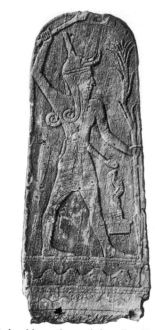

294. Stele with weather-god, from Ras Shamra. *Paris, Louvre*

295. Stele, from Beisan. Granite. *Jerusalem, Palestine Archaeological Museum*

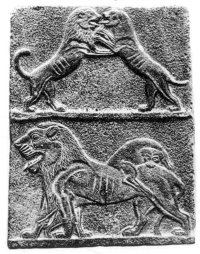

296. Development of gold bowl,
from Ras Shamra

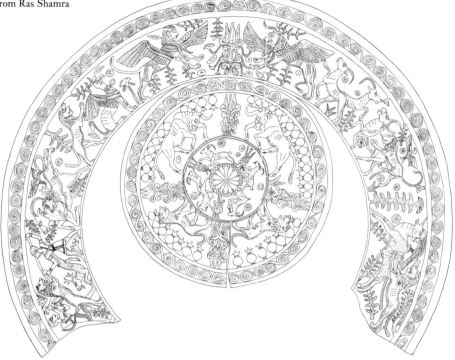

The small figure on a pedestal in front of the god probably represents a goddess allied with him. She seems to hold a plant.[58]

An entirely different type of stele was set up about the same time at Beisan (Beth Shan) in Palestine [295]. Everything about it is enigmatic. It would seem unlikely that so costly a monument was erected to commemorate the prowess of a hunting dog. But the symbolical interpretation which has been attempted, and according to which the animals represent two hostile peoples or their gods, would be more acceptable, if anywhere else in the ancient Near East mere animals, without attributes, were known to have served as such symbols. It is, of course, impossible to measure the length to which the fancy of a provincial ruler may go; in

any case his orders were in this case executed by a well-trained craftsman. The drawing of the lion closely resembles that on a gold bowl from Ras Shamra [296]; here dots or hatchings accompany the outline of the body and on the stele a separate continuous line. The articulation of the forelegs resembles that of the jumping lion on the right of illustration 296; so do the incisions marking the ribs and the stylization of the mane.[59] It seems certain, therefore, that the stele was carved in the Levant, perhaps even in north Syria. It may have been included among the loot brought back to Beisan from a raid. Such a hypothesis, based on the resemblances in design with the Ras Shamra bowl, is also attractive, because no stonework of approximately the same quality has been found in Palestine.

We have already mentioned a headless stone statue found at Ras Shamra (p. 253 above). Plastic works in the round were, however, usually cast in bronze at this time; and among these that of illustration 297 stands out. It is completely modelled in the round (which is rarely done in Syria) and seated on a three-legged stool, but this probably served to mount the whole on a more elaborate throne of other materials. The feet were fixed with dowels to a footstool. The Syrian dress with the thick rolled edge is shown here to consist of a narrow shawl with fringed border. This hangs across the knees, passes over and behind the shoulders, and is tied round the waist, leaving the chest bare. The eyes were inlaid. The line which looks in front view like a chinstrap resembles in profile that which limits Yarimlim's beard [284–6]. The tall Syrian felt cap,[60] the dress, and the bare feet distinguish this figure from the Anatolian bronzes [257–9] with which it shares its full round modelling. Similarly dressed figures are common on Syrian seals of the second group,[61] and illustration 297 shows clearly a Syrian, not a Hittite work. It probably represents a prince; for a king of Alalakh had himself depicted on his cylinder seal in the same attire.[62]

The statuette of illustration 298 would be a fitting partner to the one we have just discussed. The modelling of the face is full, as in Hittite bronzes, but it was found at Ras Shamra, and is supposed to be somewhat older. It is usual to

297. Figurine, from Mishrife. Bronze.
Paris, Louvre

298. Figurine, from Ras Shamra. Bronze.
Paris, Louvre

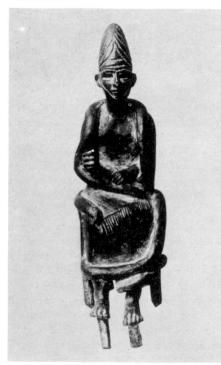

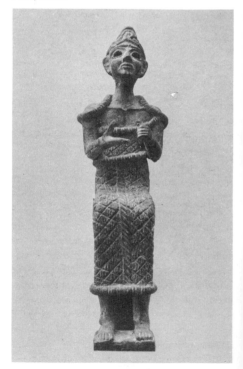

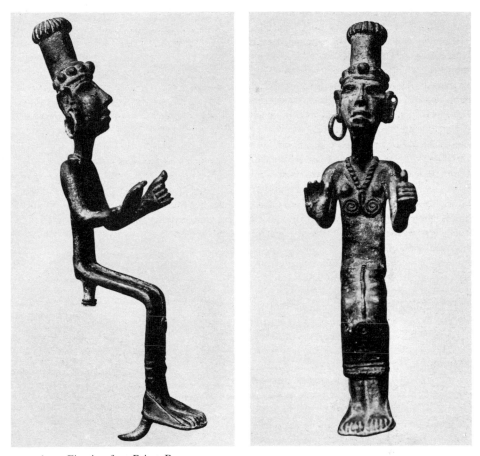

299 and 300. Figurine, from Beirut. Bronze.
Paris, Louvre

describe such figures as 'goddesses', but there is no evidence that this is correct. In our figure the headdress is a kind of turban, without horns or other divine attributes, and the dress may consist of a shawl with a thickened edge, but it is not clearly draped. It seems that a cord passing across the throat holds it in place on the shoulders, leaving the breasts bare. One hand is held out, the other may have grasped a flower, sceptre, or other attribute. It is odd that the figure is very well modelled in part only. It is not only flat at the back, but the body consists simply of a flat strip of metal bent at the hips and knees, as in illustrations 299 and 300. This is a common trait of Syrian bronzes of the fourteenth to the twelfth century B.C. We cannot say whether the figurine represents a queen or a deity, but illustrations 299 and 300 may well represent a goddess; the gesture, the headdress, and perhaps even the breast ornament[63] suggest it. There were two gold earrings, of which one is lost.

While the date of many figures in the round remains uncertain, there are two well dated gold bowls from Ras Shamra which belong to the Mitannian era. This is not only suggested by the stratification, but also by the design of one of them [296], which shows in its artificial plants, for instance, close affinities to decorative elements used in the tunic and other equipment of Tutankhamen.[64] It is an excellent example of Phoenician syncretism, half a millennium before Phoenicians in the proper sense are known. The flying leap of the lions, and perhaps also the plants growing from the upper edge of the outer band of design, are ultimately of Cretan derivation, although they may, at this time, have reached the Syrian engraver through Egyptian intermediaries. The little beardless figures attacking the lion (left-hand bottom) are Egyptian in character, but their action can only be matched on Mesopotamian seals and textiles. The squatting griffin and the winged bull are likewise Asiatic in origin – but all this is of little importance in view of the characteristic combination of motifs, which is Syro-Phoenician. The blemishes of the design are equally characteristic – the carelessness with which a fifth goat is added to the central pattern, while a plant is omitted so that the emphasis and clarity called for at this point are destroyed. The next strip, too, is without equilibrium; the lions and bulls are placed in such a manner that the first seem to pursue the latter, although the interposed plants indicate that a static – and hence symmetrical – design was intended. Nevertheless, the general impression of the bowl is rich and lively. The execution is unusually careful; the outlines of the animals are reinforced by rows of dots or hatching. The spirited drawing of the lions, goats, and bulls contrasts sharply with the three bleak monsters in which the draughtsman was obviously not interested.

The bowl finds a very close parallel in a piece of engraved bronze from Tyre [301]. It was originally nailed on a wooden, or sewn on a

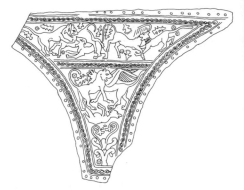

301. Engraved foil, from Tyre. Bronze

302. Dish, from Ras Shamra. Gold.
Paris, Louvre

leather object. The figured parts are framed by a guilloche instead of the running spirals used in the bowl, but the same plant designs fill the spaces above and below the fighting animals. The main group consists of a lion and a winged and crested griffin interlocked in fight. The disputed prey is the carcass of a goat.

The second gold vessel from Ras Shamra [302] is a flat-bottomed plate with a vertical rim. Its decoration differs completely both in subject

and in style from its companion. The decoration of the bowl [296] is essentially an engraving, even though the figures are cursorily embossed. The figures of the plate are, on the contrary, properly modelled in relief, and only minor details – on the ribs, ears, and muzzle, for instance, of the charging bull – are added with the graver. The decoration of the bowl is exuberant and playful; it cannot be said to have a subject at all.[65] But the designer of the plate has attempted to adapt a knightly subject to the circular surface. The centre alone bears a purely ornamental design of four wild goats, which resemble unicorns because their horns were forced out of place by the central circle. Round this decorative centrepiece whirls a chase. The hunter in his chariot is shown at the moment when he overtakes the game and has tied the reins round his waist in order to free both hands for the drawing of the bow. The game consists of a herd of wild cattle. The animal bringing up the rear is a bull, then follows a cow accompanied by her calf, then again a bull. Since this last figure closes the circle of design, it appears to pursue the hunter. The draughtsman has made a virtue of necessity by showing it lowering its head for a charge. But if this threat to the chariot were taken seriously – as has been done[66] – the hunter would be depicted on the verge of violent death, tipped out of the light vehicle, and dragged over the stony desert by his rushing team. However,

if we compare the plate with another rendering of this subject, which is not arranged within a circle, the influence of the round surface becomes clear. On the side of an ivory gaming board found at Enkomi in Cyprus [303] the disposition of the figures makes sense. Here, too, a charging bull appears; it is a wounded animal which turns to attack its tormentors, but it may be circumvented.

If we do not force a realistic interpretation on to the decoration of the gold plate, we must admit that the transposition of the conventional knightly theme to a circle is cleverly managed, even though its mechanics are transparent: the chariot and the three head of cattle form a square round the central design. A wild goat, in headlong flight, fills the outer space, somewhat clumsily, on one side; a hunting dog on the other side serves the same purpose.[67] One more small animal may have filled the space in front and above the cow where the surface is lost.

The Ras Shamra plate gives us the earliest Syrian version of a theme found throughout the ancient Near East in the second and first millennia B.C. The knowledge of the horse-drawn chariot spread with the migrations of the Hyksos Period and seems connected with the Indo-European-speaking people which were part of the migrating hordes. But the origin of the actual device has nothing to do with its rendering in art, as is often erroneously assumed.[68]

303. Gaming board, from Enkomi. Ivory

Sooner or later, but independently, each country introduced the new invention into its artistic repertoire. The Egyptians[69] and the Mycenaeans were the first to do so, in the fifteenth century B.C. But the question of priority is meaningless, where the views taken of the subject differ so completely. The Assyrian saw in the horse as a rule a labouring draught-animal [182]; the Egyptians a noble creature, prancing, with curved neck and hollow back; the Mycenaeans a miracle of fleetness hardly touching the soil.[70] The Ras Shamra plate does not conform to any of these renderings. It is less realistic than the Assyrian, but more than the Egyptian.

Notwithstanding the individual treatment of the chariot hunt in each country, it is still a traditional theme. This is best shown by the fact that the rules of the game are everywhere the same. On the flat Syrian desert one could almost everywhere let go of the reins to take aim. In Egypt – let alone at Ras Shamra – there were but few stretches of ground where this was possible. The realistic Assyrians – but also the Mycenaeans – put a charioteer in charge of the course beside the hunter. The Egyptians, and many Levantines, show themselves adhering to the proper rules, for the chariot hunt had a social, a symbolical significance. Introduced by the Mitanni, it was a knightly sport, the prerogative of kings and nobles. Its wide distribution through the ancient world illustrates well the cosmopolitan character of the Mitannian era – cosmopolitan in that intercourse between countries was easy and stimulating, yet national individuality was everywhere preserved.

THE HITTITE AND RAMESSID ERA (1360–1150 B.C.)

The prosperity of the period we have just discussed rested upon the stability which the Mitannian kingdom had brought to north Syria. The Hittites were confined to Asia Minor. With Egypt – after initial conflict – relations were friendly. From about 1450 B.C. the alliance was sealed by the entrance of Mitannian princesses into the households of successive Pharaohs. The combined powers were unassailable. Under Amenhotep III (1405–1370 B.C.) no Syrian expeditions – not even military displays – were deemed necessary. Under his son Akhenaten a false sense of security led to disaster. Dushratta of Mitanni provoked the Hittites by advancing towards the Taurus; when they struck Akhenaten did not act. He was absorbed in his religious reforms, which imposed a solar monotheism upon an unwilling people, and he gave little attention to Asiatic developments.

At first the prestige of Egypt induced caution. Mitanni was destroyed, the country as far south as Aleppo and Alalakh occupied, yet the Hittites avoided a direct conflict with Egypt. But they fostered intrigues and terrorism among the Egyptian vassals who, in the absence of support, increasingly transferred their allegiance.[71] About 1360 B.C. the great Hittite king Suppiluliumas marched south. In campaigns extended through five years he subjugated the whole of Syria.

Egypt could not attempt to regain her position in Asia before internal order had been restored. Akhenaten's second successor, Tutankhamen, abolished the religious reform; two reigns later Seti I (1318–1298 B.C.) initiated the reconquest of Palestine and Syria, and a new equilibrium was established when his son Ramses II (1298–1232 B.C.) concluded in 1273 B.C. a peace treaty with the Hittite king Hattusilis, in which he abandoned his claims to the regions north of the Lebanon. Henceforth the art of Palestine and southern Syria was dominated by Egypt, but a corresponding Hittite influence in the north cannot be observed. For Hittite art was feeble outside the capital and without tradition. The north Syrians continued to work in the hybrid styles established in the Mitannian era. But the Aegean element in these styles became stronger than it

had ever been. During the thirteenth century B.C. Aegeans were everywhere along the coasts of Anatolia and the Levant; the tombs found at Minet el Beida, the port of Ras Shamra, are almost as strongly Mycenaean (Late Helladic III) in character as those of Rhodes or Cyprus.

Once again the ivory carvings reflect most clearly the mingling influences. We have cited them before, for the same purpose (p. 236 above), and it is a mere accident that the examples from the Mitannian era are fewer and smaller than those we can now describe. For Syria had for a long time been the main source of ivory outside Egypt.[72] Thutmosis III in the fifteenth century hunted elephants near the Euphrates and killed a hundred and twenty, which shows that there were large herds.[73] Tiglathpileser I of Assyria hunted them about 1110 B.C., but already in the palace of Yarimlim, seven centuries earlier, tusks had been stored,[74] and tusks were also found in the tomb of Ahiram of Byblos.[75]

Ivory was used for ornaments; for toilet articles such as combs, small containers, mirror handles, pins; and also for inlays in furniture. It so happens that we know a large group of ivories made between 1350 and 1150 B.C., and another group, to be discussed later, of the ninth and eighth centuries B.C. In both cases the similarities between pieces from different sites are so close that they must be viewed as products of a single school of carvers with several branches. We cannot yet distinguish between these, nor do we know whether they were bound to certain localities or whether craftsmen carrying the ivory travelled from place to place selling set pieces or carving to commission.

The hallmark of the school of the fourteenth and thirteenth centuries is the crested griffin [304], best known from Crete, where it appears (as in a single instance in Egypt) at the end of the Hyksos Period. It almost certainly reached both regions from Syria during the great migrations of the late eighteenth century B.C., which broke through all frontiers.[76] It is common on Syrian cylinder seals in use during that period,[77] and it was prominent in Mitannian and Middle and Late Assyrian art [150, 187]. On some Mitannian cylinders, in the fresco of the 'throne room' in the Palace of Minos at Knossos, and on a beautiful ivory plaque from Megiddo [304] the griffin is at rest, the embodiment of a mysterious power, perhaps a personification of Death.[78] But in the post-Mitannian, Mycenaean

304. Griffin, from Megiddo. Ivory inlay.
University of Chicago, Oriental Institute

period, and also in Assyria, its destructive power (always implied by the leonine members) is especially emphasized. It hunts with lions or attacks lions, as on the bronze foil from Tyre [301], or on an ivory from Byblos [305], where

305. Ivory inlay, from Byblos.
Paris, Louvre

306. Mirror handle, from Enkomi.
London, British Museum

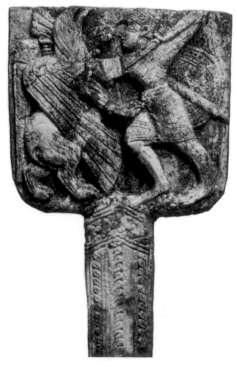

it mauls a bull which is also attacked by a lion from the rear. This piece belongs to the beginning of the thirteenth century B.C. On a splendid ivory box found at Athens two griffins are shown slaughtering deer.[79] On a mirror handle from Enkomi in Cyprus [306], which belongs to the beginning of the twelfth century, a prehellenic Theseus, his shield slung on his back, drives his sword into the monster's breast. All these works are related to one another; they are modelled in the round, not engraved.[80] They are remarkably forceful and imaginative. The collapse of the dying griffin in illustration 306 is not more strikingly rendered than the eerie, dreamlike, yet compelling power of the vision of illustration 304.

I confess to an inclination to see in such vivid renderings of imagined creatures a sign of Aegean influence. Mesopotamian equivalents are either much older – Early Dynastic or Akkadian – or roughly contemporary, namely Middle Assyrian. The characteristically Syrian treatment of these themes is illustrated by the bowl from Ras Shamra [296], where the sphinx and the winged bull look dispirited and the squatting griffin dazed, while the real animals are full of life.[81]

It is, in any case, impossible to separate clearly the Asiatic and Aegean strains among the carvings in ivory. The ivory gaming-board of illustration 303 from Enkomi, in Cyprus, shows, on the two long sides, hunting scenes which are predominantly Asiatic. The game in its headlong flight, and the galloping horses, do not conform to the Mycenaean pattern, but rather to the Syrian one which had been evolved in preceding centuries under Aegean influence. They find parallels on a number of cylinder seals.[82] The attitude of the charioteer, the bird above the horses, the attendant following the chariot on foot, and the headdress which distinguishes him, are all Syrian, not Aegean – truly Levantine, in fact. But one short side of the gaming board shows wild cattle resting under

trees.[83] The general character of the designs, the long horns, wrinkled dewlaps, and free poses of the animals, are entirely Aegean and without Asiatic parallels.

This mixture of affinities is by no means confined to Cyprus, but is found throughout the Levant at this time. The port of Ras Shamra contained tombs with a quantity of 'Mycenaean' grave goods. But a study of the proper names[84] shows a predominance of Semitic with a strong admixture of Hurrian and some Kassite, and even Anatolian forms. The texts are written in a Semitic tongue closely related to Hebrew and Phoenician, but using an alphabet developed from Babylonian cuneiform writing. In the town, in its port, and in the surrounding countryside the population was mixed.

From a tomb in the port at Minet el Beida comes the lid of a round ivory box [307],[85] dated by the objects found with it to the first half of the thirteenth century B.C. The chief figure is Creto-Mycenaean in face and dress, but not in the manner of carving nor in its setting. It is clear that the carver aimed at rendering the Great Goddess of the Aegean. Her bare torso, flounced skirt, coiffure, and cap tally with the Aegean prototypes, and the profile, too, agrees well with the fine spiritual faces of the best Aegean paintings. But her action conforms with Asiatic, not Aegean, conceptions of the goddess. She holds some greenery on which two wild goats feed. Such an explicit statement that the goddess is a personification of the vital force of nature can be found in Mesopotamian art from

307. Lid of a box, from Minet el Beida. Ivory. *Paris, Louvre*

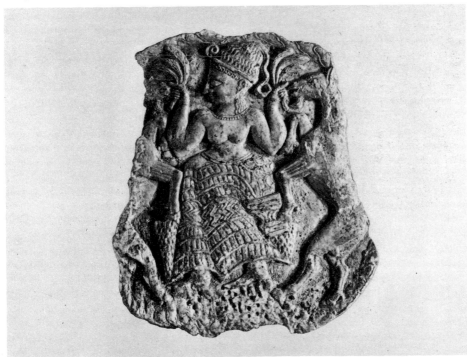

Protoliterate times onwards. But in Cretan and Mycenaean art the goddess is not shown 'feeding' the animals which attend her.[86] In the rendering of the lower part the Levantine carver has been at a loss how to proceed. One might think that the goddess is standing, but the intention was to show her seated on an hourglass-shaped stool which is set on a mountain, rendered by dots; the goats place their forefeet likewise on this mountain, and it reappears once more below the feet of the Great Mother. Now we have seen that in Asia 'the mountain' symbolizes the field of action of the gods of fertility. In the Aegean it is but one of the settings in which the gods become manifest, and they are never enthroned upon a mountain. Their appearance is rendered as a flashing epiphany, sometimes on a mountain-top, sometimes in the air. Nor does the goddess ever sit upon the hourglass-shaped object, which, in the Aegean, is an altar.

This confusion of motifs is matched by an odd rendering of the pose. A seated figure in Aegean art is rendered broadly and with a clear articulation of its limbs, not with the ambiguity of our illustration 307. But it follows from what we have said that the actual scene shown there had no Aegean prototype. It was the carver's task to combine the Great Goddess of the Aegean with the animals she was to feed and with the mountain which was to support her, in order to render an Asiatic conception. Even his pattern for the figure of the goddess can hardly have been an Aegean carving, for the pendulous breasts, the bulbous musculature of the arms, and the flat treatment of the flounced skirt are unlike Aegean work of the period.[87]

Hittite influence, in contrast with that of Egypt and the Aegean, was not assimilated by the ivory carvers. They treat Hittite themes as alien subjects which do not lose any of their native character in the process. Thus the Hittite 'Royal Sign' appears in ivory at Alalakh, and in bronze at Ras Shamra, as we have seen.[88] An elaborately carved panel [274] was found at Megiddo as part of a group of ivories, and has been treated by us simply as an example of Hittite art, even though it may have been made in Syria,[89] for the butting bulls at the bottom of the design recur on Syrian cylinders and on an ivory box[90] found at Lachish in Palestine.[91]

The Hittite plaque, which served presumably as an inlay on the side or lid of a casket, antedates the majority of pieces found at Megiddo. These comprised an ivory pen-case inscribed with the name of Ramses III (1198–1165 B.C.), but the bulk of the hoard probably dates from the thirteenth century, like the ivory from Byblos [305], while a few pieces may belong to the fourteenth. This is very probable in the case of the Hittite piece. If it was intended for a prince of Megiddo, it could only have been during Suppiluliumas' Syrian campaign (1360–1355 B.C.) or shortly afterwards. In the last quarter of the century, when Seti I was reestablishing Egyptian hegemony in Palestine, a plaque exalting a Hittite king would have compromised its owner. It is possible that the object was made for a northern potentate and was brought to Megiddo as booty, but this would also date it before the peace treaty of Ramses II and Hattusilis was concluded.

A number of ivories found at Megiddo show themes in common use throughout the Levant. There are some figures and faces of women modelled in the round. Some served as handles of spoons, the bowl of which they hold on their outstretched arms; the device is Egyptian in origin. Others decorated furniture, for instance illustration 308, of which only the back is preserved. This shows the quality of the modelling at its best. The flat cap is decorated with hanging lotus flowers and lotus buds. It recurs in illustration 316, and also in the horn-shaped object of illustration 309, probably a container for cosmetics.[92] Here the eyes are inlaid with glass.

A large number of ivories show engraved designs. A box lid,[93] for instance, shows a rosette

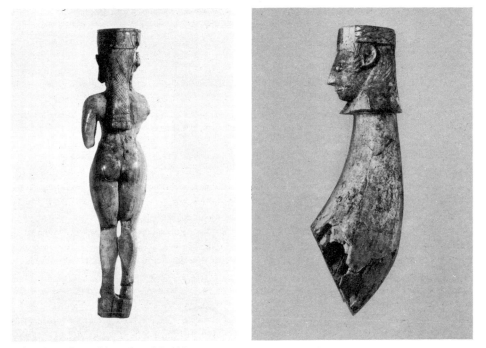

308 and 309. Ivory objects, from Megiddo.
University of Chicago, Oriental Institute

surrounded by goats, as we see in illustration 296. But at Megiddo the goats are drawn half-kneeling, an attitude which is effective as decoration but impossible in nature, and occurs also in Assyrian art.[94] Another peculiar design appears on a comb [310]. The dog which attacks the ibex seems to have passed its paw underneath it. This would be a natural gesture for a feline, which would pull its prey towards it with its claws, and the lion in the jasper group of illustration 321 is, in fact, doing precisely this. The maker of the comb probably worked after a prototype with a lion; the jasper group also shows that the curious intertwining of the animals on the comb is meant to suggest that they roll on the ground in a last struggle.

310. Comb, from Megiddo. Ivory

311. Bes, from Megiddo. Ivory inlay.
Jerusalem, Palestine Archaeological Museum

312. Sphinx, from Megiddo. Ivory inlay.
University of Chicago, Oriental Institute

There are a number of ivories found at Megiddo which show distinct Egyptian influence. This is clearest in some openwork panels, presumably for a casket [311, 312]. One shows the monstrous Bes, a dancing dwarf, demon rather than god, a spirit of pleasure, used in Egypt to decorate dadoes in banqueting halls or bedrooms and beds. At Tell el Amarna necklaces were worn consisting of a series of blue glazed pendants showing Bes beating a tambourine. But in Egypt Bes was almost always wingless.

The question as to what liberties the Asiatic carvers took with Egyptian themes becomes peculiarly difficult to answer when we look at the other openwork panels. One shows Anubis,

the Egyptian god of the necropolis, as a wolf-headed man, in the same attitude as Bes and with a long sash round his waist. Until recently this seemed quite out of keeping with Egyptian iconography, but it has lately been found on a head-rest of the Nineteenth Dynasty (thirteenth century).[95] The other panel [312] shows a sphinx, or rather a piece of sculpture in the shape of a sphinx. This is proved by the lines drawn underneath the monster; they render in the normal Egyptian convention a reed mat or tray on which such objects were placed, and which would be meaningless if the creature itself were depicted. Sculpture of this type was offered sometimes as New Year's gifts to the sovereign[96] or placed in temples where the sphinx (which represents the king in his superhuman power) offered to the gods the objects he holds in his hands. In the model followed by our ivory the object was a vase with costly ointment or incense covered by a tall lid rendering the two cartouches with Pharaoh's names. But the ivory differs in two respects from the usual sphinxes of Egypt: it does not wear the royal crown, but a fantastic headdress with plant ornaments; and it has the body of a lioness, while the Egyptian sphinxes are male.

The strange sphinx of our ivory occurs a few times in Egypt, in the Nineteenth to Twentieth Dynasty, but has always been regarded as a Syrian figure copied in Egypt.[97] It occurs among Syrian tribute offered to Seti I;[98] and it wears almost always a round medallion which is common among Syrian jewellery, but not in Egypt.[99]

On the other hand, it occurs in Egypt in a carved gem of brown sard made for Amenhotep III[100] much earlier than any of the Asiatic instances. It may well be that the hybrid creature with its fantastic accoutrements came from Syria and was introduced at the court in the second half of the fifteenth century with the Mitannian princesses and their suites. It is known sometimes to represent the queen,[101] and at a time when queens like Ty, the consort of Amenhotep III, took an altogether unprecedented place in the official monuments, our female sphinx may have been invented as a counterpart to the male sphinx rendering Pharaoh. However this may be, the Megiddo panel cannot be quoted in support of the Syrian origin of the creature, for such details as the vase it holds and the mat upon which it rests prove that it follows an Egyptian prototype as closely as the Bes and Anubis panels. In view of its possible introduction in Egypt in the Amarna Period, it is possible that the Megiddo ivory belongs to the fourteenth century.[102]

In illustration 313 an Egyptian theme is treated more freely. The object was probably part of a piece of furniture – perhaps the support of an arm-rest. On three sides it shows a traditional theme – herbivores and lions – but at the right-hand top we meet the kneeling bowman from Alaja Hüyük who is also common on Middle Assyrian seals and on Syro-Hittite reliefs of the first millennium. Some calves or fawns show the 'folded poses' characteristic of the Aegean animal style[103] and other vivid

313. Two sides of a carved rod, from Megiddo. Ivory

attitudes. The fourth side has three figures one above the other. The outer ones are beardless, and therefore gods rather than princes, wearing the tall felt cap and a horned crown respectively.[104] The middle figure is a travesty of Pharaoh, or of Osiris, who wears the Atef crown with the royal cobra, and the shepherd's crook, which was an ancient attribute of Egyptian royalty.

But secular subjects too were rendered in a manner derived from Egypt. Four narrow strips of ivory, with dovetailed ends, which went round a shallow box or the top of a small table or stool, show scenes of which we reproduce two [314, 315]. In the chariot battle the horses throw up their forelegs according to the Egyptian convention, and in another piece a tame lion is shown trotting along with the ruler's

tions of Egyptian battle and hunting scenes. A second piece shows the orderly march of chariots and infantry,[106] a third the conveyance of provisions[107] for the feast depicted in illustration 315. This would seem to be a celebration of the victory, as it is in illustration 316. The furniture illustrated in this scene is purely Asiatic – one tends, anachronistically, to say: Assyrian [cf. 217] – but no such scene had been rendered in Mesopotamian art since Early Dynastic times. One wonders whether the feasts depicted in Egyptian tombs supplied the prototype, especially since the attendant who stands comfortably with his arms crossed while he talks to two of the guests recalls figures from the Memphite tomb of Horemheb.[108] The lotus held by the ruler is an affectation of Egyptian culture.

314 and 315. Chariot battle and feast on ivory inlay, from Megiddo

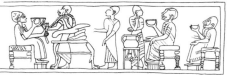

chariot, as it does in some representations of Pharaoh.[105] Yet the charioteers, unlike those depicted in either Egypt or Mesopotamia, do not stand upright, but bend forward, riding their light vehicles like jockeys standing in the stirrups. The sprawling figures of the slain, at right angles to the chariots, again recall the conven-

The engraved inlay of illustration 316 shows even more clearly how Egyptian formulas influenced the art of the Levant. On the right the prince returns from the war, with two naked captives bound to the head-stalls of his horses. They are preceded by one of his warriors. The king is protected by a design which is confused

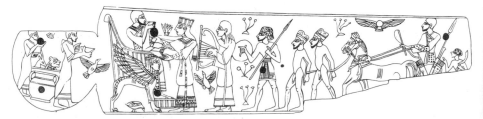

316. Victorious homecoming and feast on ivory inlay, from Megiddo

in a characteristically Levantine manner, but which has certainly an Egyptian prototype, be it Mut-vulture, Horus-falcon, or winged sun-disk. The drawing of small plants all over the field also recalls Egyptian usage. To the left the prince sits on an elaborate sphinx-throne – unknown in Egypt – and accepts a lotus and a long fringed towel from a lady in Syrian headdress [cf. 308, 309]. She is followed by a lute-player, while behind the throne two butlers are busy near a large mixing-vessel and a serving-table with two cups or rhyta in the shape of animal heads. These are known throughout the Near East – in Anatolia, Cyprus, Crete, and elsewhere – and appear regularly among the tribute brought to Egypt by the people of these regions as depicted in Theban tombs.[109] The birds remain unexplained and have no parallels in the Egyptian renderings of feasts. They seem a fortuitous addition of the engraver. The freer treatment of Egyptian themes might point to a fourteenth-century date, for in Ramessid times Egyptian motifs seem to have been more slavishly imitated.[110]

The engraving from Megiddo in illustration 316 is obviously related to the stone sarcophagus of illustration 317. This was found in a tomb at

Byblos, together with fragments of a vase inscribed with the name of Ramses II and the ivory plaque of illustration 305. At a later date the tomb was re-used for the interment of a local ruler called Ahiram, as an inscription engraved on the edge of the coffin lid tells us. Palaeographers are much concerned with the exact date of the inscription, but this problem we can ignore since the inscription is a later addition.[111]

The thirteenth-century ruler for whom the coffin was carved is shown on a throne closely resembling that of illustration 316. The table on which his food is placed recalls our illustration 315. But on the sarcophagus there are no subsidiary subjects. The ruler, holding a lotus and a cup, confronts a procession of men lifting their hands in worship or bringing him food and drink. The other long side of the sarcophagus shows the end of that procession, but the short sides of the sarcophagus are decorated with wailing women, tearing their hair and beating their bare breasts. There is little doubt, therefore, that we have here a scene in which sustenance is brought to a dead ruler, a funerary feast according to Egyptian conceptions[112] which we had not hitherto thought to have anything in common with Asiatic beliefs. It is, in fact, more

317. Ahiram's sarcophagus, from Byblos

likely that the decoration of the sarcophagus proves no more than that common usages – the offering of food to the dead, the wailing at the funeral – were in this case rendered in Egyptian fashion. But later we shall find other evidence to prove that Syrian funerary customs differed from those of Mesopotamia and Palestine. The border above the scenes is decorated with alternating lotus buds and flowers, as in the cap of the girl in illustration 308, a design likewise of Egyptian derivation. Un-Egyptian are the four supports of the sarcophagus, shaped as lions, and a similar shape is given to the two projecting knobs which allowed the lid to be put into place [318]. These lions, crudely carved like the whole of the sarcophagus, seem to anticipate Syro-Hittite sculpture of the eighth century

318. Cover of Ahiram's sarcophagus

B.C., but the resemblance is merely due to an unskilled rendering of a common subject. The obvious features are stressed. We have another instance of this style in Alalakh at about the same period [319, 320]. They flanked the entrance of a building which may have been a palace or a temple, presumably the latter. They are roughly blocked out; the squareness of the quarried slab of stone is retained, with sharp edges where front and sides meet. In the side view the disposition of the tail, the drawing of the hind leg and claw, the folding of the foreleg, and the treatment of the mane, show how a vague knowledge of traditional renderings in Mesopotamia and Anatolia served as a starting-point for improvisations which derive such coherence as they possess from the squareness of the block comprising them. A comparison with the lion from Malatya [271] shows how the tradition of Hittite art, short-lived though it was, enabled a provincial craftsman to be much more successful than his Syrian counterpart. It is also interesting to notice that the Egyptian influence, which dominates the sarcophagus at Byblos, is absent at Alalakh, a town in the Hittite sphere of influence.

The sarcophagus and the lions are the most ambitious works in stone of the post-Mitannian period. But excellent sculpture on a smaller scale was still occasionally produced. The finest example is a group of red jasper [321], probably a weight, since the bottom is hollowed to take a lead adjustment – which represents a lion and a bull fighting in an arena (for the lion wears a harness). There is no known contemporary carving of equal merit from Syria or Palestine. Yet, by a process of elimination, it may be tentatively included here. Its place of manufacture is unknown, although it is said to come from Tell el Amarna.[113] It is certainly not of Egyptian workmanship, and there is nothing against assigning it to Mesopotamia, which has an old and continuous tradition of small-scale animal figures, but it so happens that there are

319 and 320. Lions, from Alalakh. Basalt.
Antioch Museum

321. Weight in the shape of a lion mauling a bull,
from Tell el Amarna (?). Red jasper. *London, British Museum*

no Kassite or Middle Assyrian works even re-
motely resembling this group. Moreover, the
very broad face of the lion and the treatment of
its mane have no Mesopotamian parallels. The
only positive indication of affinity is the resem-
blance to the pose of the animals on the comb of
illustration 310, which is derivative, since it
depicts the dog using its paws as a member of
the cat family would use them. The jasper group
of the desperately interlocked animals may then
be assigned to some Syrian or Palestinian centre

322. Figure, from Megiddo. Bronze covered with
gold foil. *University of Chicago, Oriental Institute*

within the ken of the Levantine ivory carvers,
whose exact locality also remains unknown.

In the post-Mitannian period metalwork does
not seem to have reached the excellence of
earlier times. Many statuettes of deities were
cast, mostly of weather-gods brandishing a wea-
pon which symbolizes lightning, as in illu-
stration 294. They sometimes wear the 'White
Crown' of Egypt and are conventionally called
Reshef, Adad, or Baal, but their names no doubt
differed from one place to another. They are
dull, conventional works, which are not im-
proved by the gold foil with which they are
sometimes covered [322]. Assuming again (p.
270 above) that the personage wears the high
felt cap without horns, we may see in him a ruler
of Megiddo.

Modelling also found scope in the production
of faience vessels. This material retained the
popularity enjoyed in Mitannian times, and was
used for lotus cups, circular boxes with flat lids,
and other containers. Some goblets, however,
are modelled in the shape of a woman's head
[323] and have tubular lugs for suspension; or a
woman's face is applied in relief to the side of
the cup [324, 325]. They are found at Ur,[114]
Assur,[115] Mari,[116] Ras Shamra,[117] Tell Abu
Hawwam,[118] Enkomi,[119] and in Rhodes.[120] The
two types exist side by side, and they can be
roughly dated to about 1300 B.C. It is difficult
to believe that the cups were made locally in
all these places; for they resemble each other
very closely. Yet the cups are rather fragile
for distribution by trade. Since faience was
made throughout the region, the goblets may
have been produced locally after models distri-
buted from a single centre, perhaps a shrine. For
there can be little doubt that they had some
religious meaning; at Ras Shamra and in
Cyprus the cups were found in graves; in Mari
small faience masks of beardless faces, which
may be male or female, were also found in
graves, attached to the body.[121] It is perhaps due
to our limited knowledge of Syrian religions

323 and 324. Cups, from Cyprus. Faience.
London, British Museum

325. Cup, from Ras Shamra.
Paris, Louvre

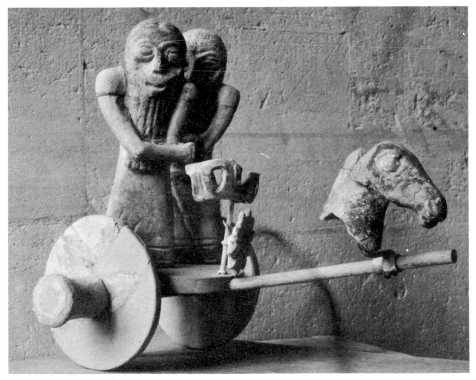

326. Chariot, from Ras Shamra.
Paris, Louvre

that one thinks of the mother goddess and her son, Adonis, whose fate might have served as a prototype of man's resurrection. This is a mere guess, since there are no texts to support the interpretation, only the occurrence of these faience objects in graves. The faience fragments [326] found at Ras Shamra and ingeniously reconstructed as a chariot with two occupants are figured here to show that complicated groups were built up in faience.

So far we have not spoken of the architectural setting in which these various objects were found. But the known buildings of the Mitannian and post-Mitannian period do not show the purposeful disposition which concerns a historian of art. The irregular, ill-built, and badly preserved buildings at Ras Shamra, Byblos, Jericho, Beisan, Lachish, and Megiddo, which are called 'temples', sometimes on very little evidence (the alternative hypothesis is 'palace'), do not allow one to recapture the builder's intention or the manner in which he solved a recognizable problem. There are only two exceptions to this generalization: the family vaults built of hewn stone underneath the richest houses at Ras Shamra, and the temples built at Alalakh.

Fourteen family vaults were discovered at Ras Shamra; they differ in detail, but all possess a short entrance passage with descending stair-way and a rectangular funerary chamber with a corbel-vaulted roof.[122] The vaults served as burial places for whole families and were used through many years. Neither the type of structure nor its excellent masonry can be paralleled in the Levant at this time, and the vaults seem a foreign intrusion. They were provided with 'Late Helladic' pottery, and family vaults, not dissimilar in character, were built in Crete and in the Argolid. Although there are differences in detail,[123] it seems best to consider the vaults of Ras Shamra as a product of the Aegean element in the population.

At Alalakh a succession of buildings in mud-brick on rough stone foundations are called temples, without much evidence to show that they were shrines rather than palaces. Their interest lies in the fact that they represent stages in the architectural development which leads from the palace of Yarimlim, via that of Niqmepa, to the *bît-hilani* of north Syrian architecture in the first millennium B.C. (see pp. 247 and 253). We shall not describe here the earliest remains of the building, of Mitannian times, which are too badly preserved to allow a certain restoration.[124] Two phases of the building in the final period, in the thirteenth century B.C., are shown, in reconstruction, in illustrations 327 and 328. Both show the two long rooms with their main axis parallel to the façade; the earlier phase A had

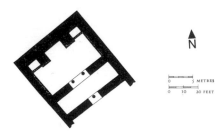

N

0 5 METRES

0 10 20 FEET

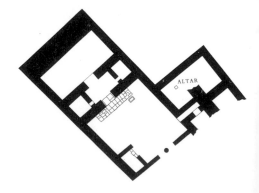

ALTAR

327 *(above)*. Tell Atchana, temple of level IA

328 *(right)*. Tell Atchana, temple of level IB

pillars in both entrances; the later phase B shows the subsidiary rooms next to the entrance room which we know in both the earlier and the later plans to which we have referred. Here, too, belong the sculptured lions of illustrations 319 and 320, which flanked the stone steps leading into the building. They follow a Hittite custom which in its turn had a Mesopotamian origin. The pillared entrance is here moved to the very front of the group and gives access to the forecourt. The features which in the later *bît-hilani* were to have an unchanging place and function are, at this stage, still used experimentally. If these buildings were temples and not palaces, their relevance to the history of the *bît-hilani* would be questionable.

In architecture we can trace a continuity between the second and first millennium in Syria which in most other fields is lost. For the twelfth century was a time of turmoil. All the sites we have mentioned in this section show contemporary layers of ash and charred remains, and they were either deserted entirely or survived in a very reduced form. The rich cosmopolitan civilization of the Levant and the related Mycenaean world is submerged in a dark age which also hides from us the first achievements of the Hellenes. In the ninth century, when some light falls on the Greek development, the new conditions of the Levant also become discernible.

ARAMAEANS AND PHOENICIANS IN SYRIA

NORTH SYRIAN ART (850–650 B.C.)

Introduction

The twelfth century brought disaster to the Levant. Barbarian peoples swarmed into Greece and Asia Minor. The Hittite empire was overrun, its cities pillaged and burned. The populations so affected went in search of new lands and swelled the masses already in process of migration. A horde containing the most divergent elements gathered round Carchemish, and from there advanced on Egypt, the warriors on foot, their women, children, and possessions loaded on ox-carts. Others went along the coast in ships. Ramses III gathered all his forces and succeeded in beating back the migrating masses in a battle in which both his fleet and his army were engaged. The movement of recoil brought the Philistines, Etruscans, and Sardinians to the countries named after them, while the Phrygians occupied central Anatolia and the Dorians Greece. Ramses III also mentions the Danunians among the 'Peoples of the Sea' whom he defeated; they are now known to have lived round Adana in south-western Anatolia during the ninth to seventh centuries B.C. They are probably related to Homer's Danaoi,[1] but the nature of that relationship cannot, as yet, be properly understood.

Direct evidence regarding the migration is confined to the account of Ramses, and this is natural enough, since all other powers in its path were overrun and destroyed. Consequently the actual events in Syria and Anatolia remain obscure. Excavators observe traces of fire and destruction on all the sites mentioned in the two preceding chapters, but the centuries from 1200

to 900 B.C. are truly a dark age, not only in Greece but also in the Levant. Sparse rays of light are shed by the Assyrian inscriptions; for instance, Tiglathpileser I reached and mentioned Malatya just before 1100 B.C.

The Assyrian texts reveal also that Bedouins from the desert – as always in times of disorder – penetrated into the settled lands of Syria. They were, on this occasion, the Aramaeans, speaking a language which was closely akin to Hebrew and Phoenician and destined to become the medium used for trade and other intercourse throughout the Persian empire. But this tongue was not put into writing before 800 B.C., though the people who spoke it began to settle in Syria and southern Mesopotamia soon after 1000 B.C., and acquired actual power in several of the Syrian principalities, as the names of their rulers show. Successive kings of Assyria barred their entry into northern Mesopotamia. The Aramaeans, like the Amorites before them, accepted the established forms of indigenous culture wherever they went, and the Assyrians included them among the 'Hittites' who, they said, inhabited north Syria.

This designation has led to a great deal of confusion in our own time; but it was reasonable enough to the Assyrians. For, in the fourteenth century B.C., when Assyria had established its independence, north Syria had been part of the Hittite empire; hence the designation of the region of Carchemish as 'the land of Hatti' in Late Assyrian texts. This has led modern scholars to interpret Syrian art of the ninth and seventh centuries as a continuation of imperial Hittite art. Demonstrably it is no such

thing, even though in other fields Hittite usages sometimes survived in north Syria. But the very nature of these survivals contrasts with what we observe in architecture and sculpture. At Carchemish, Hama, and Tell Tayanat, as at Malatya (but not at Zinjirli, Sakjegözü, and Tell Halaf), monumental inscriptions continued to be written in Hittite hieroglyphs; Hittite costume was still depicted here and there in the first millennium, especially on women; male figures are sometimes beardless, and gods often retain the Hittite dress and attributes. But in art there are no comparable links with the second millennium. The continued use of hieroglyphs proves the persistence of a specific scribal tradition. The continuity of dress bespeaks the survival of special elements of the population. There is even evidence of a particular continuity of legends at Karatepe.[2] Nothing equally specific is seen in the field of art. On the contrary, as soon as a traditional subject is treated, the difference in rendering is glaring. For instance, we find at the water-gate of Carchemish,[3] as at Malatya [272], a king pouring libations before a god who mounts a chariot drawn by a pair of oxen. A servant behind the king leads a sacrificial beast. We know that Carchemish was never taken by the Aramaeans, and this relief shows that Hittite rites were still performed before Hittite gods in the eighth century B.C. While, however, the style of the Malatya relief [272] is intimately related to that of other imperial Hittite monuments, such as the reliefs at Imamkülü and Yazilikaya, the Carchemish relief shows a clumsier treatment which is independent of the older Anatolian tradition and renders the subject in the style common to the Syrian sites of the first millennium B.C. It remains to find a name for this new style.

In the middle of the second millennium a single power had subjugated north Syria and we could speak of the art of the Mitannian era. In the ninth to seventh centuries B.C. Assyria

dominated the region, but its art cannot be called provincial Assyrian, since it has an un-Assyrian character notwithstanding the strong Assyrian influence which it underwent and which can be recognized in the surviving works. We call it north Syrian art, even though it is well represented on south-east Anatolian sites such as Marash and Malatya, for these in their turn were dependent for their art upon north Syria. If this were not so, if there had been an independent and vital Anatolian art at this time (which we should then have to assume as influencing north Syria), it would be inexplicable that at Karatepe and near Ankara sculptures were made which differed greatly from those of Malatya and Marash; the explanation lies in the diverse foreign stimuli, north Syrian for the last-named sites, Phoenician for Karatepe, Urartian, perhaps, for Ankara. The term north Syrian has the great advantage of avoiding the implications of a single ethnic basis for this art, which was, indeed, lacking.[4]

For north Syrian art of the first millennium B.C. was fostered by a number of princelings of Syrian, Aramaean, and Hittite extraction who wished to emulate the royal setting of the Assyrian kings. They built palaces with guardian figures – lions, bulls, or monsters – at the gates, and orthostats decorated with reliefs. This is true of the regions where Hittite hieroglyphs – and presumably the Indo-European language which they represented – had remained in use[5] as well as of those localities which the Aramaeans ruled. It is not possible to distinguish between the art employed by the two groups, nor is there any sign of artistic activity before the ninth century, the time of Assyrian ascendancy in the Levant. This hegemony was definitely established in the battle of Karkar (853 B.C.), when Shalmaneser III defeated a coalition led by Adadidri (Ben-Hadad) of Damascus and Ahab of Israel. Five years earlier the Aramaic prince of Zinjirli, the Hittite prince of Hama, and several others had been sub-

jected. Many of the princes who offered submission were taken to Assyria and later reinstated as vassals. Meanwhile they had come to know Assyrian ways, not only on the battlefield, but also in the royal capital, and the emergence of north Syrian art was due to their desire to equip themselves – within the limits set to subject princes – with the paraphernalia of royalty. It is significant that Kapara of Guzana (Tell Halaf) and Kilamuva of Sam'al (Zinjirli) commemorated the construction of their palaces with the phrase 'What my fathers did not accomplish I did achieve'.[6] Once it is realized that the whole of north Syrian art of the first millennium B.C. represents a fresh start, made more or less simultaneously – and with the varying resources of local talent – in a number of places, the attempts to fill the gap between 1200 and 850 B.C. with transitional works can be abandoned. The monuments never called for such attempts, which were made in accordance with a preconceived idea of continuity between north Syrian and imperial Hittite art.[7]

It was, then, under the stimulus of Assyrian examples that north Syrian art arose, and it flourished most in the reigns of kings who had come to terms with the Assyrians and were allowed a limited degree of independence and most of its trappings. When, sooner or later, such rulers aspired to effective freedom, they were destroyed, Assyrian military governors took command, and there was no further production of north Syrian art.

The influence of Assyrian art on the Levant can be divided into two phases: a distant influence in the ninth century, and a direct one in the eighth. About 743 B.C. Tiglathpileser III began to consolidate the Assyrian dominion over Syria. He garrisoned important centres and built himself palaces, where he stayed when passing through the region, and which at all times reminded the natives of their overlord and his power. Such palaces have been found at Til Barsip, Arslan Tash, and Tell Tayanat. We

have seen, for instance, that the palace at Til Barsip contained painted friezes closely resembling the sculptured dados of Khorsabad (p. 171). Thus the Syrians became not merely acquainted, but familiar with Assyrian art, since it was on view in their own country. Hence vassals like Barrekub of Zinjirli and his contemporaries at Carchemish and Sakjegözü could surround themselves with derivative splendour. The north Syrian works made before and after the beginning of the reign of Tiglathpileser III are quite distinct. The later sculptures not only render Assyrian themes; they render them in an Assyrian manner. The lions guarding the gates at the Assyrian palace of Arslan Tash[8] find their counterparts at Zinjirli and Sakjegözü [331]. The bull-guardians[9] recur at Carchemish.[10] All these sites have orthostats decorated with rows of striding soldiers or courtiers, which are characteristic of Assyrian art under Tiglathpileser III[11] and Sargon, but are absent in the ninth century and unusual in the seventh. The great battle pieces of the reigns of Sennacherib and Assurbanipal have no counterpart in north Syrian art; for by that time the independent Syrian rulers had been crushed and replaced by Assyrian military governors. Damascus was taken in 732, Samaria in 722, Zinjirli probably, too, about that time,[12] Carchemish in 717, Malatya in 713 B.C. Karatepe alone may have survived until 680 B.C.

I have insisted on these historical facts because they explain why two distinct phases can be observed in north Syrian art. The distinction is one of subject matter rather than style, for the works are too uneven in quality, too crude, and too often incompetent for stylistic criteria to be applied. Nor are the circumstances of the discovery much help for the making of chronological distinctions. Orthostats and guardian figures were often re-used when the building was reconstructed. At Alalakh, and also at the Lion Gate of Malatya, the lions are older than the gate where they were ultimately placed and

found in modern times. The statue of Idrimi was discovered in a temple or palace at Alalakh built two hundred years after the king's lifetime. Thus forewarned we may turn to the north Syrian monuments.

Architecture

The distinctive feature of north Syrian architecture is the planning of the forward section of royal palaces [329]. One enters, at the top of a low flight of steps, a portico with one to three columns which gives access to the throne room. Both portico and throne room have their main axis parallel to the façade. Stairs to the upper storey are set to one side of the portico.[13]

Buildings answering to this description occur at Tell Tayanat [329]; at Zinjirli [330, 333–5]; at Sakjegözü [331];[14] and perhaps at Carchemish.[15] They are not found in Hittite architecture,[16] but have their prototype in north Syria itself. We have described their antecedents in the palace of Niqmepa of Alalakh in the fourteenth century B.C. (illustration 293 and p. 253), which, in its turn, can be explained as a remodelling of an older type of building, represented by Yarim-lim's palace, with a view to achieving a more imposing, a truly palatial, effect. In Niqmepa's

329. Tell Tayanat, palace and temple.
Reconstruction drawing of plan

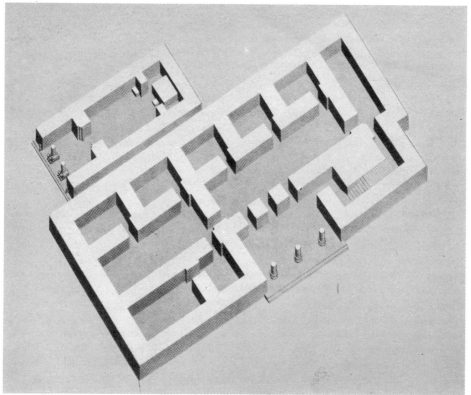

palace we see behind the main room a suite of bedroom, bathroom, and lavatory. The two buildings of the type under discussion [330] form the north-west and north-east sides of the court in the Upper Palace of Zinjirli, and here also we find bathrooms (nos. 5 and 9) on the ground floor, suggesting that the adjoining small rooms were bedrooms. Behind these two buildings there is a long store-room where wine-jars were kept.[17] There is a similar disposition in Niqmepa's palace [293]. Thus the domestic arrangements of the fourteenth century B.C. recur at Zinjirli in the eighth, an observation which corroborates the conclusion suggested

by a study of the plans.[18] We may follow Assyrian usage and call a building constructed in this manner a 'bît-hilani'. The Assyrians, as we have seen, spoke of 'a portico patterned after a Hittite palace which they call a bît-hilani in the Amorite language'.[19] The reference to Amorite – a Semitic north Syrian tongue – reminds us that the Assyrians of the first millennium located the Hittites not in Anatolia, but in north Syria. The Assyrians, moreover, did not use the complete plan, but merely the portico, with double lion bases or other bases and columns, as we see in illustrations 331 and 332. The Assyrian porticoes of this type did not serve as antechamber to

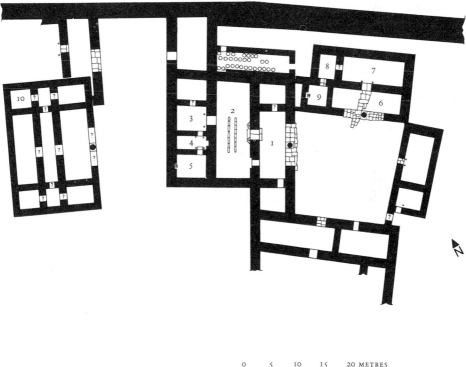

330. Zinjirli, Upper Palace

0 5 10 15 20 METRES

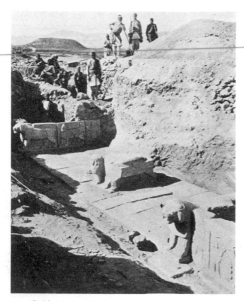

331. Sakjegözü, palace, entrance

332. Column base of temple, from Tell Tayanat.
Antioch Museum

the main apartment, but gave access to a passage, both at Khorsabad in palace F and at Nineveh. In the specific form described above in the first paragraph of this section the *bît-hilani* is peculiar to north Syrian buildings.

This becomes clear when we observe that in Mesopotamia a somewhat similar arrangement prevails. In the Assyrian palaces the 'standard reception suite'[20] consists likewise of two long, narrow rooms with their main axis parallel to the façade and a staircase adjoining the first room. But this last is not here an antechamber, but the most important room, and in palaces the throne room, as is proved by the niche with the throne base before it.[21] There are no pillars here, but there are often three doors. In contrast it is equally certain that in north Syrian buildings the second room was the more important of the two. In the Upper Palace of Zinjirli [330] the portico (6) of one *bît-hilani* is provided with flagstones leading up to the entrance of the second room (7). In the other *bît-hilani* the importance of the second room (2) is demonstrated by the ornamental pivot stones of its doors, on the Assyrian model, and by two stone 'rails' let into the pavement, upon which a movable iron hearth on bronze wheels, a veritable fire wagon, could be conveyed.[22] When, on the other hand, an Assyrian palace was built in Syria, at Arslan Tash [174], the same distinctive features – rails for the hearth and ornamental pivot stones – marked the first room, not the second, as the most important one of the private apartments.[23] The differences between the Assyrian and north Syrian plans are, therefore, at least as important as the common features. They can hardly go back to a common prototype, since the differentiation already existed at the beginning of the second millennium B.C. The Assyrian plan came into being long before Assyria became independent. It occurs at Tell Asmar [114], and was probably basic to the arrangements at Mari. At that time, however, there existed in the palace of Yarimlim of Alalakh [283] a local north Syrian ancestor of the *bît-hilani* unrelated to the Mesopotamian palaces.

In building technique, too, the north Syrian *bît-hilani* is based on local custom. The extravagant use of timber which we observed at Alalakh

(p. 253 above) recurs at Tell Halaf,[24] at Tell Tayanat,[25] and at Zinjirli [333]. The treatment of stone, however, has changed; it is frequently

A third type of sculpture is represented by guardians of the gates, mostly lions, sometimes monsters. It has a local antecedent at Alalakh

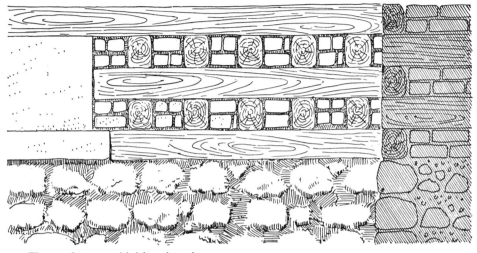

333. The use of stone, mud-brick, and wood

carved, in the round or in relief. In the first place, the wooden pillars of the portico are often supported by a pair of animals or monsters [331, 332]. Lion bases have been found at Boghazköy,[26] but it is not certain that they supported columns rather than statues, and, in any case, the double animal base seems to be a Syrian invention. In the second place, the orthostats are often decorated. There is a precedent for this in the second millennium, not at Boghazköy, but at Alaja Hüyük and Malatya (pp. 231 and 234 above), and a stone with the relief figure of a Hittite king was found at Alalakh.[27] The Assyrians developed the sculptured dado as an outstanding feature of their royal palaces, and it is perhaps reasonable to derive its use in north Syria in the ninth and eighth centuries B.C. from Assyria rather than Anatolia, although such sculptures had existed there in palaces ruined by the great migrations of the twelfth century.

[319, 320] in the second millennium, and since the chances that imperial Hittite usage was copied there are great, it would be possible to claim for the gate figures of the north Syrian cities an ultimate Hittite origin. But it is equally possible to maintain that here, too, north Syrian architecture followed an Assyrian example.

The most complete remaining specimen of a north Syrian town is Zinjirli, ancient Sam'al [334].[28] It is roughly circular, surrounded by a double wall with towers, and accessible through three gates, of which the southern, especially fortified, leads to the citadel. The gate of the citadel (A) is set between towers and decorated with sculptured orthostats [335]. Two lions protect the outer, two bulls the inner gate.[29] An enemy having forced the entry would still be confined within a limited space by an inner wall, built at a higher level. When approaching its gate the aggressor had to turn to the left, thereby

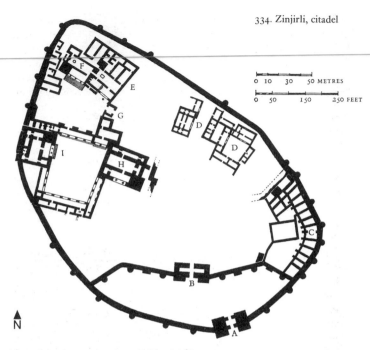

334. Zinjirli, citadel

forgoing the protection of his shield and exposing to the missiles of the defenders his body and the right arm which bore the weapons. In peace-time the gates of town or citadel played the important role which the market-place fulfilled in the Greek cities. The council of elders sat at the gate (Deuteronomy xxii, 5); it was a meeting place of notables (II Samuel iii, 27); business was carried on there (II Kings vii, 1). During the rebellion of Absalom, King David 'sat between the two gates', that is, in the transverse room between the inner and outer gate in

335. Zinjirli, citadel, southern gate

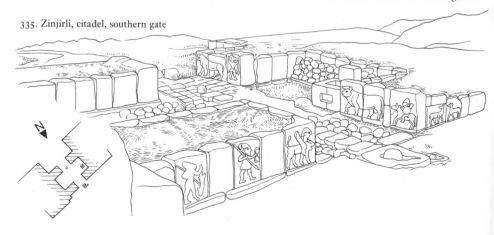

illustration 335 (II Samuel xviii, 24). At the report of his son's death 'he went up to the chamber over the gate and wept' (ibid., 33), but later 'he arose and sat in the gate . . . and all the people came before the king' (II Samuel xix, 8). And when Esarhaddon returned victorious from Egypt in 670 B.C., he had a stele erected in the gate of Zinjirli; its trough-shaped base appears in illustration 335, on the right, between inner and outer gate.

Inside the inner wall the citadel [334] rose to its highest point at D. Here a large *bît-hilani* had been built, but it was later replaced by the building shown in the plan which renders the final lay-out of the town. The building at D probably served as residence to the Assyrian governor under Esarhaddon of Assyria (680–669 B.C.), but it was certainly older and built by a ruler of Sam'al,[30] and its plan is not Assyrian at all; for both the north-west and the north-east side of the main court consist of a *bît-hilani*.[31] Both contain paved bathrooms [330] with drains for waste water, and the adjoining small rooms are probably bedrooms (3 and 8, see p. 283). The doors leading into the square chambers flanking the porticoes are conjectural; the mass of masonry actually found in one of these rooms probably supported a staircase.

To the governor's palace belong the barracks (C) built against the south-eastern curve of the citadel wall, at a point where the latter, and also the inner wall, could be manned at a moment's notice. The open space before them is believed to have served as a parking place for war chariots.[32] The horses could be stabled on the ground floor of the barracks, the troopers sleeping upstairs. The projecting piers shown in the plan would support a wooden balcony by means of which the upper rooms were entered. This arrangement would precisely resemble that of modern khans or local inns.

The north-west quarter of the citadel had not yet been completely uncovered when the plan of illustration 334 was made. Building E is the oldest; it was constructed by Kilamuva a little before 800 B.C. An orthostat with an inscription referring to him building it has been preserved. The rest of this great complex was built seventy or eighty years later by Barrekub, who placed his own inscription in a corresponding position – the west jamb of the portico – of building F.[33] Our plan does not show clearly that both E and F conform, on the whole, to the *bît-hilani*, although there are some unusual features.[34] An impressive flight of stairs led up to the portico of building F. It had three columns resting on decorated bases identical with those found at Tell Tayanat [336]. The two buildings (E and F)

336. Tell Tayanat, column base

face a large court which could be entered through a portal, G, which already existed at the time of Kilamuva and was decorated with lions [352, left]. But for ceremonial occasions under Barrekub entry was no doubt made from the splendid court which he built to the south of it and surrounded with colonnades. The large *bît-hilani* (I) was presumably Barrekub's palace. Another (H) was older. An inner defence wall, which is only partially excavated, seems to have enclosed the north-west part of the citadel. Both buildings (H and I) are so denuded that the staircases, on the right of their porticoes, appear as solid blocks of masonry.

The city of Guzana (Tell Halaf) was not round but rectangular in plan. The river Khabur protected one of its long sides. This safeguarded the northern approach, the other three sides being protected by a wall with towers. The town gate was in the southern wall and led, like the south gate of Zinjirli, directly to the citadel. The inner wall in the citadel of Zinjirli is represented here by the rear wall of the palace; the Scorpion Gate gave access to the public square in front of it.

The citadel stood on a hill beside the river. On entering one faced the back of a great building strengthened with towers [337]. This is the most impressive *bît-hilani* so far discovered, but the details of its plan remain unknown because a large part has been denuded to the level of the foundations. The outside of the terrace on which it stood was decorated with sculptured orthostats of alternating basalt and reddish limestone, which begin at the south-west and end against the Scorpion Gate [344]. One passed through this gate climbing steadily, turned the north-east corner of the terrace in front of the building, and then entered a low-level forecourt from which steps led up to the terrace in front. The façade was elaborately decorated with sculpture. In addition to the dado of orthostats and the guardian figures – here sphinxes – the three columns of the portico consisted of figures nine feet high, standing on animals and supporting the architrave by means of conical capitals. The total height of the architrave above the floor was about twenty feet. The inner door from portico to main room was flanked by stone griffins [341].

In front of this portico stood a base for a statue or an altar of polychrome glazed bricks,[35] with

337. Tell Halaf, palace of Kapara

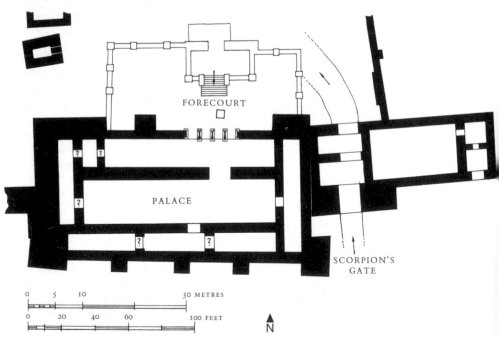

FORECOURT

PALACE

SCORPION'S
GATE

0 5 10 30 METRES

0 20 40 60 100 FEET

N

rosettes, guilloches, and other geometric designs in green, yellow, and white. In addition, one or more large basalt images of birds seem to have stood on the terrace [340].

The alternative, 'base of a statue or altar', marks our inability to define the character of this building; the all-inclusive designation 'temple palace' of the excavators further stresses our embarrassment. It is certainly true, as they state, that nowhere else in the citadel was a setting appropriate to the great official celebrations of victories, the bringing of public sacrifices, the reception of ambassadors, or the issue of proclamations. Moreover, a large building, presumably a residential palace, was found in the north-east corner of the citadel. In so far as the ruins allow one to judge, this lacks a *bît-hilani* and resembles Assyrian rather than north Syrian palaces, although the 'reception suite' customary in those (p. 148 above) is absent. On the other hand, the 'temple palace' seems to lack a shrine; and since the inscriptions on the carriers of the architrave (see below, Note 44) explicitly call it the 'palace of Kapara', we refer to it as such. The main room, behind the portico, contained a movable hearth, like those found in the Upper Palace at Zinjirli; and the masonry on the west of the portico (the two entrances shown in the plan are conjectural) would have supported the staircase. Near the palace were funerary vaults for the rulers, and a little farther to the north a large dwelling, recalling (in function, not in plan) the vizier's residence in the citadel of Khorsabad. Under the Assyrian occupation – from 808 B.C. onward – a temple was built in the town which conforms in all respects with those found at Khorsabad.[36] The buildings we have just described then fell into disuse.

If we consider the distinctive features of north Syrian architecture, which are all connected with the *bît-hilani*, it shows a character all its own. The buildings do not in the least resemble the huge palaces of Mesopotamia, mazes of rooms arranged round courts. There is little or no resemblance, either, to Hittite architecture. It is true that the employment of natural features for the purposes of defence, which we observe in the citadels of Zinjirli and Tell Halaf, recalls the fortifications of Boghazköy, but the advantages thus gained are obvious and are exploited by all hill-dwellers. In details, such as the fortified gates, there is a difference; the north Syrian town gates resemble those of Assyria rather than Anatolia.[37] There is, moreover, no north Syrian equivalent to the irregular large-windowed temples of the Hittites. The *bît-hilani*, in spite of its porticoed façade, is a severely closed block compared with the Hittite temples. It resembles rather the Greek megaron in being a self-contained unit which can neither be combined with others into a single structure nor expanded by the addition of rooms beyond a very narrow limit.[38] The palace at Tell Tayanat [329][39] is more complex than most; at Zinjirli the need for a large number of rooms was met, in both the Upper and the Lower Palace [330, 334], by grouping separate units of the *bît-hilani* type round one court, not by integrating them into a single larger unit. In this respect north Syrian architecture contrasts with its forerunners in the second millennium [283, 293]. The *bît-hilani* is a new and stylized architectural form, differing from the older palaces in the same manner as the megaron differs from the megaron-like prehistoric dwelling-houses of north-west Anatolia and the Balkans. Both are highly specialized architectural forms which are consequently no longer adaptable to larger schemes.

Behind the *bît-hilani* of Tell Tayanat[40] we meet a building very like the megaron and which has been designated as such [329]. It is a temple with two columns *in antis* and a large central room. The columns rest on pairs of lions [332]. But an important difference from the megaron

exists: at Tell Tayanat the large central apartment is not the main room (as it is in the megaron) but the antecella. Behind it is the Holy of Holies, with its altar or base for the statue of the god. Whether or not such a temple had Syrian antecedents we cannot know, since earlier Syrian temples are imperfectly preserved. But we do know that the temple of Tell Tayanat resembles, very closely indeed, the Assyrian temples as preserved at Khorsabad [167], and we have seen at Tell Halaf a temple of this type built in Syria. The resemblance to the megaron seems fortuitous, whereas that to the Assyrian temple is part of the profound influence exercised by the political centre on its dependencies. At Tell Tayanat there is only one difference: the usual Assyrian entrance lobby has been opened up and converted into the portico beloved by north Syrian architects.

Sculpture

While north Syrian architecture of the first millennium B.C. is indigenous, its sculptural decoration is inspired by Assyrian usage. It did not follow Assyrian examples, but the basic notion of decorating the orthostats, and much of the repertoire of the decoration, were derived from Mesopotamia. We have described in the introduction to this chapter the general conditions under which north Syrian art arose (p. 279). It appears that the prosperity as well as the ultimate ruin of the various cities depended on their relation with Assyria, and this conclusion is corroborated by the history of the most easterly among them, Tell Halaf. It stood in the heart of ancient Mitanni, a hundred miles east of Carchemish, as the first strongpoint on the road leading from Assyria to the west; [41] it flourished and came to grief earlier than any other north Syrian site. Already in 894 B.C. a ruler of Guzana (Tell Halaf) paid tribute to Adadnirari II when he asserted his suzerainty over the regions on the western frontier of Assyria. At the end of that century, during the minority of Adadnirari III, when Semiramis was regent, Guzana, with other Assyrian vassals, made an attempt at independence. It failed; the city was burned, and became the seat of an Assyrian governor (808 B.C.). The buildings and sculptures were all made between those two dates. [42]

The repertoire of the Tell Halaf sculptures is more varied and more dependent upon Mesopotamia than that of other north Syrian sites. This is particularly true of the reliefs, and in a lesser degree of semi-detached guardians of gates and of the few sculptures in the round. The latter are the most considerable works made on the site, and the greatest skill and care was lavished on them. The most impressive are three figures which carried the architrave of the palace portico [341]. Their height is about nine feet (excluding the conical 'capitals'), and each

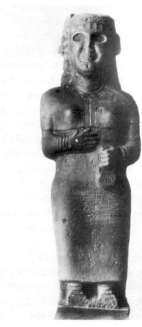

338. Column figure from the palace of Kapara, Tell Halaf. *Aleppo Museum*

stands on an animal five feet high. These supports – a bull in the middle and two lions – would be understood most easily if the figures were gods, but all explicit symbols of divinity are lacking. The woman [338] wears a flat embroidered cap known from the Megiddo ivories [308, 309, 316]. The heads of the two men are damaged and were once thought to wear horned crowns, but a careful drawing shows that they did not.[43] They are robed in a shawl worn over a tunic, a costume found almost anywhere west of the Tigris and south of the Taurus. They hold, not divine symbols, but scimitars, and it is significant that the inscriptions do not mention deities. These are carved in cuneiform on the skirt of the woman and on the left shoulders of the men.[44] We know, furthermore, that over-life-sized statues of kings were set up at Malatya and Zinjirli. The possibility that the three statues represent members of the Kapara dynasty remains, therefore, open.

The general dependence of these figures on the Mesopotamian tradition is obvious. The ill-proportioned woman, with her large head and lifeless appearance, recalls the treatment of that type at the hands of incompetent carvers of other times – for instance in the private chapels at Ur.[45] But these are generalities; there is no pronounced style, either as an imitation of better work, or as a result of a vivid original conception of the nature of statuary. Different styles are oddly combined. The ears of men, for instance, are reduced to abstractions, while their feet and sandals are rendered with painstaking realism, and the treatment of their knees may be an abortive attempt made in either of these contrary directions. Yet the boldness of the conception of the portico surpasses anything undertaken by Mesopotamian sculptors. No sculpture in the round resembling these three figures is known from other sites.[46]

The cylindrical shape of the figures reminds one of Mesopotamia, where it was the basic form of plastic composition. In north Syrian art it was not, for in rendering seated figures the opposite scheme, that of the oblong or cube, was used [339]. At Tell Halaf such figures were placed in tomb chapels. Both north and south of the palace, and also near the palace of Zinjirli, vaults for members of the ruling family were constructed, and elsewhere in Syria and east Anatolia representations of the dead at table were carved on steles set up over their graves [357]. This funerary rendering of a meal goes back at least to the thirteenth century in Syria, since it appears on the sarcophagus inscribed with the name of Ahiram of Byblos [317]. On many of the steles – among others on that of a queen of Zinjirli of the end of the eighth century B.C.[47] – the dead are shown holding a cup. This is precisely the attitude chosen for the statues of Tell Halaf. These differ greatly among themselves, but the example which we reproduce can be contrasted with all the others. In an adjoining tomb chapel was found a statue[48] resembling those of the palace portico in style. In another tomb chapel, near the southern town wall, a group of a man and a woman, carved from one block, and a standing male statue were found.[49] The double figure has a parallel in a double statue found at Marash;[50] and the fact that funerary statues were desired in Syria (in contrast with Mesopotamia) is emphasized by a number of rough or partly finished figures which were found at Tell Halaf,[51] and which might serve the needs of commoners. All these figures would seem to belong to a different school, if we compare them with illustration 339. They resemble the portico figures, although they are much coarser in workmanship and more clumsy in plastic composition; appearing to be little more than stuffed sacks. Illustration 339 shows, on the other hand, a certain elegance in the profile, with its sharp lower angles, the deeply cut hair (which reduces the heaviness of the whole), and the continuous curve from the tip of the nose, over the skull, to the ends of the

339. Funerary statue, from Tell Halaf.
Formerly Berlin, Tell Halaf Museum

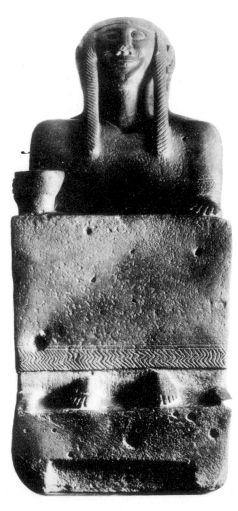

hair hanging down the back. In the front view the bold undercutting of the side locks adds interest and lightness; the cup, too, is more elongated than in the other statue. The primitive nature of this piece of sculpture nevertheless becomes clear in the deplorable three-quarter view, [52] which was not intended to be seen, as so often in pre-Greek art. The divergencies between the tomb statues are – once more – due to the absence of a sculptural tradition. Every work was to some extent an experiment and an improvisation, and the figure of illustration 339 has some merit from this point of view. It remained, however, without successors.

With the great bird of illustration 340 we enter the sphere of religious imagery. It was found on the terrace in front of the palace and may have stood on top of a polygonal column of basalt; fragments of such a column were found,

340. Bird on column, from Tell Halaf.
Formerly Berlin Museum

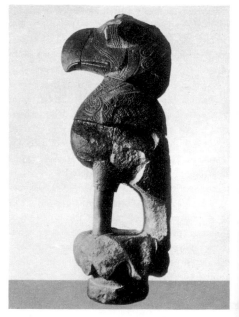

and it would explain why the bird is perched on a capital. The legs are lost and are restored in our illustration. The creature has been called an eagle, but the curls shown at the back and sides of the head connect it with the griffin of Mitannian and Middle Assyrian art. Winged griffins with low crests flanked, in fact, the doorway from the portico to the main room of the palace [341]. It is likely that they are manifestations of a similar power to that which we imagine in the bird; in Middle Assyrian art the griffin-man and the griffin seem to denote the same demon or deity. The break on top of the head of the great bird suggests a knob, such as is found on griffin heads in Greek objects of the late geometric and orientalizing periods, rather than a continuous crest. The eyes were inlaid and, unlike birds' eyes, they are trained forward like two cylindrical searchlights.

The griffins at the inner doorway belong to that large group of guardian figures whose bodies appear in relief on the jambs while their foreparts are treated as sculpture in the round. The mounts of the portico figures are treated in the same manner. In all these cases there are subsidiary reliefs on the open space below the animals' bodies, to the detriment of the effect produced by the guardians. Below the lions of the male figures there is a supine disembowelled stag; underneath the griffin a bull and a lion fighting; underneath the sphinxes on the sides of the portico fighting groups. One of these is reminiscent of the mirror handle from Enkomi [306], for it shows a hero fighting a rampant griffin, while the other group consists of a four-winged genius and two lions. The sphinxes are the clumsiest of the guardian figures, and the most accomplished are the scorpion-men at the

341. Tell Halaf, palace of Kapara.
Reconstruction of section through the portico

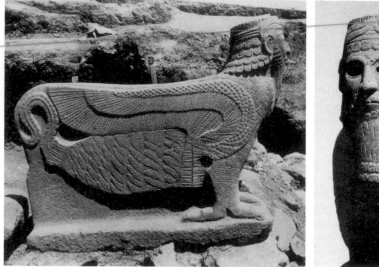

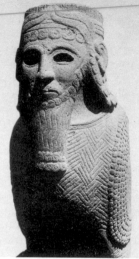

342. Scorpion-man *in situ*, Tell Halaf.
Formerly Berlin, Tell Halaf Museum

343. Scorpion-man,
from Tell Halaf. *Aleppo Museum*

344. Tell Halaf, Scorpion Gate.
Reconstruction of section

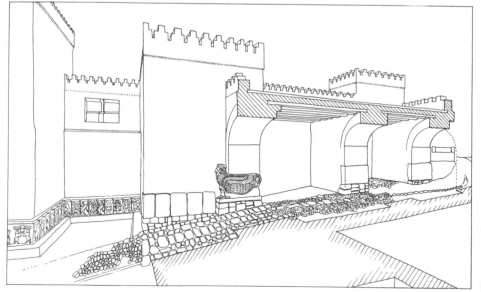

gate which gave access to the inner citadel [342-4]. They have four horns – a sign of their divinity – which spring from the temples, and they wear a low, flat cap. They have the feet and wings of a bird of prey and a nondescript body, ending in a scorpion's sting. The two figures are, curiously enough, not identical. The western one [342] lacks the fringes of curls along forehead, cheeks, and lower lip; its mouth has a more pronounced curve and its beard ends in a single, not a double, row of curls. These divergencies are signs of differences, not of period, but of hands. It is certain that many stone-carvers worked simultaneously on the mass of sculpture required for the palace. It is also possible that the eastern figure [343] was an improved version of a theme of which its fellow was a first rendering.

In addition to the dozen figures carved wholly or partly in the round, the palace decoration included twelve large and over two hundred small reliefs; the large ones were in the façade, the smaller formed a dado round the south side of the palace [344]. A few were placed inside; one appears behind the griffin in illustration 341. The material of the outer slabs was alternating basalt and reddish limestone.

The large reliefs are superior in execution to the rest; both groups derive their repertoire from the Mitanni-Assyrian tradition, and it is difficult to decide to what extent a local (Mitannian) style was revived by the sculptors, since Assyrian art, too, had absorbed Mitannian elements (see above, p. 131). But Assyria seems to be the source of most of the motifs. In illustration 345 we see the winged sun-disk supported by two bull-men. From the beginning of the second millennium bull-men appear holding a sun-disk on a standard in Mesopotamia.[53]

345. Supporters of winged sun disk, from Tell Halaf. *Aleppo Museum*

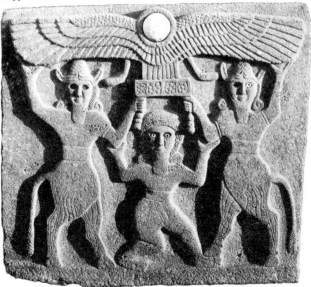

The winged sun-disk arrived by way of Mitannian art, the wings which stand for the sky, resting on a pillar.[54] But 'the pillar of heaven' had no meaning for the Assyrians, and they did not adopt it. It seems significant that in illustration 345 the Assyrian and not the Mitannian version is followed; the kneeling figure underneath the winged disk likewise follows an Assyrian prototype,[55] and there is yet another relief on which two bull-men are shown as supporters of the winged disk without a pillar.[56]

The small orthostats are likewise dependent on Mesopotamian examples. One shows a fish-man with streams of water issuing from his hands.[57] A large number[58] depict animals who are fighting in pairs, sometimes drawn cross-wise, which is an ancient theme in Mesopotamian decoration.[59] None of these groups – lion mauling bull, bull goring lion, and so on – are found on other north Syrian sites. At Tell Halaf they are not slavishly copied from Mesopotamian examples, but freely, if crudely, handled. There is a lion shown from above, spread-eagled, while it devours a calf[60] – a design to my knowledge unique. In addition, there are archers, horsemen, charioteers (as on all other north Syrian sites), and a group of three fighters, two holding their victim between them [346], which occurs, too, on Middle and Late Assyrian seals and also, as we shall see, on Phoenician bowls. There is, further, a variety of winged creatures – lions, bulls, sphinxes, griffins; scorpion-men; bull-men; a seraph – if one wishes to apply this term to a six-winged figure [347].[61] A winged demon with two lion heads[62] is the only motif which can claim an imperial Hittite

346. Two figures dispatching a third, from Tell Halaf. *Baltimore, Walters Art Gallery*

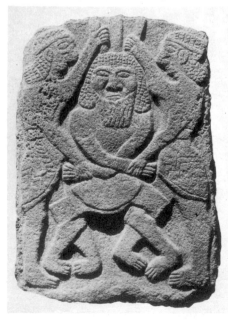

347. Six-winged genius, from Tell Halaf. *Baltimore, Walters Art Gallery*

origin; for it occurs on an ivory plaque at Megiddo (p. 236 and illustration 274). The weather-god with his axe, so common on imperial Hittite and Syrian monuments ·of the second millennium, and also on other north Syrian sites of the first, is absent from Tell Halaf, where, in fact, only one deity is represented. He wears none of the clothing of Hittite and Syrian gods, but a flat cap with two horns coming to the front, a long gown, and a mace, like the gods of Mesopotamia. Much could be added to this list to demonstrate that the repertoire of Tell Halaf reflects that of Assyria much more closely than do the other north Syrian sites.

The most surprising reappearance of a Mesopotamian theme occurs on two roughly carved orthostats.[63] They show animals acting like men: a lion plays a lyre, a lion-cub clashes cymbals, a bear and a gazelle bring vessels (these objects are obscure), while a large male donkey, a fox, and a number of other animals dance on their hind legs. This subject has not, so far, been found on Assyrian monuments, but it goes back to the third millennium B.C., where its best-known occurrence is on an inlaid harp from Ur [78]. Its survival in the ninth century B.C. has a bearing on possible sources of certain Greek fables.

It is striking that all these comparisons of the Tell Halaf reliefs have led us not to the sculpture, but to the minor arts of Mesopotamia. We have found no sign of acquaintance with the great pictorial chronicles which were, as far as we know, invented by the sculptors of Assurnasirpal II and continued by those of Shalmaneser III. This confirms what we have said in the introduction to this chapter, namely that the Assyrian mural decorations only influenced north Syrian art directly after Tiglathpileser III had built palaces in Syria. Until that happened the notion to decorate the orthostats with reliefs was adopted, but the subjects of the decoration were either improvised or – in the majority of cases – copied from such portable Mesopotamian objects as were available – bronze vessels, woven materials, engraved gems, ivory inlays, and so on. The monsters which guard the gates are also derived from this source. This is clearly shown in the case of the griffins, which, at Tell Halaf and in other north Syrian sites, retain the side-curls which they owned in Crete, in Mitanni, and also on Middle Assyrian seals.[64] In the reliefs of Assurnasirpal, the griffin-demons lack these curls and wear long hair, like the human figures.[65] This innovation of the Assyrian sculptors remained unknown in Syria. The human-headed bull, the commonest Assyrian gate figure, is not found in this role in north Syrian buildings, and for the same reason. It was not Assyrian *sculpture* that could serve as models for the craftsmen of Kapara and Kilamuva. We assume, however, that it was known that the decorated orthostats in the Assyrian palaces showed scenes of war, for this would explain the fact that horsemen, spearmen, and other soldiers appear here and there among the early reliefs at Tell Halaf and Zinjirli.

Our illustrations give a fair impression of the execution of the reliefs. In the vast majority of cases the figure was outlined, and left standing beyond the surface of the stone. Details were added by means of engraving. Even in the most carefully executed pieces like illustration 345 there is only a minimum of modelling in the faces, while the detail on the legs, for instance, is engraved, and is fussy and almost meaningless. In most cases details are scanty and the drawing, like the carving, is elementary. But reliefs like that of illustration 345 do show some sureness of design. Such works, with the sculptures in the round, must have been made by men with some training, but they were not really familiar with the traditions of any one established school. We know from the head of Yarimlim of Alalakh [284–6], and also from some of the statues found at Mari, how properly trained Babylonian sculptors worked abroad. We may

assume that the kings of Assyria could, in the ninth century, offer employment to all competent sculptors in the land, and that only some odd individuals who had obtained a mere smattering of the craft were available to Kapara.

In the methods of composition, too, the influence of the minor arts can be traced. A man carving a spoon or a mirror handle or a piece of inlay has to arrange the whole of his subject within the limits of the raw material at hand. Now we observe at Tell Halaf that no scene or motif spreads over more than one stone. Since the orthostats are, on the whole, narrow upright slabs, the subjects are adapted to this awkward shape. In Assyria this problem was solved in a different way; the orthostats were divided into two continuous bands which went round the room and could accommodate even the most complex narrative scenes. But at Tell Halaf the inventions of the Assyrian sculptors were apparently not well known; we see, for instance, men in a chariot pursuing wild cattle, but their game, at which an archer aims, does not appear in front of the horses, but above them where there is room.[66] In another scene, a lion hunt, the game appears below the horses;[67] in yet another a diminutive archer is drawn on the back of a huge rampant lion.[68] On the other hand, groups of crossed fighting animals can easily be drawn within an upright oblong, and this explains their popularity at Tell Halaf.

At Zinjirli the oldest remains are contemporary with, or but a little later than, those of Tell Halaf.[69] In the south gate of the citadel [335] some figures – the bull and the lion – are spread across two orthostats. One can consider as a single scene extended over several stones the archer taking aim at a stag and a fawn, even

348. Two reliefs (not originally adjoining), from Carchemish. *Ankara Museum*

349. Weather-god, from Zinjirli.
Berlin Museum

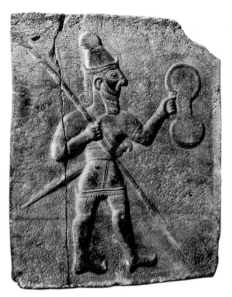

350. Warrior, from Zinjirli.
Berlin Museum

though the game is round a corner of the actual wall. At another point one stone shows an archer taking aim, and the next a stag shot through the neck pursued by the hunter's dog.[70] So we may speculate whether the gesturing man in front of the guitarist is a dancer or singer whom he accompanies; whether the man with the long staff accompanies the warrior pushing a captive before him; whether the winged monster belongs to the weather-god on the next· stone, an association valid in Mesopotamia from early to late times. Where no single idea underlies the composition, and often the joining of orthostats is obviously fortuitous, no possible interpretation is either wholly excluded or fully warranted by the juxtaposition of the stones.

The influence of the minor arts of Mesopotamia is limited at Zinjirli to some monsters. One – the sphinx with a human head, and a lion's head on the chest [348] – is probably of Hittite descent.[71] The groups of crossed fighting animals are absent; the goats flanking a tree are

a Near Eastern commonplace. In contrast with Tell Halaf, Zinjirli included a number of divinities among its reliefs [349], and they are indigenous, still dressed in provincial Hittite attire, with tall cap, kilt, and pointed shoes. Weathergods swing their axes and hold a triple lightning or thunderbolt, unknown in Mesopotamia, and appearing in Anatolia only with the Lion Gate reliefs of Malatya. The figure with a long veil and a mirror is the goddess Kupapa. It is odd that two people at a meal, a subject normally reserved for funerary steles, should be figured here on the orthostats of the citadel gate.

About this time – still in the ninth century – two large statues were set up, one at Zinjirli and one at Carchemish. The first, which was over twelve feet high, was found against the rough east wall of building J, which was built by Kilamuva[72] [351]. Its base was in place, but the statue had been lifted out of its socket and had been 'buried' alongside. In the eighth century an over-life-sized statue of a king had been

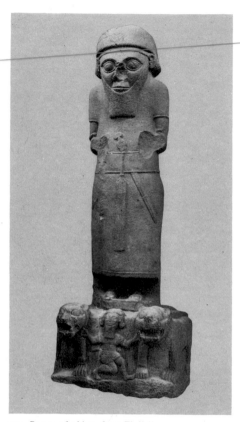

351. Statue of a king, from Zinjirli.
Istanbul, Archaeological Museum

demon; and here the statue wears, indeed, a horned crown, holds a kind of double hammer, and is identified by an inscription as the god Atarlukas.[76] This seated statue combines the squared lower portion with a rounded upper part in the manner of the funerary statues from Tell Halaf.

The statue of a king of Malatya,[77] which was buried in a grave specially cut for it, is carved in the elaborate Assyrianizing style which north Syrian art adopted in the last quarter of the eighth century B.C. He wears sandals, a long pleated gown, and a diadem with rosettes occasionally found on figures of Sargon at Khorsabad [199]. The same costume is worn by the ruler of Sakjegözü,[78] whose reliefs are executed in an identical late north Syrian style.

Instead of the variety of monsters guarding the gates of Tell Halaf, there are, at Zinjirli, almost exclusively lions, and it is worth while, at this point, to quote a contemporary text explaining their character. The Assyrian governor of Til Barsip on the upper Euphrates installed about 770–760 B.C. two gate lions at his palace. He gave them the following names:

> The impetuous storm, irresistible in attack, crushing rebels,
> procuring that which satisfies the heart

and

> He who pounces on rebellion,
> scours the enemy, drives out the evil
> and lets enter the good.

The last phrase recalls the apotropaic character of the device which had originally been reserved for temples. The Hittites of Boghazköy, the Assyrians, and finally the north Syrian princelings had adopted it to demonstrate their consciousness of power and to maintain alive among the people that fear which 'satisfies the heart' of their rulers.

The earlier north Syrian lions are merely brutish. But in the course of the eighth century

similarly treated at Malatya,[73] and this circumstance, as well as the absence of all divine attributes, makes it probable that the statue found at Zinjirli represents a king – perhaps Kilamuva – and not a god as is sometimes asserted.[74] For another large statue, inscribed and thus identified as a representation of the god Hadad, does wear a horned crown.[75] A comparison of the bases corroborates our interpretation: at Zinjirli the base consists of two lions held by a figure clothed exactly like the king. The Carchemish statue rests on a similar base, but here the lions are held, not by a man, but by a griffin-

352. Three guardian lions, from gates at Zinjirli

they change their style and allow us to judge how strongly the closer contrast with the Assyrian art of the Syrian palaces of Tiglath-pileser III influenced north Syrian sculpture. The three lions of illustration 352 were all found at Zinjirli. The one on the left protected gate G in illustration 334, built by Kilamuva, presumably about 830 B.C. and leading into the court of the palace, *bît-hilani* E. The one on the right belongs to the southern colonnade built by Barrekub after 730 B.C. It copies rather successfully the Assyrian rendering of lions, as known, for instance, from the temple of Ninurta at Nimrud.[79] The lions from Sakjegözü [331] and Tell Tayanat [332] are its near relatives. The middle lion of illustration 352 was found with some others between the outer and inner gates of the citadel, and its date remains uncertain. It does not represent a transition between the old and new types, but an abortive attempt to produce something like the later images. We cannot say whether it is older than the figure on its right or a contemporary failure.[80]

A similar contrast between works made in Syria before and after Tiglathpileser III exists in the treatment of common subjects on the

reliefs. Illustration 346 comes from Tell Halaf and belongs to the ninth century; illustration 353 shows how the theme was Assyrianized at Carchemish in the eighth century B.C. Note that

353. Reliefs, from Carchemish

A

B

not only the appearance of the figures but also their execution is very much better than in the older example. At Zinjirli there are a few commemorative reliefs in the new style (which we shall discuss presently), but not a series of decorative orthostats which could be compared with the older set at the south gate of the citadel [335]. For such a comparison we must go to Carchemish.

Carchemish was never taken by the Aramaeans, and was more intimately connected with the imperial Hittite past than any of the other cities. The subject matter of its reliefs shows traces of this continuity. The contrast is well illustrated by a relief found at the water-gate[81] to which we have referred already (p. 280). It depicts a libation ceremony also represented at Malatya [272]. The ritual and the attributes of the god evidently survived, but the rendering shows a translation of the old theme into the north Syrian idiom of the eighth century. Its companion piece,[82] also from the water-gate, shows that the king wore a beard, and he is seen at table, attended by a servant with a fly-whisk and by a lute-player, in accordance with the Assyrianizing fashions of the time. The lute, with its cord and tassels tied to the neck, resembles one depicted at Zinjirli, but not the Hittite instrument.[83]

There are, however, some reliefs at Carchemish representing named kings of the ninth and eighth centuries B.C. They are less summarily executed.[84] A stele found at Til Barsip, showing a weather-god under a winged disk, seems also to belong to the ninth century B.C.[85] The later reliefs at Carchemish draw heavily on the Mesopotamian repertoire; there is, again at the water-gate, a winged lion with the claws of a bird of prey and a fantastic tail;[86] elsewhere a pair of bull-men was found, holding spears as they hold sun-standards in their homeland, together with a lion-headed demon;[87] a hero mastering animals;[88] bulls flanking a sacred tree [353B]; and winged sphinxes of a type peculiar to Late Assyrian seals.[89] A comparison with the south gate of the citadel of Zinjirli [335] and with Tell Halaf shows the infinitely superior design of the Carchemish reliefs, a result of Assyrian influence.

At Sakjegözü this influence is even more striking. The two slabs on the right of the portico [354; cf. 331] include a griffin-demon more Assyrian in appearance than those from Carchemish;[90] it bears the bucket of holy water and the sprinkler of its prototype, but not its long

cloak, and lacks both crest and human hair. This is the stranger because the Assyrian type occurs on the orthostats of Til Barsip.[91] The two deities flanking a sacred tree beneath a winged in Syria and Assyria, but Tiglathpileser III used it extensively in his reliefs and paintings of Arslan Tash and Til Barsip. It dominated the decoration of Sargon of Khorsabad. In com-

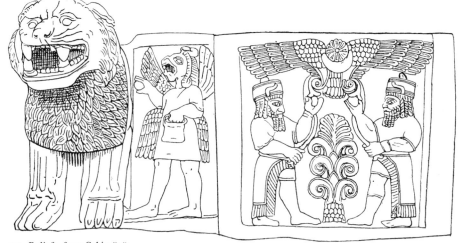

354. Reliefs, from Sakjegözü

disk of illustration 354 are likewise more Assyrian-looking than most other north Syrian gods, although they would look odd in Assyria. At this time, in the last third of the eighth century, such divergences from Mesopotamian prototypes were no longer due to negligence or lack of skill, but rather to variants of common themes which began to be established and might have given rise to a truly native art, if the development had not been interrupted by Assyrian conquest. A Syrian invention, for instance, is the double sphinx base, which occurs at Sakjegözü [331] and at Zinjirli, and which was copied in Assyria. The column base of illustration 336 is likewise typical for north Syrian art; it recurs in Barrekub's Hilani K at Zinjirli.[92] On the other hand, the Assyrian example was followed when a line of orthostats showed, instead of decorative designs, long processions of figures to serve as foil to the royal person. In the ninth century this device was unknown both

parison with these displays the north Syrian courtiers look rustic enough [355], and at Carchemish the repetition is overdone in the long and utterly lifeless rows of soldiers, courtiers, and women at a religious ceremony.[93] Yet these

355. Courtiers, from Zinjirli

356. Musicians, from Zinjirli.
Berlin Museum

furniture which to all intents and purposes was Assyrian,[96] and his artists were Assyrian-trained. But for this very reason he did not trouble to imitate the Assyrians; he appears in his official portrait with Aramaean side-locks and a shawl, shoes, and cap which would have raised eyebrows in Nineveh. And the scribe appearing before him carries not a clay tablet and stylus but a pen-case and writing material – probably papyrus – suitable for the Armenian script. In these matters customs differed from place to place. We have seen that at Sakjegözü and Malatya the rulers did not wear side-locks and appeared in sandals, bare-headed and with a rosette-studded headband, as did Sargon.[97]

The funerary stele of the queen of Zinjirli[98] is closely related to the relief of illustration 358. The lady is shown at table, a servant with side-locks waving his fly-whisk over the dishes. She holds a drinking-cup, like the statues found in the tomb chapels at Tell Halaf [339]. A number of tomb steles have been found at various places, especially at Marash.[99] They are often crude works, showing the dead at table, with cups in their hands, and sometimes associated with other persons or objects. A woman may support her child on her knee, a pomegranate in one hand and a lute in the other. In

renderings of local courts are not always without originality. There is not, to my knowledge, an Assyrian example of a falconer as at Sakjegözü, and at Zinjirli there was a procession of musicians rendered with some liveliness [356].[94] There is also a certain ease and freedom in the relief which accompanies the building inscription of Barrekub of Zinjirli [358]. In the ninth century Kilamuva had erected such an inscription, and alongside he had himself depicted painstakingly conforming to the etiquette of the Assyrian court.[95] Barrekub, almost a hundred years later, had certainly assimilated Assyrian culture to a much greater extent; he used

357. Stele, from Marash

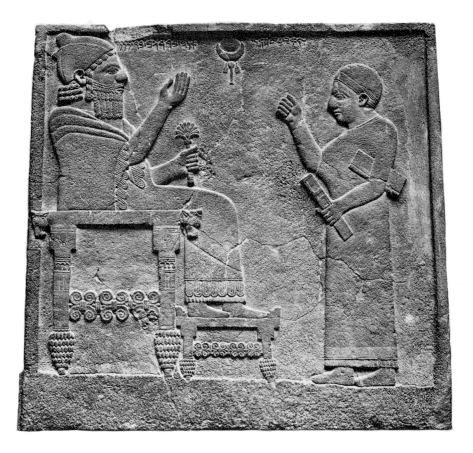

358. Stele of Barrekub, from Zinjirli.
Berlin Museum

359. Rock relief showing Urpalla king of Tyana
before the god Sandas, from Ivriz

illustration 357 the two women hold pome-granates, the smaller one (possibly the daughter) a mirror, the man an ear of corn and a cup. The man's facial type, and the way in which he has dressed his hair and beard, shows that the Aramaeans were well established even at the very foot of the Taurus Mountains. The ear of corn, and probably the pomegranates, are symbols of resurrection or rejuvenation which we have not, so far, met in Syria.

The relief of illustration 359 shows that the influence of north Syrian art had penetrated even beyond the Taurus range.[100] In this relief, which is eighteen feet high and was cut in the rocks near Ivriz, King Urpalla of Tyana stands before the god Sandas. Both figures have the stocky build, the curved nose, fleshy nostrils, large eyes, and abundant hair which distinguish the Assyrians, and suggest a strong Armenoid strain in the population. When the Aramaeans are depicted in the same manner, the question arises whether their physical appearance re-sembled that of the Assyrians or whether it is merely due to the training of their sculptors. The rock relief of Ivriz poses that question even more insistently; for there were certainly no Assyrians and perhaps no Aramaeans in this region. It has been said that we have at Ivriz an example of early Phrygian art.[101] Urpalla is known to have made submission to Tiglath-pileser III in 738 B.C., and in 690 B.C. the Phrygians were ruined by the invasion of the Cimmerians from the north. The king's robe is certainly not Assyrian nor Hittite nor Ara-maean. The god Sandas retains modified fea-tures of Hittite dress: the shoes with upturned toes, the tunic with the peculiar stylization of the lower edge which elsewhere characterizes Hittite costume [e.g. 272], and a pointed cap surrounded by two bands to which horns are attached. He holds bunches of grapes and ears of corn. Before him Urpalla clasps both hands and lifts them in a gesture of devotion unusual in Near Eastern art. Rare, too, are the em-broidered robe with the swastika border, the cloak fastened with a knobbed brooch and the patterned cap.

We had better avoid the term 'Phrygian art', just as we did not speak of 'Aramaean' or 'Hur-rian' art. In all these cases peoples without sculp-tural traditions adopted as best they could forms prevalent in the region they occupied. The rock relief at Ivriz, although influenced by north Syrian or Assyrian art, belongs to neither. It reflects a vastly different world of feeling. The north Syrian monuments seem secular in com-parison. It is true that ancient art is never with-out reference to the superhuman, and we have noted, in gate figures and reliefs, monsters, demons, or gods swinging their axes in a con-ventional gesture. But they are interspersed among the motley of designs which show game and soldiers and the king among his courtiers or musicians. At Ivriz, on the other hand, there is the stark confrontation of king and god, express-ing the god's power and the king's dependence with a simplicity and directness which we have not met, so far, outside Mesopotamia. The relief also proclaims that the fruits of the earth are gifts of the god, and however strongly this belief was held throughout the ancient world, Hittite, north Syrian, and Assyrian art did not express it in this striking fashion; they depicted the rituals devised to ensure divine favour, not the beliefs which inspired the rituals.[102]

Another group of monuments was probably Phrygian, but they are less novel and revealing; it consists of some orthostats found near Ankara and hence in ancient Phrygia, and showing a griffin, horse, lion, bull, and a bearded human-headed lion.[103] The bodies are elongated and clumsy, but the modelling is rather good. In their subjects as well as their style they diverge from north Syrian art, but share with it an ulti-mate dependence on Mesopotamia. It has been suggested[104] that they are linked with it, not through north Syrian but through Armenian, Urartian, art. The kingdom of Urartu chal-

lenged Assyrian supremacy from about 825 to about 750 B.C. It dominated the northern foothills as far west as the Orontes from 780 to 750 B.C., when Tiglathpileser III began to restore the Assyrian suzerainty in north Syria.[105] The Urartians are not known as sculptors, but were excellent metal-workers, as we shall see, although dependent for their repertoire on Assyria; and it may be that some of the orientalizing motifs which are found in Greece and Etruria in the seventh century had reached the West, not through the Phoenician ports, but from Armenia through Phrygia. Urartu and Phrygia were allied against Assyria; both were overrun by the barbarous Cimmerians. It may be that the master metal-workers of Urartu, fleeing before the Assyrian and Cimmerian invasions, betook themselves westward through Phrygia to Crete and onwards to find security in Etruria.[106] We may at least admit a possible Urartian influence in Phrygia about this time, and this would explain the pronounced difference between the reliefs from Ankara and the north Syrian works.

One other Anatolian site has produced sculpture which superficially resembles north Syrian art, but in reality stands apart from it. This is Karatepe, a small fortress on the Jeyhan (Pyramos) in the foothills of the Taurus.[107] Its builder left a record in Hittite hieroglyphs and in Phoenician. His name is Asitavandas, and he reports how he was first made great by the king of the Danunians and afterwards himself ruled over the plain of Adana. Excavations show that the fortress was built all in one, and likewise destroyed by a single great fire. This may have happened between 725 and 720 B.C., since Sargon of Assyria refers to a subjected Cilicia, or in 680 B.C., when Esarhaddon led a campaign there. The later date is the more probable.[108] The sculptures – orthostats found in two gateways – would then be later than any we have discussed so far. They also strike one as deriving from other sources. The Mesopotamian

themes, such as the griffin-demon, are barbarously malformed, and they appear alongside purely Egyptian motifs, for instance the dwarf-god Bes. These two facts, in combination, suggest a Phoenician source for the repertoire, and this conclusion is corroborated by the sphinxes guarding a gate. They do not resemble any member of their race discussed in this chapter, and show their Phoenician origin by the piece of embroidered cloth which covers their front legs; it is a standard feature of the ivory sphinxes of Phoenicia which we shall discuss in the next section. Now Esarhaddon defeated, on the campaign of 680 B.C., a coalition of the Phoenician Abdimilkutti of Sidon with Sanduarri of Sis, which is modern Kozan, thirty miles north-west of Karatepe.[109] The builder of Karatepe translated his inscription from Hittite hieroglyphs into Phoenician, not into Aramaic. And, so far, the structures excavated on the site show no trace of a bît-hilani, which one would expect in a locality which formed part of the north Syrian province. On the other hand, a large statue, over seven feet high, and placed on a pair of bulls, recalls those found at Zinjirli and Carchemish.[110] The sculptures[111] were carved on the spot and their makers were innocent even of such skill as had been acquired in north Syrian centres between the ninth century, when the south gate of the citadel of Zinjirli and the palace of Tell Halaf were erected, and the late eighth century, when the Carchemish and Sakjegözü sculptures were cut. The workmen of Karatepe were much less competent. They made, as guardian figures, two lions, maneless and high on the legs, and the two heavy-headed sphinxes to which we have referred. All these figures had inlaid eyes. The reliefs sometimes possess a liveliness uninhibited by an awareness of the artistic problems involved in their composition. Signs of haste and lack of skill are as much in evidence as lack of sculptural tradition; some pieces are unfinished. Others, though adjoining and connected by subject matter, are inconsistent in

360 and 361. Karatepe, relief with a scene of feasting

style.[112] This is the case, for instance, with the orthostats which combine to represent a scene of feasting [360, 361]. They differ in size, are unevenly divided, and carved in divergent styles. On the left, servants bring food and musicians play their instruments. These are heavy figures, placed woodenly side by side. Some of the details, such as the beards and headbands of the serving-men, as well as the modelling in general, suggest a faint acquaintance with north Syrian work.[113] But the adjacent orthostat to the right seems pure improvisation. The ruler is shown at table, with a throne and footstool. In front and behind (meaning, probably, on either side) stand servants with fly-whisks. Underneath the table heavily laden with food, a monkey seems to be picking up scraps. In the lower register additional provisions, including meat on the hoof, are brought. Not one of the figures is well constructed, but a general air of lively activity pervades the scene, aided by the queer, rather appealing profiles of the people, with the mouth drawn on the lower outline of the face.

One row of orthostats was found complete and in their original position; they render the local version of the griffin-demon under a winged disk; then a woman or goddess suckling a standing boy under a palm tree, a scene ultimately of Egyptian derivation – Isis and the king or Isis and Horus – but known from

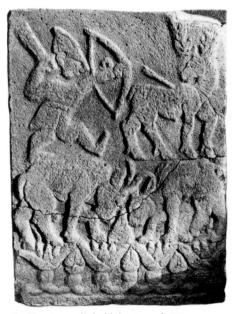

362. Karatepe, relief with hunter and stag

Phoenician bronze bowls;[114] next a man gripping a rampant lion by the head while driving his spear home. The next stone shows, above, two nondescript birds, meant no doubt to be vultures, over a prostrate animal, while below we seem to meet an inversion of the Mesopotamian theme of the hero subduing animals; for two lions are apparently getting the better of a man. Next comes an archer with his game, and, finally, against the lion at the entrance of the gate, we see Egyptian Bes with a monkey squatting on either shoulder. In illustration 362 we see a hunter and a stag, and below two butting bulls standing, not on mountains as we

363. Karatepe, relief with horsemen

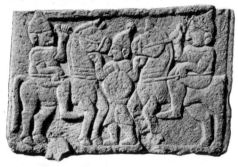

364. Karatepe, relief with two warriors

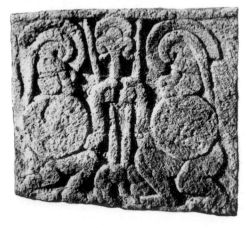

would expect, but on a border of lotus flowers and buds, a design of Egyptian derivation. Occasionally a group makes a pleasing pattern, two warriors, for instance, with the crested helmets and round shields also seen in the contemporary art of Greece [364];[115] the design of the horsemen above is likewise redeemed by their symmetry. But on the whole the designs are negligible as works of art.

It remains true that the reliefs of Karatepe, like those found on north Syrian sites, may have fulfilled an important role as transmitters of oriental themes to Greece; but on the whole Greece derived such subjects, as Syria and Anatolia had done, from the easily transported products of the minor arts. The north Syrian and Cilician ports played a part in their diffusion, but its main agents were the Phoenicians, whose repertoire is reflected in gross distortion among the sculptures of Karatepe.

Phoenician and Syrian Art

The hallmark of the Phoenicians is the lavish use of bungled Egyptian themes. After the passing of the Peoples of the Sea the inland cities of Syria drew on the Mesopotamian repertoire for a renewal of their arts; but the Phoenicians drew on Egypt. This much is clear, but any further characterization of Phoenician art must be provisional. Sidon and Tyre have not been excavated. The works which we recognize as Phoenician have been found in Assyria, Cyprus, Greece, and Etruria – regions of intense artistic activity liable not only to copy but to modify imported models. In many cases we cannot say whether ivories or bronzes are Phoenician works or more or less faithful local imitations.[116]

However, this may be, it is certain that Phoenician and Greek traders carried the products of these crafts to the West. The *Iliad* is explicit on this point,[117] and the prevalence of quasi-Egyptian themes on bronzes and ivories – whether found in the west or in the east, in

Assyria – cannot be explained on any other assumption than that of Phoenician manufacture. For such themes were not sufficiently familiar in the Asiatic hinterland; and along the Nile valley they were used in their proper context and form.

We know, in fact, that the products of the Asiatic mainland looked very different from those of the Phoenicians. Some ivory plaques found at Nimrud are engraved in a purely Assyrian style [218].[118] An engraved bronze bowl,[119] and the engraved bronze bands of masts erected in the temples,[120] present strictly Assyrian subjects. There is no trace of Egyptian motifs anywhere. The ivories and bronzes found at Toprak Kaleh, near Lake Van[121] in the kingdom of Urartu, are equally free from admixture; they are peripheral Assyrian, to put it tersely. A fine ivory head from Babylon[122] is, again, purely Mesopotamian in type and treatment, differing in both respects from those which are ascribed here to the Phoenicians.

There may have been a trickle of Urartian metalwork to the West, and it has even been supposed that Urartian metalworkers moved from Armenia to Phrygia, and hence to Etruria, before the onslaught of the Assyrians and, later, of the Cimmerians.[123] The main influence of East on West was, however, exercised through trade; and the sea-route from the Levantine ports of Syria was a great deal easier to use than the overland route through Anatolia to Ionia.[124] There is perfectly good evidence for a route from mainland Greece to Crete and Rhodes and from there to the Syrian port of Al Mina, at the mouth of the Orontes, where Proto-Corinthian pottery dated from the middle of the eighth century onward was found. A typical Luristan ring, discovered at Perakhora[125] near Corinth, and a typical Luristan ewer found in Samos,[126] can only have travelled from Persia to the Aegean through trade channels. And various objects serving as examples to local craftsmen may have reached the West in the same manner, but prob-ably not along the same route.[127] Four strands of oriental influence in Greece have been distinguished:[128] (1) Phoenician, meaning 'the composite style which began to be developed in the eighteenth century B.C., and continually absorbed new themes from other arts, without any striking change in style, till the fifth century'; (2) ivory carving of central Syria (an influence which I call, for the moment, likewise Phoenician (see p. 315 below)); (3) the sculpture of the north Syrian cities; and (4) metalwork of Urartu. And it has been argued that Greece was connected with each strand by a different route. If it is certain that Phoenicians traded in Greece, we now know also that Greeks were settled at Al Mina, at the mouth of the Orontes, far north of Phoenicia, on a main route to Mesopotamia and Urartu; and no Phoenician objects were found there, but much Greek pottery from c. 750 or a little earlier, down to c. 600 B.C.[129]

It is, however, also relevant to remember that the Syrian herds of elephants were, apparently, exterminated by the eighth century B.C. and that ivory had to be obtained by trade, probably from India through Arabian middlemen, and that the Phoenicians were engaged in this trade.[130] We do not know to what extent the Phoenicians drew on their hinterland for their supplies of finished articles in different materials, but it seems safe to assume that the objects now to be discussed were used, exported, and to a large extent made by Phoenicians.

In the dispersal of such articles towards the East, diplomacy played as large a part as trade. Several Assyrian kings[131] mention ivory stools, beds, and thrones which they received as tribute from Damascus and the Phoenician cities. The description includes small objects made entirely of ivory[132] and others decorated with turned or carved parts and inlays of ivory. Such pieces have been found in many places, and they often bear Phoenician letters scratched on the back, presumably to guide the cabinet-maker in the assembly of the parts. This is strong evidence of

Phoenician manufacture, which is not invalidated by the fact that a bed found in an Assyrian building at Arslan Tash bears an Aramaic inscription: 'This . . . is carved by . . . son of Amma for our lord Hazael in the year . . .'.[133] Since Hazael was an Aramaic king of Damascus, the inscription would, by itself, show that the bed was made there. But it does not exclude the possibility that the bed was made by Phoenician workmen – or that the carved panels (the inscription is on an undecorated piece) were obtained from Phoenicia just as damask or silk is used for upholstery away from the places where it is manufactured. However, there is little profit in guessing at the precise circumstances under which this bed was made.

The discovery would obviously give us a date for the Phoenician style of carving, if we could be sure which of the panels belonged to the bed of Hazael. This is, unfortunately, only possible to a very limited extent, for there were two beds standing in the room, and only a few carved panels can be assigned with probability to the bed of Hazael. Its presence at Arslan Tash can however be explained. Hazael's son, Ben-Hadad, made submission to the Assyrian king Adadnirari III in 802 B.C. and, among the tribute which he offered, ivory furniture is especially mentioned. But the main buildings at Arslan Tash were constructed by Tiglathpileser III, a hundred years after Hazael, and there is no certainty that some of the ivories found in the ruins do not belong to the later period.

Discoveries at Samaria raise the same problem. Ivories found there have generally been ascribed to the reign of Ahab of Israel (875–850 B.C.) because of 'the ivory house that he made' (I Kings xxii, 39). And since Ahab married Jezebel the daughter of the king of Tyre, one would expect Phoenician works in his palace. But on the other hand, Samaria was not destroyed before 722 B.C., and it is probable that more recent furniture than that made for Ahab was in use in the palace at the time of the catastrophe. In fact, the ivories found at Samaria, like those from Arslan Tash, resemble some found at Khorsabad so closely that we must assume either that they are of about the same date (end of the eighth century) or that the same motifs were repeated for a hundred years or more without much change. Although this last alternative is not impossible, one could hardly accept it without proof. The couch of Assurbanipal, for instance [217], shows at the top panels of 'the goddess at the window'. But instead of the single face of illustration 383 we see that in the seventh century two figures were depicted, at knee length. Here, then, the lapse of some fifty or more years has, in fact, produced a change in design.

It has been necessary to point out these uncertainties to explain why no history of Phoenician ivory-work can be given, not even of the development of its style from the ninth to the sixth centuries. An early and a late group are known, but the intermediate stage remains uncertain. We can distinguish a number of works made in the ninth century and a more numerous group belonging to the last third of the eighth century, when Tiglathpileser III, Shalmaneser V, and Sargon campaigned against the Syrian and Phoenician princes and obtained, as booty or tribute, the furniture into which the ivories were fitted.[134] But we do not know whether any of the pieces which happen to be preserved belong to the early part of the eighth century.

The bronze bowls are even less well dated, and it is almost impossible to isolate Phoenician metalwork and jewellery from that of other regions. But one thing is clear: the decoration of both ivories and bronzes shows affinities with the repertoire of the second millennium B.C., pointing to a continuity which is absent in sculpture. But, then, there was not at any time a tradition of stone-work in the Levant, while ivory-carving and metal-engraving were old-established crafts which, apparently, the migration of the Peoples of the Sea did not destroy.

365 to 367. Heads of women,
from Nimrud. Ivory. *London, British Museum*

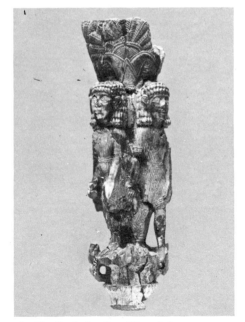

Ivories

There are two finds of ivories which belong to
the ninth century B.C. One comes from the
south-east palace at Nimrud,[135] the other from
Tell Halaf, from a tomb ante-dating the As-
syrian occupation of 808 B.C. The most charac-
teristic pieces on both sites are fine-featured

heads of women [365–7]. The majority are from
one to two inches high, but one found at Nimrud
measures more than five inches.[136] All of them
differ in specific respects[137] from the heads of
the later style of which the most beautiful one is
a quite exceptional piece, measuring six and a
half inches in height.[138] Sometimes two figures
of naked women are joined back to back [368]

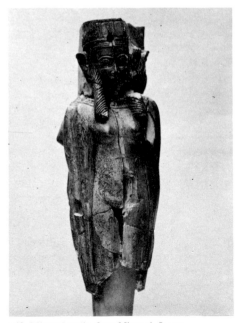

368. Mirror handle, from Nimrud. Ivory.
London, British Museum

369. Handle of a fan, from Nimrud. Ivory.
London, British Museum

to serve as an element in the decoration of a piece of furniture, or perhaps as a handle for a fan, a mirror, or some other object.[139] There are great differences in quality between pieces from the same site, but the best are very good indeed. It is a remarkable instance of the persistence of habits of dress in the East that the flat caps worn by these women are practically the same as those on the Megiddo ivories [308, 309, 316]. These caps are not shown on Assyrian monuments, and confirm the Levantine origin of the ivories. Some of these show, moreover, Egyptian features. The fan handle of illustration 369 displays four men holding hands. Clothed in Egyptian costumes, they stand round a pillar with a composite flower-and-palm-leaf capital. Another piece of ivory, the frontlet of a horse,[140] shows an Egyptian-looking woman holding a papyrus flower and standing under a winged sun-disk with two uraei, strictly conforming to the Egyptian pattern. The woman wears, however, the hair ornament which we also see in illustration 383; and this is not Egyptian.

With these pieces were a number of round unguent boxes in which Egyptian influence is much less evident [370, 371]. In fact, it is only apparent in the wigs, and in some of the costumes of the figures. It has been supposed that

370 and 371. Fragments of round boxes, from Nimrud. Ivory. *London, British Museum*

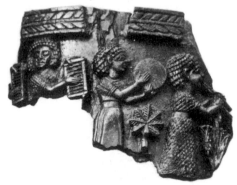
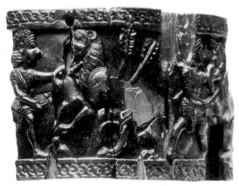

372. Development of a decoration on an ivory box, from Nimrud

they were made in north Syria rather than in Phoenicia.[141] This may be so; it is curious that the flame-like design on the thighs of the sphinxes of illustration 372, and of the lion of illustration 371, occurs also at Tell Halaf [345].[142] The manner of carving the boxes also differs from that of the Phoenicians; it is more crisp and tight. But it could possibly be argued that this contrast is due, not to locality, but to period; for here we are dealing with the earliest ivories. However that may be, the designs on the boxes are related to the two openwork plaques found at Hama.[143] Here, too, the flame-like design occurs on the hind legs of struggling sphinxes and butting bulls flanking a 'sacred tree'. But the relief is shallower and finer than that of the boxes, and the layer in which they were found belongs to the eighth century. Either the plaques of Hama were antiques when they were buried, or the stylization of the thigh muscles is not a safe indication of a ninth-century date. The subjects of decoration of the unguent boxes have no parallel among later Phoenician ivories and recall themes widely used in the Levant during the second millennium. The enthroned figure which receives food to the sound of the small orchestra of illustration 370[144] recurs on the Megiddo ivories [316], and, without the musicians, at Byblos [317] and at Beth Peleth in Palestine. The struggles with animals are popular at Ras Shamra [296] and at Enkomi in Cyprus [306]. The box with the musicians bears on its edge 'remains of Phoenician or Aramaean letters'.[145] It is perhaps most likely that the boxes were made somewhere to the north of Phoenicia proper.

Some ivories, found in Syria, but at an unknown place, may be tentatively placed in the ninth century B.C. also [373].[146] They differ from all other groups, and include a number of inlays which seem to have been directly fitted into the wood rather than forming part of a complete plaque. But the sphinxes with dowel-holes above and below belonged, apparently, to a piece of furniture, distantly recalling those of illustration 372, at least by the cast of their features. They are exceptionally well modelled in the round. The ivory is stained red and some pieces show traces of gilding.

Among the ivories discovered at Arslan Tash the fine figure of illustration 374 was found so close to the bed of Hazael (see p. 312 above) that it probably formed part of it. It differs greatly from all the other plaques, but its setting of entwined papyrus stems would not be strange in Phoenician work.[147] Other pieces found near it [377, 378] are so close to the ivories from Khorsabad that they cannot be separated from them

373. Sphinx, part of a piece of furniture. Ivory. *New York, Metropolitan Museum of Art*

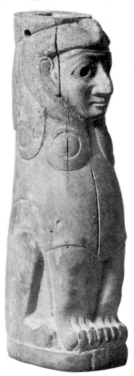

by a hundred years without some compelling reason.[148]

It is possible that the graceful frieze of palm trees is also earlier than the majority of the ivories, since it was found only at Samaria and at Arslan Tash [375] and at Carchemish, possibly in an early context.[149] The designs differ in detail; at Samaria, e.g., bunches of dates appear on palms similar to those of illustration 375.

We must now describe the large group of ivories which we assign to the last third of the eighth century B.C., when Assyria subjugated Syria and Phoenicia, admitting that some older pieces may have been accidentally included among them.[150] Most subjects are represented in sets of as many as a dozen copies, which evidently formed decorative bands or repeating insets in furniture. There were even at one site, Arslan Tash, two sets of the cow suckling her calf [376]. The one is in openwork and is most delicately modelled; the other, in which the ivory background is retained, shows a far-reaching conventionalization.[151] The eyes are sometimes inlaid. Fragments of such plaques were also found at Nimrud.[152] A design similar in general character consists of a grazing stag; it is found in openwork at Nimrud; at Assur, where it is set in a bronze background; and in solid ivory at Arslan Tash.[153] In all these animal plaques there is a simplicity and a sensitivity of

374. Figure of a man, from Arslan Tash. Ivory inlay. *Paris, Louvre*

375. Frieze of palm trees, from Arslan Tash. Ivory inlay. *Paris, Louvre*

376. Cow suckling her calf, from Arslan Tash.
Ivory inlay. *Paris, Louvre*

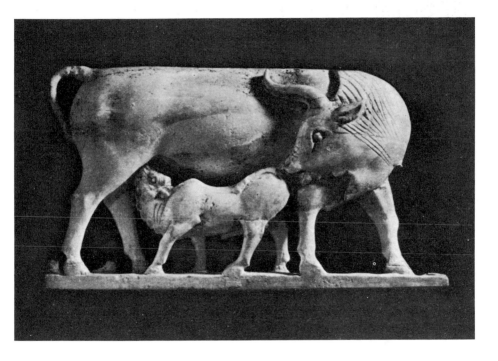

modelling which are unusual in Phoenician work; yet the stag from Assur appears among papyrus flowers, and the incongruity of this setting is in keeping with Phoenician usage.

A number of plaques are free renderings of Egyptian themes. In Egypt thrones and other royal furniture were decorated from ancient times with a symbolical design, 'Union of the two Lands', in which two gods bind together the plants of Upper and Lower Egypt. Illustration 377 shows one of a set of panels derived from this prototype; but little remains of the original vegetation, and of the costume only the wig, and a parody of the Double Crown. The central design is enriched by the small figure of a goddess, presumably Maat, although she does not hold her attribute, the ostrich feather, but a crook which is not normally shown in the hands

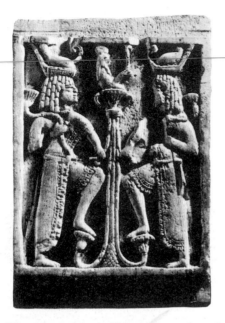

377. Design derived from the Egyptian 'Union of the two Lands', from Arslan Tash. Ivory inlay. *Paris, Louvre*

378. God on a stylized flower, with attendants, from Arslan Tash. Ivory inlay. *Paris, Louvre*

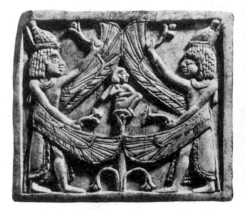

of Egyptian goddesses.[154] Another set of panels [378] shows in the centre a god on a stylized flower. This might either be the young sun-god appearing in a lotus from the primeval waters, or the birth of Horus in the marshes, where Isis had hidden him from her enemies. In that case the attendant figures should be female, not male; in the other context they are out of place altogether.[155] Yet one not disturbed by a knowledge of Egyptian iconography who considers

379. Ram-headed sphinxes between 'sacred trees', from Arslan Tash. Ivory inlay. *Paris, Louvre*

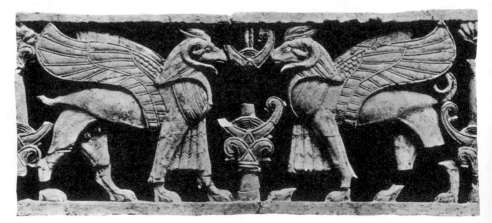

the plaques on their own merits would grant that they achieve a sumptuous ornamental effect, which was enriched by the application of gold foil to some details. There are also pieces carved on three sides, with indeterminate Egyptian figures, for insets in furniture.[156]

An exceptionally fine design both as regards composition and workmanship is shown in illustration 379.[157] Ram-headed sphinxes confront one another between 'sacred trees'. They wear an atrophied Double Crown. Their horns, genitals, feathers, and necklaces, and the bands round the 'sacred tree' were picked out with gold. The carving of the bodies, the plumage, and the cloth hanging between the front paws resemble the sphinxes from Khorsabad so closely [380] that it is hardly possible to separate them in time.[158] This applies also to some of the sphinx plaques found at Arslan Tash; others show squatting or resting sphinxes, with varying details.[159] At Samaria there are clumsy versions,[160] at Nimrud yet further variants,[161] and one sphinx plaque was found as far afield as Crete.[162]

Some themes were executed in a yet richer manner, with parts of the ivory cut away to take

381. Winged griffins and plants, from Nimrud. Ivory inlay, partly gilt and inlaid with lapis lazuli and other coloured stones. *London, British Museum*

380. Winged sphinx, from Khorsabad. Ivory inlay. *Baghdad, Iraq Museum*

incrustations of semi-precious stones and glass-paste of different colours. One piece, from Nimrud, shows the child-god on the Lotus, here with the correct Egyptian gesture sucking his forefinger. It has a close (but not exact) parallel at Samaria.[163] The splendid piece of illustration 381, in the same technique, shows what Phoenician art at its best may achieve. In a fairy-land jungle of scrolls and stylized flowers two winged griffins seem to cry out; they resemble their second millennium forebears more closely than their contemporaries on north Syrian or Assyrian reliefs or cylinder seals. An openwork version of the same theme was also found at Nimrud.[164] From Nimrud, furthermore, comes

382. Ivory inlay, from Nimrud.
London, British Museum

the fragment of a statuette adorned in this technique,[165] and two splendid pieces with an even more sophisticated enrichment [382].[166] Both show the same design: a lioness has sprung at a Negro who has fallen backwards; the beast closes its jaws over his throat. The kilt of the victim is rendered in gold foil and 'the effect of crisp curly hair was obtained by fixing gilt-topped ivory pegs in the head' – pegs the size of pinheads. The background shows a continuous pattern of Egyptian 'lilies' inlaid with lapis lazuli and smaller flowers in red and gold. Together with the two inlays, an ivory lion of the Assyrian type was found,[167] as if to emphasize the foreign origin of the richer piece, for the lioness of the inlays is neither Egyptian nor Assyrian. The naturalness of the movement of attacker and victim surpasses the usual Phoenician renderings and resembles that of the cow and calf from Arslan Tash.

The close connexion between ivories from various sites is further demonstrated by the subject of illustration 383, which has been found at Arslan Tash, Nimrud, and Khorsabad, while a

383. 'Astarte at the Window', from Khorsabad. Ivory inlay. *Baghdad, Iraq Museum*

miniature version occurred at Samaria.[168] It represents either Astarte or her votary 'at the window', leaning out and alluring men to serve the goddess by sexual union. The cult was devoted to Astarte in Phoenicia; to a 'beckoning' (*parakuptousa*: leaning out) Aphrodite in Cyprus, where the motif of our ivories recurs in a bronze support;[169] and to the goddess 'Kilili of the window' in Mesopotamia.[170] The frontlet which she wears is fastened with a cord round her head, and this was probably 'the crown made of a cord' which, according to Herodotus,[171] was worn by the women who went to the temple of Babylon once in their lifetime to offer themselves to a stranger in the service of the goddess.

In this case the Phoenician ivories could be understood throughout the Near East and interpreted in terms of a local cult. But what about the other themes? Did the sphinxes and sacred trees, and the many corrupt derivations from Egypt which had no meaning in Egyptian terms, possess significance for the Phoenicians and also for their customers? It has been maintained that these obscure designs were not unintelligible but reflected Phoenician religion in Egyptian guise.[172] This view was substantiated by reference to the religious texts from Ras Shamra which are six hundred years older, and perhaps even at the time of writing not valid along the whole of the Syrian coast. Indeed, they are by no means fully understood today. Yet if we turn to the sculpture of Ras Shamra, we can observe what happens when a people without pictorial traditions derives from a mature school of art the forms in which it wished to express its own conceptions. On various steles [294] we see figures of gods delineated according to Egyptian usage; but their attributes are distinctive and native. An alien but well-tried form was filled with a new, indigenous content. Such a procedure obviously did not give rise to the plaques of illustrations 377 and 378 nor to those from Nimrud showing a figure somewhat resembling

Pharaoh lifting his hand before a 'sacred tree';[173] nor such plaques as were found at Nimrud and in Samos and which show two nondescript Egyptian figures flanking a fantastic 'royal name' in hieroglyphs.[174] In all these cases there is nothing added to the misconstrued Egyptian themes, and it is therefore unlikely that they had a specific meaning. Other motifs, as we saw, could be understood throughout the Near East: the cow suckling her calf might stand for any mother goddess; an Egyptian cobra with two worshippers[175] could probably symbolize any earth-god manifest in serpent shape. Other monsters may likewise have possessed a generally acknowledged significance – there is, for instance, some evidence that the griffin may have represented the angel of death. But in the absence of texts we can hardly get beyond guesswork in any of these interpretations.

Moreover the wide distribution of Phoenician objects would bring them to regions where the religious significance of the designs could, in any case, not be grasped. Their popularity must have been due to an appreciation of their craftsmanship and design, and it would seem that a preoccupation with richness of decoration rather than with religion explains the peculiarities of Phoenician art. In particular the deviations from the Egyptian norm seem due to an inconsequential treatment by craftsmen indifferent to the meaning of their foreign patterns. The designs do not suggest a purposeful remodelling of foreign themes to make them suitable for the expression of native conceptions.[176]

Metalwork

The use of designs without concern for their original meaning is also characteristic of Phoenician metalwork, and here it continues a tradition represented already by the gold bowl from Ras Shamra [296]. The accumulation of unconnected motifs in concentric zones, and even the motifs themselves, recur in such examples as our illustration 393, though the hunters, monsters, sacred trees, and so on, appear in the guises suited to their different epochs. It is a fact, perhaps due to the absence of excavations, that these bowls have hitherto not been found in Phoenicia proper. They come from Assyria, Cyprus, Greece, and Etruria, and we may possibly include some that were made elsewhere. Cyprus, in any case, may be reckoned as part of the Phoenician cultural orbit. We know that Phoenicians were settled there, although they do not seem to have occupied the whole island. Fragments of fourteen bowls, found on the island, bear a Phoenician dedication of a governor of Hiram II of Tyre (c. 738 B.C.).[177] We know that in 713 B.C. seven kings of Cyprus came to do homage to Sargon at Babylon, 'seven kings . . . whose distant abodes are situated a seven days' journey in the sea of the setting sun and the name of whose land, since the far-off days of the moon-god's time not one of the kings, my fathers, who lived before my day, had heard, [these kings] heard from afar, in the midst of the sea, the deeds which I was performing in Chaldea and the Hittite land, their hearts were rent, fear fell upon them, gold, silver, and so on, of the workmanship of their land, they brought before me in Babylon and they kissed my feet.'[178] It was a shrewd and prudent act, and they no doubt arranged for a stele of Sargon inscribed with the words just quoted to be set up in their lands, but it would be quite wrong to suppose that the event made a change in the relations between Cyprus and Phoenicia.

The discoverers of the Arslan Tash ivories assigned them to 'un art phénico-chypriot', but this term merely evades the issue, which is to know whether Phoenicia or Cyprus was the original home of this hybrid art. I have given some reasons why I consider Phoenicia their land of origin, and other reasons will appear as we proceed. Meanwhile the gold bracelet of

384. Bracelet, from Cyprus. Gold

illustration 384 may serve as an emblem of the artistic links between Cyprus and Phoenicia; for the pattern of the four main elements of the bracelet has been called the 'Cypriot palmette', and it certainly was much in evidence on the island, being even used for the capitals of stone pilasters [385].[179] But it is also a standard design on the Phoenician ivories: it encloses the griffins of illustration 381 and the infant Horus on an ivory from Samaria,[180] and forms part of the 'sacred tree' on many of them – for instance in

illustration 379. It is equally common on Phoenician bowls, for instance illustration 393. These belong to the latest group and were actually found in Cyprus; an older group is known from Nimrud, where Layard discovered them in the north-west palace, the contents of which date to the reign of Sargon. It is quite possible that older pieces were among them, but at present we cannot distinguish these,[181] and we shall describe the Nimrud bowls, as far as they are published, as one group.

385. Cypriot capital of a pilaster

386. Bronze bowl, from Nimrud.
London, British Museum

We may begin by describing three pieces which stand apart. One bowl [386] presents a frantic mêlée of animals. Lions and griffins, bulls, and perhaps some other animals, are fighting madly without any traceable pattern in the design. So sophisticated an avoidance of order is a high achievement, but there is nothing in Assyria, or elsewhere (including the contemporary Aegean), which would indicate the provenance of this bowl.[182]

Two other bowls are equally remarkable. Their decoration with unprecedented boldness suggests a mountain landscape seen from above [387]. In one case[183] the separate tops combine into four ranges forming a cross. In the centre is a lake, and between the arms of the cross, trees and wild animals, including a bear, are engraved. There is nothing in this design to preclude it from being Assyrian (there are no parallels anywhere), but it cannot be separated from the bowl of illustration 387, which cannot be a native product, for here the mountains surround a fourfold centrepiece with four quite un-Assyrian heads. They recall Egyptian women,

387. Bronze bowl, from Nimrud.
London, British Museum

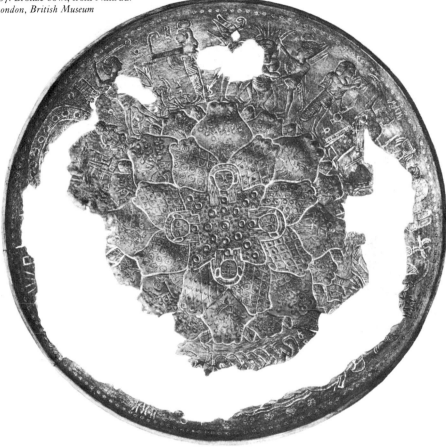

in a general way, but not, for instance, in the detail of their hair ornament. This kind of general resemblance to Egypt is characteristic of Phoenician work. The frieze which surrounds the mountain clinches the matter; in fact, the design has been described as 'the Phoenician pantheon on its Olympus'.[184] All the figures are dressed as Egyptians and wear Egyptian attributes, and not only in the conventional scheme of Pharaoh destroying a group of enemies but also in the Asiatic scene of two men attacking a third [cf. 346].

This surrounding frieze connects the bowl of illustration 387 with more usual specimens. The group of Pharaoh destroying his enemies is common among the Phoenician bowls of the seventh century and the three fighting figures which are found in the Tell Halaf reliefs (and of more ancient Mesopotamian lineage) form the centrepiece of another bowl from Nimrud[185] of which the surrounding design shows lions hunted from chariots, on horseback, and on foot [388, 389]. This subject would seem to be Assyrian, especially since a lion approaches the

388 and 389 *(above and right)*. Bronze bowl,
from Nimrud. *London, British Museum*

chariot from behind, but the hunters in the
chariot look like Egyptians, a mixture of affini-
ties which suggests Phoenician manufacture. A
similar bowl has been duly found in the West at
Olympia,[186] with a winged sphinx drawing the
chariot. This odd combination recurs on a bowl
from Delphi.[187] Here the sphinx wears an As-
syrian-looking helmet, but at Olympia a heavy
Egyptian uraeus. The Olympian bowl also re-
sembles the example from Nimrud in its work-
manship; the figures are heavily embossed. At
Delphi the design is lightly engraved as in some
of the seventh-century Phoenician bowls with
which it shares the rest of its design. The heavy
embossing is also used in a Nimrud bowl[188]
showing a succession of heroes between pairs of
lions, an old Mesopotamian motif rendered
with a total absence of Assyrian gravity; the
heroes are in many cases beardless, and wear
kilts, tunics, and Egyptian-looking wigs. The

outer border shows hounds and hares, exactly
as they occur on Greek orientalizing vases; the
central design is engraved and portrays a file of
antelopes round a rosette, an old Levantine
device. On some Nimrud bowls, animals in pro-
cession fill all the concentric zones, or alternate
with a circle in which they struggle.[189] A differ-
ent scheme of composition occurs when five
concentric zones of finely drawn animals in file
are cut through by figures along the radii of the
bowl, as we also see in illustration 390. But in
the Nimrud bowl[190] these upright figures are
mummy-shaped and double-faced. In illus-
tration 390 they vaguely resemble Egyptian
divinities and appear, indeed, underneath
winged sun-disks; the two bearded figures with
their striped garments reflect, perhaps, render-
ings of the Nile-god Hapi. The female figures
are only Egyptian in their headdress; their
nakedness and the gesture of holding the breasts

belong to the great mother of Asia. Two of the four figured panels in this bowl depict a meal in the manner of Egyptian and north Syrian funerary steles. Those who offer or consecrate the food hold an Egyptian *ankh* sign in the left hand; the recipient of the meal is, in one case, a nursing mother, possibly intended for Isis, although no attributes are given. The presence of musicians with double flute, tambourine, and lyre, already appears in such a context in the second millennium [316] and in north Syrian reliefs. The killing of the griffin shown in the fourth panel is an equally old motif, but commonly recurs also on the later Phoenician bowls. It is important to realize how intimately the repertoire of these bowls is connected with older Syrian traditions which were transmitted through them to Greece. In fact, the bowl of illustration 390 was found, as we saw, at Olympia. Yet it is related to the Nimrud bowl not only because the Janus-like figures of the latter stand along radii, as do the quasi-Egyptian gods of illustration 390, but also because the central

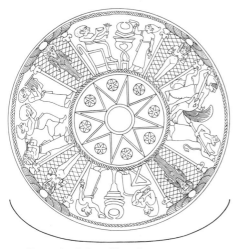

390. Bronze bowl, from Olympia

design of the two bowls is identical. Cyprus, too, can be brought in at this point, because a bronze bowl found at Idalion depicts a meal in a style which, though different, is not entirely dissimilar.[191] Here the frieze is continuous and Egyptian features are lacking. Behind the three musicians, who move less jauntily on this bowl, a row of women is shown holding hands in a dance still practised in the Levant today. They wear the flat caps shown in the older Nim-

rud, and even in the Megiddo ivories, and also in the statues from Tell Halaf. It is very probable that the bowl was made in Cyprus,[192] but this detail of dress suggests that it was made there by Syrians – i.e. Phoenicians – settled in the island.[193]

Among all these hybrid pieces, one bowl from Nimrud is curiously exclusive in the use of Egyptian motifs [391],[194] winged scarabs and correctly drawn falcon-headed sphinxes tramp-

391. Bronze bowl, from Nimrud.
London, British Museum

ling their enemies. Yet even this has no Egyptian parallel, the geometric central design is quite un-Egyptian, and the whole decoration is jejune and over-elegant, like those which Napoleon's cabinet-makers produced after the return of the Egyptian expedition. Once again we are led to Phoenicia.

The later group of Phoenician bowls is mainly found in Cyprus and Etruria. The Etrurian context dates them to the early part of the seventh century,[195] but some of the Cypriot bowls may be later. There are definite links with the Nimrud bowls: a network of six foliate rosettes covers the centre of one of them and also of one from Idalion.[196] A vase found at Delphi has the sphinx chariot of a Nimrud bowl, and a battle scene with Pharaoh destroying a group of bunched enemies. This subject decorated most of the temple pylons in Egypt and a number of Egyptian small objects, but it is not, I think,

392. Bowl, from the Bernardini tomb at Palestrina. Bronze

393. Bowl, from Curium, Cyprus. Bronze

known on Egyptian bowls. It occurs in the outer zone of the Nimrud bowl of illustration 388. In a bowl from the Bernardini tomb at Palestrina [392], the motif is almost correctly rendered by Egyptian standards[197] and the surrounding design, too, is purely Egyptian: the papyrus boats with the sun-beetle or Osiris are common on Egyptian tomb furniture. Moreover, the four boats 'square the circle', which is a characteristic Egyptian solution of the decoration of a round surface.[198] Between the boats appears Isis nursing the young Horus in the marshes.[199] The bands of hieroglyphs do not make sense, and this, the most purely Egyptian of the bronze bowls, carries a Phoenician inscription. Also, I do not know of Egyptian bowls with similar designs; the normal Egyptian decoration consists of marsh scenes – fish, fowl, and wild oxen, or boats and swimmers among the reeds.[200]

In another bowl, from Idalion in Cyprus, the same centre design is surrounded by a zone of various sphinxes trampling the enemies of Pharaoh, and the outer zone contains 'hunting scenes' with Egyptian- and Asiatic-looking participants. But in illustration 393, from Curium in Cyprus, the group of Pharaoh as victor appears in the outer frieze while a four-winged Assyrian demon despatches a lion in the centre. His action is unlike that of Assyrian hunters, but is known on Cypriot monuments of an earlier age [306]. Moreover, the Horus-falcon, normally hovering above Pharaoh, has been retained above the Asiatic demon. A similar combination of Asiatic and Egyptian figures occurs on a fragmentary silver bowl from Amathus in Cyprus;[201] a city is attacked, from the right, by Assyrian-looking archers and Greek-looking spearmen with crested helmets and round shields. From the left, however, soldiers of Egyptian appearance scale the walls, while their comrades cut down the city's orchards with an un-Egyptian implement, the double axe. On either side indistinguishable horsemen are shown to be converging on the beleaguered town. Any inclination to interpret this design as a record of actuality should be suppressed, for the defenders of the city consist of precisely the same mixture of peoples. In the second row of this bowl two Asiatics flank a 'sacred tree' bearing the 'Cypriot palmette', but these men hold *ankh* signs in their hands, and the other themes in this zone are Egyptian. The sphinxes in the inner zone also have Egyptian pretensions.

The Amathus bowl, and some found in Etruria,[202] show, in the continuous designs of some of their zones, attempts to tell a story, however fantastic or incoherent it may appear to be. We see hunts and warlike exploits, as on the Greek orientalizing vases with which the bowls are contemporary. The ivory carvers, on the other hand, rendered such scenes on unguent boxes of the ninth century, but after that they disappear.

The examples we have given illustrate both the virtues and the shortcomings of the most popular class of Phoenician metalwork. Like the ivories they tend to be garish. But they supplied Greece with a wealth of traditional themes, when it had exhausted the potentialities of the geometric style and a new start was made. In this function the earlier group of Phoenician bowls is the most important, and it is significant that examples of the later group, though common in Etruria, are rare in Greece. In the seventh century B.C. Greece was no longer avid for foreign goods; the oriental themes which had been borrowed in an earlier age had now been transformed into truly Greek designs.

THE ART OF ANCIENT PERSIA

INTRODUCTION

Persia alone among the peripheral regions possessed an individual style. This first appeared in prehistoric times and was never lost, even though it was overshadowed for long periods by Mesopotamian influences. The predominance of decoration over representation which marks the painted pottery of the fifth millennium is also characteristic of Achaemenian sculpture of the fifth century B.C. and sets it apart from its Assyrian and Greek contemporaries.

Vase painting was practised throughout Iran in prehistoric times, but it reached perfection in the south-west.[1] It used so-called geometric designs as well as natural representation, but the latter do not appear in their own right, but are integral parts of the design [394]. The mountain goats and hunting dogs, in their stylized forms, emphasize the roundness or the splaying height of the cups. The fine-lined transparent pattern below the lips of the beakers appears, upon closer inspection, to consist of a row of long-necked birds. There would be no point in asking which species was intended; for throughout this phase of painting the association of forms with living creatures merely imparts a peculiar richness to the design. Even if it were true, as has been surmised – but we have no means of knowing – that some of these animals had a religious significance, their treatment shows an exclusive concern with decorative potentialities; hence their austere, stylized, abstract character.

The best-known pottery of this school derives from Susa[2] [394]. At most of the other sites the style is represented by the mediocre products of ordinary craftsmen, but at Persepolis, as at Susa, there was a remarkable creative centre, using somewhat different shapes and more massive

394. Prehistoric vases, from Susa

designs.[3] Yet the essential similarity with the pottery from Susa is demonstrated by illustration 395. The swelling spirals are admirably suited to the conical shape of the cup; when one

395. Prehistoric cup, from Persepolis

turns the cup upside down, one realizes that they are the horns of two mountain sheep whose heads and bodies are drawn close to the base.

An off-shoot of this Persian school of vase painting is found at Samarra [1], and a debased derivative was made and used by the earliest settlers in south Mesopotamia, who had come from the highlands to Eridu, Al 'Ubaid, Ur, Warka, and other sites. But in Sumer vase painting fell into disuse after the efflorescence of civilization towards the end of the fourth millennium. In Iran it survived until the beginning of the first millennium, even though the highlands were under Mesopotamian influence.

Elam, the region bordering on southern and central Mesopotamia, was most thoroughly affected by Sumerian culture, although it retained, at first, a considerable degree of independence; it adopted a script inspired by, but not identical with, that of Sumer. It retained its language. It adopted the cylinder seal, and while its seal designs are, on the whole, variants of those of Mesopotamia, the earliest Elamite examples show distinctive features in both style and subject. They depict, for example, monsters more grim than those imagined by the men of the lowlands. Illustrations 22 and 23 give an idea of these designs.

When, towards the end of the Protoliterate Period, Mesopotamian influence radiated as far west as Egypt, it also penetrated farther into Iran. It is first traceable at Sialk, near Kashan on the edge of the central plateau,[4] and then, in Early Dynastic times, beyond the south-eastern shores of the Caspian, at Astrabad. But these traces are isolated; whether others remain to be discovered, or whether Iran stayed for a long time at a low level of civilization, we cannot say. In the west, in Elam, many arts and crafts followed Mesopotamian examples closely, as is often the case when one region supplies raw materials to another of superior culture. All kinds of metal came from Iran, which may well have been the homeland of copper-working on a significant scale; even the prehistoric painted pottery of Susa was found in graves containing sizeable copper tools and even mirrors. Gold and lapis lazuli came from Bactria in modern Afghanistan, by way of Iran. Elam supplied livestock needed continually to refresh the breeds which degenerated in the unwholesome climate of the plain. In time of peace the intercourse between Mesopotamia and Iran was lively, and the frequent wars which interrupted it supplied the mountaineers with Mesopotamian goods, notably works of art, which could serve as patterns for native artists; the steles of Naramsin and Hammurabi [91, 134] and all the known statues of rulers of Eshnunna were carried as loot to Susa and discovered there in recent times. And so we find that in the Early Dynastic Period the current Sumerian types of alabaster statues and plaques, of seal cylinders, vessels, and ornaments were also made in Elam. The stele of Naramsin was imitated in rock carvings by rulers of the very mountain tribes who overthrew the Akkadian dynasty.[5] The fine vases carved in bituminous stone during that dynasty and in the Isin–Larsa Period can also be matched at Susa.[6] Later, in the thirteenth century B.C., Elam flourished greatly. Its art showed splendid local variants of Mesopotamian themes. At Choga Zambil, in the neighbourhood of Susa, an unusually well-preserved Ziggurat has recently been discovered.[7] Instead of

396. Statue of Queen Napirasu, from Susa. Bronze.
Paris, Louvre

three staircases against one side ending in a gatehouse, the Elamite Ziggurat has a single staircase against three of its sides and each of these staircases ends in a gatehouse chapel which gave access to the upper stages. A life-size statue of Queen Napirasu of Susa, a triumph of the Elamite metal workers [396], may yet count as the most perfect realization in bronze of a plastic ideal essentially Mesopotamian – the achieving of three-dimensionality through cylinder and cone – but which had rarely found expression in such majesty and freedom.

Metalwork once more looms large among the remains of the kingdom of Urartu, near Lake Van.[8] Here, in the seventh century, Assyrian models were closely followed in bronze and also in ivory carving. The bronze bull-centaur – or probably centauress – shown in illustration 398 shows all the characteristics of Urartian work. It formed part of a piece of furniture, presumably a throne. The face was carved in ivory or stone; the horns were inlaid, perhaps in lapis lazuli, and other inlays enriched the front of the wing; the other side, turned away from the beholder, was nevertheless carefully engraved with the pattern of its feathers. Hair, garments, ornaments, all are richly rendered by metalworkers in complete mastery of their craft. Many of the figures were originally gilt. In a history of art all the works mentioned can count

397. Figure of a god, from Susa. Bronze. *Paris, Louvre*

398. Centauress, part of a throne, from Toprak Kale, near Van. Bronze. *London, British Museum*

as peripheral to the great Mesopotamian tradition, and they need not detain us; but they demonstrate the persistence of a metal industry at a very high level in western Persia through the centuries. And it was, again, in the field of metalworking that an original and peculiarly Persian school of art emerged in the seventh century B.C.

At this time conditions in Persia were very unstable. From about the year 1000 B.C. groups of mounted men speaking Indo-European languages pressed into Iran from Central Asia. The Medes and Persians were among them, but moved too far to the east to be observed in any detail by the Assyrians, our main source of information for the period. Only once, in 836 B.C., are the Medes mentioned by Shalmaneser III. But towards 700 B.C. new invaders arrived, this time via the Caucasus. The Cimmerians, who had lived to the north of the Black Sea, were driven from their homeland by the Scythians, horsemen of the Eurasian plains who were themselves under pressure from the Huns at war with the Chinese at the eastern end of the Steppe belt.[9] The Cimmerians moved into Armenia and crushingly defeated Rusas of Urartu in 714 B.C., but were headed off towards Anatolia six years later. They spread havoc throughout the peninsula, destroyed the Phrygian state, and endangered even Lydia in the west until Gyges defeated them in 660 B.C. Other groups of Cimmerians seem at some time to have moved southwards, into the Zagros mountains which form the border between Persia and Iraq in Kurdistan and Luristan. But the Scythians also moved into Iran, and stayed for some considerable time in the area between Media, Urartu, and Mesopotamia, an area extending southwards from Lake Urmya. The Scythians were a power to reckon with; Herodotus states that they ruled Persia for twenty-eight years.[10] The Assyrians were anxious to enlist them against Urartu and the Medes. One of the Scythian chieftains wished to marry a daughter of Esarhaddon of Assyria. But in the end he betrayed Assyria and joined the Medes and the Babylonians in an attack which led to the sack of Nineveh in 612 B.C.

Of events taking place within Iran we know little for certain, but we can imagine their nature by analogy with a similar protracted upheaval which destroyed the Roman empire. If we remember the vicissitudes of the Visigoths, from their first appearance on the north-eastern marches of Byzantium until the fall of their kingdom in Spain, we have an analogy for the history of the Scythians, Cimmerians, and other new arrivals, fighting among themselves and fighting the native princes, or serving them; gaining power in existing communities or creating ephemeral dominions of their own. The Scythians, and probably the Cimmerians, spoke an Indo-European language, like the Medes and the Persians. Yet we must not think of any of these mobile peoples as homogeneous. It was a mode of life, not common descent, that kept them together. The Aryan-speaking people may have been comparatively insignificant in numbers, but yet they dominated the natives. In particular they claimed from the local metalworkers a continuous supply of the weapons, horse-trappings, and other goods which they required. It was this conjunction of new demands and established native skill that produced a fresh outcrop of original work in the seventh century in western Persia.

A recent discovery illuminates the tangle of relationships which made up the art of the period. It was made at Ziwiyeh, near Sakkiz in Kermanshah province.[11] Sakkiz seems to preserve the name of the Scythians or Sakai,[12] which makes it likely that the modern town survives on the site of their ephemeral capital in Iran. The hoard of gold, silver, and ivory objects forms a heterogeneous collection, as the history of the region would lead us to expect. There are four groups: Assyrian, Scythian, Assyro-Scythian, and native. Purely Assyrian are a gold

399. Disk, from the Ziwiyeh treasure. Silver

bracelet with snarling lions,[13] and a number of carved ivories showing goats and 'sacred trees', scenes of lion hunts resembling the reliefs of Assurbanipal.[14] Purely Scythian are a small gold figure of an ibex[15] and the large silver dish ornamented with gold studs along its rim and measuring fifteen inches in diameter [399]. To appreciate their importance we must remember that Scythian art is best known to us from tombs in south Russia.[16] It appears there as a hybrid in which Assyro-Achaemenian and Greek elements are freely used within the context of the 'animal style'. This latter is found from Hungary in the West to Mongolia in the East, since it was patronized (though not always produced) by the mounted nomads of the steppes to which we have referred above. Its history can be reconstructed with a certain degree of probability; it has been suggested that it originated in carvings in wood and bone, and such objects have actually been found, for instance near Minusinsk on the Yenisei in Siberia; textile examples were preserved somewhat to the south, at Pazyryk in the Altai mountains. The earliest Scythian goldwork, with its compact shapes and its sweeping planes meeting with sharp ridges, recalls the shapes of the earlier carvings in wood or bone. The gold ibex from the hoard of Ziwiyeh conforms in every detail to this style.

The three motifs engraved on the silver dish are also characteristically Scythian. There is a stylized head of a bird of prey – commonly called the Scythian beakhead; a hare; and a compact crouching figure, found also, for instance, on the gold hafting of a Scythian axe from Kelermes in the Kuban valley.[17] It has been called a lynx,[18] and has been recognized on a fragment of a gold scabbard, also found at Ziwiyeh,[19] where it is merely a mask with pointed ears appearing at the crossings of a network of scrolls which circumscribe the figures of ibexes and stags; the stag shows the well-known Scythian pattern, with legs folded underneath the body, head thrown up, and antlers,

with many curling tines pressed against the back. The chape of the scabbard shows two small animals confronting one another;[20] similar creatures make up the tails and claws of the gold lioness from Kelermes, and two lions confront one another on the chape from Melgunov's barrow.[21]

The lynx and the hare of the silver bowl appear quite unexpectedly on another object from the hoard of Ziwiyeh. It is a crescent-shaped pectoral of gold, and the Scythian animals are used to fill the narrow sectors at both ends of the half-moon. Where the band widens, larger figures can be accommodated, but these are totally alien to the Scythian repertoire; they are peripheral Assyrian, perhaps even provincial Assyrian, as close – in any case – to Assyrian art as the metalwork of Urartu. There are ibexes flanking a 'sacred tree'; winged bulls, a griffin, and a sphinx wearing the cloth over its forelegs which we have met in the ivories from Khorsabad and Arslan Tash[22] (illustration 380 and p. 319).

In referring, in a first classification, to this pectoral as Assyro-Scythian I evaded the problem of its origin. It seems hardly possible to assume that the Scythian animals at its ends were engraved by Assyrian jewellers. Since the Scythian chieftains were on friendly terms with the Assyrians, there were exchanges of valuable gifts (the gold bracelet from Ziwiyeh may have been one), and these would supply the Scythian chief's armourers and jewellers with the patterns for Assyrian subjects such as appear on the pectoral.[23] The sword scabbard from the barrow of Melgunov supplies an exact parallel from south Russia.[24] The shape of the scabbard is Iranian, like that of illustration 432. Its decoration consists largely of garbled Assyrian motifs, but it includes one characteristic Scythian theme, the crouching stag.

Who the jewellers and armourers working for the Scythians were, is another matter. In Iran one would expect them to employ the native

metalworkers whose traditional skill was high. And at Ziwiyeh a bronze horse-bit of a type produced in quantities in western Persia was actually found.[25] We are now prepared to survey this native school of metalwork and to consider its relation with the Scythians.

THE LURISTAN BRONZES

During the last twenty years large numbers of bronze objects have been found by the wild tribesmen of Luristan, who did not encourage the competition of qualified excavators.[26] Only one expedition has investigated some tombs in these valleys, and its results are still unpublished.[27] As is usual when a fertile source of antiquities has been tapped, objects deriving from other places are given the fashionable label by dealers, and every kind of uncertainty attaches, therefore, to our present discussion. Yet a distinctive and homogeneous group of works can be isolated, and we shall restrict the designation 'Luristan bronzes' to this group.

Many bronzes which are quite probably found in Luristan must be left out of account.

For in Luristan, as elsewhere in Iran, more or less close imitations of Mesopotamian articles were made at most periods, and merely peripheral products of this type are not to be considered here.[28] One feels a little more doubtful about a number of buckets with Assyrian, or at least provincial Assyrian, designs [400]. Many of these are said to come from Luristan, and one was found near Kermanshah.[29] The thick-set, hirsute hunters can be matched by Elamites depicted in Assurbanipal's reliefs, and the ostriches and female sphinxes occur on Assyrian seals of the eighth century. Yet at least one design [400A] seems un-Assyrian.[30]

Some engraved bronze belts, once assigned to the hoard of Ziwiyeh, are now known to come from Luristan.[31] They resemble pins with flat round heads found in that region [401],[32] engraved with crude but lively designs in which Mesopotamian themes are used as a starting point for ornamental compositions. In this respect, and in some odd schemes, such as the fish-tail-like excrescence on the back of the goat in illustration 401, they resemble the horse-bits [402A], pole-tops, and other heavy castings for

400. Buckets, from Luristan. Bronze

A B C D

401. Pinheads

A B

C D E F

402. Two horse-bits (A, B)
and four cheek-pieces (C–F), from Luristan

which I reserve the designation Luristan bronzes. Some of the pins may be a little later in date,[33] but the bosses with the lion mask of these pins show nevertheless their close affinity with the weapons of illustrations 409 and 410.

The Luristan bronzes, in the narrow sense of the term, are without parallel in either Mesopotamia or Persia. They correspond to what has been described[34] as 'the nomad's gear'. Of this it is said: 'By their nature they must have everything portable, and it is to these portable things that they applied their art: daggers, with special sheaths, axes, bow-cases and quivers, shields, and hones; horse-gear, particularly the cheek-pieces of their bridles . . ., frontlets, and saddles, wagon parts, specially pole tops and standards. Men and women had metal plates sewn to their clothes, and straps (women's gear are nearly always foreign imports), belts and buckles and strap-ends, cauldrons, cups and bowls, mirrors.' There is no need to assume that the newcomers

in Luristan – be they Cimmerians, Scythians, or Medes – made these things themselves; in fact, the repertory of the Luristan bronzes, with its close affinities to Mesopotamian themes, suggests that the native metalworkers were set to supply the needs of their new masters. There are, in the first place, horse-bits with decorated cheek-pieces; they are shaped like a horse, a winged moufflon [402A], a crouching wild boar; some show monsters [402D, E]; another link-bit has at both ends of the bar-shaped cheek-piece, the small mouse-like heads which are common in the animals of Luristan [402B]. They recur in the four nondescript animals filling the spaces between the four main figures in the pinhead of illustration 403. Below, and hence appearing upside down, is the head of a moufflon; opposite, at the top, a man-shaped being supports with its hands the horns which grow from its head. Two little men stand at right angles to the figures just described.[35]

403 and 404. Pinheads, from Luristan. Bronze.
David-Weill Collection

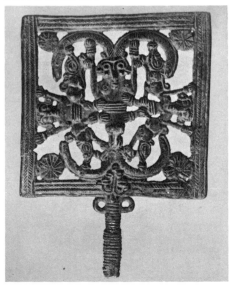
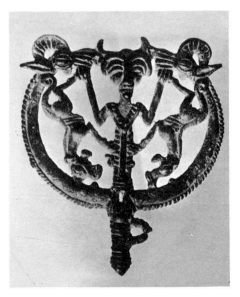

The vivid imagination that produced these designs is not unrelated to that of the seal-cutters of the Early Dynastic Period in Mesopotamia; but it is different in one important point. In Sumer each creature was conceived as a living organism; even the monsters looked as if they were capable of life. Although the designs were intricate and decorative, the organic coherence of each imaginative creature was respected. In Luristan, on the other hand, they are ruthlessly abbreviated or malformed to suit the decorative purposes of the designers, who show, in this respect, their affinity with the prehistoric vase painters of Persia.

The old Mesopotamian theme of a hero between beasts assumes forms quite unknown in Sumer. On the pinhead of illustration 404 he appears horned (as often in Luristan, and on some seals of Early Dynastic II), and clearly

406. Pole top, from Luristan. Bronze. *Paris, Louvre*

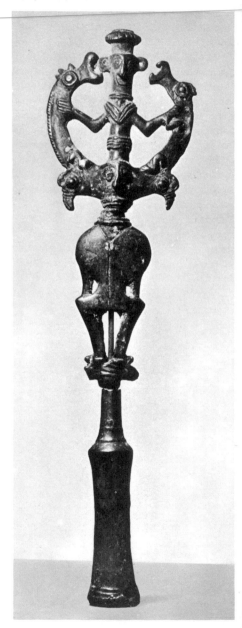

405. Pole top, from Luristan

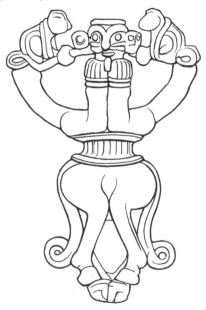

represented, holding two animals by the hind legs, upside down, within a surround shaped like goats' necks with heads flanking the hero's face. In illustration 405 nothing remains of him but his head, jutting out from the lion's joined paws, and his girdle, joining – incongruously but beautifully – the two great beasts. In illustration 406 he is better preserved, but duplicated, and the effect recalls totem poles. The old theme served in Luristan as a starting-point for all kinds of fascinating inventions, while the original meaning is lost sight of. For the hero between beasts, like all symmetrical motifs, carried in itself a balanced harmony which would appeal to decorators. The group, like the pairs of antithetical animals [407], was, for instance, highly effective as the finial of the four poles of the funerary car on which a chief was buried.[36] The composition of such splendid

pieces need not be questioned too closely. In illustration 406 one may doubt whether the lower part belongs to the 'man' in front view or renders the hindquarters of two animals. But this is quite unimportant; what matters in all these pole tops is the dashing outline; the rich play of light over the varied forms; the surprising suggestion, in many places, of life breaking forth. In the 'totem-pole' designs that is obvious, but in illustration 407 the volutes enriching the main theme – two ibexes – include two small animals; and in illustration 408 two goats' heads emerge from the front paws of the beasts, and their rumps have been replaced by two small lions. The pins [403, 404] achieve similar effects within a closed outline and the cheek-pieces repeat them; in one [402E] the top of a monster's wing lives as a bull, the hindquarters of a moufflon exist as a horned demon [402F]. Belt

407. Pole top, from Luristan. Bronze.
A. Godard Collection

408. Pole top, from Luristan. Bronze.
Bela Heine Collection

409. War axes, from Luristan

buckles, bracelets, and war axes [409] are treated in the same manner. The outline of the axes, for instance, is but little less bold than that of the pole tops; the thorns may turn into animal heads: the haft is shaped like a lion's open maw to accommodate the blade.[37] In an early study on Scythian art this has been aptly called a 'zoomorphic juncture',[38] by which fish-tails are made to end in rams' heads, tines of a stag's antlers in birds' heads, and so on. The rumps of the large lions in illustration 408 and the birds' heads and face in illustration 406 illustrate the same device. A most interesting case of zoomorphic juncture is presented by the halberds of illustration 410. Their character of Luristan bronzes in the narrowest sense is not in doubt, since in one of them the characteristic

small animal surmounts the haft. It is joined to the blade by a bearded face [410B]. But the other halberd reveals the origin of this motif in the ancient Mesopotamian monster, the lion-headed eagle Imdugud [63, 70]. The inflated cheeks, the square ears, the eyes with the inner corner pointing downwards, these are specific evidence of the derivation, which is, moreover, corroborated by the spreading feathers of the tail, which is all that remains of the bird in illustration 410A and has become a beard in the other halberd and some other examples. Once again we observe the stimulus which the smiths of Luristan found in ancient Mesopotamian themes. But this connexion raises a problem of very wide import, for it seems, then, that through the Luristan bronzes the 'animal style' of the steppes, the 'art of the northern nomads' is tied to the basic repertoire of western Asia – that of Sumer. The first question is that of the relation between the art of Luristan and that of the nomads, in particular the Scythians.

Now it is remarkable that the zoomorphic juncture, so characteristic for Luristan, is absent from the earliest Scythian metalwork. In south Russia the earliest pieces – from the Kostromskaya, Kelermes, and Melgunov barrows – show animals shaped in the typical Scythian manner, compact, sharply edged, richly antlered, but without zoomorphic junctures. The Scythian objects found in the hoard at Ziwiyeh,

A B

410. Halberd blades, from Luristan

equally early in the development of Scythian art, also lack the zoomorphic juncture. In Scythian art the zoomorphic juncture seems to have been an addition to the 'animal style', but in Luristan it is part of the prevalent procedure of using natural forms irrespective of their meaning or organic coherence for ornamental purposes. The zoomorphic juncture is applied to pole tops and pins, cheek-pieces and weapons, with a freedom and variety which one would expect in the application of a native invention. Thus there appears to be a case for supposing that the Scythians derived the zoomorphic juncture from Luristan.

The full import of that conclusion cannot be discussed here. It seems that Eastern examples of zoomorphic jucture depend on Western inspiration,[39] and since, in any case, influences from the West are known to have travelled east through the steppes, a new significance may attach to the resemblance of some Tao Tieh heads of Chinese art to the residual head of the Sumerian bird Imdugud in illustration 410; they have the same bulging cheeks, slanting eyes, and square ears. The same head, rather than the lion mask, seems to adorn a weapon closely related to the Luristan bronzes, the T. E. Lawrence dagger-hilt in the British Museum [411]. The silver was cast on to the iron blade and hilt-case by the *cire perdue* process, so that the rosettes which simulate rivets are really mere ornaments. The curious type of pommel, with a wedge-shaped space between the splayed lunate wings, which was filled with wood or bone, recurs in other daggers from Luristan and in the Caucasus region, but is also depicted among the weapons captured by Sennacherib in southern Mesopotamia about 700 B.C.[40] It is not found in Achaemenian times, and seems, therefore, confined to the seventh century, where the zoomorphic juncture would likewise place the hilt. The lions on the latter resemble the animals on round-headed pins and bronze girdles from Luristan. On these, too, the necks of the animals

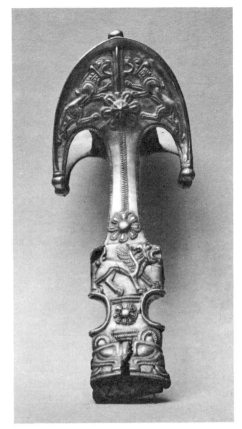

411. The T. E. Lawrence dagger-hilt. Silver. *London, British Museum*

are striped lengthwise, and there is hatching along their outlines.

The use of Imdugud by the metal-workers of Luristan shows that their connexion with Mesopotamia was of long standing. Imdugud can hardly be found in Assyrian art, and other motifs basic for Luristan designs (such as the hero between two rearing animals) were equally outmoded in Mesopotamia by the seventh century B.C. The survival in Luristan is understandable if the relation between the native metal industry

and Mesopotamia was an old one, and for this there is evidence, as we have seen (pp. 340 ff. and Note 28 thereto). The novelty of the bronzes would then represent the response of an established craft to the demands of the newly-arrived Aryan horsemen. What little we know of the archaeological context corroborates this view. The Luristan bronzes have been discovered, it seems, in conjunction with long-spouted bronze ewers and certain painted pots which are also found in Necropolis B at Sialk, near Kashan, well to the east of Luristan.[41] The Sialk tombs were equipped with simple horse-bits, daggers not unlike some found in Luristan, ornaments of solid bronze and of punched and engraved bronze foil obviously related to some of the Luristan finds, but without the elaborate decoration which we have been studying. There are no decorated cheek-pieces to the horse-bits, no huge pins, no axes or pole tops with zoomorphic junctures. In short the Luristan bronze industry appears as a special local development within a cultural province occupying a much larger area. With the establishment of the Achaemenian empire the best craftsmen were concentrated where the court resided and the folk art of Luristan was superseded.

ACHAEMENIAN ART

Introduction

The Medes, allied with Scythians and Babylonians, destroyed Assyria, but did not extend their power outside Iran. Eighty years later the Persians took over the empire which Babylonia had meanwhile administered. A tribe of nomadic or semi-nomadic horsemen took charge of the civilized world and did not destroy civilization but enhanced it.

This was mainly the work of one man: Cyrus of the family of the Achaemenids led the Persians, but had begun his chieftainship as a vassal of the Medes (559 B.C.). Ten years later he de-

feated the Median ruler, Astyages. In 546 he defeated Croesus of Lydia, in 539 Nabonidus of Babylon. He died in 529, and his successor Cambyses conquered Egypt in 525. This king was violent and unbalanced, an exceptional figure among the descendants of Achaemenes. With Darius I (522–486 B.C.) the empire resumed the course set by Cyrus the Great. For two centuries it was ruled with efficiency, justice, and tolerance.

The decisive conquest had been that of Babylon, the Rome of the ancient world. The dignity of 'King of Babylon' – like that of Roman Emperor – carried implications far beyond the scope of political power, and the Persian chieftain, in assuming it, became a symbolical figure whose significance was derived from immemorial associations. Cyrus acknowledged the peculiar prestige of the title by using the style 'King of Babylon' in his inscriptions, and he resided as frequently at Babylon as in his homeland or at Ecbatana, the capital of the now befriended Medes which served as winter residence to the Achaemenids. Darius I gave precedence to the Persian titles, but when he styled himself 'King of this Earth' we catch an echo of the religious aspect of Babylonian kingship, which Cyrus explicitly acknowledged by calling himself, in the old way, 'King of the Universe, King of the Four Quarters [viz. of the World]'.

Mesopotamia had evolved a setting appropriate to its royalty, but the native traditions of the Persians ignored monumental art. We may credit them with an interest in fine and showy weapons and horse trappings, rugs, blankets and hangings, and leatherwork. Achaemenian architecture and sculpture were created to meet the unprecedented situation in which the Persians found themselves when their leader ascended the throne of Babylon. To achieve their end they exploited all the various skills and traditions of the peoples of the empire. This is explicit in the building inscription for Susa

which Darius I composed. After a preamble the text runs:[42]

A great god is Ahuramazda, who created this earth ... who made Darius king, one king of many, one lord of many.

I am Darius, great king, king of kings, king of countries, king of this earth ... what was done by me, all that by the will of Ahuramazda I did.

This is the palace which at Susa I erected. From afar its ornamentation was brought. Down the earth was dug until rock-bottom I reached. When the excavation was made, rubble was packed down, one part 40 ells in depth, the other 20 ells in depth. On that rubble a palace I erected.

And that the earth was dug down, and that the rubble was packed down, and that the brick was moulded, the Babylonian folk, it did that.

The cedar timber, this – a mountain named Lebanon – from there was brought; the Assyrian folk, it brought it to Babylon; from Babylon the Carians and Ionians brought it to Susa.

The Yaka wood from Gandara was brought and from Carmania.

The gold from Sardis and from Bactria was brought, which was used here.

The stone – lapis lazuli and carnelian – which was used here, this from Sogdiana was brought.

The stone – turquoise – this from Chorasmia was brought which was used here.

The silver and the copper from Egypt were brought.

The ornamentation with which the wall was adorned, that from Ionia was brought.

The ivory which was used here, from Ethiopia and from Sind and from Arachosia was brought.

The stone pillars which here were used – a place named Abiradush, in Uja – from there were brought.

The stone-cutters who wrought the stone, those were Ionians and Sardians. The goldsmiths who wrought the gold, those were Medes and Egyptians. The men who wrought the ishmalu, those were Sardians and Egyptians. The men who wrought the baked brick, those were Babylonians. The men who adorned the wall, those were Medes and Egyptians.

Says Darius the king: At Susa, here, a splendid task was ordered; very splendidly did it turn out.

May Ahuramazda protect me; and Hystaspes who is my father; and my country.[43]

It is an astonishing fact that this motley crowd produced a monument which is both original and coherent; a style of architecture and a style of sculpture possessing unity and individuality to an extent never achieved, for instance, in Phoenicia. The pervading spirit, the very design of the buildings and reliefs, never changed from the reign of Darius I until the defeat of Darius III by Alexander. And that spirit – that design, too – was Persian.

It is instructive to trace the foreign strains in Achaemenian art precisely because they set off the novelty of the works in which they are integrated. One observes, for instance, that the Achaemenian palaces follow Mesopotamian usage in many respects. They are built on artificial terraces; the walls are of mud-brick, sometimes embellished by carved slabs of stone and panels of polychrome glazed bricks. The gates are protected by huge figures of human-headed bulls. The great god Ahuramazda, never hitherto depicted, was rendered as Assur had appeared in the Assyrian palaces, a bearded figure in a winged disk. At the same time, however, the doorways of the palaces were crowned by an Egyptian cavetto moulding; and this rested – as it never did in Egypt – on the Greek astragal, an egg-and-reel moulding. The bases and shafts of the earliest columns are Ionian, too, but the capitals are not found outside Persia, and the height and number of the columns are without parallel in Aegean lands. As to the reliefs, they have little in common with their Egyptian and Assyrian counterparts in subject matter, and nothing at all in style; they show the influence of Ionian workmanship.

But the tracing of the diverse strains in the architecture and sculpture of the Achaemenians is supererogatory, if we seek to recognize the distinctive character of these arts, a character established in the reign of Darius I and maintained, unchanged, for two centuries.

Architecture

It has been suggested that the Persians entering Iran learned 'cyclopean architecture' – the building with large blocks of untrimmed stone – from the Urartians.[44] In any case, two terraces built in this manner in the modern province of Khuzistan, which the Persians considered as their homeland, have been interpreted as strong points of the first Achaemenian chieftains and of Cyrus the Great at the beginning of his reign.[45] One of these, the terrace at Masjed-i-Sulaiman

[412], about twenty-five miles south-east of the modern town of Shuster, shows several features recurring at Persepolis in a more elaborate version. It is backed against a mountain; it utilizes a natural spur of rock which was levelled and enlarged towards the east by means of an artificial terrace; a number of stairways give access to it, and one of these is of impressive proportions; its twenty-five steps have a width of seventy-five feet. But there are few traces of buildings on the terrace. At its southern end there is a three-roomed pavilion raised on a

412. Masjed-i-Sulaiman, terrace

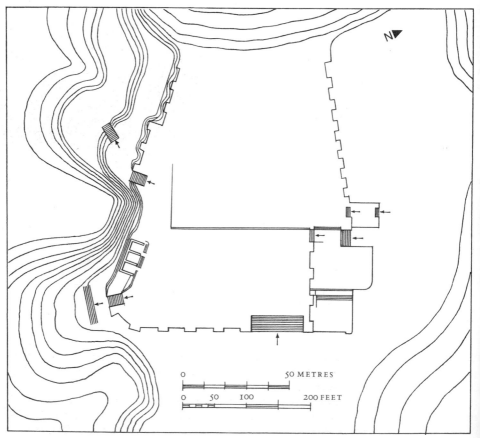

plinth, where one can imagine the chieftain presiding over an assembly of the nobles, or even of the tribe, all living in tents in the surrounding plain.

The permanent residence which Cyrus the Great erected at Pasargadae [413] still retains the character of a settlement of a nomad chief.[46] Separate pavilions stood in a vast park surrounded by a wall thirteen feet thick. A monumental gatehouse gave access to the enclosure. Its outer entrance was guarded by two huge winged bulls, its inner opening by human-

posite crown [427], and bore the building inscription:

> I, Cyrus, the king, the Achaemenid
> [*viz.* built this].

Six hundred feet farther on stands an Audience Hall (Palace S). It consists of an oblong hypostyle audience chamber surrounded by four pillared porticoes. On the south-western side, where one entered, the portico was flanked by square towers; at the back the portico was *in antis*. The central room had niches and door

413. Pasargadae

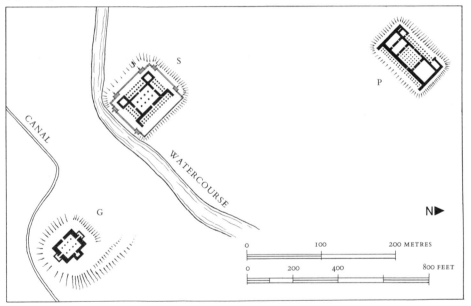

headed bulls of the Assyrian type, all of greyish-black limestone. Eight columns on black stone bases supported the roof of the main room; there were small chambers on either side. One of the door jambs of these is preserved. It shows, in relief, a four-winged demon with an odd com-

frames of stone and was presumably lighted from above, for its ceiling rose well beyond those of the porticoes, and there was, therefore, opportunity for clerestory lighting. Its columns stood thirty-six feet high and those of the surrounding porticoes only eighteen. Throughout

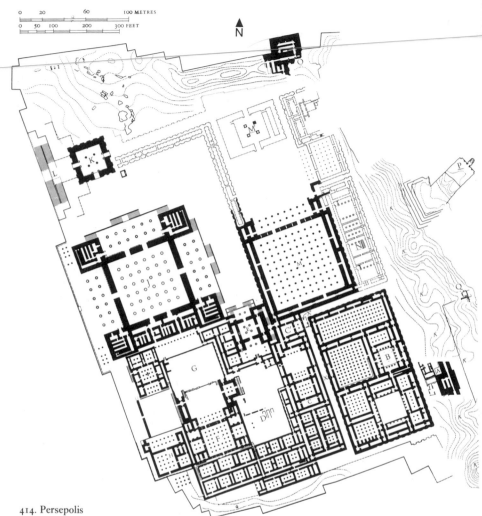

414. Persepolis

A, A′, etc. Eastern fortifications
(partially excavated)
B Treasury
C Harem
D Ruined building
E Tripylon
F Palace of Xerxes
G Ruined building
H Unidentified palace
I Palace of Darius I
J Audience hall of Darius I

K Gatehouse of Xerxes
L Stairway to terrace
M Throne hall of Xerxes
M′ Gate to court of throne hall
(partially excavated)
N Outbuildings (partially excavated)
O Northern fortifications
(partially excavated)
P Royal tomb
Q Cistern
X Street between harem and treasury

the buildings at Pasargadae the stonework is in two colours, an enrichment not, apparently, used in later reigns: black column bases support white shafts; black niches and door frames are set in white walls.

There were reliefs on the door which led into the audience chamber, but only the lower parts are preserved. There are two themes only. On the doors of the short walls one saw two figures, the first of which had birds' claws instead of feet. Perhaps it was the victim of the second. On the doors of the long walls the relief showed an ox led in by three barefooted persons, perhaps priests.[47] The columns had capitals of the type better known from Susa and Persepolis, though with unusual variations.[48]

Another building (Palace P) stood some eight hundred feet farther to the north. It is interpreted as a residential palace. Its front consists of an open portico of twenty wooden columns *in antis*, about eighteen feet high, as a surviving pilaster shows. At the back of this portico there ran a long bench, of white limestone with a black top, and black bands are let into the white limestone pavement. A single door leads to the central hall, which is almost square and contains thirty columns. There is no trace of the capitals, but curved remnants of brightly coloured plaster seem to derive from the casing of the columns. The building contained another portico at the back, but at the sides there were a number of smaller rooms, closed and built of mud-brick with mud floors – presumably the living apartments. The two doorways between the central hall and the porticoes were carved with figures of the king followed by a servant leaving the hall. These embellishments were perhaps made or completed by Darius, as we shall see in discussing the reliefs.

The best-known Achaemenian site is Persepolis [414].[49] Here work continued for over fifty years, through three successive reigns, from Darius I, who began it in 518 B.C., through reign of Xerxes into that of Artaxerxes I, about

460 B.C.[50] The terrace is bordered by mountains in the north and east. It measures about 1,500 by 900 feet and is about forty feet high. It was once topped by an enclosing wall of mud-bricks, from forty-five to sixty feet high, which was stepped back to the single entrance at the north-west end, the gatehouse K.[51] One approached this by means of a large stairway (L) which was so gently graded and of such width that groups of horsemen could mount it without difficulty. The gatehouse was built by Xerxes, who gave it the curious but significant name 'All Countries'. The implication seems to be that all peoples passed through it to pay homage.

The gatehouse resembles that at Pasargadae in possessing a pillared room and also in having its outer entrance guarded by bulls, its inner entrance [415] by human-headed bulls. Turning to the right, one reaches the great audience hall (J) begun by Darius I and completed by Xerxes and Artaxerxes I. It stands on a terrace of its own. Beyond the audience hall stands the

415. Persepolis, Gate of Xerxes

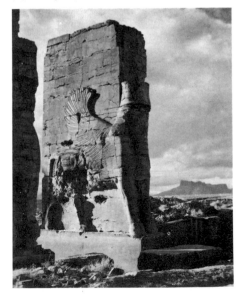

throne hall, the Hundred Column Hall (M), started by Xerxes and completed by his son.

These two square halls effectively separate the northern part of the terrace, accessible to a restricted public, from the royal apartments situated behind them. Access to these was by means of a very beautiful staircase, placed at the end of an esplanade or *cour d'honneur* between the two audience halls [416, 417]. It leads into a

Not only in the details to which we have referred, but also in general layout, Persepolis recalls Pasargadae. In both cases separate buildings are loosely grouped together. A reconstruction of the palace at Susa suggests a different plan. South of a pillared hall resembling those which we have described (J and M)[54] there appears a complex of rooms grouped round three courts in the manner of the Mesopotamian

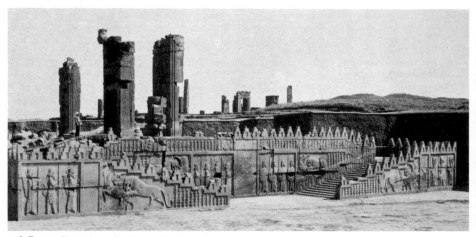

416. Persepolis, staircase leading to the Tripylon

building (E) called the Tripylon because it had, in addition to its entrance and exit, a third door which led down to the level of the harem in the east.[52] Leaving the Tripylon and turning sharply to the west, we pass through the ruins of a building (G) perhaps constructed by Artaxerxes III and reach, at the edge of the platform, the residential palace of Darius I (I). Building H, to the south, is now believed to have been constructed from remains of an older structure after the burning by Alexander the Great.[53] Next to it are the residential palace of Xerxes (F) and the ruins of another building (D). The L-shaped complex surrounding D is called the harem, and B, at the foot of the rocks, the treasury.

palaces. But the excavations were carried out here with very little understanding, and what now remains is far too equivocal for us to consider the existence of this Mesopotamian type of plan in Achaemenian architecture a certainty.

The architecture of the Achaemenids is remarkably original, especially in the lavish use of columns and the predominance of square rooms. At Pasargadae all the main apartments are oblong, but at Persepolis the plans, which otherwise resemble those of the older buildings, are redrawn round a square. The square chamber appears as an independent unit in the gate of Xerxes (K); as the central feature in the pillared halls J and M; in the residential palaces I, F, and

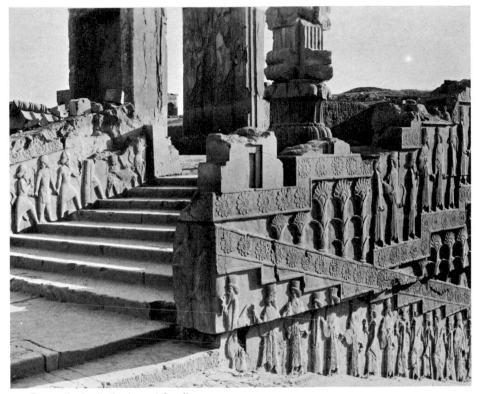

417. Persepolis, detail of staircase (cf. 416)

H; in E; and in C, the harem. Here, moreover, the hypostyle main rooms of its twelve apartments are also square. Insistence on square rooms is a lasting feature of Achaemenian architecture, established in the reign of Darius. While Cyrus was king, both architecture and sculpture were still in an experimental stage.

Much has been written on the origin of the Achaemenian pillared halls, but to little purpose. They have been derived from Median architecture, of which nothing remains,[55] and from the *bît-hilani*, which is different in all important respects.[56] The audience hall of Darius (J) is, in any case, an impressive structure, 250 feet square, with a height computed at sixty feet. It is said that it could accommodate ten thousand people. The four corner towers contained, presumably, guard-rooms and stairs. There are porticoes on three sides, and service rooms on the fourth; the latter feature differentiates the building from the palaces of Cyrus at Pasargadae. The western portico commanded a free view of the plain and the sunset, for the fortress wall which stood on the edge of the terrace was interrupted here and replaced by a low parapet.[57] The great stairways which gave access to the separate platform on which it stood (cut from the living rock) were decorated with the great procession of tribute bearers [418, 435, 436, 439].

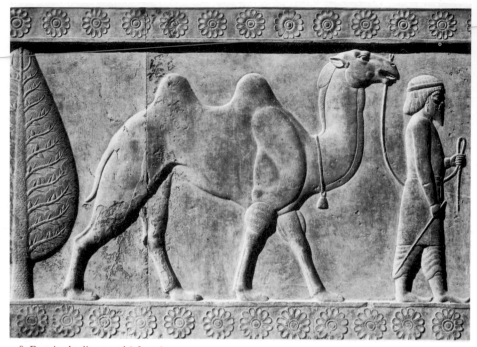

418. Bactrian leading camel (cf. 439)

The throne hall or Hall of the Hundred Columns (M) was begun by Xerxes and finished by Artaxerxes I. It had a portico on the north side with sixteen pillars and two huge figures of bulls as guardians at either end built into the walls of the towers. On the other three sides it was surrounded by a narrow service passage. There are two doors in each wall, and seven stone-framed windows in the wall between hall and portico; in the other walls there are niches instead of windows.[58] The insides of the doors were carved in relief; those on the north and south sides showing the king enthroned; those on the east and west sides depicting the king in combat with monsters. The hall stood at the southern end of a courtyard to which a gate-house, resembling the 'Gate of All Countries' (K), gave access. Thus the throne hall was re-

markably well guarded, for it was only accessible through its portico. It has been suggested that in this hall the greatest royal treasures were exhibited surrounding the enthroned monarch with additional splendour at great functions.[59]

In the residential palaces (I and F) we also find the portico with a double row of columns leading into a square main room, but this is surrounded on three sides by small chambers, as one would expect in living quarters. At Pasargadae this type of building is represented by 'Palace P'.

A somewhat similar building (C) lies in front of the harem with its twelve apartments, each consisting of a square hypostyle room connected with one or two long narrow chambers. The main building (C) is faced across the court by a complex (C¹), which has been interpreted as the

quarters of the guard. A flight of steps leads down into this from the Tripylon. Since there is also a connexion between c^1 and the Hall of the Hundred Columns, the first building might also have contained the royal robing chamber. We are reduced to guesswork if we wish to define the function of the rooms more precisely.

To the east of the harem lies a building (B) which is called the treasury by the discoverer,[60] who means by this term the royal storehouse and armoury. It is surrounded by a wall with stepped recesses, in the Mesopotamian manner, and only one gateway led into this enclosure. Its main feature was the number of large pillared halls surrounded by narrow corridors. The single entrance gave access to guardrooms leading into the court (marked B) with the four porticoes; in two of these are orthostats with a relief showing Darius receiving an official in audience [430]. Thousands of arrow-heads, javelins, and other weapons and many hundreds of tablets were found in the surrounding rooms. Its pillars were of wood covered with plaster which was painted in blue, red, and white [419].

419. Column of wood covered with painted plaster, from the treasury of Persepolis

After our survey of the layout we shall now consider the elevations of the buildings, and we must first comment on the peculiar nature of the stonework. We have mentioned stone door frames and window frames and niches; they are best preserved in the residential palace of Darius [435, background], but all are treated in the same way. They are not built up logically, as was done in Egypt or Greece, from four separate pieces: lintel, sill, and two jambs. They are sometimes carved in a single block; at other times parts, one-half or three-quarters of the circumferences, were cut from one block and the rest from one or more separate pieces. In other words, the stone was treated in the manner of a sculptor, not that of a mason. The same odd treatment is observed in the stairs; these are not regular units cut in quantities and used in a set fashion, a number of identical blocks for the treads and a number of blocks to build the parapet, but 'it is the rule that an arbitrary width and length of steps is hewn out of the same block with part of the parapet. In a similar way columns are never made of a fixed number of drums' of a given size.[61]

The columns are the most characteristic feature of Achaemenian architecture. Many were of wood, on stone bases, the shaft sometimes plastered and painted [419]. We know nothing of the capital which topped these, but we have all the elements of the stone columns, and we shall discuss these elements separately. Here, again, Pasargadae represents the formative phase of Achaemenian art and Persepolis the mature, established form.

The base of the columns of Pasargadae is a torus with horizontal flutings. This is the Ionian form of base, represented, in the time of Cyrus, by the columns which Croesus of Lydia gave to the Artemision at Ephesus.[62] In Greece Ionian columns retained this type of base into later times, but at Persepolis and Susa bell-shaped bases with flower or plant designs replaced the fluted torus [424, 426].

The fluted shaft of the columns at Persepolis is likewise derived from Ionia, although the Greeks never used so large a number of flutings (forty to forty-eight). At Pasargadae the shafts of the columns are smooth.

The capital of the Achaemenian column is without alien prototypes, although foreign motifs are utilized for it. Its upper part has been rightly compared with a forked sapling used to this day in native houses in Persia to support the rafters.[63] In Achaemenian architecture the fork becomes an impost block shaped into the foreparts of two animals [425, 426]. These may be bulls, bull-men, or dragons.[64] They may either rest directly on the shaft of the column, or two members may be interposed, namely a corolla-shaped capital [425] and a connecting piece composed of eight vertical double scrolls [426].

The capital is itself of complex design; it rises from a ring of drooping sepals, and its shape to some degree recalls the Egyptian palm-leaf capital; but even in Egypt the papyrus and lotus capitals had, in the second half of the first millennium, assumed this kind of segmentation.[65] Moreover, each segment is decorated at the centre with a papyrus flower. This proliferation of vegetal ornament unconnected with the basic form of the capital is also common in Ptolemaic temples in Egypt.

The connecting piece with the eight vertical double scrolls brings us back to Ionia again, or rather, to the eastern Mediterranean. The Achaemenian capitals can be understood as unusually rich offshoots of a development which took place in the Levant in the sixth century B.C. and led to the Ionian capital. The distinctive double volute of this capital can be traced back through a number of divergent Levantine forms to the turned-down sepals of the Egyptian 'southflower', the so-called Lily of Upper Egypt.[66] Examples of volutes are known on the capitals of pilasters on various Palestinian sites, for instance, at Megiddo; and in Cyprus [385];

they appear, three times repeated, in a 'sacred tree' at Sakjegözü [354], and in double or triple form on the glazed brick façade of Nebuchadnezzar's palace at Babylon as recently reconstructed.[67] It is clear, therefore, that a pair of volutes was used throughout western Asia as the finial of column-shaped objects, pilasters, and so on. The drooping sepals of the capital are known in north Syrian architecture in the ninth to eighth centuries B.C. We recognize this from renderings of capitals in relief;[68] from the capital supporting the eagle of Tell Halaf [340]; and from the columns appearing in the ivories below the window of the 'beckoning Astarte' [383].

Now, the double volute and the drooping sepals occur together in capitals found at Nape and Neandria in Lesbos [420]. The double volutes appear on the front of an oblong impost block above the two rings of leaves. These rings turn, in Greek architecture, into cymatium and astragalus (egg-and-reel moulding); an early example is found in a column from the Ionian colony of Naukratis in Egypt, dated about 500

420. Capital, from Neandria

421. Capital, from Naucratis

B.C. [421]. More complete is the column erected to support a sphinx [422] by the Naxians at Delphi, in the first half of the sixth century B.C. Here the double volute has almost, but not quite, assumed the shape it has in the classical Ionian column; for it is still used as a separate impost block supporting the figure of the sphinx.

423. Stand, from Curium, Cyprus. Bronze. *London, British Museum*

422. Capital of the column of the Naxians, from Delphi

There is other evidence, too, that the double volute was used as an independent element; the most important evidence is supplied by the bronze stand for a mixing vessel from Cyprus [423], for here they are used vertically, as in the Achaemenian columns, and on a column too.[69] It is a sacred tree, with a double volute on either side – in reality, therefore, probably, on four sides – above a capital rendered by two single volutes. The various transitional forms which we have briefly reviewed here show that the Ionian and the Achaemenian columns are both the products of a development which was centred in the eastern Mediterranean in the sixth century B.C. Yet how great is the contrast. The Ionian column, for all the richness of its fluted base and shaft and its efflorescent capital, remains a clear and logical architectural member;

424. Persepolis, Hall of the Hundred Columns.
Reconstruction by Charles Chipiez

the Achaemenian column is bizarre in the extreme. But its massed effect has splendour, as a reconstruction of the Hall of the Hundred Columns shows [424]; and this effect is not the result of a more or less haphazard combination of borrowed features, but of an original and carefully conceived design. Illustrations 425 and 426 illustrate the point; observe, in the middle of each segment of the corolla-shaped capital, a papyrus flower on a fluted stem, as unknown to Egypt as the use of the astragalus as an edging is unknown in Greece. The derivations

425 *(above)*. Column, from Persepolis

426. Column with human-headed bull capital, from
the Tripylon, Persepolis (cf. 442)

have been integrated in a whole which possesses its own peculiar harmony – a harmony which cannot be appreciated if one is merely preoccupied with the historical origins of its elements.[70] It was a Persian creation, just like the remarkable building of which it was a part, the palace of which Darius said in an inscription: 'I built it secure and beautiful and adequate, just as I was intending to.'[71]

Outside the palaces Achaemenian architecture seems to have been insignificant. There were no temples; the Zoroastrian cult called for fire altars under the open sky surrounded by an enclosure wall. At Pasargadae a stepped platform rose at one end of the enclosure, and it has been supposed that it supported a small building.[72] The main argument in favour of this view is supplied by Cyrus's tomb at Pasargadae, which consists of a simple gable-roofed sarcophagus chamber placed on a platform comprising, like that of the sacred enclosure, six steps. But the requirements of a burial differ obviously from those of an aniconic cult; and in the reliefs of the royal tombs at Naksh-i-Rustam near Persepolis [433] the dead king appears in adoration, before a fire altar and under sun and moon, and standing on a bare stepped platform.

The tomb of Cyrus, of extreme simplicity, stood in a park.[73] The tombs of his successors are cut into the rocks at Naksh-i-Rustam and their sculptured façades can better be discussed in connexion with the sculpture of the period.

Sculpture

As far as we know, there were no free-standing statues.[74] Sculpture in the round was made subservient to architecture in the capitals and in the gate figures, and also in the reliefs. These show – like the architecture – a combination of Ionian craftsmanship and Persian design which seems to have been achieved in the reign of Darius I and to have served as a model for succeeding generations. For the rapid development of Greek sculpture between 520 and 460 B.C. – the period during which Persepolis was built – is without any influence on Achaemenian work. It was Greek sculpture of the last quarter of the sixth century which, once and for all, put its stamp on the Achaemenian style. Compared with the Greek originals even of that early period, the Persian reliefs appear inhibited, frozen, thoroughly oriental, yet the Greek strain in their make-up differentiates them from almost all Near Eastern reliefs that went before.

The contrast is a formal one. At Susa and Persepolis relief was conceived as a plastic rendering of bodies. In Egypt and Mesopotamia modelling played a subordinate part in relief which remained linear in character. The surface of the carved figures stood out before the background as a parallel plane, not as the protruding mass of a three-dimensional body emerging from the stone. Near Eastern relief remained essentially flat, even when enriched with modelled details; and details were often engraved rather than modelled. It is one of the achievements of Greek art that sculpture in the round and sculpture in relief became related as branches of plastic art and shared more than the material in which they were executed.

It is true that Neo-Babylonian usage differed from that of Assyria and that the boundary stone of Mardukapaliddina II [229] has a more plastic character than the reliefs of the Assyrians. It is possible that such work was not uncommon in Babylonia (very little remains of Neo-Babylonian sculpture) and that it prepared the way for the Ionian conception of relief work. But if one compares similar themes – say the horses of illustrations 436 and 439 with those of illustrations 182, 203, and 204 – the difference is obvious; there is no earlier parallel for so plastic a treatment of a body as that of the camel in illustration 418,[75] even though some of the human figures are but little advanced beyond what can be seen on the Neo-Babylonian boundary stone.

The earliest Achaemenian relief is that of the demon on a door jamb of the gatehouse of Pasargadae [427]. It is purely Oriental, in design as well as in style. The body is flat; there is no modelling of the limbs through the clothing, and the long, fringed, shawl-like gown recalls those worn by the courtiers of Sargon of Assyria [198].[76] The four wings, elaborately engraved, are also known in Assyria [180]. The beard, on the other hand, is short and round, after the Persian fashion. Upon the cap, which

427. Pasargadae, winged genius on a door jamb

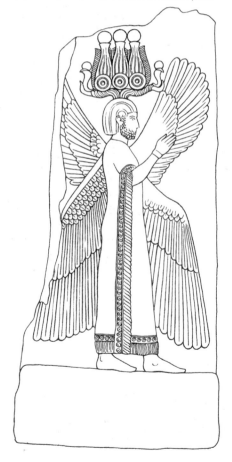

is without known parallel, is placed the most elaborate of the divine crowns of Egypt. This may be copied directly from imported Egyptian bronzes or from Phoenician work. In fact, the closest parallel to our figure occurs on a Phoenician or Syrian stele representing a fertility-god.[77] The figure is hybrid but predominantly Assyrian, not only in its design but also in its function as guardian of the gate. The inscription above it is the building inscription of Cyrus which has been quoted: it has led to the erroneous view that the figure represents Cyrus.

At Pasargadae a relief in the later, mature style was also found. It may date from the end of Cyrus's reign,[78] but that is by no means certain and, I think, unlikely. In fact, the text written against the reliefs differs from the building inscription of Pasargadae which we quoted above (p. 351). It reads 'Cyrus, the great king, the Achaemenid'. The divergence from the building inscription preserved at the gatehouse and also on the pilaster of 'Palace P' can hardly be accidental; lacking the personal pronoun, it is a title rather than a building inscription; in other words, it may indicate that the figure depicted is Cyrus. Such a legend would be comprehensible if the king who completed the reliefs had been, not Cyrus, but Darius, and this interpretation seems to me the most probable. Achaemenian kings did habitually complete buildings started by their predecessors. They were, to a quite unusual degree, conscious of their corporate individuality as the dynasty of the Achaemenids. The relief would certainly be more comprehensible if it were considered to have been carved after the rock relief which Darius I cut at Behistun [428], 300 feet above springs of clear water, on the road to Ecbatana (Hamadan), the former capital of the Medes. It was cut in the rocks in the sixth year of his reign. It commemorates the victory of Darius over rebel kings and uses a formula introduced in the third millennium B.C. in Mesopotamia by Naramsin of Akkad [91] and continually adhered to in

subsequent centuries. The king places his foot on the neck of Gaumata, the false Smerdis, while the other insurgents appear shackled before him. Above them hovers Ahuramazda in the winged disk blessing the king with a gesture.

This rock relief shows the new style only just emerging. It ignores the complex forms used commonly at Persepolis and Susa, and – in the one case just referred to – at Pasargadae. Yet the figures are modelled well in the round (in contrast with illustration 427), and in some of the

garments there is a series of folds, where they are drawn tight by the belt; it is but one aspect of the tendency to give to relief a greater plasticity than it had obtained in Egypt or Assyria. At Persepolis this tendency has found expression in a much more sophisticated rendering of the drapery by means of a formula [e.g. 431] developed in the sixth century in archaic Greek art and actually adopted from about 525 B.C. onwards. Its most striking feature can be described as a 'convention' by which 'the loose garments

428. Behistun, rock relief of Darius I

of the Persians are arranged in stacked folds
with zigzag edges. On the outer side of the
sleeve, when seen in profile, the stacked folds
are obliquely placed with a zigzag edge in one
direction; in the lower part of the garment a
bunch of vertical folds, symmetrically stacked in
two directions with a zigzag edge running up
and down from a central pleat, is flanked by
curving ridges'.[79] This convention was, as has
been shown, in use in Greece from about 525
B.C. until the early years of the fifth century, but
the matter is not – and never was – one of chrono-
logy only.[80] In Greece the particular convention
represents the solution of a problem which had
occupied Greek sculptors from the end of the
seventh century; but the ancient Near East had
been precluded from considering it by the non-
plastic conception of relief to which it adhered.
In Greece a whole series of works can be listed,[81]
to illustrate the various experiments in the ren-
dering of the clothes as a separate entity folding
round the body, experiments lasting throughout
the sixth century B.C. and leading to the formula
we have described. This formula reached Iran
with the Ionian craftsmen employed by Darius.
Proof of the activity of such men in Persia has
quite recently been published. It consists of
two drawings lightly scratched on a relief from
Persepolis, on a foot of a figure, in fact, prepared
to be covered with a red paint which was ex-
pected to obliterate the sketches. These show
astonishingly vivid heads of bearded men
matched so closely by Greek vase painting dated
between 510 and 500 B.C. that their authorship
cannot possibly be in doubt.[82] They are spon-
taneous and quite unofficial expressions of those
Ionians whom Darius mentions in his building
inscription at Susa. Their contribution to the
style of the Achaemenian reliefs consists in the
heightened plasticity of the figures of which the
emphasis in the folds is but one aspect. But it is
curious to observe how narrow were the limits
set to the sculptors; in the treatment of the ani-
mals they were, apparently, left a free hand, but

429. Figurine. Silver.
Berlin Museum

in the rendering of men they were not allowed to
develop the contrast between drapery and body
to its full extent, as was done in Greece, or to
use it throughout their work, for in Achae-
menian art it became an iconographic device
which set the Persians apart from other people.
In illustration 436, for instance, the 'Immortals'
are grouped in such a manner that Persians and
Medes alternate. The Medes are not only distin-
guished by cap, coat, and trousers, but also by
the fact that their garments appear smooth,

without folds. In the rendering of the tribute bearers [439] some show of folds is made in certain groups, but the sophisticated convention we have described is used only in the case of the Persian ushers leading various bodies of men. The other ushers are Medes; they wear the long staffs of their office, but their garments are smooth.

So the Greek sculptors were given limited scope; they were not allowed to follow the trend, which was so strong in their homeland, to intensify the three-dimensional character of their work; they were not even allowed to use an accepted device, which served the purpose, indiscriminately; for they worked to a Persian plan.

Before determining the main features of that plan we must survey the extant body of reliefs.

chin, with either the crown prince or a servant behind him.[85] This group, like that of illustration 431, is placed on a huge stool, with elaborately turned legs connected by horizontal rods; between these rods there are rows of figures, representing the peoples of the empire, who with uplifted arms support the rods. The design also occurs in Assyrian furniture in Sargon's reliefs and, again, in the relief of the royal tombs at Naksh-i-Rustam [433].

The purely ornamental character of all these reliefs is obvious. Even the audience scene of illustration 430 is repeated, not only in the treasury, but also in the Hall of the Hundred Columns, where it appears high up in doorways, above five rows of 'Immortals'.[86] This is the least effective of the door-jamb decorations, and

430. Persepolis, treasury, Darius with Xerxes, giving audience

In describing the buildings we have mentioned reliefs on the door jambs, occurring in pairs. There may be a king or hero struggling with a monster or lion, an abstract scheme in which the animal places one hind foot against the victor's shin, while the latter, holding the lion's forelock or the dragon's horn, plunges a sword into its breast.[83] Another group shows the king leaving the audience hall, followed by a servant with a ceremonial sunshade and fly-whisk.[84] A third shows the king enthroned under a balda-

since it represents Artaxerxes I, at the end of the period in which Persepolis was built (about 460 B.C.), it shows perhaps that the sure taste of the first two generations of designers and craftsmen was on the decline.

The scene itself, set up in a portico of the treasury, as a true orthostat – the other reliefs are all carved on building blocks – is a noble work [430]. Darius is enthroned upon a dais with Xerxes, the heir-apparent, standing beside him.[87] Both are drawn on a larger scale than

their attendants, a procedure – 'hierarchic scaling'[88] – common in pre-Greek art but less common in Assyria than in Egypt and elsewhere. Two incense burners are placed before the king, presumably at the front corners of the dais; on either side (but shown behind it) are two high court officials: the Bearer of the Royal Weapons (bow-case and battle-axe) and, perhaps, the Royal Cup Bearer (in the *bashlik* or muffler-cap). The official received in audience is a Mede, perhaps the Chiliarch, the commander of the king's bodyguard – that is, the first thousand of the ten thousand 'Immortals' – and commander-in-chief. He is known to have given daily reports to the king. Spearmen of the bodyguard close the

scene at either end. The embroidered baldachin, with lions and winged sun-disks [see 431], is lost. The elegance and minute perfection of the reliefs are shown by illustration 432, in which the belt and sheathed dagger of the Bearer of the Royal Weapons are reproduced on a large scale.[89]

One religious scene has been rendered in relief not in the palaces but on the façade of the royal tombs at Naksh-i-Rustam [433]. On either side of the door leading into the tomb chamber two columns with bull capitals support an entablature, upon which stands a huge couch or throne, its sides decorated with two rows of subjects supporting it with uplifted arms. Above

431. Persepolis, Hall of the Hundred Columns, relief on the southern doorway

432. Sword scabbard of the Bearer of the Royal Weapons (cf. 431)

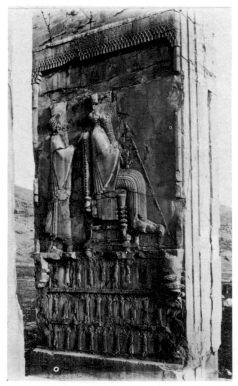

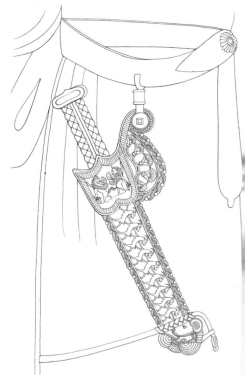

433. Naksh-i-Rustam, Achaemenian royal tomb

this couch appears the king, standing on a stepped platform, holding his bow in one hand and lifting the other in prayer or adoration. He faces a fire altar. Above him are the winged disk with Ahuramazda, and the sun and moon.

Another group of reliefs covers the parapets of the stairs leading to the separate platforms of the buildings. The residential palace of Darius [414, I] is merely decorated with an antithetical arrangement of guardsmen. The stairs leading to the Tripylon (E; illustrations 416 and 417) also show on the outer parapet guardsmen, and the group of lion attacking bull which is a standard filling for corners; the remaining space is filled with stylized plants. On the inner parapet

434. Persepolis, relief at the southern end of the stairway to the audience hall of Darius and Xerxes

435. Persepolis, the audience hall of Darius and Xerxes with its eastern stairway and the palace of Darius in the background

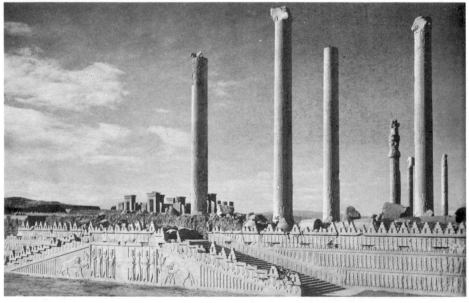

'Immortals' mount the stairs, conversing and holding hands, and tribute bearers from outlying parts of the empire are led in by ushers [434].

The same themes recur, displayed on a huge scale, on the two stairways leading to the audience hall of Darius (J) [435, 436, 439]. The width covered is about 300 feet.[90] The outer

parapet again shows the guardsmen; and these appear also on a small scale on the inside, forming an oblique border against which the three main bands of figures abut, their triangular ends filled with some trees of diminishing sizes. On the right of the central stair [435] stands a crowd of guardsmen at attention, holding their spears, a dull design, but intended, perhaps, as a demonstration of the king's power. Farther on, beyond the right-hand edge of illustration 435, the design becomes more interesting [436]. The king's horses and chariots are shown in the upper register, and underneath it officers of the guards, Medes and Persians alternating. They carry flowers, and it has been supposed that this indicates a celebration of the Nauroz or New Year's Festival. On this occasion, the nations of the empire brought their obligatory presents. This is, indeed, shown on the left side of the central staircase, part of which is reproduced in illustration 439. Lydians (centre, bottom register) bring precious vases and woven stuffs; Scythians, above, bring a set of their characteristic clothing – trousers and coat – bracelets, and a splendid stallion. Bactrians bring a two-humped camel, Cilicians rams, skins, cloths, and precious bowls. Each group is led by a Persian or Median usher carrying a wand of office. The vessels, armlets, and other gifts of precious metals are, on the whole, purely Achaemenian

436. Procession of Medes and Persians (cf. 435)

in type. Whether the different peoples bought or made such things for the purpose of presentation to the king, or whether the Persepolitan artists simply depicted the type of valuables with which they were familiar, we cannot say.

It is difficult to realize that these sculptures glittered in bright colours. Traces of turquoise blue, scarlet, emerald-green, lapis-lazuli blue, purple, and yellow have been observed. Metal trappings were gilded.[91] A figure of Darius had crown and necklace covered with gold foil and a beard inset with imitation lapis lazuli. Something similar has been observed at Pasargadae.[92]

At Susa glazed bricks supplied the colour.[93] Some panels have been reconstructed [438], but their place in the buildings cannot be determined. One section showed a row of guardsmen with their tall spears.[94] The design is much coarser than that of the reliefs, perhaps because it is produced indirectly by clay being pressed in a mould, perhaps also because these panels

437. Support in the shape of three lions, from Persepolis. Bronze. *Teheran Museum*

belong to a much later period, that of Artaxerxes Mnemon (404–358 B.C.). But they continue an old-established tradition [171, 233], and the colours of the glazes are the same as they always had been: blue, white, yellow, and green. The

438. Relief, from Susa. Polychrome glazed bricks. *Paris, Louvre*

subjects, too, are similar: processions of lions, winged bulls, and dragons; the dragons are of a type peculiar to Persia. The panels measure seven by five feet.

Repetition is of the essence of Achaemenian art. When we look at a section of the great stairway [439], we see a number of varied groups. Their arrangement is, however, strictly decorative; they are not only separated by stylized trees which form vertical bands, but their most striking feature is made to recur in the three registers; for instance, the camel appearing at the right-hand top recurs at the extreme left edge of the figure in the uppermost and in the bottom register. The stallion and the bull also recur. The figures ranged round the animals and forming a group with each vary in disposition and in their accoutrements, but hardly in pose. There is thus some play of variation within a scheme strict enough to preserve homogeneity throughout this extensive decoration. If

we exclude the repetitive guardsmen, we find a similar interplay of sameness and variety on the other side of the stair [436]: a turned head, a hand affectionately laid on the shoulder of a friend, a flower grasped firmly in one hand or delicately held in another, prevent the design from becoming monotonous without ever weakening its ornamental function. The interweaving of the separate parts by means of repetition goes very far indeed. At the extreme end of the stairway [434] we find again, above the lion and bull, groups of tribute bearers preceded by ushers, now divided among the separate steps and drawn on a small scale. We touch here the essence of Achaemenian art, its weakness as well as its strength.

For if we compare Achaemenian relief work with that of earlier periods, we observe that it is poorer in two respects. In both Egypt and Mesopotamia relief had become a perfect vehicle for narrative. Complex events, like battles

439. Procession of tribute bearers (cf. 435)

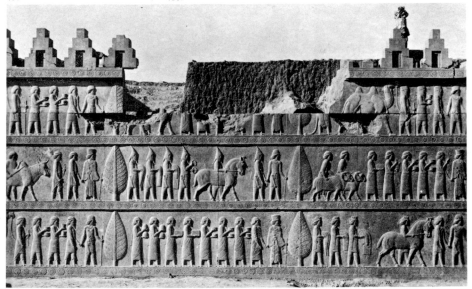

[182–4, 200–8], could be adequately, even impressively, rendered.[95] Other subjects, such as scenes of mourning in Egyptian tombs, or hunting scenes in Assyria, are genuinely moving [213–16]. Achaemenian reliefs neither tell a story nor do they express feeling. Their repertory is restricted and they are apt to be monotonous, in spite of their exquisite details.[96]

But we misconstrue the intentions of the Persian designers if we put the Achaemenian reliefs on a line with those of Egypt and Mesopotamia. They were not intended to be scrutinized, and a comparison with Assyrian reliefs in particular is fallacious, because these fulfilled a different function. In the Assyrian palaces the reliefs embellished corridors, courts, anterooms, and audience chambers, where those who waited – foreign envoys or subjects – had ample opportunity to follow the pictorial narratives in all their details. The Achaemenian reliefs were placed on the parapets of stairs, or in door jambs – places where one passed them by. Moreover, the stairways were constructed against the outside of an artificial terrace, so that the sculpture was reduced to an ornamental band at the foot of the gateway and walls, with its turrets and the roofs of buildings overtopping it. The reliefs merely served to emphasize an important architectural feature of the terraced complex, the stairway entrance.

440 and 441. Achaemenian cylinder seal.
London, British Museum

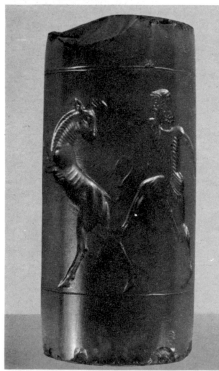 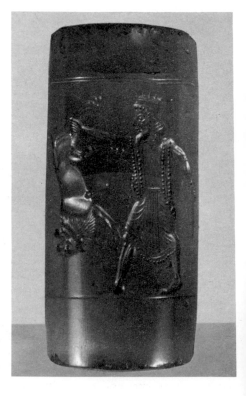

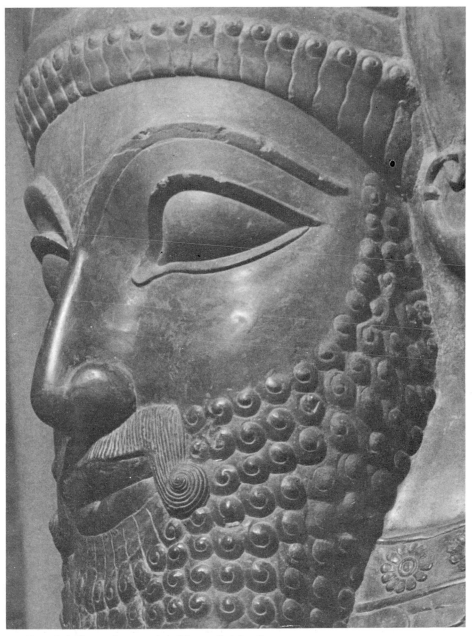

442. Face of a bull-man, from a capital of Persepolis (cf. 426)

Achaemenian sculpture in the round possessed likewise an ornamental character, whether it was used in the capitals or for gate figures. Compared with its Assyrian prototypes it has less vigour; it seems milder, almost subdued; the sharp edges, re-entrant surfaces, bold shadows of the Assyrian figures [178–80] have been smoothed out [442]. We cannot hold the Ionians responsible for this change, for east Greek art is most vigorous and vivacious. But we have already stressed the limitations imposed on the Ionian sculptors. Craftsmen of many nations gathered at Susa and Persepolis contributed their diverse skill to produce monuments for which there were no parallels in any of the countries whence they came. The work as a whole, and the spirit which pervaded it, were Persian. The very features which seem shortcomings, when we compare Achaemenian sculpture with that of Egypt and Assyria, appear consistent with its true nature, when we consider them on their own merits. For Achaemenian sculpture is a form of decoration, and it is in the nature of ornament to be subservient. When a design arrests us by its subject matter or the exceptional vigour of its execution, it transgresses the limits set to decoration. The patterns and rhythms achieved by a repetition of figures or groups are, on the other hand, preeminently suitable for ornament.

Achaemenian sculpture is more closely related to the applied arts than that of most other

443. Bracelet, from the Oxus treasure. Gold.
London, British Museum

countries. Here, too, there is exquisite detail, richness, and at the same time strict appropriateness of design. Many of the motifs recur; the monster which the king destroys on the door jambs of his palaces and which, built in with glazed bricks, adorns their walls [438], forms the finials of a bracelet set with enamels or semiprecious stones [443], or decorates the spout of a libation vessel, a rhyton [444]. But not only do the motifs recur; the very method of design is the same whatever medium is used. On the sword scabbard of illustration 432, the central subject is a repetition of goats, diminishing in size towards the point, posed as unnaturally as the bull in illustration 434. The rows of lions which are embroidered upon the canopy over the king's throne and on the hem of his robe[97] recur in metal in the frame of his chariot.[98]

When we realize that the principles of Achaemenian sculpture are the same as those of the applied arts we can solve the paradox of its origin. We have stated that the Persians did not possess a monumental art of their own, that foreign craftsmen built and decorated the Achaemenian palaces, and that the resulting monuments were, nevertheless, essentially Persian in character. The oddities of the architecture – the scattering of buildings over platforms, the elongated columns, their number, the bizarre capitals – all this betrays the direction of people foreign to the tradition, the practice, and the potentialities of Near Eastern

444. Rhyton, from Armenia. Silver.
London, British Museum

445. Handle of a jar, in the shape of a silver ibex inlaid with gold, upon a satyr's head.
Paris, Louvre

446. Figurine, from the Oxus treasure. Silver.
London, British Museum

447. Jug, from the Oxus treasure. Gold.
London, British Museum

architecture. But they were not people devoid of aesthetic sense; on the contrary, they betray throughout a cultured inclination towards rich, harmonious, but essentially decorative designs. This is a taste not uncommon among nomads, and it would seem that the Persians drew on the traditions of their native crafts when they directed the hosts of foreign craftsmen collected at Persepolis and Susa.

It is a pity that but a few patterns of embroidered or woven stuffs are rendered on the reliefs. One expects that here, as in some of the jewellery, and perhaps in objects of popular use – the successors to the Luristan bronzes – ancient Mesopotamian motifs of proved ornamental value survived, for the textiles of south-west Persia seem to have preserved an unbroken tradition, whether they were produced under Babylonian, Achaemenian, Sassanian, or Arab rule. They transmitted to Europe, in the twelfth century A.D., a wealth of ancient Near Eastern themes which replaced the disembodied animal style of the illuminations and enriched the capitals and archivolts of Romanesque churches. This remarkable movement repeated, in a more complex manner, the enrichment of Western art in the seventh century B.C., when influences from the Levant replaced the exhausted geometric by the orientalizing style of Greece. We cannot, in this volume, attempt to deal with the later movement; but Achaemenian art was an important link in the chain of transmission, since in it, at the close of the period in which the Near East had been the centre of highest culture, many traditions, both of barbarians and of Greeks, assumed a new form.

NOTES

Bold figures indicate page reference

CHAPTER I

17. 1. The word 'Protoliterate' has been adopted in parallelism to 'Protodynastic'. We retain it, although it is a hybrid, to avoid confusion. The Protoliterate Period includes most of the 'Uruk Period' and all of the 'Jemdet Nasr Period' of the older literature. See Delougaz and Lloyd, *Pre-Sargonid Temples in the Diyala Region* (Chicago, 1942), 8, n. 10.

2. Thence the modern designation 'Sumerian'; they called themselves 'the black-headed people'. Their language, Sumerian, is without demonstrable affinities to any modern tongue. It is agglutinative and not inflectional, and therefore neither Semitic nor Indo-European. The human skeletons dated to the fourth and third millennium B.C., when Sumerian was the dominant language, cannot be distinguished from those of Semitic-speaking Asiatics. At all times the population seems to have consisted of long-headed 'Mediterranean' plainsmen with a mixture of short-headed 'Armenoid' mountaineers due to a thin but continuous trickle of immigration from the east and north-east.

3. Hitherto unknown early stages of their painted pottery have been discovered recently at Abu Shahrein (ancient Eridu) confirming its south-west Persian origin. In the absence of writing of this period, we cannot prove that these Persian immigrants were Sumerians, but the continuity of their culture with that of the Protoliterate Period suggests it. The only alternative would be to see Sumerians in the makers of red and grey pottery which first intermingles with, then displaces, the Al 'Ubaid ware at the end of the Prehistoric Period. The makers of these vessels seem to have immigrated from the north or north-east. The problem has often been discussed of recent years, but rarely with a sufficient appreciation of the continuity which links the Protoliterate and the Al 'Ubaid Period. The Al 'Ubaid culture, spreading along the rivers, and displacing throughout northern Mesopotamia the Tell Halaf culture of north Syrian affinities, was the first to prevail throughout Mesopotamia.

4. The earliest village culture of north Mesopotamia is called after Hassuna (*Journal of Near Eastern Studies*, IV (1945), 255–89; XI (1952), 1–75). It is succeeded by the Halaf Period, named after Tell Halaf in north Syria. During this period the Al 'Ubaid people entered southern Mesopotamia from Persia. The appearance of red and grey pottery marks the succeeding Warka Period. This is the last stage of Mesopotamian prehistory in the south. It was succeeded by the Protoliterate Period. In the north there are no exact equivalents for the Warka and Protoliterate Periods, and prehistoric conditions persisted for some considerable time (Gawra Period). All the relevant material has been discussed by Ann Louise Perkins, *The Comparative Stratigraphy of Early Mesopotamia* (Chicago, 1949). A prehistoric settlement even more primitive than Hassuna was found at Jarmo in Iraqi Kurdistan. Even here clay figurines of men and animals were found. See Braidwood, in *Sumer*, VII (Baghdad, 1951), and *Bulletin of the American Schools of Oriental Research*, no. 124 (Baltimore, 1951).

5. This ware is fully discussed in *Journal of Near Eastern Studies*, III (1944), 48–72.

18. 6. See *Sumer*, III (Baghdad, 1947), 84 ff.; IV (Baghdad, 1948), 115 ff.

7. Arthur J. Tobler, *Excavations at Tepe Gawra*, II (Philadelphia, 1950), 30 ff., and plates xi, xii, and xxxvii–xxxviii. There were three temples grouped round a court, showing variations of a typical plan which is best preserved in the one we reproduce.

19. 8. Tobler, *op. cit.*, maintains that the absence of double recessed niches from the north-western or rear wall shows that the buttresses served an ornamental purpose.

9. These earlier experimental phases are represented by temples numbered VIII and XVI which precede that of illustration 3.

10. H. and H. A. Frankfort, J. A. Wilson, and Th. Jacobsen, *Before Philosophy* (Harmondsworth, 1948), 159 ff.

20. 11. After Th. Jacobsen, in *Journal of Near Eastern Studies*, V (1946), 140.

12. It survived as a sacred hill within the precincts of a temple of Anu, built in Hellenistic times, three thousand years later.

13. These stairs were built in a re-entrant angle of the mound, and seem to have continued through the brickwork of the terrace, while a ramp led off to the right and also mounted the terrace. In the drawing of illustration 4 the recesses in the slope of the mound have not been continued round the southeastern side because the ruins are denuded there. The most recent discussion of the buildings is by Heinrich J. Lenzen, in *Mitteilungen der Deutschen Orient-Gesellschaft*, no. 83 (Berlin, November 1951), who rejects the early date assigned to it by Perkins and establishes that it was built in the latter part of the Protoliterate Period.

14. It measures seventy-four by fifty feet.

15. *Achter vorl. Bericht . . . Abh. Preuss. Akad.* (1936), Phil.-Hist. Kl., no. 13, plate 41.

16. The word means simply 'to be high' or 'pointed', and was the Mesopotamian name for the temple tower.

22. 17. *Zeitschrift für Assyriologie*, N.F., VI (1931), 1 ff.; *Syria* (1940), 161, n. 2.

18. Seton Lloyd and Fuad Safar, 'Tell Uqair', in *Journal of Near Eastern Studies*, 11 (1943), 132–58; plates i–xxxi.

19. It so happens that no Ziggurat belonging to the third millennium B.C. is known to us. The Early Dynastic shrines stand on plinths or platforms. Sir Leonard Woolley surmises that an Early Dynastic Ziggurat existed at Ur, but there is no evidence that this was so (Heinrich Lenzen, *Die Entwicklung der Zikurrat* (Leipzig, 1941), 40 ff.; 45). The Early Dynastic seals showing the building of a high temple (Frankfort, *Cylinder Seals*, 76) may represent platforms as well as Ziggurats, since the proportions suit the engravers' convenience. From the Third Dynasty of Ur onward Ziggurats occur regularly.

20. One temple, temple C (*Siebenter vorl. Bericht . . . Abh. Preuss. Akad.* (1935), Phil.-Hist. Kl., no. 4, plate 2), is well enough preserved to show that it consists of a combination of two parts, each laid out according to the plan of the Anu temple [4], but using different scales. The north-western part of the building is the sanctuary proper, with an ornamentation of recessed brickwork on the inside walls. Against this shrine a large open court surrounded by rooms is nothing but a repetition of the same plan, at right angles and on a large scale.

23. 21. In the temple on the Anu Ziggurat [4] the rooms at the west and south corners each contained such a staircase.

22. Lenzen, *Die Entwicklung der Zikurrat*, 8.

24. 23. In the façade of Waradsin's fort at Ur, for example; see *Antiquaries' Journal*, XII, plate LXV. The figures built by means of moulded bricks in the façade of the temple of Karaindash at Warka [143] can be regarded as an application of the same principle.

24. *Zweiter vorl. Bericht . . .*, Abh. Preuss. Akad. (1930), Phil.-Hist. Kl., no. 4, 35 ff.; figures 25–7; *Dritter vorl. Bericht . . .*, Abh. Preuss. Akad. (1932), Phil.-Hist. Kl., no. 2, plate 18; *Elfter vorl. Bericht . . .*, Abh. Preuss. Akad. (1940), Phil.-Hist. Kl., no. 3, plate 34.

25. 25. The peculiar excellence of the composition is best elucidated by H. A. Groenewegen-Frankfort, *Arrest and Movement*, 150–2, whom I follow.

27. 26. Such vases have actually been found in the excavations at Khafaje. Delougaz and Lloyd, *Presargonid Temples* (Chicago, 1942), 18, 29.

27. A. Falkenstein and Th. Jacobsen have recognized that the man holds a writing sign which marks him as the ruler of Warka.

28. Ernst Heinrich, *Schilf und Lehm*, and the drawings of Edward Bawden in *Horizon*, VII, no. 41 (May 1943).

28. 29. On seals where the feeding of the temple herd is depicted the food consists sometimes of ears of barley and sometimes of rosettes.

30. This is clearly shown in two figures in the Babylonian Collection of Yale University; see H. Frankfort, *The Birth of Civilization in the Near East* (London, 1951), plate X, figures 17 and 18.

31. This head may have belonged to a cult-statue, although in later times Mesopotamian gods were not given animal shape. But it has been suggested that the ewe stood for the mother of Tammuz (Thorkild Jacobsen, in *Journal of Near Eastern Studies*, XII (1953), 165); moreover the cow of illustration 62 fitted the base on the altar of the temple in which it was found and may thus represent its deity, the goddess Nintu. A great variety of heads of sheep and rams which served as ornaments in the temple have been found. See Ernst Heinrich, *Kleinfunde aus den archaischen Tempelschichten in Uruk* (Berlin, 1936), plates 4–8; *Elfter vorl. Bericht . . .*, Abh. Preuss. Akad. (1940), Phil.-Hist. Kl., no. 3, plate 33; *Journal of Near Eastern Studies*, V (1946), 153 ff.

32. See the vase from Khafaje, Frankfort, *Progress of the Work of the Oriental Institute of Iraq*, 1934/35 (O.I.C. 20), 69, figure 54, and the vase *British Museum Quarterly*, 11 (1927), plates vi–vii.

33. Its occurrence at the very beginning of the Protoliterate Period is shown by such cylinder seals as Louvre A-26 (Frankfort, *Cylinder Seals*, plate v(b)).

29. 34. Similar vases are known from Fara, Tell As-

mar, Tell Agrab, Khafaje, and elsewhere. See H. R. Hall, *Babylonian and Assyrian Sculpture in the British Museum*, plates 11, 111, 1; G. Contenau, *Manuel d'archéologie orientale*, page 643, figure 446; page 1990, figure 1078; *Antiquaries' Journal*, X111 (1933), plate lxv, 1; Ernst Heinrich, *Fara*, plate 14A; *Illustrated London News* (12 Sept. 1936), 435; *idem* (6 Nov. 1937), 793, figures 7 and 8.

35. *Illustrated London News* (26 Sept. 1936), 524, plate i; Heinrich, *Kleinfunde*, plates 25–8.

31. 36. He is not mentioned in literature, and his identification with the hero of the Gilgamesh epic is entirely without foundation. See Frankfort, *Cylinder Seals*, 62–7.

37. On a later seal (Leon Legrain, *Ur Excavations*, 111, plate 16, no. 298), the bearded bull is shown as the numen of a mountain. It is attacked by the lion-headed eagle, personifying the spring rains (see below). The bull seems to symbolize some power of the earth, or perhaps the scorched summer earth. The lions would attack it, since they belong to the Great Mother, the power of life.

33. 38. Discussed by Edith Porada in *Journal of the American Oriental Society*, LXX (1950), 223 ff.

39. Frankfort, *Oriental Institute Discoveries in Iraq 1933/34* (O.I.C. 19), 52, figure 61; Heinrich, *Kleinfunde*, plate 13.

40. The same feature occurs on a small figure of a lion found at Tell Agrab and cut from the same hard crystalline limestone as our monster, but in neither case is the modelling an unmistakable rendering of the symbol.

34. 41. For this contrast in the attitude towards historical events see H. A. Groenewegen-Frankfort, *Arrest and Movement*, 148–62.

35. 42. Nies-Keiser, *Historical and Religious Texts*, plate 76(e); Frankfort, *Cylinder Seals*, plate v(d).

36. 43. This can be seen even in the impression here illustrated because the damaged spot at the base where the cylinder is chipped appears twice and thereby demonstrates that the animal on the right is a second impression of that on the extreme left.

37. 44. For a detailed discussion, see Frankfort, *Cylinder Seals*, 23–9.

45. H. H. von der Osten, *Ancient Oriental Seals in the Collection of Mr E. T. Newell* (Chicago, 1934), no. 695.

46. Frankfort, *Cylinder Seals*, plate v(c); the examples quoted in the text are discussed *ibid.*, 17–29.

47. The impression in our illustration is wrongly cut; the temple should appear in the middle, with the three men on the right and the boat on the left of it.

48. This interpretation of the lion-headed eagle has been substantiated by Professor Thorkild Jacobsen in lectures in Chicago and I am indebted to him for permission to refer to it.

CHAPTER 2

39. 1. The First, Second, and Third Early Dynastic Periods, abbreviated E.D. I; E.D. II; E.D. III. The end of E.D. III, from about 2425 to 2340 B.C., is sometimes distinguished as the Protoimperial Period.

40. 2. The close connexions between the various vases of this group are of the greatest interest. On the left, in illustration 31, we notice a small fragment of a building near which the activities of the musicians and their companions took place. This building recurs on a vase found at Tell Agrab (*Illustrated London News* (12 Sept. 1936), 434, figures 10, 12). In front of it sits a person resembling those of illustration 32. Inside the building we see a humped bull before its manger. But the zebu is not indigenous in Mesopotamia; it appears regularly on the seals found in the Indus valley, where bulls are often shown at mangers. In one case a zebu is shown accompanied by a bird (Sir John Marshall, *Mohenjo-Daro and the Indus Civilization*, plate cxi, 338), and on the vase from Tell Agrab the bull is shown together with a bird, a snake, and a scorpion. The latter two recur in the same form on other vases of the period found in Mesopotamia and corroborate the Mesopotamian origin of the example from Tell Agrab. The precise nature of the relations with India which these vases bespeak remains uncertain.

3. Frankfort, *Oriental Institute Discoveries in Iraq, 1933/34* (O.I.C. 19), 47, figure 53.

4. Fragment from Ur (*Antiquaries' Journal*, III, plate xxxiii) which shows the scorpion of the vase from Tell Agrab and the heads of the panther-headed snakes of the Khafaje vase. Vases in the Berlin Museum, and one from Mari (*Syria*, XVI (1935), plate xxvii), also show snakes' bodies marked with drill holes.

5. Contenau, *Manuel d'archéologie orientale*, 423, figure 321; palaeography links its inscription with that of the Imdugud figure from Khafaje (Frankfort, *Progress of the Work of the Oriental Institute in Iraq, 1934/35* (O.I.C. 20), 32, figure 25).

42. 6. So a vase fragment from Khafaje (Frankfort, *Oriental Institute Discoveries in Iraq, 1933/34*, figures 54–5) which shows groups of animals common on the seals from Fara (E.D. II). The scalloped designs which, on the fragment from Ur mentioned in Note 4 above, decorate the necks of the monsters, occur in E.D. II on lions for the rendering of the

mane, as it does on the mace-head of Mesilim which is also, probably, E.D. II in date.

7. One of the cylindrical bases in Baghdad (I.M. 25676) shows two tiers of buildings. In the upper tier the criss-cross pattern used in the rendering of buildings on the Bismaya and Tell Agrab bases recurs, and this vase in Baghdad is, therefore, perhaps earlier than the others of this class. The same applies to a vase in the Louvre (Contenau, *Manuel*, 644, figure 448) with palm trees resembling that in illustration 32.

8. The relatively late (E.D. III) date of the patterned bases is proved by their occurrence at Mari (*Syria* XVI (1935), plate xxvii, 3) and in the tomb of Shubad at Ur (Woolley, *Ur Excavations*, II, plate 178). Fragments of vases of this type have been found in Iran, where they were even imitated in pottery (Sir Aurel Stein, *Archaeological Reconnaissance in North-Western India and South-Eastern Iran*, plate vi), and even at Mohenjo-Daro, in the Indus valley (E. J. H. Mackay, *Further Excavations at Mohenjo-Daro* (Delhi, 1937), 321 and plate cxlii, no. 45).

9. This form is unexplained, but since these bricks were used in herringbone pattern, standing on their narrow side, in alternation with layers of headers and stretchers, and since unhewn stones are used in the same manner in the hill districts of northern Iraq even now, it has been suggested that mountaineers settling in the plain imitated in brick the traditional building material. P. Delougaz, *Planoconvex Bricks and the Methods of their Employment* (Chicago, 1933).

10. *Syria*, XIX (1938), plate ii.

11. H. R. Hall and C. L. Woolley, *Ur Excavations*, I (London, 1927), plate xxiv, 1.

12. Frankfort, *Iraq Expedition of the Oriental Institute*, *1932/33* (O.I.C. 17), figures 5–7; 10–12.

13. Frankfort, *The Birth of Civilization in the Near East*, plate xxii, no. 42.

14. *Syria*, XVI (1935), 12–28, 117–40; XVII (1936), 3–11; XVIII (1937), 55–65. The cloisters are shown in figure 3, p. 58, in the last article.

43. 15. Very little is known of secular buildings of the Early Dynastic Period. They are generally grouped together, suggesting administrative offices. At Kish there was a complex of three buildings (Ernest Mackay, *A Sumerian Palace and the 'A' Cemetery at Kish, Mesopotamia;* Field Museum of Natural History Anthropology Memoirs, I, no. 2, Chicago, 1929). One shows steps leading up to an entrance set far back between three pairs of towers forming a narrowing approach. Two thousand years later the palace of Nabonidus at Ur had a similar entrance (*Antiquaries' Journal*, XI, plate liii). But at Kish the building to which this impressive entrance

gave access is lost. Of the other two buildings the entrances have not been recovered. The northernmost has a double enclosure wall and a block of rooms at the back of a square court, obviously planned for privacy. It might be a residential palace. The other building resembles a store, treasury, or office building. It is here that the columns were found (*op. cit.*, plates xxvi, xxvii, and xxxii, 3), made of especially prepared wedge-shaped bricks which are elsewhere used for circular wells. Moreover, this building had a portico with columns on a parapet. At Eridu (Abu Shahrein) two buildings almost identical in plan have been found (Fuad Safar, in *Sumer*, VI (1950), 31–3) which show the mazes of square and oblong rooms grouped round and between courts which are characteristic of large public buildings in Mesopotamia at all times. They do not contain the 'standard reception suite' of the Assyrian palaces, which can be traced back to about 2000 B.C. (see below). These buildings at Eridu, like those at Kish, belong to the beginning of E.D. III, perhaps even to E.D. II.

16. P. Delougaz, *The Temple Oval at Khafaje* (Chicago, 1940). This author also discovered a similar temple oval at Al 'Ubaid (*ibid.*, 140–5; *Iraq*, V (1938), 1 ff.).

44. 17. The fenestration of the shrine in the temple oval is hypothetical and perhaps incorrect. It is safer to assume that the shrines, like the houses, had square windows high up in the walls with grilles of wood or baked clay. Examples of the latter have actually been found at Tell Asmar (Frankfort, *Iraq Expedition of the Oriental Institute, 1932/33* (O.I.C. 17), figure 9).

45. 18. It is generally believed, after Andrae's suggestion, that they represent private houses, but their shape is not easily squared with this view. They are shown, with bowls of incense and food placed upon them, on cylinder seals – e.g. Frankfort, *Cylinder Seals*, plate xxiv (f).

19. See H. A. Groenewegen-Frankfort, *Arrest and Movement*, 161.

20. *Revue d'Assyriologie*, XXII (1925), 42 ff.

' 21. Thureau-Dangin, *Sumerisch-Akkadische Königsinschriften*, 72, translation Thorkild Jacobsen.

46. 22. *Revue d'Assyriologie*, XXXI (1934), 139.

23. Thureau-Dangin, *loc. cit.*

24. For details see Frankfort, *Sculpture of the Third Millennium from Tell Asmar and Khafaje* (Chicago, 1939).

49. 25. The evidence for this interpretation is discussed in Frankfort, *Sculpture*, 45–7. In a shrine of the First Early Dynastic Period at Khafaje over six hundred cups were found smashed, presumably after a feast held in this sanctuary.

51. 26. Groenewegen-Frankfort, *Arrest and Movement*, 24.

27. *Sculpture*, plates 33, 34.

52. 28. *Sculpture*, frontispiece, plate 62(a–c).

53. 29. Small figurines of copper representing men and women would also seem to belong to E.D. II; one, in the Louvre (Contenau, *Manuel*, IV, figure 1124; *Monuments Piot*, XXXVII, 37 ff.), is, in fact, dressed and groomed like those of the hoard from Tell Asmar [39]. Others were found at Tell Agrab (Frankfort, *More Sculpture*, plates 56–7).

54. 30. Frankfort, *Sculpture of the Third Millennium*, plate 115, no. 206.

31. This is a kind of wild ass not now domesticated.

56. 32. *Encyclopédie photographique de l'art*, I, 204.

33. *Syria*, XVI (1935), plates ix, xx, and xxiv.

34. W. Andrae, *Die archaischen Ischtartempel*, plates 30–1.

35. Frankfort, *Sculpture*, plates 52–3.

36. The earlier style, hitherto not found in regular excavations outside the Diyala region, has recently been discovered at Nippur: *Illustrated London News* (28 June 1952), 1087.

60. 37. A cow's head in copper found at Khafaje represents the earlier style; it is more ornamental (Frankfort, *op. cit.*, plate 104).

38. Hall and Woolley, *Ur Excavations*, I, plate x.

39. *Ibid.*, plates xxvii–xxx.

63. 40. The object was crushed flat in the soil and the excellent restoration has not done away with all deformations.

66. 41. De Sarzec, *Découvertes en Chaldée*, plate I ter; *Encyclopédie photographique de l'art*, I, 176.

68. 42. See G. Rachel Levy, 'The Oriental Origin of Herakles', in *Journal of Hellenic Studies*, LIV (1934), 40 ff.; for the hydra on seals see Frankfort, *Cylinder Seals*, 71, 121 f.

43. In Frankfort, *Sculpture*, plate 105, no. 125, the two figures face one another in the lowest row.

44. Others were found at Tell Agrab (Frankfort, *More Sculpture*, plate 65; plate 67, no. 327). Examples from Khafaje are *Sculpture*, plate 108, no. 188; plate 109, no. 192; from Fara and Susa, *Sculpture*, 45.

70. 45. Frankfort, *More Sculpture*, plate 62.

46. *Sculpture*, plate 105.

47. *More Sculpture*, plate 64B.

48. Contenau, *Manuel*, figure 357.

49. F. Thureau-Dangin, *Die Sumerischen und Akkadischen Königsinschriften*, 35, i.

50. Witnesses, plaintiffs, and defendants who were prepared to swear by the gods were taken to the temple and, in pronouncing the oath, pulled the divine emblem from its socket. This act unchained the force with which the sacred object was charged and which would destroy the perjurer. Cases are on record in which parties recanted previous statements when faced with the necessity to repeat them under oath. This explanation was given in lectures of Professor Thorkild Jacobsen at Chicago.

71. 51. It was observed at Ur that the rein ring of chariots drawn by oxen was embellished with the figure of an ox, that of spans of onagers by the figure of a wild ass. By analogy the chariot on this face of the stele of Eannatum was drawn by lions, which would mark it as the chariot of the god Ningirsu [cf. illustration 93].

52. *Syria*, XVI (1935), plate xxviii; *ibid.*, XXI (1940), plate vi, 4 (Mari). For similar inlays see Mackay, *A Sumerian Palace . . . at Kish*, plates xxxv–vi; Frankfort, *Oriental Institute Discoveries in Iraq, 1933/34* (O.I.C. 19), figure 25.

75. 53. At Tell Asmar these knives were part of a service, and thus identified as knives, not daggers; Frankfort, *Oriental Institute Discoveries in Iraq, 1932/33* (O.I.C. 7), 37 ff.

76. 54. The line on the lion's left paw does not set off the animal skin against the human wrist of its wearer, but forms part of the conventional rendering of animals; it recurs on the hind legs of the wolf and the donkey.

55. L. Legrain, *Ur Excavations*, III (London, 1936), plate 20, no. 384.

56. Frankfort, *Cylinder Seals*, 94, figure 30.

77. 57. M. von Oppenheim, *Tell Halaf* (London, 1933), plate xxxviii.

CHAPTER 3

83. 1. This is best traced by means of seals: Frankfort, *Cylinder Seals*, 227–32.

2. M. Mallowan, in *Iraq*, IX (1947).

3. Parrot, in *Syria*, XVI–XVII (1935–6). Cf. *Revue d'Assyriologie*, XXXI (1934), 180 ff.

4. W. Andrae, *Die archaischen Ischtartempel in Assur* (Leipzig, 1922).

5. See B. Landsberger, 'Die Eigenbegrifflichkeit der Babylonischen Welt', in *Islamica*, II, 355–72.

84. 6. *Annals of Archaeology and Anthropology . . . Liverpool*, XIX (1932), plate L; Andrae was the first to recognize the head as Akkadian.

85. 7. Other heads of this period are Contenau, *Manuel*, 685, figures 474–5; *Bulletin of the Fogg Museum of Art, Harvard University*, IX (1939), 13–18; of lesser quality: Frankfort, *More Sculpture*, plate 72.

86. 8. For example Contenau, *Manuel*, 673, figures 467–8.

9. On this stele, see Groenewegen-Frankfort, *Arrest and Movement*, 163 f.

10. This is rarely the case in Mesopotamia. See Frankfort, *Kingship and the Gods*, chapter 21.

11. The term 'landscape' has been loosely, and wrongly, used whenever a tree, or plant, or a wavy ground line is found in ancient art. But it is applicable to the stele of Naramsin, where a coherent rendering of the scene of action is given.

12. Essad Nassouhi in *Revue d'Assyriologie*, XXI (1924), 65 ff.; Contenau, *Manuel*, 666 ff.

87. 13. C. J. Edmonds, in *Geographical Journal*, LXV (1925), 63 ff. Cf. Sidney Smith, *Early History of Assyria* (London, 1928), 96 ff. and figure 9. Another stele of Naramsin, found near Diarbekr and now in Istanbul, is lost but for a single fragment which shows the upper part of the king's figure only: L. W. King, *A History of Sumer and Akkad*, 245, figure 59.

89. 14. The hero has his left arm round the lion's neck and his right arm round the beast's belly. He presses his knee against its back, squeezing the breath out of the body. The lion's head is thrown back so that it appears upside down, its ear overlapping with the hero's wrist. A chipped place in the cylinder surface somewhat obscures the upper part. Note, however, the detail with which the pads and claws are rendered. The inscription on the right formed a panel, flanked on the other side by a reversed group of hero and lion. The whole design was thus strictly symmetrical, but a narrow space on the cylinder surface was left over, and this was filled by a clump of reeds, which appears on the left of the fragment of which we reproduce an enlargement.

90. 15. E. Douglas van Buren, *The Flowing Vase and the God with Streams* (Berlin, 1933).

91. 16. This is a hypothesis; Egyptian texts testify that the belief in a nightly journey of the sun underneath the soil was commonly held, but there is no such evidence for Mesopotamia. Parrot, in *Studia Mariana*, 117 ff., supposes that the god in the boat was a chthonic deity, and it is true that he is not always shown with rays emerging from his shoulders.

17. Frankfort, *Cylinder Seals*, 70 ff., 119–20.

18. *Op. cit.*, 124–7, to which must be added *Analecta Orientalia*, XXI (Rome, 1940), no. 14.

CHAPTER 4

93. 1. The original publications are E. de Sarzec, *Découvertes en Chaldée* (Paris, 1884–1912); Gaston Cros, *Nouvelles Fouilles de Tello* (Paris, 1910–14).

The latest excavator has published his results together with a critical study of those of his predecessors and a full bibliography: André Parrot, *Tello, vingt campagnes de fouilles (1887/1933)* (Paris, 1948). The texts of Gudea have been translated by F. Thureau-Dangin, *Les Inscriptions de Sumer et d'Akkad* (Paris, 1905) (*Die Sumerisch-Akkadischen Königsinschriften*, Leipzig, 1907). Recent discoveries suggest that Gudea's reign overlapped with that of Urnammu (*Orientalia*, N.S. XXIII, Rome, 1954, 6, n. 3).

2. Contenau, *Manuel*, figure 465. It is too badly damaged to be illustrated here.

97. 3. Parrot, *Tello*, plate xiv(d) shows these instruments carved in relief upon the drawing-board.

4. Statue L.

98. 5. Translated by Professor Thorkild Jacobsen.

6. In Istanbul. See Parrot, *Tello*, 197, figure 42(c).

7. *Museum Journal*, xviii (Philadelphia, 1927), 76.

8. Parrot, *Tello*, figure 42; de Sarzec, *Découvertes en Chaldée*, 231 and plate 24, 3.

9. Parrot, *Tello*, figure 42H.

10. *Ibid.*, plate xx(a).

99. 11. E. Douglas van Buren in *Iraq*, I (1934), 60–89.

100. 12. Parrot, *Tello*, plate xxiii (b and c).

13. *Ibid.*, plate xxiii(a).

101. 14. *Ibid.*, figure 44; E. Douglas van Buren, *Foundation Figurines and Offerings* (Berlin, 1931).

104. 15. See Sidney Smith, *The Statue of Idrimi* (London, 1949), 92 ff.

16. H. Lenzen, *Die Entwicklung der Zikurrat*, 47 ff.

17. The temples and other buildings found within the sacred enclosure at Ur are larger and more complex than those from Tell Asmar and Ishchali (see pp. 104–9), but they incorporate the units for which the simpler buildings have supplied clearer examples. For Ur, see *Antiquaries' Journal*, V (1925), 347–402; XIV (1934), plate xlix.

18. When at the end of the reign of Gimilsin's successor the kingdom of Ur disintegrated, this temple was secularized and became part of the adjoining palace of the ruler of Eshnunna.

107. 19. The continuity of the architectural tradition of Mesopotamia (which has often been doubted) appears when one compares the temple we have just described with that built later by a Kassite king at Ur (*Antiquaries' Journal*, V (1925), 373, figure 4). Here, too, one passes through a towered entrance into a lobby, and hence into the central court. The main cella is on the right, as in the old shrines with a bent axis approach; but there is another cella straight in front, as at Tell Asmar-Eshnunna. It is peculiar that the door has been shifted to one side, so that there is no axial arrangement of the main features.

109. 20. Delougaz and Lloyd, *Presargonid Temples of the Diyala Region* (Chicago, 1942), plates 22 and 23, c and d; 186, figure 146; 202, figure 162.

21. Other temples of this period have been found at Mari; see *Syria*, XIX (1938), 21–7; XX (1939), 4–14; XXI (1940), 1–24. The great palace of Zimrilim at Mari, covering an area of 650 by 200 feet (*Syria*, XVII (1936), 14–31; XVIII (1937), 65–84; XIX (1938), 8–21; XX (1939), 14–22), can best be understood as the combination of a series of architectural blocks. The function of some of the main rooms, explained by Parrot as shrines, can be better understood in terms of royal functions. At the far side of the main court is a deep audience hall (no. 132), with not only religious but also warlike scenes painted behind the throne base. The square court 106, like that at Tell Asmar, and later at Khorsabad, is flanked by a throne room (64) and a great hall, here probably open to the sky (65), with a shrine (66) at one side. See Note 46 below. The outer wall of the palace lacks buttresses and recesses.

110. 22. For an Akkadian city, see Frankfort, *Iraq Excavations of the Oriental Institute, 1932/33* (Chicago, 1934), 1–46. For the end of the third millennium Woolley's report in *Antiquaries' Journal*, XI (1931), 359 ff.

23. *Op. cit.*, plate xliv, 1.

24. *Ibid.*, plates l–lii, *Antiquaries' Journal*, VI (1926), plates li–lii.

25. It is now in the collection of Colonel Norman Colville. See *Archiv für Orientforschung*, XII, 128 ff.

112. 26. See *Archiv für Orientforschung*, IX, 165–71; *Journal of Near Eastern Studies*, III (1944), 198–200.

114. 27. E. Douglas van Buren, *Clay Figurines of Babylonia and Assyria* (New Haven, 1930). The only series of dated types is in Frankfort, Lloyd, and Jacobsen, *The Gimilsin Temple and the Palace of the Rulers at Tell Asmar* (Chicago, 1940), 206–14 and figures 108–22. The interpretation of these objects has also been discussed there.

28. Clay lions, two to three feet high, were found at Tell Harmal and Khafaje Mound D. Bronze lions with inlaid eyes were found at Mari in the Dagan temple (*Syria*, XIX, 1938, plate x). They probably stood on the blocks of masonry flanking the entrance (*op. cit.*, figure 13 and plate ix).

29. It is not entirely isolated. A statue in Brussels (Contenau, *Manuel*, 798, figure 557), a head from Tell Asmar (Frankfort, *More Sculpture*, plate 73, no. 334), and perhaps a head from Mari (*Syria*, XIX (1938), plate viii) belong to this group of works, which strike us as archaizing.

116. 30. They were carried off as booty to Susa, where they were excavated. (Contenau, *Manuel*, 801–3, figures 559–61.)

31. Andrae, *Das wiedererstehende Assur* (Leipzig, 1938), 88 and plate 44.

119. 32. A stele in the Louvre depicting a defeat of enemies refers perhaps to a victory of Hammurabi, but this is not certain. It is an undistinguished work (Contenau, *Manuel*, 837, figure 596).

33. L. W. King, *A History of Babylon*, 96.

34. See H. A. Groenewegen-Frankfort, *Arrest and Movement*, 168 ff.

35. *Oxford Editions of Cuneiform Texts*, I, 23.

36. James B. Pritchard (editor), *Ancient Near Eastern Texts relating to the Old Testament* (Princeton, 1950), 164.

122. 37. This figure has a companion piece which served, perhaps, as a stand upon which offerings were placed. Three ibexes, reared up and with their horns interlocked, are placed on a base fitted, again, with a small cup or basin, which is here supported by two goddesses. The faces of the goats are rendered in gold foil (*Encyclopédie photographique de l'art*, I, 261).

123. 38. Frankfort, *More Sculpture*, plates 79–81.

39. Frankfort, *Cylinder Seals*, plate xxvi(k).

124. 40. *Encyclopédie photographique de l'art*, I, 248–9.

41. *Syria*, XVIII (1937), plate xxxviii (2), and 352, figure 14.

42. Andrae, *Coloured Ceramics from Assur*, plate 8.

43. *Syria*, XVIII (1937), plate xli (2).

126. 44. It has been studied, and ingeniously interpreted, by Marie-Thérèse Barrelet, in *Studia Mariana* (Leiden, 1950), 9–35.

45. An alternative source would be scarabs from Egypt, where scarabs of the Middle Kingdom show splendid spiral designs which were ultimately derived from Crete.

46. Room 46, and Court 31; *Syria* XVIII (1937), 326.

47. *Op. cit.*, 328 ff. The analogies with Tell Asmar and Khorsabad prove that this was the king's throne room, and that the base was not intended to carry a god's statue, as Parrot thinks (*Syria*, XVIII (1937), 70). Moreover, the room lacks the seclusion of a sanctuary, and the base has two sets of steps leading up to it at either end, an arrangement common to Assyrian (and Egyptian) throne bases, but not known in temples. The symmetrical arrangement of the steps served not only the purpose of mounting the dais, but also the grouping of dignitaries in a seemly manner around the throne during audiences and other functions. The fact that the statue of illustrations 131 and 132 was found here is irrelevant; the palace was sacked and its contents scattered

through the ruins. The statue represents, moreover, a minor goddess.

48. There are a few exceptions: the seal of Ilishuilia of Eshnunna shows the theme of the stele of Naram-sin (Frankfort, Lloyd, and Jacobsen, *The Gimilsin Temple and the Palace of the Rulers at Tell Asmar* (Chicago, 1940), 215, figure 100).

CHAPTER 5

127. 1. Sidney Smith, *Alalakh and Chronology*, 21–5.
128. 2. *Iraq*, Supplement, 1944; Supplement, 1945; and VIII, 1946, 73–93.
3. See above, p. 43.
4. *Syria*, XX (1939), plate i.
129. 5. *Erster vorl. Bericht . . . Uruk-Warka* (Abh. Preuss. Akad. der Wiss. (1929)), Phil.-Hist. Kl. no. 7, 30–8.
6. But Kurigalzu's temple at Ur conforms, but for one detail, the placing of the door of the cella, to the plan usual in southern Mesopotamia since the Third Dynasty of Ur. See pp. 106–7 and Note 19 to Chapter 4.
130. 7. W. J. Hinke, *A New Boundary Stone of Nebuchadnezzar I* (Philadelphia, 1907).

CHAPTER 6

131. 1. This is called the Old Assyrian Period, in contrast with the phase now under discussion, the Middle Assyrian Period.
2. See above.
3. Sidney Smith, *Early History of Assyria* (London, 1928), 122 ff.
132. 4. Frankfort, *Cylinder Seals*, plate iii(a).
134. 5. Andrae, *Coloured Ceramics from Assur*, plate 8.
6. Frankfort, *Cylinder Seals*, 208 ff., 275–8.
135. 7. Andrae, *Das wiedererstehende Assur*, plate 51A.
8. Andrae, *Coloured Ceramics from Assur*, 11 ff., plate 6 (originally from Adad temple of Tiglath-pileser I).
9. See Andrae, *op. cit.*, 7–10, plates 1–4.
10. In a forthcoming book Dr Helene J. Kantor will present a thorough study of the history of plant ornaments in the ancient Near East.
11. See *Annual of the British School of Archaeology at Athens*, XXXVII (1936–7), 106–22.
137. 12. Sidney Smith, *Early History of Assyria*, 123.
13. E. Porada, *The Collection of the Pierpont Morgan Library* (Corpus of Ancient Near Eastern Seals in North American Collections, vol. 1), no. 956.
138. 14. The Ziggurat at Khorsabad, with its winding ramp, cannot be considered typical, since it stood within the precincts of the palace [169].

139. 15. *Syria*, XX (1937), plate i.
16. It is of secondary importance that the outer entrance on the west is not in the central axis of court and cella. The shifting of entrance out of the central axis served as a safety measure in many buildings of this and other periods; it presented an obstacle to surprise attacks which otherwise might penetrate to the heart of a building in the rush of the first onslaught.
17. The evidence comes from the Assur temple of the city of Assur which was built by Shamsi-Adad I, the contemporary of Hammurabi (see W. Andrae, *Das wiedererstehende Assur*, 85, figure 41), where the foundations of the two entrances and the stairs leading to them are preserved.
18. An interesting feature of the temple of Assur at Kar Tukulti-Ninurta is the great hall to which the northern entrance gives access. It has niches at either end. Subsidiary deities were worshipped here, and it is possible that the great Marduk of Babylon was one of them. Tukulti-Ninurta I conquered Babylon and demolished its fortifications in the course of a conflict with its Kassite ruler. This meant that Marduk had withdrawn his protection from the city. His statue was taken to Assyria, which could be supposed to profit from such power as was left to it; but it was placed in the temple of the state god Assur.
140. 19. See W. Andrae, *Der Anu-Adad Tempel* (W.V.D.O.G., no. 10). The reconstruction published in that volume has since been discarded by Andrae in favour of that which is shown in illustration 157.
20. Anton Moortgat, *Vorderasiatische Rollsiegel* (Berlin, 1940), nos. 591 and 592.
141. 21. Delaporte, *Catalogue des cylindres orientaux*, Bibliothèque Nationale (Paris, 1910), no. 307.
22. Moortgat, *op. cit.*, no. 586.
142. 23. *Zeitschrift für Assyriologie*, N.F. XIV, 36 ff., figures 35–8.
24. *Op. cit.*, 43, Abb. 46, and Moortgat, *Vorderasiatische Rollsiegel*, nos. 591 and 592.

CHAPTER 7

143. 1. Victor Place, *Ninève et l'Assyrie, avec des essais de restauration par Félix Thomas* (Paris, 1867–70). His work continued that begun more haphazardly by Botta; P. E. Botta et E. Flandin, *Monuments de Ninève* (Paris, 1849–50). Gordon Loud, *Khorsabad*, I (Chicago, 1936).
146. 2. Gordon Loud, *Khorsabad*, II, 11 and plate 86; *Revue d'Assyriologie*, XXXIII (1936), 153–60.
3. K. Bittel and R. Naumann, *Bogazköy*, II (Berlin, 1938), plate 25B.

148. 4. *Encyclopédie photographique de l'art*, 11, 2–3.

5. This plan was published by Place and Thomas (see Note 1 above) with the irregularities straightened out; in illustration 172 the parts re-examined by the Iraq expedition of the Oriental Institute have been marked in black.

149. 6. Frankfort, *Kingship and the Gods* (Chicago, 1948), 252–61.

150. 7. These have been carefully studied by W. Andrae, *Coloured Ceramics from Assur* (London, 1925), chapter 6: Enamelled knob-plates and knobs.

8. Loud, *Khorsabad*, 11, plates 49–50.

151. 9. Our illustration renders a base found in the palace of Sennacherib at Nineveh; the bases from Palace F are figured by Loud, *Khorsabad*, 11, plate 48. The north Syrian examples are published in Von Luschan, *Ausgrabungen in Sendschirli*, 93, 142, and 198.

10. D. Luckenbill, *Ancient Records of Assyria and Babylonia*, 11, para. 84.

11. The use of figured column bases in Assyria is known, not only from texts like that we have just quoted, but also from a model for such a base; it shows a human-headed cow with wings supporting a base of the ornamental Syrian type used also at Khorsabad. The model was found at Nineveh (Hall, *Babylonian and Assyrian Sculpture in the British Museum*, plate lviii).

12. On the *bit-hilani*, see Chapter 11, below.

152. 13. C. J. Gadd, *Stones of Assyria* (London, 1936), Appendix, 3, figure 1, s.

14. Thureau-Dangin a.o., *Arslan Tash* (Paris, 1931), 41 and plate v, 2; and on plan: no. 1 (portico) and no. 2 (passage). For a fuller discussion see *Iraq*, XIV (1952), 120–31.

15. Gadd, *Stones of Assyria*, figure opposite p. 30; Andrae, *Das wiedererstehende Assur*, plate 4.

156. 16. E. Unger, *Der Obelisk des Königs Assurnasirpal I aus Nineveh* (Mitteilungen der Altorientalischen Gesellschaft VI, Leipzig, 1932). Landsberger (*Sa'mal* (Ankara, 1948), 24) dates the obelisk to the ninth century, while Unger assigns it to the eleventh century B.C. We follow Landsberger.

17. F. Matz, *Frühkretische Siegel* (Berlin, 1928), 89–94.

157. 18. H. Layard, *Monuments of Nineveh*, 11 (London, 1853), plates 53 and 54, shows fragments of bricks or panels of polychrome glazed ware with battle scenes, which were found in the south-east corner of the enclosure of Nimrud. Cf. also Andrae, *Coloured Ceramics from Assur*, plates 7, 8.

19. It is true that the mural paintings of earlier palaces may have included circumstantial battle scenes; a few small fragments from Mari, showing wounded soldiers, suggest this. But there is no reason to suppose that these had been more than isolated scenes such as we find on the stele of Eannatum or Sargon of Akkad. The dado of orthostats, on the other hand, offered very different possibilities, and in the palace of Assurnasirpal II at Nimrud (883–59 B.C.) they have become the vehicle of a true pictorial chronicle [182–6].

160. 20. E. A. Wallis Budge, *Assyrian Sculpture in the British Museum* (London, 1914), plate xvi, 1.

21. *Op. cit.*, plates xxi, xxii.

22. *Op. cit.*, plate xvi, 2.

23. *Op. cit.*, plate xvii, 1.

24. It has been rightly pointed out (H. A. Groenewegen-Frankfort, *Arrest and Movement*, 173) with how fine an understanding the reaction of the horses to various conditions is rendered by Assyrian artists.

25. Wallis Budge, *op. cit.*, plate xlii.

26. H. R. Hall, *Ancient History of the Near East*, plate xxv, 1.

27. Wallis Budge, *op. cit.*, plate xix.

162. 28. *Op. cit.*, plate xi.

29. Frankfort, *Kingship and the Gods*, 259.

163. 30. This relief has been frequently misinterpreted as the battle between Marduk and Tiamat.

164. 31. L. W. King, *Bronze Reliefs from the Gates of Shalmaneser* (London, 1915).

165. 32. L. W. King, *op. cit.*, 23.

166. 33. *Op. cit.*, 31.

169. 34. H. A. Groenewegen-Frankfort, *Arrest and Movement*, 175. The question must be considered as part of the interpretation of the Assyrian manner of rendering space which appears in an entirely new light, *op. cit.*, 174–81.

171. 35. F. Thureau-Dangin a.o., *Til Barsip*, 45.

36. Layard, *Monuments of Nineveh*, 1 (London, 1849), plates 86–7. Another design, discovered at Nimrud, is reproduced in *Iraq*, XII (1950), plate xxx.

37. The dotted surface in illustration 181 represents the portion of the painted plaster which was actually recovered in the excavation.

174. 38. *Illustrated London News* (28 July 1951), 134, figure 2 (Assurnasirpal II).

39. Loud, *Khorsabad*, 1, 60, figure 72.

176. 40. Groenewegen-Frankfort, *loc. cit.*

41. Fulanain, *The Marsh Arab, Haj Rikkan* (London, 1928), 21.

178. 42. Gadd, *Stones of Assyria* (London, 1936), plate 13.

179. 43. *Op. cit.*, plate 10.

180. 44. Plates showing on one sheet of reproduction the several orthostats which belong together have been published by A. Paterson, *Assyrian Sculpture in the Palace of Sinacherib* (The Hague, 1915).

181. 45. Groenewegen-Frankfort, *Arrest and Movement*, 179.

183. 46. Line drawings have been published by Perrot et Chipiez, *Histoire de l'art dans l'antiquité*, II, 143, and Meissner, *Babylonien und Assyrien*, I, 202.

47. Loud, *Khorsabad*, II, plates 32B and 48, nos. 15–17.

48. Thorkild Jacobsen and Seton Lloyd, *Sennacherib's Aqueduct at Jerwan* (Chicago, 1935).

184. 49. This term refers to a scene viewed from a high point, from horseback, for instance.

186. 50. Groenewegen-Frankfort, *op. cit.*, 180.

187. 51. The report of such encounters fought within living memory derives from Sir Leonard Woolley's Arab foreman Hamudi; but I do not remember which of the two told me about them. Julian Huxley reported the story and commented upon it in *The Observer*, 18 June 1950. On an Assyrian ivory relief found in Persia, the hunter offers a small shield-like object to the lion's maw. A. Godard, *Le Trésor de Ziwiyeh*, 93, figure 81. But on royal seals the version of illustration 211 is used from the time of Shalmaneser III onwards (*Iraq*, XV (1953), 167ff.) and the theme survives in Achaemenian art.

194. 52. Andrae, *Das Gotteshaus und die Urformen des Bauens im alten Orient*, 12, refers to Streck, *Assurbanipal*, II, 301, n. 11, and the scene as ritual. Barnett, in *Iraq*, II, 185, refers to Thureau-Dangin, *Rituels accadiens*, 111, where the king is said to bring with him to the New Year Festival of Ishtar of Arbela three captive kings and the head of Teumman of Elam, which appears in the tree of illustration 217. But there is no evidence that the scene has a religious significance, although it includes one feature not easily explained: a hand holding a long stick appears to emerge from the palm tree on the right. Andrae sees in it an act of the numen embodied in the tree.

53. Professor Mallowan has recently discovered similar engraved ivories of purely Assyrian style at Nimrud (*Illustrated London News* (22 Aug. 1953), 297, figures 5–7).

54. Gordon Loud, *The Megiddo Ivories*, frontispiece and plates 1–3.

55. They have been published and studied by R. D. Barnett in *Iraq*, XII (1950), 1–43, plates i–xxii. The impression that Urartian metalwork has no character of its own is confirmed by the important discoveries of an Urartian fortress at Karmir Blur, near Erivan. For a full summary, see *Iraq*, XIV (1952), 132–47. Both in themes and in style the objects found are provincial Assyrian. Only the pottery is characteristic.

195. 56. *Journal of Near Eastern Studies*, V (1946), 155, and plate ii.

57. In the shape of a gazelle (Berlin); in the shape of a lion (British Museum and Louvre), Contenau, *Manuel*, 1304, figure 824. *Illustrated London News* (22 Aug. 1953), 298, figure 17.

58. Gordon Loud, *Khorsabad*, II, plates 49–50.

196. 59. See Ludwig Curtius in *Münchener Jahrbuch der bildenden Kunst*, VIII (1913), 1 ff. The object is in the museum at Erlangen. At the top there are remnants of what was probably a flat saucer, as on a candlestick; and a similar object, with the saucer complete, was found at Van. See C. F. Lehmann-Haupt, *Armenien einst und jetzt*, II, 2 (Berlin, 1931), 483 and 523. Lehmann-Haupt calls these candelabra Vannic, but the dependence of the Urartian metal industry on that of Assyria is so far-reaching that his decision seems impossible to me, and the reasons he gives are certainly not convincing.

60. The legs of the candelabra mentioned in the preceding note consist each of a bull's leg protruding from a lion's maw. *Op. cit.*, 523.

61. The object is in the Department of Oriental and Classical Antiquities in the National Museum at Copenhagen.

198. 62. E. Wallis Budge, *Assyrian Sculpture in the British Museum, Reign of Assurnasirpal II*, plates xlix–lii.

63. Andrae, *Coloured Ceramics of Assur*, plates 20–8.

CHAPTER 8

202. 1. See R. Koldewey, *Babylon (Das wiedererstehende Babylon*, 1925), and *Die Tempel von Babylon und Borsippa* (Leipzig, 1911). *Antiquaries' Journal*, X, plate xxxv; XI, 374 ff. Ch. Watelin, *Excavations at Kish*, III (Paris, 1930).

203. 2. The latest reconstruction is given by Andrae, *Die Ionische Säule* (Berlin, 1933), plate vii. In colour, Koldewey, *Das wiedererstehende Babylon*, Abb. 64.

3. See O. E. Ravn, *Herodotus' Description of Babylon* (Copenhagen, 1932).

4. A. Parrot, *Ziggurats et Tour de Babel* (Paris, 1949), gives a survey of all the temple towers and of the various solutions of that of Babylon.

CHAPTER 9

207. 1. I have discussed this contact in *American Journal of Semitic Languages*, LVIII (1941), 329–58, and in the Appendix of the *Birth of Civilization in the Near East* (London and Bloomington, 1951).

208. 2. Carl W. Blegen a.o., *Troy*, I (Princeton, 1950), figure 190; *American Journal of Archaeology*, XLI (1937), plate xx.

3. Blegen, *op. cit.*, for Hissarlik; *Annals of Archaeology and Anthropology* (Liverpool), XXVI, 38ff. and plates xl and xli for Mersin in Cilicia.

4. Winifred Lamb, *The Excavations of Thermi in Lesbos* (Cambridge, 1936).

5. A. J. B. Wace and M. S. Thompson, *Prehistoric Thessaly* (Cambridge, 1912), 79–81.

210. 6. They are classified according to their forms by Dr Hamit Zubayr Koşay in *Annual of the British School of Archaeology at Athens* (1937), 160–6.

7. The skeletons were not well enough preserved to allow the sex to be determined, but it has not unreasonably been assumed that where mirrors were found in a tomb the occupant was a woman.

211. 8. Figures found more recently show bands of silver along haunches or shoulders, or a body spangled with pellets of red copper or silver. For some of these see H. Z. Koşay, *Les Fouilles d' Alaca Höyük* (Ankara, 1951), plates 129 and 162.

212. 9. Pharmakovsky in *Transactions (Otchet) of the Russian Imperial Archaeological Commission*, 1897.

10. The various interpretations of the vase design are conveniently summarized by Franz Hancar, *Urgeschichte Kaukasiens* (Vienna, 1937), 292–310; a number of those, e.g. by zoologists, are fanciful because they show unfamiliarity with the procedure of primitive draughtsmen and interpret the details too literally.

11. Woolley, *Ur Excavations II. The Royal Cemetery*, plates 166 and 167.

12. The stag occurs as attribute or mount of gods on a small steatite relief from Yenikeuy (Remzi O. Arik, *Les Fouilles d' Alaça Hüyük* (1937), 26, figure 36; Contenau, *Manuel*, IV, figure 1238) and on a relief from Malatya (Delaporte, *Malatya*, plate xxii). The stag occurs on Hittite reliefs at Alaja Hüyük itself, as we shall see, in a context which leaves it uncertain whether they are mere game. And a silver rhyton in the shape of a stag was found in a shaft grave at Mycenae, and is rightly viewed as an importation from Asia Minor (Georg Karo, *Die Schachtgräber von Mykenai* (Munich, 1930–3), 94). See also S. Przeworski, 'Le Culte du cerf en Anatolie', in *Syria*, XXI (1940), 61–76. At Yazilikaya the name of the god no. 32 is written with a stag's antler.

214. 13. See Sedat Alp, in *Jahrbuch für Kleinasiatische Forschung*, I (1950), 125 ff.; Gelb, *idem*, II (1951), 23 ff.; Bittel, in *Historia*, I (1950), 267 ff.

215. 14. See above, pp. 60 and 78–9.

15. Frankfort, *Cylinder Seals*, 208. There is a difference even here: the wings of the disk are straight in Syria, but the Hittites render them with curled-up tips.

217. 16. H. H. von der Osten a.o., *The Alishar Hüyük Season 1930–32*, II, 32, figure 30.

17. C. F. A. Schaeffer, *Stratigraphie comparée*, plate ix.

218. 18. A. Goetze, *Kleinasien* (Iwan von Müller-Walter Otto, *Handbuch der Altertumswissenschaft*, III, I, 3), 155.

220. 19. K. Bittel, *Bogazköy, Die Kleinfunde der Grabungen, 1906–12* (Leipzig, 1937), plate 8.

221. 20. In *Mitteilungen der deutschen Orient-Gesellschaft*, no. 76 (April 1938), 21, fragments of a lion are mentioned. It remains to be seen whether or not these belong to guardians of a gate.

222. 21. See B. Landsberger, *Sam'al* (Ankara, 1948), 113, n. 269.

223. 22. Kurt Bittel, *Die Ruinen von Boghazköy*, figure 6. *Bogazköy, Die Kleinfunde der Grabungen, 1906–12* (Leipzig, 1937), plates 4–6.

23. See E. Akurgal, *Späthethitische Bildkunst*, 42, figures 27–9.

24. This fashion is also followed in the only female sphinx known in Egypt, namely the one representing Queen Hatshepsut (1511–1479 B.C.).

25. See John A. Wilson in *American Journal of Semitic Languages*, LVIII (1941), 225–36.

224. 26. Notice how much less disturbing the same juxtaposition is in illustration 199 for instance.

225. 27. Another bronze figure, said to be found at Boghazköy, is of an earlier age: O. Weber, *Die Kunst der Hethiter* (Orbis Pictus 9), plate i; K. Bittel, *Bogazköy, Kleinfunde der Grabungen, 1906–12*, plate i, 1 and page 4. It is a peripheral work of Mesopotamian appearance, hardly a Hittite work. It shows a bearded man with short hair and a Mesopotamian shawl tied round the waist and flung over the left shoulder. The eyes were inlaid. It is probably dated correctly by Moortgat and Bittel to about 2000 B.C., or a little later. One would be inclined to connect it with the Mesopotamian trading colonies in Cappadocia. It shares, however, with the later Syrian figures [299, 300] the primitive modelling of the body as a flat strip of metal, bent forward below the waist, and downward at the knees. It is the dress, coiffure, and beard which induce me to assign to it an earlier date, since they would be inexplicable after the middle of the second millennium B.C. An ivory figurine of a naked woman, of unknown provenance, has been called Anatolian (R. D. Barnett, in *British Museum Quarterly*, X (1936), 121–3, plate xxxiv). This is possible, but

cannot be proved, much less its affinities to Hittite art. Influence of archaic Greek sculpture on this piece is not entirely excluded.

28. Published in full in *Wissenschaftliche Veröffentlichungen der deutschen Orientgesellschaft*, no. 61. See also K. Bittel, *Die Felsbilder von Yasilikaya* (Bamberg, 1934), and John Garstang, *The Hittite Empire* (London, 1929). In *Boghazköy* (Berlin, 1935), 46–51, Bittel argues that the sanctuary must be dated between 1450 and 1230 B.C., and probably between 1350 and 1230 B.C. E. Laroche, in *Journal of Cuneiform Studies*, VI (1951), 121 ff., suggests that the reliefs in the main gallery must date from the reign of Tudhaliyas IV, about 1250 B.C.

226. 29. In illustration 260 the building to the southeast, which suggests direct access to the small gallery, must be disregarded. It seems of a different date from the other structures, and its character is not clear. Nowadays access to the small gallery at this point is blocked by fallen rocks, and it seems likely that in antiquity, too, it could only be entered from the main gallery.

227. 30. This is the usual interpretation. Güterbock maintains, however, that the figure represents the sun-god ('Siegel aus Bogazköy II', Beiheft 7, *Archiv für Orientforschung* (Berlin, 1942), 24, n. 101 and p. 53). E. Laroche holds the same view (*op. cit.*, 117 and 119). The arguments are impressive, but they leave unexplained that the alleged god, alone among all the divine figures, should be indistinguishable in dress and attributes from a Hittite king.

228. 31. That this was, in fact, the proper explanation of the relief was first seen by G. R. Levy, who, in *The Sword from the Rock* (London, 1952), gives a full discussion of Hittite religion. While I am more doubtful than the author about the relevance of Mesopotamian conceptions and usages to Hittite religion, I found that the book throws much light on Yazilikaya.

32. E. de Sarzec, *Découvertes en Chaldée*, plate 61 bis, no. 2.

231. 33. A. Goetze, *Kleinasien*, in I. von Müller-W. Otto, *Handbuch der Altertumswissenschaft*, III, 1, 3.

34. E. Laroche, in *Journal of Cuneiform Studies*, VI (1951), 115–23, regards the assembly of gods in the main gallery of Yazilikaya as a representation of the Hittite pantheon as established by Tudhaliyas IV, after a great number of Hurrian deities had been introduced under the influence of his mother Puduhepa, a daughter of a priest from Kizzuwadna, a region to the south-east of Cappadocia. Güterbock, *Siegel aus Bogazköy*, I, 99 ff., has pointed out that Hurrian gods had been introduced into the imperial pantheon (or native gods had been identified

with Hurrian gods) under Muwatalli, late in the fourteenth century.

35. This is the view of G. R. Levy, expressed in *The Sword from the Rock*.

36. K. Bittel, in *Archiv für Orientforschung*, XIII (1940), 181–93.

37. *Antiquaries' Journal*, XXX (1950), plate vi.

38. In the older literature this site appears as Euyuk.

39. Frankfort, *Cylinder Seals*, plate xxv (f).

232. 40. The relief at Alaja Hüyük would not by itself justify the interpretation of the object as a mirror, since it is broken at the top and the remainder resembles a champagne glass with spreading foot. But actual mirrors found in the tombs at Alaja Hüyük have handles which widen towards the base. The goddess with the mirror is Kupapa.

233. 41. H. G. Güterbock, *Siegel aus Bogazköy*, II (1942), 50 ff. *Ibid.*, no. 220 shows a kneeling hunter shooting arrows at game; Güterbock (p. 50) compares this rightly with the Alaja Hüyük reliefs.

42. E. Akurgal, *Späthethitische Bildkunst*, plate B, 2; cf. *ibid.*, figures 27–9.

43. Akurgal, *op. cit.*, plate A, 2.

44. It is relevant to recall here that huge basalt figure of a lion standing over a man which was found at Babylon (Koldewey, *Das wiedererstehende Babylon*, 159, figure 101). Although it is unfinished, the material and the subject seem to point to a non-Mesopotamian origin. It was possibly a trophy brought down on a Euphrates raft from north Syria.

45. Güterbock, *loc. cit.*; Moortgat thinks that these themes are due to Hurrian, i.e. north Syrian influence (*Zeitschrift für Assyriologie*, N.F. XIV (1949), 158). There are Mitannian or Hurrian traits in Hittite religion and Hurrian texts have been found at Boghazköy. But there is no proof at all of the existence of 'Hurrian' sculpture in stone, or of monumental art of any description which could be labelled Hurrian or Mitannian. The problem has been carefully considered by K. Bittel ('Nur hethitische oder auch hurritische Kunst?', in *Zeitschrift für Assyriologie*, N.F. XV (1950), 256–90). In view of the occurrence of allegedly 'Hurrian' themes in Hittite seals, there is no need to invoke a foreign origin. In this controversy it has been overlooked that the continuity of Mesopotamian civilization vitiates the alternative 'Hittite or Hurrian' from the start, since both derive much of their repertory from one and the same source. This is, for instance, clear in the case of the monsters at Yazilikaya [263], which have a Mesopotamian ancestry going back to Akkadian times and may have reached north Syria and Anatolia independently at any time between 2300 and 1300 B.C. Exactly the same

is true of the bull-man, the god emerging from the mountain, and so on. In some cases independent origin of motifs can be proved. Bittel has pointed out that the wings of the winged disk have turned-up tips in Hittite art, while they are straight on north Syrian monuments (*op. cit.*, 264 ff., 267).

46. Güterbock, *loc. cit.*

47. See below Chapter 10. Ekrem Akurgal has systematically studied these sculptures (*Remarques stylistiques sur les reliefs de Malatya*, Istanbul, 1946), and has established their close affinity to imperial Hittite art. But even he does not dare to draw the conclusion that they belong to the second millennium, as his own evidence suggests to me. This is due to his overrating the continuity between Hittite art and the sculptures of the ninth–seventh century B.C., which we have labelled north Syrian (Akurgal, *Späthethitische Bildkunst*, Ankara, 1949; on Malatya, especially pp. 140 ff.). His argument that the lions cannot belong to the imperial period (*ibid.*, 72, n. 201a) is not convincing; his figures 25–48 show that the lions are certainly not closer to those of the first than those of the second millennium. They share, moreover, with the god at the Royal Gate of Boghazköy the most peculiar device of hair rendering by a network of single linear spirals. It is of some importance that we now know lions made in the thirteenth century B.C. as squarely shaped, and as crudely modelled as those of north Syrian art. They come, on the one hand, from the southern periphery of the Hittite domains, from Alalakh [319, 320] and, on the other, from Byblos [317, 318].

The date of the Lion Gate of Malatya is, in any case, not a mere matter of chronology. The point at issue is this: could the city preserve intact a detailed iconographical tradition throughout the period of the migrations of the Sea People which utterly destroyed the Hittite empire? The reliefs from the Lion Gate tally in a number of small details with those from Yazilikaya; there must have been continuity, not merely in beliefs, but in imagery. On the other hand, Malatya lay on the very route which the Kashi from the Pontic shores and the Muski from central Anatolia must have taken when, as an aftermath of the migrations, they harassed Assyria. Consequently we should need strong proof before we could accept the view that it survived unscathed.

Dating the Malatya sculptures to the empire does not mean that the lions and the reliefs are found where they were placed originally; on the contrary, there is strong evidence that they were re-used in a building dating to the eighth century B.C. (Delaporte, *Malatya*, plates xiii–xv). It is also true that the Malatya sculptures differ in several points from those

of Boghazköy and Yazilikaya, but the same is true of the reliefs of Alaja Hüyük, as we have seen. Hittite art did not possess a body of tradition and local variations exceeded in scope those found in Egypt or Mesopotamia. Even the re-use of the royal name Sulumeli – whether as a conscious link with the imperial past, or because it actually remained in use – does not imply that a full and detailed iconographical tradition linked the twelfth and the eighth century.

234. 48. His name, Sulumeli, is known in the eighth century, and has been taken as proof that the reliefs are as late, but Landsberger has shown (*Sam'al*, 25 n.) that this name was used in the second millennium B.C.

49. *Antiquaries' Journal*, XXX (1950), plate vi(a) and (b).

50. Delaporte, *Malatya*, plate xxii, 2. Two gods confront a snake. We do not know whether the element in which it writhes is fire or water. The wavy lines above the snake recur on the Tyskiewicz cylinder (Frankfort, *Cylinder Seals*, plate xliii(n) and (o)), which is certainly Hittite, and there they seem to render flames in which the victim is burned. If the relief should depict a fire-dragon, the three figures above could be compared with illustrations 110 and 111, minor deities pouring water to quench the monsters' flames. The relief has been connected with one of the few known myths of the Hittites, in which the snake Illuyankas is killed in connexion with a battle between the weather god and the sea (translated by A. Goetze, in *Near Eastern Texts relating to the Old Testament* (Princeton, 1950), 125 ff.; also *Kleinasien*, 130 ff.). In that case the wavy lines may mean water, but the connexion with the myth is not proved. It is unfortunate that the stone is broken above the snakes' heads, for if there were seven, it would represent a link between Greece and Mesopotamia (where it is known in the third millennium) in the diffusion of the myth of Herakles and Iolaus killing the Hydra (see Chapter 2, Note 42). In that case the deities above would be pouring out oil to feed the flames in which the monster perished.

51. Bossert, *Altanatolien*, nos. 550–64. The Hittite rock sculptures of western Anatolia are discussed by Bittel in *Archiv für Orientforschung*, XIII (1940), 181–93, and *Zeitschrift für Assyriologie* N.F. XV (1950), 271.

52. H. Swoboda, J. Keil, and F. Kroll, *Denkmäler aus Lykaonien, Pamphylien und Isaurien* (Brünn, 1935). Also Bossert, *Altanatolien*, nos. 565–6.

235. 53. This reasonable suggestion has been made by Güterbock in *Halil Edhem Hatira Kitabi* (Ankara, 1947), 63.

54. It has recently been described in detail by Güterbock, 'Alte und neue hethitische Denkmäler', in *Halil Edhem Hatira Kitabi*, 59–70.

55. The monument has been studied by Sedat Alp, in *Archiv Orientalni*, ~~xviii, part 1–2~~ (Prague, 1950), 1–8.

236. 56. Frankfort, *Cylinder Seals*, plate xlii(k); xliv(d), (j), and (l); and figures 84–6 (p. 270). Another characteristic Syrian feature is the pose of the bull with lowered horn at the bottom of the ivory plaque. See *Cylinder Seals*, plate xlii(h).

57. *Cylinder Seals*, plate xliv(n). They also occur on an ivory box from Megiddo, where sufficient remains to justify the restoration of Loud, *The Megiddo Ivories*, plates 1–3.

58. This detail was established by Dr Helene J. Kantor in studying the original. See Loud, *Megiddo Ivories*, plate 11(g).

59. See below Chapter 11, Note 69.

60. Güterbock thinks, however, that it may be the Hittite sun-god. See Note 30 above.

61. Güterbock, *Siegel aus Bogazköy* (Beiheft 5, 7, *Archiv für Orientforschung* (Berlin, 1940, 1942)); Frankfort, *Cylinder Seals*, plate xliii(n) and (o).

237. 62. See p. 244 below.

CHAPTER 10

239. 1. *Annals of Archaeology and Anthropology, Liverpool*, XXII, 166.

2. See Alexis Mallon, S.J., Robert Koeppel, S.J., René Neurille, *Teleilat Ghassul I* (Rome, 1934).

3. See the preliminary report by Dr Kathleen Kenyon in *Illustrated London News* (17 October 1953), 603–4, with plate iv.

241. 4. The work still awaits publication; a preliminary report appeared in *American Journal of Archaeology*, XLI (1937), 12, figure 3. I am obliged to Dr R. J. Braidwood, the discoverer, and to the Director of the Oriental Institute, who have kindly allowed me to reproduce these sculptures.

5. Gods carrying a spear occur among certain rather crude figurines cast in copper which seem to derive from the Lebanon. They were found associated with pins and torques which point to a date in the first third of the second millennium B.C. See Seyrig, in *Syria*, XXX (1953), 24–50, with plates ix–xii.

6. M. E. L. Mallowan, *Excavations at Brak and Chagar Bazar*, in *Iraq*, IX (1947). The heads are discussed on pp. 91–3 and illustrated in plates 1–11. Our interpretation differs in some points from that of the excavator.

7. An alternative interpretation would see in the projections which I have described as dowels, the rendering of a narrow, tall cap such as is worn by a bronze figure from Ras Shamra, 1,500 years later. See C. F. A. Schaeffer, *Ugaritica I*, plates xxxi–xxxii.

242. 8. *Iraq*, IX, plate ii, 3.

9. H. Frankfort, *Sculpture of the Third Millennium*, plate 58D; *More Sculpture*, plate 28G.

10. Frankfort, *Sculpture*, plates 59 and 94.

11. At Hama in north Syria a stone head was found in early, allegedly chalcolithic, layers. It is rather rough and badly preserved. It wears the conical cap. The eyes were inlaid and the head formed part of a statue completely carved in stone, two features which suggest a more advanced stage of sculpture than the figures from Brak. Moreover, the figures from Hama (there were four) were almost life-size. See Harold Ingholt, *Rapport préliminaire sur sept campagnes de fouilles à Hama* (Copenhagen, 1940), 25 and plate vii, 1. The closest parallels to the head published there are found in such Early Dynastic sculptures as I illustrated in *Sculpture of the Third Millennium*, plate 30, c and d, but the Hama sculptures were covered with a coating of painted plaster.

12. Max von Oppenheim, *Tell Halaf* (London and New York, 1933), 226–52, plates lxii–lxiii. Most of the comparisons made and conclusions reached are baseless.

13. *Encyclopédie photographique de l'art*, I, 204.

14. Contenau, *Manuel d'archéologie orientale*, 673, figures 467–8.

243. 15. A basalt object which can be called either stele or statue was found at Tell Brak. It is 1·45 m. high, and the rounded top is made to resemble the hair surrounding a face of which nose and eyebrows, and drill-holes for eyes, are indicated. It recalls the limestone stele from the first city of Troy (p. 208); but crude works made in out-of-the-way places are not necessarily very ancient. See *Syria*, XI (1930), 360–4.

16. See J. A. Wilson, in *American Journal of Semitic Languages*, LVIII (1941), 225–36; S. Smith, *Alalakh and Chronology* (London, 1940).

244. 17. Contenau, *Manuel d'archéologie orientale*, 2296, figure 1304. Schaeffer, *Ugaritica*, II, plate xxii.

18. Pierre Montet, *Byblos et l'Égypte* (Paris, 1928). Objects which have probably the same provenance in *Bulletin du Musée de Beyrouth*, I (Paris, 1937), 7–21, plates i–iv.

19. F. W. von Bissing, *Ein Thebanischer Grabfund aus dem Anfang des Neuen Reichs*.

20. G. Karo, *Die Schachtgräber von Mykenae*, plates xci–xciv and 132–42, where other examples found on the Greek mainland are mentioned. Karo ignored the fact that niello technique was known

much earlier in Syria. See Helene J. Kantor, *The Aegean and the Orient in the Second Millennium B.C.*, 65 ff.

21. Kantor, *op. cit.*, 18–21.

22. Kantor, *op. cit.*, 77 states rightly: 'It would be oversimplification to assume that the spirals apparently introduced into Asia by Middle Minoan trade were ancestral to all those used afterwards in that area.'

23. F. Bisson de la Rocque, G. Contenau, F. Chapouthier, *Le Trésor de Tôd* (Institut français d'archéologie orientale, Documents de fouilles, xi, Cairo, 1953).

245. 24. *Op. cit.*, plate xxxi, bottom right. The Aegean features of the hoard have been studied in detail by Chapouthier.

25. Furumark's refusal, in *Opuscula archaeologica*, vi (Lund, 1950), to acknowledge Aegean influence when running spiral patterns occur unless exact Aegean parallels are known, is unwarranted. The unending running spiral patterns differ in essence from those used normally in ancient Near Eastern decoration. Moreover they have nothing to do with the spectacle spirals which are an obvious embellishment to the worker in metal (at Ur, Hissarlik, and elsewhere), or with the isolated imitations of nummulites or ammonites on predynastic Egyptian pots. The running spiral appears, in Egypt as well as in Asia, for short periods during which intercourse with the Aegean is proved to have existed by importation of pottery and other objects. It is perverse to deny that the running spiral decoration, which is not universal but has certain well-defined areas of popularity in the old and new worlds, made an intermittent appearance in western Asia and Egypt as a result of contact with one of its centres of distribution, namely the area stretching from the Danube southwards to Crete.

26. H. E. Winlock, *The Treasure of Three Egyptian Princesses* (New York, 1948), plate xxiv.

27. Ivory inlays of a somewhat later period were found at El-Jisr, in Palestine. They also show strong Egyptian influence while remaining quite un-Egyptian. See *Quarterly of the Department of Antiquities in Palestine*, xii (1946), 31–42 and plate 14.

28. On terracotta figurines from Byblos, see Maurice Dunand, *Fouilles de Byblos* (Paris, 1939), plates xlvii-li. On a gold-covered bronze figure from Ras Shamra, see C. F. A. Schaeffer, *The Cuneiform Texts from Ras Shamra Ugarit* (Schweich Lectures, 1936), plate 33.

29. The nearest parallel is the headdress of the Muu-dancers at Egyptian funerals. See *Journal of Egyptian Archaeology*, xi (1925), plate v; E. Brunner Traut, *Der Tanz im alten Ägypten* (Glückstadt,

1928), 43, 53–9; J. Vandier, in *Chronique d'Egypte* (1944), 35 ff.

30. It is quite inadmissible to 'read' such decorations as if they told a story, as is done by R. Dussaud, *L'Art phénicien du II millénaire* (Paris, 1949), 39 ff.

31. *Annales du Service des Antiquités*, vii (Cairo, 1906), 115–20.

246. 32. This site, discovered and excavated by Sir Leonard Woolley, has become the key to the chronology of the second millennium as a result of the work of Sidney Smith, *Alalakh and Chronology* (London, 1940).

247. 33. In these rooms a multitude of tablets and further more costly objects were found: elephants' tusks, inlays on caskets, bronze weapons, alabaster vases. Were they stores or offices of the Private Purse?

34. I have to thank Sir Leonard Woolley for the photographs and for permission to reproduce them. The preliminary report appeared in *Illustrated London News* (25 Oct. 1947), 470 ff. I do not endorse the description of the head as 'Hittite'.

248. 35. *Illustrated London News* (25 Oct. 1947), 471, figures 3, 4.

36. A. Moortgat, *Die bildende Kunst des alten Orients und die Bergvölker* (Berlin, 1932), has attempted to assign to various groups of mountaineers distinctive themes or styles, but without success. His recent attempt to separate north Syrian and Hittite themes was equally unsuccessful. See above, Chapter 9, Note 45.

37. Frankfort, *Cylinder Seals*, 273–84.

38. Hurrian ware, Atchana ware, Billa ware.

249. 39. See Mallowan's study in *Mélanges syriens offerts à M. Réné Dussaud*, ii, 887–94.

250. 40. Helene J. Kantor, *The Aegean and the Orient in the Second Millennium B.C.*, 78.

41. It belongs to level ii, of the thirteenth century b.c. See Sidney Smith, *Alalakh and Chronology*, 46.

42. *Antiquaries' Journal*, xxviii (1948), 5 and plate viii(a). Cf. A. W. Persson, *New Tombs at Dendra near Midea*, 105 and 108.

43. R. F. S. Starr, *Nuzi* (Cambridge, Mass. 1937, 1939).

44. Starr, *op. cit.*, plate 110 (a).

252. 45. Frankfort, *Cylinder Seals*, 272, and plate xliv(c).

46. *Annals of Archaeology and Anthropology*, xix (Liverpool, 1932), plate xliii.

47. *Antiquaries' Journal*, xix (1939), plates xiii and xiv.

48. This sign is often impressed on clay pots in Anatolia; five of these are from Boghazköy and were always found in connexion with tablets; several come from Kültepe. It was in publishing these that

H. de Genouillac, in *Céramique cappadocienne*, proposed to call it 'signe royal', a reasonable designation, since it is certainly an official mark. It is quite gratuitous to describe it as 'représentant le soleil et la foudre', as Schaeffer does, who did not recognize its Hittite connexions when he found it on a bronze object (*Syria*, XII (1931), plate xiii(4)). Bittel and Güterbock, in *Boghazköy* (Berlin, 1935), 41 ff., confuse the issue by considering it related to the Babylonian sun-symbol; for this had a four-pointed star with multiple zigzags between the points, and not the peculiar butcher's hook and dots of the Hittite sign. When the Hittites did borrow a symbol, such as the 'winged disk', there is no such discrepancy, and the 'signe royal' is therefore not to be derived from the Mesopotamian sun-disk with its very different design. It also deserves notice that the 'royal sign' never occurs in the sun of the 'winged disk', again in contrast with the Mesopotamian design. Its absence from the royal sealings indicates that it does not stand for the king, but for some part of the machine of government which we cannot identify as yet.

49. The Mycenaean parallels are listed by Helene J. Kantor, *The Aegean and the Orient in the Second Millennium*, 101.

50. *Antiquaries' Journal*, XIX, 13.

51. Sidney Smith, *The Statue of Idrimi* (London, 1949). He dates Idrimi to 1414–1385 B.C. Goetze (*Journal of Cuneiform Studies*, IV, 1950, 231) suggests the first half of the fifteenth century B.C.

52. To be published by the Oriental Institute of the University of Chicago.

53. *Antiquaries' Journal*, XXVIII (1948), plate vii.

254. 54. *Syria*, XXVIII (1951), 15, figure 17. The most recent excavations have shown that the palace was a very large building indeed, containing several more courts with a pillared portico which gives access to the rooms beyond.

55. C. F. A. Schaeffer, *Stratigraphie comparée*, plates iii, vii, and ix. *Syria*, XXVIII (1951), 1 ff. The extent of these fortifications is not yet known. They may belong to an earlier period, i.e. 1650–1450.

256. 56. Frankfort, *Cylinder Seals*, plate xliv(c), (d), (h), (j) and (l); also on the Anatolian cylinder, *op. cit.*, plate xliii(n) and (o).

57. R. F. S. Starr, *Nuzi*, II, plate 101; I, 421–2.

257. 58. It has been suggested that this figure represents a ruler of Ugarit. There is no reason to expect a beardless king of the Hittites at this site. And even among the Hittites the shawl was a woman's garment. On another stele (Schaeffer, *The Cuneiform Texts of Ras-Shamra-Ugarit*, plate xxxi) two figures are explicitly related to one another. It is a crude piece of carving, lacking not only the clarity and sureness of line of illustration 294, but also the modicum of plasticity of its hands, knees, and face. The figures of the other stele stand out with sharp edges before a background roughly cut away, and the detail is engraved. Its interest lies in a mixture of derived and native features. The winged disk crowns the scene, as it does on Egyptian steles, but it is Syrian in design. The god's throne is a piece of Egyptian furniture, his crown is Syrian, and his gesture and dress are Syrian or Babylonian; the standing figure who seems to offer the god refreshment was supposed by the discoverer to be the king of Ugarit, but his beardless face and headdress suggest an Egyptian, not a Semitic king; moreover, the royal serpent seems to be fastened to the front of his crown. If this view is correct, the staff he holds might be crowned with the ram of Amon, and the whole scene would appear as a chauvinistic interpretation of the city's relations with Egypt, Pharaoh being shown doing homage to El, the chief god of Ugarit.

59. The hair star on the shoulders of lions is too widely distributed in both space and time to be relevant here. See Helene J. Kantor's article in *Journal of Near Eastern Studies*, VI.

258. 60. The engraved lines are generally thought to represent horns and the figurine to render a god. But several figures in the round show that the horns of the divine crowns were not rendered in this way; they were separately made and stood out from the side of the head and curved forward. So, for instance, in a fine figurine from Ras Shamra (C. F. A. Schaeffer, *The Cuneiform Texts from Ras-Shamra-Ugarit*, plate xxxiii). A stone head from Djabbul, now in the Louvre, shows the same engraved lines (Contenau, *Manuel*, II, 1016; Moortgat, *Bergvölker*, plate ix, a proper profile), but here the whole headgear is rendered more clearly. The felt cap seems to be pressed to the back and sides of the head by a metal diadem which splays out in front into four strips hammered flat and curving upwards. In this head they are, however, connected by a vertical strip, which our bronze figurine does not show.

61. Frankfort, *Cylinder Seals*, plates xlii(f) and xliv (g).

62. *Antiquaries' Journal*, XIX (1939), plate xviii, 3.

259. 63. The spectacle spiral is easily produced whenever metal wire is used for ornaments; but in ancient Egypt and ancient Mesopotamia it is connected with the goddess of birth – see *Journal of Near Eastern Studies*, III, 198 ff.

260. 64. H. J. Kantor, in *Journal of Near Eastern Studies*, VI, 255; cf. *Journal of Egyptian Archaeology*, XXVII (1941), 113 ff., esp. plate xx.

261. 65. For a criticism of Schaeffer's opposite viewpoint, see *Bibliotheca Orientalis*, VIII (Leiden, 1951), 96 ff.

66. C. F. A. Schaeffer, *Ugaritica*, II, 8–18, interprets the decoration of the plate as if it were the rendering of an actual adventure of a ruler of Ugarit.

67. The rope attached to the dog's collar is a loop through which the leash was passed. The dogs were released by letting the leash slip through the loop.

68. Bruno Meissner, *Beiträge zur altorientalischen Archaeologie* (Leipzig, 1934), 1–14. A. Moortgat, *Die bildende Kunst des alten Orients und die Bergvölker* (Berlin, 1932), increases confusion by the use of the term 'Bildgedanke', which effectively prevents him from distinguishing the role in a work of art of three separate things: actuality, imagination, and style.

262. 69. Tomb of User, N. de Garis Davies, *Five Theban Tombs*, plate xxii, reign of Thutmosis I. Tomb of Userhet, reign of Amenhotep II, Wreszinski, *Atlas zur Aegyptischen Kulturgeschichte*, I, plate 26A.

70. Georg Karo, *Die Schachtgräber von Mykenai*, plate xxiv, no. 240. So also the horses on the sword blade, *ibid.*, plate lxxxvi.

71. Part of the archives of Akhenaten's capital has been recovered; it is known as the 'Tell el Amarna letters', and consists of reports and appeals for help from Egypt's allies and vassals in Asia which disclose the ascendancy of the Hittites and their methods of intimidation and indirect aggression.

263. 72. Sidney Smith has collected the evidence and discussed the location of the 'preserves with elephants' on the Euphrates, near Meskineh, in *The Statue of Idrimi* (London, 1949), 48 ff. Goetze advocates (like Gardiner and Albright) a location in the Upper Orontes valley, north-west of Hama, in *Journal of Cuneiform Studies*, IV (1950), 230.

73. J. H. Breasted, *Records of Ancient Egypt*, II, 233, § 588.

74. *Antiquaries' Journal*, XXVIII (1948), 14.

75. P. Montet, *Byblos et l'Égypte*, 220. These may date from the thirteenth century, as do other objects found here, or from a later date (tenth century), when the inscription was cut on the existing sarcophagus.

76. See *Annual of the British School of Archaeology at Athens*, XXXVII (1936–7), 106–22. Monuments inscribed with the name of the Hyksos ruler Khian have been found in Egypt, Crete, and Babylon, and such an ephemeral empire would coincide with the griffin's habitat after the period of the migrations. In Egypt it appears once at the end of the Hyksos period, on the axe of Queen Aahhotep. It reappears, in the nineteenth dynasty (thirteenth century B.C.),

on objects depicted among Syrian tributes in the tombs of certain Pharaohs; textiles, shields, and vessels. See P. Montet, *Les Reliques de l'art syrien dans l'Égypte du Nouvel Empire* (Paris, 1937), 111–13.

77. This is the First Syrian Group discussed in Frankfort, *Cylinder Seals*, 252–8, plate xli. The dates given there should be corrected by the new date of Hammurabi (1792–50 B.C.) and read as about 1800–1500 B.C.

78. *Annual of the British School of Archaeology at Athens*, XXXVII, 121 ff.

264. 79. *Illustrated London News* (22 July 1939), 163, figure 16.

80. Recently the engraved design of a lion attacking a griffin has been found with other ivories in Delos, *Bulletin de Correspondance Hellénique*, LXXI-II (1947–8), 148–254.

81. A group of ivory plaques inlaid on the footboard of a bedstead have recently been found at Ras Shamra. They resemble the stele of illustration 294 in that the drawing is strongly influenced by Egypt while the subjects are native, and very unusual. A bearded king kills a kneeling enemy with his sword; a horned and winged goddess gives her breasts to two mortals; a man carries a small lion, etc. See *Illustrated London News* (27 March 1954), 489 ff.

82. E.g. Frankfort, *Cylinder Seals*, plate xliv(b). *American Journal of Archaeology*, LI (1947), plate xxiii(A) (drawing).

265. 83. A. S. Murray, A. H. Smith, and H. B. Walters, *Excavations in Cyprus*, plate i.

84. R. de Langhe, *Les Textes de Ras Shamra et leurs rapports avec le milieu biblique de l'Ancien Testament* (Paris, 1945), II, 251–354.

85. Published by C. F. A. Schaeffer in *Syria*, X (1929), 291–3.

266. 86. There is, possibly, one exception in a badly damaged ivory from Mycenae, where Schaeffer and Dussaud, *Gazette des Beaux-Arts*, LXXII (1930), 6–7, recognize a front leg of a goat of which the rest has disappeared.

87. The differences between the box lid and Aegean works are fully discussed by Helene J. Kantor, *The Aegean and the Orient in the Second Millennium B.C.*, 87 ff.

88. See above, p. 252.

89. See above, p. 236.

90. Olga Tufnell, Charles H. Inge, and Lankester Harding, *Lachish II, The Fosse Temple* (London, 1940), plate xviii.

91. In addition to the box referred to in the preceding note, the finds at Tell ed Duweir (Lachish) included a tall flask for perfume, its neck carved in the shape of a woman's head, while the body of the

flask was decorated as if it rendered a gown. A spoon-shaped lip projecting beyond the opening allowed one to collect a few drops of the precious contents at a time by tilting the flask. Other finds include ivory masks of statuettes, and the usual small accessories or ornaments shaped like ducks' heads, a gazelle's head, a cat, and so on (*op. cit.*, plates xv–xvii).

92. Such objects figure among the tribute received by Pharaohs of this period: Pierre Montet, *Les Reliques de l'art syrien* (Paris, 1937), 48 f.

93. Gordon Loud, *Megiddo Ivories*, plate 13, no. 54.

267. 94. E. Wallis Budge, *Assyrian Sculpture in the British Museum, Reign of Assurnasirpal*, plate li, 3.

269. 95. *Mémoires de l'Institut Français d'Archéologie Orientale*, XVI (1939), 229, figure 118. Anubis acquired this active pose probably as a protector against demons of the nether world; the head-rest was found in a tomb, and Anubis, and his pendant, a lion, hold the knives known from vignettes of the *Book of the Dead* and similar works where Anubis and his helpers destroy dangerous spirits.

96. N. de Garis Davies, *The Tomb of Kenamun* (New York, 1930), plate xviii.

97. P. Montet, *Les Reliques de l'art syrien dans l'Égypte du Nouvel Empire* (Paris, 1937), 173–4.

98. *Ibid.*, 110 with figure 148.

99. *Ibid.*, 45–8; 173 ff.

100. *Journal of Egyptian Archaeology*, III (1916), plate xi.

101. Montet, *op. cit.*, 173, figure 200. This is the figure from the base of the statue of Horemheb and Queen Mutnedjem in Turin. Cf. *Journal of Egyptian Archaeology*, XXXIX (1953), plate 1.

102. Its long thin neck also recalls works from Tell el Amarna, and a comparison with other Palestinian ivories seems to corroborate the date we assign to it. See below, Note 110.

103. Kantor, *The Aegean and the Orient*, p. 97.

270. 104. The photograph of this piece (Loud, *Megiddo Ivories*, plate 22), suggests that the lowest figure might be a goddess wearing a crown as shown in *Cylinder Seals*, plate xliv, (g), (h), and (j).

105. Loud, *op. cit.*, plate 9, no. 36. Cf. Frankfort, *Kingship and the Gods*, figure 12.

106. Loud, *op. cit.*, plate 33, no. 161.

107. Loud, *op. cit.*, no. 162.

108. These are discussed in *Journal of Egyptian Archaeology*, VII, 31 ff. – the closest parallel is the hindmost scribe supervising Negroes in Bologna: Steindorff, *Kunst der Aegypter* (Leipzig, 1928), 248.

271. 109. There has been a long controversy about the origin of these bringers of tribute, the Keftin, marked, on the whole, by a lack of critical acumen.

See now Arne Furumark's discussion in *Opuscula Archaeologica*, VI (Lund, 1950), 223–46.

110. It is interesting to compare this piece with one found in the extreme south of Palestine, at Tell Fara (W. M. Flinders Petrie, *Beth Peleth I* (London, 1930), 19 and plate lv). It is dated by its discoverer to the reign of Seti I. It follows Egyptian prototypes much more closely than the Megiddo ivory. On the box lid from Tell Fara the principal person – one tends to say, the Egyptian governor – is attended by an Egyptian-looking butler. He sits on an Egyptian camp-stool; a maidservant fills his cup, and a dancing girl performs to the sound of a double flute, played by her companion. The rest of the box lid shows a stiff rendering of another Egyptian theme, a papyrus marsh. A man returns with ducks dangling from a pole, another carries a calf through a water-course, a third catches birds in a net – all purely Egyptian motifs. The style, on the other hand, is un-Egyptian. The calf, and the beautiful long-horned bulls moving through the reeds, are rather Aegean in character, recalling the bulls on the narrow side of the gaming board from Enkomi. And a thoroughly un-Egyptian palm tree closes the scene at each end. Its fronds are S-shaped, like those of the Samaria and Arslan Tash ivories of a later period. The mixture of derivations shows, once again, that we are dealing with a Levantine work, even though it follows Egyptian examples in remarkable detail.

111. Sidney Smith, *Alalakh and Chronology*, 46, n. 117, was, I think, the first to argue that the date of the sarcophagus was independent of that of the inscription and fell within the confines of the thirteenth century B.C. as the archaeological evidence suggests. The inscription is thought to be of the tenth century B.C.

112. The very complex problem of the funerary feast depicted in Egyptian tombs has been elucidated by Miriam Lichtheim, 'The Songs of the Harpers', *Journal of Near Eastern Studies*, IV (1945), 178–212.

272. 113. *Journal of Egyptian Archaeology*, XI, 159 ff. and plate xvii, where H. R. H. Hall assigns it to Syria.

274. 114. Mallowan, in *Iraq* (1947), 174.

115. Hall, in *Journal of Hellenic Studies*, XLVIII (1928), 64–74; Andrae, *Die jüngeren Ischtartempel*, 79.

116. Parrot, in *Syria*, XVIII (1937), 83, plates xiv, 3 and 4; xv, 3.

117. C. F. A. Schaeffer, *Ugaritica*, I, 9 ff., p. 32 and plate x.

118. *Quarterly of the Department of Antiquities of Palestine*, IV (1934), plates xxviii–xxix.

119. Hall, *loc. cit.*; Murray, Smith, and Walters, *Excavations in Cyprus*, 22, plate iii.
120. Information supplied by Mr R. W. Hutchinson.
121. *Syria*, XVIII (1937), 83.
276. 122. C. F. A. Schaeffer, *The Cuneiform Texts of Ras Shamra*, 50 f.
123. This point is very clearly brought out by C. F. A. Schaeffer in the second chapter of his *Ugaritica I*, esp. 77 ff., 90 ff.
124. *Antiquaries' Journal*, XXX (1950), 2–8.

CHAPTER 11

279. 1. This is shown by the texts from Karatepe referring to Mopsos-Moxos. See below.
280. 2. Asitavandas, the builder of Karatepe in Cilicia in the seventh century B.C., claims descent from Mopsos whom Greek tradition connects with the fall of Troy and with Cilicia, while Hittite tradition connects him with the fall of the Hittite empire. See H. T. Bossert, in *Revue Hittite et Asiatique*, IX (1949), 1–9; *Orientalia*, XIX (1950), 122–5. See a good summary by M. Mellink in *Bibliotheca Orientalis*, VII (1950), 148 ff., who also gives a bibliography. See also R. D. Barnett in *Journal of Hellenic Studies*, LXXIII (1953), 141 ff.
3. C. L. Woolley, *Carchemish*, II, plate B30a.
4. I avoid the commonly used term neo-Hittite because it is misleading through its suggestion of continuity with the Hittites. Puchstein spoke of pseudo-Hittite; Przeworski of Syrian; Unger of Aramaean; Moortgat of Hurrian. The last two terms are inadmissible, since they refer to ethnic and linguistic groups. Sidney Smith, 'The Greek Trade at Al Mina', *Antiquaries' Journal*, XXII (1942), 87–112, suggests that the dominance of Urartu over north Syria from about 780 to 750 B.C. brought the non-Semitic-speaking elements, Hittites and Hurrians, to the fore. This may be so, but the new sculpture started, at Tell Halaf and Zinjirli, in the ninth century, and there is little reason to call it Hurrian, even though motifs used in Mitanni (and in Middle Assyrian) art are frequent, for Mitannian art was dependent on that of Mesopotamia. The Hurrians (like the Aramaeans and the Indo-Europeans) arrived without arts of their own. (See also below, Note 41.) When Landsberger, *Sam'al*, I, insists that any analysis of the art should lead to a distinction between '*Hettitertum*' and '*Hettitische Reichskultur*', he asks for the impossible, as is clear, for instance, on his pp. 33, 34, n. 68, 35 or on p. 98, where the '*Volkstum*' he wants to define lacks all substance. Hittite culture was not the sole product

of the Hittite-speaking subjects of the king; it has never yet been possible to translate into a cogent argument the common feeling that certain groups of people are predisposed to one rather than another style. Landsberger's wish to see an 'aprioristische Erkenntnis der Volkstümer aus den Kunststilen' calls up a chimaera, unless one translates *Volkstum* by culture. I say this without denying that some such predisposition may exist; but if it does, it is one of the imponderabilia of historical development. See my *Birth of Civilization in the Near East* (London and Bloomington, Indiana, 1951).
5. B. Landsberger, *Sam'al*, I, 13 ff., 26 ff., explains this continuity by assuming that north Syria was occupied by Luvians, a people from south-west Anatolia who spoke a language closely related to Hittite, and it is this language which is written in the hieroglyphs. These Luvians allegedly moved south-eastwards as part of the great migration of the 'Peoples of the Sea'. Even for Landsberger these Luvians are, however, a 'provisional' and 'heuristic' concept (*op. cit.*, 14, n. 29, 30). Sidney Smith (*op. cit.*, 93) also ascribes the use of hieroglyphs in north Syria to Anatolians driven southward by the Phrygians rather than to a heritage of imperial Hittite rule in north Syria.
281. 6. Neither inscription is in Aramaean, which does not seem to have become a written language before 800 B.C. Kapara uses a 'barbaric Assyrian' (Meissner, *Aus fünf Jahrtausenden morgenländischer Kultur*, Beiheft no. 1, Archiv für Orientforschung, 72–8). Kilamuva's inscription is in Phoenician, and it has been supposed by Landsberger, *Sam'al*, I, 43 ff., that the scribe came not from the Phoenician cities, but from the Assyrian court. He rightly observes that Kilamuva is dressed in every detail like an Assyrian.
7. The latest and most thorough attempt was made by Ekrem Akurgal (see above Chapter 9, Note 47), who has, however, not allowed his belief in continuity to influence his excellent formal analyses. In his *Späthethitische Bildkunst* he postulates an 'altspäthethitische Stufe' as a transition between imperial and north Syrian art. He assigned to this the Lion Gate at Malatya, and the reliefs from the water-gate at Carchemish. Yet he has shown more systematically than anyone else that the Lion Gate and its reliefs have close affinities with imperial Hittite art, and if we accept the consequences of his argument to the full and assign them to the thirteenth century B.C. (as we have done), there is nothing to substantiate the '*Blütezeit*' of this transitional stage which was alleged to fall between 1200 and 900 B.C. For Akurgal observes that the other works assigned to this stage show a mixture of features, some belonging to this,

some to the next (mittelspäthethitische Stufe; see, e.g., p. 140; and p. 130 for Zinjirli). This really means that the 'altspäthethitische Stufe' is a mere abstraction which isolates the clumsier features of north Syrian art of the ninth and eighth century. But one cannot project features thus isolated into the vacuum of the dark ages. Moreover, the alternative 'Hittite or Assyrian' does not exhaust the possible sources of north Syrian sculpture, nor de we need to refer to Urartu or other foreign countries (137 ff.). If it is true that the stimulus to seek plastic expression derived from Assyria, it is also true that it led to a sudden outburst of native carving, with varying degrees of success, as will be shown in the text. The lions of Alalakh [319, 320] and the sarcophagus of Ahiram of Byblos [317] show similar local efforts of an earlier age. On the relatively late date of the water-gate at Carchemish see p. 280.

8. Thureau-Dangin, Barrois, Dossin, Dunand, *Arslan Tash*, plates iii and vi.

9. *Op. cit.*, plates iv and vi.

10. On a pillar base, *Syria* (1926), plate 11, figure 36.

11. *Arslan Tash*, plates viii, ix, x, etc.

12. A. Dupont-Sommer, *Les Araméens* (Paris, 1949), 68.

282. 13. In buildings of which only the foundations are preserved the staircase appears as a solid block of masonry. So at Zinjirli.

14. Plan in Garstang, *The Hittite Empire*, 266, figure 29.

15. The building is so badly preserved that we cannot be certain. See Woolley and Barnett, *Carchemish*, III (London, 1952), 179–184, and plates 38–41.

16. Bittel and Naumann, *Boghazköy*, II, 18–20, have tentatively reconstructed fragmentary foundations of a building in Boghazköy to tally with the plan described in our text. The actual remains shown, *op. cit.*, plate iii, simply present an oblong central hall or court surrounded by rooms – an almost ubiquitous arrangement in Near Eastern architecture. The remains in no way recall the peculiar north Syrian plan, and would never have been reconstructed to agree with one, but for the belief in continuity between north Syrian and Hittite architecture. It has been shown that the word *hilani* comes from the Hittite and means gatehouse (Joh. Friedrich, in *Zeitschrift für Assyriologie*, XXXVII, 179; A. Goetze, *op. cit.*, XLI, 246). Bossert, *Archiv für Orientforschung*, IX (1933–4), 127, has drawn attention to the shape of the hieroglyph which seems to stand for this '*bît-hilani*'; it shows a gatehouse with a round doorway and a window in the wall above it. There are no columns, and the sign

confirms that the typical north Syrian building which the Assyrians (and we after them) call *bît-hilani* has no connexion with Anatolian architecture, but was evolved in Syria and only named there, as it seems, with a Hittite word meaning gate or gatehouse. One may object to our use of the term *bît-hilani* for the whole of the north Syrian palace with its two long rooms and portico, but it is convenient, since we need a designation for this distinctive type of building. The extensive literature on the subject is quoted by Bossert, *loc. cit*, n. 1.

283. 17. These various arrangements can also be observed in the north-west complex of the citadel, where the layout is more complicated since Barrekub added *bît-hilani* K and outbuildings L to the existing *bît-hilani* J of Kilamuva, which was in some way which cannot be ascertained (denudation below level of doorsteps) connected with a square building behind it. See Von Luschan, *Ausgrabungen in Sendschirli*, plate l.

18. Naumann, in a very thorough study of the extant bases and ancient representations of columns (*Jahrbuch für kleinasiatische Forschung*, II (1953), 246–61), concludes that columns of the Cretan type, wider at the top than at the base, survived in some north Syrian buildings in the ninth century B.C., thus establishing another link with the second millennium.

19. See above, pp. 253–4.

284. 20. So called by Gordon Loud, *Revue d'Assyriologie*, XXXIII (1936), 153–60; idem, *Khorsabad*, II, 11 and plate 86.

21. Hence our reconstruction of the palace at Tell Asmar [114], where the stairs likewise are joined to the first rooms. The palace of Mari has a throne base in the first room, but no stairs adjoining it.

22. Remains of such a wagon have been found at Tell Halaf. (See M. von Oppenheim, *Tell Halaf*, plate lviii(b), and Naumann, *Tell Halaf*, II, plate 12, 45 ff.)

23. This is established Assyrian usage. At Khorsabad three stone slabs were let into the floor of the throne room (Loud, *Khorsabad*, I, 56 ff.). At Nimrud the throne room had stone rails (*Nineveh and its Remains*, II, 14 ff. and plan 4). The throne rooms were the first rooms reached from the court, as was room XXIV in the Assyrian palace at Til Barsip, which also had stone rails for a hearth (Thureau-Dangin a.o., *Til Barsip*, plan B).

285. 24. R. Naumann, *Tell Halaf*, II, figures 23–4; 40.

25. *American Journal of Archaeology*, XLI (1937), figure 5.

26. Bittel and Güterbock, *Kleinfunde aus Bog-*

hazköy, plates 2, 3; E. Akurgal, *Späthethitische Bildkunst*, figures 27–9.

27. *Antiquaries' Journal*, XXX (1950), plate VI. It was out of place when found.

28. F. von Luschan, *Ausgrabungen in Sendschirli* (Königliche Museen in Berlin, Mittheilungen aus den orientalischen Sammlungen, XI–XIV, Berlin, 1893–1911).

29. In the foreground of illustration 335 are two perforated stones closed with stoppers; these closed a drain which took off water rushing downhill during a rainstorm through a channel constructed underneath the pavement of the gate.

287. 30. Landsberger, *Sam'al*, p. 50, n. 128, assigns it to Kilamuva on the strength of the building inscription of Barrekub.

31. F. von Luschan, *Ausgrabungen in Sendschirli*, 259, sees in them a men's lodge and a women's lodge. At Arslan Tash, too, there were two separate suites situated at the corner of a court (our illustration 174).

32. Von Luschan, *op. cit.*, 135.

33. Von Luschan deduces the original position of the building inscriptions in a manner which seems to me quite unexceptionable: *Ausgrabungen in Sendschirli*, 377.

34. These are seen in the detailed plan, Von Luschan, *op. cit.*, plate L. (In illustration 334, above, the buildings marked E and F correspond with Von Luschan's J and K.) The complex, as ultimately used by Barrekub, is an interesting example of the methods followed when the *bît-hilani*, which was not itself capable of extension, was too small for the builder's purposes, and had to form part of a larger whole. The portico of J (E in illustration 334) is on a level with the court, and the step leads up from the portico to the main room. The stairs to the second storey are not placed in a square tower, but between two long walls, on the left when one enters. The entrance room (J1) is divided into two, and the main room (J3) has a fixed hearth of bricks. All these are merely unusual features. But the following illustrate the methods of enlargement: observe that there is no proof for any direct connexion between the *bît-hilani* (J) and the oblong building behind it; all the intermediate doors are conjectural. It is possible that the first room was divided and that J2, now separated by a door with a stone still from J1, was made to serve as main room precisely because J3 had become a space connecting the *bît-hilani* with the secondary rooms behind it. In any case it is the only inside room decorated with low orthostats round its walls. The rooms at the back of J3 include bathrooms and toilets (J6) and presumably bedrooms, as in the Upper Palace.

Bît-hilani K was evidently planned in view of the available space. Beyond the main room there was only room for the small room K3. The rest of the area was taken up by magazines (J14) belonging to the complex J. The main room in K had a fixed hearth and a low dais for a throne against a short wall beyond it. At the west side of K are a number of service and living rooms, including a bathroom (L6) with a handled bath-tub of bronze. Von Luschan thinks of this suite of rooms as a harem, with building J as the royal residence and building K the ceremonial palace (*op. cit.*, 261).

288. 35. R. Naumann, *Tell Halaf*, II, figure 36. It was placed about five feet in front of the easternmost lion. At Carchemish, too, polychrome glazed bricks were used (Woolley and Barnett, *Carchemish*, III, plate 33).

289. 36. R. Naumann, *Tell Halaf*, II, figure 165.

37. *Op. cit.*, figure 184 shows this very clearly.

38. See above, Note 34.

39. The plan in *American Journal of Archaeology*, XLI (1937), figure 4 on p. 9 shows a side entrance which was omitted in the reconstruction of illustration 329, which was also published by the excavator. I would only accept the existence of this side entrance as part of the original plan on incontrovertible evidence. The triple doors between portico and main room are conjectural. One expects a single wide door here, and need not accept the reconstructed plan on this point.

40. There are no inscriptions to date these buildings, but the very accomplished carving of the lions and the identity of the carved pillar base with that of Barrekub's Hilani K at Zinjirli indicates the last third of the eighth century B.C. Moreover, six sculptured limestone slabs of the time of Tiglathpileser III were re-used as pavement. (*American Journal of Archaeology*, XLI (1937), 8–15.)

290. 41. This route led from Nisibin via Guzana (Tell Halaf), Harran, Khadatu (Arslan Tash) to the Euphrates crossing at either Til Barsip or Carchemish. Til Barsip was taken by the Assyrians in 856, Carchemish was subjugated in 849, and finally taken in 717 B.C. Bittel (*Zeitschrift für Assyriologie*, N.F. XV, 284) loses sight of the political significance of this route, when he seeks to explain the distribution of north Syrian art by claiming different relations between Hurrians and Aramaeans. East of the Euphrates the country was Assyrian from about 800 B.C. onward. West of the Euphrates vassal princes maintained a degree of independence which called for palace sculpture, until the end of the eighth century, when Assyrian governors had everywhere taken the place of the local rulers.

42. The date of the sculptures has for many years been a matter of controversy, with Von Oppenheim and Herzfeld arguing vigorously for a third-millennium origin, which had always seemed impossible. The matter was settled in an article by Raymond Bowman, 'The Old Aramaic Alphabet at Tell Halaf', to which Robert J. Braidwood contributed an important study of the small objects from Tell Halaf in which he compared them with his own discoveries at Tell Judeideh in the plain of Antioch (*American Journal of Semitic Languages and Literatures*, LVIII (1941), 359–67). The archaeological material gives a range from 850 to 600 B.C., the palaeographic material points to 'the last half of the ninth or to the beginning of the eighth century B.C.'. The authors of *Tell Halaf*, II assign Kapara to 850–830 B.C. They emphasize that the Aramaic buildings of the Kapara dynasty are the first important remains on the site. The final publication of the sculpture has not yet appeared. Baron Max von Oppenheim's *Tell Halaf, A New Culture in Oldest Mesopotamia* (London and New York, 1933) is boastful and misleading but well illustrated. The arguments, on 143 ff., intended to show that the small orthostats were older than Kapara and re-used and inscribed by him do not seem conclusive. The various irregularities can easily be explained as the results of that lack of skill which is anyhow abundantly illustrated by the reliefs, and in some cases to changes of the destination of stones while the work was going on.

291. 43. Naumann, *Tell Halaf*, II, 65, figure 29.

44. The text runs (somewhat freely rendered), 'Palace of Kapara, son of Khadianu. What my father and my grandfather, of blessed memory [lit. the deified], did not accomplish, I did achieve. Whosoever shall delete my name to put here his own, his sons shall be burned before the weather-god, his daughters shall become temple prostitutes of Ishtar. It is Abdiilu who has written the name of the king.' See Meissner, in *Aus fünf Jahrtausenden morgenländischer Kultur*, Beiheft No. I, Archiv für Orientforschung (1939), 71–9.

45. *Antiquaries' Journal*, XI (1931), plates l, 3; li, 1 and 3.

46. Bossert, *Altanatolien*, figure 956, shows a figure from Mardin very like those from Tell Halaf, but he has not been able to discover anything about its provenance (*op. cit.*, 68), and the modern city is close enough to Tell Halaf to make it possible that it was brought from there at some time or other.

47. Von Luschan, *Ausgrabungen in Sendschirli*, plate liv.

48. Von Oppenheim, *Tell Halaf*, plate xliv(B).

49. *Op. cit.*, plate xlv. The place is called 'Kultraum', but it is probably a tomb chapel, not a shrine.

50. Akurgal, *Späthethitische Bildkunst*, plate xl. The woman holds a mirror, the man a bunch of grapes. In two features it recalls Egyptian funerary statues: the man and woman each have one arm round the shoulder of their partner; and the group is carved in one piece with its own background of stone which is left standing.

51. Von Oppenheim, *op. cit.*, plate xlvi.

292. 52. *Illustrated London News* (25 Oct. 1930), 707.

295. 53. Frankfort, *Cylinder Seals*, 161, 171, and plate xxvii(k) and xxviii(g).

296. 54. *Op. cit.*, 205–15, esp. 209 ff.

55. *Op. cit.*, plate xxxiv(b) and figures 66 and 67 on p. 219.

56. Von Oppenheim, *Tell Halaf*, plate xxxvi(A). The sun-disk is supported by a stool on Late Assyrian seals, Bibliothèque Nationale, no. 364; Ward, *Cylinder-seals of Western Asia*, no. 1100.

57. Von Oppenheim, *op. cit.*, plate xxxv(B).

58. *Op. cit.*, plates xxxvi–xxxxviii gives a selection.

59. It is best known in the Early Dynastic Period, but never quite disappears. Later examples are, for instance, Frankfort, *Cylinder Seals*, plates xxv(d) and (g); xxxv(a); xxxvi(k); these are the extreme form of 'crossed animals'; fighting pairs of animals are much commoner.

60. Von Oppenheim, *op. cit.*, plate xxviii(b).

61. This has been commonly done, but I doubt whether this figure represents an established type rather than a designer's whimsy. In any case, one cannot describe it as the seraph of Isaiah vi, 2, who, having six wings, 'with twain he covered his face, and with twain he covered his feet, and with twain he did fly'.

62. Von Oppenheim, *op. cit.*, plate xxxiii(a).

297. 63. Von Oppenheim, *Tell Halaf*, plate xxxviii.

64. Edith Porada, *Ancient Oriental Seals in the Library of J. Pierpont Morgan*, nos. 608 and 609.

65. E. Wallis Budge, *Assyrian Sculpture in the British Museum, Reign of Assurnasirpal*, plates xxxviii–xl and xliv–vi.

298. 66. *Op. cit.*, plate xix(b).

67. *Op. cit.*, plate xx(a).

68. *Op. cit.*, plate xxii(a).

69. The south gate of the citadel and other defences were probably built by Kilamuva son of Khayani, and the latter made submission to Shalmaneser III in 853 B.C.

299. 70. Von Luschan, *Ausgrabungen in Sendschirli*, plate xxiv(g) and (h).

71. It occurs on a signet ring, bought at Konya

(D. Hogarth, *Hittite Seals*, plate vii, no. 195), where it supports a winged god which Bittel and Güterbock, *Boghazköy* (Berlin, 1935), 44, cf. *Zeitschrift für Assyriologie*, N.F. XV (1950), 258, assign with good reason to imperial Hittite times.

72. Von Luschan, *Ausgrabungen in Sendschirli*, 288 f., 363.

300. 73. Delaporte, *Malatya*, plates xiv, xv, xxvi–xxviii.

74. Landsberger, *Sam'al*, I, 49 f. and n. 127 supposes that the Zinjirli statue represents a god known only by the epithet 'lord of the lion cubs'.

75. Von Luschan, *op. cit.*, 84, figure 19.

76. R. D. Barnett, *Carchemish*, III (London, 1952), 260.

77. Delaporte, *Malatya*, plates xxvi–xxx. Landsberger, *Sam'al*, 76 ff., identifies this king as Mutallu, king of Kummuhi, who received Malatya in 712 B.C. for his services to Sargon of Assyria, but was suspected of treason in 708. The richness of surface detail does not succeed in hiding the plastic inadequacy of the work, which is clumsy and ill-proportioned.

78. Delaporte, *op. cit.*, plate xxix; Garstang, *The Hittite Empire*, plate xlix, 1.

301. 79. H. R. H. Hall, *Babylonian and Assyrian Sculpture in the British Museum*, plate xix.

80. For a similar figure, see H. Ingholt, *Rapport préliminaire sur sept campagnes de fouilles à Hama* (Copenhagen, 1940), plates xxxvi–xxxvii.

302. 81. Woolley, *Carchemish*, II, plate B30(a). Akurgal, in his *Späthethitische Bildkunst*, assigns this relief to an older period, together with those from Malatya (see above, Note 7), but the stylistic differences (as opposed to the identical subject matter) exclude contemporaneity, since the affinities of the Malatya style are with imperial Hittite monuments and those of the Carchemish relief with north Syrian works, in particular with its companion piece (Woolley, *op. cit.*, plate 30B), of which the eighth century date is beyond doubt, as set out in our text.

82. Woolley, *op. cit.*, plate B30(b).

83. Von Luschan, *Ausgrabungen in Sendschirli*, 220, figure 119. These lutes differ in their arrangement of the cords from that depicted at Alaja Hüyük, in imperial Hittite times: Garstang, *Hittite Empire*, plate xxx(b).

84. R. D. Barnett dates Katuwas (*Carchemish*, II, plate A13d) to the beginning of the ninth century (*Carchemish*, III, 260 ff.) and Araras (*Carchemish*, I, plate B7) to the beginning of the eighth century. They differ in style but both figures, and particularly that of Katuwas, resemble the north Syrian reliefs.

85. Thureau-Dangin and Dunand, *Til Barsip*, plate i. This stele is dated by Barnett before 856 B.C. (*Carchemish*, III, 260).

86. Woolley, *Carchemish*, II, plate B29(b). In Mesopotamia the creature belongs to the weather-god.

87. Hogarth, *Carchemish*, I, plate B14(b).

88. *Op. cit.*, plate B10(a).

89. *Op. cit.*, plate B15(a), cf. Frankfort, *Cylinder Seals*, plate xxxv(e).

90. *Op. cit.*, plate B12.

303. 91. Thureau-Dangin a.o., *Til Barsip*, plate xi(3).

92. Von Luschan, *Ausgrabungen in Sendschirli*, plate liii. We have seen (p. 151, illustration 173) that the Assyrians adopted this type of base when they constructed a portico occasionally.

93. As in the case of the relief from the water-gate, the presence of these processions among the reliefs shows that certain Hittite usages continued in the cult, not that a tradition of imperial Hittite *art* was maintained. It is characteristic that the processions occur after they had become important in Assyrian decoration. If there had been a connexion with, say, Alaja Hüyük, their appearance by the end of the seventh century would be most odd.

304. 94. Von Luschan, *op. cit.*, plate lxii.

95. *Op. cit.*, 375.

96. See the stool of Assurnasirpal in illustration 186 and bronze pieces of similar furniture from Nimrud in the British Museum. S. Smith (*Antiquaries' Journal*, XXII, 93, n. 1) calls the stool of Barrekub Urartian; but Urartian is peripheral Assyrian. See below Note 105.

97. See above, p. 174, illustration 199.

98. Von Luschan, *op. cit.*, plate liv.

99. John Garstang, *The Hittite Empire*, 224–35. Stele from Neirab near Aleppo in Clermont Ganneau, *Études d'Archéologie Orientale*, II (Paris, 1897), 182–223; Bossert, *Altanatolien*, nos. 806–15.

307. 100. This is also shown by the monument of Darende (I. Gelb, *Hittite Hieroglyphic Monuments*, plates xxiv–xxv; Delaporte, *Malatya*, plate xxxv).

101. R. D. Barnett, in *Journal of Hellenic Studies*, LXVIII, 8–9. Phrygians, in this sense, includes the Mushki of Phrygia proper, and the people of Tabal (Lycaonia and Cappadocia); Urpalla was one of the princes of Tabal. Barnett points out that the knobbed brooch (fibula) is known to be Phrygian and that the S-shaped ear pendants of Urpalla recur at Ephesus. He also stresses that the term 'Phrygian art' implies, perhaps, too much.

102. We have noted that plants are held by the figures on the funerary steles from Marash. Ears of

corn are carried by women in procession at Carchemish (Woolley, *Carchemish*, 11, plates B20, B21).

103. Ekrem Akurgal, *Späthethitische Bildkunst*, plate xlviii(b)–l.

~~104. Barnett, *Journal of Hellenic Studies*, LXVIII~~ (1948), 10.

308. 105. This whole question has been discussed by Sidney Smith, 'The Greek Trade at Al Mina' in *Antiquaries' Journal*, XXII (1942), 87–112. The difficulty remains that Urartian products are to such an extent dependent on Assyria that it is very hard to distinguish the influence they exercised from that emanating from Assyria directly. One cannot ascribe the north Syrian revival of sculpture to Urartian influence, because at Tell Halaf and Zinjirli it antedates the Urartian ascendancy in Syria.

106. Barnett in *Iraq*, XII, 39. Barnett points out in *Journal of Hellenic Studies, loc. cit.*, that on the reliefs from Ankara the griffin is shown open-mouthed, knobbed, and horse-eared, as in Greek and Etruscan bronzes. But the griffin demons at Sakjegözü show these features too (Akurgal, *op. cit.*, 80 and plate xliv); here, too, it might be due to Urartian influence, but (probably contemporary) ivories from Van also show the griffin-demon open-mouthed although without knob or horse-ear. *Iraq*, XII (1950), plate xv. The question remains open.

107. H. Th. Bossert, N. Bahadir Alkin, H. Çambel, *et al.*, 'Karatepe Kazilari (Birinci Ön-rapor)', *Die Ausgrabungen auf dem Karatepe*, Türk Tarik Kurumu Yayinlarindan, v. seri, no. 9 (Ankara, 1950). This contains an up-to-date bibliography of the literature already published concerning the discoveries. An excellent critical study of the problems raised has been made by Machteld J. Mellink, in *Bibliotheca Orientalis*, VII (Leiden, 1950), 141–50.

108. Mellink, *op. cit.*, 147 ff. There are historical, palaeographical, philological, and archaeological arguments in favour of this late date.

109. Mellink, *op. cit.* 148.

110. *Orientalia*, XVII (Rome, 1948), plate xxxiii. The statue was actually found at Domuztepe, a hill facing Karatepe across the river, and apparently dependent upon it.

111. These are well studied by Dr Halet Çambel, in *Oriens*, I (1948), 147–62.

309. 112. Dr Mellink, *op. cit.*, speaks of 'a different ethnic background of the artists'; she means, no doubt, cultural rather than ethnic.

113. *Karatepe Kazilari*, plate xiii, figure 68.

310. 114. The relevant material has been studied by Mellink, *op. cit.*, 144, col. 2. Her argument that the ship depicted at Karatepe suggests that the sculptors knew Sennacherib's reliefs at Nineveh is not con-clusive, since that king, as she (quoting D. D. Luckenbill, *Annals of Sennacherib*, 73 and ff.) rightly states, 'had the "Hittite" people build ships for him at Nineveh and Til Barsip in which he put Phoenician and Cypriot sailors'. The Karatepe sculptors may, therefore, have depicted such a ship because such craft plied to Cilician and Phoenician ports, and not because they knew the sculptures at Nineveh; if they did, we should have expected more signs of influence of these sculptures on the Karatepe reliefs.

115. *Karatepe Kazilari*, plate xvi, no. 83.

116. Thus the beautiful ivory head found at Perakhora seemed oriental to its discoverer Payne (*Journal of Hellenic Studies*, LI (1931), 192, figure 8). But no exact parallel, especially not with eyes set in bronze, is known in the Levant. Yet it differs strikingly from the ivory head from Samos which is Greek (*op. cit.*, LXVIII (1948), plate iii(b)). Barnett's suggestion (*op. cit.*, 25, n. 153) that the Perakhora head and the earliest Spartan ivories derive from Cilicia was made when the discoveries at Karatepe had just become known. But this site is thoroughly derivative and provincial and the suggestion is improbable. A number of bronze shields found in Crete are likewise of uncertain affinities, although E. Kunze, *Kretische Bronzereliefs* (Stuttgart, 1931), has made a strong case for their local origin.

117. *Iliad*, XXIII, 741 ff.; cf. VI, 289 ff.

311. 118. Schaefer-Andrae, *Die Kunst des alten Orients* (Berlin, 1925), 495 (1942 edition, p. 535). *Illustrated London News* (28 July 1951), 136, figures 9 and 12.

119. *Journal of Near Eastern Studies*, III (1946), 155 ff., plate ii. It seems a provincial work.

120. Gordon Loud, *Khorsabad*, II (Chicago, 1938), plates 49 and 50.

121. Published by R. D. Barnett in *Iraq*, XII (1950), 1–43.

122. W. Otto, *Handbuch der Archaeologie* (Munich, 1939), plate 173, 3 and 4.

123. R. D. Barnett, *Journal of Hellenic Studies*, LXVIII (1948), 1–25. It is there also maintained that the ivory carvers, too, formed a closed guild of ambulant craftsmen. It seems to me that export from a few Levantine centres explains more satisfactorily the close resemblance between pieces found, say, at Crete and at Nimrud or Khorsabad.

124. This matter is well dealt with by R. M. Cook, in *Journal of Hellenic Studies*, LXVI (1946), 67–98.

125. *Journal of Hellenic Studies*, LIII (1933), 295, figure 19.

126. *Forschungen und Fortschritte*, VIII (1932), 161.

127. The most convincing connexion with Urartu is established by an arrangement by which the

handle is fixed to bronze cauldrons. The pair of loops is attached at the cauldron by means of winged bulls' heads or human figures. There is, for instance, an example from Delphi showing a purely Assyrian figure. Kunze (*Kretische Bronzereliefs*, Anhang II) listed eight from Urartu, and two from Etruria, while there are over forty Greek imitations. Kunze, against Karo (*Athenische Mitteilungen*, XXXXV (1920), 106–16), claimed a north Syrian origin for this device. Barnett (*Iraq*, XII, 39), like Karo, prefers Urartu. This is, indeed, more likely than Syria, but it may yet be that such vessels are found to be Assyrian in the first place.

128. Sidney Smith, in *Antiquaries' Journal*, XXII (1942).

129. *Journal of Hellenic Studies*, LVIII (1938), 1–30, 133–70; LX (1940), 2–21.

130. This has been demonstrated by R. D. Barnett, *Journal of Hellenic Studies*, LXVIII (1948), 1, n. 4.

131. Assurnasirpal II; Shalmaneser III: Adadnirari III; Tiglathpileser III; see *Iraq*, XIII (1951), 5, 21–4.

132. A stool of ivory was found at Zinjirli: *Ausgrabungen in Sendschirli*, V, plates 61–3.

312. 133. Thureau-Dangin a.o., *Arslan Tash*, 135 ff.

134. R. D. Barnett, in *Iraq*, II, 185, suggests 'possibly the first half of the eighth century' as a compromise, since he accepts, as we do not, a ninth-century date for the ivories from Arslan Tash and Samaria.

313. 135. R. D. Barnett has pointed out that the Nimrud ivories in the British Museum include those found by Loftus in the south-east palace and others found by Layard in the north-west palace. He has also shown that the first belong probably to the reign of Assurnasirpal II, the second to that of Sargon. See *Iraq*, II (1935), 170–210. His dating of the Loftus group is corroborated by its resemblance to the ivories from Tell Halaf (von Oppenheim, *Tell Halaf* (London), plate lix, 2, 3). The recent discoveries of Professor Mallowan at Nimrud (*Illustrated London News*, 28 July and 4 Aug. 1951 and 16 Aug. 1952) made him doubt the distinction between a ninth-century and eighth-century group, since both styles are represented among the finds from the well he discovered in the north-west palace. But the evidence from Tell Halaf is incontrovertible. The well at Nimrud was used from its construction by Assurnasirpal II until the destruction of the palace at the end of the reign of Sargon. It is natural enough that it contained late pieces (*loc. cit.*, 16 Aug. 1952, frontispiece) as well as early ones (*op. cit.*, 255, figure 13). The circular inlays in the latter are characteristic of the early group. At the burnt palace (the south-east

palace of the Loftus group) at least one head of the later group (known from Khorsabad) was discovered too (*op. cit.*, 255, figure 5).

136. *Op. cit.* (16 Aug. 1952), 255, figure 13.

137. The common features are: long, pointed, shallow eyes with pinpoint pupils, in contrast to those of the Arslan Tash and Khorsabad figures; hair shown in parallel strands brushed towards the temples, not in little curls; headdress, either a flat cap with vertical lines or one with rosettes or flat disk in alternation, cf. *Iraq*, plate xxv, 2, and plate xxvii, 2. The hair was sometimes gilded.

138. *Illustrated London News* (8 Aug. 1953), frontispiece.

314. 139. Barnett, *op. cit.*, 193 ff. and plate xxvii, suggests that they formed part of a certain kind of bowl, of which Greek examples in pottery survive. Similar double figures were found in Rhodes (Hogarth, *Excavations at Ephesus*, plates xxx, xxxi) and in Crete (*Athenische Mitteilungen*, LX–LXI (1935–6), plate 84, no. 11).

140. *Iraq*, II (1935), plate xxiv, 2.

315. 141. *Op. cit.*, 194 ff. (Barnett).

142. Von Oppenheim, *Tell Halaf*, plates viii(a), ix(a), xxi(b), xxii(a). It also occurs, simplified, on the reliefs found near Ankara.

143. Harold Ingholt, *Rapport préliminaire sur sept campagnes de fouilles à Hama en Syrie* (Copenhagen, 1940), plate xxxiv, 4, 5.

144. See also *Illustrated London News* (4 Aug. 1951), 195, figure 24, from Nimrud.

145. *Iraq*, II, 189.

146. *Bulletin of the Metropolitan Museum of Art* (1936), 221 ff.; (1937), 89 ff.

147. Other pieces possibly belonging to Hazael's bed include turned knobs and capital-like pieces, used at all times in this type of furniture; further pieces, not carved but engraved, show a sun-disk with two correct uraei but with a non-Egyptian star and dots in the disk. Further lotus and bud borders, a guilloche, and a fragmentary figure of a man, differing from illustration 374, and resembling the Egyptian rendering of Syrians, with headband, curls, necklace, fringed shawl, and bare feet. The head is in profile.

316. 148. One must remember that a second bed stood beside that of Hazael.

149. Woolley and Barnett, *Carchemish*, III, 167 ff. and plate 71 f. The ivories were found in a temple courtyard near a door jamb inscribed in the ninth century B.C.

150. It is likely enough that there was some antique furniture in the palace at Samaria when it was destroyed in 722 B.C. There was also a stone vase of Pharaoh Osorkon II, a contemporary of Ahab

(875–50 B.C.). But we cannot separate these antiques, if any, from the other pieces. At Arslan Tash the main occupation dates from Tiglathpileser III (745–727 B.C.); at Khorsabad the ivories belong to the lifetime of its founder, Sargon (721–705 B.C.). It is relevant to remember that the ivories from Samaria may find an analogy at Nimrud, where no objects ante-dating Sargon were found in the north-west palace, although it was founded by Assurnasirpal II. This was pointed out by Barnett (*Iraq*, 11, 185) and confirmed by Mallowan on the evidence of his own excavations there (*Iraq*, XIII, 3).

151. The same convention for the rendering of the folds in the neck occurs in figures in the round of bulls supporting an ivory tray at Nimrud (*Illustrated London News* (22 Aug. 1953), 298, figures 13–16).

152. Contenau, *Manuel d'archéologie orientale*, III, figure 840; *Iraq*, XIII, plates i, ii, and iii. Cf. also *Illustrated London News* (4 Aug. 1951), 195, figure 25.

153. The three objects are figured side by side in *Journal of Hellenic Studies*, LXVIII, plate ii.

318. 154. A different version of the theme, without the goddess, was found at Nimrud: *Iraq*, 11, plate xxiv.

155. Loud, *Khorsabad*, 11, plate 52, nos. 38 and 39 seem to render the same subject. Here the figures wear wigs which in Egypt would mark them as women.

319. 156. *Iraq*, XIII, plate vii; *Ausgrabungen in Sendschirli*, v, plates 66–7. *Op. cit.*, plate 68, i (=plate 69(a)) is an ivory in purely Egyptian style; plate 68 (f) (=plate 69(l)) is purely Mesopotamian. These set off the Phoenician character of the pieces we are here discussing.

157. It occurs also at Samaria: J. and G. Crowfoot, *Early Ivories from Samaria*, plate VI, 2.

158. G. Loud, *Khorsabad*, 11, plates 52–4. None of them is complete, but all the elements are preserved, if one takes the group as a whole. A late geometric vase (Kunze, *Kretische Bronzereliefs*, plate 55C) shows the cloth between the forepaws of the sphinx and is dated about 750 B.C.

159. Thureau-Dangin a.o., *Arslan Tash*, plates xxx–xxxi.

160. Crowfoot, *op. cit.*, plate v, 1 and 3.

161. Poulsen, *Der Orient und die frühgriechische Kunst* (Leipzig, 1912), 40, figure 24.

162. *Athenische Mitteilungen*, LX–LXI (1935–6), plate 84, 1, which resembles the profile sphinxes from Arslan Tash, but is a little coarser and wears a sun-disk on its head.

163. Crowfoot, *Early Ivories from Samaria*, plate i, 1.

164. Poulsen, *Der Orient und die frühgriechische Kunst*, 48, figure 37.

321. 165. *Iraq*, 111, plate xiii, 1. It is in keeping with the late date of this – the Layard – group of Nimrud ivories that this figure wears a crown of rosettes, like the kings of Malatya and Sakjegözü depicted at the end of the eighth century B.C. See above p. 304.

166. *Illustrated London News* (16 Aug. 1952), colour plate opp. p. 256.

167. *Op. cit.*, figure 19.

168. Crowfoot, *loc. cit.*

169. Murray, Smith, and Walters, *Excavations in Cyprus* (London, 1900), 10, figure 18.

170. The discussion by Herbig and Zimmern in *Orientalistische Literaturzeitung*, XXX–XXXI (1927–8), is conveniently summarized by Barnett, in *Iraq*, 11, 182 and 203.

171. *History*, I, 199.

172. R. D. Barnett in *Iraq*, 11, 198–210, an attempt made with a full realization of its tentative character.

322. 173. *Iraq*, 11, plate xxiii, 4.

174. *Journal of Hellenic Studies*, LXVIII, plate 1.

175. Thureau-Dangin, *Arslan Tash*, plate xxxii.

176. I have not discussed the ivories discovered in the British Museum excavations at Ephesus, since these are not clearly connected with any group of Near Eastern ivories and seem to me to belong to provincial east Greek art entirely. But see Barnett, in *Journal of Hellenic Studies*, LXVIII, 1–25 and P Jacobsthal, *op. cit.*, LXXI (1950), 85–95.

177. References in Dussaud, *Civilisations pre-helléniques* (Paris, 1914), 308 ff. Dussaud claims a Cypriot origin for the bronzes and ivories we call Phoenician (*op. cit.*, 304–26), but since he wrote, the influence of the Aegean on the Asiatic mainland has appeared in a new light and the motifs called 'gréco-chypriote' (312 ff.) occur elsewhere, too. Nor was Cyprus ever important enough to account for the wide distribution of these goods.

178. David Luckenbill, *Ancient Records of Assyria and Babylonia*, 11, §186.

323. 179. Dussaud, *loc. cit.*, 321 ff.

180. J. and G. Crowfoot, *Early Ivories from Samaria*, plate i, 1.

181. Poulsen's fundamental work, *Der Orient und die frühgriechische Kunst*, 6 ff., distinguishes bowls with predominantly Egyptian and Assyrian decoration and a 'special style', but this division does not seem to be tenable. See Barnett on the north-west palace in *Iraq*, 11, 185.

324. 182. Poulsen classes it with his Assyrian group, but the Assyrian designs are orderly, arranged in bands, well spaced, and regular. The great battle

scenes were not yet designed at this time. There are Syrian antecedents in the second millennium, e.g. Frankfort, *Cylinder Seals*, plates xliii and xliv (b).

183. Layard, *Monuments of Nineveh*, 11, plate 66; Contenau, *Manuel*, 111, figure 841.

325. 184. R. D. Barnett, in *Iraq*, 11, 202; see our reservations, 195.

185. Layard, *op. cit.*, 11, plate lxv.

326. 186. Poulsen, *op. cit.*, 22, figures 12 and 13. The bowl is in the Ashmolean Museum.

187. *Op. cit.*, figure 11.

188. Layard, *op. cit.*, 11, plate lxiv.

189. Layard, *op. cit.*, 11, plate lx. In the middle zone panthers attack herbivores and griffins. *Op. cit.*, plate lxii, shows three pairs of vultures devouring a carcass.

190. *Op. cit.*, plate lxi.

328. 191. Gjerstad, in *Opuscula Archaeologica*, IV (Lund, 1946), plate i.

192. Gjerstad, *op. cit.*, 5, has shown that the vessels placed on the table in this bowl are well-known types of Cypriot Iron Age pottery.

193. C. Watzinger, *Handbuch der Archaeologie . . . herausgegeben von Walter Otto* (Munich, 1939), 839, speaks of Cypriot imitations of Phoenician bowls, formulates their peculiarities, and lists those for which he thinks Cypriot manufacture likely. Professor Einar Gjerstad has devoted a detailed and penetrating study to the bowls found in Cyprus, in *Opuscula Archaeologica*, IV (edidit Institutum Romanum Regni Sueciae) (Lund, 1946), 1–18 with plates i–xvi. His classification as Proto-Cypriot, Cypro-Phoenician, Cypro-Egyptian (each in three stages), etc., does not so much establish groups (since often only one or two specimens forms a stage in this scheme) as draw attention to real differences and similarities. If we are not convinced of the island origin of all these bowls, Gjerstad, for his part, acknowledges the existence 'of a Syro-Phoenician school to which the Cypro-Phoenician group is a parallel series' (*op. cit.*, 18, cf. 13).

194. Layard, *Monuments of Nineveh*, 11, plate lxiii.

329. 195. E. H. Dohan, *Italic Tombgroups* (Philadelphia, 1942), 108, dates the main influx of oriental and Greek products to 680–50 B.C. (So also D. Randall McIver, *Villanovans and Early Etruscans* (Oxford, 1924), 228–30.)

196. Layard, *op. cit.*, 11, plate 62A and a bowl from Idalion in the Louvre, Perrot et Chipiez, *Histoire de l'art*, 111, 779, figure 548. (Poulsen, *op. cit.*, 20, group A1.)

331. 197. The figure carrying a dead or captive body behind Pharaoh is un-Egyptian. It recurs on other

bowls and has been studied, inconclusively, by G. Schneider-Hermann, in *Jaarbericht No. 10*, Ex Oriente Lux (Leiden, 1948), 355–69. The crawling – probably wounded – enemy under the group is likewise un-Egyptian.

198. F. Matz, *Frühkretische Siegel* (Berlin, 1928), 39–50.

199. This is the centre design in a silver bowl, *Opuscula Archaeologica*, IV, plate iv; Horus on the lotus, without Isis, Poulsen, *op. cit.*, figure 20.

200. The Leiden bowl, perhaps from the Bernardini tomb, has a wild cow in the marshes as its centre design. The rest of the design resembles the Idalion and Palestrina bowls. See W. D. van Wijngaarden, in *Oudheidkundige Mededeelingen uit het Rijksmuseum van Oudheiden*, XXV (Leiden, 1944), 1–9.

201. This bowl has been studied in great detail by Sir John L. Myres, in *Journal of Hellenic Studies*, LIII (1933), 25–39.

202. E. G. Poulsen, *op. cit.*, figures 14–18.

CHAPTER 12

333. 1. From the point of view of style the various fabrics, on which see Donald E. McCown, *The Comparative Stratigraphy of Early Iran* (Chicago, 1942), are merely variations, whether they are black-on-red or black-on-buff. There is, of course, an enormous difference in quality between the various fabrics and periods.

2. The bulk was published by Edmond Pottier, in volume XIII of Jacques de Morgan, *Mémoires de la Délégation en Perse* (Paris, 1912), and *Corpus Vasorum Antiquorum*, France, Musée du Louvre, fascicule 1.

334. 3. A. Langsdorfer and D. E. McCown, *Tall-i-Bakun* A (Chicago, 1942).

4. R. Ghirshman, *Les Fouilles de Sialk près de Kashan* (Paris, 1938, 1939).

5. Another rock relief, of Anubanini, king of the Lullubu, is less crude; it shows a goddess bringing bound captives in a frieze below. It is modelled on Akkadian monuments. See, for description and literature, Neilson C. Debevoise, 'The Rock Reliefs of Ancient Iran', in *Journal of Near Eastern Studies*, I, 76–83.

6. *Encyclopédie photographique de l'art*, I, 248–9.

7. See Dr Ghirshman's preliminary report in *Illustrated London News* (8 Aug. 1953), 226–7.

336. 8. See R. D. Barnett, 'The Excavations of the British Museum at Toprak Kale near Van', in *Iraq*, XII (1950), 1–43, with plates i–xxii, where older

literature and a tentative reconstruction of the throne is given. Rachel Maxwell-Hyslop, 'Daggers and Swords in Western Asia', *Iraq*, VIII (1946), 44, writes, 'It is possible that where weapons were concerned Vannic smiths began to copy Assyrian technique as early as the reign of Assurnasirpal II when the cuneiform system of writing was introduced to Armenia from Assyria'.

337. 9. The problem of the Scythians is concisely and brilliantly treated by Professor Sir Ellis H. Minns in his lecture 'The Art of the Northern Nomads', in *Proceedings of the British Academy*, XXVIII (1942). 'We must not regard nomadism as a mere stage on the way from food-collecting to agriculture. When completely developed it is a highly specialized mode of life enabling man to utilize vast tracts in which continuous settlement, whether pastoral or agricultural, is impossible' (p. 7 – but the whole passage should be read). There is also a valuable bibliography. The history of the period is treated by G. Cameron, *History of Early Iran* (Chicago, 1936), and also by König; see next Note.

10. F. W. König, *Älteste Geschichte der Meder und Perser* (Leipzig, 1934), suggests that this was from 642 to 615 B.C.

11. André Godard, *Le Trésor de Ziwiye* (Haarlem, 1950); see also the important study of R. Ghirshman, in *Artibus Asiae*, XIII (1950), 181–206, which contains some illustrations now known to be of a different provenance. See Note 31 below.

12. Ghirshman, *loc. cit.*, 201.

339. 13. Godard, *op. cit.*, figures 40–2.

14. *Op. cit.*, figures 81–3.

15. *Op. cit.*, figure 39.

16. See the extensive 'Selected Bibliography', in E. H. Minns, 'The Art of the Northern Nomads', *Proceedings of the British Academy* (1942).

17. Minns, *op. cit.*, plate xiii(a).

18. Ghirshman, in *Artibus Asiae*, XIII (1950), 183 ff.

19. Godard, *op. cit.*, figure 48.

20. Ghirshman, *op. cit.*, 185, figure 7. Ghirshman saw in it a lion mask, but the comparison with the lioness of Kelermes and the Melgunov chape is conclusive.

21. *Op. cit.*, figure 13.

22. There is therefore no reason to connect it with the reign of Esarhaddon (Ghirshman, *op. cit.*, 198) and it is not an Egyptian feature. These matters do not affect Ghirshman's main views, with which I agree.

23. Ghirshman, *op. cit.*, 191 suggests that it was made by Assyrian goldsmiths for the Scythian allies of their king. If this were so, I should not expect any but purely Assyrian designs to be used; the gifts sent

by Pharaohs of the Middle Kingdom to Byblos, Qatna, and other places in Asia suggest this.

The relation of the pectoral to Assyrian art is similar to that of Urartian metalwork to its prototypes, and it would be possible to consider the pectoral a Vannic product but for the Scythian animals at either end. It seems to me highly improbable that they should have been used anywhere outside the domains of the Scythians.

24. E. H. Minns, *Scythians and Greeks* (Cambridge, 1913), 171, figure 65.

340. 25. Godard, *Le Trésor de Ziwiye*, figure 46.

26. See A. Godard, 'Bronzes du Luristan' (*Ars Asiatica*, XVII) (Paris, 1931).

27. It was led by Dr Erich F. Schmidt of Chicago. See *Bulletin of the American Institute for Iranian Art and Archaeology*, VI (1938), 206–13. Schaeffer's attempt to establish a 'Louristan ancien, moyen récent', in *Stratigraphie comparée et chronologie de l'Asie occidentale*, 477–95 and figures 263–8, is not sufficiently well founded.

28. These consist of bronze vases inscribed with names of Akkadian and later Mesopotamian rulers (*Illustrated London News* (28 Oct. 1929), 667, figures 9, 10); daggers and 'poker-butted spears' of Early Dynastic affinities; battle-axes with simple thorns on the back of the haft, known in Mesopotamia on cylinder seals of Akkadian times; daggers and swords with a cast-on hilt, some of which are inscribed with the name of Marduk-nadin-akhe of Babylon and other rulers. The latter are types 32–6 of Rachel Maxwell-Hyslop's classification in *Iraq*, VIII (1946), 36 ff., 44 ff.; plates iv–v. I suspect that the time range, given as 1800–600 B.C., is narrower and does not start much before 1100 B.C.

All these inscribed weapons raise a problem which has not, to my knowledge, been faced. If they were really found in Luristan (and for this we have, on the whole, nothing but dealers' assurances) they were either never despatched to the owner for whom they were intended, or they were obtained as loot or received as presents, in which case they have no bearing on the Luristan metalwork at all. The first alternative – that they were made in Luristan for a Mesopotamian – is not excluded by the presence of the cuneiform inscriptions; even today the Mandaean silversmiths in the bazaars of Baghdad will execute any inscription in their niello silverwork which is drawn out for them by their clients. It is possible that weapons made in Luristan had a reputation, like Damascene swords in a later age. But it seems to me simpler to assume that inscribed objects found in Luristan represent loot or presents, and were made in Mesopotamia.

29. *Gazette des Beaux Arts*, 6me série (1933), 33.

30. The triangular design along the flank of the sphinxes (Contenau, *Manuel*, 2171, figure 1207) recurs on the pectoral from the hoard of Ziwiyeh.

31. Godard, in *Artibus Asiae*, XIV (1951), 241 ff., referring to the girdles depicted in *Artibus Asiae*, XIII (1950), figures 18, 19, and 20.

32. *Syria*, XXVI (1949), 198 ff., figures 1–7, plates ix–x; *Illustrated London News* (6 May 1939), 790–5.

343. 33. Kantor, in *Journal of Near Eastern Studies*, V, 238, points out that the concavity of the wings of the bulls on pins which she publishes suggests a date in the sixth century B.C. But the one piece among the Luristan bronzes proper which shows affinities with Achaemenian art (Godard, *Bronzes du Luristan*, plate xlvi, no. 177) is quite isolated and it seems, therefore, that the manufacture did not survive to any extent into Achaemenian times.

34. E. H. Minns, 'The Art of the Northern Nomads', 10.

35. Since the heads of these pins are large and heavy, there are one or two loops on the stem for a safety fastening of the pin to the dress.

345. 36. We know that this was their purpose from properly excavated burials in the Kuban valley, north of the Caucasus.

346. 37. This particular type of stylizing the hafting should not be confused with the numerous decorations of sword and dagger-hilts with complete lions or lion heads, found throughout the Near East, at least from Early Dynastic times onward. This is a specific type, 'tête de lion crachant le fer', and it is true that this was invented in the second millennium before zoomorphic juncture became popular in Luristan. There is an example from Ras Shamra (Schaeffer, *Ugaritica*, I (Paris, 1939), 107–25) and another from Susa (De Mecquenem, Jacques de Morgan, *Mémoires de la délégation en Perse*, VII, 61 and plate xvii, 8).

38. Ludwig Curtius, *Münchener Jahrbuch* (1913), 19.

347. 39. For instance, the rich example of zoomorphic juncture from east Siberia in Minns, 'The Art of the Northern Nomads', plate xviii(h), shows its Western inspiration by a griffin of Greek extraction which is drawn on neck and shoulders of the reindeer; and a saddle found at Pazyryk shows a winged bull (or winged lion with bull's head) attacking an ibex; the monster is clearly of Near Eastern origin. See *Illustrated London News* (6 Aug. 1932), 207, figure 8.

40. This was pointed out by C. J. Gadd, who published the dagger-hilt in *British Museum Quarterly*, XII (1938), 36 ff. It is type 45 in Rachel Maxwell-Hyslop's classification (*Iraq*, VIII (1946), 51, where further references are given).

348. 41. R. Ghirshman, *Les Fouilles de Sialk*, II (Paris, 1939).

349. 42. This is the revised version, from *American Journal of Archaeology* (1946), 25, of the translation by R. G. Kent, *Journal of the American Oriental Society*, LIII (1933).

43. Erdmann, 'Griechische und Achaemenidische Plastik', in *Forschungen und Fortschritte*, XXVI (1950), 151, points out that the inscription must be dated between 494 and 490 B.C., for in 490 B.C. Hystaspes, the father of Darius, whom he mentions, died. And the Carians and Ionians settled in Babylon, who brought the cedars from there to Susa, were probably those deported after the fall of Miletus in 494 B.C.

350. 44. This was the view of Herzfeld, who exaggerated the influence of Urartian art out of all proportion of what we know of it; it was taken up by Ghirshman, see next Note.

45. R. Ghirshman, 'Masjid-i-Solaiman, résidence des premiers Achéménides', in *Syria*, XXVII (1950), 205–20.

351. 46. Recently excavated. See E. Herzfeld, in *Archaeologische Mitteilungen aus Iran*, I (1928), 4–16.

353. 47. Herzfeld, *op. cit.*, 12.

48. Herzfeld, *Iran and the Ancient East*, plate xxxix, and below p. 357.

49. Erich F. Schmidt, *Persepolis*, I (Chicago, 1953).

50. The additions of Artaxerxes III, towards the end of the fifth century, can be disregarded.

51. Schmidt, *op. cit.*, 64 postulates a service gate at the south-east corner.

354. 52. I prefer this designation, which does not prejudge the purpose of the building, to that of council hall, proposed by Dr Schmidt (*op. cit.*, 107), because of the reliefs showing processions of nobles, on the stairway [416, 417]. Is it likely that 'a place of assembly of the nobles before the king' would, at the same time, be 'a main link of communication' between the northern area of the terrace and the residential quarters?

53. De Mecquenem, in *Mémoires de la mission archéologique en Perse*, XXX (Paris, 1947). If we compare the actual remains as shown on pp. 8–9 with the reconstruction on pp. 24–5, we realize that the essential parts, namely the connecting links between the separate buildings, are mere postulates. The plan in A. Upham Pope, *A Survey of Persian Art*, I, 322, figure 75, is misleading, because it does not suggest the extremely fragmentary state of the remains and the purely conjectural character of the reconstruction. Andrae (*Arch. Anzeiger* (1923–4), 95–106) points out the resemblance of a group of rooms south of the western court at Susa, and the southern fortress of Babylon. But perhaps the alleged courts at Susa were pillared halls?

54. At Susa this audience hall has six rows of six columns and two porticoes, in front and at the back.

355. 55. Herzfeld, *Iran and the Ancient East*, 224, claims that 'the constituent element of the complex of buildings on the terrace [*viz.* of Persepolis] are single houses of the old Iranian type which we have studied'. These houses are, however, a mere postulate of Herzfeld's, derived first from a study of tombs of uncertain age which he believes to be pre-Achaemenian, but which may well be later (see p. 49, n. 2), and secondly from the modern popular usage of Iran (*op. cit.*, 200–12). It is quite possible that modern mosques and houses with a portico and two to four roof supports with impost blocks in the main room continued a tradition going back three thousand years, and that this type of house was taken over by the Aryan invaders of Iran. But there is no proof of these contentions, and alternative explanations exist; for instance, that the many-columned hall derives from the huge tents used by some nomad chiefs. Herzfeld's more explicit statement – difficult to reconcile with the one we have just criticized – namely that 'old Persian architecture descended from Median, this from Urartaean and this, again, from Anatolian architecture' (*op. cit.*, 247) refers to entities which are either unknown or badly known. What we do know, however, suggests that the statement is fallacious.

56. F. Wachsmuth, reviving a view put forward by Koldewey in 1898 (*Ausgrabungen in Sendschirli*, 191 ff.), has connected the Achaemenian audience halls with the north Syrian *bît-hilani*. This equation disregards the characteristics of buildings which can sooner be regarded as each other's opposites; the north Syrian building is a severely closed unit but for its single portico; it is essentially residential, with an oblong narrow main room. The other is a wide, columned, ceremonial building open to all sides. As so often when one type of building is said to 'change' or be 'converted' into another, the statement means no more than that the metamorphosis can be effected on paper. ˙

57. *Op. cit.*, 62.

356. 58. Herzfeld computes the height of the hall at thirty feet, denies that there could have been clerestory lighting, and declares that the hall was therefore 'completely dark' (*op. cit.*, 229). This cannot, of course, have been the case, and since the results of his work at Persepolis were never published in detail one must consider his denial of clerestory lighting an unproved assertion.

59. *Op. cit.*, 42. Dr Schmidt aptly refers to a similar arrangement in the Gulistan Palace of Tehran.

357. 60. Erich F. Schmidt, *op. cit.*, 165–200. In his pre-liminary report, 'The Treasury of Persepolis and other Discoveries in the Homeland of the Achaemenians', *Oriental Institute Communications*, no. 21 (Chicago, 1939), he has depicted a number of objects which sustain his interpretation of this building.

61. Herzfeld, *op. cit.*, 238.

62. F. W. von Bissing, 'Ursprung und Wesen der persischen Kunst', *Sitzungsberichte der Bayerischen Akademie* (Munich, 1927), has pointed out the importance of this gift, mentioned in Herodotus (1, 92), since it must ante-date the defeat of Croesus by Cyrus in 546 B.C.

358. 63. Herzfeld, *Iran and the Ancient East*, 209 ff.; figures 319–21.

64. *Illustrated London News* (2 Jan. 1954), 18, figures 5–8, griffins. Herzfeld, *op. cit.*, plate xxxix, shows a piece of a capital which may have consisted of foreparts of horses, and another of lions, unless these belonged to the usual dragons. These capitals are from Pasargadae. His view (*op. cit.*, 240) that this type of impost block derived from Paphlagonia rests on the unproved – and, I think, improbable – assumption that various Persian and Anatolian rock tombs are prototypes and not imitations of Greek and Anatolian forms (*op. cit.*, 201 ff.). In his *Archaeological History of Iran*, 51, second paragraph, Herzfeld formulates concisely why his alleged 'proto-Ionic' should, on the contrary, be recognized as 'bad Ionic', i.e. derivative, degenerate, and rather late than early. An excellent record of one of these tombs, with a relief of two Medes flanking a fire altar and bastard Ionic columns, is C. J. Edmonds, 'A Tomb in Kurdistan', *Iraq*, I (1934), 183–92.

65. For instance, G. Jéquier, *Manuel d'archéologie égyptienne* (Paris, 1924), 220–74, and, especially, figures 167–82.

66. The significance of this 'Southflower' has been clarified in Helene J. Kantor's forthcoming book.

67. W. Andrae, *Die Ionische Säule* (Berlin, 1933), plate vii.

68. A piece was found at Tell Tayanat (*American Journal of Archaeology*, XLI (1937), 16, figure 12) and another at Tell Halaf (R. Naumann, *Tell Halaf*, 11).

359. 69. A capital of a pilaster from Didyma shows three single volutes used one above the other (Andrae, *Die Ionische Säule*, plate viii(d)).

363. 70. Double volutes were commonly used for sleeves in Assyrian joinery [186, 217] but it is unlikely that so secondary an element of the cabinet-maker's craft should have been squared, enlarged, and introduced into stone architecture, as Herzfeld contends (*op. cit.*, 243 f.). The Lesbian capitals and the column from Naxos show, in any case, that

experiments with the double volutes as an impost block were being made by architects at the time.

71. Schmidt, *op. cit.*, 63.

72. Herzfeld, *Archaeologische Mitteilungen aus Iran*, I, 8 ff.

73. It is surrounded by a peribolos which belongs to a mosque built in the thirteenth century with materials taken from the Achaemenian buildings all round. It thus enriched a monument which, then as now, was venerated as 'the tomb of the mother of Solomon'.

74. There is a fine head of limestone of a king in the Stoclet Collection (*Survey of Persian Art*, plate 108E), but it is only 2¾ inches high.

75. In a useful summary of the discussion on the relation of Greek and Achaemenian art, Erdmann ('Griechische und Achaemenidische Plastik', in *Forschungen and Fortschritte*, XXVI (1950), 150–3) suggests that the Babylonian reliefs of glazed bricks equal Achaemenian art in plasticity and may have influenced it. I doubt this, since these reliefs, like their Assyrian prototypes and their Achaemenian imitations [438], cut up the forms of the bodies with the sharp lines of the separate glazes and elaborate details like the stylized muscles, manes, etc.

364. 76. It is true, of course, that the Assyrian palaces were deserted, but the reliefs were visible in the ruins and there were innumerable objects of daily use decorated with Assyrian themes.

77. Moortgat, *Die bildende Kunst des alten Orients und die Bergvölker*, plate xxvi. The god holds an ear of corn; Barnett (*Iraq*, II, 206) identifies him with Mot of the Ras Shamra texts.

78. Herzfeld, *Iran and the Ancient East*, 259–60, assigns it, with all the rest of Pasargadae, to the years 559–550 B.C. Erdmann, *op. cit.*, 151 rightly points out that the use of a parallel text in Babylonian in the building inscription suggests that it was made after the conquest of Babylon in 539 B.C. The relief in the new style is depicted in *Archaeologische Mitteilungen aus Iran*, I (1928–9), plate iii.

366. 79. Gisela M. A. Richter, 'Greeks in Persia', *American Journal of Archaeology*, L (1946), 17.

80. This has not been properly appreciated by those who wanted, on the strength of dates only, to consider the Greek usage as derived from Persia. So A. Moortgat, *Hellas und die Kunst der Achaemeniden* (Leipzig, 1926); Herzfeld, *Iran and the Ancient East*, 260. The Greeks did take over another convention, however, namely the rendering of the edge of the hair by one or more rows of small round spirals. This is a thoroughly oriental device, adapted by the north Syrians from Assyria and appearing in Greece in the last quarter of the sixth century B.C. Dr Richter

wrongly sees in it another sign of Greek influence in Persia (*op. cit.*, 18 and figures 19 and 20). The Greek renderings earlier in the century had been of a different type and both the Persian and the archaic Greek adoption of the device derives, directly or indirectly, from Assyria.

81. Collected by Dr Richter, *op. cit.* Erdmann (*op. cit.*, 152) rightly emphasizes that Dr Richter overrates the influence of the Greeks and does not quite realize that the graffiti prove that Greeks arrived once more about – or soon after – the year 500 B.C.

82. Herzfeld, *Iran and the Ancient East*, plate lxxii. They are reproduced, together with the Greek vases they resemble, in *American Journal of Archaeology*, L (1946), 29.

367. 83. A. U. Pope, *Survey of Persian Art*, plate 95; Schmidt, *op. cit.*, plates 114–17, 144–6, 195–6.

84. *Survey*, plate 86C; Schmidt, *op. cit.*, plates 138–41, 179, 193–4.

85. *Survey*, plate 84; Schmidt, *op. cit.*, plates 77–81, 103–13.

86. Schmidt, *op. cit.*, plates 96–7.

87. Beside him, although shown behind, according to the normal procedures of all art which ignores perspective ('pre-Greek', ideoplastic, conceptual art) and achieves clarity by translating the three-dimensional disposition of figures in space to a juxtaposition in the two dimensions of the plane of drawing. For the same reason the stacked folds of the dress, which in reality hang in front between the legs [see 446], are shown neatly in the middle of the side view. This problem is discussed in great detail by H. Schaefer, *Von Aegyptischer Kunst*, 3rd ed. (Leipzig, 1930).

368. 88. This useful term was introduced by Miriam Schild Bunim, *Space in Medieval Painting and the Forerunners of Perspective* (New York, 1940).

89. The audience scene is fully discussed by Erich F. Schmidt, *Persepolis*, I, 162–9. He gives reasons why it might be assigned to the years 491–486 B.C.

370. 90. Schmidt, *op. cit.*, plate 19, a large folding plate, shows the eastern stairway complete.

372. 91. Herzfeld, *Iran and the Ancient East*, 255.

92. Herzfeld, *op. cit.*, plate lxxii.

93. Glazed bricks were much more sparingly used at Persepolis, where stone reliefs fulfilled their function. Schmidt, *op. cit.*, 32; 91; figure 35.

94. *Encyclopédie photographique de l'art*, II, 50, 51.

374. 95. A revealing study of the Egyptian battle scenes is in H. A. Groenewegen-Frankfort, *Arrest and Movement* (London, 1951), 114–41.

96. Schmidt, *op. cit.*, plates 25, 26, 50, 71A.

377. 97. Schmidt, *op. cit.*, plate 142.

98. Herzfeld, *Iran and the Ancient East*, plate lxxvii. Schmidt, *Persepolis*, I, plate 52.

ABBREVIATIONS USED IN THE BIBLIOGRAPHY

AND THE LIST OF ILLUSTRATIONS

Akurgal	E. Akurgal, *Späthethitische Bildkunst* (Ankara, 1949)
Andrae 1	W. Andrae, *Coloured Ceramics from Assur* (London, 1925)
Andrae 2	W. Andrae, *Das Wiedererstehende Assur* (Leipzig, 1938)
Ann. Archaeol. Anthro. Liv.	*Annals of Archaeology and Anthropology*, Liverpool, XXII
Antiq. Jnl	*Antiquaries' Journal*
Bittel 1	K. Bittel, *Bogazköy, Die Kleinfunde der Grabungen, 1906–12* (Leipzig, 1937)
Bittel 2	K. Bittel, *Die Ruinen von Bogazköy* (Berlin, 1937)
Bittel, Naumann, Otto	K. Bittel, R. Naumann, H. Otto, *Yazilikaya* (Leipzig, 1941)
Brit. Mus. Qrt.	*British Museum Quarterly*
Contenau 1	G. Contenau, *Antiquités orientales*, Musée du Louvre (Paris)
Contenau 2	G. Contenau, *Manuel d'archéologie orientale depuis les origines jusqu' à l'époque d'Alexandre* (Paris, 1927, 1931, 1947)
Dalton	O. M. Dalton, *The Treasure of the Oxus* (London, 1905)
Delaporte 1	L. Delaporte, *Catalogue des cylindres orientaux*, Musée du Louvre (Paris, 1920, 1923)
Delaporte 2	L. Delaporte, *Malatya* (Paris, 1940)
Delougaz	P. Delougaz, *The Temple Oval at Khafaje* (Chicago, 1940)
Delougaz and Lloyd	P. Delougaz, S. Lloyd, *Pre-Sargonid Temples in the Diyala Region* (Chicago, 1942)
De Sarzec	E. de Sarzec, L. Heuzey, *Découvertes en Chaldée* (Paris, 1884–1912)
Dussaud 1	R. Dussaud, *L'Art phénicien du deuxième millénaire av. J.-C.* (Paris, 1949)
Dussaud 2	R. Dussaud, *Les Civilisations préhelléniques* (Paris, 1914)
Frankfort 1	H. Frankfort, *Cylinder Seals: A Documentary Essay on the Art and Religion of the Ancient Near East* (London, 1939)
Frankfort 2	H. Frankfort, *More Sculptures from the Diyala Region* (Chicago, 1943)
Frankfort 3	H. Frankfort, *Oriental Institute Discoveries in Iraq, 1933–4* (Chicago, 1939)
Frankfort 4	H. Frankfort, *Sculpture of Third Millennium from Tell Asmar and Khafaje* (Chicago, 1939)
Frankfort, Lloyd, and Jacobsen	H. Frankfort, S. Lloyd, Th. Jacobsen, *The Gimilsin Temple and Palace of the Rulers of Tell Asmar* (Chicago, 1940)
Gadd	C. J. Gadd, *Stones of Assyria* (London, 1936)
Garstang	J. Garstang, *The Hittite Empire* (London, 1929)
Gelb	I. J. Gelb, *Hittite Hieroglyphic Inscriptions* (Chicago, 1939)
Godard	A. Godard, *Les Bronzes du Louristan* (Paris, 1931)
Hall & Woolley	H. R. Hall and C. L. Woolley, *Ur Excavations I* (London, 1927)
Hdb. der Arch.	*Handbuch der Archäologie I* (Munich, 1939)
Heinrich 1	E. Heinrich, *Fara* (Berlin, 1931)
Heinrich 2	E. Heinrich, *Kleinfunde aus den archäischen Tempelschichten in Uruk* (Leipzig, 1936)
Herzfeld	E. Herzfeld, *Iran in the Ancient East* (Oxford, 1941)
Jnl Nr East. Stud.	*Journal of Near Eastern Studies*

King 1	L. W. King, *The Bronze Reliefs from the Gates of Shalmaneser III* (London, 1915)
King 2	L. W. King and R. C. Thompson, *The Sculpture and Inscriptions . . . of Behistun* (London, 1907)
Koldewey 1	R. Koldewey, *Das Ischtar-Tor in Babylon* (Leipzig, 1908)
Koldewey 2	R. Koldewey, *Das wiedererstehende Babylon* (Leipzig, 1925)
Langsdorff and McCown	A. Langsdorff and D. E. McCown, *Tall-i-Bakun A* (Chicago, 1942)
Layard	A. H. Layard, *The Monuments of Nineveh I* (London, 1849)
Loud 1	G. Loud, *Khorsabad I* (Chicago, 1936)
Loud 2	G. Loud, *Khorsabad II* (Chicago, 1938)
Loud 3	G. Loud, *The Megiddo Ivories* (Chicago, 1939)
Luschan	F. von Luschan, *Ausgrabungen in Sendschirli* (Berlin, 1893–1911)
Meyer ed.	E. Meyer, *Reich und Kultur der Chethiter* (Berlin, 1914)
Montet 1	P. Montet, *Byblos et l'Égypte* (Paris, 1928)
Montet 2	P. Montet, *Les Reliques de l'art syrien dans l'Égypte du Nouvel Empire* (Paris, 1937)
Münch. Jhb.	*Münchener Jahrbuch der Bildenden Kunst VIII* (1913)
Mus. Jnl	*Museum Journal*
Naumann	R. Naumann, *Tell Halaf II* (Berlin, 1950)
Nies–Keiser	J. B. Nies and C. E. Keiser, *Historical, Religious, and Economic Texts* (New Haven, 1920)
Oppenheim	M. von Oppenheim, *Tell Halaf* (London)
Perrot et Chipiez	G. Perrot and Ch. Chipiez, *Histoire de l'art dans l'antiquité* (Paris, 1882, etc.)
Puchstein	O. Puchstein, *Die Ionische Säule* (Leipzig, 1907)
Rowe	A. Rowe, *The Topography and History of Beth Shan* (Philadelphia, 1930)
Schaeffer 1	C. F. A. Schaeffer, *Stratigraphie comparée* (Oxford, 1948)
Schaeffer 2	C. F. A. Schaeffer, *Ugaritica I* (Paris, 1939)
Schaeffer 3	C. F. A. Schaeffer, *Ugaritica II* (Paris, 1949)
Schmidt	Eric F. Schmidt, *Persepolis I* (Chicago, 1953)
Smith	S. Smith, *Assyrian Sculpture in the British Museum, from Shalmaneser III to Sennacherib* (London, 1938)
Starr	R. F. S. Starr, *Nuzi* (Cambridge, Mass., 1937, 1939)
Thureau-Dangin a.o.	F. Thureau-Dangin, A. Barrois, J. Dossin, et M. Dunand, *Arslan-Tash* (Paris, 1931)
Tobler	A. J. Tobler, *Excavations at Tepe Gawra II* (Philadelphia, 1950)
Trans. Imp. Archaeol. Comm.	*Transactions of the Imperial Archaeological Commission 1897*
Upham Pope ed.	A. Upham Pope, *A Survey of Persian Art from Prehistoric Times to the Present* (London and New York, 1938)
U.V.B.	. . . vorläufiger Bericht über die von der Deutschen Forschungsgemeinschaft in Uruk-Warka unternommenen Ausgrabungen. U.V.B. I–XI in *Abhandlungen der Preussischen Akademie der Wissenschaften*, Jahrgang 1929, Phil.-hist. Klasse, no. 7; 1930, no. 4; 1932, no. 2; 1932, no. 6; 1933, no. 5; 1935, no. 2; 1936, no. 13; 1937, no. 11; 1939, no. 2; 1940, no. 3. U.V.B. XII–XIII, XIV–XXII in *Abhandlungen der Deutschen Orient-Gesellschaft*, nos. 1 (1956), 3–11 (1958–66).
Woolley 1	C. L. Woolley, *Ur Excavations II* (London and Philadelphia, 1939)
Woolley 2	C. L. Woolley, *Ur Excavations V* (London and Philadelphia, 1939)
Zervos	C. Zervos, *L'Art de la Mésopotamie* (Paris, 1935)
Zschr. f. Assyriol.	*Zeitschrift für Assyriologie*

BIBLIOGRAPHY

The following works may be of interest to the general reader, some for their illustrations only. Specialized works such as excavation reports are quoted in the notes.

GENERAL WORKS

Cambridge Ancient History. Vols. 1–4. Cambridge, 1923–6.
Many fascicles of the revised edition of vols. 1 and 2 have now appeared (1969).
CONTENAU, G. *Manuel d'archéologie orientale depuis les origines jusqu'à l'époque d'Alexandre*. 4 vols, Paris, 1927, 1931, 1947.
Encyclopédie photographique de l'art. Editions Tel. Vols. 1–2. Paris, 1934–7.
FRANKFORT, H. *Cylinder Seals, A Documentary Essay on the Art and Religion of the Ancient Near East*. London, 1939.
GROENEWEGEN-FRANKFORT, H. A. *Arrest and Movement: An Essay on Space and Time in the Representational Art of the Ancient Near East*. London, 1951.
PARROT, A. *Ziggurats et Tour de Babel*. Paris, 1949.
PRITCHARD, J. B. (ed.). *Ancient Near Eastern Texts relating to the Old Testament*. Princeton, 1950.
 This is an invaluable collection of up-to-date translations of religious, historical, literary, legal, and didactic texts from all the nations of the Ancient Near East.
SMITH, S. *Alalakh and Chronology*. London, 1940.
 The study on which the chronology adopted in this volume is based.
SMITH, S. *Early History of Assyria*. London, 1928.
 A critical study, not only of Assyria, but of the history of the Ancient Near East as a whole.

CHAPTER 1

FRANKFORT, H. *The Birth of Civilization in the Near East*. London, 1951.
HEINRICH, E. *Kleinfunde aus den archaischen Tempelschichten in Uruk*. Leipzig, 1936.
LENZEN, H. J. *Die Entwicklung der Zikkurat von ihren Anfängen bis zur Zeit der dritten Dynastie von Ur*. Leipzig, 1941.

CHAPTER 2

FRANKFORT, H. *More Sculpture from the Diyala Region*. Chicago, 1943.
FRANKFORT, H. *Sculpture of the Third Millennium from Tell Asmar and Khafajeh*. Chicago, 1939.
PARROT, A. *Mari*. Neuchâtel, 1953.
WOOLLEY, C. L. *The Royal Cemetery: A Report on the Predynastic and Sargonid graves excavated between 1926 and 1931*. London and Philadelphia, 1934.

CHAPTERS 3 TO 5

GADD, C. J. *History and Monuments of Ur*. London, 1929.
PARROT, A. *Tello, Vingt Campagnes de fouilles (1877–1933)*. Paris, 1948.

CHAPTER 6

ANDRAE, W. *Coloured Ceramics from Assur*. London, 1925.
ANDRAE, W. *Das wiedererstehende Assur*. Leipzig, 1938.

CHAPTER 7

GADD, C. J. *Stones of Assyria*. London, 1936.
HALL, H. R. *Babylonian and Assyrian Sculpture in the British Museum*. Paris and Brussels, 1928.
LOUD, G. *Khorsabad II*. Chicago, 1938.
PATERSON, A. *Assyrian Sculpture in the Palace of Sinacherib*. The Hague, 1915.
SMITH, S. *Assyrian Sculpture in the British Museum, from Shalmaneser III to Sennacherib*. London, 1938.
WALLIS BUDGE, E. A. *Assyrian Sculpture in the British Museum. Reign of Ashurnasirpal, 885–860 B.C.* London, 1914.

CHAPTER 8

KOLDEWEY, R. *Excavations at Babylon*. London, 1914.
RAVN, O. E. *Herodotus' Description of Babylon*. Copenhagen, 1942.

CHAPTER 9

LLOYD, S. *Early Anatolia*. Penguin Books. Harmondsworth, 1956.
BOSSERT, H. TH. *Altanatolien: Kunst und Handwerk in Kleinasien von den Anfängen bis zum völligen Aufgehen in der griechischen Kultur*. Berlin, 1942.
GURNEY, O. R. *The Hittites*. Penguin Books. Harmondsworth, 1952.

CHAPTER 10

ALBRIGHT, W. F. *The Archaeology of Palestine*. Penguin Books. Harmondsworth, 1949.
BOSSERT, H. TH. *Altsyrien: Kunst und Handwerk in Cypern, Syrien, Palästina, Transjordanien und Arabien von den Anfängen bis zum völligen Aufgehen in der griechisch-römischen Kultur. Unter Mitarbeit von Rudolf Naumann*. Tübingen, 1951.
GOETZE, A. *Hethiter, Churriter und Assyrer, Hauptlinien der vorderasiatischen Kulturentwicklung im zweiten Jahrtausend v. Chr. Geb*. Oslo, 1947.

KANTOR, H. J. *The Aegean and the Orient in the Second Millennium B.C*. Bloomington, Indiana, 1947.
LOUD, G. *The Megiddo Ivories*. Chicago, 1939.
MONTET, P. *Les Reliques de l'art syrien dans l'Égypte du Nouvel Empire*. Paris, 1937.

CHAPTER 11

AKURGAL, E. *Späthethitische Bildkunst*. Ankara, 1949.
BOSSERT, H. TH. *Altanatolien: Kunst und Handwerk in Kleinasien von den Anfängen bis zum völligen Aufgehen in der griechischen Kultur*. Berlin, 1942.
DUPONT-SOMMER, A. *Les Araméens*. Paris, 1949.

CHAPTER 12

GODARD, A. *Le Trésor de Ziwiyé (Kurdistan)*. Haarlem, 1950.
GODARD, A. *Les Bronzes du Luristan*. Paris, 1931.
HERZFELD, E. *Iran in the Ancient East*. Oxford, 1941.
MINNS, E. H. *The Art of the Northern Nomads*. London, 1942.
SCHMIDT, E. F. *Persepolis I*. Chicago, 1953.
UPHAM POPE, A. (ed.). *A Survey of Persian Art from Prehistoric Times to the Present*. London and New York, 1938.

ADDITIONAL BIBLIOGRAPHY (TO 1968)

The preliminary work for this annotated bibliography was undertaken by John Wootton (general titles and those for Chapters 1–6) and Leri Davies (Chapters 7–12). The whole has been edited and amplified by Professor Helene J. Kantor, to whom the editor is especially grateful.

GENERAL

AMIET, P. 'Les Combats mythologiques dans l'art mésopotamien du troisième et du début du second millénaires', *Revue archéologique*, XLI (January–June 1953), 129–64.
BARRELET, M. TH. 'Les Déesses armées et ailées', *Syria*, XXXII (1955), 222–60.
BOTTÉRO, J., CASSIN, E., and VERCOUTTER, J. (eds.). *Delacorte World History*, II, *The Near East: The Early Civilizations* (A. Falkenstein on the pre- and proto-history of Western Asia; D. O. Edzard on the Early Dynastic period; J. Bottéro on the First Semitic Empire; D. O. Edzard on the Third Dynasty of Ur and the Old Babylonian period). Transl. R. F. Tannenbaum. New York, 1967.
BUCHANAN, B. *Catalogue of Ancient Near Eastern Seals in the Ashmolean Museum*, I, *Cylinder Seals*. Oxford, 1966.
Cf. review by M. E. L. Mallowan, 'Impressions of the Past', *Antiquity*, XLI (1967), 202–12.
Cambridge Ancient History, I–IV. Cambridge, 1923–6.
Many fascicles of the revised edition of vols. I and II have now appeared; some specific numbers are listed under individual chapters.
DELOUGAZ, P. P., HILL, H. D., and LLOYD, S. *Private Houses and Graves in the Diyala Region.* Chicago, 1967.
EHRICH, R. W. (ed.). *Chronologies in Old World Archaeology.* Chicago, 1965.
Fifteen studies on the archaeological evidence for relative and absolute dating of the cultures of Europe, Egypt, and Asia from the prehistoric periods to about the second millennium B.C. With extensive bibliographies.
FRANKFORT, H. *Stratified Cylinder Seals from the Diyala Region.* Chicago, 1955.

This book presents a very important body of seals with well-documented proveniences. A significant contribution is the demonstration of the often divergent dates of the seals and the contexts in which they were found; this provides a salutary warning of the care necessary in using glyptic for dating purposes.
HEINRICH, E. 'Von der Entstehung der Zikurrate', in K. Bittel a.o., eds., *Vorderasiatische Archäologie: Moortgat Festschrift.* 113–25. Berlin, 1964.
KRAMER, S. *The Sumerians: Their History, Culture, and Character.* Chicago, 1963.
With translations of myths, letters, votive inscriptions, and many other types of documents.
LAESSØE, J. *People of Ancient Assyria: Their Inscriptions and Correspondence.* Transl. F. S. Leigh-Browne. London, 1935.
LANDSBERGER, B. 'Assyrische Königsliste und "Dunkles Zeitalter"', *Journal of Cuneiform Studies*, VIII (1954), 31–73, 106–33.
A basic analysis of chronological and related problems.
LEGRAIN, L. *Ur Excavations*, X, *Seal Cylinders.* Oxford, 1951.
LENZEN, H. J. 'Mesopotamische Tempelanlagen von der Frühzeit bis zum zweiten Jahrtausend', *Zschr. f. Assyriol.*, LI, N.F. XVII (1955), 1–36, figures 1–41 (plans).
Lenzen assumes the existence of two distinct temple types, the southern, Sumerian one and the northern, 'East-Tigris' one, and considers the Diyala area as an intermediate region exposed to influences of both traditions. In contrast Frankfort envisaged a more unified tradition with the Diyala temples taking their place as integral stages in the main line of development.
LENZEN, H. J. 'Gedanken über die Entstehung der Zikkurat', *Iranica Antiqua*, VI (1966), 25–33.

PARROT, A. *Sumer (Arts of Mankind).* London, 1960. Mesopotamian art from the prehistoric through the Kassite period; profusely illustrated; extensive bibliography.

RAVN, O. E. *A Catalogue of Oriental Cylinder Seals and Impressions in the Danish National Museum.* Copenhagen, 1960.

STROMMENGER, E. 'Das Menschenbild in der altmesopotamischen Rundplastik von Mesilim bis Hammurapi', *Baghdader Mitteilungen*, 1 (1960), 1–103.

STROMMENGER, E. *The Art of Mesopotamia.* Trans. from *Fünf Jahrtausende Mesopotamien* by C. Haglund. London, 1964. Outstanding photographs by Max Hirmer.

WISEMAN, D. J. *Catalogue of the Western Asiatic Seals in the British Museum, I, Cylinder Seals: Uruk – Early Dynastic Periods.* London, 1962.

ZIEGLER, C. *Die Terrakotten von Warka (Ausgrabungen der deutschen Forschungsgemeinschaft in Uruk-Warka*, VI. Berlin, 1962. Chronological range: prehistoric through Parthian.

CHAPTER 1

AMIET, P. *La Glyptique mésopotamienne archaïque.* Paris, 1961.

An indispensable and comprehensive collection and analysis of glyptic, including a number of unpublished examples, of the prehistoric, Protoliterate, and Early Dynastic periods, with some Akkadian seals brought in as comparisons. In continuation of the work of Le Breton the individuality of glyptic at Susa is emphasized; the early Protoliterate phase there is sharply distinguished from the following Proto-Elamite phase of glyptic.

HEINRICH, E. *Bauwerke in der altsumerischen Bildkunst (Schriften der Max Freiherr von Oppenheim Stiftung*, no. 2). Wiesbaden, 1957.

The greater part of the material dealt with is Protoliterate, but Early Dynastic and Akkadian representations are also included.

VAN BUREN, E. 'The Drill-worked Jemdet Nasr Seals', *Orientalia*, XXVI (1951), 289–305.

WOOLLEY, L. *Ur Excavations*, IV, *The Early Periods.* Philadelphia, 1955.

Ubaid period pottery and figurines; Late Protoliterate pottery and stone vessels with relief decoration.

Prehistoric Studies

Research in recent years has shown the prehistoric development to be more complex than indicated above, pp. 17 f. In the south it is now clear that Ubaid as originally known from the type site is not the earliest culture, but was preceded by Eridu and Hajji Mohammed phases. In the north the problems involving the chronological position and affinities of Jarmo in Iraqi Kurdistan (referred to in Chapter 1, Note 4) are being clarified by materials from excavations at Tell Shemshara, in the same general region, and at Tepe Gurgan in Luristan. It now seems unlikely that the early sites in northern Iraq can all be considered as stages of a single development: rather, two cultural traditions should be distinguished, a Zagros one represented at Jarmo, Gurgan, and sites in the Kermanshah plain of Iran, and the specifically Mesopotamian Hassuna tradition (cf. Chapter 1, Note 4), which, in addition to the type sites, is known from Tell Shemshara and Tell es Sawwan near Samarra.

Tell es Sawwan is giving spectacular results. In the first place, it provides new evidence on the vexed problems surrounding the Samarra ware (cf. p. 17 and illustration 1) – its origins, affinities, and status as the characteristic feature of a cultural phase distinct from the Hassuna period. Levels V and IV contain only Samarra ware, but in architecture and other features demonstrate unbroken continuity with the earlier levels, namely the transitional Level III, containing both Samarra and Hassuna wares, and the lowest Levels II and I, dated by their Hassuna types of pottery. The second major contribution of Tell es Sawwan is the evidence it provides for the unexpectedly high level of architecture and stoneworking achieved by the people of the Hassuna period. Not only are the two many-roomed buildings of Level I well-constructed complexes, but in one of them a niche facing the doorway of the innermost of three axial rooms presumably originally contained a female figurine found on the floor and thus may be a shrine and, if so, the earliest to be found in Mesopotamia. The Level I graves sunk into virgin soil below the floor levels of the buildings contained many alabaster vessels and female statuettes which carry back the beginnings of representational sculpture in Mesopotamia to an amazingly early date.

In addition to Perkins, *The Comparative Stratigraphy of Early Mesopotamia*, cited Chapter 1, Note 4, which remains the standard survey of the materials known until 1949 and the illustrations of which can be

supplemented by the useful collection of pictures in B. L. Goff, *Symbols of Prehistoric Mesopotamia*, New Haven and London, 1963 (the interpretative portions of this book cannot be relied upon – cf. review by M. J. Mellink, *Artibus Asiae*, XXVII (1964), 285 f.), the following studies should be consulted.

BRAIDWOOD, R. J., and HOWE, B. *Prehistoric Investigations in Kurdistan (Studies in Ancient Oriental Civilization*, no. 31). Chicago, 1960.
Preliminary report superseding briefer ones cited in Chapter 1, Note 4.

MELLAART, J. *Earliest Civilizations of the Near East (The Library of Early Civilizations)*. London, 1965.

MORTENSEN, P. 'On the Chronology of Early Village-farming Communities in Northern Iraq', *Sumer*, XVIII (1962), 73–80.

MORTENSEN, P. 'Additional Remarks on the Chronology of Early Village-farming Communities in the Zagros Area', *Sumer*, XX (1964), 28–36.

OATES, J. 'Ur, Eridu: The Prehistory', *Iraq*, XXII (1960), 32–50.

OATES, J. 'The Baked Clay Figurines from Tell es Sawwan', *Iraq*, XXVIII (1966), 146–53.

STRONACH, D. 'The Excavations at Ras al 'Amiya', *Iraq*, XXIII (1961), 95–137.

EL-WAILLY, F., and ABU ES-SOOF, B. 'The Excavations at Tell es Sawwan: First Preliminary Report (1964)', *Sumer*, XXI (1965), 17–32.

ZIEGLER, C. *Die Keramik von der Qala des Haggi Mohammed (Ausgrabungen der deutschen Forschungsgemeinschaft in Uruk-Warka*, V). Berlin, 1953.

Protoliterate Sculpture and Relief

Statuette of bearded man, Warka (U.V.B., XVI, 37–40, plates 17–18).
This carving had already lost its lower part in the Protoliterate period when it was deposited in a pot. Lenzen is undoubtedly correct in attributing the work to the earlier part of the Protoliterate period (*ibid.*, 40). Despite its smaller size, in quality and importance it almost rivals the Warka head (illustration 20 here).
Three male statuettes, Louvre (U.V.B., XVI, 39, plate 19) and Zürich (ibid., 19).
Female statuette, Warka (U.V.B., XVI, 37, plate 16).
Peg figure, Warka (U.V.B., XVII, 24, plate 13).
See also two copper statuettes of a booted man with ibex-horn headdress (Barnett, R. D., 'Homme masqué ou dieu-ibex?', *Syria*, XLIII (1966), 259–76, plates XX, 1; XXI, 1).

These figures are still somewhat problematic, but are presumably of Protoliterate date and perhaps from Iran.
Fragments of life-size figure of goddess in very high relief or the round, Warka (U.V.B., XIV, 37, plate 42a).
Stele fragment, Warka (Brandes, M. A., 'Bruchstück einer archaischen Stele aus Uruk-Warka', *Archäologischer Anzeiger* (1965), 590–619. Cf. Strommenger, E., *Archäologischer Anzeiger* (1967), 1 ff. for different reconstruction).

Found in the first season of work at Warka but hitherto unpublished, this fragment is of great importance as the second Protoliterate stele to become known. Its composition is far more formal than that of illustration 24; it is divided into four registers which from the bottom up show hill-like elements, men with pots, men carrying baskets, and a man standing between large plants and an irrigated field of plants.
Stone vessels with relief and sculpture (Delougaz, P. P., *Miscellaneous Objects from the Diyala Region*, part I: *Stone Vases, Plain and Decorated*. In preparation.)

Warka

For plan of entire site see U.V.B., XXI, plate 27.

HEINRICH, E. 'Die Stellung der Uruktempel in der Baugeschichte', *Zschr. f. Assyriol.*, XLIX, N.F. XV (1949), 21–44.

LENZEN, H. J. 'The E-Anna District after Excavations in the Winter of 1958–59', *Sumer*, XVI (1960), 3–11.

LENZEN, H. J. 'Die Tempel der Schicht Archaisch IV in Uruk', *Zschr. f. Assyriol.*, XLIX, N.F. XV (1949), 1–20.
With also some summarizing remarks about the glyptic associated with the various structures.

LENZEN, H. J. 'Zur Datierung der Anu-Zikurrat in Warka', *Mitteilungen der Deutschen-Orient-Gesellschaft*, no. 83 (November 1951), 1–32.

The seasons from 1954 on have revealed many details of the development of the Eanna area, which in the earlier part of the Protoliterate period, Eanna V–IV, was the location of elaborate architectural complexes. The articles of summary and analysis by Heinrich and Lenzen provide helpful introductions to the detailed material presented in the preliminary reports (U.V.B., I–XXII). The temples proper belong to the tripartite class represented by the White Temple near the Anu Ziggurat (see above, p. 20, illustrations 4

and 5), but are for the most part larger and more complex, though by no means as well preserved. They occur in association with terraces, enclosure walls and gateways, large courtyards, pillared halls, and various other, subsidiary, structures. Outstanding new examples of cone mosaic decoration have been found. The main structures of the earlier Protoliterate period are as follows.

Eanna V

Pillared-Hall Terrace and North-south Terrace (U.V.B., IV, 10–12, plate 4).
 Built of disproportionately large bricks (*Patzen*) and remaining in use until Eanna IVb.
Limestone Temple (U.V.B., II, 48–50, plate 4).
 Appears to have remained in use throughout Eanna IVc and b.

Eanna IVb

For plan of entire area see *Zschr. f. Assyriol.*, XLIX, plate 1.
Pillared Hall (or Cone-mosaic Building) and adjacent Cone-mosaic Court (U.V.B., IV, 12–17, plates 7–8).
 The Pillared Hall is built on the terrace of Eanna V. Some of the engaged columns bordering the stairway between the Pillared Hall and the Cone-mosaic Court are illustrated here [8].
Temple A = North-south-Terrace Temple (U.V.B., VI, 5–6, plate 3; *Zschr. f. Assyriol.*, XLIX, plate 1).
Temple B (U.V.B., VI, 6–7, plate 3).
 Tripartite in plan but markedly smaller than the other Eanna temples of similar type.

Eanna IVa

For plan of entire area see U.V.B., XXI, plate 31. The main structures are listed below in their approximate south-east to north-west order.
Gateway at south edge of new terrace (U.V.B., V, plate 5). Room 165 and adjoining wall in Pc XVII$_2$ (U.V.B., XXI, plate 31).
 This is the entrance to the new terrace which covers the dismantled structures of Eanna IVb and supports the new temples C and D. In earlier reports this structure was assigned to IVb, but in later plans appears as IVa.
'Red Temple' (U.V.B., II, 29–31, plate 4; *Zschr. f. Assyriol.*, XLIX, plate 11).
 Located above the now destroyed Limestone Temple. The 'Red Temple' is very incomplete in plan, but it clearly was not a true temple.

Temple D (U.V.B., V, 7–8, plate 6b; U.V.B., VII, 8, plate 2).
 Built above old Pillared Hall and part of Temple A.
Temple C (U.V.B., VII, 6–9, plate 2; U.V.B., XXI, 16–18, plates 4b–7a, 31, 32; U.V.B., XXII, 12–13, plates 2, 3b).
New Pillared Hall and adjacent court, gate and bath structures (U.V.B., XXII, 13–20, plates 5–11, 23, 24).
 This complex of buildings fills the space between Temple C and the Great Court. The new Pillared Hall is decorated by many varying cone-mosaic patterns. See Mark A. Brandes, 'Supraporten und Horizontalfries aus Stiftmosaiken der Pfeilerhalle der Schicht IVa in Uruk-Warka', *Heidelberger Studien zum Alten Orient: Adam Falkenstein zum 17 September, 1966*, 13–27.
Great Court (U.V.B., XIX, 12, plate 44; U.V.B., XX, 8–10, plate 29).
 Baked-brick benches run along the interior of the walls, which were apparently originally decorated by cone mosaic.
Stone-cone-mosaic Temple (U.V.B., XV, 12–19, plates 36–8, 41).
 This small temple of very simplified tripartite plan is surrounded by its own courtyard and remarkable for its walls of gypsum concrete on limestone foundations, these being at first interpreted as two different building phases.
Riemchen Building (U.V.B., XIV, 24–8, plates 9–13, 31–9; U.V.B., XV, 8–11, 17–19, plates 35, 39a–d, 40).
 This remarkable building, consisting of an L-shaped room surrounded by a corridor entered from an ante-chamber but without any entrance from outside, was built into the north-eastern corner of the Stone-cone-mosaic Temple towards the end of Eanna IVa. It was crammed with pottery, inlays from furniture, and other objects. It was perhaps a ceremonial place of burial for the contents of the Stone-cone-mosaic Temple after the destruction of that building.

At the end of the early Protoliterate period the complexes of Eanna IVa were completely destroyed, and in the later Protoliterate period, represented at Warka by the various phases of Eanna III, this area has no building in common with its predecessor, but the same borders. The rebuilding of the site is preceded by emplacements for burnt offerings interpreted as the evidence for the ceremonial purification of the site carried out before its new development. In place of the various large temples of the preceding phases Eanna III is dominated by the foundation and development during three sub-stages of the earliest high

terrace, the ancestor of the ziggurat which was to exist at this spot until the Neo-Babylonian period. The sides of this high terrace were decorated by niches and cone mosaic, which is shown here in illustration 9 (Eanna IIIa).

Eanna III

Building phases of high terrace and surrounding structures (U.V.B., VII, 9–13; U.V.B., XX, 11–18, plates 30, 31).
Pisé Building (U.V.B., XXI, 11–12, plate 31).
Constructed in Eanna IIIa and used in the following levels during the Early Dynastic period.

CHAPTER 2

GADD, C. J. 'The Cities of Babylonia', in the *Cambridge Ancient History* (revised ed.), I, chapter XIII. Cambridge, 1964.
History of the Early Dynastic period.
MOOREY, P. R. S. 'The Plano-convex Building at Kish and Early Mesopotamian Palaces', *Iraq*, XXVI (1964), 83–98.
A hitherto unpublished and not completely excavated complex in Area P at Kish consists of blocks of rooms and long corridors organized around a large courtyard and enclosed by a massive buttressed wall. After comparing this structure with the roughly contemporary Early Dynastic palace of Mound A at Kish, Moorey concludes that the latter was essentially a residential palace and the Plano-convex Building a fortified residence or arsenal. He ends with a brief survey of palace architecture from the late Protoliterate period to the second millennium at Mari and Warka, arriving at conclusions similar to the remarks of Frankfort, Chapter 2, Note 15 above.
WOOLLEY, L. *Ur Excavations*, IV, *The Early Periods*. Philadelphia, 1955.
Includes a variety of Early Dynastic works, including sculptures, relief plaques and stele fragments, and steatite vase fragments.

Engraving and Relief (including Inlays)

Major additions to the available material have been made since 1954, both by museum acquisition and excavation, the latter for the most part unpublished or only preliminarily reported. Alongside examples of well-executed relief are others of noteworthily crude workmanship, such as some of the plaques from Nippur or the steles acquired by the Iraq and Metropolitan Museums. These are, however, of great importance as enlargements of the range and character of Early Dynastic art. At the other extreme from the cruder of the stone reliefs are the refined shell and ivory inlays of Mari, the elements of a 'priestesses' panel found near the Early Dynastic Dagon Temple being particularly outstanding.

BASMACHI, F. 'Stela of Ur-Nanshe in the Iraq Museum', *Sumer*, XVI (1960), 45–7; Arabic Section, plates I–III.
CRAWFORD, V. E. 'Art of the Ancient Near East: The Third Millennium B.C.', *Bulletin of the Metropolitan Museum of Art*, XVIII (1960), 245–7 (stele of Ushum-gal).
HANSEN, D. P. 'New Votive Plaques from Nippur', *Jnl Nr East. Stud.*, XXII (1963), 145–66.
HANSEN, D. P., and DALES, G. F. 'The Temple of Inanna, Queen of Heaven, at Nippur', *Archaeology*, XV (1962), 78, figure 6 (inlays), 80, figure 7 (relief vase), 82, figure 11 (plaque).
MOOREY, P. R. S. 'Some Aspects of Incised Drawing and Mosaic in the Early Dynastic Period', *Iraq*, XXIX (1967), 97–116.
PARROT, A. 'Les Fouilles de Mari', *Syria*, XXXIX (1962), 163–8, plates XI, XII, 3 ('priestesses' inlays); XLII (1965), plate XIV, 1, 2 (reliefs); 3 (inlays), plate XV, 3 (inlay); XLIV (1967), plate IV, 1–3 (reliefs and inlays).
PARROT, A. *Les Temples d'Ishtarat et de Ninni-Zaza (Mission archéologique de Mari*, III), Paris, 1967, pt II, chapters II–IV (relief and inlay).

Mari

PARROT, A. *Le Temple d'Ishtar (Mission archéologique de Mari*, I). Paris, 1956.
Final publication, superseding the preliminary reports in *Syria* cited above p. 384, Note 14.
PARROT, A. 'Les Fouilles de Mari: Septième campagne (Hiver, 1951–52) – Dixième campagne (Automne 1954), Douzième campagne (Automne 1961) – Seizième campagne (Printemps 1966)', in *Syria*, XXIX (1952), 183–203; XXX (1953), 196–221; XXXI (1954), 151–71; XXXII (1955), 185–211; XXXIX (1962), 151–79; XLI (1964), 3–20; XLII (1965), 1–24 and 197–225; XLIV (1967), 1–26.

Since 1951 Early Dynastic structures have been excavated in two areas, a palace below the north-east quarter of the great palace of the Isin-Larsa period, and temples, identified by their plans and their contents, and including sculpture with dedicatory inscriptions, lying along a street south-east of the palace and Dagon Temple of the Isin-Larsa period.

Palace

For plan as of Season 1966 see *Syria*, XLIV, 13, figure 9; for location under the Zimrilim palace see *Syria*, XLII, 19, figure 17; description in *Syria*, XLII, 8–9, 11, 16–24, 199–211, and XLIV, 2–3, 9–26.

So far only a portion of the elaborate complex of courtyards surrounded by corridors and halls is known. The niched walls of one court suggest that it belonged to a palace chapel or temple. The existence of two phases of the palace, thought to belong respectively to Early Dynastic II and III, is established.

Quarter of Sanctuaries

For plan of area combine *Syria*, XXXII, 204, figure 10, and XLI, 6, figure 1. Contiguous Ninni-Zaza and Ishtarat Temples (Parrot, *Les Temples d'Ishtarat et de Ninni-Zaza*, pt 1, chapters I–III; plates I–III [plans]).

Both show the typical Early Dynastic plan of a bent-axis cella and subsidiary rooms reached from a court-yard that is itself separated from the entrance by an antechamber. The layout of the main parts of the larger temple, that of Ninni-Zaza, is strikingly regular; its courtyard stands out for its niching on all walls, bitumen-paved walks, and 1.5-metre-high 'masseba' of conical shape.

Shamash (= P25) and Ninkhursag Temples (for plans see *Syria*, XXXI, 168, figure 8, and XXXII, 204, figure 10; for Shamash Temple see *Syria*, XXX, 198–204; XXXI, 159–64; and XXXII, 206–8; for Ninkhursag Temple see *Syria*, XXXI, 167–70, and XXXII, 208–10).

Badly destroyed, adjacent temples, one named from the superimposed Ur III temple with foundation deposits for Ninkhursag – see *Syria*, XXI, 6, figure 4. No cellae are preserved, only courtyards.

Dagon Temple (for plan see *Syria*, XLI, 6, figure 1; description in *Syria*, XXXIX, 159–63, 169–72, and XLI, 5–16).

The plan, still incomplete, suggests the presence of a broad-room cella with direct axis comparable to that of the Inanna Temple at Nippur.

'Massif rouge' (for plan see *Syria*, XXX, 216, figure 14; description in *Syria*, XXIX, 190–4, and XXX, 215–18).

This consists of a mass of mud brick some 9 metres high and 40 × 25 metres in size immediately east of the Dagon Temple; Parrot considers it to be an archaic ziggurat.

Nippur

CRAWFORD, V. E. 'Nippur, the Holy City', *Archaeology*, XII (1959), 74–83.

HANSEN, D. P., and DALES, G. F. 'The Temple of Inanna, Queen of Heaven, at Nippur', *Archaeology*, XV (1962), 75–84.

MCCOWN, D. E. 'Recent Finds at Nippur, A Great City of Ancient Mesopotamia', *Archaeology*, V (1952), 70–5.

The post-war excavations have uncovered two Early Dynastic temples, an anonymous one with a hoard of statues (*Archaeology*, V, 75) and the Inanna Temple. The modest Early Dynastic I structure of rather irregular plan did not develop the usual com-pact form of courtyard with adjoining cella and side rooms. Instead in Early Dynastic II and III the Inanna Temple became an increasingly elongated sequence of courtyards and subsidiary rooms with as focal elements not only a normal bent-axis shrine but also, in the immediately preceding courtyard, a re-markable broad-room cella with a straight axis approach, the scheme to become normal in later times (for plan see *Archaeology*, XII, 75).

Sculpture in the Round

In recent years three sites have provided major additions to the corpus of Early Dynastic sculpture. Some of the statues from Nippur are illustrated in the pre-liminary reports; one example, in the geometric style, is referred to above, Chapter 2, Note 36. Mari has continued to be a productive source of naturalistic sculptures of the Early Dynastic III style; among the outstanding pieces from the sanctuary quarter the cross-legged statue of the singer Ur-Nanshe is prob-ably the most famous, while over life-size pieces, such as an anonymous head and a torso belonging to a Tagge, testify to the ambition of the stone carvers. Despite the importance of the Nippur and Mari finds, they are in certain respects now overshadowed by the startling discovery of Sumerian statues at Tell Khuera in the westernmost part of the Khabur region. Frankfort in 1934 emphasized the importance of the discovery of Sumerian sculpture at Mari, far from the southern Mesopotamian centres of Sumerian civiliza-tion ('Mari and Opis: essai de chronologie', *Revue d'Assyriologie*, XXXI, 173–9). Now the range of Su-merian sculpture has been extended to a site far to the north-west of both of its previous outposts, Mari and Assur. Thus the finds at Tell Khuera will contribute significantly to our understanding of the influence

abroad of Sumerian civilization in the Early Dynastic period. Furthermore, the statues from Tell Khuera represent Frankfort's geometric style of Early Dynastic II and thus provide striking corroboration of that style's existence as a general phase of Sumerian sculpture.

Note that the full titles of articles cited below by journal number are given under the headings of *Mari* and *Nippur*.

CRAWFORD, V. E. 'Art of the Ancient Near East: The Third Millennium B.C.', *Bulletin of the Metropolitan Museum of Art*, XVIII (1960), 247–9 (copper statuette of a naked man carrying a burden on his head).

HANSEN, D. P., and DALES, G. F. *Archaeology*, XV (1962), 79–81 (Nippur).

MOORTGAT, A. *Tell Chuera in Nordost-Syrien: Bericht über die vierte Grabungskampagne 1963*, 17, 23–40. Cologne and Opladen, 1965.

PARROT, A. *Le Temple d'Ishtar*, 67–110, plates XXVI–XLIII (Mari).

PARROT, A. *Mari (Collection des Ides photographiques*, no. 7), plates 6–56. Neuchatel and Paris, 1953.

PARROT, A. *Syria*, XXXIX, plate X; XLI, plate III; XLII, plate XIII.

PARROT, A. *Les Temples d'Ishtarat et de Ninni-Zaza*, pt II, chapter I.

Steatite Vases decorated in Relief
(Discussed above pp. 39–42 and Chapter 2, Note 2)

DELOUGAZ, P. P. 'Architectural Representations on Steatite Vases', *Iraq*, XXII (1960), 90–5.

A large number of such vessels along with a comprehensive discussion of them will be presented by Delougaz in *Miscellaneous Objects from the Diyala Region*, Part I: *Stone Vases, Plain and Decorated* (in preparation).

DURRANI, F. A. 'Stone Vases as Evidence of Connection between Mesopotamia and the Indus Valley', *Ancient Pakistan* (Bulletin of the Department of Archaeology, University of Peshawar), I (1964), 51–96.

PARROT, A. *Le Temple d'Ishtar*, 113–19, plates XLVI–XLIX, LI.

Warka

Eanna II–I (U.V.B., VIII, 14–19, plates 7–13 (Eanna I), 14 (Eanna II); U.V.B., XI, 6–9, plates 4–6; U.V.B., XIX, 14, plate 47).

Most of what is known of the fragmentarily preserved structures surrounding the high terrace of the Early Dynastic period was already published by 1940.

CHAPTER 3

BARRELET, M. T. 'Notes sur quelques sculptures mésopotamiennes de l'époque d'Akkad', *Syria*, XXXVI (1959), 20–37.

Deals with both heads in the round and reliefs; on the basis of the latter suggests a development from a style similar to that of Early Dynastic III to an advanced naturalism with the reign of Naramsin as the climax of Akkadian sculpture. Note Frankfort's discussion of this development and conclusion that 'the reign of Naramsin exhibits the highest achievement of Akkadian sculpture', pp. 85 ff. above.

BOEHMER, R. M. *Die Entwicklung der Glyptik während der Akkad-Zeit*. Berlin, 1965.

A comprehensive study which suggests the division of Akkadian glyptic into three major stages, Akkadian I corresponding approximately to the reign of Sargon and subdivided into three phases, II covering approximately the reigns of Rimush and Manishtusu, and III extending from the reign of Naramsin to the end of the dynasty.

GADD, C. J. 'The Dynasty of Akkad, and the Gutian Invasion', in the *Cambridge Ancient History* (revised ed.), I, chapter XIX. Cambridge, 1966.

STROMMENGER, E. 'Das Felsrelief von Darband-i-Gaur', *Baghdader Mitteilungen*, II (1963), 83–8 and plates 15–18.

A new discussion, with excellent photographs, of the relief considered above on p. 87.

Stele Fragments found c. 1953 near Nasiriyah, southern Iraq

Fragments with prisoners and soldiers from a work of outstanding quality composed in registers are an important addition to the corpus of Akkadian relief.

BASMACHI. F. 'An Akkadian Stele', *Sumer*, X (1956), 116–19. For restoration in museum see *Sumer*, XIII (1959), 222 and figures 1, 2. For good photographs see Strommenger and Hirmer, *The Art of Mesopotamia*, plates 118, 119.

MELLINK, M. J. 'An Akkadian Illustration of a Campaign in Cilicia?', *Anatolia*, VII (1963), 101–15.

CHAPTER 4

GADD, C. J. 'Babylonia *c.* 2120–1800 B.C.', in the *Cambridge Ancient History* (revised ed.), I, chapter XXII. Cambridge, 1965.

GADD, C. J. 'Hammurabi and the End of his Dynasty', in the *Cambridge Ancient History* (revised ed.), II, chapter V. Cambridge, 1965.

MCCOWN, D. E., and HAINES, R. C., assisted by HANSEN, D. P. *Nippur I: Temple of Enlil, Scribal Quarter, and Soundings.* Chicago, 1967.

The Enlil Temple, founded by Urnammu, lies at the foot of the ziggurat and consists of two old-fashioned bent-axis cellae and subsidiary rooms, two with large ovens. The structure was rebuilt in the Kassite period with the same plan. McCown interprets this complex as a 'kitchen temple'. For plan of the Inanna Temple of the Third Dynasty of Ur, incompletely known since the cella area was destroyed by the Parthians, see Hansen and Dales in *Archaeology*, XII (1959), 74.

OPIFICIUS, R. *Das altbabylonische Terrakottarelief.* Berlin, 1961.

A collection of examples from twenty-six sites.

PARROT, A. *Le Palais (Mission archéologique de Mari, II): pt 1: Architecture, Paris, 1958; pt 2: Peintures murales, Paris, 1958; pt 3: Documents et Monuments, Paris, 1959.

Glyptic

The cylinder seals of the Old Babylonian period (Isin-Larsa and First Dynasty of Babylon), considered on p. 126 above, provide many problems, for example in the details of dating, in iconography, and in the relationships with dependent classes of glyptic outside Mesopotamia, as indicated in the following selection of pertinent studies.

AMIET, P. 'Notes sur la répertoire iconographique de Mari à l'époque du palais', *Syria*, XXXVII (1960), 215–32.

Some seal designs reconstituted from ancient impressions are excellent representatives of Old Babylonian glyptic and of its influence in Syria.

BUCHANAN, B. 'On the Seal Impressions on some Old Babylonian Tablets', and 'Further Observations on the Syrian Glyptic Style', *Journal of Cuneiform Studies*, XI (1957), 45–52, 74–6.

KUPPER, J.-R. *L'Iconographie du dieu Amurru dans la glyptique de la I^re dynastie babylonienne* (Académie royale de Belgique, *Mémoires*, LV, no. 1). Brussels, 1961.

NAGEL, W. 'Glyptische Probleme der Larsa-Zeit', *Archiv für Orientforschung*, XVIII (1957–8), 319–27.

List of dated seals or impressions and brief discussion of stylistic groups.

ÖZGÜÇ, N. *Seals and Seal Impressions of Level Ib from Karum Kanish.* Ankara, 1968.

ÖZGÜÇ, N. *The Anatolian Group of Cylinder Seal Impressions from Kültepe.* Ankara, 1965.

These two publications of glyptic from Kültepe are of fundamental importance not only for Anatolian seals, but also for the many classes of glyptic (including Old Assyrian and Old Syrian) dependent on or related to Old Babylonian glyptic.

PORADA, E. 'Syrian Seal Impressions on Tablets dated in the Time of Hammurabi and Samsu-iluna', *Jnl Nr East. Stud.*, XVI (1957), 192–7. See also Porada, review article in *Journal of Cuneiform Studies*, V (1950), 155–62, for impressions which, though in the style current during Hammurabi's reign, are dated as early as Sin-iddinam of Larsa.

Warka

Palace of Sinkashid (for plan see U.V.B., XII, plate 35; for description U.V.B., XVII, 20–3, plate 30a, b; U.V.B., XVIII, 23–9, plates 34–6; U.V.B., XIX, 25–36; U.V.B., XX, 28–32; U.V.B., XXII, 28–30, plates 31–4).

This Old Babylonian complex in the western part of Warka, already discovered in the first season, 1912–13, and extensively dug from 1959 to 1964, appears to have been founded on the ruins of a palace of the period of the Third Dynasty of Ur. Many courtyards and rooms are enclosed within a very regular rectangular area by a buttressed wall.

Eanna District (plan of the structures of the period of the Third Dynasty of Ur already published in 1940 – U.V.B., XI, plate 3).

CHAPTER 5

BERAN, T. 'Die babylonische Glyptik der Kassitenzeit', *Archiv für Orientforschung*, XVIII (1957–8), 255–78.

After due references to earlier discussions of the subject distinguishes three phases: I = an older stage beginning in the Old Babylonian period and characterized by the dominance of inscriptions at the expense of representations, usually limited to one or two human figures and small symbols or filling motifs; II = a fourteenth-century stage closely related to Middle Assyrian glyptic and characterized by refined modelling and a variety of human, animal,

and plant motifs, mountain and water deities being prominent; III = late phase of *c.* thirteenth-eleventh centuries (Herzfeld's group of the Second Dynasty of Isin) characterized by linear execution in soft stone or frit and more limited motifs and simpler composition than in phase II.

JARITZ, K. 'Die Kulturreste der Kassiten', *Anthropos,* LV (1960), 17–84.

A wide-ranging collection of pertinent material and discussion of the probable origins and affinities of the Kassites. The distinction between features typical for the Kassites as a specific group and those merely typical for the civilization of Mesopotamia during the rule of Kassite kings remains a difficult one to draw with certainty.

PORADA, E. *Cylinder Seals from Thebes* (in preparation).

A hoard of lapis lazuli seals found in the Mycenaean palace of Thebes in Boeotia includes a number of important Kassite cylinders as well as those in Aegean styles.

VAN BUREN, E. 'The Esoteric Significance of Kassite Art', *Orientalia,* XXIII (1954), 1–39.

WOOLLEY, C. L. *Ur Excavations,* VIII, *The Kassite Period and the Periods of the Assyrian Kings.* London, 1965.

CHAPTER 6

FINE, H. *Studies in Middle-Assyrian Chronology and Religion.* Cincinnati, 1955.

Assur

HALLER, A. *Die Gräber und Grüfte von Assur (Wissenschaftliche Veröffentlichung der Deutschen Orient-Gesellschaft,* LXV). Berlin, 1954.

Incised ivory pyxis and comb; a complete and a fragmentary alabaster vessel with relief decoration; jewellery.

PREUSSER, C. *Die Paläste in Assur (Wissenschaftliche Veröffentlichung der Deutschen Orient-Gesellschaft,* XLVI). Berlin, 1955.

Architecture; ivory inlays of trees, mountain gods, and winged bulls.

Glyptic

BERAN, T. 'Assyrische Glyptik des 14. Jahrhunderts', *Zschr. f. Assyriol.,* LII, N.F. XVIII (1957), 141–215.

Assyrian and Mitannian seal impressions on tablets from Assur, the earliest belonging to the reign of Assur-nirari II (*c.* 1424–1418), but the majority contemporary with Eriba-Adad I (*c.* 1390–1364) and Assur-uballit I (*c.* 1363–1328); discussion of connexions between Mitannian and Assyrian glyptic.

KANTOR, H. J. 'The Glyptic', in MCEWAN, C. W., *et al., Soundings at Tell Fakhariyah,* 69–81. Chicago, 1958.

Middle Assyrian seal impressions from a site in the Khabur region.

MOORTGAT, A. 'Assyrische Glyptik des 13. Jahrhunderts', *Zschr. f. Assyriol.,* XLVII, N.F. XIII (1942), 50–88.

Seal impressions on tablets from Assur, which are for the most part dated by the names of officials, provide basic information for the early phases of Assyrian art.

MOORTGAT, A. 'Assyrische Glyptik des 12. Jahrhunderts', *Zschr. f. Assyriol.* XLVIII, N.F. XIV (1944), 23–44.

MOORTGAT-CORRENS, U. 'Beiträge zur mittelassyrischen Glyptik', in *Vorderasiatische Archäologie: Festschrift Moortgat,* 165–76. Berlin, 1964.

Additional seal impressions from Assur supplementing those published by Beran and Moortgat.

Tell al Rimah

OATES, D. 'The Excavations at Tell al Rimah, 1964, 1965, 1966', *Iraq,* XXVII (1965), 62–80; XXVIII (1966), 122–39; XXIX (1967), 70–96.

Frankfort, p. 131 above, referred to the obscurity enveloping Assyria until approximately the middle of the second millennium B.C. The excavations at Tell al Rimah were undertaken precisely to provide material to fill this gap and have already revealed a temple and ziggurat complex which existed during most of the second millennium B.C. Its three main stages are III, Old Assyrian, the founding of the complex being attributed to Shamsi-Adad I (*c.* 1726–1694); II, Mitannian, ending at the same time as Nuzi, *c.* 1475; and I, Middle Assyrian, lasting until after the reigns of Shalmaneser I (*c.* 1272–1243) and Tukulti-Ninurta I (*c.* 1242–1206). When originally built, the complex was strictly axial and symmetrical, consisting of a square court surrounded by rooms in front of a classical broad-room antechamber and cella with the ziggurat behind (see plan, *Iraq,* XXIX, plate XXX). The complex is characterized by advanced vaulting construction and by a particularly remarkable and sophisticated architectural decoration of niches and half-columns. The latter are made of bricks carved as spirals or as palm trunks with diamond or scale patterns (*Iraq,* XXIX, plates XXXII,

425

XXXIII,XXXVI,XL). Furthermore, three stone reliefs attributed to the Old Assyrian stage are of great significance as carrying back the use of rather large-sized architectural sculpture to an early date in Assyria (torsos of a hybrid figure, *Iraq*, XXVIII, plate XXXIV, b, and female figure between palms, *Iraq*, XXIX, plate XXXI, a; mask of Humbaba, ibid., plate XXXI, b).

CHAPTER 7

HROUDA, B. *Die Kulturgeschichte des assyrischen Flachbildes (Saarbrücker Beiträge zur Altertumskunde, 11).* Bonn, 1965.
Thorough collection of types of objects represented in Assyrian reliefs.
MALLOWAN, M. E. L. *Nimrud and its Remains.* London, 1966.
Definitive account of the excavations carried out at Nimrud from 1949 to 1963 – architecture, seals, pottery, sculpture, glass, metalwork, and especially ivories. Vol. 11 is devoted to Fort Shalmaneser and the magnificent collection of ivories found within it.
MALLOWAN, M. E. L. A succession of articles entitled 'Excavations at Nimrud (Kalhu)', published annually in *Iraq* (up to vol. XXI, 1959); also in the *Illustrated London News* (from 22 July 1950 to 25 June 1960).
OATES, D. A succession of articles on the excavations at Nimrud and Fort Shalmaneser, published annually in *Iraq* (from vol. XXI, 1959, to vol. XXV, 1963).
PARROT, A. *Nineveh and Babylon.* London, 1961.
Excellent illustrations of Assyrian, Neo-Babylonian and Achaemenid art.
SAFAR, F. 'The Temple of Sibitti at Khorsabad', *Sumer*, XIII (1957), 219 ff.
An account of the discovery of a large temple, situated outside the citadel mound in the low plain between Gate no. 7 and Gate A.
WOOLLEY, C. L., and MALLOWAN, M. E. L. *Ur Excavations IX. The Neo-Babylonian and Persian Periods.* London, 1962.

Relief Sculpture

BARNETT, R. D. *Assyrian Palace Reliefs.* London, 1959.
Good illustrations of reliefs in the British Museum.
BARNETT, R. D. 'The Assyrian Sculptures in the Collection of the Royal Geographical Society', *Geographical Journal*, CXXV (1959), 197 ff.

Publishes reliefs from the palaces of Sennacherib and Assurbanipal at Nineveh.
BARNETT, R. D. 'Canford and Cuneiform. A Century of Assyriology', *Museum Journal*, LX (November 1960), 192 ff.
Includes discussion of seven reliefs from the palace of Sennacherib at Nineveh, discovered in Canford Manor, the home of Sir John Guest. (See also under Smith.)
BARNETT, R. D., and FALKNER, M. *The Sculptures of Assurnasirpal II, Tiglath-pileser III and Esarhaddon from the Central and South-west Palaces at Nimrud.* London, 1962.
Comprehensive account of the excavation of the Central and South-west palaces at Nimrud between 1845 and 1854; publication of all known drawings with photographs of originals.
BARNETT, R. D. 'The Siege of Lachish', *Israel Exploration Journal*, VIII, 3 (1958), 161 ff.
Interpretation of Sennacherib's reliefs from Nineveh.
DYSON, R. H. 'A Gift of Nimrud Sculptures', *Bulletin of the Brooklyn Museum*, XVIII (1957), 1 ff.
Describes twelve reliefs from Nimrud acquired by the museum in 1955.
MADHLOUM, T. A. W. *The Chronology of Neo-Assyrian Art.* In press.
A detailed account of the stylistic development of Assyrian art in the ninth–seventh centuries B.C. which includes a valuable analysis of individual features which may be used as dating criteria. The author also makes an assessment of the influence of Assyria on her neighbours and vice versa.
READE, J. E. 'A Glazed-brick Panel from Nimrud', *Iraq*, XXV (1963), 38 ff.
A panel 4·07 by 2·91 m., originally set into the wall above a doorway in Fort Shalmaneser; dated by inscription to the reign of Shalmaneser III.
READE, J. E. 'More Drawings of Ashurbanipal Sculptures', *Iraq*, XXVI (1964), 1 ff.
Publishes drawings made by Rassam's draughtsman, Charles Hodder, in 1853; the original sculptures are now mostly lost.
READE, J. E. 'Twelve Ashur-nasir-pal Reliefs', *Iraq*, XXVII (1965), 119 ff.
An analysis of the original positions of formal reliefs from the North-west Palace at Nimrud now scattered in various museums, with reference to hitherto unpublished examples.
READE, J. E. 'Two Slabs from Sennacherib's Palace', *Iraq*, XXIX (1967), 42 ff.
Discusses a British Museum relief of Sennacherib, recarved by Assurbanipal, and a relief from the

Metropolitan Museum of New York which the author suggests may depict the Crown Prince.

SMITH, W. STEVENSON. 'Two Assyrian Reliefs from Canford Manor', *Bulletin of Fine Arts, Boston*, LVIII, no. 312 (1960), 45 ff.

See also under Barnett. These two reliefs acquired by Boston depict deportation scenes and mountain combat. The author also discusses comments on the evolution of style from Assurnasirpal II to Assurbanipal.

STEARNS, J. B. 'Reliefs from the Palace of Ashurnasirpal II', *A.f.O.*, Beiheft XV. Graz, 1961.

A description of eighty-three reliefs now in American Museums, mostly excavated by Layard, with an attempt to establish their original positions in the palace.

Sculpture in the Round

GARBINI, G. 'Some Observations on a Boston Assyrian Statuette', *Orientalia*, XXVIII (1959), 208 ff.

A discussion of the statuette of illustrations 176–7 of this volume. See also under Parrot.

KINNIER WILSON, J. V. 'The Kurba'il Statue of Shalmaneser III', *Iraq*, XXIV (1962), 90 ff.

Publishes statue found at Nimrud in 1961; inscription, translation, and general discussion.

PARROT, A. A review article of *Art and Architecture in the Ancient Orient*, in *Journal of Semitic Studies*, 11 (1957), 98 ff.

The author questions the authenticity of the statuette of illustrations 176–7 of this volume. See also under Garbini above.

UNGER, A. 'Die Wiederherstellung der Statue des Königs Salmanaser III von Assyrien', *Turk. Arkeoloji Dergisi*, VII (1957), 42 ff.

Statue in Istanbul Museum, from Nimrud.

Glyptic

MILLARD, A. R. 'The Assyrian Royal Seal Type Again', *Iraq*, XXVII (1965), 12 ff.

PARKER, B. 'Seals and Seal Impressions from the Nimrud Excavations, 1955–8', *Iraq*, XXIV (1962), 26 ff.

Metalwork

PARROT, A. 'Plaques assyriennes', *Syria*, XXXV (1958), 171 ff.

Metal plaques acquired by the Louvre, one with ivory inlay.

STRONACH, D. 'Metal Objects from the 1957 Excavations at Nimrud', *Iraq*, XX (1958), 169 ff.

CHAPTER 8

AMANDRY, P. 'Situles à reliefs des princes de Babylone', *Antike Kunst*, IX (1966), 57–71.

Amandry proposes a tenth-century date and a Babylonian origin for a group of vessels which are cited above, p. 340 and illustration 400, and which are frequently considered western Iranian because of their presumed find spots; see below, Chapter 12, Calmeyer and Maléki.

Warka

Eanna in the Neo-Babylonian period and later (for plan see U.V.B., XIV, plate 5; ibid., 7–11; also U.V.B., XI, 12–15).

CHAPTER 9

AKURGAL, E. *Die Kunst Anatoliens von Homer bis Alexander*. Berlin, 1961.

Superb illustrations, but the text should be used with some caution as attributions and dates are sometimes given on the basis of inconclusive evidence; see the reviews by R. S. Young in *American Journal of Archaeology*, LXVIII (1964), 73 ff.

AKURGAL, E. *Die Kunst der Hethiter*. Munich, 1961.

A comprehensive survey, from the beginnings to *c.* 700 B.C., with a detailed bibliography. Excellent illustrations, including some previously unpublished pieces. The English edition of this work should be avoided, because of inaccuracies in the translation.

MELLINK, M. J. 'Archaeology in Asia Minor', *American Journal of Archaeology*, LIX (1955–).

An invaluable summary of current excavations and archaeological results in Anatolia published yearly.

NAUMANN, R. *Architekur Kleinasiens von ihren Anfängen bis zum Ende der hethitischen Zeit*. Tübingen, 1955.

Anatolia: Prehistoric–Middle Bronze

BLEGEN, C. W. *Troy and the Trojans*. London, 1963.

A useful short account with illustrations.

BURNEY, C. A. 'Eastern Anatolia in the Chalcolithic and Early Bronze Age', *Anatolian Studies*, VIII (1958), 157–209.

Detailed analysis of pottery, problems of dating (including that of the Maikop barrow discussed above on p. 211), and cultural development.

LLOYD, S., and MELLAART, J. *Beycesultan*, I, II. London, 1962, 1965.

This site provides a long stratigraphic sequence, in a region previously blank archaeologically, covering Late Chalcolithic–Early Bronze I–III (vol. 1), Middle Bronze (vol. 2), and Late Bronze (to be published in vol. 3). The Middle Bronze Burnt Palace is an example of partly timbered construction, which is particularly characteristic for Anatolia. Since no written evidence was found the hypothesis that Beycesultan lay within the Luvian state of Arzawa could not be corroborated. For a detailed review see Machteld J. Mellink, 'Beycesultan: A Bronze Age Site in South-western Turkey', *Bibliotheca orientalis*, XXIV (1967), 3–9.

MELLAART, J. *Çatal Hüyük: A Neolithic Town in Anatolia*. London, 1967.

This book summarizes the epoch-making discoveries made during the first three seasons of excavations at Çatal Hüyük. The discovery there of a complex Neolithic culture with an astoundingly specialized religious quarter and art as early as the seventh millennium B.C. is revolutionizing our conceptions of both the origins of civilization in the ancient Near East and of Anatolia's role in that development.

MELLAART, J. 'Excavation at Hacilar, First–Fourth Preliminary Reports', *Anatolian Studies*, VIII (1958), 127–56; IX (1959), 51–65; X (1960), 83–104; XI (1961), 39–75.

A new Neolithic culture with painted pottery and important terracotta figurines.

OLIVER, P. 'Art of the Ancient Near East: The Second Millennium B.C.', *Bulletin of the Metropolitan Museum of Art*, N.S. XVIII (1959–60), 253 ff.

Illustrates a gold ewer and a bronze sistrum and standard akin to objects from Alaça Hüyük and Horoztepe.

ÖZGÜÇ, T. 'The Art and Architecture of Ancient Kanish', *Anadolu*, VII (1964), 27–48.

ÖZGÜÇ, T. *Kültepe-Kaniş. New Researches at the Centre of the Assyrian Trade Colonies*. Ankara, 1959.

The results of the excavations at Kültepe begun in 1948 are to be published as monographs; this one is concerned with the architecture of the early second millennium (Karum Ia–b and II).

ÖZGÜÇ, N. Acemhüyük Excavations: see references listed under Chapter 11, Ivories.

ÖZGÜÇ, N. *The Anatolian Group of Cylinder-Seal Impressions from Kültepe*. Ankara, 1965.

ÖZGÜÇ, N. *Seals and Seal Impressions of Level Ib from Karum Kanish*. Ankara, 1968.

ÖZGÜÇ, T., and AKOK, T. *Horoztepe. An Early Bronze Age Settlement and Cemetery*. Ankara, 1958.

The finds at this site are parallel with those from the graves of Alaça Hüyük; they include bronze weapons, figurines, fibulae, vessels, and furniture attachments.

The Hittite Empire

BERAN, T. *Die hethitische Glyptik von Bogašköy*. Berlin, 1967.

BERAN, T. 'Fremde Rollsiegel in Boğazköy', in K. Bittel a.o., eds., *Vorderasiatische Archäologie : Moortgat Festschrift*, 27–38. Berlin, 1964.

DANMANVILLE, J. 'Iconographie d'Ištar-Šaušga en Anatolie ancienne', *Revue d'Assyriologie*, LVI (1962), 9–30, 175–90.

LAROCHE, E., and SCHAEFFER, C. F. A. 'Matériaux pour l'étude des relations entre Ugarit et le Hatti', in C. F. A. Schaeffer a.o., *Ugaritica III*, 1–161. Paris, 1956.

Tablets found in the palace of Ras Shamra contribute greatly to our knowledge both of the political history of the Hittite empire and of its glyptic art.

MELLINK, M. J. 'A Hittite Figurine from Nuzi', in K. Bittel a.o., eds., *Vorderasiatische Archäologie : Moortgat Festschrift*, 155–64. Berlin, 1964.

ORTHMANN, W. 'Hethitische Götterbilder', in *Vorderasiatische Archäologie (op. cit.)*, 221–9.

OTTEN, H. 'Zur Datierung und Bedeutung des Felsheiligtums von Yazilikaya: Eine Entgegnung', *Zschr. f. Assyriol.*, LVIII, N.F. XXIV (1967), 222–40.

Cites and discusses recent treatments of the problem of the dating of the sanctuary referred to above on p. 392, Note 28.

CHAPTER 10

Professor Frankfort made some references to Palestinian sites, but did not deal in detail with material from these sites. References given below therefore include a few general works which give information on recent research in this field and which themselves include detailed bibliographies.

Discoveries made during the last decade and a half show that the mural painting of Ghassul, mentioned above on p. 239, represents only one aspect of a Chalcolithic culture characterized by its unexpectedly rich and diverse art: see below, Bar-Adon and Perrot.

AMIRAN, R. *The Ancient Pottery of Eretz Yisrael from its Beginnings in the Neolithic Period to the End of the First Temple*. Jerusalem, 1963.

In Hebrew, but numerous illustrations and references.

ANATI, E. *Palestine before the Hebrews*. London, 1963.

DUNAND, M. *Fouilles de Byblos*, 11, *1933–1938*. Paris, 1954–8.

KENYON, K. M. *Archaeology in the Holy Land*. London, 1964.

KUPPER, J.-R. *Northern Mesopotamia and Syria*, in the *Cambridge Ancient History*, 11, chapter 1.
Primarily a historical account, but also discusses topics such as Hurrian elements in the art of the second millennium.

MATTHIAE, P. *Ars Syra*. Rome, 1962.

SCHAEFFER, C. F. A., a.o. *Ugaritica III–IV*. Paris, 1956, 1962.
Included in these volumes are many works of art. Vol. 111 presents evidence very important for Hittite and other glyptic. Vol. IV, though chiefly devoted to stratigraphic soundings (prehistoric–Middle Bronze), also illustrates some important Late Bronze ivories from the palace. For other ivories from the palace see *Syria*, XXXI (1954), plates VIII–X, and Culican, W., *The First Merchant Venturers: The Ancient Levant in History and Commerce* (London, 1966), 58–9, figures 57, 59.

SMITH, W. S. *Interconnections in the Ancient Near East*. New Haven, 1965.

The Fourth and Third Millennia

AMIET, P. 'La Glyptique syrienne archaique', *Syria*, XL (1963), 57 ff.

AMIET, P. 'Cylindres syriens présargoniques', *Syria*, XLI (1964).
Three unpublished seals not included in the previous article.

BAR-ADON, P. 'The Expedition to the Judean Desert, 1961: Expedition C – The Cave of the Treasure', *Israel Exploration Journal*, XII (1962), 215–26, plates 35–42.

BRAIDWOOD, R. *Excavations in the Plain of Antioch*, I, *The Earlier Assemblages*. Chicago, 1960.
This is the publication referred to in Chapter 10, Note 4. See Tadmor, M., 'Contacts between the 'Amuq and Syria–Palestine' (review article), *Israel Exploration Journal*, XIV (1964), 253–69.

DUNAND, M. 'Rapport préliminaire sur les fouilles de Byblos 1957–9', *Bulletin du Musée de Beyrouth*, XVI (1960), 69 ff.

DUNAND, M. 'Rapport préliminaire sur les fouilles de Byblos 1960–2', *Bulletin du Musée de Beyrouth*, XVII (1964), 21 ff.

MOORTGAT, A. *Tell Chuera in Nordost-Syrien:*

Vorläufige Berichte über die Grabungskampagne 1958, 1959, 1960, 1963. Wiesbaden, 1960, 1960, 1962, 1965.
This site on the western edge of the Khabur area is contributing much material for filling the gap in our knowledge of this region during the third and second millennia B.C.; see under sculpture of the Early Dynastic period above.

PERROT, J. 'Statuettes en ivoire et autres objets en ivoire et en os provenant des gisements préhistoriques de la région de Béershéba', *Syria*, XXXVI (1959), 8–19.

PERROT, J. 'Les Ivoires de la 7e campagne de fouilles à Safadi près de Beersheva', *Eretz-Israel*, VII (1963), 92–3.

PERROT, J. 'Une Tombe à ossuaires du IVe millenaire à Azor, près de Tel Aviv', '*Atiqot, Journal of the Israel Department of Antiquities*, III (1961), 1–83.

TUFNELL, O., and WARD, W. A. 'Relations between Byblos, Egypt and Mesopotamia at the End of the Third Millennium B.C.: A Study of the Montet Jar', *Syria*, XLIII (1966), 165–241.

VAUX, R. DE O. P. *Palestine in the Early Bronze Age*, in the *Cambridge Ancient History*, I, chapter XV.
Includes a detailed survey of sites with full bibliography.

The Second Millennium

BARRELET, M.-T. 'Deux Déesses syro-phéniciennes sur un bronze du Louvre', *Syria*, XXXV (1958), 27 ff.
Iconographic and stylistic study of a plaque which the author dates to *c*. 1400–1200 B.C.

DOTHAN, T. *The Philistines and their Culture*. Jerusalem, 1967.
In Hebrew; definitive study with many illustrations and references.

HARAN, M. 'The Bas Reliefs on the Sarcophagus of Ahiram King of Byblos in the Light of Archaeological and Literary Parallels from the Ancient Near East', in *Israel Exploration Journal*, VIII (1958), 15 ff.

KANTOR, H. J. 'Syro-Palestinian Ivories', in *Jnl Nr East. Stud.*, XV (1956), 153 ff.
This is a review article of de Mertzenfeld's *Inventaire commenté des ivoires phéniciens et apparentés découverts dans le Proche-Orient*, and of von Oppenheim's *Tell Halaf III*. In it ivories of the Canaanite era (*c*. sixteenth to thirteenth centuries B.C.), when the Syrian and Palestinian cities were centres for international trade, are classified stylistically. Various problems involving the ivories are discussed, including the persistence of the hybrid Canaanite–Mycenaean class in the first millennium B.C. and its

influence on the large-scale reliefs and sculptures of Tell Halaf.

KENYON, K. M. *Palestine in the Middle Bronze Age*, in the *Cambridge Ancient History*, II, chapter III. Includes a detailed survey of sites and a full bibliography.

MCEWAN, C. W., and others. *Soundings at Tell Fakhariyah*. Chicago, 1958. This is the publication referred to in Note 52 to Chapter 10.

MATTHIAE, P. *Missione archeologia italiana in Siria: Rapporto preliminare della Campagna 1964, 1965, 1966 (Tell Mardikh)* (Università di Roma: Centro di Studi semitici, Serie archeologica, VIII, X, XIII). Rome, 1965, 1966, 1967. A statue in the round and two rectangular basins with relief decoration are dated by Matthiae to the earlier part of the Middle Bronze Age period (early second millennium B.C.). These works are of major importance as they come from an area and a phase which have been almost complete blanks in so far as major sculpture is concerned. The Tell Mardikh pieces are presumably somewhat later than those from Jebelet el Beida discussed above on pp. 242–3.

POSENER, G. BOTTÉRO. J., and KENYON, K. M. *Syria and Palestine c. 2160–1780 B.C.*, in the *Cambridge Ancient History*, I, chapter XXI. Primarily a historical account, but gives up-to-date bibliography and survey of sites.

WOOLLEY, L. *Alalakh. An Account of the Excavations at Tell Atchana in the Hatay, 1937–49*. Oxford, 1955. This is the final publication of the site referred to on p. 246.

YADIN, Y., *et al. Hazor*, I–III. Jerusalem, 1958, 1960, 1961. The Beisan stele (illustration 295) stood for many years as the only known large-scale work in stone from Late Bronze Palestine; one of the very important contributions of the Hazor excavations is a series of statues in the round, steles, and lion orthostats.

CHAPTER 11

Several works on the Urartians and the Phrygians are included in this section: recent research has revealed the importance of these peoples in the first millennium B.C. In particular, it is now realized that they both played a considerable part in the transmission of oriental motifs to the west, especially through the medium of metalwork.

BIRMINGHAM, J. M. 'The Overland Route across Anatolia in the Eighth and Seventh Centuries B.C.', *Anatolian Studies*, XI (1961), 185 ff.

A detailed discussion of the evidence to show that much Urartian and probably Iranian merchandise reached Ionian cities overland across the central Anatolian plateau.

HARDEN, D. *The Phoenicians*. London, 1963. A useful general survey of the Phoenicians and their role in the Mediterranean.

HROUDA, B. *Tell Halaf, IV, Die Kleinfunde aus historischer Zeit*. Berlin, 1962. This volume ends the final publication of the old excavations. Hrouda supports a ninth-century date for the Aramaic levels. See also the review of this volume by J. V. Canby in *American Journal of Archaeology*, LXVIII (1964), 71 ff.

MELLINK, M. J. (ed.). *Dark Ages and Nomads c. 1000 B.C.* Istanbul, 1964. Aspects of the problem of nomadic intrusions in the settled world of ancient Greece and the Near East c. 1000 B.C., when large areas of the ancient world were engulfed in 'Dark Ages'. Discussions of the rise of Thracian and Phrygian tribes in Asia Minor, invasions of Cimmerians and Scythians via the Caucasus, and the Iranian migration which affected the Manneans and brought in the Medes and Persians. This study is of special interest in view of recent excavations at Urartian sites in Turkey and Russia, at Gordion and at Hasanlu; it also has a bearing on the problem of the Luristan bronzes.

SETON-WILLIAMS, M. V. 'Preliminary Report on the Excavations at Tell Rifa'at', *Iraq*, XXIII (1961), 68 ff. This site is probably the ancient Arpad, capital of the Aramaean state Bit-Agusi, which was established in the early ninth-century B.C. and whose relation to Assyria was one of alternating subjugation and revolt.

SETON-WILLIAMS, M. V. 'The Excavations at Tell Rifa'at 1964. Second Preliminary Report', *Iraq*, XXIX (1967), 16 ff. The site revealed levels ranging from Roman of the fourth century A.D. to Chalcolithic of the fifth–fourth millennium. Discoveries include an East Gate of the eighth or seventh century B.C., a diorite statue from the Aramaean level (tenth–ninth century B.C.), and Assyrian, Neo-Babylonian, Achaemenian, and second-millennium Syrian seals.

WEINBERG, S. (ed.). *The Aegean and the Near East. Studies Presented to Hetty Goldman*. New York, 1956.

Architecture

ALBRIGHT, W. F. 'The Date of the Kapara Period at Gozan (Tell Halaf)', *Anatolian Studies*, VI (1956), 75 ff.

The author concludes that most of the Iron I constructions and sculpture at Tell Halaf belong to the time of Kapara, who must be dated to the end of the tenth century B.C. The North-east Palace (Wohnpalast) has nothing to do with Kapara but was the residence of Assyrian governors of the eighth century B.C.

FUGMANN, E. *Hama, Fouilles et recherches de la Fondation Carlsberg 1931–8*, II, *L'Architecture des périodes pré-héllenistiques*. Copenhagen, 1958.
Ranges in date from the Neolithic of the fifth millennium to Late Assyrian.

GÜTERBOCK, H. G. 'When was the Late Hittite Palace at Sakçegözü built?', *B.A.S.O.R.*, CLXII (April 1961), 49 ff.
The author suggests, on the evidence of the reliefs, that the palace was erected as early as the late eighth century B.C.

HANFMANN, G. M. A. 'On the Date of the Late Hittite Palace at Sakçegözü', *B.A.S.O.R.* CLX (December 1960), 43 ff.
Maintains that the palace on Caba Hüyük was inhabited as late as the third quarter of the seventh century B.C.

USSISHKIN, D. 'The Date of the Neo-Hittite Enclosure at Sakçegözü', in *B.A.S.O.R.*, CLXXXI (February 1964), 15 ff.
The author maintains on the basis of the reliefs that there are two levels: I, the wall surrounding the enclosure and its gate; II, the buildings within the enclosure. He dates the portico reliefs to the second half of the eighth century and agrees with Güterbock and Landsberger that the portico probably dates to Mutallu; but he maintains that the gate reliefs are earlier and should be dated to the first half of the eighth century.

Sculpture

VON OPPENHEIM, M., OPITZ, D., and MOORTGAT, A. *Tell Halaf*, III, *Die Bildwerke*. Berlin, 1955.
This is the publication referred to above, Chapter 11, Note 42.

Ivories

BARNETT, R. D. *A Catalogue of the Nimrud Ivories with Other Examples of Ancient Near Eastern Ivories in the British Museum*. London, 1957.
Includes a discussion of Syrian and Phoenician art and a detailed analysis of Near Eastern, Greek, and Etruscan ivories with reference to iconography, style, and technique.

BARNETT, R. D. 'Hamath and Nimrud', *Iraq*, XXV (1963), 81 ff.
Shell fragments associated with ivories from Fort Shalmaneser bore inscriptions in Hittite hieroglyphs referring to Urḫilina, king of Hamath – an enemy of Shalmaneser III – and may thus point to Hamath as the source of some of the ivories.

BARNETT, R. D. 'North Syrian and related Harness Decoration', *Vorderasiatische Archäologie: Studien und Aufsätze (Moortgat Festschrift)*, 21–6, plates 1–5. Berlin, 1964.

BARNETT, R. D. 'Phoenicia and the Ivory Trade', *Archaeology*, IX (1956), 87 ff.
A discussion of the ivories from Arslan Tash, Megiddo, Nimrud, etc., with special reference to iconography.

BROWN, W. L. Review of R. D. Barnett, *Catalogue of the Nimrud Ivories etc.*, in *Palestine Exploration Quarterly* (1958–9), 65 ff.
Incorporates a detailed discussion of the problems related to the styles and chronology of ivories of the first millennium B.C. The author's analysis differs in some respects from that of Barnett: for instance, he questions the viability of Barnett's division of the Nimrud ivories into 'Layard' and 'Loftus' stylistic groups.

MILLARD, A R. 'Alphabetic Inscriptions on Ivories from Nimrud', in *Iraq*, XXIV (1962), 41 ff.
These inscriptions contribute to our knowledge of the origin of the ivories. They include a label probably inscribed 'Hamath' (see also above under Barnett), a plaque inscribed 'Lu'ash', and fitter's marks in Phoenician or Aramaic alphabet.

ORCHARD, J. J. *Equestrian Bridle-Harness Ornaments. Ivories from Nimrud*, Fascicule 1, Part 2 [Catalogue & Plates]. London, 1968. Part 1 [Commentary] in preparation.

ÖZGÜÇ, N. Report on excavations at Acemhüyük in M. J. Mellink, 'Archaeology in Asia Minor', *American Journal of Archaeology*, LXXI (1967), 160–1.

ÖZGÜÇ, N. 'Excavations at Acemhüyük', *Anadolu*, X (1966), 1–52, especially 42–6.
Materials excavated at Acemhüyük in 1966 demonstrate that the ivories referred to on p. 315 and Note 146, Chapter 11 of this volume represent an Anatolian school of art dating to the period of the Assyrian colonies, i.e. *c*. nineteenth–eighteenth centuries B.C.

Metalwork

AMANDRY, P. 'Objets orientaux en Grèce et en Italie aux VIIIᵉ et VIIᵉ siècles avant J.-C.', *Syria*, XXXV (1958), 83–93.

BARNETT, R. D. 'Layard's Nimrud Bronzes and their Inscriptions', *Eretz-Israel*, VIII (1967).

A discussion of bowls, tripods, and sceptre heads found at Nimrud: inscriptions suggest that they represent part of the booty taken by the Assyrians during campaigns in Syria and Phoenicia; they may have been brought to Nimrud in the baggage train of Tiglathpileser III *c.* 740 B.C.

BARNETT, R. D. 'North Syrian and related Harness Decoration', in K. Bittel a.o., eds., *Vorderasiatische Archäologie: Moortgat Festschrift*, 21-6, Berlin, 1964.

BARNETT, R. D. 'A Syrian Silver Vase', *Syria*, XXXIV (1957), 243 ff.

A vase with incised decoration of sphinxes and griffins confronting sacred trees which the author dates to the late eighth–seventh centuries B.C. Includes a discussion of these motifs in the first millennium.

HERRMANN, H.-V. *Olympische Forschungen*, VI, *Der Kessel der orientalisierenden Zeit*, part 1: *Kesselattaschen und Reliefuntersätze*. Berlin, 1966.

KANTOR, H. J. 'A Bronze Plaque with Relief Decoration from Tell Tainat', in *Jnl Nr East. Stud.*, XXI (1961), 93 ff.

Discussion of a triangular horse frontlet, perhaps of the late eighth century B.C., in a 'North Syrian' style; see also Barnett, 1964.

YOUNG, R. 'A Bronze Bowl in Philadelphia', *Jnl Nr East. Stud.*, XXVI (1967), 145–54.

Discussion of a vessel in the North Syrian style decorated with sphinxes and of related objects.

The Phrygians

BARNETT, R. D. *Phrygia and the Peoples of Anatolia in the Iron Age*, in the *Cambridge Ancient History*, II (revised ed.), chapter XXX.

Although primarily a historical account, this chapter includes a section on Phrygian art and is as well an invaluable source of information on the latest discoveries relating to Phrygia; it also includes a full bibliography.

BELLINGER, L. 'Textiles from Gordion', in *Bulletin of the Needle and Bobbin Club*, XLVI (1962), 5 ff.

YOUNG, R. A series of articles on the important Phrygian capital, Gordion:

I.L.N., 10 November 1956, 797 ff.; 17 May 1958, 828 ff.

American Journal of Archaeology, LIX (1955), 1 ff.; LX (1956), 249 ff.; LXI (1957), 319 ff.; LXII (1958), 139 ff.; LXIV (1960), 227 ff.; LXVI (1962), 153 ff.; LXVIII (1964), 279 ff.; LXX (1966), 267 ff.; LXII (1968), 231 ff.

'Bronzes from Gordion's Royal Tomb', *Archaeology*, II, no. 4 (1958), 227 ff.

'The Gordion Tomb', *Expedition*, I, no. 1 (1958), 3 ff.

'Phrygian Construction and Architecture', *Expedition*, II, no. 2 (1960), 2 ff.

'Phrygian Architecture and Construction, II', *Expedition*, IV, no. 4 (1962), 2 ff.

'Gordion of the Royal Road', *Proceedings of the Prehistoric Society*, CVII (1963), 362 ff.

'Early Mosaics at Gordion', *Expedition*, VII, no. 3 (Spring 1965), 4–13.

The Urartians

AKURGAL, E. *Die Kunst Anatoliens von Homer bis Alexander*. Berlin, 1961.

In great part replaces Akurgal, 'Urartäische Kunst', *Anatolia*, IV (1959), 67–114.

BARNETT, R. D., and WATSON, W. 'Further Russian Excavations in Armenia (1949–53)', *Iraq*, XXI (1959), 1 ff.

A summary of excavations at Karmir Blur; much of the material from this site can be closely related to discoveries at Nimrud.

BARNETT, R. D. 'The Urartian Cemetery at Igdyr', in *Anatolian Studies*, XIII (1963), 153 ff.

Translation and summary of a report on a Russian expedition and its discoveries.

BURNEY, C. A. 'A First Season of Excavations at the Urartian Citadel of Kayalidere', *Anatolian Studies*, XVI (1966); 55 ff.

BURNEY, C. A. 'Urartian Fortresses and Towns in the Van Region', *Anatolian Studies*, VII (1957), 37–54.

BURNEY, C. A., and LAWSON, G. R. J. 'Measured Plans of Urartian Fortresses', *Anatolian Studies*, X (1960), 177–96.

BURNEY, C. A. 'Urartian Reliefs at Adilcevaz on Lake Van, and a Rock Relief from the Karasu, near Birecik', *Anatolian Studies*, VIII (1958), 211–18.

MAXWELL-HYSLOP, R. 'Urartian Bronzes in Etruscan Tombs', *Iraq*, XVIII (1956), 150 ff.

MUSCARELLA, O. 'Oriental Origins of Siren Cauldron Attachments', *Hesperia*, XXXI (1962), 317 ff.

ÖZGÜÇ, T. 'Excavations at Altintepe', *Belleten*, XXV (1961), 269 ff.

ÖZGÜÇ, T. 'The Urartian Architecture on the Summit of Altintepe', *Anatolia*, VII (1963), 43 ff.

ÖZGÜÇ, T. *Altintepe. Architectural Monuments and*

Wall Paintings (Türk Tarih Kurumu Yainlarindan,
V. Seri, no. 24). Ankara, 1966.
Excavations began at this great Urartian centre in
1959. Wall paintings decorated the Audience Hall
and Temple and seemed to have been an important
and spectacular part of Urartian decoration under
Assyrian influence.
PIOTROVSKY, P. P. *Iskusstvo Urartu: VIII–VI vv.
do N. E.* Leningrad, 1962.
PIOTROVSKY, P. P. *Vanskoi Tsarstvo (Urartu).*
Moscow, 1959. (English ed., London, 1967.)
VAN LOON, M. N. *Urartian Art: Its Distinctive Traits
in the Light of New Excavations.* Istanbul, 1966.

CHAPTER 12

BISI, A. M. 'Il Grifone nell'arte dell'antico Iran e dei
popoli delle steppe', *Rivista degli Studi Orientali,*
XXXIX (1964), 15–60.
DYSON, R. H. 'Problems of Protohistoric Iran as seen
from Hasanlu', *Jnl Nr East Stud.,* XXIV (1965),
193–217.
With very comprehensive bibliography.
GHIRSHMAN, R. 'Notes iraniennes XII: Statuettes
archaiques du Fars (Iran)', *Artibus Asiae,* XXVI
(1963), 151–60.
GHIRSHMAN, R. *Persia from the Origins to Alexander
the Great.* London, 1964.
Particularly useful for its comprehensive and superb
illustrations.
GHIRSHMAN, R. 'Le Trésor de l'Oxus, les bronzes
du Luristan et l'art mède', in *Festschrift Moortgat*
(1965), 88–94.
GODARD, A. *L'Art de l'Iran.* Paris, 1962.
GOLDMAN, B. 'Early Iranian Art in the Cincinnati
Art Museum', in *The Art Quarterly,* XXVII (1964),
324–41.
Iranica Antiqua, VI (1966): *Melanges Ghirshman,* I.
With articles on various aspects of Iranian and
ancient Near Eastern studies.
Jnl Nr East. Stud., XXIV, Numbers 3 and 4: *Erich F.
Schmidt Memorial Issues.*
With articles on various aspects of Iranian and
ancient Near Eastern studies.
MALLOWAN, M.E.L. *Early Mesopotamia and Iran.*
London, 1965.
A general account of Mesopotamia and Iran in the
third millennium B.C.
POPE, A. U., and ACKERMAN, P., eds. *Survey of
Persian Art,* XIV: *Proceedings of the IVth Internation-
al Congress of Iranian Art and Archaeology (April 24–
May 2, 1960).* Japan, 1967.

Papers on many aspects of Iranian art and archaeo-
logy.
PORADA, E. *The Art of Ancient Iran.* New York, 1965.
A survey of art from *c.* 6000 B.C. to the Sasanians.
VAN DEN BERGHE, L. *Archéologie de l'Iran ancien.*
Leiden, 1959.
Survey of monuments and excavations in Iran up
to the time of writing. Ample bibliography and
illustrations.

YOUNG, T. C., Jr. 'Survey in Western Iran, 1961',
Jnl Nr East. Stud., XXV (1966), 228–39.
YOUNG, T. C., Jr. 'The Iranian Migration into the
Zagros', *Iran,* V (1967), 11–34.
On the basis of both the written and the archaeo-
logical evidence proposes a historical reconstruction
for the phases of migration referred to above, p.
337.

Elam: Prehistoric and Historic Periods

AMIET, P. *Elam.* Auvers-sur-Oise, 1966.
Illustrates and discusses the art of Elam from the
fourth millennium to the seventh century B.C.
AMIET, P. 'Éléments émaillés du décor architectural
néo-élamite', *Syria,* XLIV (1967), 27–46.
AMIET, P. 'Glyptique susienne archaique', *Revue
d'Assyriologie,* LI (1957), 121–9.
BARNETT, R. D. 'Homme masqué ou dieu-ibex?',
Syria, XLIII (1966), 259–76.
GHIRSHMAN, R. 'L'Architecture élamite et ses tradi-
tions', *Iranica Antiqua,* V (1965), 93 ff.
Stresses the importance of the influence of Elamite
architecture on later periods: a typical feature of
second-millennium houses and palaces at Susa – a
long 'reception room' adjacent to the main court – is
found in the palace of Darius at Susa. The author
suggests that these rooms were roofed by a system of
double vaulting, both in Elamite and Achaemenid
times; a system echoed in the palace of Shapur II
(*c.* A.D. 350) at Eiwan-è Kerkha. The author repro-
duces a plan of the palace of Darius at Susa, with the
results of the 1964–5 season added.
GHIRSHMAN, R. 'Une Hache votive au nom du roi
élamite Šilhak-inšušinak (*c.* 1165–1151)', *Iraq,* XXII
(1960), 210 ff.
Suggests that the owners of the Luristan tombs may
have been Cimmerians, since they were mercenaries
in the Assyrian army of Sennacherib when Babylon
was destroyed and Elam invaded.
GHIRSHMAN, R. *Tchoga Zanbil,* I, *La Ziggurat.* Paris,
1966.

LE BRETON, L. 'The Early Periods at Susa, Mesopotamian Relations', *Iraq*, XIX (1957), 79–124.

The evidence which has been accumulating shows that the prehistoric relations between Iran and Mesopotamia referred to above, p. 333, were very complex.

PORADA, E. *Les Cylindres et les cachets de Tchoga Zanbil* (*Mémoires de la Délégation archéologique en Iran*). In press.

VANDEN BERGHE, L. 'Les Reliefs élamites de Mālāmir', *Iranica Antiqua*, III (1963), 22–39.

Choga Zanbil, situated about 40 km. south-east of Susa, was the ancient Dur-Untash, an important religious centre of the Elamite king Untash-GAL. The final report on the contemporary palaces is not yet out, but a good summary will be found in R. Labat, *Elam c. 1600–1200 B.C.*, in the *Cambridge Ancient History*, II, chapter XXIX, section II, 'Architecture and the Arts'.

Hasanlu

AMIET, P. 'Un Vase rituel iranien', *Syria*, XLII (1965), 235 ff.

A comparison of a copper vase acquired by the Louvre with vases found at Hasanlu and dated to the eleventh–ninth centuries B.C.

DYSON, R. H. 'The Death of a City', *Expedition*, II, no. 3 (1960), 2 ff.

'Digging in Iran: Hasanlu 1958', in *Expedition*, I, no. 3 (1959), 4 ff.

'Hasanlu and Early Iran', *Archaeology*, XIII, no. 2 (1960), 118 ff.

'Hasanlu Excavations 1964', *Archaeology*, XVIII (1965), 157 ff.

'Hasanlu Discoveries 1962', *Archaeology*, XVI (1963), 131 ff.

'Hasanlu: 1960 Campaign', *Archaeology*, XIV (1961), 63 ff.

'New Discoveries at Hasanlu', *American Journal of Archaeology*, LXVII (1963), 210 ff.

'Ninth Century Men in W. Iran', *Archaeology*, XVII (1964), 3.

'A Season at Hasanlu', *Archaeology*, XII (1959), 65 ff.

'The Silver Cup of Hasanlu', *Archaeology*, XII (1959), 171 ff.

All these articles relate to excavations at Hasanlu, a citadel-mound apparently occupied since the early third millennium but of most interest at a later period, *c.* 1000–750, when it was an important centre within the territory of the Mannai.

MELLINK, M. J. 'The Hasanlu Bowl in Anatolian Perspective', *Iranica Antiqua*, VI (1966), 72–87.

MUSCARELLA, O. 'Lion Bowls from Hasanlu', *Archaeology*, XVIII (1965), 41 ff.

PORADA, E. 'The Hasanlu Bowl', *Expedition*, I, no. 3 (1959), 19 ff.

VAN LOON, M. N. 'A Lion Bowl from Hasanlu', *Expedition*, IV, no. 4, 14 ff.

YOUNG, T. C., Jr. 'Thoughts on the Architecture of Hasanlu IV', *Iranica Antiqua*, VI (1966), 48–71.

Luristan

BIRMINGHAM, J. 'Luristan Bronzes in the Nicholson Museum, Sydney', *Iran*, I (1963), 71 ff.

Vary in date from the third to the first millennium. Includes a comment on metal technology.

BIRMINGHAM, J., KENNON, N. F., and MALIN, A. S. 'A Luristan Dagger; an examination of ancient metallurgical techniques', *Iraq*, XXVI (1964), 44 ff.

CALMEYER, P. 'Eine westiranische Bronzewerkstatt des 10./9. Jahrhunderts v. Chr. zwischen Zalu Ab und dem Gebiet der Kakavand', *Berliner Jahrbuch für Vor- und Frühgeschichte*, V (1965), 2–65; VI (1966), 55–70.

See also Amandry cited above under Chapter 8.

GHIRSHMAN, R. 'À propos des bronzes inscrits du Luristan de la collection Foroughi', *Iranica Antiqua*, II (1962), 165 ff.

The author states his views on the origins and chronology of some early inscribed 'Luristan' bronzes: inscriptions suggest that some came from Babylon, some from Elam . . . there is a possibility of a link with the Cimmerians. See also above, Ghirshman in *Iraq*, XXII. For a different analysis, see Porada in *The Art of Ancient Iran*.

MALÉKI, Y. 'Une Fouille en Luristan', *Iranica Antiqua*, IV (1964), 1 ff.

The author gives an account of the illicit excavation of a cemetery near Chesmeh Mahi, where she maintains that tenth–ninth-century bronzes of 'Luristan' type were found in a tomb which also yielded pottery of Giyan III type (second millennium B.C.). This statement has been the object of some controversy.

MALÉKI, Y. 'Situle à Scène de Banquet', *Iranica Antiqua*, I (1961), 21 ff.

Discusses chronology of this type of situla and the influence of Mesopotamia. See also Calmeyer cited above.

MAXWELL-HYSLOP, R., and HODGES, H. W. M. 'Three Iron Swords from Luristan', *Iraq*, XXVIII (1966), 164 ff.

MAXWELL-HYSLOP, R. 'Bronzes from Iran in the Collections of the Institute of Archaeology, University of London', *Iraq*, XXIV (1962), 12.

MUNN-RANKIN, J. M. 'Luristan Bronzes in the Fitzwilliam Museum, Cambridge', *Iraq*, XXIX (1967), 1 ff.

Marlik (Amlash) Culture

KANTOR, H. J. 'A Bronze Deer from Iran', *The Nelson Gallery and Atkins Museum Bulletin*, IV (1962), 1–7.

NEGAHBAN, E. O. 'A Brief Report on the Excavation of Marlik Tepe and Pileh Qal'eh', *Iran*, 11 (1964), 13 ff.
Description of tombs containing rich finds of gold and bronze, etc. The author suggests on comparative evidence that the Marlik culture is to be dated to the late second/early first millennium B.C.

NEGAHBAN, E. O. 'Notes on some Objects from Marlik', *Jnl Nr East. Stud.*, XXIV (1965), 309 ff.
Description of seals, bronzes, weapons, jewellery, gold and silver vessels, etc., found in tombs. The richness of the finds may indicate that they are royal tombs. Some are those of warriors buried with their horses.

NEGAHBAN, E. O. *A Preliminary Report on Marlik Excavation: Gohar Rud Expedition: Rudbar 1961–1962*. Tehran, 1964.
Extensively illustrated report on one of the most spectacular and important sites of the Near East, the excavation of which has provided the first definite knowledge of a new culture characterized by wide cultural contacts and an amazingly creative artistic vitality.

TERRACE, E. L. B. 'Some Recent Finds from Northwest Persia', *Syria*, XXXIX (1962), 212 ff.
Unpublished material in the Boston Museum: includes bronzes and gold ornaments dated by the author to c. 1000–800 B.C.

WILKINSON, C. K. 'Art of the Marlik Culture', *Bulletin of the Metropolitan Museum of Art*, XXIV (1965), 101–9.

Median and Achaemenian Art and Architecture

AMANDRY, P. 'Newly Found Achaemenian Gold and Silver', *Illustrated London News*, 27 December 1958, 1140–2; 23 May 1959, 892–3.

AMANDRY, P. 'Orfèvrerie achéménide', *Antike Kunst*, I (1958), 9 ff.
An important study of gold and silver jewellery with discussion of style and dating.

AMANDRY, P. 'Toreutique achéménide', *Antike Kunst*, II (1959), 38 ff.

Discusses fine household ware, in particular amphorae with handles.

BARNETT, R. D. 'Median Art', *Iranica Antiqua*, II (1962), 77 ff.
A discussion of the influences discernible in Median art, the role played by this art, and its chronology.

BARNETT, R. D. 'Persepolis', *Iraq*, XIX (1957), 55 ff.
A review of Schmidt's *Persepolis*, I. In addition, the author gives a catalogue of reliefs from Persepolis acquired through clandestine digging and now scattered throughout the world; present location is given with, wherever possible, original position at Persepolis. An identification of the tributaries is given, partly differing from that of Herzfeld and Schmidt.

COONEY, J. D. 'The Lions of Leontopolis', *Bulletin of the Brooklyn Museum*, XV (1953), 17–30.
A discussion of two Egyptian statuettes showing Persian influence.

COONEY, J. D. 'The portrait of an Egyptian Collaborator', *Bulletin of the Brooklyn Museum*, XV (1953), 1–16.
Discusses evidence of Persian influence in the dress and jewellery shown on an Egyptian statue of the Persian period.

CULICAN, W. *The Medes and Persians*. London, 1965.
A general account of history and art in Iran in the first millennium.

DALTON, O. M. *The Treasure of the Oxus*. London, 1964.
This is the third edition, which has some additions to text and illustrations, and new plates throughout.

GHIRSHMAN, R. 'L'Apadana de Suse', *Iranica Antiqua*, III (1963), 148 ff.
Excavations since 1957 have revealed elements of columns, etc.; the Apadana at Susa was built on an artificial terrace like that of Persepolis. Two inscriptions were found, versions of that of Artaxerxes II, mentioned by Loftus, and referring to a repair carried out by him.

GHIRSHMAN, R. 'Notes Iraniennes: un plat achéménide de la collection Foroughi', *Artibus Asiae*, XXIV (1961), 39 ff.

GOLDMAN, B. 'Achaemenian Chapes', *Ars Orientalis*, II (1957), 43 ff.

HAMILTON, R. W. 'A Silver Bowl in the Ashmolean Museum', *Iraq*, XXVIII (1966), 1 ff.
Publishes a bowl made in Assyria c. 722–612 but later embellished with lions which may be Median: perhaps carried off to the mountains at the fall of Assyria and decorated for a Median owner.

KANTOR, H. J. 'Goldwork and Ornaments from Iran', *The Cincinnati Art Museum Bulletin*, V (1957), 9–20.

Includes a gold cup for which a Median origin is proposed.

KANTOR, H. J. 'Achaemenid Jewelry in the Oriental Institute', *Jnl Nr East. Stud.*, XVII (1958), 1 ff.

SCHMIDT, E. F. *Persepolis*, II, *Contents of the Treasury and other Discoveries; III, The Royal Tombs and other Monuments.* Chicago, 1957, and in preparation. Vol. III, in addition to the Achaemenid rock-cut tombs and the Sasanian reliefs, will discuss in detail the tower at Naksh-i-Rustam and its interpretation.

STRONACH, D. 'Excavations at Pasargadae: First Preliminary Report', *Iran*, I (1963), 19 ff.
'Excavations at Pasargadae: Second Preliminary Report', *Iran*, II (1964), 21 ff.
'Excavations at Pasargadae: Third Preliminary Report', *Iran*, III (1965), 9 ff.
Results of a new series of excavations, conducted under the auspices of the British Institute of Persian Studies, at the first of the two great Achaemenian capitals to be built in ancient Persia.

WILKINSON, C. K. 'The Achaemenian Remains at Qaṣr-i-Abu Naṣr', *Jnl Nr East. Stud.*, XXIV (1965), 341 ff.
Describes a site 4½ miles south-east of Shiraz which is essentially Sasanian, but where some re-used Achaemenian architectural elements survive.

Scythia and the Art of the Steppes

AMANDRY, P. 'L'Art scythe archaique', *Archäologischer Anzeiger* (1966), 891–914.
Discusses Scythian art in the light of important recent discoveries in Iran.

AMANDRY, P. 'Un Motif scythe en Iran et en Grèce', *Jnl Nr East. Stud.*, XXIV (1965), 149 ff.
A discussion of the animal style where the animal is shown 'couché à la mode scythe'. The author concludes that this represents an old Near Eastern motif which the Scythians adopted in the first millennium, and to which they gave a cachet of their own.

GRYAZNOV, M. P. *Drevnie iskusstvo Altaya.* Leningrad, 1958.

GRYAZNOV, M. P. *Pervyi Pazyrykskii Kurgan.* Leningrad, 1950.
The frozen tumuli of Pazyryk in the Altai region have yielded material, much of it of types not normally preserved, of the utmost importance for the history of Scythian art and its relations with that of Persia and also that of the Far East. The first work by Gryaznov cited is a picture book with brief introduction in Russian and French. His second work publishes the first tumulus. For the bulk of the material see the two books by Rudenko listed below.

JETTMAR, K. *Art of the Steppes,* transl. Ann E. Keep. London, 1967.

RICE, T. T. *The Scythians.* London, 1957.

RUDENKO, S. I. *Kul'tura naseleniya gornovo altaya v skifskoe vremya.* Moscow–Leningrad, 1953.

RUDENKO, S. I. *Kul'tura naseleniya tsentral'novo altaya v skifskoe vremya.* Moscow–Leningrad, 1960.

SULIMIRSKI, T. 'Scythian Antiquities in Western Asia', *Artibus Asiae*, XVII (1954), 282–318.

Ziwiyeh

AMANDRY, P. 'A propos du trésor de Ziwiye', *Iranica Antiqua*, VI (1966), 109–29.

BARNETT, R. D. 'The Treasure of Ziwiye', *Iraq*, XVIII (1956), 111 ff.
Challenges Godard's dating and suggests that it was buried *c.* 600 B.C.

DYSON, R. H. 'Archaeological Scrap. Glimpses of History at Ziwiye', *Expedition*, V, no. 3 (Spring 1963), 32 f.
A discussion of surface finds from Ziwiyeh, with analysis of style and date.

KANTOR, H. J. 'A Fragment of Gold Appliqué from Ziwiyé and Some Remarks on the Artistic Traditions of Armenia and Iran during the Early First Millennium B.C.', *Jnl Nr East. Stud.*, XIX (1960), 1 ff.
An analysis of various artistic influences – Urartian, Median, Scythian – discernible in objects from the treasure of Ziwiyeh. See also above, Barnett, in *Iranica Antiqua*, II.

WILKINSON, C. K. 'Assyrian and Persian Art', *Bulletin of the Metropolitan Museum of Art*, XIII (1954–5), 213–24.
Outstanding acquisitions of gold objects: some from Ziwiyeh and others of the Achaemenid period.

WILKINSON, C. K. 'More Details on Ziwiye', *Iraq*, XXII (1960), 213 ff.
Publishes material from Ziwiyeh now in the Metropolitan Museum. Discusses the bronze container in which treasure was reputedly found and part of which is in the Metropolitan Museum.

WILKINSON, C. K. *Two Ram-headed Vessels from Iran* (*Monographien der Abegg-Stiftung*, I). Bern, 1967.

WILKINSON, C. K. 'Treasure from the Mannean Land', *Metropolitan Museum of Art Bulletin*, XXI, (1963), 274–84.
A discussion of the Ziwiyeh treasure.

LIST OF ILLUSTRATIONS

room, from Khorsabad (cf. 168). H.*c*.457cm: 180in. *University of Chicago, Oriental Institute* (Loud 1, figure 56)

179. Khorsabad, citadel, gate A (Loud 2, plate 7)

180. Khorsabad, citadel, gate A, winged genius (cf. 179). H.*c*.365cm: 144in. (Loud 2, plate 46)

181. Khorsabad, citadel, Residence K, Room 12, painted wall. Reconstruction by Charles Altman (Loud 2, plate 88)

182. Assurnasirpal II at war, from Nimrud. H.*c*.99cm: 39in. *London, British Museum* (Photo, Mansell)

183. Fugitives crossing a river, from Nimrud. H.*c*.99cm: 39in. *London, British Museum* (Photo, Mansell)

184. City attacked with a battering ram, from Nimrud. H.*c*.99cm: 39in. *London, British Museum* (Photo, Mansell)

185. Assurnasirpal II killing lions, from Nimrud. H.*c*.99cm: 39in. *London, British Museum* (Photo, Mansell)

186. Assurnasirpal II, from Nimrud. H.*c*.233cm: 92in. *London, British Museum* (Photo, Mansell)

187. Griffin-demons and sacred tree, from Nimrud. H.*c*.109cm: 43in. *London, British Museum* (Photo, Mansell)

188. Weather-god and dragon, relief from the temple of Ninurta, Nimrud

189. Assurnasirpal II receiving homage, from Nimrud. H.*c*.99cm: 39in. *London, British Museum* (Photo, Mansell)

190. Assyrians receiving tribute, from Balawat. H.*c*.27cm: 11in. *London, British Museum* (King 1, plate 64)

191. Tribute from Tyre; Assyrians on the march, from Balawat. H.*c*.27cm: 11in. *London, British Museum* (King 1, plate 13)

192. Assyrians at the source of the Tigris, from Balawat. H.*c*.27cm: 11in. *London, British Museum* (King 1, plate 59)

193. Black Obelisk of Shalmaneser III, from Nimrud. H.*c*.205cm: 81in. *London, British Museum* (Courtesy, Trustees)

194. Booty from a city taken by Tiglathpileser III. H.*c*.101cm: 40in. *London, British Museum* (Photo, Mansell)

195. Religious ceremony, time of Tiglathpileser III, from Nimrud. H.*c*.80cm: 31½in. *Woburn Abbey, Duke of Bedford*

196. Khorsabad, Residence K, Room 12, wall painting. H.*c*.1340cm: 528in. (Loud 2, plate 89)

197. Hunting scene, from Khorsabad. H.*c*.106cm: 42in. *London, British Museum* (Courtesy, Trustees)

198. Courtiers facing Sargon, from Khorsabad. H.*c*.304cm: 120in. *University of Chicago, Oriental Institute* (Loud 1, figure 38)

199. Men bringing offerings, from Khorsabad. H.*c*.304cm: 120in. *Paris, Louvre* (Archives Photographiques)

200. Sennacherib at the capitulation of Lachish, from Kuyunjik (Nineveh). H.*c*.137cm: 54in. *London, British Museum* (Photo, Mansell)

201. Sennacherib's war in the marshes, from Kuyunjik. From a drawing. *London, British Museum* (Layard, plate 25)

202. War in the marshes, detail of illustration 201. H.*c*.152cm: 60in. *London, British Museum* (*Assyrian Sculptures in the British Museum*, 1938, plate L)

203. Sennacherib at war, from Kuyunjik. From a drawing. *London, British Museum* (Gadd, plate 13)

204. Assurbanipal's Arab war, from Kuyunjik. H.*c*.149cm: 59in. *London, British Museum* (Photo, Mansell)

205. Capture of Madaktu, in Elam, from Kuyunjik. H.*c*.149cm: 59in. *London, British Museum* (Photo, Mansell)

206. The sack of the city of Hamanu, from Kuyunjik. H.*c*.91cm: 36in. *London, British Museum* (Photo, Mansell)

207. Elamites in flight, from Kuyunjik. H.*c*.205cm: 81in. *London, British Museum* (Photo, Mansell)

208. The defeat of the Elamites, from Kuyunjik. H.*c*.132cm: 52in. *London, British Museum* (Photo, Mansell)

209. Lions in royal park, from Kuyunjik. H.*c*.99cm: 39in. *London, British Museum* (Photo, Mansell)

210. Lion released and killed, from Kuyunjik. H.*c*.68cm: 27in. *London, British Museum* (Photo, Mansell)

211. Assurbanipal killing a lion, from Kuyunjik. H.*c*.53cm: 21in. *London, British Museum* (Photo, Mansell)

212. Lion springing at Assurbanipal, from Kuyunjik. H.*c*.157cm: 62in. *London, British Museum* (Photo, Mansell)

213. Dying lion, from Kuyunjik. H.*c*.53cm: 21in. *London, British Museum* (Photo, Mansell)

214. Dying lioness, from Kuyunjik. H.*c*.60cm: 24in. *London, British Museum* (Photo, Mansell)

215. Wild asses hunted with mastiffs, from Kuyunjik. H.*c*.53cm: 21in. *London, British Museum* (Photo, Mansell)

216. Herd of gazelles, from Kuyunjik. H.*c*.53cm: 21in. *London, British Museum* (Photo, Mansell)

217. Assurbanipal and queen taking refreshment in a garden, from Kuyunjik. H.*c*.53cm: 21in. *London, British Museum* (Photo, Mansell)

271. Lion, from Malatya. H.*c*.152cm: 60in. *Ankara Museum* (Courtesy, Director General of Antiquities, Ankara)

272. King libating before the gods, from Malatya. H.*c*.81cm: 32in. *Ankara Museum* (Delaporte 2, plate 24)

273. Imamkülü, rock sculpture. H.*c*.180cm: 71in. (Gelb, plate 27)

274. Ivory plaque, from Megiddo. H.*c*.10cm: 4in. (after Loud 3, plates 10, 11)

275. Metal belt, from Boghazköy. H.*c*.10cm: 4in. (*Mitt. X. Or. Ges.*)

276 and 277. Head of a figure, from Jericho. Clay, with eyes of shell. H.*c*.22cm: 9in. *Jerusalem, Palestine Archaeological Museum* (*Ann. Archaeol. Anthrop.*, liv. XXII, plate 53)

278. Figures, from Tell Judeideh. Bronze. H.*c*.19cm: 7½in.; and *c*.13cm: 5½in. *Boston, Museum of Fine Arts* (Courtesy, Robert J. Braidwood)

279. Head, from Tell Brak. Gypsum. H.*c*.17cm: 7in. *London, British Museum* (Courtesy, M.E.L. Mallowan)

280. Stele, from Jebelet el Beida. H.*c*.350cm: 138in. (after Oppenheim)

281. Gold dagger and sheath, from Byblos (Dussaud 1, figure 5)

282. Dagger hilt, from Sakkara (Montet 2, figure 171)

283. Tell Atchana, palace of Yarimlim. Plan (*Antiq. Jnl*, XXVIII, plate 1)

284 to 286. Head of Yarimlim (?) of Alalakh. H.*c*.16cm: 6½in. *Hatay Museum* (Courtesy, Sir Leonard Woolley)

287. Mitannian seal impression (Frankfort 1, figure 99)

288. Mitannian pottery, from Tell Atchana and Tell Billa (*Antiq. Jnl*, XVIII, plates, 11, 16, 18, 19; *Mus. Jnl*, XIII, plate 61)

289. Lion, from Nuzi. Glazed pottery. H.*c*.22cm: 9in. *Philadelphia, Pennsylvania University Museum* (Starr, plate 111B)

290. Knob in the shape of a boar's head, from Nuzi. Faience. H. of disk *c*.12cm: 5in. *Baghdad, Iraq Museum* (Starr, plate 112B)

291. Fragment of a wall painting, from Nuzi palace (Starr, plates 128–9)

292. Painted cup, from Tell Brak. H.*c*.12cm: 5in. (*Iraq*, IX, plate 40)

293. Tell Atchana, palace of Niqmepa. Plan (*Antiq. Jnl*, XIX, plate 3)

294. Stele with weather-god, from Ras Shamra. H.*c*.144cm: 57in. *Paris, Louvre* (Schaeffer 3, plate 23)

295. Stele, from Beisan. Granite. H.*c*.92cm: 37in. *Jerusalem, Palestine Archaeological Museum* (Rowe, frontispiece)

296. Development of gold bowl, from Ras Shamra. D.*c*.17cm: 7in. (Schaeffer 3, plate 8)

297. Figurine, from Mishrife. Bronze. H.*c*.17cm: 7in. *Paris, Louvre* (Archives Photographiques)

298. Figurine, from Ras Shamra. Bronze. H.*c*.25cm: 10in. *Paris, Louvre* (Schaeffer 2, plate 29)

299 and 300. Figurine, from Beirut. Bronze. H.*c*.16cm: 6½in. *Paris, Louvre* (Archives Photographiques)

301. Engraved foil, from Tyre. Bronze (Dussaud, figure 64)

302. Dish, from Ras Shamra. Gold. D.*c*.19cm: 8in. *Paris, Louvre* (Schaeffer 3, plate 1)

303. Gaming board, from Enkomi. Ivory. H.*c*.5cm: 2in. (drawing by Helene J. Kantor)

304. Griffin, from Megiddo. Ivory inlay. H.*c*.3cm: 1½in. *University of Chicago, Oriental Institute* (Loud 3, plate 9)

305. Ivory inlay, from Byblos. H.*c*.3cm: 1½in. *Paris, Louvre* (Montet 1, plate 142, 878)

306. Mirror handle, from Enkomi. H.*c*.12cm: 5in. *London, British Museum* (Courtesy, Trustees)

307. Lid of a box, from Minet el Beida. Ivory. H.*c*.15cm: 6in. *Paris, Louvre*

308 and 309. Ivory objects, from Megiddo. H.*c*.22cm: 9in.; *c*.12cm: 5in. *University of Chicago, Oriental Institute* (Loud 3, plates 39, 43)

310. Comb, from Megiddo. Ivory. H.*c*.6cm: 2in. (drawing by Helene J. Kantor)

311. Bes, from Megiddo. Ivory inlay. H.*c*.10cm: 4in. *Jerusalem, Palestine Archaeological Museum* (Loud 3, plate 8)

312. Sphinx, from Megiddo. Ivory inlay. H.*c*.10cm: 4in. *University of Chicago, Oriental Institute* (Loud 3, plate 7)

313. Two sides of a carved rod, from Megiddo. Ivory. H.*c*.19cm: 7½in. (Loud 3, plate 22)

314 and 315. Chariot battle and feast on ivory inlay, from Megiddo. H.*c*.5cm: 2in. (Loud 3, plate 32)

316. Victorious homecoming and feast on ivory inlay, from Megiddo. H.*c*.6cm: 2½in. (Loud 3, plate 4)

317. Ahiram's sarcophagus, from Byblos. H. without cover 80cm: 32in. (*Syria*, XI, figure 180)

318. Cover of Ahiram's sarcophagus (*Syria*, XI, figure 181)

319 and 320. Lions, from Alalakh. Basalt. H.*c*.121cm: 48in. *Antioch Museum* (*Antiq. Jnl*, XXX, plates 3, 4)

321. Weight in the shape of a lion mauling a bull, from Tell el Amarna (?). Red jasper. H.*c*.6cm: 2½in. *London, British Museum* (Courtesy, Trustees)

322. Figure, from Megiddo. Bronze covered with gold foil. *University of Chicago, Oriental Institute* (Courtesy, Director)

Arslan Tash. Ivory inlay. H.*c*.8cm: 3½in. *Paris, Louvre* (Thureau-Dangin a.o., plate 26)

379. Ram-headed sphinxes between 'sacred trees', from Arslan Tash. Ivory inlay. *Paris, Louvre* (Thureau-Dangin a.o.)

380. Winged sphinx, from Khorsabad. Ivory inlay. H.*c*.9cm: 3½in. *Baghdad, Iraq Museum* (Loud 2, plate 52, 43)

381. Winged griffins and plants, from Nimrud. Ivory inlay, partly gilt and inlaid with lapis lazuli and other coloured stones. H.*c*.12cm: 5in. *London, British Museum* (Photo, Mansell)

382. Ivory inlay, from Nimrud. H.*c*.6cm: 2¾in. *London, British Museum* (Courtesy, British School of Archaeology in Iraq)

383. 'Astarte at the Window', from Khorsabad. Ivory inlay. H.*c*.10cm: 4in. *Iraq, Baghdad Museum* (Loud 2, plate 51, 29)

384. Bracelet, from Cyprus. Gold (Perrot et Chipiez, 111, figure 603)

385. Cypriot capital of a pilaster (Dussaud 1, 323)

386. Bronze bowl, from Nimrud. D.*c*.16cm: 6½in. *London, British Museum* (Courtesy, Trustees)

387. Bronze bowl, from Nimrud. D.*c*.22cm: 9in. *London, British Museum* (Courtesy, Trustees)

388 and 389. Bronze bowl, from Nimrud. D.*c*.21cm: 8½in. *London, British Museum* (Courtesy, Trustees)

390. Bronze bowl, from Olympia. D.*c*.20cm: 8in. (Perrot et Chipiez, figure 550)

391. Bronze bowl, from Nimrud. D.*c*.21cm: 8½in. *London, British Museum* (Courtesy, Trustees)

392. Bowl, from the Bernardini tomb at Palestrina. Bronze

393. Bowl, from Curium, Cyprus. Bronze (Perrot et Chipiez, figure 552)

394. Prehistoric vases, from Susa (after Pottier)

395. Prehistoric cup, from Persepolis. H.*c*.19cm: 7½in. (after Langsdorff and McCown, plates 4, 10)

396. Statue of Queen Napirasu, from Susa. Bronze. H.*c*.129cm: 51in. *Paris, Louvre* (Photo, Giraudon)

397. Figure of a god, from Susa. Bronze. H.*c*.17cm: 7in. *Paris, Louvre* (Photo, Giraudon)

398. Centauress, part of a throne, from Toprak Kale, near Van. Bronze. H.*c*.20cm: 8in. *London, British Museum* (Courtesy, Trustees)

399. Disk, from the Ziwiyeh treasure. Silver (Courtesy, Dr and Mme Ghirshman)

400. Buckets, from Luristan. Bronze (Contenau 2, IV, 2172–3)

401. Pinheads (*Syria*, XXVI, figures 2, 6, 7)

402. Two horse-bits and four cheek-pieces, from Luristan (Schaeffer 1, figure 266, nos. 9, 10, 11)

403 and 404. Pinheads, from Luristan. Bronze.

H.*c*.17cm: 6¾in.; *c*.12cm: 5in. *David-Weill Collection* (Godard, plates 38, 159; 36, 156)

405. Pole top, from Luristan (after Godard)

406. Pole top, from Luristan. Bronze. H.*c*.30cm: 12in. *Paris, Louvre* (*Encyclopédie photographique de l'art*, 11, 33A)

407. Pole top, from Luristan. Bronze. H.*c*.20cm: 8in. *A. Godard Collection* (Godard, plate 55, 203)

408. Pole top, from Luristan. Bronze. H.*c*.13cm: 5¼in. *Bela Heine Collection* (Godard, plate 53, 197)

409. War axes, from Luristan (Schaeffer 1, figure 266, nos. 2, 3)

410. Halberd blades, from Luristan (Schaeffer 1, figure 265, nos. 9, 10)

411. The T. E. Lawrence dagger-hilt. Silver. H.*c*.15cm: 6¼in. *London, British Museum* (Courtesy, Trustees)

412. Masjed-i-Sulaiman, terrace. Plan (*Syria*, XXVII, 208)

413. Pasargadae. Plan (after Herzfeld, plate 42)

414. Persepolis. Plan (Courtesy, Dr Erich F. Schmidt)

415. Persepolis, Gate of Xerxes (Courtesy, Dr Erich F. Schmidt)

416. Persepolis, staircase leading to the Tripylon (Courtesy, Dr Erich F. Schmidt)

417. Persepolis, staircase leading to the Tripylon, detail (Courtesy, Dr Erich F. Schmidt)

418. Bactrian leading camel (cf. 439) (Courtesy, Dr Erich F. Schmidt)

419. Column of wood covered with painted plaster, from the treasury of Persepolis (Courtesy, Dr Erich F. Schmidt)

420. Capital, from Neandria (after Puchstein)

421. Capital, from Naucratis (after Poulsen)

422. Delphi, column of the Naxians (after Herzfeld)

423. Stand, from Curium, Cyprus. Bronze. H.*c*.11cm: 4½in. *London, British Museum* (Courtesy, Trustees)

424. Persepolis, Hall of the Hundred Columns. Reconstruction by Charles Chipiez (Perrot et Chipiez, v, plate 8)

425. Column, from Persepolis (Courtesy, Director, Oriental Institute, University of Chicago)

426. Column with human-headed bull capital, from the Tripylon, Persepolis (cf. 442) (Courtesy, Dr Erich F. Schmidt)

427. Pasargadae, winged genius on a door jamb (after Ker-Porter)

428. Behistun, rock relief of Darius I (G. Bourdelon)

429. Figurine. Silver. H.*c*.12cm: 5in. *Berlin Museum* (Upham Pope ed., plate 108A)

430. Persepolis, treasury, Darius with Xerxes, giving

INDEX

References to the notes are given only where they indicate matters of special interest or importance; such references are given to the page on which the note occurs, followed by the number of the chapter to which it belongs, and the number of the note. Thus, the reference 384(2)[19] indicates that the entry will be found on page 384, in the note numbered 19 under the heading of chapter 2.

THE PELICAN HISTORY OF ART

COMPLETE LIST OF TITLES

* Published only in original large hardback format.

† Latest edition in integrated format (hardback and paperback).

‡ Latest edition in integrated format (paperback only).

§ Published only in integrated format (hardback and paperback).

‖ Not yet published.

* Published only in original large hardback format.
† Latest edition in integrated format (hardback and paperback).
‡ Latest edition in integrated format (paperback only).
‖ Not yet published.